Unpacking Culture

WITHDRAWN

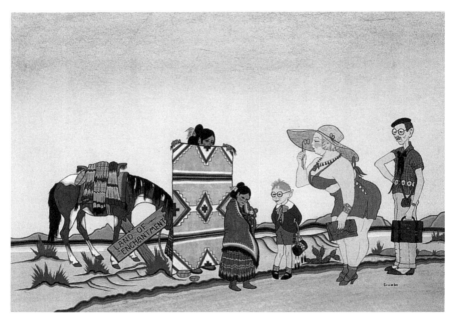

Woodrow (Woody) Crumbo (Potowatomi, 1912–89), *Land of Enchantment,* c. 1946, watercolor on board (17.5 × 23 inches). Gift of Clark Field. The Philbrook Museum of Art. Reproduced by permission.

Unpacking Culture

Art and Commodity
in Colonial and Postcolonial Worlds

EDITED BY

Ruth B. Phillips and
Christopher B. Steiner

UNIVERSITY OF CALIFORNIA PRESS

Berkeley Los Angeles London

University of California Press
Berkeley and Los Angeles, California

University of California Press, Ltd.
London, England

Library of Congress Cataloging-in-Publication Data

Unpacking culture : art and commodity in colonial and postcolonial worlds / edited
 by Ruth B. Phillips and Christopher B. Steiner.
 p. cm.
 Includes bibliographical references and index.
 ISBN 0-520-20796-3 (alk. paper). —ISBN 0-520-20797-1 (alk. paper)
 1. Tourist trade and art. 2. Art and society. 3. Art—Economic aspects.
I. Phillips, Ruth B. (Ruth Bliss), 1945– . II. Steiner, Christopher Burghard.
 N72.T68U57 1999
 306.4'7—dc21 98-38035
 CIP

Printed in the United States of America
 9 8 7 6 5 4 3 2 1

CONTENTS

PART SIX · STAGING TOURIST ART:
CONTEXTS FOR CULTURAL CONSERVATION

ILLUSTRATIONS

PREFACE

The origins of this volume go back to the first meeting of the coeditors at a College Art Association conference in 1992, where Christopher Steiner presented a paper on his research into the commoditization of contemporary West African art. Ruth Phillips, sitting in the audience, was struck by the remarkable parallels between the Côte d'Ivoire art market in the 1990s and her research on souvenir production by northeastern Native Americans in the eighteenth century. The similarities of process occurring in two parts of the world so widely separated in space and time seemed to point to the importance of examining the commoditization of non-Western arts in broader frameworks of colonial power relations and capitalist economics than was usual in the literature.

The announcement of a conference on the theme "Arts and Goods," organized jointly by the Council for Museum Anthropology and the American Ethnological Society, offered an ideal opportunity to pursue this subject by bringing together an interdisciplinary group of scholars who would present and analyze case studies of the development of commoditized arts in different periods and places. About half of the chapters in this volume were presented at a panel discussion entitled "Hybrid/Purebred: Art, Authenticity, and Touristic Production in Colonial Contexts," organized by the editors for that conference, which was held in Santa Fe, New Mexico, in April 1993. The remaining chapters were solicited after the conference in order to provide as broad a view of the topic as possible. It may strike readers that there is a preponderance of essays that address Native American topics. Although partly a matter of circumstance, this balance also reflects the increasing focus of Native Americanists interested in art and material culture on the long-ignored transitional era of the late nineteenth and early twentieth centuries. This focus is, in turn, representative of work being done by scholars in other

settler colonial societies, such as Australia and New Zealand. Although we were unfortunately unable to include studies of arts from that part of the world, we recommend that readers consider the growing literature on this region alongside this collection.

This book is the first anthology on the broadly defined topic of "tourist" arts since the landmark publication of Nelson Graburn's edited volume *Ethnic and Tourist Arts: Cultural Expressions from the Fourth World,* published in 1976 by the University of California Press. Graburn's book was developed, in part, from an Advanced Seminar at the School of American Research on the topic "Contemporary Developments in Folk Art," held in Santa Fe in April 1973— exactly twenty years before the conference that inspired this volume.[1] Although Graburn's original seminar was relatively small in scope—in attendance were Richard Beardsley, Paula Ben-Amos, Edmund Carpenter, Charles Cutter, Kate Peck Kent, Yvonne Lange, Renaldo Maduro, and Lucy Turner— the published volume that grew out of the seminar included many of the major scholars in art and anthropology from the late 1960s and early 1970s.

Ethnic and Tourist Arts grouped its essays by region, a practice that was consistent with the area studies approach of anthropological work during the 1970s. In contrast, we have organized the essays in this volume thematically in order to highlight common aspects of global process and shared experiences of colonialism and postcolonial critique. Many of the essays could fit under more than one heading. The overlapping nature of the themes points to the multiple representational functions of the objects and to the different subject positions of makers and consumers elucidated in many of the essays.

This book brings together a distinguished international group of art historians and anthropologists, who are among the leaders in current thinking and research on the subjects of the production, circulation, and consumption of commoditized art forms. Their essays illustrate how the study of so-called tourist art fits into broader trends in present-day anthropology and art history. They point to the fact that the academic investigation of these art forms is almost as fiercely contested and controversial today as it was when Graburn published his seminal study two decades ago.

Unpacking Culture: Art and Commodity in Colonial and Postcolonial Worlds aims to "unpack" some of the mystifications of meaning and value that surround commoditized art forms in the contexts of the gallery and the marketplace, the museum and the exposition, the private collection and the domestic interior. In so doing, this volume of essays also strives to unload and, as it were, (en)lighten some of the symbolic baggage that such art forms carry with them in their rapid flow through the world economic system.

In putting together this volume we have benefited from the help and advice of the contributors, especially Nelson Graburn, who supported the initial

idea for the panel and whose scholarship and teaching have facilitated all work in this area. We would also like to thank Susan Bean for her role in organizing the "Arts and Goods" conference and for her critical insight at various stages of our project. Monica McCormick enthusiastically welcomed the manuscript, and she and Sue Heinemann oversaw the book's publication at the University of California Press. We also wish to thank the four anonymous readers for the Press, whose feedback was instrumental in helping us refine the structure of the book. Finally, we are especially grateful to the Getty Research Institute for the History of Art and the Humanities for logistical support during the last stages of editing and production and, in particular, to staff photographers Jobe Benjamin and John Kiffe for their exquisite work. Last-minute photographic work was provided graciously by Michael Brandon-Jones of the School of World Art Studies and Museology at the University of East Anglia. Final bibliographic research and cross-checking could not have been accomplished without access to the comprehensive collections of the Robert Sainsbury Library at the University of East Anglia; and we are especially grateful to Pat Hewitt and Asia Gaskell for their kind assistance there.

Ruth B. Phillips
Vancouver, British Columbia

Christopher B. Steiner
New London, Connecticut

Introductory Remarks

Art, Authenticity, and the Baggage of Cultural Encounter

Ruth B. Phillips and Christopher B. Steiner

Whereas in the Western ideal the artist is a fiercely independent, even rebellious, creator of art for art's sake, the African artist aims to please his public. This does not make all African artists crassly commercial, although that epithet can be justly applied to those who turn out knick-knacks for the tourist trade.
"AFRICAN ART BLACK MAGIC," *ECONOMIST*, DECEMBER 24, 1994

Throughout history, the evidence of objects has been central to the telling of cross-cultural encounters with distant worlds or remote Others. The materiality and physical presence of the object make it a uniquely persuasive witness to the existence of realities outside the compass of an individual's or a community's experience. The possession of an exotic object offers, too, an imagined access to a world of difference, often constituted as an enhancement of the new owner's knowledge, power, or wealth. Depending on the circumstances of their acquisition, such objects may evoke curiosity, awe, fear, admiration, contempt, or a combination of these responses. The exotic object may variously be labeled trophy or talisman, relic or specimen, rarity or trade sample, souvenir or kitsch, art or craft.

For the past century or so, the objects of cultural Others have been appropriated primarily into two of these categories: the artifact or ethnographic specimen and the work of art. They have, that is, been fitted into the scholarly domains defined in the late nineteenth century when anthropology and art history were formally established as academic disciplines. As a construction, however, this binary pair has almost always been unstable, for both classifications masked what had, by the late eighteenth century, become one of the most important features of objects: their operation as commodities circulating in the discursive space of an emergent capitalist economy. Although the growth of a consumer commodity culture in Europe and North America has undoubtedly been one of the most important organizing forces of social and economic life during the past two centuries, there has been a surprising silence about processes of commoditization in standard art histories and ethnographies.[1] Scholars whose theories privileged this new reality—

from Marx to Veblen, Baudrillard, and Bourdieu—were, until quite recently, marginalized within orthodox art history and anthropology.

The inscription of Western modes of commodity production has been one of the most important aspects of the global extension of Western colonial power. Moreover, the role of this process in transforming indigenous constructions of the object has intensified rather than diminished in many parts of the world since the formal demise of colonial rule. This volume explores instances of this inscription, together with other equally significant processes of mediation and negotiation engaged in by the inhabitants of colonial and postcolonial worlds. In every case, important consequences have flowed from innovations in the design, production, and marketing of objects, not only to those who consumed them but also to those who produced them. The makers of objects have frequently manipulated commodity production in order to serve economic needs as well as new demands for self-representation and self-identification made urgent by the establishment of colonial hegemonies.

The studies in this book range broadly both geographically and historically. The comparative perspective they offer reveals repeating patterns of imperialist encounter and capitalist exchange, as well as specific cultural and historical factors that give local productions their unique forms. Although the objects under discussion originated in such diverse times and places as mandarin China circa 1850, the American Plains circa 1880, and Kenya circa 1994, they are all equally difficult to contain within the binary schema of art and artifact. In some instances, where the fact of commoditization could be hidden, the objects have been accorded a place in one or the other category. In others, where their commoditized nature has been all too evident, they have most often fallen into the ontological abyss of the inauthentic, the fake, or the crassly commercial. A particularly dense aura of inauthenticity surrounds objects produced for the souvenir and tourist trades because they are most obviously located at the intersection of the discourses of art, artifact, and commodity. Many of the essays in this collection focus on "tourist arts" and offer particularly concentrated examples of the clash and resolution of culturally different ideas about the nature of authenticity.

Unpacking Culture is, in many ways, a successor to the groundbreaking anthology edited two decades ago by Nelson H. H. Graburn, *Ethnic and Tourist Arts: Cultural Expressions from the Fourth World* (1976). That volume was the first major publication to pay serious scholarly attention to the art commodities of marginalized and colonized peoples and to recognize their importance in the touristic production of ethnicity. In his introduction Graburn established a model that set the terms for the discussion of these arts. For the present volume, Graburn has provided a concluding essay, which discusses trends in the study of tourist art during the intervening years and the

relationship of the individual essays in this volume to the current field of study.

Scholars today also build on recent discussions of primitivism and of the representation of non-Western arts, subjects that have achieved a new prominence in postcolonial art history and anthropology. For example, Arthur Danto et al. (1988), Sally Price (1989), Marianna Torgovnick (1990), Susan Hiller (1991), Thomas McEvilley (1992), Michael Hall and Eugene Metcalf (1994), Elazar Barkan and Ronald Bush (1995), George Marcus and Fred Myers (1995), and Deborah Root (1996) have investigated the appropriation of non-Western artists into Western aesthetic discourses. Graburn (1976a, 1984), Bennetta Jules-Rosette (1984), and more recently James Clifford (1985, 1988, 1997), Suzanne Blier (1989), Sidney Kasfir (1992), Shelly Errington (1994a), Barbara Babcock (1995), and Marta Weigle and Barbara Babcock (1996) have examined the circulation of objects among categories of scientific specimen, art, souvenir, and others. Arjun Appadurai (1986b) and Igor Kopytoff (1986) examine anthropological conceptualizations of commoditized exchange, and Nicholas Thomas (1991) and Ruth Phillips (1998) scrutinize specific historical negotiations of commoditization and art in the western Pacific and northeastern North America, respectively. Steiner's study of the contemporary West African art market (1994) focuses most closely on the mediation of knowledge that accompanies twentieth-century manifestations of art and artifact commerce, a complex network of cultural transactions similar to those addressed by many of the essays in this book.

Much of the literature on the reception of non-Western arts takes the dualistic art/artifact distinction as a given and focuses on its ambiguities and inadequacies. Confining the problem within these parameters, however, puts us in danger of validating the very terms that require deconstruction (see Faris 1988). Similar difficulties were articulated in the 1980s by Rozsika Parker and Griselda Pollock (1981) in relation to the feminist revision of standard art-historical discourse. They argued for the deconstruction of the conventional classification of art into major and minor genres ("fine" and "applied" arts) because those hierarchies have devalued women's art. Like Parker and Pollock, we do not underestimate the difficulty inherent in challenging the categories with which scholars have been trained to think, but we concur that this process is crucial to the "radical reform" of the disciplines that is now under way.[2]

In the remainder of this introduction, we outline the historiographical context that has given rise to problematic aspects of contemporary Western practices of representation and evaluation of non-Western arts particularly pertinent to the essays in this book. We examine the formation of three parallel discourses about objects, formalized during the second half of the nineteenth century, which continue to inform the thinking of both scholars and

consumers about these arts. These three discourses arose from (1) the art-historical classification system of fine and applied arts, (2) anthropological theories of the evolution and origins of art, and (3) Victorian responses to the industrial production and commoditization of art. We aim, in particular, to add to the dichotomy of art and artifact a third, pivotal category, the commodity, and, further, to discuss how some aspects of the discourses surrounding all three were complementary and mutually reinforcing while others were intersecting, contingent, and contradictory. In the last section of this introduction we demonstrate the continuing operation of these paradigms, together with their contradictions, by examining the Western context into which most global art commodities are absorbed and which therefore can be said to provide their primary raison d'être, the interior decoration of the "modern" home.

FOLDING NON-WESTERN OBJECTS INTO WESTERN ART HISTORY

Despite the mythology of "discovery" that surrounds the promotion of non-Western art by early-twentieth-century modernist artists, this encounter is only the latest in a succession of appropriations of non-Western objects into the Western art and culture system. By 1907 the ground had been well prepared by half a century of theoretical work by Victorian art theorists and anthropologists (see Goldwater 1967; Jonaitis 1995). The growth of the two bodies of theory generated by these scholars was, furthermore, closely entwined. Anthropologists and art theorists thought with each other's categories, swapping between them particular concepts of the "primitive" and exchanging standard typologies of media and genre.

The standard Western system of art classification has its origins in the sixteenth century in the emergence of the concept of the artist as an autonomous creator, but its intellectual armature was provided three centuries later by the new discipline of art history in texts written by a group of Germanic scholars whom Michael Podro (1982) has termed the "critical historians of art." As he has written, these scholars grounded their work in "the Kantian opposition between human freedom and the constraints imposed by the material world" (xxi). Human beings, according to Kant, are fettered by their physical dependency on Nature, but are free in their exercise of Reason. "The role of art," Podro summarizes, "was seen as overcoming our ordinary relations to the world." Within the realm of the aesthetic, therefore, the highest forms are those that are most free—"art for art's sake"—and the lowest are those that are the most utilitarian. The defining force of the concept of fine art as free creation was further supported in the 1930s by the Idealist aesthetics of Collingwood and has remained relatively undisturbed since then in mainstream art history.[3]

The incorporation of non-Western objects into the disciplinary fold of

art history that began around the middle of the twentieth century was a lib-eral gesture of inclusion typical of its era. Formal recognition was extended, like the political sovereignty granted to a newly independent colony, but the infrastructure of Western knowledge formations remained firmly in place. To be represented as "art," in other words, the aesthetic objects of non-Western peoples had to be transposed into the Western system of clas-sification of fine and applied art.[4] Feminist and Marxist art historians have revealed how this system reinforces hierarchies of gender and class. Its hege-monic implications for race have, however, been less clearly set out, in large part because the highly selective promotion of non-Western art by modernist artists has constructed the illusion that a universalist inclusiveness has been achieved.

The worldwide distortion of indigenous systems for attributing value to objects through the modernist inscription of a discourse of "primitive art" is particularly well illustrated by the example of Native American arts. The visual aesthetic traditions of the majority of these peoples are a particularly bad "fit" with the Western classification system, for Western hierarchies of media, genre, and conditions of production rarely match those that have historically operated within Native American communities. In order to iden-tify a corpus of objects that could be identified as fine art—that is, sculpture (monumental, if possible) and graphic depiction (painted, if possible)— scholars have often privileged objects of lesser status within their producing communities, arbitrarily promoting some regions of the continent over oth-ers and ignoring the indigenous systems of value and meaning attached to objects.[5]

ANTHROPOLOGICAL THEORIES OF THE ORIGINS OF ART

The nineteenth-century critical historians of art also grounded their work in a Hegelian notion of progress in which the increased freedom of the artist and the greater incidence of fine art become signs of advanced civilization. The idea of progress in history closely parallels the belief in the historical evolution of human material cultures formalized during the second half of the nineteenth century by early European anthropologists such as Semper, Stolpe, Grosse, Haddon, and Balfour. These men saw in the "primitive" peo-ples of the European empires a great laboratory for the investigation of hu-man cultural evolution.[6] Art assumed prominence within their larger proj-ect precisely because it constituted, for Westerners, the ultimate measure of human achievement. The presence or absence of "true art," defined as free creation unfettered by functional requirements, could be used as a kind of litmus test of the level of civilization a group of people had supposedly achieved.[7]

Although they debated the specifics of historical patterns of evolution,

the early anthropologists all assumed both the universal validity of the Kantian equation of progress, freedom, and art and the Western scheme for classifying and evaluating art. In addition to adducing the macro-categories of fine and applied arts, they often did further violence to their subject matter by categorizing it by material—textiles, ceramics, jewelry, etc. These assumptions built into their arguments a teleological fallacy that reproduced Victorian and imperialist hierarchies of race and gender and ultimately doomed to failure the Victorian project of investigating the origins of art. The evidence of this is contained in a number of contradictions within cultural evolutionist texts. The arts of hunter-gatherer groups like the Eskimos and the Australian Aborigines, for example, became the focus of study because these peoples were perceived to live in an extreme state of dependence on nature. Because the "primitiveness" of their arts was taken as a given, Victorian anthropologists focused almost exclusively on the "inferior" category of "ornament" and often willfully blinded themselves to the existence of objects that could have fit their fine art category.

The cultural evolutionists also identified the sculpted or graphic images on weapons, tools, fabrics, and the human body as applied art because they were imagined to serve utilitarian purposes and were therefore insufficiently autonomous to be regarded as "purely aesthetic" or as fine art objects. Grosse, for instance, asserted in 1897 that apparently abstract geometric designs on tools or weapons could be found to be stylized representations of animals or humans made for magical or religious purposes. "Figures constructed with entire freedom nowhere play any important part in ornamentation" (1928: 116). The inconsistency that arises here is that, while in Western art the symbolic was identified with fine art and the natural and imitative with decorative art, the reverse became true for "primitive" art.

A spate of publications on the evolution of art appeared during the 1890s, and this body of theory continued to inform the work of anthropologists throughout the first half of the twentieth century. Frank Speck, for example, in what has become a classic text on eastern Cree ritual art was in 1935 still using dialectically opposed categories of the "purely aesthetic" and the "symbolic," the commercial and the "magical" (1977: 127). Within only a decade of the earlier publications, however, the modernist revolution in European art had begun to displace this body of theory and to refocus the discourse of "primitive" art. In sharp contrast to the emphasis the anthropologists placed on ornamentation, the modernist artists appropriated a different set of non-Western objects, those that most closely fit the Western fine art categories of sculpture and painting. They adopted a form of tunnel vision every bit as narrow as that of the cultural evolutionists, though differently directed. Their exclusion of textiles, basketry, and beadwork, of the stylistically naturalistic, and of anything seen as artistically "hybrid" meant that the most important aesthetic traditions of many peoples were denied the status of fine art.

COMMODITIZATION AND THE HYBRID

The different kinds of objects that interested ethnologists and modern artists stimulated different kinds of demand. Markets for art and artifact coexisted, furthermore, with a souvenir trade that had greatly expanded in response to the rapid growth of tourism during the Victorian era. During this period, too, the interactive process between producer and consumer intensified, resulting not only in greatly increased replications of "traditional" objects but also in the production of many innovative hybrid art forms. The interactive process between producer and consumer, which began almost everywhere as soon as contact with the West took place, entered a new phase in the Victorian era, during which far greater quantities and varieties of objects were produced by efficiently organized cottage industries. These new art forms, typified, for example, by the wares Woodlands Indians made to sell at Niagara Falls, signal the entry of colonized peoples into industrial-age consumerism, an economic integration forced on many by the destruction of their former modes of subsistence and on others by the introduction into traditional material culture both of labor-saving manufactured materials and of attractive new mass-produced Western commodities that could only be acquired with cash.

Neither the speed and acuity with which indigenous artists responded to changes in taste and market nor the dialogic nature of their creative activity has been adequately recognized. Rather, until recently, both art historians and anthropologists have resoundingly rejected most commoditized objects as spurious on two grounds: (1) stylistic hybridity, which conflicts with essentialist notions of the relationship between style and culture, and (2) their production for an external market, which conflicts with widespread ideas of authenticity. Although both of these reasons for rejection arise directly from the nineteenth-century philosophical foundations of art-historical and anthropological thinking, they are inconsistent with key aspects of these same intellectual traditions.

Objections to stylistic hybridity, for example, diverge in several ways from the general positions many theorists held on this subject. First, the negative view of stylistic mixing conflicts with the general cultural evolutionist principle that contact and cross-fertilization were important, if not essential, to the advancement of cultures. In Alfred Haddon's 1902 treatise *Evolution in Art,* for example, the author drew on a biological metaphor to conclude that "the isolation of a people and uniformity in their existence will tend to stagnation in art, and . . . intercourse with other peoples, whether by trade, war or migration, serves as a stimulus to artistic expression" (317).

Yet this principle is not followed in the judgments routinely made of specific bodies of material culture. In 1896, for example, Stolpe lamented the "difficulty" of working with one Native American collection, because "It so

often bears obvious traces of the influence of the white man's industry. The furniture nails driven into clubs or pipe-stems, the garniture of glass beads on all sorts of articles, prove that the style is no longer genuine, but spoiled by European importations" (1927: 93).

He regarded the widespread use of floral motifs as particularly "suspicious," commenting that "in all these plant designs I see nothing but the debasing influence of a vicious style of drawing on the white man's gaudy bartered wares" (94). As this statement makes clear, one reason for the rejection of stylistic hybrids was pragmatic: they greatly complicated the scholarly project of reconstructing evolutionary histories of "primitive" art. Another, more profound, reason had to do with the Victorian biological discourse of race, in which hybridity was defined as degenerate and weakening of a racial "stock" (Young 1995).

Accusations of inauthenticity were also based on the assertion that commodities were produced for external markets and not used by the producers themselves. This allegation ignored plain facts. Colonized peoples all over the world often did wear the same kinds of garments and ornaments they sold as souvenirs, and many forms of aesthetic expression within indigenous communities were profoundly transformed by their makers' intensified involvement in market production. In tying the definition of authenticity for non-Western arts to these arts' putative preindustrial quality, scholarly practice also denied art makers their place in modernity. A particular irony of the authenticity paradigm, finally, is revealed by the mounting evidence that many of the objects purchased both as ethnological specimens and as art objects during the heyday of collecting in the late nineteenth and early twentieth centuries were, in fact, commercially produced replicas, although curators and collectors were frequently either unaware of this fact or chose to suppress it (R. Phillips 1995). This is equally true of masks and carvings collected during the early colonial period in Africa (Schildkrout and Keim 1990) and from the Canadian Northwest Coast; many Eskimo toolkits now in museums were made for the market (Lee, this volume), as were many forms of Plains Indian weaponry and beadwork (Bol, this volume).

Objects that incorporated Western materials, styles, and forms failed, however, to satisfy the longing among Western consumers for the lost authenticity of the local and handmade that accompanied industrialization. Finally, rejection on the grounds of hybrid and acculturated elements contradicted widely held positions on progress. The same scholars and collectors who complained about inauthenticity subscribed to one of the basic rationales for the global imposition of colonial rule: that the desired outcomes of the "civilizing" of indigenous peoples would be their own increased "industriousness," as evidenced by their more efficient production of "manufactures," together with the transformation of these populations into consumers of Western manufactured goods.

Ambivalence about commoditized forms of "primitive" art was part of a much wider discomfort with industrial production in Victorian society. This unease found its most concentrated expression in the reactions of intellectuals to the Great Exhibition of 1851 in London. Popularly known as the Crystal Palace, the Great Exhibition was based, as Thomas Richards has written, on the idea that "all human life and cultural endeavor could be fully represented by exhibiting manufactured articles" (1990: 17). The development of this system brought two schema for ordering things into uneasy relation: the old art hierarchy and a newer hierarchy based on commodity type. As Richards notes, Prince Albert initially urged the adoption of a traditional categorization of the things of the world into four divisions: raw materials, machinery and mechanical inventions, manufactures, and sculpture and plastic art. Through the efforts of the exhibition's planning commission, however, these were later supplemented by twenty-nine additional categories, "which cross cut the others, like a department store," and "by which articles of a similar kind from every part of the world could be disposed in juxta-position" (Richards 1990: 32). In other words, the old hierarchy was placed side by side with the essentially democratizing, leveling representation produced by capitalist production. Objects from all parts of the world were presented in these displays as manufactures and commodities and were eagerly purchased by the hordes of exhibition visitors. "In effect, though hardly by intention," notes Richards, "the Crystal Palace advanced a prescient vision of the evolutionary development of commodities" (27). Many of the wares exhibited at this and other exhibitions form today the core of ethnological and art museum collections. Science here follows the model of commerce rather than the reverse, as is often supposed; the universalizing typology used in the 1851 exhibition predated by several decades its employment in museum displays such as that installed at the Pitt Rivers Museum at the end of the nineteenth century (Chapman 1985).[8]

The enthusiastic consumer response to the exotic commodities at the Crystal Palace—most of which were stylistic hybrids—was typical of all such exhibitions and contrasted with the rejection of these same objects by the intellectual establishment (Richards 1990: 32–33).[9] Indeed, the Great Exhibition and its successors revealed to contemporary intellectuals the disjunctions that were emerging between the old elitist hierarchical schematization of art, with its reliance on rarity and the handmade, and the democratization of art made possible by new forms of industrial production. The exhibition acted as the catalyst for several important theoretical formulations.

It is not coincidental, for example, that the nineteenth-century theorist Gottfried Semper wrote major treatises on Western architectural and ornamental style as well as on the origins of art. Both interests were stimulated in important ways by the Great Exhibition, for which he was com-

missioned to design displays for the products of four different countries.[10] His major early treatise of 1852, *Science, Industry, and Art: Proposals for the Development of a National Taste in Art at the Closing of the London Industrial Exhibition,* was directly stimulated by this experience. In this rich text we can trace the great debates of the era as Semper struggled to rationalize his own seemingly contradictory responses. He acknowledged his attraction to many of the commercial products of non-European nations, although he disdained commercial motivations for the production of art; he respected the high level of craftsmanship of "barbaric" peoples in comparison to that displayed by the new Western industrial products, although he remained convinced of the essential superiority of Western aesthetic achievement; he was led, ultimately, to consider Western industrial and exotic commercial forms of production as equally inferior. He wrote, for example, "*A work of art destined for the marketplace cannot have this relevance, far less than an industrial object can, for the latter's artistic relevance is supported at least by the use for which it is expected to have. The former, however, exists for itself alone,* and is always distasteful when it betrays the purpose of pleasing or seducing a buyer" (Semper 1989: 143).

Semper's was by no means a lone voice. The Great Exhibition also inspired William Morris and his colleagues to attempt to revalidate the decorative arts through a revival of medieval forms of handicraft. Ultimately, however, the effort to reconcile the fundamental contradictions failed. The emerging disjunctions between the cultural arrogance of art connoisseurship and the leveling of art appreciation that flowed from new technologies for mechanical reproduction could not, in the end, be reconciled. Consumers were motivated both by a genuine admiration for the technical expertise and aesthetic sensibility of non-Western artists and, like the anthropologists, by a romantic and nostalgic desire for the "primitive" induced by the experience of modernization.

It is important to emphasize that the sentimental quest for simplicity, with its attendant, but ambivalent, rejection of modernity, was neither new in the Victorian era, nor limited to the realms of art and visual culture. Suspicion of mass manufacturing and mass marketing and the desire to retrieve the authenticity belonging to the rare and the singular lost through the new modes of production both go back to the eighteenth century, and they have permeated many other domains of consumption from then until now. A telling eighteenth-century example having to do with cuisine is provided by Brillat-Savarin's famous disdain for mechanically ground coffee. As Roland Barthes comments, the great gastronome's objections probably arose more from semiotic and epistemological considerations than from a truly palatable discrimination: "The grinder works mechanically . . . its produce is a kind of dust—fine, dry, impersonal. By contrast, there is an art in wielding the pestle. Bodily skills are involved. . . . The choice between pounding and

grinding is thus a choice between two different views of human condition and between metaphysical judgments lying just beneath the surface of the question" (quoted in M. Douglas and Isherwood 1979: 73–74).

Brillat-Savarin's sentimental preference for *hand*ground coffee beans parallels the enthusiasm of consumers for *hand*made objects; both are located at the intersection of a scholarly discourse of authenticity and an emerging discourse on the canons of "good" or "refined" taste (see Bourdieu 1984). Both tapped into a deep current of sentimental nostalgia for the loss of the handmade and the unique. If industrially produced objects could not satisfy these yearnings, recourse to invented notions of the "primitive" and the preindustrial would have to.

More often than not, these needs were displaced onto a special category of exotica, tourist art, which was constructed not just to represent the idea of the handmade, but also to display iconographic motifs and forms that signified "old" ways of life imagined as simpler and more satisfying. In this sense, Victorian ambivalence toward the commoditization of folk or non-Western art directly paralleled a discourse of tourism and anti-tourism identified by James Buzard (1993) as a major theme in nineteenth-century literature. "Anti-tourism," as defined by Buzard, corresponds almost exactly to the discourse of authenticity that cleaved the community of consumers of art commodities into two opposed camps of fine art cognoscenti and populist collectors of tourist art. The irony here, however, is that the possibility of evading commoditization was as illusory as the efforts of Victorian intellectuals to identify themselves as "travelers" rather than "tourists."

EMBEDDED CONTRADICTIONS

As we have seen, the exclusion from the canons of art and science of the stylistically hybrid and openly commoditized forms adopted by many commercial and souvenir productions resulted from the same discursive matrix. Moreover, notions of the essential value and uniqueness of "art" and of the scientific interest of the "artifact" were givens that became part of the inscription of colonialism. Despite contemporary deconstructions of these terms, they remain operational concepts that outsider-producers have to negotiate together with the contradictions embedded in essentialist and evolutionist approaches to style and authenticity. Two further examples can be added to those already mentioned. Stolpe's aversion to hybrids and souvenir art, typical of his influential scholarly generation, led him to make some gross errors of fact. He praised, for example, the sculptural qualities of Haida argillite carving, an art form invented during the first half of the nineteenth century exclusively for trade to Westerners, under the mistaken impression that it was an ancient art form (1927: 114–15). At the same time, he rejected out of hand the majority of Plains and Woodlands museum objects (which

conformed, for the most part, to age-old generic types) because they incorporated some European motifs and materials. As such they were, in his words, "proof of the helpless decadence of the native style" (94).

A second, slightly more recent example illustrates, through a richly ironic and unexpected incident, the contradictions embedded in essentialist attempts to distinguish "art" from "commodity" on the basis of particular craft processes and materials or an allegedly pre- or non-industrial style. In 1928 Edward Steichen attempted to import into the United States Brancusi's abstract bronze sculpture *Bird in Space*. The sculpture was blocked in New York City by U.S. Customs, which declared that nonrepresentational and abstract forms fell outside the limitations of paragraph 1807 of the U.S. Customs Tariff Act of 1922, which allowed "original" works of art to enter the country duty free. Brancusi's *Bird* was to be charged the normal duty for objects of utility or industrial use that are "composed wholly or in chief part of copper, brass, pewter, steel or other metal" (*United States Treasury Decisions* 1928). The importer asked the U.S. Customs Court to determine "whether the *Bird* was art or merely bronze in an arbitrary shape" (MoMA 1936: 5). The judge in the case ultimately ruled in favor of the appeal and determined that Brancusi's sculpture was indeed a work of art and not an industrial metal commodity. For the record, he stated:

> The decision [that works of art as defined in paragraph 1807 refer to imitations of natural objects] was handed down in 1916. In the meanwhile there has been developing a so-called new school of art, whose exponents attempt to portray abstract ideas rather than imitate natural objects. Whether or not we are in sympathy with these newer ideas and the schools which represent them, we think the fact of their existence and their influence upon the art world as recognized by the courts must be considered. (*United States Treasury Decisions* 1928: 430–31)

The clash over definitions of art between collectors and connoisseurs and the U.S. Customs bureaucracy did not end with the debate over Brancusi's *Bird*. A few years later, the Museum of Modern Art encountered the same problem when it tried to import objects of African art for an exhibition in 1935. As it was reported in the *Bulletin of the Museum of Modern Art:*

> Many objects in its exhibition of African Negro Art had been refused free entrance [into the United States] because it was impossible to prove that certain sculptures were not more than second replicas, or because the artist's signature could not be produced, or because no date of manufacture could be found, or because ancient bells, drums, spoons, necklaces, fans, stools and head rests were considered by the examiners to be objects of utility and not works of art. (MoMA 1936: 2)

It is fitting perhaps that the struggle over proper definitions of "art" and "commodity" should have taken place in the early decades of the twentieth cen-

tury at a port of immigration—a point of respite and cultural evaluation wedged momentarily into the otherwise rapid transnational circulation of goods and objects. Definitions of art, artifact, and commodity typically occur at such interstitial nodes—sites of negotiation and exchange where objects must continually be reevaluated according to regional criteria and local definitions. At each point in its movement through space and time, an object has the potential to shift from one category to another and, in so doing, to slide along the slippery line that divides art from artifact from commodity.

SHIFTING DISCOURSES

Within recent historiography it was only through the renewal of an ideological analysis of art practice mounted by scholars such as Janet Wolff in the 1980s that the Kantian basis of art-historical representation was again challenged. "The division we generally make between the 'high' and the 'lesser' or 'decorative' arts can be traced historically, and linked to the emergence of the idea of 'the artist as genius,'" Wolff wrote, arguing that "it is difficult to defend the distinction between, say, the painting of an altar-piece and the design of furniture or embroidery on any intrinsic grounds" (1984: 17). She also refuted the notion of the freedom of the artist from market forces, quoting Vacquez's statement that "'the artist is subject to the tastes, preferences, ideas, and aesthetic notions of those who influence the market . . . [and] cannot fail to heed the exigencies of this market; they often affect the content as well as the form of a work of art'" (17–18).

Since then, two processes have simultaneously challenged and reconfigured the art-artifact-commodity triad. On the one hand, serious studies by anthropologists and art historians of non-Western objects intended largely for trade and export have recognized the artistic nature of objects classified as artifact and commodity. Far from being a "mere" commercial craft, many forms of tourist or export art have been shown to exhibit all the communicative and signifying qualities of "legitimate" or "authentic" works of art. On the other hand, studies of mainstream Western artworks and artists have argued the importance of dynamics of commoditization in much post-Renaissance Western art (e.g., Alpers 1988). Far from being either produced or consumed without regard for matters of money or market, works of art, aesthetic valuations, and judgments of taste are indeed highly dependent on an object's commodity potential and economic value (Bourdieu 1984). Most recently, Robert Jensen has suggested in his book *Marketing Modernism in Fin-de-Siècle Europe* (1994) that the avant-garde movement in European art actually thrived on the commercial appeal of anti-commercialism at the turn of the twentieth century. Thus, one might say that the delicate membrane thought to encase and protect the category "art" from contamination with

the vulgar "commodity" has been eroded and dissolved from both sides. No longer treatable as distinct and separate categories, the art-artifact-commodity triad must now be merged into a single domain where the categories are seen to inform one another rather than to compete in their claims for social primacy and cultural value.

THE DECOR OF NOSTALGIA IN THE 1990S

If the public space of the museum is the site of art and artifact, then the private space of the home is the site of the commodity. A wider public acceptance of "ethnic" and "tourist" arts, whose legitimacy was cogently argued by such scholars as Graburn (1976a) and Jules-Rosette (1984), has in recent years become routinized through a series of publications that seek to justify the use of "natural" objects in modern home and interior design. Coffeetable books with such alluring titles as *Living with Folk Art* (Barnard 1991), *Ethnic Interiors* (Hall 1992), and *Ethnic Style* (Innes 1994) perpetuate many of the myths of authenticity and primitivist nostalgia that flourished during the Victorian era. The consumption and recontextualization of the art commodities within domestic settings have, for more than a century, provided the ultimate rationale for their production, for it is the private consumer rather than the museum or the scientific investigator who provides a market on a scale that motivates global production and circulation of these objects (see Halle 1993b). The museum increasingly acts as a purveyor of goods as well as a custodian of art and artifact. Gift shops, offering "museum reproductions" and commoditized "fine arts" and "ethnic arts," bridge the boundary between the academic precinct and domestic consumption (see Zilberg 1995).

The long-standing continuity between public and private space is well illustrated by the writings of a turn-of-the-century British colonial officer named T. J. Alldridge, a man of middle-class background and average talents who nevertheless played an instrumental role in establishing colonial rule over the rural interior of Sierra Leone. In his two books on the new Sierra Leone protectorate, Alldridge regularly expressed admiration for traditional forms of Mende textiles. As early as the 1880s, at an initiation celebration held only fifteen years or so after the establishment of direct contact, he already expressed nostalgia for the passing of older forms of "handicraft." The display of traditional country cloths was, he wrote, "a pleasure to behold, and reminded me of past times. Such large and elaborately hand-worked cloths are not now to be obtained, as the choice country-grown cotton and the subdued tints of the vegetable dyes are giving place to imported yarns of harsh and crudely bright colours, as distasteful to the eye as the others were inviting. That, however, is in the march of trade and the creating of new wants" (1910: 227).

Elsewhere, Alldridge noted his negative response to the hybridization that had inevitably occurred as the result of "the march of trade," specifically to the new uses the Mende found for imported cloth. "I must admit," he wrote, "that these modern things do not harmonise with the bulky fibrous costume [of the masked spirit impersonators], and considerably detract from the characteristic effect of this barbarous dress with which so much fetish and mystery is associated" (1910: 223–24). Alldridge's ultimate response to the perceived dilemma of the Western witness to modernization is almost shockingly contemporary: "A few of us, at any rate, regret the good old country-made cloths, and are thankful we managed to secure enough of them to make our English home a pleasure to the eye of every artist who sees them there" (58). Alldridge's remarks reproduce with remarkable economy the characteristic form of class discrimination based on taste, rare art collecting (Alsop 1982), and domestic display (as theorized by Bourdieu 1984). They also convey with an equally remarkable transparency the way in which the paradigm of authenticity was directly generated by imperialist economics, its problematic results, and its characteristic form of resolution: consumption. The example of Alldridge demonstrates, finally, the parallelism of public and private forms of consumption—of the ethnology museum and the intimate domestic display, for he collected not only for his living room but also for important British museums.[11]

Modern texts on interior decorating articulate and further develop similar views. In particular, three major themes may be discerned: (1) that "ethnic" art is closer to nature and therefore less artificial than its modern counterpart; (2) that the "ethnic" arts of all regions share a common denominator, making them largely interchangeable and somehow comparable on a formal level; and (3) that "ethnic" art represents the final, fleeting testimony to the tenuous existence of rapidly vanishing worlds.

One recent book on interior decoration, subtitled "Decorating with Natural Materials," opens with an approving nod toward a passage from Owen Jones's 1856 treatise *The Grammar of Ornament:* "'If we would return to a more healthy condition, we must even be as little children or as savages; we must get rid of the acquired and artificial, and return to and develop normal instincts'" (quoted in Hall 1992: 10). The author goes on to distinguish, however, between the "return to the natural," which characterized the period of the 1960s and early 1970s—"the much-reviled 'hippy ethnic' . . . with its joss sticks and Indian bedspreads"—and what is happening in Europe and North America in the 1990s. Interest in "ethnic" arts, according to the author, "is not a rejection of the way we live, it is almost a way of coming to terms with it by keeping in touch with our fundamental sensual appetites for beauty and creativity. . . . [Ethnic arts] work best in the most modern interiors, where crudeness and sophistication can act as a foil to each other" (Hall 1992: 13, 16). Thus, the "return to the natural" is viewed more as a frivolous or con-

trastive enhancement to the modern than as an outright rejection of the fundamental triumph of industry and capitalism. Just as the threatened indigenous inhabitants of the world's rainforests can putatively be saved by watching rock stars' heartfelt music videos, filmed on whirlwind jaunts through the Amazon, ethnic arts purport to evoke the barbarity of untamed nature without encroaching too deeply on the creature comforts of modernity.

And just as all "ethnic" worlds are thought somehow to be closer to nature than their "modern" counterparts, so too these ethnic worlds are thought to share attributes that bond them together in a "fraternity of otherness," making them mutually intelligible to one another while remaining uniformly foreign, and sometimes wondrous, to those who inhabit the West. "It is interesting to realise," writes the author of *Ethnic Interiors,* "that ethnic cultures, even those from opposite corners of the world, have always shown a striking similarity of expression and inspiration; the ethnic motifs and artefacts from one continent often sit happily with those of another" (Hall 1992: 18).[12] This Disney-like portrait of a world united by the simplicity of common attributes—the "erasure of inequality" that binds the "family of nations" together in the sentimental theme-park lyrics of "It's a Small World" (see Maalki 1994: 51–52)—is sometimes played against the academic dogmatism that supposedly seeks to complicate this paternalistic model. In advising her readers how to create the perfect "ethnic" interior, one design author suggests, "Authenticity is all very well, but harmony of decoration and colour are more satisfying to the humble amateur of interior design—you want to create an atmosphere that gives you pleasure, not research a dissertation" (Innes 1994: 76–77).

The discussion of "authenticity" in the above passage reveals an interesting twist in the overall concept of cultural "purity," which has generally characterized definitions of authenticity in non-Western art (see Steiner 1994: 100–103). The quest for the pristine and nonhybrid is criticized in this new literature as a haughty pursuit of pedantic scholars and learned connoisseurs. The "masses" are told to celebrate hybridity because, the argument goes, in the end all ethnic cultures are pretty much alike. So, ironically, whereas earlier writings on collecting "primitive" art stressed the importance of cultural homogeneity, the new argument celebrates hybridity by denigrating the uniqueness of different cultural identities. One argument constructs an artificial world in which there is ideally no contact among cultures; the other portrays a kind of Lévy-Bruhlian world, in which contact is irrelevant because primitiveness is a quality shared by all those deemed Others.

Finally, recent publications on "ethnic style" continue to inscribe the idea, articulated a century earlier by Alldridge, that objects of "ethnic" art are being rescued, like victims off a sinking ship, from vanishing cultural worlds (see Clifford 1987: 122). As Nicholas Barnard writes in *Living with Folk Art:* "When the collector takes time to visit an ethnographic museum, or attends

a private view of a tribal art exhibition at a culture centre or gallery, sipping wine amongst fellow guests, he or she is surrounded by the wonders of a world now extinct or near-extinct, and will have cause to dwell upon what has now been lost in the tides of acculturation" (1991: 65).

From the earliest times of contact and colonialism to the present day, the worlds in which "ethnic" arts are produced are said to have been teetering precariously on the brink of extinction. Producers, middlemen, and consumers have all capitalized in their own ways on this myth of imminent demise and on the frenzied acts of collecting engendered by the fear of extinction. In the end, however, it is apparent that each generation reclassifies the arts of world cultures in order to set high against low, authentic against touristic, traditional against new, genuine against spurious.

The illusion of "authentic art" could probably not persist were it not for the invention of its baser counterparts against which aesthetic merits can be measured and judged. Just as Mary Douglas demonstrated so convincingly in *Purity and Danger* (1966) that the category "sacred" could not exist without its "profane" opposite, so too the authentic could not survive without its unorthodox antithesis—the inauthentic (see Steiner 1996a: 213). But the very impermanence of the boundaries that separate the "good" from the "bad" reveals the mystification imposed by the whole system of classification and its judgments of taste. Distinctions between categories of art, artifact, and commodity are projections of individual experience that reveal, in the end, far more about those who collect objects than those who produce them. One author of a how-to book on ethnic interior decor, for example, asks her readers to consider the question "When does ethnic art become the much-disdained 'souvenir'"? (Hall 1992: 16). Her own answer is disclosed in an anecdote. "Back home, a cheap blue and white Moroccan plate, even though it was one of hundreds on a market stall, will continue to give the same thrill that made your heart beat faster when you first saw it on the streets of Marrakech. The expensive panic-buy at the airport, however, will always be a souvenir in the worst sense" (16).

Thus, the solution to defining the authenticity of an object circulating in the networks of world art exchange lies not in the properties of the object itself but in the very process of collection, which inscribes, at the moment of acquisition, the character and qualities that are associated with the object in both individual and collective memories (see S. Stewart 1984). In order to interpret such objects we must begin to unpack the baggage of transcultural encounter with which they travel and search for the meanings and memories stored inside.

My Father's Business

Frank Ettawageshik

My name is Naakwehgeshik of the Little Traverse Bay Bands of Odawa Indians from the northern part of the lower peninsula of Michigan. My English name is Frank Ettawageshik, and I live near Harbor Springs on Lake Michigan's Little Traverse Bay. This area, from Little Traverse Bay north some forty miles to the Straits of Mackinac, has been known for a few hundred years by the Odawa people as Waganakising (*Wagana.kising*), which means "crooked top of the tree" or "the crooked tree." The settlement, which became the town of Harbor Springs, was established in the 1820s around a Catholic mission church. Over the years it has grown to become a major tourist and resort center on Michigan's lower peninsula. My family has lived in and around Harbor Springs since before its founding.

In this essay I first outline the history of the Indian art business operated by my grandfather and father, discussing the types of work that they sold, who made them, and who bought them. In the second section, I discuss how I believe our family business, and others like it, have helped preserve traditional art forms in the communities of the Little Traverse Bay Bands. Finally, I consider the implications of the debate over the authenticity of "tourist art" for the Odawa communities of Little Traverse Bay.

In order to explain fully my understanding of and feeling for this topic, I will tell you a little about my family tree. I was born in 1949. My father was Fred Ettawageshik, who was born in Harbor Springs on Little Traverse Bay in 1896. My grandfather, Joseph Ettawageshik, was born in Harbor Springs in 1863. My great-grandfather was Amable Ettawageshik, who was born in 1839 at Little Traverse Bay. Amable's father, my great-great-grandfather, was Paul Ettawageshik, who was born at Waganakising in 1810. His father, Miskomemingwon (Red Butterfly), was born at Waganakising around 1765. His father, Wakezhe, and grandfather, Pungowish, were also

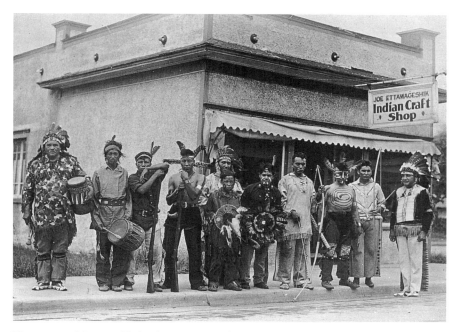

Figure 2.1. My grandfather's store c. 1938. Joseph Ettawageshik (far left) and Fred Ettawageshik (far right) and other Odawa men before the annual naming ceremony.

born at Waganakising. Back to the early 1700s, these are some of my grandfathers.

One of the commonly accepted meanings of the name for my tribe, Odawa (or Ottawa as a nonspeaker of our language would say), comes from the word, *odaweh,* which means trading, selling, or doing business. My family has been "in business" for many generations.

HISTORY

In 1903 my grandfather Joseph Ettawageshik opened his first store near the base of the Harbor Springs pier. Tourist and resort ships docked there regularly and provided a steady market for crafts and artwork made by the members of the Harbor Springs Odawa community. My grandfather's store was not the first Indian-owned shop to open on Little Traverse Bay, but his was the first in Harbor Springs (fig. 2.1). Basil Petoskey had opened a shop five miles across the bay in the 1890s in the village of Petoskey.

My grandfather's first shop was so successful that by 1920 he had opened

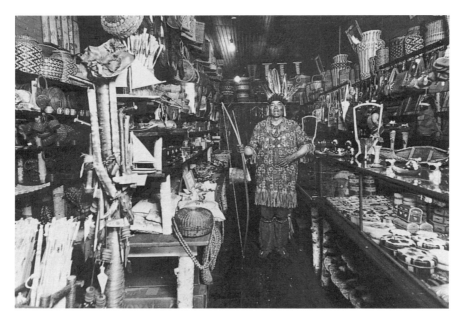

Figure 2.2. Joseph Ettawageshik, my grandfather, in his store in Harbor Springs, Michigan, c. 1920. Private collection.

a much larger store on the pier. In addition to the work produced by my family, he sold many different types of Indian art and craft work made by other families in the area: basswood fiber bags, quill boxes, rush mats, wooden spoons, black ash baskets, and many items made of birch bark (fig. 2.2). Through the work they made to sell to my grandfather, community members gained only a meager supplement to their family income. This was because customers would pay very little for these items, which they considered to be merely curios or souvenirs. Although this income was not much, its importance should not be minimized, for often these earnings provided food for the families of the artists.

In 1910 my father, Fred Ettawageshik, left home to attend the Government Indian School at Carlisle, Pennsylvania. After graduating, he served in the United States Army in the First World War. He then worked at various jobs around the country before coming home in the mid-1930s to help my grandfather run the business. By the early 1940s they had moved the store from the pier to the main street of Harbor Springs (fig. 2.3). When my grandfather died in May of 1946, my father took over the business.

Who bought the items that were sold in our store? Most of the customers came from the scores of tourists who began visiting the Little Traverse Bay

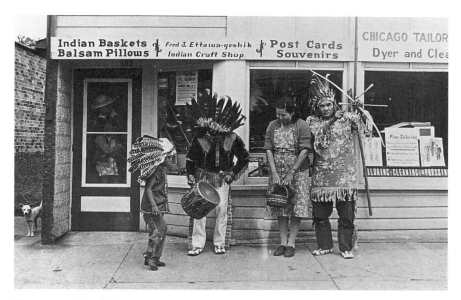

Figure 2.3. The fifth successive Ettawageshik shop in Harbor Springs, c. 1940. From left: unidentified boy, Fred Ettawageshik (my father), unidentified woman, Joseph Ettawageshik (my grandfather). Private collection.

area in the late 1880s. The steamers that traveled the Great Lakes brought tourists from Chicago, Detroit, and cities to the east. After the railroad was extended north to Harbor Springs, even more tourists came to the town, now often called "the Ottawa Indian Capital." Many of these visitors built seasonal homes along the pleasant shores of the bay, and their families still visit each summer. Those summer visitors, or resorters, made up a significant portion of our trade as I was growing up. I learned how to ring up sales on our large hand-cranked cash register and to make change before I was seven years old. I remembered the customers who returned each year in the summer.

A second but no less important group of customers were the collectors looking for "authentic" work. One of my father's friends who visited and made purchases was the noted anthropologist Dr. Frank Speck. I was named after Dr. Speck, who had introduced my father and mother in 1946. My mother, Jane Willets, was an anthropology graduate student who came to do her fieldwork in Harbor Springs. After earning her master's degree, and following her marriage to my father, she completed several more years of study. An unpublished manuscript in the American Philosophical Society in Philadelphia contains the information collected during her study. In fam-

ily records we have correspondence from Dr. Speck to my father ordering deer-toe leg rattles, in which he jokes about the appropriateness of his becoming a good Odawa (trader) doing business with my Odawa father. Many distinguished visitors from both the Indian and the non-Indian worlds visited our shop.

While others may analyze businesses like ours from afar and miss details because of their distance from the subject, my view may suffer from my closeness to this story. I remember playing in the clump of small birch trees outside the back door of my father's store on the bluff just above the Ottawa Indian Stadium in Harbor Springs. The birch trees are still there, although the building has been gone for a long time now.

Hand-carved totems were the main type of work produced by my father. He carved them in various sizes, from large freestanding sizes to small pocket sizes. I still have many of the tools hand-made by my father for use in this process as well as examples of his work in various stages of completion. At the age of seven, I was painting small totem poles in my father's workshop. I sometimes helped him by painting the basic colors while he did the finishing details. Each piece of his work was stamped with his name and labeled "Genuine Ottawa Indian Craft." On other days we sat around a large box and folded the small pieces of paper on which the story of the totem was printed. We folded thousands and thousands of them, filling the box. We later attached a folded paper to the back of each totem with a tiny rubber band. In addition to selling his work in our own retail store, my father shipped thousands of items at wholesale to gift shops and museum stores across the country, including the American Museum of Natural History in New York and the Kansas City Museum.

The image of large totem poles is most commonly associated with the tribes of the Northwest Coast of North America. Although these large representations were not commonly made in the Great Lakes region, the word *totem* comes from the Algonquian word *ododem,* which means "of my family." Small images were carved on short posts, which were placed outside the doorways of our lodges or homes to indicate the "clan" or family who lived in the residence. Smaller miniature carvings were often placed in our homes or in medicine bundles. Thus, it was not the cultural stretch that many scholars have believed for Indian people of the eastern woodlands to carve totem (*ododem*) poles. The mark or symbol of my family is "Pepegwesanse" or Sparrow Hawk. My father was known as Pipigwa (an anglicized form of Pepegwesanse). His symbol, a small bird sign, was a part of all of the work he produced.

For other projects we drove my father out of town in the morning to the other side of a large swamp and dropped him off. He always took his knife and a large burlap sack with him. He walked home through the swamp carrying a huge sack of willow and alder saplings on his back. He used these to

make the ring toss game, *pommawanga*, which we sold in our shop as well as by the gross to museum stores. He also made picture frames from willow and birch bark, elm-bark rattles, and bows and arrows. In addition to the work produced by my father, we sold Indian artwork and crafts made by other families in our area. My father's shop sold basswood bags, black ash baskets, sweetgrass baskets, quill boxes, and many other items that were made only for the tourist trade.

In the late 1950s the steamers stopped sailing the lakes, the railroads were slowly giving way to the automobile, and the Japanese were beginning to mass-produce "genuine" Indian souvenirs. It became increasingly difficult for my father to stay in business. With his health failing slowly in the early 1960s, he decided to close the retail store and to service the wholesale accounts he had developed over the years from his home workshop. He made and sold his own work until shortly before his death in 1969.

EFFECTS

One of the most popular items produced in the Little Traverse Bay region is the quill box. These birch-bark boxes are decorated with porcupine quills, which are often dyed various colors before being attached to the boxes. The making of quill boxes is a prime example of the positive effect that businesses like my father's had on the production of traditional art forms in the Little Traverse community. The tourist trade was the driving force behind the production of most of the items made from the 1920s through the 1970s. The people who learned to make Indian art during that time are now prominent artists and have set the pace for the resurgence of these traditional art forms. Mary Anne Kiogima was a noted basket maker and quill worker in Harbor Springs in the 1920s and 1930s. She taught her daughter, Susan Shagonaby, who came to be regarded as one of the leading practitioners of quill work during the 1950s and 1960s. Susan Shagonaby's apprentice, Yvonne Walker Keshick, is now regarded as one of the best quill workers ever to work in northern Michigan. Her art not only is technically superb but also has an overriding spiritual essence that transcends the physical and engages the viewer's emotions.

Forty years ago, quill working was considered to be well on its way to becoming a lost art in northern lower Michigan. Today there are reported to be nearly seventy-five quill workers in the Little Traverse Bay area. The many apprentices that these women have taught are having a major effect on the preservation of traditional arts in the communities of the Little Traverse area. The tourist market served by my father's business and other businesses like his was instrumental in keeping people working in this art form while the art world was becoming more sophisticated in its appreciation of American Indian art. In contrast to the meager prices for which my father and grandfather were

able to sell their quill boxes, today they sell for hundreds and even thousands of dollars. It has become possible for Indian artists to support themselves with their work instead of earning only a supplement to another full-time job.

Another effect of my father's business has been the example he set for his children and others concerning traditional Odawa attitudes and feelings toward artwork. Just as I hear my father's voice in my own as I tell the stories and legends that I learned from him, I feel his presence and that of all of my other ancestors in my hands as I do traditional artwork. Although I did not follow in his footsteps and carve totem poles, I have continued in the family tradition of being in business and selling the products of my hands. I became a potter and have revived the making of traditional Odawa pottery, a skill that lay dormant in the northern Great Lakes area for more than 150 years. Many of the skills and attitudes toward working with my hands that my father taught me are incorporated into my pottery making. One thing in particular that I use every time I make a pot is basswood bark cord, with which I decorate or "cord-mark" the pottery.

Having done the research and experimentation needed to revive traditional pottery making, I am now taking steps to ensure that this pottery work will not die with me but will once again become a thriving part of the artistic expression of the American Indian communities of northern lower Michigan. I have taught my children and have begun teaching numerous apprentices. Because of what my father taught me about caring for my work, I consider potential apprentices carefully. I view apprenticeships as long term and low key rather than short term and intense. I ask apprentices to make a lifetime commitment to three things before I will take them on. First, I ask that they make a long-term commitment to learning the process and to making the pottery. An apprenticeship lasts a number of years, and I see myself as making a lifetime commitment to the apprentice. Second, I ask my apprentices to commit themselves to the process. Making the pots requires not only making the form of the vessel but also tending its spirit. Sometimes this requires things to be done "the hard way"; the apprentice must be willing to learn not to take shortcuts. I do not expect that all of the people I teach will make pots and sell them. In fact this will probably be rare. Most of those I teach will make pots for themselves and their families. Finally, though, I ask that they commit themselves to teach at least one other person to make pottery as I have taught them.

I benefit today from the increased awareness and sophistication of the market for American Indian art. In my gallery, Pipigwa Pottery Gallery, my wife, Mary Anne, and I sell the stoneware pottery that she makes and the Woodland Indian pottery that I make. We have supported ourselves for more than twenty years working out of our own gallery (fig. 2.4).

A third effect of our family business is reflected in today's Little Traverse Bay business community. Shortly after my father closed his store in Little

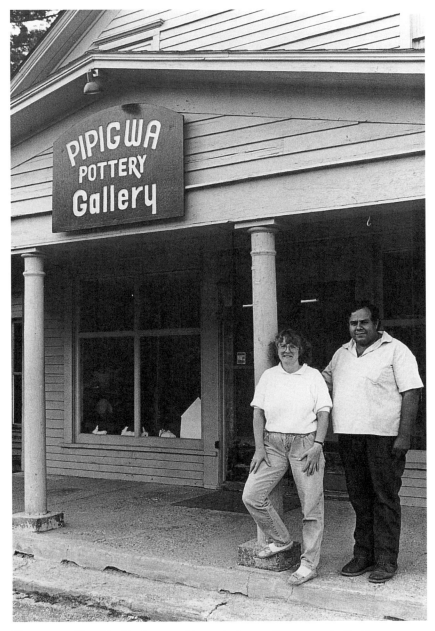

Figure 2.4. My wife, Marianne, with me in front of our store in Karlin, Michigan, c. 1990.

Traverse Bay in 1963, it had a successor. Victor Kishigo opened the "Indian Hills Trading Company" in Petoskey, about ten miles from the last location of my father's store. Victor sells the same types of products that my father and grandfather sold, but they are no longer low-priced curios and souvenirs. They are the artistic expressions of American Indian people and their culture. The people from the Little Traverse Bay area who produce many of the traditional items sold in Victor's store are the inheritors of family traditions passed down from the artists who kept making their work to sell to Basil Petoskey, my grandfather, and my father.

AUTHENTICITY

Since the middle of the nineteenth century, every aspect of Odawa culture has been under assault. We have been under pressure to assimilate, to relocate, and to discard our culture in exchange for non-Indian ways. But throughout this era we have managed to keep our traditions through stubbornness and adaptation. Keeping our traditional artwork alive through economic adaptation has helped us keep other elements of our culture alive as well. It is important to note that traditional art forms continue to play an important role in nonbusiness affairs in our communities. The most obvious use of traditional artwork is in the making of dance regalia. Leatherwork, beadwork, woodcarving, and painting are used to fashion the components of both traditional and fancy dance outfits. Quill work, pottery, stone carving, bark containers, and the like are used in ceremonies and presented as gifts at ceremonial giveaways. It is in these traditional artistic media that artists produced and still produce artwork for the tourist trade.

For many years a debate in the academic and museum world has centered on the question of whether artwork produced and sold in stores, such as my family's business, is an authentic reflection of the culture of the people who produce it. Or, it is asked, is this artwork only "tourist art"—a "less authentic" degeneration of true Indian art? This discussion assumes that the only "real" or "authentic" Indians are those "uncorrupted" by European influence, and thus that the only "real" or "authentic" Indian art must be similarly uncorrupted. This "uncorrupted," "pure," or "authentic" work becomes the yardstick by which anything produced after contact with outsiders is measured. Any modification of old techniques or methods is considered less good, and any innovation is considered to be a symptom of the degeneration of the old culture. Once assimilation or adaptation has occurred, the old ways, the old culture, the old people are considered to be gone.

The danger for American Indian people is that this debate, which starts in the discussion of material goods, quickly moves on to other fields. As noted by Peter Welsh of the Heard Museum, "If we question the authenticity of tourist art then we question the authenticity of those who make it."[1]

The Bureau of Indian Affairs and others concerned with developing the federal government's policy concerning American Indians continue today to use a standard that considers change in Indian culture as assimilation and "assimilation as obliteration."[2] If scholars continue to assert that the art of the modern American Indian is not "authentic," can it be long before federal bureaucrats conclude that today's American Indians are also no longer authentic?

Art is a reflection of culture as well as one of the forms of interaction with other cultures. We should consider that tourist art is a manifestation of this interaction rather than a sign of the destruction of the makers' cultures. If Indian art and culture have brought change to the art and culture of the non-Indian, has this resulted in the creation of "inauthentic" American art or culture? I would argue that both cultures have adapted to each other and that each remains equally authentic. The "tourist art" products that developed from traditional arts and became export and import items in a cross-cultural exchange substantiate the continued existence of both cultures.

CONCLUSION

For more than a hundred years the Little Traverse Bay area has had an Indian-owned store retailing the work of the local community. My father and grandfather were part of this marketing effort. The tourist market, and those people from the Little Traverse Bay Indian communities who produce and sell their artwork for this market, have contributed to the preservation and revival of the traditional art forms of the Odawa people.

The production of art for the tourist market by the Little Traverse Bay Odawa is a reflection of cultural continuity and adaptation in the face of enormous pressures to relocate, assimilate, or otherwise fade away. This continuation of the economic adaptation reflected in the production of what observers have come to call "tourist art" is one of the leading indicators of a strong and sustained cultural existence.

Constructing the Other

Production as Negotiation

Nuns, Ladies, and the "Queen of the Huron"

Appropriating the Savage in Nineteenth-Century Huron Tourist Art

Ruth B. Phillips

Charles Mackay's 1859 travel book, like those of other contemporary visitors to North America, contains a description of his trip to Quebec City, the "picturesque" Montmorency Falls, and the nearby village of Lorette. Here, he tells his readers,

> resides the last scanty remnant of the once powerful tribe of the Hurons, the former lords and possessors of Canada. Paul, the chief or king of the tribe, is both the most exalted and the most respectable member of the tribe, and carries on with success, by means of the female members of his family, a trade in the usual Indian toys and knickknacks which strangers love to purchase, and in his own person cultivates a farm in a manner that proves him to be a skillful and thrifty agriculturalist. His aged mother and her sister, the "Queen of the Hurons," received us hospitably in their neatly-furnished cottage. (1859: 369)

It would be hard to find an anecdote that better typifies the mixture of historical commemoration (the "once powerful tribe"), sentimentalism ("the last scanty remnant"), discourse of the Noble Savage (the "king" and the "Queen"), assimilationism (the "thrifty agriculturalist"), and commerce (the "successful" trader) that characterizes the representation of Native Americans in what Mary Louise Pratt has called the "contact zones" of colonial interaction (1992: 4).

Nineteenth-century Lorette was representative of such sites. Wendake, as it is known today, was founded in the late seventeenth century by Catholic Hurons fleeing the destruction of their homeland east of Lake Huron. The "Indian toys and knickknacks" routinely bought there during the eighteenth and nineteenth centuries were quintessential examples of the transcultural arts that contact zones produce. My purpose in this essay is to examine these objects as visual texts that produced ethnicity not simply by reflecting im-

posed stereotypes but by actively negotiating and contesting them. Lorette tourist arts, in this sense, can be seen as authentic "autoethnographic" expressions, to use another of Pratt's key concepts (1992: 7).

One category of tourist art associated with Lorette is particularly useful in such an investigation, the bark and fabric objects embroidered in dyed moosehair that were among the most popular "Indian" souvenirs of the eighteenth and nineteenth centuries. These objects, which were displayed in eighteenth- and early-nineteenth-century European and North American cabinets of curiosities, include domestic ornaments and personal accessories such as ladies' handbags, cigar cases, calling card trays, and sewing boxes. Many feature embroidered pictorial vignettes of the "typical" Indian way of life. These wares present a particularly rich source for the study of transcultural image construction both because their two-hundred-year history of production permits the examination of diachronic process and because, most unusually, this history comprises three overlapping phases of production associated with ethnically different makers.

French-Canadian nuns invented the original bark and moosehair objects toward the beginning of the eighteenth century, and the production reached its height between 1759 and 1810. Around 1800, and sporadically until midcentury, moosehair embroidery on birch bark also enjoyed a brief vogue as a genteel pastime for Euro-Canadian women. The Native phase of production was by far the largest; it began early in the nineteenth century and peaked during the explosion of tourism in northeastern North America during the second half of the century.[1] The iconographic tradition displayed on these wares evolved in response to the complex play of subjectivities that the history of their production suggests. During the first two phases, nuns and ladies constructed images of Indianness out of a conventional array of tropes of the Noble Savage and the picturesque exotic. As we will see, when Native women took over this iconography they exploited the preexisting tradition selectively, stressing aspects of self-representation that had value in indigenous systems of thought and eliminating others that made no sense within these systems.

Past generations of ethnologists and art historians not only have failed to recognize the mediating role of souvenir and other transcultural arts but also have actively devalued them, damning them as acculturated and therefore "degenerate," and as commercial and therefore inauthentic (Kasfir 1992; Phillips 1995). Most museums and collectors have, furthermore, routinely assigned all objects made in these media to the Hurons. This systematic inaccuracy is particularly striking because of the abundant testimony to the initial phase of convent manufacture in contemporary travel books, such as those of Isaac Weld (1799) and Priscilla Wakefield (1806). In the 1940s, moreover, the Canadian ethnologist Marius Barbeau published his discovery, in the basement of the Ursuline convent in Quebec City, of account books, inventories,

and artifacts that proved the nuns' role as the originators of the art (Barbeau 1943). Paradoxically, it would seem, Barbeau's intervention had the effect of deauthenticating the whole category of bark and moosehair work. Essentialist discourses hate a hybrid; salvage anthropology and Idealist art history alike have continued to define both productions as derivative: the nuns' because of their commercial appropriation of Indian materials and object types and the Indians' because of their adoption of Euro-American styles and genres.[2] The failure to recognize the diachronic and dialogic aspects of Huron moosehair embroidery is itself an artifact of the inability of conventional academic discourses to represent transcultural art forms adequately.[3]

ORIGINS: THE CONVENT PHASE OF MOOSEHAIR EMBROIDERY

The history of moosehair and bark wares begins sometime around 1700. In 1714, during an epidemic outbreak of disease, the Ursuline nun Mère St. Joseph journeyed from her convent at Trois Rivières, Quebec, to Quebec City to receive instruction in the preparation of medicines from the nursing sisters of the Hôtel Dieu. The convent's *Annals,* written about five years later, say that as a gesture of reciprocity Mère St. Joseph offered to teach two of the nuns the Ursuline specialty of embroidery, first in silk thread and cloth:

> And then Mother St Joseph demonstrated before us the making of some boxes in the Indian style [*boëtes sauvages*] in order to teach us how to work in bark; this inspired in several of the sisters the desire to try to make them, and they perfected the art so well that, the next year, their works were sought after as examples of proper workmanship and good taste, of the type that, since that time, we have sold every year for small sums, and that furnishes us also with things to give as presents to people to whom we are obliged. (Jamet 1939: 393; my translation)

Initially, the nuns made these elegant embroidered birch-bark curios as gifts for important patrons in Quebec and France. The incorporation of pictorial motifs allowed them to meet their ever-present need to depict to benefactors in France the Aboriginal people whom they were attempting to convert.[4] The production of this fancywork soon became an important source of income not only for the Ursulines but, as Barbeau documented, for other Quebec orders as well.

The invention of moosehair and bark wares seems to be part of a general trend during the early eighteenth century toward the invention and commoditization of objects that could act as souvenirs of New France and its Native peoples. Nicolas Perrot, writing between 1680 and 1718, for example, reported on the commercial manufactures of Great Lakes peoples who, he wrote, made "many curious little articles which are much in demand by our French people, and which they even send to France as rarities" (Blair 1911,

1: 76). In 1708 the Sieur de Diereville recorded the Mi'kmaq's specialized production of decorated moccasins for the consumption of French curio buyers (1933: 167), and Ruth Whitehead has convincingly argued that the Mi'kmaq also invented their popular line of porcupine quill–decorated birch-bark boxes, chairseats, and other objects sometime during the first half of the eighteenth century (1982). Visitors to New France were clearly eager to acquire "Indian" curios, and the nuns, always good entrepreneurs, were quick to capitalize on the new market.[5]

The growth of consumer demand corresponds with the reformulated attitudes toward the Aboriginal peoples of North America disseminated through early-seventeenth-century books of history and travels. The three volumes on his Quebec travels published by Lahontan in 1703 are credited as the earliest to set out a coherent view of the North American Native as a Noble Savage living a life that was (in comparison with the European) more free, easy, and in harmony with nature and less full of conflict, superstition, and irrational cruelty. This idealized view displaced earlier and more ambivalent representations circulated in such texts as the Jesuit Relations and controlled European discourse about the Indian well into the nineteenth century.[6] Through their incorporation into the writings of the French philosophes, the idealized models of Native life were circulated throughout Europe and came to inform the tastes and expectations of the largely French viewers of pictorial imagery on early souvenir wares.

During the fifty years following the British conquest of Canada in 1759, the market for "Indian" curios was expanded by the influx into the region of military personnel, administrators, and their wives, most of whom either passed through or were stationed at Quebec City and Halifax, the centers of the trade in moosehair and bark wares. These newcomers arrived with a keen interest in Indians shaped by the discourse of the Noble Savage, as elaborated in French and Scottish Enlightenment texts. The habits of consumption of these British and Continental newcomers were also formed by the upper-class vogue for curiosity collecting of the period, and they eagerly sought out Indian curiosities not only for themselves but also as gifts of choice for friends and relations at home. One accomplished Ursuline embroiderer, Mère Esther de l'Enfant-Jesus, gave a vivid account of this trend in a letter of 1761:

> Despite all the troubles that have been visited on this country, one doesn't lack for the necessities of life if one has enough money; but we have nothing except what we earn from our little works in bark. As long as they remain in fashion the earnings that we get from them will be an important source of income, for we sell them really dear to Messieurs les Anglais. Moreover, the people who buy them seem to us to feel under an obligation to do so, and they consider themselves privileged and happy in being able to acquire them. It is impossi-

ble, in effect, despite our zeal for the work, to furnish this kind of merchandise to all the people who request them. (Letter to Father Delaunay, quoted in Barbeau 1943: 84–85; my translation)

The enthusiasm of the British remained strong throughout the remaining decades of the century. According to later notions of authenticity, Indian souvenirs made by non-Indians should have been problematic for these curiosity seekers. It is important to recognize, however, that British buyers were often motivated as much by a desire to commemorate their experience of the colorful French Catholic population they had colonized as to acquire souvenirs of the indigenous peoples. The travel books of the period make it clear that the British constructed both the French-Canadian *and* Aboriginal peoples of Quebec as Other, commenting with as much curiosity on the customs and exotic appearance of the *habitant* farmers as they did on the local Indians. Their purchases of moosehair and bark curios thus seemed doubly romantic and exotic, serving as mementos not only of the Indians of North America but also of the Catholic world of French Canada. As Isaac Weld noted in his description of his visit to the Ursuline convent at Trois Rivières at the end of the eighteenth-century, "we selected a few of the [embroidered bark] articles which appeared most curious, and having received them packed up in the neatest manner in little boxes kept for the purpose, [we] promised to preserve them in memory of the fair Ursulines" (1799, 2: 17).

The convent records do not tell us what images were embroidered on the early-eighteenth-century bark souvenirs, and not until the period of the American Revolution do we have firmly dated examples of these objects. They are stylistically connected to convent-made ecclesiastical embroidery, reproducing similar species of flowers executed with the same "nuances" or monochromatic shadings and also certain compositional devices, such as the enclosure of figures within medallion frames. We know that during the early 1700s the nuns read the works of French historians with close attention.[7] The two-dimensional pictorial representation of those texts would have posed no problem, for their prowess at drawing is amply displayed in the accomplished late-Baroque style of the figurative scenes they embroidered on church textiles. The European graphic tradition the nuns brought to their "savage" curiosities is evident in the distinctively European style employed in the depiction of humans and animals. One particularly clear example is the outline of a deer incised on a bark panel for an unfinished pincushion that entered the famous *Kunstkammer* of Herzog Anton Ulrich of Braunschweig in the late eighteenth century. It displays a naturalistic, curvilinear style, which contrasts dramatically with the simplified and economical graphic contours of animal representations in early-contact-period Aboriginal art.[8]

Two of the largest and most iconographically complex surviving examples of convent moosehair and bark work are a lady's work basket from the Bedford Collection, now in the Royal Ontario Museum, and a large oval lidded box in Frankfurt. Each piece constitutes a kind of emblem book of Indian symbols. In a series of pictorial vignettes that read continuously across their curving surfaces, the seasonal round of Indian life is depicted much as it is described in eighteenth-century philosophical histories. Landscapes of forest, lake, and snow are painstakingly represented, unified by a continuous groundline. Indian figures, accompanied by their dogs, paddle in canoes and walk through the pine trees while birds swim in the water and alight on the tops of their bark wigwams. Other figures sit on the ground smoking long-stemmed pipes beside trade kettles suspended between forked sticks. Women carry cradleboards on their backs, men pull toboggans over the snow, and children hold out tomahawks. The objects depicted are presented as signs of the condition of the Indian as "natural man." Proffered by an outstretched hand or otherwise isolated, they resemble the attributes of saints in Christian religious art.

Flowers bloom everywhere in these scenes, creating an atmosphere of perpetual spring (despite the presence of toboggans in some scenes) and conveying a sense of the endlessly renewable bounty of nature. Close literary equivalents to these scenes occur not only in philosophical history but also in contemporary poetry. *Tomo-Cheeki,* Philip Freneau's work of the 1790s, is typical of such texts. In it the idealized Creek Indian hero describes the Woodlands Indian way of life:

> In the morning early we rise from the bed of skins to hail the first dawn of the sun. We seize our bows and arrows—we fly hastily through the dews of the forest—we attack the deer, the stag, or the buffaloe, and return with abundance of food for the whole family. Wherever we run it is amidst the luxuriant vegetation of Nature, the delectable regale of flowers and blossoms, and beneath trees bending with plump and joyous fruits. (Quoted in Pearce 1988: 144)

A small piece of bark work usually features just one of the component scenes found on larger pieces. One embroidered bark base for a lady's reticule, for example, shows a man in a feather headdress drinking; others depict moose or people paddling their canoes over the water (fig. 3.1).

These scenes are emblematic in the manner typical of eighteenth-century art. The figures display actions and objects tied to specific verbal texts, or *topoi,* whose complex meanings eighteenth-century viewers were expected to be able to supply (Paulson 1975: 15). The texts engaged by the sequences of emblematic images on moosehair and bark wares were, as we have seen, the philosophical-historical disquisitions on the life of the Noble Savage familiar to contemporary viewers. The complex readings generated by the linking of verbal and visual texts have to do not only with the variations of

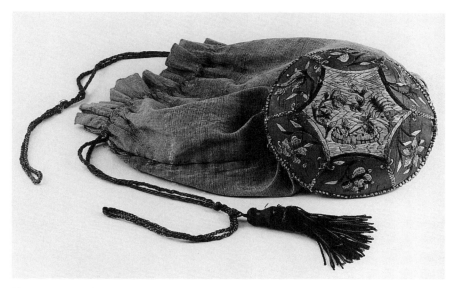

Figure 3.1. Lady's reticule, late eighteenth century, attributable to French-Canadian nuns, diameter 12 cm. Courtesy of the Trustees of the National Museums of Scotland (Museum no. 1975.3).

argument and representation within the written literature, but also with contradictions and gaps between textual representations and the experiences and observations of visitors to North America.

The contradictions between experiential realities and idealized fictions are particularly evident in the contrasting styles of dress depicted on the eighteenth-century bark wares. For the nuns, clothing style was the primary visual signifier of difference between Indians and Europeans and also among different Aboriginal groups. The "domiciliated" Indians who settled near European towns and were, at least nominally, converts to Christianity, were shown in clothing made of European fabric, although foreign in style and ornament. In contrast, the still nomadic "savage" and pagan peoples who came to trade or to treat with the Europeans were described as naked or scantily clothed. Such visible signs of cultural difference were also exploited within the picturesque, the dominant British aesthetic of the late-eighteenth century, as pleasurably exotic manifestations that, like rough and irregular features of landscape, added necessary interest to painting. Vignettes of both "domiciliated" and "savage" Indians occur regularly in the views of late-eighteenth-century British topographical painters such as James Peachey and Thomas Davies.

In most convent-made bark and moosehair work of the eighteenth century

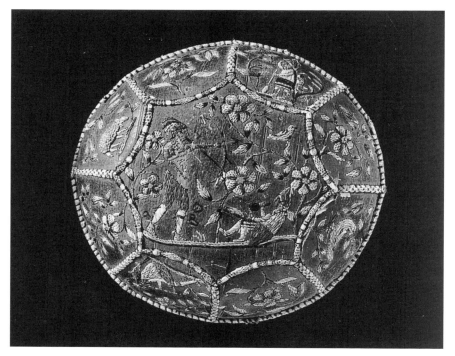

Figure 3.2. Embroidered bark base for a lady's reticule, late eighteenth century, attributable to French-Canadian nuns, diameter 12.5 cm. Courtesy of the Cambridge University Museum of Archaeology and Ethnology (Museum no. Z35131).

the Indian figures wear the picturesque dress of the domiciliated Indians; the detail with which their shirts, leggings, wampum ornaments, and peaked caps are depicted is remarkable considering the minute scale of the figures. On a few pieces, however, the sharply contrasting image of the pagan savage appears. On one, a man wearing only a breechcloth and feather headdress is shown brandishing a club and is strangely juxtaposed with a lounging female figure.[9] On another, the man is shown as a hunter, pulling back an arrow in a bow string while a woman sits back, a bottle to her lips (fig. 3.2). Prototypes for these images of Noble Savages exist, as they do for the picturesque figures of Indians, in contemporary European paintings and prints. The widely circulated prints of eighteenth-century author and illustrator Grasset de San Sauveur are perhaps the closest to these examples of moose-hair-embroidered souvenir wares, and some of his prints may have been used as direct sources by the nuns. It is nevertheless striking that the nuns, who rigorously distinguished on moral grounds between unclothed pagans and

clothed converted Indians, replicated the full range of contemporary textual representations in their souvenir art. This range of representations seems to illustrate both their skill in assessing the expectations of their customers and the authority that textual constructions of the Indian as Noble Savage had by then gained in the popular imagination.

A GENTEEL ART: WHITE WOMEN
AND THE FASHION FOR MOOSEHAIR

By the end of the eighteenth century the making of fancywork in moosehair embroidery and birch bark had become fashionable among the well-born ladies of Quebec and Halifax, an activity that was possibly first introduced by convent-educated young women. In 1789 a Mrs. Cottnam placed an advertisement in a Halifax newspaper for her school for young ladies in St. John, New Brunswick, where lessons were given in "Plain work and Marking; with variety of fine Works on Muslin, Silk and Bark, etc."[10] Barbeau published a photograph of a birch-bark box in a private collection embroidered in moosehair by a Mlle. Normanville at Quebec in 1798 (1943: n.p.).[11]

An elaborate workbox given to Mrs. Benedict Arnold as a parting gift when she left Nova Scotia for England in 1791 appears to come from this same milieu (fig. 3.3). The outer box, of bird's-eye maple, is a piece of professional European or Euro-Canadian cabinetry. Its interior is intricately fitted with eight boxes and a pincushion made of birch bark, fabric, and silk and ornamented with motifs of cornucopias and flowers executed in a combination of silk embroidery and moosehair. In style and technique the box and its component parts are unlike the pieces associated with the convents; these differences include the construction of the pincushion and individual boxes that make up the set, the needlework materials, and the designs and stitches used for the embroidered flowers.

Inside one of the boxes is a small booklet made of bark enclosed in a strawwork slipcase. On the first page of the booklet are inscribed the words: "When more pleasing scene engage / And you in Polish'd Circles shine, / Then let this wild, this Savage Page / Declare that gratitude is mine!" It is signed "Elisaba of the Micmac Tribe." Although Elisaba is the Mi'kmaq form of Elizabeth, all the evidence leads to the conclusion that the writer of these lines—and the maker of the fancywork—was a genteel English or Euro-Canadian woman, a friend, obviously, of Mrs. Arnold. The divergent needlework techniques, the style of the handwriting, and the verse form all support this attribution. More general aspects of late-eighteenth-century British literary culture add further evidence. A popular plot in contemporary novels involved lost or captured English ladies and gentlemen who experience the idyllic life of the Noble Savages for a period before returning to civilization. The verses—and the style—

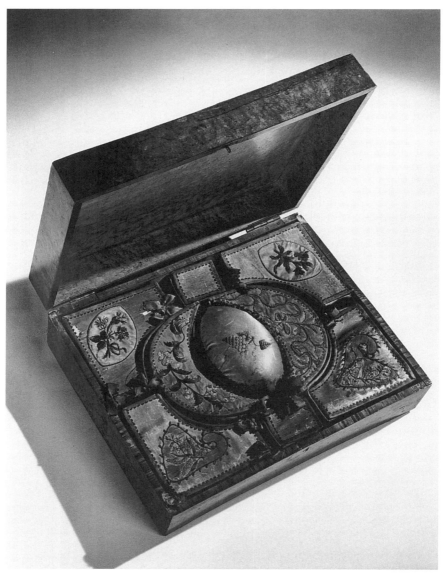

Figure 3.3. Workbox formerly belonging to Mrs. Benedict Arnold, 1791, English or Euro-Canadian work, 44 x 35 x 15 cm. On loan to the American Museum in Britain, Claverton Hall, Bath (Museum no. 15487.112).

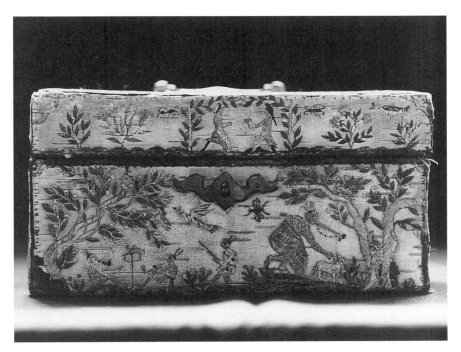

Figure 3.4. Tea caddy, late eighteenth century, English or Euro-Canadian, 20 x 13 x 12.5 cm. Cotehele House, Cornwall. Reproduced by permission of the National Trust.

of Mrs. Arnold's box directly relate to this kind of fashionable romantic literary imagery. Elisaba, as the one who stayed behind in Canada, playfully appropriated a "native" Mi'kmaq identity either as a self-satirizing reference to her temporary exile from society in a "savage" land or, perhaps, to her more permanent assumption of a North American identity. This example suggests, further, that the consumers of both convent-made and hobbyist bark ware, who were drawn from the same social milieu, may also have read the imagery on their curiosities with a hitherto unsuspected sense of irony.

A box that is perhaps the most splendid of all surviving examples of late-eighteenth-century bark and moosehair work is also, I believe, the product of the upper class rather than the convent milieu. The wooden box, which is now in Cotehele House in Cornwall, is of European manufacture and is covered with a uniquely elaborate set of moosehair-embroidered birch-bark panels (fig. 3.4).[12] It has the shape of a tea caddy, a use further confirmed by an unusual embroidered vignette on one side showing two Europeans drinking tea. On the larger surfaces of the box are scenes showing soldiers

in eighteenth-century military uniforms fencing, a mounted horseman hunting with Indian companions, and, in the most prominent position on the top, Indian warriors in a forest setting. The hunting and domestic scenes are unlike anything found on the examples previously discussed. They depict the favorite pursuits of the British gentry living in Canada at the time. The scenes showing Indian warfare, in contrast, resemble the Noble Savage imagery that is part of the convent production. The elaborate narrative structure of the main scene on the top of the box is unique, however, as is a depiction of an Indian crouched for attack on one of the long sides. These scenes seem to reflect the engagements of European soldiers with Indian allies and enemies during the wars of the late eighteenth and early nineteenth centuries.

Moosehair embroidery in lady's fancywork continued to interest Euro-American women sporadically during the first half of the nineteenth century. Lady Mary Durham, for example, daughter of one governor-general of Canada and wife of another, Lord Elgin, took lessons in bark embroidery in Quebec City in the 1830s (Godsell 1975: 121). In 1860 the Prince of Wales made a much-heralded visit to Canada, the first tour by a member of the royal family. Among the many gifts presented to him were a large number of Aboriginal artworks, which are now preserved in the Swiss Cottage Museum at Osborne House on the Isle of Wight. Among the objects of moosehair and bark is a small group that can be identified as the work of a young white woman named Sarah Rachel Uniacke, a member of a prominent Nova Scotia family likely to have been involved in welcoming the prince. Two of the objects display motifs of seashells, which appear on no other examples of the genre, as well as unusual techniques of construction. Mrs. Uniacke's identity is conclusively established by a bookmark she sent to relatives in England as a sample of her work in moosehair with a note reporting that she was taking weekly lessons from a Mi'kmaq woman. It displays a conch shell motif identical to one that appears on an object in the prince's collection.[13]

The presentation to the Prince of Wales of Sarah Rachel Uniacke's work side by side with the works of Mi'kmaq women, as well as their subsequent juxtaposition in the glass cases of the Swiss Cottage Museum, is, we must conclude, a further example of the ease with which exotic artisanal techniques and materials could still be appropriated in the 1860s. This minor footnote to the history of moosehair embroidery, when considered together with the work of the nuns and of the makers of the Cotehele House box and Mrs. Benedict Arnold's sewing kit, illuminates attitudes toward stylistic authenticity in the middle of the nineteenth century that were to change radically during the next few decades. The earlier examples involve prominent people and the exchange of gifts of value; they demonstrate an easy acceptance

of the appropriation of "Native" materials and imagery by white makers and consumers. In these instances imitation does seem to have been the sincerest form of flattery, as was also the case when Aboriginal women took over and made their own the production begun by the nuns. With the establishment of anthropology as a scientific discipline, and particularly with the development of doctrines of cultural evolutionism, the fluidity of cultural exchanges in the contact zone would harden into a more rigid system of classification. Authenticity would be defined—retroactively, in the case of moosehair and bark work—in essentialist ways, as functions of the maker's ethnic identity and of the cultural "purity" of style, materials, and techniques. The great expansion of consumerist economics during the second half of the nineteenth century reinforced this tendency, causing Aboriginal people to become careful of their cultural copyright as a means of protecting their markets.

THE ABORIGINAL REAPPROPRIATION: MOOSEHAIR EMBROIDERY AND SOUVENIR PRODUCTION

By about 1810 the nuns seem to have largely given up their production of Indian wares, and visitors to Quebec and Lorette attest that Native appropriation—or reappropriation—of bark and moosehair souvenir manufacture had begun. In that year, John Lambert saw women from Lorette bringing baskets of birch-bark objects and moccasins into the market at Quebec (1810, 1: 93). Jeremy Cockloft noted a year later that "at Laurette are to be sold toys, made of bark, by the Indians" (1960: 31).[14] Economic necessity lay behind the Native involvement in the trade. During the half-century from 1800 to the 1850s seizures and cessions of Aboriginal land escalated, forced by the flood of Europeans settling in eastern Canada, and Aboriginal people became ever more dependent on the production of handicrafts as a source of subsistence. The Lorette Huron and other communities located at strategic places along the tourist itinerary did well, and they developed sophisticated marketing networks that distributed their products to the major tourist markets at Niagara Falls and elsewhere.

The German traveler Johann Georg Kohl, visiting Lorette in 1861, saw "tuns and chests full of moccasins embroidered with flowers, cigar-cases, purses, &c." being prepared for shipment to Montreal, Niagara, and New York (1861: 180). During his subsequent visit to Niagara, Kohl saw these items displayed for sale and noted their distinctive qualities:

> The taste displayed in them is peculiar, quite unlike anything to be seen in Europe, so that I believe it to be, as I have been assured it is, of real Indian invention. They seem to have a very good eye for colour, and much richness of fancy; and they imitate strawberries, cherries, and other wild fruits of their

woods, very exactly, as well as daisies, wild rosebuds, and countless beautiful flowers of their prairies, which are represented in the most lively and natural colours and forms. (1861: 155)

Kohl's account attests to the Native mastery of the mid-nineteenth-century Euro-American naturalistic aesthetic. The peculiar genius of this Native appropriation of European decorative art is that it managed, at the same time, to remain stylistically distinctive. Kohl's admiration is typical of mid-nineteenth-century audience reception; Lewis Henry Morgan made similar remarks about Iroquois beadwork during the same years (Tooker 1994: 151–52; Morgan 1967).

The pictorial vignettes displayed on Indian-made souvenir wares continued to inscribe stereotypical and ever more outdated images of the nomadic life (fig. 3.5). They also became increasingly metonymic, the tripod and cooking pot standing for the Indian encampment in the forest, the hunter with his game or the fruit picker and her tree representing their work-free Edenic natural setting. Under the conditions of colonial domination in the nineteenth century, the employment of the common currency of stereotypes could not have been avoided. It is important to recognize, however, that Huron and Mi'kmaq artists modified the iconographic tradition they had inherited from late-eighteenth-century nuns and ladies in subtle but significant ways (R. Phillips 1991). Toward the mid-nineteenth century, Huron and Mi'kmaq artists added new motifs to the standard iconography. The stock figure of the basket seller accurately portrays the itinerant Native peddlers whose marginal economic life depended in many areas on such production. Such figures also appear in the contemporary paintings of white artists like Cornelius Krieghoff. Men and women are frequently depicted drinking from bottles, an image white viewers would have interpreted as portraying the negative stereotype of the drunken Indian. At the same time, as Richard Rhodes (1993) has argued, such images probably still retained for nineteenth-century Aboriginal viewers positive references to eat-all feasts, well-being, and plenty that have deep precontact roots, despite the terrible addictive consequences of "binge consumption" when applied to alcohol.[15]

Native women also intervened in the representation of dress that occurs on moosehair-embroidered objects. The archaic images of semiclothed warriors were not taken up by Aboriginal artists. Instead, the later production is characterized by the depiction of figures clothed in the full dress they actually wore for special occasions. Fine clothing, traditionally an important form of visual artistic expression among Woodlands Indians, was represented on Huron-Mi'kmaq bark work as a positive sign of difference. This kind of image also, however, continued to resonate with the tastes of the consumers for the picturesque, evidence of the necessity incumbent on artists working for the tourist trade to portray their own ethnicity in ways that coincided with the views of the dominant society.

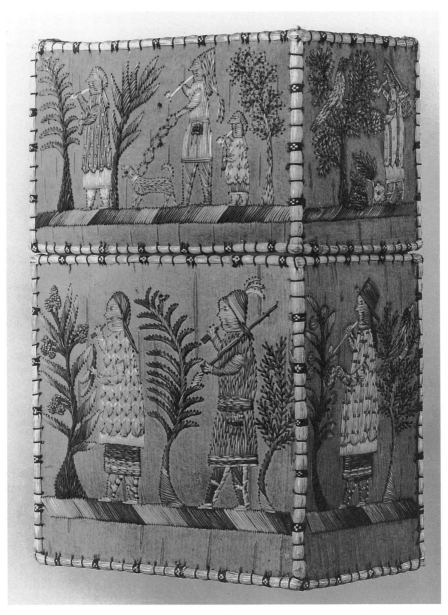

Figure 3.5. Cigar or cigarette case, 1847, Huron-Wendat work, 14 x 8.5 cm. Collected by Mr. Døllner at Niagara Falls. National Museum of Denmark (Museum no. E Hc 152). Reproduced by permission of the Department of Ethnography, National Museum of Denmark.

The central theme of the pictures of Indians in moosehair embroidery through its long history remains the harmonious existence of human beings in a benevolent world of nature. This image, sanctioned by theoretical and romantic traditions in European thought, also refers to an ideal embodied in indigenous oral traditions. To live in a balanced way on the land, supported by its resources, was the goal of Aboriginal people in the nineteenth century (as it is today), however difficult accomplishing this goal had already become. The multiple readings of images I have suggested here must, of course, remain speculative. But they offer ways of thinking about how Aboriginal artists may have been able to produce their ethnicity in terms that were acceptable to the politically dominant classes and at the same time made sense in their own eyes. The recognition of such polyvalence may explain the remarkably long life of the iconography of "natural man."

SOUVENIRS AND THE NEGOTIATION
OF NORTH AMERICAN IDENTITIES

This brief discussion suggests that in the three overlapping phases of bark and moosehair production the constructed identities of "Native," of "North American," and of "Indian" are reexamined by each successive group of makers. The iconographic tradition established by the nuns inscribed the fiction of the Indian as natural man living a free nomadic life in a bountiful Edenic landscape. The later production shifted the emphasis to the picturesque, archaic, and folk qualities of the Noble Savage trope, neutralizing its potential threat to the land tenure and lifestyle of immigrant North Americans. The transfer of this art form among three groups of women also has important implications for the negotiation of gender roles. There is a complex relationship between the democratization of the art of embroidery from an aristocratic to a bourgeois pastime, which occurred between the eighteenth and the late nineteenth centuries, and the formalization of assimilationist doctrines during the same period (Parker 1989). These doctrines reconstructed the idealized image of Aboriginal people from that of nomads of the wild to that of docile agricultural peasants. The references to Chief Paul as a good farmer and to his great aunt as "Queen of the Hurons" in the 1858 passage quoted at the beginning of this essay show that during the transitional period of the middle decades of the century both images were in play. This was the period when Lorette embroidery was at its height. A further explanation for its popularity, I would argue, is the successful exploitation of two sets of positive associations of embroidery with femininity—older references to the typical pursuit of noblewomen and newer ones to the home crafts of "civilized" Victorian housewives.

The inscription of the souvenir cannot be adequately understood without reference to such implied texts, for in popular audience reception these

meanings frequently overrode or elided literal readings of the iconography. This intertextuality is wonderfully illustrated by an Englishwoman named Agnes Grau West, who presented a moosehair-embroidered box to the governor-general of Canada at the beginning of the twentieth century. The object in question, which bears a depiction on its lid of two Europeans drinking tea, is almost certainly the product of the same late-eighteenth-century European lady who made the box now at Cotehele House. The fanciful gloss provided by Mrs. West, however, ascribes it to the wife of Chief Paul and incorporates almost exactly the sentimentalized discourse of the disappearing Indian and the domestication of savagery that characterized Mackay's description of fifty years earlier, with which I opened this essay. Mrs. West wrote:

> This box was worked by the squaw of the last chief of the Huron tribes now extinct. It represents the French governor of Canada and his wife at tea, as seen by the Huron chief and his squaw during their visit to them and is embellished with emblematic Napoleonic bees. It was given by the Huron chief and his squaw to my ancestor Captain Eyre Powell in return for a kindness he rendered the Huron chief and his squaw and it is presented by Captain Eyre Powell's lineal descendant.[16]

By the end of the nineteenth century, forces had combined to wind down the production of moosehair and bark embroidery, the most powerful of which were the definitions of authenticity that arose as a byproduct of cultural evolutionism.[17] Where mid-nineteenth-century travelers had admired the picturesque hybridity of Huron dress represented by and on tourist wares, a late-nineteenth-century tourist could write, disparagingly, that "the dress worn by 'warriors' and chiefs on exceptionally solemn occasions, are almost wholly artificial in their make-up. . . . No trace is seen of the mythical and symbolic forms characteristic of the primitive art of the Huron-Iroquois" (Guerin 1900: 564). For some years, only the Plains Indian had been able to meet the criteria of Indian ethnicity established by scientific ethnology and the embryonic primitivist movement within art history, and Woodlands Indians would increasingly replace elements of their earlier dress with the pan-Indian styles derived from Plains clothing.[18] By insisting on equations of outer appearance, ethnic or racial difference, and subjectivity, late-nineteenth-century commentators effectively "disappeared" the Indian in keeping with their own predictions.

Much of the recent work on tourist art has focused, very naturally, on the twentieth-century global explosion of its production. Theoretical work on tourism and tourist art by MacCannell (1989, 1992), Graburn (1976a, 1984), and others proposes powerful models, which, although not precisely synchronic, compress the diachronic phases of transcultural interaction. Ethnohistorically framed studies add a needed dimension to the study of these arts, offering insight into the complex historical relationships among visual and

verbal texts in contemporaneous circulation. They also foster new under-standings of the dialogic aspects of transcultural expression, revealing the importance of souvenir arts as a medium of visual expression. It is largely in the twentieth century that Aboriginal people have gained access to print me-dia to reach a broad public; visual texts inscribed by commoditized arts have had a much longer history of circulation. The study of souvenirs, then, adds a temporal dimension to the models of social scientists that permits us to lo-cate the narrow but crucial space for negotiation claimed by peoples sub-jected to colonial domination and capitalist commoditization.

Tourist Art as the Crafting of Identity in the Sepik River (Papua New Guinea)

Eric Kline Silverman

For centuries, New Guinea has attracted visitors. First, from the East, came Malayan hunters in search of birds-of-paradise. Now, from the West, art dealers and tourists seek the exotic "primitive" Other, especially along the Sepik River. A more suitable place they could not have found, for New Guinea invokes primal images in the Western imagination: Hobbesian savagery, cannibalism, pagan rituals, and Rousseauesque ideals of sensuality, innocence, and beauty.

It is this popular imagination that tends to frame Sepik River tourist art. But these meanings have little in common with indigenous experience, social life, and aesthetics. Focusing on the Iatmul people of the middle Sepik River, I offer here three related arguments concerning Sepik tourist art. First, I argue that the art adheres to traditional aesthetic canons and cultural themes. Second, I attempt to demonstrate that the art also conveys messages about emergent notions of village, regional, and national ethnicity. Finally, I suggest that Sepik River tourist art expresses changing and often contradictory notions of self and personhood in the contemporary conjuncture of tradition and modernity. Indeed, many of these artworks express ambiguous bodily imagery—at once devouring, birthing, excreting, and regurgitating—in order to convey the predicament of Sepik culture today.

My essay first considers the position of Sepik art in the Western imagination; next, the traditional social and artistic themes that frame tourist art; and last, regional tourism. In conclusion, I offer a reading of tourist art that situates its iconography in terms of authentic and localized meanings within an aesthetics of self and society, culture and (post)modernity.

SEPIK ART AND THE EUROPEAN GAZE

European explorers, scientists, and colonizers who penetrated the Sepik River in the late 1880s were enthusiastic collectors (see Kaufmann 1985). Archival photographs suggest that Sepik dwellers in the early twentieth century reproduced works specifically for external exchange, most likely for metal tools (Douglas Newton, personal communication, 1988). Sometimes, the art was simply taken by force, with firearms. When the colonial proprietorship of German New Guinea was transferred to Australia after World War I, Sepik artists began to sell their wares to missionaries, patrols, travelers, and traders in addition to anthropologists and museums. By the mid-1960s art was becoming a substantial source of income in the region (Wilson and Menzies 1967; May 1977). This process entered a new phase in the 1970s, when Sepik dwellers encountered independence and tourism.

In 1975 Papua New Guinea became an independent nation within the British Commonwealth. Traditional sociolinguistic distinctions have persisted, but they coexist with new and often contentious concepts of ethnicity, nationhood, and citizenship (see Lipset 1987; Premdas 1987; Gewertz and Errington 1991: chap. 6). A year after independence, Melanesian Tourist Services introduced the *Sepik Explorer* houseboats, which were soon replaced by the *Melanesian Explorer* steamship, itself succeeded in 1988 by the *Melanesian Discoverer,* a luxurious state-of-the-art vessel. In 1990 a rival tourist boat, *The Sepik Spirit,* entered the river. Like national ethnicity, tourism significantly alters local identity (F. Errington and Gewertz 1989; Gewertz and Errington 1991; Schmid 1990).[1]

Western tourists and dealers tend to purchase Sepik objects as images of the mysterious and "natural," "primitive" Other. These travelers might, for example, read "The Art Market in Southern Oceania," published in *African Arts* (Crowley 1985), which describes "whatever *objets de vertu* may be available there." Others succumb to Western tropes of possession, consumption, and collection (Gewertz and Errington 1991: 38–57; Stewart 1984).[2]

The widespread dispersal of Iatmul and Sepik River art is a visual commentary on the postmodern world's sense of detachment. Tourists, disillusioned with modernity, long for the "primitive" essence of humanity. Thus an article in the *New York Times* is illustrated with a photograph of a Sepik mask on the wall of a physician's office. Sepik art can also be seen at Ye Olde Curiosity Shop and Museum along the Seattle waterfront. The brochure for the shop *qua* museum (or is it a museum masquerading as a shop?) is enticing: "The Lord's Prayer engraved on a grain of rice; Fleas in dresses; Genuine shrunken human heads . . . and thousands more from every corner of the globe!" Sepik River art is also featured at the Tambaran Gallery on Madison Avenue in New York City; the gallery is subtitled "Primitivism-Minimalism."[3] And readers familiar with the Pottery Barn stores and catalog were

perhaps tempted by the "Barrister Bookcase" in the January 1991 "Catalog for Today's Home." On its nearly bare shelves is a Lower Sepik mask, an example of the recent "decor of nostalgia" (Phillips and Steiner, this volume).

Sepik art has occupied many of the central and shifting categories of "things" in Western institutions, including the authentic, inauthentic, masterpiece, and artifact (Clifford 1988). It is found in curio shops, antique stores, galleries, offices, homes, and natural history and art museums.[4] Depending on institutional framing, the same Sepik object might embody curio(sity), relic, trophy, art, and artifact. Our "liaisons" with objects, contends Thomas, are "promiscuous" (1991: 208).

Dennis O'Rourke's acclaimed 1987 documentary film *Cannibal Tours* featured Iatmul and Sepik tourists. A subtext of the film is a dichotomy between the dominant and encompassing tourists, who represent the crisis of modernity, and the encompassed Sepiks, who typify the dependent "primitive" in ruin (E. Silverman 1996a).[5] This Eurocentric dichotomy, wherein cultures are either pure or defiled, often conceals hybridity as well as indigenous negotiation and resistance (Lips 1937; D. Evans-Pritchard 1989; but cf. Thomas 1996). It also denies local subjectivity, agency, and creativity within the touristic encounter. Art, after all, has mediated many encounters between Sepik dwellers and foreigners. Tourist art is a new form of culture, locally understood *as* "culture," which is used to negotiate with and often to challenge modernity (F. Errington and Gewertz 1996; K. Adams 1995).

CULTURAL THEMES AND THE ART OF TRADITION

As this section indicates, several cultural and artistic themes are relevant for interpreting Sepik River tourist art.[6] My focus is the Eastern Iatmul village of Tambunum, a horticultural fishing village of some one thousand inhabitants. The village consists of patrilineal descent groups that are chartered by totemic names (*tsagi*) and related mystical *sacra* such as masks, dance costumes, and bamboo flutes (Bateson 1958).

The human body is a focal symbol in the culture for society, morality, and cosmology (E. Silverman 1996c). Eastern Iatmul equate bodily cleanliness, sexual and dietary modesty, and control over orifices with a bounded, restrained, and authoritative social order. However, this "moral" body is mocked by the "grotesque" body's juxtapositions of death and birth, consumption and expulsion, violence and renewal (see Bakhtin 1984). Inasmuch as the "moral" body represents order, the "grotesque" body alludes to transformation. Together, the two bodies have a dialogic rather than an oppositional relationship, yielding ambivalence rather than closure.[7]

Nearly all Iatmul objects are ornamented with intricate curvilinear patterns. "The curve in this case attains its greatest freedom. . . . It can scarcely exhaust itself, setting forth on ever new courses with sharp spiral hooks, form-

ing meanders, circling around the whole surface and swooping again toward the middle" (Speiser 1966: 144). Many patterns evoke the serpentine Sepik River, whose banks were formed in mythic history from the undulating bodies of a totemic snake and eel. Other patterns symbolize movement, as do flute music tones, which are named after rapid tides and swift fish. In fact, "good" (*epman*) art evokes literal or figurative movement and blurring, which instances the cultural ideal of *yivut* or "liveliness" (Bateson 1958: 129 n. 1).

Sacred objects do not represent totemic spirits; they *are* spirits. An ornamented art object is a "body" (*mbange*) animated by the totem's "soul" (*kaiek*). The wooden carving is akin to "bones" (*ava*); decoration is "skin" (*tsümbe*). Totemic entities (*tsaginda*) signify the mystical power and fertility of a specific descent group. Yet a group's ritual and totemic art must be created, adorned, and displayed by its sisters' children (*laua nyanggu*) and (alter ego) partners (*tshambela*) (E. Silverman 1995). In this regard, the production and ritual use of art celebrate the autonomy of the group yet admit to its dependence on exchange relations.

This aspect of traditional art relates to personal identity, which is prismatic in Tambunum. The self is plural or "partible" (Strathern 1988; E. Silverman 1995). This collective or composite self is embedded in social relations and gift exchanges. Yet it is opposed by an ideal of individual autonomy.

A totemic object and its human namesake have the same identity. As Gregory Bateson observed: "This is a region of what, for lack of a better term, we may call assertive art. Its basic theme is a sort of immanent totemism. The crocodiles, weevils, and ancestors with noble noses *are* the people who made them and the people who admired them. . . . This positive assertion, which equates the self with a traditional ego ideal, is the basis of the art of this area" (1946: 119–20).

Since a totemic name can be given to only one living person, a ritual object represents both the unique person and the totemic foundation of the group. In this way, traditional art expresses the problematic dynamic between the individual and collective self, which is similar to Bateson's differentiation between "monism" and "pluralism" in Iatmul cognition or eidos (1958: 235).

Space is another important aspect of ritual art. Paints, manufactured from clays and stones that are located in the surrounding region, evoke mythic-historic locations and ancestors. Because most woodcarvings require paints that originated in the topographic domain of another descent group, paint symbolizes exchange and social relations in addition to sociotopographic space (E. Silverman, n.d.).

Decorative nassa, cowrie, and conus shells were once obtained through long-distance canoe travel to the Murik of the Sepik Estuary or through down-the-line exchange that began along the north coast of New Guinea. Today, shells are sold in town markets, often in used beer bottles. Still, shells con-

tinue to symbolize travel, distance, and successful exchange (or monetary transaction), as do acrylic paints and shoe polish, which decorate many touristic woodcarvings.

From their landed Sawos neighbors, Eastern Iatmul obtained tree oil for putty, cassowary and bird-of-paradise feathers, and boars' tusks. Even the wood itself comes from afar, either hauled to the village from the surrounding jungle or found drifting down the river. In order to create art, therefore, men must traverse culturally salient geographic zones, conduct successful exchange relationships, and negotiate through social space.

Sepik River cultures constantly exchange artistic materials, valuables, nonmaterial traits (e.g., magic spells), and mundane objects such as baskets and pottery (Mead 1938: 157–58; Gewertz 1983; Barlow, Bolton, and Lipset 1987; Terrell and Welsch 1990; S. Harrison 1993). Villages often transform importations according to the logic of their cultural system and then export them anew, cloaked in a superior mystical ethos (Mead 1938, 1978: 70). Many early-twentieth-century Iatmul masks, in fact, were ornamented with European buttons and enamel plates (see, e.g., Bateson 1958: pl. 27), a practice that endures (see also O'Hanlon 1993).

Eastern Iatmul claim to have been a pivotal nexus in regional exchange networks, many of which were evolving into hierarchies of unequal economic and symbolic power (S. Harrison 1987). People in Tambunum have an aggressive ethos of cultural, totemic, and military superiority in the Sepik, which is evident in their success with tourism. Eastern Iatmul proudly state that theirs was the first Sepik village to carve art specifically aimed at Westerners. Their pride is fueled by visits to tourism trade fairs in Australia and participation in the New Guinea Sculpture Garden that was created at Stanford University by a select group of Sepik carvers in 1994. The village, moreover, has been a center for anthropological research—Gregory Bateson, Margaret Mead, Rhoda Metraux, and I, to name but a few, have studied there—which is often noted by villagers.

In this section I have described some of the traditional cultural patterns that are important for understanding tourist art. These include body symbolism, an aesthetic of movement, problematic constructions of self and society, aggression, and the regional position of Iatmul villages as cultural purveyors. My point is that Tambunum contained institutions and a cultural logic that facilitated the incorporation, encompassment, and (re)production of tourist art.

SEPIK TOURISM AND TOURIST ART

Eastern Iatmul living in the village can acquire the perceived necessities of existence from the abundant local environment. Nevertheless, money enables the acquisition of prestige goods, such as kerosene lanterns, outboard

motors, clothing, radios and tape decks, sacks of rice, tins of meat and fish, and tobacco and rolling newspaper. As "incarnated signs," these items symbolize a hybrid of traditional and capitalistic process such as restriction, prestige, acquisition, specialized knowledge, and links to the amorphous sources of European power (Appadurai 1986b: 38). Traditional markets based on fixed exchange ratios (Gewertz 1983) have been supplanted by currency markets, and money is necessary to procure artistic materials, pay school fees, travel to town, subsist in urban areas, and purchase medicine.[8]

These circumstances imply that the society depends on a world economic system about which most people in Tambunum understand little, and over which they exercise even less control. This is true, to some extent. But, ironically, the encroachment of the world system and tourism enable the village to exist not as a waning shadow of precontact efflorescence but as an emergent and relevant culture (F. Errington and Gewertz 1996). The West has not eclipsed indigenous creativity and authentic meaning.

Tourism provides the village with some 20,000 kina per year and is by far the largest source of income in the village.[9] Most of the earnings are derived from the sale of art and curios.[10] However, related activities also provide cash. When the *Melanesian Discoverer* arrives, men paint the faces of tourists on the upper deck of the ship or under houses, for which they receive five to eight kina each. Sometimes a traditional dance is performed, fetching sixty to seventy kina. Clans alternate in providing these activities. Tourists may also pay a fee to see any rituals that are in progress.[11]

More adventuresome and budget-minded travelers, frequently guided by the Lonely Planet guide *Papua New Guinea: A Travel Survival Kit,* also contribute to village income. They pay to unfurl their sleeping bags and mosquito nets in private homes and frequently hire outboard-motor canoes and drivers. Some visitors stay at the guest house across the river from the main village.[12] It employs men and women on a rotating basis for security, grass cutting, building maintenance, housecleaning, cooking, and other chores.

The *Melanesian Discoverer,* berthed at the Madang Resort Hotel, introduces most tourists to Tambunum. In addition to visiting the Trobriand Islands and Manam Island, the ship winds its way along the Sepik several times a month, stopping at Tambunum for two to four hours. Some groups are as large as forty people, mainly from Europe, the United States, and Australia. These tourists, who can afford to pay the high cost of air and sea freight, are more likely than others to purchase large items, such as six-foot figures, crocodile-shaped tables, and woven dance costumes.

Dealers often visit Tambunum, perhaps every month or so. As the most populous village along the middle Sepik, Tambunum creates the greatest quantity and diversity of art in the region, perhaps even in the entire country. The Lonely Planet guide calls it the "artifacts factory" of the Sepik. I have

seen dealers purchase upwards of six hundred objects for a total of 5,697 kina. This mode of tourism and artifact sales, one could say, democratizes both carving and access to wealth.

SEPIK TOURIST ART

When buyers and the tourist boat arrive in Tambunum, men and women, and sometimes children, spread an astounding variety of objects on both sides of the main village path, perhaps as many as a thousand: baskets, wood-carvings, shell necklaces, stools, tables, masks, pots, walking canes, woven animals.[13] Potential purchasers stroll down the path, gazing at the items aligned on either side (fig. 4.1). In this multilingual setting, English and pidgin are the lingua francas, with the local vernacular heard in the background. The two lines of art mediate the encounter in the sense that Westerners and the inhabitants of Eastern Iatmul, each curious about the actions of the other, talk across and through the artworks, which are indigenous interpretations of Western aesthetic desires. As tourists gaze down on the objects, the artists look across the spatial and aesthetic boundary to the tourists' faces, thus reading their reading of the art.

In this conversation, tourists and buyers are central, framed by the two rows of objects. The sellers are usually marginalized by their creations, which also filter their subjectivity. The direction of power in this spatio-cultural encounter is ambiguous; its ethos is maladroit. Still, like the traditional acquisition of paints and feathers, success in this encounter requires the skilled negotiation of social space.

Tourism has fostered "mechanical reproduction" (Benjamin 1969b) in the form of wooden crocodile-shaped napkin rings and naturalistic snakes, birds, and frogs. These objects have expressive meaning in the relatively narrow sense that they draw on elements of the socionatural world in an attempt to fulfill a perceived Western aesthetic desire. Symbolic messages, one could suggest, are muted in sheer quantity (see also Gewertz and Errington 1991: 53–54).

Another kind of commoditization occurs when carvers seemingly replicate ritual art. These carvings, however, usually differ from traditional forms. Unlike ritual *sacra*, moreover, these objects are devoid of totemic names and were not carved by sisters' children and *tshambela* partners. Some forms are unable to be (re)produced for sale, especially objects such as bullroarers— long, narrow, and flat wooden objects that are whirled on twine in order to create a roaring sound—which must never be glimpsed by women. Moreover, if a man sees the totemic spirit of a carving in a dream he must not sell the object but place it inside the cult house.

Typically, carved objects reflect local interpretations of Western taste. Sometimes, however, an economic asymmetry influences the artistic process

Figure 4.1. Tourists looking at a display of art for sale in Tambunum village along the Sepik River, Papua New Guinea. Photograph by Eric Kline Silverman.

more directly.[14] In the mid-1980s, a man carved a large orator's stool, which was purchased by a Canadian art dealer and featured in a poster advertising her store. When she returned in 1989, she gave the carver the poster and asked him to carve a replica. Eight years later she had yet to return for it. Such instances of commoditization in the village arise from, and in turn escalate, asymmetrical economic and creative power. This example also illustrates the successful marketing of "primitive" Otherness and the canonization of that representation.

Many forms of tourist art convey messages about three new forms of collective identity. First, Iatmul tourist art, to a degree greater than traditional art, conforms to styles that are largely indigenous to individual villages. I have recognized many styles that are specific to Tambunum in art shops in Australia, Hawaii, and the mainland United States. Local carvers, too, recognize that tourist art symbolizes village identity.

Second, people from the Sepik region are known as "Sepiks" in the national context of Papua New Guinea. Despite artistic variation from village to village, Iatmul recognize that, taken together, their tourist art differs stylistically from that of other regions of the country. Many women weave the letters "PS" on baskets, an abbreviation of the pidgin phrase "pikinini Sepik" or "child of the Sepik."[15] In this respect, Sepik tourist art is an index of Sepik ethnicity. The use of writing on tourist art, moreover, is a new form of aesthetic communication, what O'Hanlon (1995) calls "graphicalization" (see also Gewertz and Errington 1991: chap. 5).

Finally, Papua New Guinean ethnicity is also evident in tourist art, particularly in carvings of the national emblem. Instead of merely replicating the national symbol, however, carvers in Tambunum create numerous variations, thus rendering national ethnicity in a local, village-based idiom (fig. 4.2).[16] The diversity and number of these objects increased between 1990 and 1994, as did the frequency of Christian and biblical slogans beneath the emblem, which represent another dimension of emergent identity. Eastern Iatmul living in Wewak also carve emblems of the PNG military and constabulary, which they sell at the local police headquarters and army barracks.

Another prominent style of tourist art expresses the tension between the bounded and partible self (fig. 4.3). Through a series of hidden faces—or masks within a mask—these woodcarvings contain no visual self-focus. They seem to deconstruct bounded identity. This style, one could argue, expresses visually one valence of traditional personhood in which the self is inextricably bound to social relationships. Yet this notion of the person is at odds with the contemporary economic emphasis on individuation (see below).

Often a painted face is mounted on top of another face—signaling dualistic identity?—and a bird is placed on top of that. Escher-like, the bird is interstitial, emerging from or receding into two-dimensional and three-dimensional spaces. Crocodiles do likewise on wooden tables. Birds and croc-

Figure 4.2. Stylized variations of the national emblem and mask with emergent crocodiles in Tambunum village, Papua New Guinea. Photograph by Eric Kline Silverman.

odiles, like snakes, are liminal creatures in the local imagination because they cross spatial boundaries that in myth are sites of danger and transformation. In this sense, some tourist carvings represent contradictions in personhood as well as cultural themes that were formerly conspicuous only in myth.

In their attempt to (re)define their identity aesthetically, Eastern Iatmul now venture symbolically into previously unknown regions of the East Sepik Province. It is increasingly common for men to carve objects that are entirely unrelated to the traditional culture of Tambunum. They may, for example, carve a yam mask that is characteristic of the distant nonriverine Kwoma (see Bowden 1983). The novel painting style on one such yam mask, as the whim of one man, does not derive from any traditional Eastern Iatmul or Kwoma style.

Eastern Iatmul at times purchase masks, pots, shell ornaments, and necklaces from other villages and town markets, which they may modify and sell at a profit to tourists and dealers. Men in the village delight in recounting

Figure 4.3. Multiple faces, multiple selves: carved masks in Tambunum village, Papua New Guinea. Photograph by Eric Kline Silverman.

to tourists all sorts of fictions about these items—for example, tales of initiations and homicides—in order to surround these imported objects with a new mystique. Such tales also appeal to Western desires for authentic objects—older things that were used in "genuine" ritual.[17] In addition, Tambunum women now weave Murik-looking (Sepik Estuary) baskets and make looped *bilums* (string bags) that are characteristic of other regions of the country, such as the long-fringed "Madang style." The importation of alien cultural forms that are then invested with a local aura continues through tourism. This practice also arises from the precontact position of the village as a nexus for regional, now global, exchange networks.

Tourist art fosters individuality. This relation explains the prevalence of faces in contemporary carvings, which was not the case formerly. As men state, "If we all carve the same things or just traditional objects, then nobody's objects would stand out; since all men carve, there is competition to be unique." Some carvers draw on affinal relations with non-Iatmul villages in order to acquire the "rights" to reproduce and sell distinct art forms. Other men try to carve unique objects by scanning regional art catalogs[18]—although many dealers tell carvers not to create these "fake" art objects (Shiner 1994). Through art, then, tourism places the bounded individual into the foreground of social life, thus deemphasizing group motivation. Before tourism, this traditional facet of identity lacked for the most part a visual expression.

In traditional societies, according to Igor Kopytoff (1986: 89), persons and things have social identities and biographies; in complex societies their identities and biographies are highly individualized and unique. Men with increasing frequency, therefore, sign distinctive carvings with their Christian name rather than their totemic name. Tourists often ask for the (Christian) name of the artist—rarely the name of his or her lineage or clan—thus further strengthening the bond between bounded personhood and the aesthetics of tourist art.

The pursuit of capitalistic goals and monetary profit often problematizes social relations and gift exchange (Sahlins 1992; Maclean 1994), which form a self who is embedded in constant moral obligations for reciprocity that can never be fully reciprocated or renounced. As I have suggested, this tension, which is locally acknowledged, finds expression in tourist art. At the same time, the competitive ethos of capitalism fits well with the former warlike posture of the village. Tourists, in fact, often remark that Tambunum is the most aggressive village in the river when it comes to peddling art. Once again the reason is self-assertion, as well as the traditional relationship between exchange and hostility, rather than group, village, or totemic motivation (Mauss 1990).

I have already mentioned the local aesthetic ideal of "liveliness" (*yivut*), which holds that ritual art should be viewed while in motion and that floral decoration and other ornaments should resemble the chaotic break of ocean

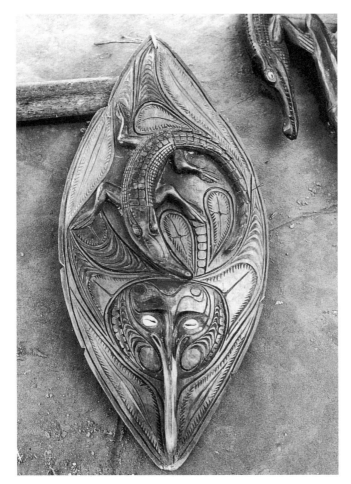

Figure 4.4. The movable, blurred self: mask with crocodile motif in Tambunum village, Papua New Guinea. Photograph by Eric Kline Silverman.

surf (*woli kapmagarl*). Thus many forms of tourist art represent movement through perspective and implication. The crocodile (fig. 4.4), for example, evokes movement, yet its movement is bounded by the plane of the wood-carving itself. It is, after a fashion, going nowhere. In fact, one man carved a "mask" similar to the one just mentioned, but it lacked the face; it was simply a crocodile in motion. These masks express the rapidity of social and economic change and the inability of the self to become firmly anchored in the

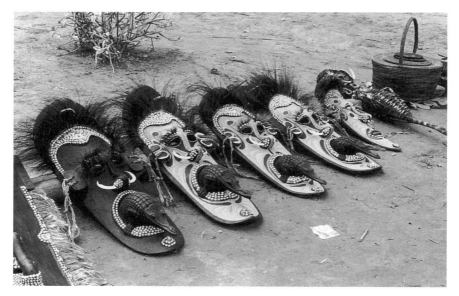

Figure 4.5. The body emerging, devouring, and birthing: masks in Tambunum village, Papua New Guinea. Photograph by Eric Kline Silverman.

contemporary context. To some Eastern Iatmul they also represent small islands (*agwi*) on the river, which are literally afloat.

Many large figures depict a huge face with wide-open eyes.[19] As a striking, bold affirmation of identity, these woodcarvings express an imposing, glaring, vigilant self. On the reverse, however, a small head staring backwards seems to negate the asserted identity of the frontal face. Numerous forms of Eastern Iatmul tourist art, I suggest, communicate an open-endedness of identity that, although traditional, is particularly salient at the confluence of modernity and tradition.

Carved and painted faces often display a pattern of thin red and white swirling lines, which signify menstrual blood and semen respectively—in other words, somatic reproduction. This pattern is painted on the faces of young men during the *tshugukepma* ritual, which enacts cosmic creation and the totemic (re)production of the world (E. Silverman, n.d.). Eastern Iatmul say that tourists like this pattern, which they also paint on the faces of tourists. In the context of tourism, this style represents village identity, but it also allows Eastern Iatmul men to continue to reflect on traditional idioms of gender, reproduction, and cosmology.

Binary structures influence village social organization and eidos (Bateson 1958: 235–48, 271). Hence, many tourist masks exhibit remarkably bal-

anced symmetries. However, these symmetries are often prominent only in profile. From the front, they are barely evident. This visual technique is reminiscent of the multidimensional animals carved on masks and tables. Everything has a unique totemic name. Yet all names are associated lexically and spatially with other names, just as all objects, when viewed from different semantic angles, have myriad associations (E. Silverman 1996c). Local reality is totemically prismatic. This worldview seems conveyed by tourist art symmetries that are visible from only a single perspective as well as by the multiple faces and scenes exhibited by other carvings, no less the different valences of personal identity.

The final aesthetic message I interpret concerns the prevalence of orificial motifs (fig. 4.5). Here I again refer to Mikhail Bakhtin's (1984) concept of "grotesque realism," wherein dramatic orificial imagery, such as gaping maws, symbolically challenges the established morality of social order (see also Jonaitis 1986; Rosman and Rubel 1990). Distinctions between outside and inside, self and other, and containment and movement are blurred. Totemic animals—often crocodiles, which are contemporary symbols of the Iatmul and "Sepikness"—are at once born, regurgitated, excreted, and eaten. This ambiguity is indigenous on the part of carvers and other villagers.

Some carvings display a crocodile emerging from the plane of the mask. Half of the animal, carved in the round, is visible on the front; the other half can be seen only on the underside. The crocodile is locally recognized to be a symbol of ethnic and societal identity. Yet in many contemporary carvings the crocodile is unable to be seen in full from any perspective. Part of it is always hidden. Other carvings blend different styles and faces. They may be selected from the traditional repertoire or from non-Iatmul cultures; sometimes the two are combined.

As the village undergoes dramatic transformation, the dissolution of the previous order is not yet ensured, and the emergence of a new polity is not yet achieved. Many new styles of carving express this ambivalence, which Eastern Iatmul voice. Men are often equivocal about carving—sometimes they are pleased with tourist art; at other times they feel that it is only a minor step toward that elusive goal of "development."

"Carnivalesque" images in Eastern Iatmul tourist art do not celebrate the boundaries and categories of society. However, they do not lead to revolution or chaos. Instead, the images express the emergence of new social forms from the previous order—an emergence that combines an integrated tradition with the disjunctions of modernity.

CONCLUSION

Gregory Bateson noted the Iatmul "proneness to visual . . . thought" (1958: 22). Expanding on this, I argue that Eastern Iatmul tourist art meaningfully

expresses local experiences and processes as the Sepik River community becomes enmeshed in wider global systems. Although I may have omitted much of the pathos of the contemporary moment, it is only to emphasize indigenous creativity and negotiation.

I make four main points. First, touristic processes build on and alter traditional artistic forms as well as regional and village sociocultural processes. In fact, tourism provides an impetus for the refiguration of traditional institutions so they become relevant rather than antiquated in the context of an encroaching world system and rapid sociocultural and economic change. Second, tourist art conveys messages about village, regional, and national ethnicity. Third, some styles of tourist art emphasize personhood that alternates between individuality and dispersal, capitalism and social relations. Finally, I suggest that orificial motifs—at once devouring, regurgitating, birthing, and excreting—refer to an emergent state of social formation.

By distorting so-called tradition, contemporary carvers contest the totemic and moral structure of their social universe. At the same time, Eastern Iatmul embrace capitalism and "modern" things, encompassing them within their own cultural logic and aesthetic gaze. Tourist art, a result of these practices, expresses ambiguities about the self, identity, and ethnicity as the Eastern Iatmul world expands into a state of global (post)modernity.

5

Samburu Souvenirs
Representations of a Land in Amber

Sidney Littlefield Kasfir

This essay is about the interplay between commoditized and noncommoditized forms and the situating of cultural practice within the creative tension between representation and identity. Discussions of so-called tourist art often focus on its commodity status. While essential in locating such objects within (or "against") an art-historical discourse whose premises lie in notions of uniqueness and authenticity, the category of commoditization tends to resist analysis of the patron (or spectator) as anything but a consumer and the artist as anything but a producer. Thinking about aesthetic objects as goods is productive for locating and contextualizing them within systems of exchange, but the language of commodity forms works less successfully in dealing with the highly contingent and often somewhat blurred realities of cultural practice; and it cannot do full justice to the ethnographic complexity of the encounter between artist and audience. I therefore intend to proceed in a somewhat different fashion and examine two related sets of artifacts—photographs *of* and spears *made by* Samburu pastoralists of northern Kenya—in the context and language of the souvenir and theories of collecting. I contrast souvenir collecting with the use Samburu themselves make of their photographs and their attitudes, both artisanal and sociological, toward making spears for foreigners. While neither rigorous nor codified, these attitudes constitute an aspect of Samburu social theory underlying their notions of identity and self-representation. The pairing of photograph and spear is not arbitrary, considering that the most common postcard and coffeetable book image of the Samburu is the spear-carrying warrior. This image, in effect, defines the spear as the ideal souvenir of the hoped-for (if seldom realized) "authentic" encounter between the traveler and the romanticized pastoralist.

For the returned traveler (who in this context is also the collector and was once the spectator), both the spear and the postcard are alike in the

sense that they exist as fragments of something else—they are metonymic references to a larger cultural experience that is being remembered and objectified. By contrast, the meaning that Samburu attach to spears is mediated not by time and distance but by social context. Spears have multivalent properties as weapons, social markers, metaphors of virility, and, for members of the blacksmith group, objects with exchange value. But to Samburu, photographs are primarily mnemonic devices used to recall specific occasions and events.[1] It can be seen that Samburu and foreigners' ideas about the same artifacts are not "parallel" concepts (as in "producer" and "consumer"). There is an inclination on the part of both anthropologists and art historians to see the world in terms of key dualisms: center/periphery, self/other, artist/patron, producer/consumer. But, in fact, one is just as often working with ideas generated by culturally laden encounters that are in conflict but not necessarily in opposition.

A souvenir (from the Latin *subvenire,* "to come into the mind") is an object of memory; a token of remembrance of a person, a place, or an event—that is, an object that stands for something remembered. In that sense, its meaning is private and specific to its owner rather than public and collective. Yet certain kinds of objects become accepted repositories of such recollections in particular cultures and time periods (the Victorian locket, the family photograph album, the stolen street sign displayed in a college student's room), suggesting that there is also a social meaning to the souvenir—something that affirms and legitimates the memory for other viewers as well as for its collector. It is also clear that these "memory-objects" function as signs that recall for their owners and other "knowing" viewers a complex set of associated meanings. I suggest that the Samburu spear is one such sign when it is introduced into a collecting context.

Samburu (who also call themselves Lokop) are one of several subgroups of Maa-speaking pastoralists spread over Kenya and eastern Tanzania.[2] In a sparse but dramatic semidesert landscape framed by the mountains of the northern Great Rift Valley, they herd cattle, sheep, goats, and nowadays also camels. The spear is not only an important social marker of warriorhood in the Samburu age-grade system and in ownership terms an "inalienable possession";[3] it is also a practical necessity. Predators such as lions and hyenas pose an ever-present threat to the safety of herds, and Samburu have intermittent human enemies as well. During periods of prolonged drought, hostilities may erupt between Samburu and rival pastoralist groups (Boran and Turkana) over competition for the scarce grazing land, which has been radically reduced by colonial and postcolonial land-use policies as well as by desertification. Cattle-raiding is another common source of instability (in 1992 several thousand head of Samburu cattle were taken in a single night raid by the Pokot), which requires that Samburu be armed. Finally, since the 1960s, the *ngoroko* (bandits armed with guns originating in northeastern

Uganda) and Somali *shifta* (guerrilla fighters) have introduced a new type of danger—ambushes using firearms. For these reasons, Samburu black-smiths continue to make spears for local use and tailor their production to very specific purposes. There are at least seven types in the repertory of good Samburu smiths, ranging from the lightweight twin spears carried by warriors (one for throwing and one for thrusting) to the largely ceremonial versions carried by elders.

It is possible to describe Samburu solely in terms of the environmental determinism favored by ecologists or the age-grade system that has traditionally been the focus of anthropological study. But what Samburu (and more broadly the Maa-speaking pastoralists) represent to the Euro-American traveler in the East African savanna is quite different from either a cattle-herding people struggling on the edge of survival or an age-graded social system in the control of elders. They are aestheticized and reinvented as proud nonconformists: the last living sign of a "primordial" Africa. From the period of initial Western contact in the nineteenth century (e.g., Krapf 1860; Thomson 1885), this view has been remarkably consistent in the European popular imagination. From archival accounts of colonial district commissioners to the memoirs of white adventurers and literary representations by colonial writers such as Isak Dinesen (Karen Blixen), the physical presence of the Maasai and their apparent disdain for things Western have been the leitmotif of European description (e.g., Blixen 1966). In particular, three aspects of East African pastoralism have caught European fancy: comportment, body decoration, and the accoutrements of warrior-hood (particularly weaponry). Samburu would not describe any of this as "art," but it is in these three areas that the "aesthetic locus"[4] of the culture is highly visible.

To understand outsiders' representations of Samburu and how they affect the souvenir, one need only look at that most ubiquitous of all representations: the postcards sold in safari lodges and hotels throughout Kenya (fig. 5.1). Here, as in the plethora of coffeetable books with names like *The Last of the Maasai* (a title first used by Hinde and Hinde in 1901, and most recently by Amin and Willetts in 1987) and *Vanishing Africa* (Ricciardi 1977), the focus is squarely on pastoralists as a "disappearing" beautiful people who exist in a remote and exotic environment—among the elephant, lion, buffalo, and zebra in the spectacular natural landscape of the Great Rift Valley. A recurring image is that of the warrior with his spear, encapsulating a set of behaviors, an elaborate aesthetic system of body arts, and weaponry as an essential social marker (fig. 5.2). It should not surprise anyone that spears have become, at least for male travelers, a highly desirable souvenir.

The postcard or tourist photograph as an object of memory has two functions; as a mnemonic, and as a repository of nostalgia. As a mnemonic, it instantly recalls for the traveler his safari and his encounter with an exotic cul-

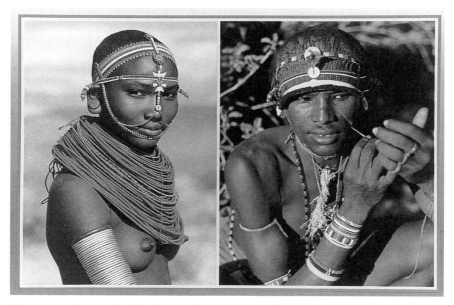

Figure 5.1. Postcard sold in Nairobi, captioned "African Tribe." Left: Samburu girl from the lowlands; right: Samburu warrior (moran) applying facial designs. Reproduced by permission of Sapra Studios.

ture in a remote place. As a marker of nostalgia, it allows the male traveler to identify himself at some deep level of consciousness with someone who seems to encapsulate a perfect manhood that no longer exists in European culture. The *lmurrani* appears to be effortlessly at one with nature, able to subsist independently in a harsh environment, and uninterested in the trappings of Western civilization. Further, these pastoralists are "natural aristocrats," not only in preferring the spear to the hoe but in their physical attributes as well—tall, slender, and graceful, slim of hip and long-legged. As Hammond and Jablow (1992: 165) have pointed out, "Maasai worship" was a well-developed British colonial phenomenon, and the postcolonial Kenya Ministry of Tourism certainly has no desire to let go of that image. So there is the seemingly endless production of postcards, travel posters, and game park brochures with Maasai and Samburu as generic cultural symbols of an "authentic" Africa, and even carved representations of them by Kamba artists—a subject that itself calls into play indigenous ideas of otherness.

Moving through this field of objects, the male traveler with a nostalgic propensity to identify with "lost worlds" almost inevitably yearns to acquire a Samburu spear.[5] He will also, if possible, collect images of Maasai and Sam-

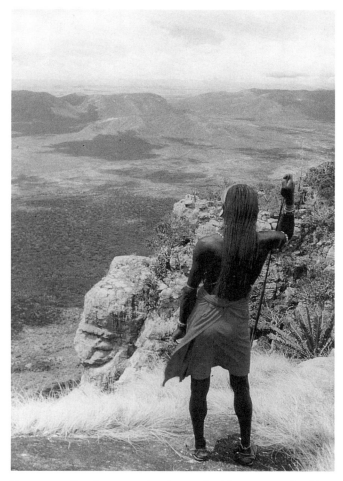

Figure 5.2. Samburu warrior (moran) with spear overlooking lowlands settlements in Samburu District. Photograph by Nigel Pavitt. Reproduced by permission.

buru moranhood (warriorhood)—postcards, snapshots, and perhaps one of the lavishly illustrated books sold in Nairobi shops or upcountry safari lodges.

Theories of collecting, both Marxian (Benjamin 1969a) and psychoanalytic (Baudrillard 1968), intersect with those of the souvenir (MacCannell 1989; S. Stewart 1984), the latter often situated within the phenomenon of tourism. Collections of stamps, butterflies, or rare editions exist for a dif-

ferent reason than collections of souvenirs. Collecting the former is moti-
vated by a passion for completeness; collecting the latter by something else:
nostalgia, longing, memory, and the proof of an authenticating experience.
Both may involve competition with other collectors, and both are important
sources of legitimation for their owners, whether or not the artifacts are rare
or costly. The souvenir is entirely self-referential, whereas the object collected
as part of a set derives its significance from its relation to others in the same
category (Schor 1992: 200; MacCannell 1989: 79–80). Postcards are pecu-
liar in that they bridge these two types of collection: the series and the sou-
venir. A person may begin collecting postcards as evidence of having "been
there" but continue collecting them in order to augment or complete an
iconic category (I myself collect Maasai and Samburu postcards for this rea-
son). As Naomi Schor points out with reference to her own collection of Paris
postcards, "the metonymy of origin is displaced . . . by a secondary metonymy,
the artificial metonymy of the collection" (1992: 200).

Photography, including the postcard photograph, has its own internal so-
cial history and theories of representation apart from its role as collectible
artifact, but what interests me here is its power of evocation as an object of
memory. (In this sense the spear and the postcard are equivalent, though
as representations they are at different degrees of remove.) Two other ap-
proaches to the interpretation of these types of photographs are well known.
The first, which I mention only briefly, is the notion that tourism, or more
revealingly "sightseeing," is a modern, commoditized ritual and the taking
of photographs a type of ritualized enshrinement and consumption through
mechanical reproduction (MacCannell 1989: 42–45). In this interpretation,
images of Samburu and Maasai become material commodities that circulate
and are consumed in a world system of exchange. Although this is an obvi-
ous social fact, it is one of those useful surface observations that does not
get us closer to the encounter itself.

The second approach is the interpretation of the subject through the pho-
tographer's gaze. Implicit in the gaze discourse is an assumption about power,
about dominance and subordination, which translates roughly here into the
dominance of the colonizer over the colonized or, more accurately, the dom-
inance of the camera- and money-wielding foreigner over the spear-carrying
native. Although this inequality is indeed axiomatic, the tourist is not quite
as powerful as the colonizer once was, because the "native" has the right of
refusal, and Samburu at least do not hesitate to exercise it. Indeed it is the
Samburu's and Maasai's seeming *imperviousness* to the gaze that has earned
them the awe of Europeans—"an object for contemplation . . . which is to
be seen . . . but which itself does not see" (Blixen 1966: 146).[6] For the most
part, their own theories of self-representation do not allow for their inter-
pretation as "victims" or unwilling subjects. For this reason, I avoid some of
the assumptions of the gaze discourse but embrace many of its conclusions.

The one exception to their seeming imperviousness concerns photographs of women—representations that more obviously reflect the inequalities of power between the colonizer/spectator and the colonized/subject. There is a type of postcard that Malek Alloula, in his study of the erotic images of colonized Algerian women, described as "The lucky bastard!" postcard, sent home by French soldiers to elicit envy from their comrades by implying that this smoldering oriental eroticism was theirs simply for the asking (1986: 105). This has its counterpart in the postcards for sale in Nairobi hotels depicting young, bare-breasted pastoralist women and girls—Samburu, Maasai, Turkana, and others. These are usually posed by the photographer to occupy the full frame of the camera and thus blot out any contextual background while at the same time focusing upon the upper torso. The woman is smiling and dressed in her beads and perhaps a leather skirt (fig. 5.1 left).

Alloula argues that the colonial postcard is the perfect expression of the violence of the gaze, in which "the colonizer looks, and looks at himself looking" (1986: 130–31). A radical social critique would say that tourism is also a form of colonization and tourist postcards as criminal as colonial ones. This kind of explanatory model, though accepted by many neo-Marxian critics, situates the colonized in a helpless passivity—a state that does not fit Samburu ideas of either social worth or prescribed behavior. Even Samburu women, who are clearly subordinate to men and have very limited access to strategies of protest, sometimes manage to subvert this "tourist gaze." A woman of my acquaintance, when she discovered that her photograph, taken without her knowledge by an Italian priest at her marriage rituals, had been made into a postcard and was being sold in Nairobi, complained to her husband, who took legal action on her behalf and successfully sued the postcard makers. This points up another weakness of the gaze discourse: its frequent reliance on universalizing psychoanalytic arguments that frequently are not deconstructed or nuanced any further than colonizer/colonized. Samburu, like many other formerly colonized peoples, have their own theories of self-representation that do not fit the domination/subordination model imposed by the standard radical social critique of colonialism.

Sexual themes in the representation of both women and warriors form a recurrent *topos* in Western photographs of pastoralists, just as in other representations of the "savage" throughout history. They play heavily into fantasies of possession on the part of the spectator, but to assume that they are merely an exotic version of the Western magazine pinup would be to miss part of their significance. There is also a nostalgia being voiced for physical perfection itself—that same ephebic idealism seen in the Attic *kouroi* of classical antiquity. Maasai warriors are admired for their "breeding"—a term of approval found in the discourse of the European settler aristocracy, which conjures up associations with rarity and distinction, posed in the idiom of the animal world: "Physically, they are extraordinarily beautiful, with slen-

der bones and narrow hips, and the most wonderful rounded muscles and limbs. So delicately built are they that they look more effeminate than the women. But their beauty is entirely masculine. Their breeding shows in their finely-cut nostrils and the precise chiselling of their lips" (Cameron 1955: 45).

In some photographs for the art-book souvenir trade, notably those of Samburu and Maasai circumcision rituals, the nostalgic longing that permeates the souvenir picture is intensified by something closer to voyeurism but is legitimated as *National Geographic*–style documentation (see Lutz and Collins 1993). There is a Western horror and fascination at the very idea of semipublic genital "mutilation," which along with its relative infrequency makes these group ceremonies a magnet for outsiders of all kinds. Detailed photographs, somewhat more discreetly contained within coffeetable books than on postcards, typically show the nude initiate, the moment of cutting, and the aftermath.[7]

Other instances of young male nudity are also caught by the camera—states of ritual undress, private moments intruded upon, and the performance of tasks such as taking water from deep wells (Pavitt 1991: 88–90, 158; Saitoti and Beckwith 1980). Because all published photographs and postcards raise the issue of multiple spectatorship, the readings they are given vary with the propensities of the viewer. But whether they are aestheticized, treated as "data," or viewed as a disguised form of pornography, there is an element of the erotic underlying both nostalgia and voyeurism.

In one sense, the Western spectator's notions of warriorhood, especially of the warrior body, lie at a distant remove from those of the Samburu themselves. But in another sense, they are close to the mark, because the display of sexual virility is also wholly intentional to the warrior's view of himself. Yet the socially meaningful signs of this are very different and a good deal more subtle than simply the bare expanses of muscle and flesh accentuated by ochre and adorned with beads, which are the focus of Western spectatorship in the tourist postcard. Little boys (who are still asexual) and old men (who as patriarchs do not care what people think) are often careless about the exposure of the body, but warriors and middle-aged men are very aware of their explicit places within a regime that maps the body and its adornments onto the existing age-grade structure and its power relationships. While the photograph is a container of memories for both outsiders and Samburu themselves, no such parallel exists for the spear, which has emerged as a specifically intended souvenir only since the 1980s. To understand the "spear narrative" it is necessary to review what has happened to Samburu pastoralism under colonial and postcolonial intervention.

Although Samburu are deeply committed to herding as a way of life, they have also been brought increasingly into the cash economy since the onset of British colonial administration of their grazing lands around 1918. The government introduced taxation in the Northern Frontier District in 1930

in order to force the pastoralists to sell cattle and thereby satisfy the growing demand for meat in the developing urban areas around Nairobi. But since the late 1960s a series of what one writer calls "stochastic shocks" have greatly speeded up this change (Hjort 1979: 80, 143).

Between 1963 and 1968 a territorial war was fought in which both Kenya and Somalia claimed rightful ownership of the vast Northern Frontier District. Many Samburu lost their herds to Shifta fighters armed with rifles. Their losses were compounded by the severe drought of 1976 and a series of epizootics brought on by drought and starvation. Since the 1970s, droughts have occurred frequently, resulting in a sharp decline in herds. The impoverishment caused by these events has resulted in a now-familiar pattern: when pastoralists lose their stock, they either try to take up farming (if rainfall is adequate) or migrate toward towns—in either case they adjust to a more sedentary lifestyle. The valley on the outskirts of Maralal town where blacksmiths and other pastoralists have settled in recent years is known by the Kiswahili nickname *kula pesa*, "eat money." But the Samburu stance toward the money economy is complicated. Many think it pitiable to be engaged in wage labor because this involves subordination to an employer—and one may in addition be required to perform tasks that are thought of as demeaning. Livestock trading is perfectly acceptable, however, being seen as an extension of traditional patterns of wealth accumulation.

The blacksmiths who ply their trade in the valley sell most of their spears to other Samburu and sometimes to their rivals the Turkana. But Maralal is also a stop on the northern game park circuit, and the relatively few tourists who get as far north as this—disgorged for an hour or so from microbuses or the big-wheeled Saharan overlander trucks—provide a small supplementary form of patronage for them. Another large portion of the local spear production is reserved for the beaches north and south of Mombasa, which is the other locale of this story.

The Lkurorro age-set, initiated in 1976, became warriors at a time of great difficulty in the pastoralist economy of northern Kenya (fig. 5.3). Many of their fathers and older brothers had lost massive numbers of cattle in the 1974 drought and subsequent spread of east coast fever. To the older generations of Samburu, cattle are the only recognized form of wealth, but these young moran were the first age-set to realize fully that money can be a safer investment than cattle. A few Lkishili were the first to make the long journey to the Swahili coast, but the Lkurorro were the first Samburu age-set to migrate there seasonally in numbers. So beginning in about 1981, when most of them reached their early twenties, pairs or small groups of Lkurorro, mainly but not exclusively from blacksmith families, made the seasonal migration all the way to the coast, where they congregated up to a hundred at a time in one small enclave between Mtwapa and Kikambala, a few miles north of Mombasa, among the beach hotels that hold German, Italian,

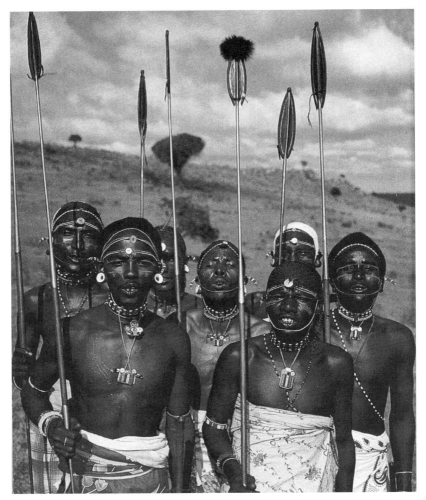

Figure 5.3. Warriors of the Lkurorro age-set singing while carrying spears, Lorroki plateau, Samburu highlands. Photograph by Nigel Pavitt. Reproduced by permission.

British, and American tourists. On the beaches, they sell the spears they have carried on the long journey from upcountry Maralal to coastal Mombasa. Since about 1995, they have been supplanted by the Lmooli age-set, who entered the warrior age-grade beginning in 1990.

Everything about this new style of migration is a departure from older patterns of Samburu transhumance. First, there are no cattle on the journey. Second, instead of walking, one takes public transportation. Third, the everyday dress of the moran (*shuka*, sandals, and beads) and his sword and

twin spears are abandoned in favor of the generic town dress of blue jeans, jacket, and sneakers. Like the liminal period between circumcision and the *lmugit* (ceremony) that confers warrior status, this journey to the coast is another time-out-of-time, requiring different visible signs of identity. In this guise, the Samburu male is almost indistinguishable from other Kenyan young men in the overcrowded *matatus* carrying passengers from upcountry stations to Nairobi. Although they seek anonymity, two things inevitably draw people's attention: their pierced and enlarged earlobes, in which ivory plugs normally are set, and the *lringa,* the throwing stick thought to be necessary for self-defense in dangerous places like Nairobi. Yet, in other ways, this trip is not very different from the far-flung wanderings of warriors in Samburu District, except that the distances are greater and the cultures encountered more foreign to pastoralist norms. Warriors are beholden to no one but themselves, and the journey is a logical extension of their freedom. Nairobi, halfway to the coast, is not used as a place to break the journey for long, partly because most moran travel with little or no money, but also because it is perceived as a hostile place where police harass "primitive" pastoralists (the most frequent reason moran give for not wearing the *shuka* while traveling). Most warriors go directly from the *matatu* to wait for the Malindi Bus, a popular coach line plying daily at perilous speeds between Nairobi and the coast. Once they reach the Samburu enclave there, they change back into their *shukas* and beads because Samburu ideas of self-representation dictate that they identify themselves as moran, not merely as generic (and socially inferior) Kenyan youth. Their dress is a manifestation not only of warrior aesthetics and Samburu/Maasai claims to social distinctiveness but also a strategy to attract tourist attention. Moran know that dressed in a pair of jeans they stand far less chance of marketing their spears. Thus there is a highly instrumental convergence of traditional norms of dress with an understanding of how to deal with tourists as a new clientele for Samburu artisanship—these moran seemingly can have it both ways.

What happens at Mtwapa could best be described as a closely circumscribed set of artistic innovations that relate not only to a new and different kind of patronage but also to the Samburu/Maasai distinctions between insiders and outsiders. Donna Klumpp has pointed out that for the Maasai, innovations in beadwork can be traced to newly formed warrior cohorts (personal communication, January 28, 1991). The general point about innovation is also true for Samburu. Each new age-set looks for ways to distinguish itself from the previous ones (Michael Rainy, personal communication, February 6, 1991). This competitiveness is especially felt toward the age-set that is immediately senior—in this case, the Lkurorro feel special competition with the Lkishili and the Lmooli with the Lkurorro. While most of the warriors who come to the coast are of the *lkunono* blacksmith caste, they do little smithing there. Most of the spear blades and tails sold on the coast are made by smiths in the southern part of Samburu District and are a minia-

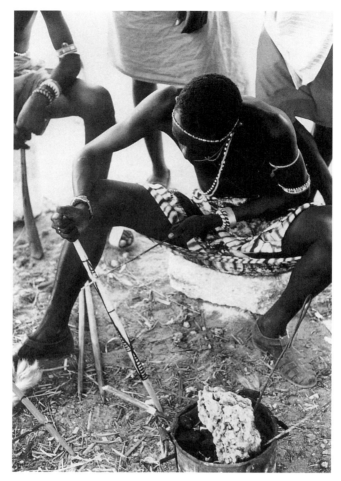

Figure 5.4. Samburu warrior (moran) burning in design on wooden midshaft for tourist spear in Mtwapa (near Mombasa), 1991. Photograph by Sidney L. Kasfir.

turized version of the small-bladed Samburu spear type known as *nkuchuru* or "youth's spear." At Mtwapa the wooden midshafts are embellished by the burning in of geometric designs (fig. 5.4) and the making of a highly elaborated spear-blade cover. These in themselves are innovations that developed out of a known and shared artisanal tradition as it came into contact with a new set of patrons. One important crossover is that of warrior to craftsman, and another is the blurring of traditional distinctions between spear pro-

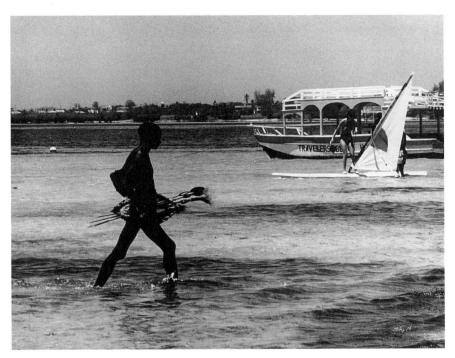

Figure 5.5. Samburu selling miniaturized spears and shield on Bamburi Beach north of Mombasa, 1991. Photograph by Sidney L. Kasfir.

duction as a male occupation and the beading of leather by women. In Samburu District, the spear-blade cover is a simple but expertly fitted piece of leather that may or may not be embellished with a black ostrich feather. At the coast, it more closely resembles a piece of women's beadwork to which has been added a plume, not of ostrich but of goat hair. The Lkurorro perception is that male tourists, especially Germans and Italians, who are the main buyers of spears, want brightly colored (e.g., red and yellow) beads on whatever they buy. The black (male) ostrich feathers, however, are used by Samburu as a sign of themselves, "the people of the black-and-white cattle." The word *ge-sidae*, "beautiful" or "good" (in the moral sense), is applied to black-and-white savanna animals such as the male ostrich and the zebra. Although both types of spear-blade decoration are part of the Samburu grammar of representation, one is a Samburu extrapolation of a Western aesthetic preference and the other is driven by a complex indigenous symbology.

The other major departure from the "authentic" working model resides in the miniaturization of the tourist spear (fig. 5.5). The difference in scale

between a warrior's spear, which should be substantially taller than the warrior himself, and the much smaller versions made for tourists is explained by Samburu as a practical matter: foreigners will not buy a large spear both because they do not want to pay what it should cost (the equivalent of one or two she-goats) and because they cannot transport it back to Europe on an airplane. But in the language of signification, something else has also happened: the relation between the abstract and the material nature of the sign has changed (S. Stewart 1984: 43, 52–53). The object has become smaller, with the net effect of compressing its meaning—a process similar to that which creates bumper stickers ("I love Samburu"), "Karibuni Kenya" T-shirts with Maasai warrior logos printed on the front, and, indeed, postcards depicting warriors. Both miniaturized spear and postcard are intensified repositories of messages and memories.

This intentional aesthetic separation—simple versus elaborate, large versus small—is symptomatic of the whole approach Samburu have both to making objects for strangers and to sojourning far from home. On the one hand, they have learned everything they need to know (including in many cases rudimentary German) about tourists and tourist hotel operators. On the other hand, they know nothing about the food, customs, religion, or community structure of the Swahili people of Mombasa among whom they move daily. The reverse, of course, is also true, and they are known (and identify themselves) as generic "Maasai" to the tourists, the hotel owners, and the Swahili alike. There are, in fact, a few Maasai moran among them, and away from their respective homelands both are comfortable with this common ethnic identity reinforced by both language and custom as well as body arts and the studied aloofness toward non-Maa speakers cultivated by both. Their habit of dressing exactly as warriors would at home reinforces the view of them by both tourists and locals as exotic others. They live in pairs in a barracks-like concrete enclave of rented rooms, the functional equivalent of an all-male cattle camp, but without cattle. They eat together at the small canteen across the road owned by a Maasai whose mother is Samburu. Their decision not to mix—with locals, traders, or tourists—is not imposed by language skills, since they are almost all fluent in Kiswahili. Rather, it is imposed by their view of the coast as a place that is physically as well as culturally inhospitable to Samburu and Maasai. The sea-level climate is unremittingly humid and usually hot—in contrast, at 7,000 feet, the Lorroki plateau in Samburu District is "cold" (meaning healthy, bracing). On the coast there are mosquitoes and malaria. Even worse, people eat fish and other seafood, a practice that violates Samburu and Maasai food prohibitions. There are also unclean people: prostitutes, both male and female, with whom it is considered dangerous to associate. Finally the warriors must be concerned about the attitude of Samburu back home. The older age-sets regard those who spend time at the coast as wastrels and adventurers who lack discipline, and

the older men are ready to criticize the younger ones at any public meeting. It is important therefore to prove that one is a "real Samburu" despite these sojourns to the coast. The trips must not be too often or too long because the Lkurorro are no longer warriors; they have married, and must pay more attention to their herds. To do otherwise would leave them open to serious community criticism.

It remains to discuss how Samburu encounters with tourists fit into a more general discourse on commoditization within what used to be called "traditional society." First, tourism is not the only source of money. Lkurorro often refer to any exchange that results in the acquisition of shillings, whether livestock trading or selling spears, by the English term "making business," just as they also use the English term "town" to refer to a non-Samburu settlement. What one does in a "town" is "make business." But loading a bundle of spears onto the back of a donkey and walking into Turkana country to sell them is also "making business," so the term need not carry the association of selling to foreigners. For the blacksmith at least, a spear is a commodity regardless of the client for whom it is made: a fellow Samburu, a Turkana, or a tourist.

The more interesting question is what the spear means for the moran who travels to the coast. He owns and carries his own twin spears in the context of his life as a pastoralist and a member of the warrior age-grade. These, as I have said, are inalienable possessions. The less favored of the two weapons, the one whose feel in the hand is less perfect, may be lent to another warrior or even to a young boy if he is grazing animals far from the manyatta, or settlement. But it is never sold or given away. Like the circumcision ritual, the spear is a rich source of metaphor concerning virility, prowess, maleness, and embeddedness in the values of pastoralism and the age-grade. It is also a real, not a ceremonial, weapon. This juxtaposition of ideas embodying both sexuality and violence is what makes the warrior spear so potent as an artifact.

But when it is commoditized by warriors themselves, it undergoes a transformation not unlike that of a ceremonial weapon: it is a distinctly different size and weight and is heavily elaborated and embellished. It is unambiguously *not* a weapon to be used for fighting but becomes instead an aesthetic object. Recall also that the elaboration is done not by blacksmiths in Samburu District but by the moran of the blacksmith caste at the coast. I suggest that this removal of the spear both from its usual place and from its socially embedded position, and the alterations to its scale and decoration, are all necessary in order to "defuse" its power and reinvent it as a neutral object for a new clientele and a different purpose. Its commodity status depends first of all on its redeployment into a different system of objects where it will take its place among other souvenirs.

The ease with which the tourist spear business (and the sale of other goods such as beadwork and services such as safari guide or "traditional dancer"

at hotels or safari lodges) can be incorporated into pastoralist life with only minimal changes is striking. In most cases this business takes the Samburu away from the manyattas for only a few weeks a year. Despite a new worldliness that comes from Samburu encounters with exotic others, and despite their development of an ease with money transactions, the currency by which wealth is calculated back home is still cattle. Trips to the coast are not seen as all-or-nothing commitments to a new lifestyle but as periodic attempts to augment resources. For the younger moran, they are mainly adventure, a kind of *wanderjahr* far from the control of elders. For the older ones, the trips provide a chance to build up capital for the purchase of animals. In the late 1990s at least, most of the young men who travel to the coast are still firmly ensconced in the values of pastoralism. This situation contrasts sharply with that of Melanesian societies such as the Iatmul, in which the very continuation of village life is seen by many as economically viable only because of the presence of the tourist trade in the villages (Silverman, this volume). Both because of their geographical remoteness from the most popular game reserves and because of their scattered settlements, most Samburu have no contact at all with tourists.

The ethnographic encounter with tourists is actually a source of innovation, which then finds expression in "traditional" and noncommoditized forms. Because warriors have become skilled at certain kinds of beadwork while at the coast and away from the women of the family in whose province it normally resides, their new designs—modified by tourist encounters and also by the presence of nonpastoralist (e.g., Kamba) beadwork for sale in the same places—find their way back to the manyattas.[8] The town itself is also a source of innovation, and the tinsel Christmas ornaments and plastic baubles sold in markets there have found their way into warrior headgear in the same way that zippers and buttons first became ornaments in the early colonial period.

I have tried to show that there is a creative tension and interplay between the warrior's spear and the spear made for tourists in much the same way that there is an unresolved ambiguity between the representation of the Samburu and Maasai by photographers and their own self-representation through body arts, weapons, and comportment. As Waller and others have pointed out, there are essentially two approaches to Maasai identity—one, with many variants, constructed *by* the Maasai, and the other (as we have seen here) constructed *for* them (Spear and Waller 1993: 300). These are not mutually exclusive but have existed in interactions between the Maa-speaking pastoralists and others—allies, enemies, colonizers, missionaries, ethnographers, and now tourists. The connection between constructed identities and the spears narrative is simply this: spears are potent badges of identity in-

scribed within the material world. They are both metonyms for the moran and metaphors of his virility, and for the Maasai and Samburu, the spears are inseparable from their notions of who they are. But in response to a depletion of traditional resources and a need for other sources of income, they have been able to invent a parallel system of objects that is externally directed yet compatible with the internal and socially embedded one. Furthermore they have been able (unintentionally at first and later knowingly) to market these artifacts using their external identity as the "last vestige" of warrior aristocrats in a golden land.

In conclusion, I suggest that souvenirs have, from the point of view of their makers, a marked status that puts them outside the rules of accepted cultural practice. The fact that Samburu have made them firmly client-centered— providing what people are perceived to want or need—can be recognized as their way of embedding new forms of patronage in a much older set of ideas about artisanship. In the Western tendency to see the meaning of the souvenir for its recipient as if that were its only meaning, it is easy to lose sight of its different place within Samburu (or any indigenous) social theory and aesthetic practice. Once an artifact has been separated from its customary social and ritual roles, it is free to be newly invented and theorized for a different clientele and a different purpose. In a more conventional Western context, we might refer to this invention as "art." But however much we may prefer to disarm, deconstruct, or neutralize it, the tourist spear remains for Samburu a very significant locus of aesthetic practice.

PART TWO

Authenticity

The Problem of Mechanical Reproduction

Authenticity, Repetition, and the Aesthetics of Seriality
The Work of Tourist Art in the Age of Mechanical Reproduction

Christopher B. Steiner

Virtual sweatshops have been set up in Africa to produce wood sculptures for the tourist trade. . . . Contemporary artists feel no pleasure in the act of creation. They win their place by training rather than by talent. They copy old models over and over again.
LADISLAS SEGY, *AFRICAN SCULPTURE SPEAKS* (1955)

Throughout Africa artisans in "craft centers" catering to tourists simply churn out copies of authentic items.
KERRY HANNON, "OUT OF AFRICA,"
U.S. NEWS AND WORLD REPORT, MAY 5, 1997

When Walter Benjamin wrote his famous essay "The Work of Art in the Age of Mechanical Reproduction" in 1936,[1] he was grappling with two different issues relating to the changing concept of art in the industrial and post-industrial ages. The first issue, and by far the more easily comprehensible, concerns the *production* of artworks. "Authentic" art, according to Benjamin, is produced (and indeed must be produced) in the context of the religious cult and in response to the demands of tradition. In other words, Benjamin writes, "the unique value of the 'authentic' work of art has its basis in ritual, the location of its original use value" (1969b: 224). The mechanical re-production of artworks, suggests Patrick Frank in a commentary on Benjamin's essay, "severs them from their places in the fabric of tradition and thus erodes the aura of originality, uniqueness, and permanence which attended them at first" (1989: 29). Even as late as the Italian Renaissance, Benjamin locates the production of authentic art in the ritual and traditional spheres, noting that "however remote, the ritualistic basis is still recognizable as secularized ritual even in the most profane forms of the cult of beauty" (1969b: 224).

In this regard, then, the advent of the mechanical reproduction of art is not simply a new form of technical production (i.e., creating something by *machine* rather than by *hand*); instead, it engenders an entirely new philosophy of production in which the work of art is "emancipated . . . from its parasitical dependence on ritual" and brought into the secular realm of daily life (Benjamin 1969b: 224). "The instant the criterion of authenticity ceases to be applicable to artistic production," concludes Benjamin on this point, "the total function of art is reversed. Instead of being based on ritual, it begins to be based on another practice—politics" (224). Or, as Rosalind Krauss puts it, for Benjamin "authenticity empties out as a notion as one approaches those mediums which are inherently multiple" (1986: 152).

The second issue discussed in Benjamin's essay is what he calls the "perception" of art in the age of mechanical reproduction, but what I propose really concerns the *consumption* of art in industrialized, class-stratified societies. What happens, Benjamin asks, when the mechanical reproduction of artworks makes it possible to disseminate identical images throughout the world and, more important, to distribute images across economic and social barriers? Visual representations are no longer the property of the privileged few but become accessible to the wider population and to the lower and middle classes (see Snyder 1989: 162). The impact of mechanical reproduction on the perception of art, according to Benjamin, is that "the quality of the original's presence is always depreciated." In a typically dense statement on the subject, Benjamin concludes, "That which withers in the age of mechanical reproduction is the aura of the work of art. . . . By making many reproductions it substitutes a plurality of copies for a unique existence" (1969b: 221).[2] Benjamin's essay suggests that art must be industrialized to be truly modern and thus "to reach and respond to the needs of the masses" (Wollen 1991: 53).

Although Benjamin is concerned with two very specific forms of mechanical reproduction, photography and sound motion pictures—two genres of visual representation that at first glance may appear somewhat distant or perhaps even irrelevant to the subject of "tourist" art—I believe his argument applies universally to the study of any art form that is embedded in a wider economy and subject to the market forces of production and consumption. For, in the final analysis, his essay hinges not so much on a technical contrast between things made by hand and things generated by machine, but on contested definitions of reality or, more to the point, authenticity. His essay, in other words, is an extended discussion of standards—exemplars we employ in determining the kinds of things and sorts of relations that we have a legitimate claim to call "genuine" or "real." According to Benjamin, the authentic is equivalent to the auratic, and it is for him the "aura" of art that declines in the age of mechanical reproduction. As Joel Snyder suggests: "Benjamin contends that the relation between the mass

audience and the film producer is one that cannot arise in the context of auratic art. The producer is forced to produce what the mass audience will pay for and is constantly concerned by the need to meet its demands" (1989: 167).

Are these not precisely the same claims that have been made about producer-consumer relations in the context of the tourist art economy? Using Benjamin's essay as a stepping-stone into the world of mass-produced souvenirs and related art forms, I explore in this essay the relationship between production and consumption—that is, between the creation of visual representations and their perception in the so-called tourist art industry, especially in Africa, today.[3] Many studies of African tourist art by anthropologists and art historians have dealt with production and consumption as discrete entities. On the production side, studies have asked: Are those who create tourist art really artists? Where do they get their training? And where do they get their ideas? (See, for example, Ben-Amos 1971, 1976; Silver 1976, 1981a, 1981b; Dolores Richter 1980; Ross and Reichert 1983; N. Wolff 1985.) On the consumption side, studies have asked: Is tourist art really "art"? Who buys it? And what do people do with it after it has been bought? (See, for example, Clifford 1988; Price 1989; Torgovnick 1990; Halle 1993a; Root 1996.)

Bennetta Jules-Rosette (1984, 1990) was among the first to look at African tourist art as the output of a negotiation between producers and consumers. My essay (and indeed this book) owes much to her pioneering work on the semiotics of tourist art exchange networks. Among other things, Jules-Rosette aims to heighten the cultural validity and scholarly significance of tourist art by demonstrating that such an art form does not consist merely of mindlessly mass-produced objects but exhibits signs of genuine aesthetic creativity and often artistic genius (in contrast to Benjamin's model). Although I share Jules-Rosette's view on this point, I argue here that to "justify" the authenticity of tourist art one must begin from an entirely different starting point. I consider the category "tourist art" to represent a paradigmatic form of mass-produced art and argue that its authenticity and cultural rationality flow from the qualities it shares with *other* mass-produced objects and commodities throughout industrial and postindustrial history. In other words, if one accepts mass production or mechanical reproduction as legitimate forms of cultural expression—worthy of the same attention and intellectual respect as other categories of so-called art—then the burden of proof necessary to rationalize tourist art as an "authentic" art form requires one to demonstrate only the logic of production and consumption that it shares with other classes of mass-produced things.

If one looks at production and consumption as Benjamin did—as a continuum along which reality is measured by those who produce and those who receive it—the category "tourist art" emerges as a complex form of visual rep-

resentation that is defined and negotiated by a plurality of artists, critics, and consumers in the world (art) system. I contend that, in the end, tourist art might perhaps better be understood not as a unique form of art produced in the restricted conditions of colonial and postcolonial encounters but as an example of material culture that fits into a more generalized model of producer-consumer relations including other major innovations in mechanical reproduction, mass production, and the universal dissemination of popular culture, which both preceded the rise of the tourist art industry and continue to flow in the wake of its swelling tides. Among the specific historical moments considered here are: (1) the development of the printing press, movable type, and plate engraving during the fifteenth and sixteenth centuries, and their relation to the literature of travel and exploration; (2) the Industrial Revolution and its impact on textile manufactures and social stratification in England during the eighteenth century; and (3) the dissemination of mass culture and an emerging web of "intertextual dialogue" in the postmodernist era.

TOURIST ART AND THE PRINTING PRESS

The mechanical reproduction of images and text in printed form made possible the quick and easy diffusion of identical representations to a huge number of people across a vast territorial expanse. Pictorial prints, in particular, were one of the earliest forms of mass-produced images for popular markets, and their availability helped to cultivate consumer behavior in the lower classes of society. From the consumer's viewpoint, Chandra Mukerji (1983) explains, popular prints, especially those with a religious theme, were desired in the fifteenth century not for any new information they communicated but for their potential to awaken pious emotions. "The important issue in designing prints," she writes, "was making their content identifiable to a broad population. This led to a kind of standardization that was peculiar to this commercial type" (53).

Some of the earliest printed books (after the Bible) were accounts of travel and exploration in distant lands. Curiously, however, many of these accounts used identical images almost interchangeably to report on widely dissimilar parts of the world (see Steiner 1995). In the first major illustrated account of European voyages and discovery, Hartmann Schedel's so-called Nuremberg Chronicle, published in Germany in 1493,[4] the editor employed identical woodcuts by Michael Wolgemut to represent different cities in Europe and the Middle East (figs. 6.1 and 6.2). Commenting on the reduplication of urban landscapes found in this early travelogue, art historian E. H. Gombrich once made the following critical observation:

> What an opportunity such a volume should give the historian to see what the
> world was like at the time of Columbus! But as we turn the pages of this big

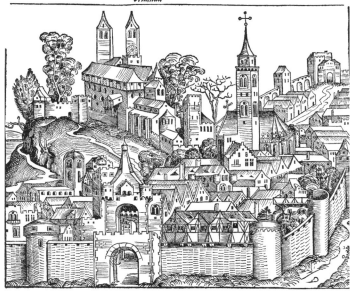

Mantua

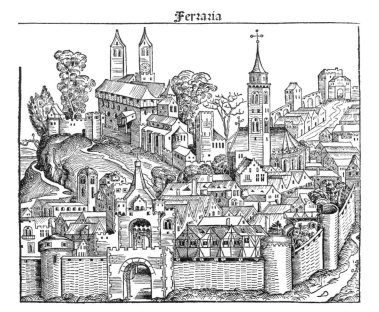

Ferraria

Figures 6.1 and 6.2. Michael Wolmegut, *Mantua* and *Ferraria*, woodcuts. From Hartmann Schedel, *Registrum huius operis libri cronicarum cum figuris et ymaginibus ab inicio mundi* (Nuremberg: Anthonius Koberger, 1493). Reproduced by permission of the J. Paul Getty Trust.

folio, we find the same woodcut of a medieval city recurring with different captions as Damascus, Ferrara, Milan, and Mantua. Unless we are prepared to believe these cities were as indistinguishable from one another as their suburbs may be today, we must conclude that neither the publisher nor the public minded whether the captions told the truth. All they were expected to do was to bring home to the reader that these names stood for cities. (1960: 68–69)

Clearly, the authenticity of these images did not depend on either originality or verisimilitude; instead, their truth-value was derived from their redundancy. That is to say, Damascus, Ferrara, Milan, and Mantua must all be "read" as important, beautiful cities because they are all represented by the same visual code.

Gombrich uses this example of iconographic redundancy to make a more general point about "truth and stereotype" in the visual arts. After discussing why an illustration of a rhinoceros published in 1789 depicts anatomical errors identical to those found in Dürer's original woodcut of a rhinoceros published in 1515 (both show the animal covered in interlocking armored plates, much like a medieval representation of a dragon), Gombrich concludes that the "familiar will always remain the likely starting point for the rendering of the unfamiliar; an existing representation will always exert its spell over the artist even while he strives to record the truth" (1960: 81–82).

Most European representations of non-Europeans since the Age of Discovery have relied on the evidence of earlier models to make claims about both their visual authenticity and their ethnographic accuracy. Rather than incorporate new data collected in the course of travel and exploration, accounts of voyages generally copied earlier sources. Thus, the first representations of the indigenous peoples of Africa, the Americas, and the Pacific often established the model or standard idiom by which the inhabitants of such "exotic" locales were thereafter represented in visual form. The authenticity of the representation was grounded on its adherence to the already-known rather than on its incorporation of new and (presumably) more accurate data.

This practice of redundancy and repetition was not unique to the exploration of distant or "primitive" worlds; even travels within Europe employed narrative and descriptive conventions in order to establish textual authority. As Charles Batten writes in a study of eighteenth-century travel literature and the Grand Tour: "Having no other relatively reliable means of verifying the truthfulness of an unknown author, eighteenth-century readers necessarily judged the veracity of a travel book on the basis of its adherence to recognized conventions of travel literature" (1978: 59). These "conventions," Batten explains, often amounted to the repetition of established or already-known information:

> In describing cities, buildings, natural settings, customs, and the like, a degree
> of *similarity strengthens the credibility* of both works: if they do not agree in their

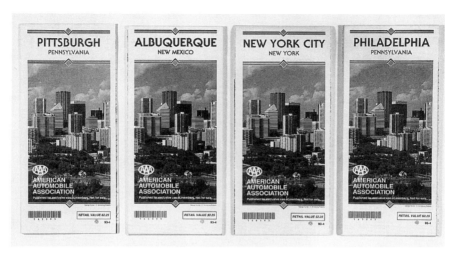

Figure 6.3. Four road maps of U.S. cities published by the American Automobile Association in the late 1980s. Reproduced by permission of the American Automobile Association.

most basic descriptions of a place like Venice, the reader inevitably suspects that at least one of the travelers is inaccurate, if not dishonest. Scientists like Samuel Stanhope Smith, who invariably distrusted the first descriptions of any place, demanded a concurrence between several travel accounts before crediting any treatment of faraway countries. (1978: 62; my emphasis)

Thus the logic of representation that guided the reduplication of Wolgemut's city woodcuts in 1493 continued well into later centuries as a marker of both visual and narrative authenticity. Indeed, the practice of iconographic repetition—a notion of authenticity that turns on its head the classical view that authentic things must be originals, not copies—continues into the present as a direct result of the logic of representation engendered by mechanical reproduction. Witness, for example, a series of road maps distributed in the late 1980s by the American Automobile Association (fig. 6.3).[5] Maps for such distant and diverse metropolitan regions as Pittsburgh, Albuquerque, New York City, and Philadelphia are all illustrated on the cover with an identical generic skyline. The lost road traveler who gazes quickly at the front of the map may assume for an unthinking moment that the photograph does indeed represent the city it claims to be. The point is simply that the illustration of this universal cityscape is an encrypted form of semiotic shorthand—an iconic trope characteristic of the age of mechanical reproduction, which is understood and accepted by both map maker and map reader.

This type of authenticity, which relies on redundancy and repetition to

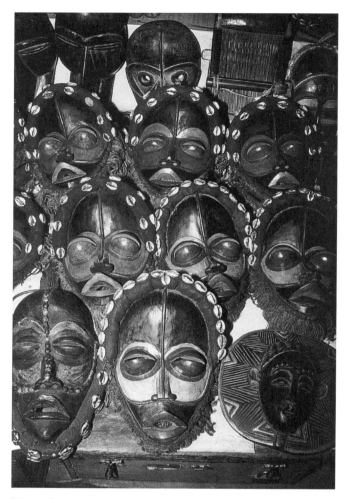

Figure 6.4. Masks lined up for sale at an Abidjan market-place, Côte d'Ivoire, October 1987. Photograph by Christopher B. Steiner.

create its own standards of reality, is found today throughout the African tourist art market. Browsing through any art gallery or marketplace stall in urban West Africa, one is struck immediately by the rows of identical objects placed side by side on display shelves and walls (figs. 6.4 and 6.5). It is almost as though *mass* production must somehow be echoed in its presentation through a scopic regime of *mass*-mediated consumption. Anthropolo-

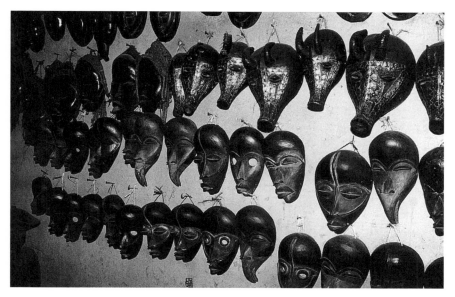

Figure 6.5. Masks displayed on interior wall in an art storage facility, western Côte d'Ivoire, March 1988. Photograph by Christopher B. Steiner.

gist Hans Himmelheber, one of the pioneer European scholars of the arts of Côte d'Ivoire, once remarked disparagingly on this practice of mass display in an Abidjan marketplace. "The African art traders' lack of knowledge as entrepreneurs is astonishing. They set out the same objects fiftyfold, one next to another, so that the customer sees at once that everything is mass-produced" (1975: 20; my translation).

I do not believe that it is from lack of knowledge that art traders display objects for sale in this manner; rather, it is a direct result of the curious form of authenticity born in the shadow of mass-produced images and texts. For just as printed illustrations and words both in the past and today have achieved visual and textual authority through repetition, so too, I suggest, does tourist art effectively produce its own canons of authenticity—a self-referential discourse of cultural reality that generates an internal measure of truth-value. And, therefore, just as in Benjamin's model of mechanical reproduction, "the copy becomes associated with the true and the original with the false" (Wollen 1991: 53).

Because an object's economic worth in the African art market depends not on its originality or uniqueness but on its conformity to "traditional" style, displays of nearly identical objects side by side underscore to prospective tourist buyers that these artworks indeed "fit the mold." There is no room left for

ambiguity in this visual exhibition of iconographic reiteration and its attendant display of formal juxtapositions. In this scheme, the unique object represents the anomalous and undesirable, while a multiple range of (stereo)types signifies the canonical and hence what is most desirable to collect.

TOURIST ART AND THE INDUSTRIAL REVOLUTION

A second moment in the history of mass production that conditions the interpretation of tourist art today is the Industrial Revolution beginning in England in the eighteenth century. Among the greatest change brought about by the Industrial Revolution was the rapid rise in the production of cotton cloth, which quickly replaced wool, linen, leather, and silk as the material of choice for clothing and personal adornment (Chapman 1972; Mukerji 1983: 210–42). Cotton was not only better suited to the lighter, more flowing styles of dress favored by eighteenth-century British women consumers, but more significant for the present discussion, cotton provided the lower and middle classes with a cheap imitation of the latest, most fashionable attire. In this regard, cotton is said to be not only a product *of* but indeed functioned *to create* the emulative world of the eighteenth century, where middle-class men and women strove to imitate the dress of their social betters; a world in which maids were often mistaken for their mistresses (Lemire 1991). In 1811, for instance, a certain "Lady of Distinction," alarmed by the improved appearance of the working and middle classes due to the availability of inexpensive muslins and calicoes, noted: "It is not from a proud wish to confine elegance to persons of quality that I contend for less extravagant habits in the middle and lower orders of people; it is a conviction of the evil which their variety produces that impels me to condemn in toto the present levelling mode. A tradesman's wife is now as sumptuously arrayed as a countess, and a waiting maid as gaily as her lady" (quoted in M. Edwards 1967: 48). One of the direct results of this leveling trend in fashion was that symbols of high rank were continuously shifted so that the elite could distinguish themselves from the rest of the population by staying one step ahead of the newest modes of attire (see Steiner 1985).

In a similar manner, within the contemporary African art market, the categories "authentic" African art and "inauthentic" tourist art are continually shifting and being modified by those who have a stake in maintaining a category of high-end investment objects. Imitations of African "fine art," like imitations of haute couture in an earlier epoch, are frowned upon by those with a speculative interest in the consumption of cultural capital (see Bourdieu 1984). Writing in 1959, for example, William Fagg notes the general negative attitude toward African tourist art and aesthetic hybridism then held by "elite" consumers of African art who took it upon themselves to advocate the preservation of "traditional" artistic forms and styles: "Hybridism in art, in

the sense of fusion of the aesthetics of widely differing civilisations or cultures, is seldom very successful. . . . In Negro Africa, the impact of the European aesthetic (nearly always, it must be admitted, in a very debased form) has been almost uniformly devastating, particularly during the past century" (vii).

Writing in 1962, Denise Paulme also sums up much of the connoisseur's contemptuous assessment of African tourist art: "[African] art has degenerated and veritable studios have opened up to meet the demand of tourists. All that was good in African sculpture has disappeared in these examples conceived solely for sale. . . . the sculptures in which European influence is apparent are generally ugly and all sense of rhythm has disappeared" (150).

Writing in 1966, J. A. Stout captures the Western observer's skeptical reception of African artistic innovation, characterizing tourist art as a kind of "anti-art that emerges insidiously with the rapid fading of ways of life that generated the famous traditional African art" (quoted in Ben-Amos 1977: 128). And finally, consider a review of Nelson Graburn's *Ethnic and Tourist Arts* (1976) that appeared in the high-end, collector-oriented magazine *African Arts*. The review, by anthropologist Daniel Crowley, begins: "Offensive though the subject of this collection of essays may be to our more *raffiné* readers . . ." (1977: 8).[6]

Just as the Industrial Revolution made cheap (but expensive-looking) cotton fabrics available to a wide and diverse population, including those in the lower ranks, so too does tourist art make imitations of high-end investment art affordable to a broad economic and social spectrum of the consumer society. Although the "serious" collector would argue that the quality of tourist reproductions pales in comparison to the "original" work, the degree of similarity nonetheless establishes a certain competition between the original and its lookalike. Art-historical scholarship and expertise intervene to draw a sharp distinction between the two potentially contagious categories. But the categories remain volatile because they are never objectively fixed or, in certain cases, even immediately distinguishable.

The tourist replica displayed in the domestic interior often "passes" to the untrained eye as "authentic" art. Consider, for example, photographs in popular magazines that show celebrities in their multi-million-dollar homes appointed with "classic" examples of contemporary African tourist arts—see, for instance, a recent photo layout of actor Wesley Snipes's Hollywood home in *Architectural Digest* (April 1997). Consider also the stage set of *Frasier,* a popular primetime television comedy about a Seattle psychiatrist in which the main character's posh penthouse apartment is filled with stunning examples of Asante, Dogon, Malinke, and Bamana tourist art.[7] To the public, viewing African artworks in both of these contexts, the objects, in their sumptuous surroundings, are coded as "real"—variously making statements about the cultural roots of African-American identity on the one hand and the clichés of a Freudian fixation with the "primitive" on the other. The point is

simply that most "receivers" of African art cannot tell the difference between the (falsely constructed) categories of "fine" art and "commercial" art. As one tourist consumer asked me in an Abidjan marketplace: "Why should I spend so much money to buy art in the Hôtel Ivoire [art gallery] when I can get stuff that looks exactly the same, for almost nothing, right here?"[8]

Many tourists are aware that not everything sold in the marketplace is "authentic," so they often "train their eyes" in the upscale galleries and then search for similar items in the open-air markets, where they can haggle over the price. The telltale signs of "authenticity" are also revealed to travelers in tour books and in the press. In a recent article in *U.S. News and World Report* on collecting African art in America, for instance, a spokesperson for Christie's auction house in New York is quoted as saying, "Once you have seen and handled enough of [a type of artwork] you will recognize genuine wear marks and true patinas that come from age" (Hannon 1997: 73).

One of the simplest indicators of the "authenticity" of an African mask are "sweat marks" on the inside—a sign that the mask "has been danced." African traders who sell to tourists in the marketplace are well aware of this clue and often stain the inside of a mask with palm oil or score abrasions with sandpaper in appropriate places. To the "trained" eye these marks are far too obvious to be interpreted as genuine sweat marks (which would normally reveal themselves very subtly and only when the mask was held at a correct angle to the light), but to tourists eager to purchase the "real thing" these marks provide the evidence that they are looking for. In fact, real sweat marks would probably be overlooked in the typical haste of a marketplace purchase.

This process of visual overdetermination is not limited to the African tourist art market; it crops up in other circumstances in which replicas destined for a mass market are passed off as high-end or authentic merchandise. In a *Fortune* magazine article on the two-billion-dollar-a-year industry in manufacturing counterfeit designer goods, for example, New York City socialite Nan Kempner critiques a suitcase allegedly designed by Louis Vuitton that "flaunts a Louis Vuitton logo stitched on askew in addition to the LV insignia." She declares, "I know this is fake because Louis Vuitton doesn't go to that much trouble to let you know it is authentic. For some reason, the people who make copies think they have to give you more features than the original" (quoted in Rice 1996: 139).

THE AESTHETICS OF SERIALITY

In an important essay devoted to the aesthetics of innovation and repetition in Western art traditions, Umberto Eco guides the reader through a brief history of shifting attitudes toward redundancy and novelty in Western art. Beginning with the classical theory of art, from ancient Greece to the Mid-

dle Ages, Eco notes that no distinctions were made between arts and crafts. "The classical aesthetics," he writes, "was not so anxious for innovation at any cost; on the contrary, it frequently appreciated as 'beautiful' the good tokens of an everlasting type" (1985: 162). Only in the modern period did crafts emerge as distinct from art. The aesthetic experience of craft was not based on novelty but on the "pleasurable repetition of an already known pattern" (161). The category art, on the contrary, "corresponded rather to a 'scientific revolution': every work of modern art figures out a new law, imposes a *new paradigm,* a new way of looking at the world" (161). In the postmodern era, Eco argues, we have returned to an appreciation of the familiar as it is expressed in intertextual dialogue and to the "aesthetics of seriality" in popular art and mass media. He suggests that serial arts grow out of a taste for the iterative scheme in postmodernist sensibility, which is consumed by a mass audience with a "hunger for redundance" (1984: 120). In this regard, serial arts contain little or no new information but are characterized instead by the transmission of a high-redundance message. As Eco summarizes: "A novel by Souvestre and Allain or by Rex Stout is a message which informs us very little and which, on the contrary, thanks to the use of redundant elements, keeps hammering away at the same meaning which we have peacefully acquired upon reading the first work of the series. . . . From this viewpoint, the greater part of popular narrative is a narrative of redundance" (1984: 120).

In keeping with Eco's observation, I suggest that tourist arts, like popular narratives, are structured around heavily redundant messages. In their consumption of African artworks tourists are not looking for the new but for the obvious and familiar. This pattern of consumption is indeed part of a more general phenomenon in the structuring of tourist experience—one that Kenneth Little (1991) elaborates on in relation to the anthropology of the East African safari. "What the tourist industry sells to tourists on safari," he writes, "is spectacles and performances they already know and recognize. The safari is not a new story, nor are safari images new images" (1991: 150). He concludes, "Tourists come to Africa with a perspective and a story in mind and they try to find scenes that resemble these prior images that evoke recognition and an easy sense of familiarity" (156–57).

Beginning with William Fagg's canonical oeuvre, *Tribes and Forms in African Art* (1965), the arts of Africa have been presented to the public as a highly conventionalized aesthetic genre.[9] Tribes are viewed as "closed systems" in which the symbolic interpretation of objects is readily accessible to insiders but totally inaccessible to outsiders (Kasfir 1984). Fagg writes: "It is the unity of art and belief which makes understanding and acceptance of the forms of art easy for members of the tribe, but correspondingly difficult for non-members, since they do not share the belief" (1965: 12). This apparent lack of mutual knowledge is compensated through standardization.

In this context, the redundancy of tourist art makes available to nonindigenous patrons the stereotypical forms they have come to expect from classifications such as those presented in Fagg's foundational model. What tourists are looking for, then, in their collecting practices are the forms they already know. The repetition of these forms characterizes the production of African tourist art today, and their redundancy in merchandising typifies the visual presentation of such art in marketplace display.

TOURIST ART AND LINGUISTIC MODELS

In her seminal essay "Pidgin Languages and Tourist Arts," Paula Ben-Amos argued in 1977 for an analytic correlation between the languages that develop as a result of transcultural encounter under colonial rule and the art forms that arise under similar economic and political conditions. She points out that both pidgin languages and tourist arts are often criticized by members of the dominant society as inferior or debased forms of cultural expression. She notes, however, that in addition to the negative attitudes that Western observers hold toward both, there exists a profound and meaningful similarity between the two. "Both phenomena originate in the same types of circumstances," she writes, "and must meet similar functional requirements of communication" (1977: 128). Viewed as a form of transcultural exchange based on special-purpose, restricted, and standardized codes, tourist arts may then be analyzed according to a set of more general linguistic models as they have been applied to the study of pidgin language. Ben-Amos writes: "If we start from the premise that tourist art is not the visual equivalent of 'simplified foreigner talk' but is a communicative system in its own right, then we are led to ask questions about how and why these forms arise, what are the patterns of development, how is communication accomplished and what are the rules governing the creation and acceptance of new forms within the system" (1977: 128).

Although Ben-Amos's argument remains valid and important today, I believe that there may be yet another correlation between tourist art and language: the qualities of repetition and redundancy.[10] In linguistic theory the notion of redundancy is linked to the predictability of a standardized message—its opposite is entropy. Because most redundant messages are highly conventional, they communicate little or no information. The function of redundancy in language is at once technical and social. Claude Shannon and Warren Weaver (1949) established the technical function of redundancy in language by demonstrating its role in facilitating the accuracy of decoding. John Fiske summarizes their argument: "I can only identify a spelling mistake because of the redundancy in the language. In a nonredundant language, changing a letter would mean changing the word. Thus,

'comming' would be a different word from 'coming' and you would not be able to tell that the first word was a misspelling" (1990: 11). The technical problem created by redundancy becomes particularly acute in the translation of cultural metaphors. "The hardest thing to know, in a foreign culture, is whether somebody is presenting a completely original thought, or whether what they're saying is a cliche" (Johnstone et al. 1994: 5).

The social functions of redundancy range from what Roman Jakobson calls "phatic communication"—acts of communication that "contain nothing new, no information, but that use existing channels simply to keep them open and usable" (Fiske 1990: 14)—to increasing the effectiveness of message transmission over a "noisy" channel: "An advertiser whose message has to compete with many others for our attention (that is, who has to use a noisy channel) will plan a simple, repetitious, predictable message" (Fiske 1990: 11).

The marketing of tourist art in Africa could be said to operate along the social equivalent of a "noisy" channel of discourse or communication. The African art market (as both a place of transaction and a figurative economic context) is a bustling locale of sensory overload, where tourists are stimulated with exhilarating new sights, smells, and sounds. The visual redundancy of tourist artworks is intended to rise above the "noise" of transcultural exchange—communicating via the sobering force of repetition with relative clarity and precision across the disorder of the volatile, hypersensory state. In the midst of this social and aesthetic chaos, tourist consumers may quickly seize upon the orthodoxy of the already-known, grasping for the creature comforts of the canonical. Like the messages in mass media discussed by Eco, tourist art must be "received and understood in a 'state of inattention'" (Eco 1985: 181). The power of redundancy and the persistent reduplication of the conventional momentarily fix the undirected gaze of the tourist buyer on the proverbial—thereby ultimately forestalling and perhaps even avoiding the more demanding task of serious cultural translation and interpretation that might otherwise be produced in a less superficial encounter with the visual culture of Africa.[11]

CONCLUSION

The tourist art market in Africa today is characterized by a central contradiction that results from the intersection of different principles of mass production and serialization. Thus, on the one hand, authenticity is measured generally through redundancy rather than originality. Anything that deviates too far from the accepted canons of a particular ethnic style is judged to be inauthentic. A Baule face mask, for example, covered with an arrangement of multicolored glass beads (something that would never be done for indigenous consumption) is viewed as inauthentic by many outsiders because

of its originality (in the sense of novelty) and thus lack of reference to "tra-ditional" sources.[12]

At the same time, objects that remain faithful to a putative canonical or "traditional" style are also often judged inauthentic by "serious" collectors, who object that such artworks are not produced in the context of custom-ary, indigenous ritual needs—that is, they are replicas of high-end artworks intended for a mass audience. Because the objects are replicas, they are thus also by definition not original (this time in the sense of not being primor-dial or of originary purity).

Similar paradoxes of originality and repetition have been discussed in the context of modern art by Rosalind Krauss in her landmark essay "The Orig-inality of the Avant-Garde" (1986). Far from being "original" or new, Krauss argues, avant-garde art in the Western tradition, while framed in "van-guardist discourse," is really grounded in a process of inescapable repetition. She writes: "If the very notion of the avant-garde can be seen as a function of the discourse of originality, the actual practice of vanguard art tends to reveal that 'originality' is a working assumption that itself emerges from a ground of repetition and recurrence" (157–58). For Krauss, the basis of this repetition is to be found, at least in part, in the (re)discovery of the "grid" as a basic language of vanguardist visual expression.[13] "Structurally, logically, axiomatically, the grid *can only be repeated,*" writes Krauss. "That so many gen-erations of twentieth-century artists should have maneuvered themselves into this particular position of paradox—where they are condemned to repeat-ing, as if by compulsion, the logically fraudulent original—is truly com-pelling" (160). In the tourist art trade in Africa, repetition is equally in-escapable because the demands of the market are such that tourists, on the one hand, require the validation of multiple exemplars to authenticate their acquisition of souvenirs, and, on the other, the canons of "authenticity" in African art as set by outsiders are such that the styles and forms of the past take precedence over developments that may arise in the present or future.

To conclude, then, systems of mass production engender their own stan-dards of authenticity, or what Benjamin called their own "exemplars of re-ality." Tourist art in Africa is destined to be viewed as inauthentic because two conflicting principles are at work. Original works of art are inauthentic because they do not imitate an agreed-upon style; while objects that imitate the defined styles are also inauthentic because they are not, as it were, orig-inals. Evaluations of tourist art are grounded in modes of production and systems of perception that are deeply rooted historically in other, earlier forms of mass production. Rather than conceive of tourist art as an isolated system of cultural production and reproduction, it ought more properly to be seen as one of several systems of representation. Viewed in the context of other modes of mass production—the circulation of popular printed

iconography, the proliferation of cheap cotton fabrics in the Industrial Revolution, or the aesthetics of seriality characteristic of postmodern networks of cultural expression—the logic of the tourist art industry may be seen to be grounded in broader discourses of cultural truths and authenticities typically forged in the nexus of production and consumption in mass cultural and economic markets.

Northwest Coast Totem Poles

Aldona Jonaitis

In 1889 the naturalist John Muir landed in Wrangell, Alaska, and described the behavior of the tourists, who were indiscriminately consuming Native culture: "There was a grand rush on shore to buy curiosities and see totem poles. The shops were jammed and mobbed, high prices being paid for shabby stuff [such as model totem poles] manufactured expressly for the tourist trade" (1979: 276). On May 16, 1993, the cover of the *New York Times Magazine* travel supplement, featuring "American Classics," depicted a line of people, each carrying a typical regional American icon: an African-American boy with a bald eagle, a white woman with a roast turkey, another with a model of Mount Vernon, a California mission monk with a votive candle, a Hawaiian woman with a palm tree, and a bearded lumberjack with a totem pole (fig. 7.1). For more than a hundred years, the Northwest Coast totem pole has held a status rare among Native art: it is an attraction tourists wish to see, a commodity they desire to purchase, and a symbol of the region to which they travel. As this essay attempts to demonstrate, tourism in southeastern Alaska and coastal British Columbia has had profound effects on the distribution and understanding of the region's totem poles.

Travel literature and advertisements aimed at potential tourists make good use of the totem pole, and have done so for more than a century. In 1891 the Pacific Coast Steamship Company's *All about Alaska* identified totem poles as the feature that made Tlingit villages especially interesting to visit:

> It is not often that one would want to call a tourist's attention to an Indian village, for the average encampment or habitation of the "noble red men" is not the most attractive sight or study. But in the T'linkit town we have no such hesitation, because of the curiosities to be seen in their houses and surroundings. . . . They are the artistic savages of the world. In front of each long-house,

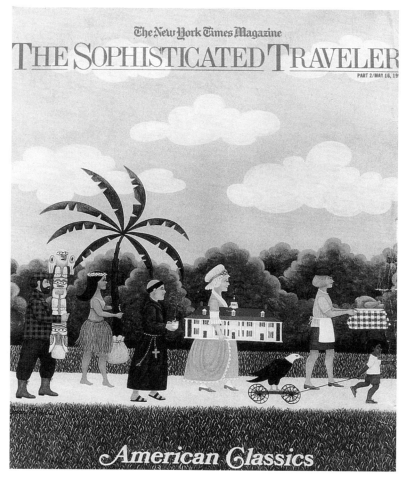

Figure 7.1. "American Classics," cover of the *New York Times Magazine*
travel supplement, Sunday, May 16, 1993. Reproduced by permission
of The New York Times.

and often rearing its head much higher than it by two or three fold, are one
or two posts, called "totem poles." (40–41)

Tourism-related businesses have also long recognized the commercial po-
tential of totem poles. In 1940 Walter Waters, owner of the Bear Totem Store
in Wrangell, Alaska, published *Totem Lore,* describing poles, their associated
legends, and the Alaskan landscape in which they could be seen. On the back
of this publication are advertisements for a steamship company ("See Alaska's

Totems with The Alaska Line") and for the Bear Totem Store. The ideal visitor would travel north on the Alaska Line, purchase *Totem Lore* as a guidebook, visit various totem poles *in situ,* and purchase a memento of her trip at the Bear Totem Store.

When airplanes replaced steamships as the most convenient mode of transportation to the Northwest Coast, they too appropriated the totem pole as a means of attracting customers. In 1962 Western Airlines offered *Much about Totems,* "a fascinating, easy-to-read book published for your enjoyment." After answering the question "What is a totem pole?" and describing the different types of poles, their regional styles, their manufacture, and their raising, the book lists communities where tourists can see totem poles, including Ketchikan, Wrangell, Sitka, and Juneau—all served by the airline. The publication concludes: "All that remains is for you to see these magnificent Totems yourself. Right now would be an excellent time to visit the big 49th state and plan your memorable trip to the Land of Surprises. It's easy to do! Call your travel agent or Western Airlines today" (Western Airlines 1962).

HISTORY OF THE TOTEM POLE

Although commonly thought of as ancient artifacts of "traditional" Native culture, totem poles are actually relatively recent additions to Northwest Coast art. Poles were rare when the first ships engaged in sea otter fur trade visited the Northwest Coast at the end of the eighteenth century. In 1789 John Meares sighted and briefly mentioned an exterior pole on Haida Gwai (Queen Charlotte Islands) (Meares 1790: 364). Two years later John Bartlett, a seaman on the ship *Gustavus III,* drew the earliest known depiction of what we now think of as a totem pole, a forty-foot frontal pole in the Haida village of Dadens (Henry 1984: 191).

Because so few firsthand accounts of exterior poles exist from that era, Marius Barbeau, in *Totem Poles of the Gitksan* (1930), concluded that totem poles postdated contact. Barbeau posited that the Tsimshian made the first large poles after the metal tools they obtained from Europeans and Americans enabled them to make larger carvings more quickly. Not everyone agreed with Barbeau. In his review of *Totem Poles of the Gitksan,* W. A. Newcombe (1931) argued that the early travelers visited only temporary fishing camps instead of permanent winter villages, which had numerous poles. In his 1948 essay "The Antiquity of the Northwest Coast Totem Pole," Philip Drucker suggested that precontact Natives used tools of metal retrieved from Asiatic shipwrecks to carve what he identified as a local manifestation of an ancient circum-Pacific grave marker complex.

Today most scholars agree that before the arrival of Europeans and Americans, Northwest Coast people did carve some monumental exterior poles, mostly, but not exclusively, using stone tools. Comparatively small carved

posts (eight to ten feet high) that stood inside houses were more common, such as the Nuu-chah-nulth interior house posts illustrated in 1778 by John Webber, the artist on Captain James Cook's voyage (Henry 1984: xii). As wealth from the fur trade poured into the Northwest Coast, a demand arose for increasingly impressive representations of wealth and power in the form of larger poles. Thus, while the pole itself originated in precontact times, its abundance during the nineteenth century in certain Northwest Coast villages, especially those of the Haida and Tsimshian, had a great deal to do with the interchanges between Natives and non-Natives.

The Haida produced what many consider to be the most elegant and most elaborate totem poles on the coast (fig. 7.2). Nineteenth-century photographs show monuments erected in front of, attached to, and behind Haida houses. Because of the devastating smallpox epidemics that decimated the Haida population, reducing it from a precontact estimate of 14,000 to 1,200 in 1890, the histories inscribed on these poles are largely lost. By the time these photographs were made, the surviving Haida had abandoned their traditional communities and moved to one of the two remaining villages, Skidegate and Masset. The abundance of totem poles in those amalgamated communities resulted both from the increased number of monuments made for the original inhabitants of each village and from the poles erected by the newcomers. By the end of the century, most Haida had embraced Christianity, given up potlatching, and ceased making artworks connected to their traditional ceremonials.

The Haida did, however, persist in carving miniature totem poles for sale to outsiders. As early as the 1820s, Haida carvers made portable argillite items for sale to the foreigners who sailed to Haida Gwai. Although many of the early carvings depicted Euro-Americans and imitated Western objects such as platters, by the 1860s the model pole had become a favorite subject of the carver's repertoire, and by the 1890s it had outstripped all other types of representations in argillite (Macnair and Hoover 1984: 113, 175). It is of considerable interest that model totem pole carving flourished while Haida full-scale pole carving declined (Jonaitis 1993).

During the nineteenth century, totem pole carving spread north from the Haida and Tsimshian, becoming a feature of the southern Tlingit cultural landscape. Muir, for example, commented that in Wrangell "the carved totem-pole monuments are the most striking of the objects displayed" (1979: 72). However, both the Krause brothers, who visited Alaska between 1881 and 1882, and U.S. Navy lieutenant George Thornton Emmons, who was stationed there in the 1880s and 1890s, commented on how few poles existed among the northern Tlingit, especially in contrast with the Haida and Tsimshian (Krause 1956: 89; Emmons 1991: 194). Some northern communities, such as the highly conservative town of Klukwan, considered poles foreign and thus limited their heraldic carvings to interior house posts (Jonaitis 1986).

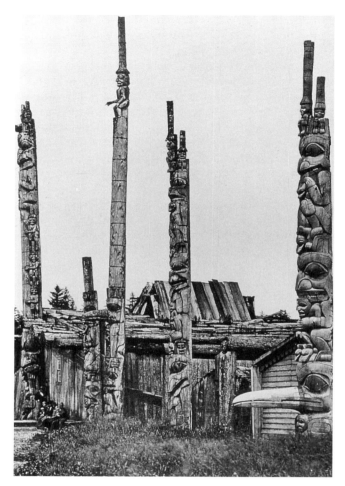

Figure 7.2. Haida village of Masset, Haida Gwaii (Queen
Charlotte Islands), 1881. Photograph by Dossetter. Courtesy
of the Department of Library Services, American Museum
of Natural History (Neg. no. 42264).

Like the Haida, some Tlingit made model totem poles for the masses of
tourists who created an enthusiastic market for such carvings. Late-nineteenth-
century missionaries and educators, such as those at the United States In-
dian School at Ketchikan and the Sheldon Jackson School in Sitka, encour-
aged Natives to carve such models in order to become more economically
self-sufficient and helped market good-quality work (Jonaitis 1989: 240). Sep-

tima Collis, in *A Woman's Trip to Alaska,* mentioned that during the winter Native Alaskans made numerous miniatures that they sold to summer tourists, including herself (1890: 81, 172).

Until the late nineteenth century, elaborately carved totem poles were rare among the Wakashan-speaking Kwakwaka'wakw and the Nuu-chah-nulth. In the 1894 photographs Franz Boas had O. C. Hastings take of Fort Rupert, then the highest-ranking Kwakwaka'wakw community, simple poles topped with birds, coppers, and human figures punctuate the skyline, their numbers fewer and their imagery less complex than Haida examples. Similarly, most Nuu-chah-nulth communities had simple poles topped with birds much like the Kwakwaka'wakw examples (Drucker 1951: 76; Arima 1983: 160). It was only at the end of the nineteenth century and in the first several decades of the twentieth century that the Kwakwaka'wakw carvers, such as Mungo Martin and Willie Seaweed, began making their boldly carved and vividly painted full-size poles as well as small model poles (Nuytten 1982; Holm 1983).

Although almost all the model poles mentioned thus far were made for outsiders, in at least one instance miniature carvings played a role in more "traditional" ceremonies. In his monograph on the "Bella Coola Indians" (now known as the Nuxalk), T. F. McIlwraith describes a memorial potlatch that he observed between 1922 and 1924 (1948: 469–71). Mourners carried model totem poles depicting crests of the deceased, while an orator described the family legends associated with images on the carvings. At one point in the ceremony, a young boy received a model pole and was instructed in details of his ancestral history. As McIlwraith makes explicit, this use of miniature poles did not occur in earlier times (1948: 471); it could well be that the popularity of model poles for the twentieth-century tourist market motivated the Nuxalk to invent a new ceremonial use for them.

Many tourist-oriented writers have underlined the antiquity of the totem pole, despite its relatively recent proliferation throughout much of the Northwest Coast. Eliza Scidmore, in *Alaska: Its Southern Coast and the Sitka Archipelago,* for example, commented that "the steamer wandered among the islands, touching at infant settlements and trading posts, and anchoring before Indian villages with traditions and totem poles centuries old" (1885: 269). Almost forty years later, John Goodfellow, in *Totem Poles of Stanley Park,* concurred with that assessment: "The totem is an indication of an old and wide culture. It points to the past and illuminates the present" (1923: 13). The mystique of antiquity enhances the monuments' value as authentic signifiers of a "dying culture," which progress will soon overwhelm.

Even today, some writers still draw upon that mystique. In *Totem Poles* (1995), a general overview, Pat Kramer acknowledges the relatively recent history of monumental carving on the Northwest Coast. At the same time, Kramer points to a seven-thousand-year woodworking tradition upon which

totem pole carving is based and to prehistoric artifacts on exhibit at the Simon Fraser University Museum of Archaeology and Anthropology that represent "the roots of totemic figures" (1995: 11, 18). Kramer apparently cannot forgo the opportunity to hint at an appealingly romantic origin of the totem pole in the distant past.

TOTEM POLES AND TOURISM

Since early contact, whites have been fascinated by totem poles. In their efforts to record what they believed to be the last vestiges of disappearing cultures, anthropologists as well as nonprofessionals and museum collectors assembled vast collections of Northwest Coast artifacts, the most prized of which were totem poles. In 1901 Charles Newcombe, collecting for the Field Museum of Natural History in Chicago, set a standard price for these monuments: $1.00 per foot for house posts, $1.50 per foot for grave posts (Cole 1985: 188–89). Eight years later, Harlan Smith traveled to British Columbia to acquire poles for the American Museum of Natural History. In a letter to AMNH authorities, Smith described how "poles are now practically wiped off the Earth in many localities where they were numerous twelve years ago when I had the buying fever" (quoted in Jonaitis 1988: 226). As David Darling and Douglas Cole state, "in the 'museum age' of the late nineteenth and early twentieth centuries, the totem pole became for ethnological exhibits what the tyrannosaurus was to a paleontological display" (1980: 29). At that same time, the totem pole was an important element in a tourist's experience of Alaska.

The discovery of gold near Juneau in the early 1880s brought thousands of people to Alaska, many of whom traveled on steamships from San Francisco and Seattle. In order to fill the empty berths on these boats, the steamship companies began to encourage "excursionists" to that region. To provide the easiest access to what became a favorite Victorian vacation, the Pacific Coast Steamship Company arranged with several railway companies to transport the excursionists from their homes to the ships and back again (Hinckley 1965: 68–79).

In 1899 the *Seattle Post-Intelligencer* sponsored an economic opportunity fact-finding trip to Alaska for 165 Seattle businessmen. These excursionists saw numerous poles in seemingly unpopulated villages and decided to bring one home. They acquired a fifty-foot specimen from a village near Ketchikan that they claimed was completely abandoned, although they did see "somebody, probably a vagrant fisherman, who refused to come out of his hut." They felled the pole, chopped it in half, transported it back to Seattle, "renewed and recolored" it, and erected it in Pioneer Square.[1] At the "unveiling" ceremony on September 3, 1899, mention was made in the *Seattle Post-Intelligencer* of its having been carved "a century or more ago"—an unlikely

claim.[2] The newspaper also published a poem written by one William J. Lampton and read by him at the unveiling ceremony. It celebrated the conquest of traditional Native culture:

I am the only Civilized totem pole On earth,
And civilization suits me well . . .
While all the others of my kind
Are slowly settling On their stems
Among the salmon scented Silences,
Sequestered from the sight of man,
Here in Seattle's surging scenes
I stand, incomparable, And swipe the admiration Of mankind
As Caesar swiped the world,
And for the first time In a hundred years I'm having fun . . .
For centuries I hid my light Beneath a bushel, now
It gleams and glistens Where its rays will meet
A million eyes . . .
So here's farewell to all my past
And welcome to the things that are;
With you henceforth my die is cast,
I've hitched my wagon to a star.
And by the Sacred Frog that hops, And by the Bird that flies,
And by the Whale and by the Bear, I'll sunder all the ties
That bound me to the ancient creed Which holds my people flat,
And I will be a Totem pole
That knows where it is at.

Transported from an abandoned village in the wilderness to a bustling city, the pole has been translated from savagery to civilization. The monument has severed all connections to its pagan past, no longer reflecting the culture of its creators; instead, it has become the "star" of a prosperous city that reaps economic benefits from Alaska. The poem's reference to Caesar draws an analogy to the conquest of barbarians and enhances this celebrated pole's new status as a triumphal monument of imperial appropriation.

At the time it was generally accepted by most tourists (as well as by almost all other whites) that the innate savagery of Native people had to be tamed by missionaries and teachers. Ironically, the more successfully "civilized" Indians became, the less attractive they were to those same tourists. In the mid-1880s Scidmore described how, "with the advance of civilization," the Tlingit willingly destroyed some artworks and sold others, "rob[bing] these villages of their greatest interest for the tourists" (1885: 54). For Scidmore, Sitka was hopelessly acculturated: "There are no totem poles . . . to lend outward interest to the village, and the Indians themselves are too much given to ready-made clothes and civilized ways to be really picturesque" (175).

The popular appeal of totem poles at the end of the nineteenth century

was thus embedded in an identification of antiquity with authenticity. As time-less monuments made by genuine Indians, they stood in opposition to those Natives in Western clothing whom tourists judged inauthentic and thus un-interesting—despite their apparent acceptance of "civilization." Mary Louise Pratt (1992: 216–21) characterizes such attitudes as "the white man's lament," a trope that suggests the dismissal and condemnation of byproducts of accul-turation and the attempts to discredit Native responses to intrusions into their lands by non-Natives. One solution to this dilemma, arrived at successfully by those who obtained and erected the Pioneer Square pole, was to disassociate the Native from the totem pole completely, which could then assume new em-blematic meanings, in this case, the progress and prosperity of Seattle.

THE MOVEMENT OF POLES IN AND AROUND THE NORTHWEST COAST

In the interest of tourism, some totem poles were moved from their origi-nal villages to sites closer to tourist traffic, while others, newly carved, were erected near tourist centers. Between 1926 and 1930 the Canadian govern-ment collaborated with the Canadian National Railway to restore thirty Tsimshian poles along the railroad's Skeena River route. In 1924 a "totem pole preservation committee," consisting of Duncan Campbell Scott, Su-perintendent of Indian Affairs, J. B. Harkins of the Canadian Parks Service, and Edward Sapir and Marius Barbeau of the National Museum of Canada, was constituted to oversee the restoration of poles that would "encourage tourist travel" to this region. Marius Barbeau, an anthropologist thoroughly familiar with the area, recommended that restoration work begin at Kispiox, a town with the greatest number of poles as well as the friendliest and most agreeable inhabitants, then continue at Hazelton and Hagwelget, and only at the end proceed to the Kitsegukla and Kitwanga monuments. As it turned out, the committee ignored Barbeau's recommendation, for Kispiox, at twelve miles distance from the rail line, was too far away to warrant restora-tion. Instead, they started work at Kitwanga and Kitsegulka, communities di-rectly on the line. Harlan Smith, assigned to oversee the project, received instructions to "preserve the poles and other objects that will be of interest to tourists" (Darling and Cole 1980: 35). Smith seems to have taken his role as tourist promoter quite seriously; he suggested that information explain-ing the poles be printed on the backs of dining car menus and that any trees obstructing the view of the poles from trains be removed.

Smith also produced a film, *The Tsimshian Indians of the Skeena River of British Columbia (1835–1927)*, which opens with the caption, "The National Railway speeds through the mountain walled valleys of British Columbia toward the land of the Tsimshian, where totem poles and costumed Indians recall the glories of a vanished past" (quoted in Morris 1994). After showing scenes of

the landscape and local wildlife, Native subsistence, transportation, wood-working, and ceremonialism, the film focuses on the tourists who travel to the area to see and photograph totem poles. It shows fallen poles that might have rotted away were it not for the foresight and energetic intervention of the railway and the Canadian government (Morris 1994: 66–68). Such an optimistic celebration of the project was unwarranted, for some Tsimshian found the outsiders' activities profoundly disturbing.

Although the restorations were carried off relatively successfully during the first few years, by 1927 antagonism toward the project began to develop and Tsimshian criticized a government that was now spending money to pre-serve totem poles whose carving it had strongly discouraged only a few years earlier. In 1931 a Kitwanga village committee asserted: "The Canadian National Railway Company is getting all the successful benefit out of it and us people, the sole owners, get nothing" (quoted in Darling and Cole 1980: 45).

Across the border, in southeastern Alaska, another totem pole project got under way a few years later (Jonaitis 1989). In 1933 President Franklin Roosevelt had approved the founding of the Indian Civilian Conservation Corps (CCC), which initially sponsored Alaskan projects such as the construction of housing for teachers and nurses in Hoonah, with the goal of improving social conditions for the Natives. By 1938 the Indian CCC had moved into the more aesthetically oriented activity of restoring totem poles. This project, managed by the Forest Service, supported the retrieval of poles from abandoned villages, their restoration by Native artists, and their erection along the ferry route.

Like the Skeena River project, the Alaskan totem pole restoration encountered difficulties with the Natives—in this case, the Tlingit. According to the Forest Service, any poles located in abandoned villages belonged to the U.S. government, which had the power to decide their fate. The Tlingit disagreed because, from their perspective, the clans that had erected these poles still owned them, regardless of where those clans actually resided. Some of the Tlingit ultimately agreed to transfer to the Forest Service their rights to certain poles, which ended up in Ketchikan. The Tlingit of Tuxehan, however, refused to do so, and their resistance led to the founding of Klawak Totem Park, close to old Tuxehan but far from the tourist routes.

The Indian CCC, which ultimately employed about 250 Native people, restored forty-eight poles, copied fifty-four that were beyond salvage, and created nineteen new ones. Many of these poles are in Ketchikan, the first stop for ferries and cruise ships from British Columbia and Washington State. As ships approach the town, they pass close to the Native-owned and run Saxman Totem Park, which today has a number of CCC poles as well as a new clan house, a gift shop, and a shed where Native artists carve totem poles.[3] These poles are so appealing to tourists that the February 1996 *Alaska Airlines Magazine* showed two of them on its cover along with the painted facade

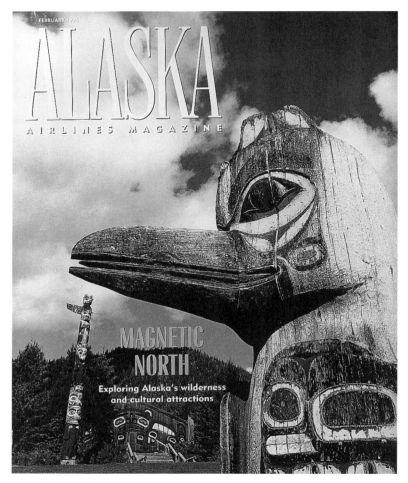

Figure 7.3. Cover of *Alaska Airlines Magazine,* February 1996. Reproduced
by permission of Alaska Airlines.

of the Saxman Totem Park big house (fig. 7.3). The same issue also featured
an article claiming that Saxman, with 65,000 visitors annually, was the most
popular tourist attraction in Ketchikan (Halliday 1996).

By the 1960s totem pole carving had become a favorite program for mu-
seums such as the University of British Columbia Museum of Anthropology
and the British Columbia Provincial Museum (now the Royal British Colum-
bia Museum). The provincial government took advantage of the 1966–67 cen-
tennial celebration of the union of Vancouver Island with British Columbia

to sponsor its own totem pole–carving program to mark the "Route of the Totems" along the east coast of Vancouver Island and to embellish ferry terminals as far north as Prince Rupert. As the *BC Centennial Spokesman* reported on April 7, 1966, Native carvers were commissioned to make poles twelve feet high and three and a half feet wide, each depicting a bear with other figures "appropriate to the area in which the totem pole is to be located."

Hillary Stewart's *Looking at Totem Poles* is widely used as a guidebook to poles, such as those just discussed, that stand "along highways; at ferry terminals; in parks, gardens and shopping plazas, outside hotels, public buildings, tourist bureaus, schools and, of course, in museums. . . . The totem poles illustrated are all outdoors, are easily accessible (with one exception), and for the most part are in places frequented by visitors" (1990: 8). The typical tourist who purchases this book would probably never question the presence of poles in such places, nor request further information about their cultural biographies, in which tourism is so profoundly implicated. For most visitors, totem poles on the Northwest Coast simply exist as stately presences of an ancient Indian heritage presented to them in a most convenient fashion.

WHY THE TOTEM POLE?

Many players have, then, contributed to the historical development and contemporary spatial distribution of the Northwest Coast totem pole. Foremost, of course, are the carvers themselves, who have responded in a variety of ways to the demands of the consumers, both Native and non-Native. Other players have included the chiefs, who commissioned carvers to create displays of their chiefly status; the visitors, who gladly purchased mementos of their trips to the Northwest Coast in the form of argillite or wooden totem pole models; and the museums and government agencies that initiated the restoration, replication, and carving of poles. It is of interest to reflect on how profoundly non-Natives are implicated in the creation and distribution of so many of these poles—both full scale and miniature.

The totem pole, furthermore, has become not just a symbol of the Northwest but of Indianness in general. In this volume, Frank Ettawageshik and Trudy Nicks describe the appearance of poles among Native people in the eastern woodlands. A traveler today can see poles on reservations in Montana, New Mexico, and New York. In the 1990s the popular Playmobil line of children's toys includes an Indian set that features a feather-bonneted Plains Indian, a tipi, a birchbark canoe—and a totem pole. The Boy Scouts have for years been making totem poles as projects.

Why has the totem pole become so significant a symbol of the Northwest Coast Natives, of the northern Pacific region, and of Indians in general? While no simple or single answer to this question is possible, it may be that the totem pole represents an intriguing combination of exoticism and fa-

miliarity. As Priscilla Boniface and Peter Fowler say in their book *Heritage and Tourism in the "Global Village,"* "Difference has its place, but for many people the crucial element in a touristic experience is that it should not threaten, or allow them to feel uncomfortably deprived of the comforts of home. . . . We want stimulation, through simulation of life ways as we would wish them to be, or to have been in the past" (1993: 7).

Ironically, totem poles actually have little to do with totemism, which some anthropologists define as the belief of a kin group that they descended from a certain animal, which they treat with special care and do not hunt or eat. The crests that decorate Northwest Coast poles are not totems according to that definition, for most represent beings that some ancestor in the legendary past encountered and whose images the descendants have, as a result, the right to depict in art. In most cases, the Northwest Coast Natives do not consider these creatures ancestors of their lineage, nor do they avoid eating them (except for animals, such as frogs, that are considered undesirable as food). Nevertheless, so firmly entrenched in the language is the connection of these carvings to totemism that in many tourist contexts they are referred to simply as "totems." It is possible that this term remains popular because it suggests to nonspecialists a primitive ancient belief system and endows the poles with a mysterious aura that appeals strongly to consumers of Native culture.

If the totem pole embodies the foreignness of a Native sensibility, it is also a monumental wooden work of art comfortingly situated in the Western artistic category of "sculpture," as opposed to other varieties of Native American art, such as quillwork, beadwork, and basketry, which are often labeled "craft." In addition, the totem pole presents its viewer with little apparent difficulty in the interpretation of its images. The pole's interconnected humans, animals, and hybrids depict beings easily read as people, birds, mammals, fish, or transformational creatures. As Scidmore wrote, in drawing a parallel between Native and Western culture, "Their bears, whales, frogs, and wolves are no more difficult to recognize in their rigidly conventionalized carvings than the griffins, dragons, and fleur-de-lis of European heraldry" (1898: 44).

The poles are not, however, *too* easy to understand; both the *stories* behind the images and the specific animal species depicted can remain intriguingly mysterious until they are explained. In his pamphlet on the totem poles of Vancouver's Stanley Park, S. W. A. Gunn underlines the simultaneous accessibility and inaccessibility of the carvings: "The art style of totem carving can be described as stylized realism. Once the salient diagnostic details are understood most figures become quite recognizable. . . . However, even while recognizing the crests, one may not always be able to interpret a totem pole. Knowledge of Indian mythology helps but one must know the actual story out of many similar legends in order to decipher a particular pole"

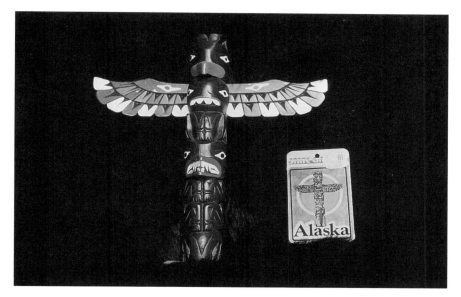

Figure 7.4. Model totem pole carved by Alaskan Native, c. 1900, and Alaska sticker, c. 1993. Private collection. Photograph by Aldona Jonaitis.

(1965: 5). To learn those stories, the tourist must purchase a guidebook that reassuringly spells out the artwork's meaning.

The most popular tourist-oriented totem poles are topped by a bird with outstretched wings. Such a pole appears on the covers of the *New York Times Magazine* travel supplement and the *Alaska Airlines Magazine*. It is the overwhelming favorite for model totem poles (fig. 7.4). It became a main symbol of British Columbia during its 1966 centennial, when paintings of two totem poles with birds on top flanked the entrance to the "BC Centennial Caravan," two fifty-five-foot trailer trucks that were transformed into a mobile exhibit described as "a corridor of time from 1778 through 1966, with an imaginative look into the future." And, in Pasadena, the BC float in the 1966 Rose Bowl Parade carried two similar poles positioned above the words "A Royal Welcome—Centennial 1966"—all formed of roses (*BC Centennial Spokesman,* January 1966: 3).

Wings are common only on poles made by the relative latecomers to totem pole carving, the Kwakwaka'wakw. In contrast, projecting elements rarely break through the shallow relief carving of Haida, Tsimshian, and many (but not all) Tlingit poles. In September 1995 my research associate Aaron Glass interviewed forty tourists in Stanley Park, asking them to identify their favorite from the group of Haida, Tsimshian, and Kwakwaka'wakw

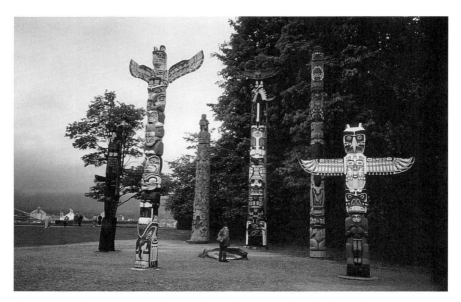

Figure 7.5. Totem poles in Stanley Park, Vancouver, British Columbia, 1994. Photograph by Aldona Jonaitis.

poles (fig. 7.5). Thirty liked the Kwakwaka'wakw poles best, especially those with birds on top. According to Seattle Art Museum curator Steve Brown, most non-Native people who commission poles ask for ones with wings (personal communication, 1995). It could be that a bird perched atop a pole, ready to fly off, gives a dynamic energy to the carving and attracts the observer's attention in a way that strictly columnar poles cannot.

Among all the bird-topped poles, one depicting a thunderbird with outstretched wings perched above a bear that holds a small being between its paws stands out as especially popular. The 1930s catalog of the Olde Curiosity Shop in Seattle charged 60¢ for a five-and-a-half-inch version of this pole and $1.25 for an eight-inch model.[4] A postcard from Alaska depicts this pole (fig. 7.6). And a drawing of the same pole is prominent in a 1929 *National Geographic* advertisement for the Canadian National Railway trip to "Alaska: Land of Gorgeous Scenery. Where the Romance of the Gold Rush Days Still Lives" (O'Barr 1994: 53, 55). Models of this pole, or close variations, are sold as mementos of both British Columbia and Alaska, and can even be purchased in the East from the Cherokees. Its image appears, too, in a large number of Alaska souvenirs, including refrigerator magnets, toothpick holders, and backscratchers.

In the early twentieth century, two carved poles originally intended as in-

En route Raymond-Whitcomb Land Cruises; voyaging along the
Alaskan Coast among the Indian Totem Poles.

Figure 7.6. Postcard of Alert Bay pole, c. 1910.
Although the image is British Columbian, the card
states that the pole is Alaskan. Reproduced by
permission of Candy Waugaman.

terior posts for a house that was never completed stood in front of a Nimp-
kish chief's house in Alert Bay, Vancouver Island (Bill Holm, personal com-
munication, 1996). This pair provided the models for the vast number of
replicated totem pole images that have been used to symbolize not just Kwak-
waka'wakw culture or British Columbia, but also Alaska, four hundred miles
to the north. Just what about the Alert Bay pole makes it so popular a tourist

icon? It is, first of all, as Bill Holm comments, "very photogenic," an important quality for an image that appears in magazines, postcards, advertisements, and tourist souvenirs. Most totem poles are difficult to photograph well, for carved details become lost when the poles are shown in full. Columnar poles without projections, such as those made by the Haida and Tsimshian, do not usually make compelling or interesting photographs, except in close-up shots. The Alert Bay pole, in contrast, fits nicely into the rectangular frame of a postcard; its two large, boldly carved and painted animals can be easily identified, and its crosslike form provides a simple, clear, visually interesting motif that translates successfully into a variety of different graphic contexts.

The particular animals on this pole may also contribute to its popularity. The image of a raptor with outstretched wings suggests the bald eagle, the national symbol of the United States, which is abundant in British Columbia and Alaska but rare in other parts of America. The toothy carnivore beneath it, which seems to overwhelm and dominate a small, insignificant human at its chest, represents the powerful, dangerous grizzly bear of the wilderness (Steve Brown, personal communication, 1996). As Will Thompson commented at the unveiling of the Seattle totem pole in 1899, poles are strongly associated with the natural world: "The shadow of the wilderness is in its deep barbaric lines. It was fashioned and grew out of [the Indian's] love and reverence for the birds and the beasts and the wallowing leviathan of the deep, out of his feelings of affinity and nearness to the trees and the whispering wind" (*Seattle Post-Intelligencer,* September 2, 1899).

Tourist literature exploited the association of poles with the mountains, glaciers, fjords, and abundant wildlife of Alaska. The Pacific Coast Steamship Company's 1911 Alaska brochure states that "the totem poles of Alaska are as different from everything else in the world as the scenery surpasses all other scenery." The page describing totem poles in a 1930 brochure for the Canadian Pacific Railroad's Alaska tours faces a page about hunting, replete with a photograph of a grizzly bear. And a recent *Alaska Airlines Magazine,* which promotes travel to Alaska, contains an essay entitled "Bear Essentials," about where to see Alaska brown bears, placed immediately before the article on Ketchikan totem poles mentioned above (Tillinghast 1996). The typical tour brochure advertising Alaska today includes a totem pole, a glacier, a bear, and an eagle.

For many years, Native Americans have been linked in the popular imagination with nature; this linkage becomes specific in the case of the totem pole. The cover of *Our Fifty Years* (Pacific Coast Fire Insurance Company 1940), a publication celebrating Vancouver's fiftieth anniversary, features a Native sitting near two Kwakwaka'wakw poles in Stanley Park, looking at the apparition of a city of skyscrapers. The caption states, "Years ago, on the shores of Burrard Inlet, the natives squatted beneath their totem poles, on

which were carved in fantastic symbolism the history of their clans, and viewed contentedly the forests, hills and water that was their tribal heritage. They sensed no portent of a great city in the sky, but it was there." Before the settlement of Vancouver, nobody would have "squatted beneath totem poles" because the Natives of that region, the Musqueam, had no tradition of totem pole carving. Nevertheless, the artist and editor of this volume associated the natural world embodied in the pole with the "natural man"—a Native.

The Northwest Coast totem pole touches a number of stereotypes of Nativeness that today's postmodern critiques have thus far been unable to erase from the popular imagination. In his essay "Notable Quotables: Why Images Become Icons," Thomas Hine (1996) discusses how certain artworks (such as Munch's *The Scream*), melodies (such as the theme song from *The Twilight Zone*), and architectural images (such as the Eiffel Tower) have become "quotable," disseminated in a wide variety of contexts through advertising, news, and the entertainment media. Such "icons" work because they resonate with a meaning relevant to their consumers; that meaning might or might not be at odds with the meaning of the original upon which the icon was based. This process was immeasurably speeded up, beginning in the second half of the nineteenth century, when photography, new commercial printing technologies, and later, electronic media made it possible to multiply, to radically recontextualize, and to globalize the images belonging to local communities. In a similar fashion, the totem pole has become, in its transformation into a commodity, an icon embodying what its consumers—and, in particular, tourists—think about Natives, history, authenticity, and the wilderness.

Master, Machine, and Meaning
Printed Images in Twentieth-Century India

Stephen R. Inglis

"A society becomes modern when one of its chief activities is producing and consuming images." According to this definition, proposed by Susan Sontag (1977: 153), India is very much a modern society. The mechanically reproduced image to which Sontag refers has become indispensable to the economy, politics, and religion of India and is an integral part of both public and private spaces.

The birth of the "age of mechanical reproduction" (Benjamin 1969b), which has made image proliferation and the entire concept of modern media possible, is relatively recent. Photography was invented more than 150 years ago, and color lithography was perfected at about the same time. The interaction of these two processes eventually led to modern color photo-offset printing machines. Although the modern printed image took longer to penetrate the layers of society and the diverse regions of India than it did in western Europe, the seeds of image communication were planted almost simultaneously. The first daguerreotype camera arrived in Calcutta in 1840, only a year after the device was invented, and "foul-smelling oleographs" (Nagam Aiya 1906) from Europe were flooding the Indian markets in the 1880s, only shortly after they became widely available in France. India had several of its own chromolithographic presses operating before the turn of the century.

The concept of an age of mechanical reproduction and the speed, ubiquity, and commercial potential of modern mass media imply that the social shape and consequences of image communication will be similar regardless of where in the world it operates. Walter Benjamin argued that wherever it was introduced "the technique of reproduction detaches the reproduced object from the domain of tradition" (1969b: 223). Many art historians studying India certainly believed this. E. B. Havell, A. K. Coomaraswamy, and Vincent

Smith, for example, all saw printed pictures as degenerate and a threat to what was distinctive and culturally precious in Indian art. Richard Lannoy went even further. The popular arts in India, he proclaimed, "block individuation, alienate people from personal experience and intensify their moral isolation from each other, from reality, and from themselves" (1971: 29).

A more particular concern of those who fear that an "image world" is replacing a "real" one is that the increasing reproduction of images is part of the desacralization of society. Their argument, as articulated by E. H. Gombrich (1950), is that the farther back we go in history the less sharp is the distinction between images and real things. In traditional societies an image and the thing it depicts are two manifestations of the same spirit. As the reproduction of images increases, spreads, and speeds up, we become farther and farther removed from the world of sacred times in which the image "was taken to participate in the reality of the object depicted" (Sontag 1977: 155) and image making and "consuming" were practical, magical, and sacred activities.

Recent field investigations indicate, however, that mechanically reproduced images may not have a uniform influence in all societies and that the technique of reproduction may not necessarily result in a cultural "detachment." In India, mechanically reproduced images continue to participate in the reality of the "objects" or personages depicted, and this participation, the active association of the image with its sacred source, helps to account for the nature, popularity, and ubiquity of images in modern India.

Whether we think of technology as a curse or a blessing, we often assume, as Judith Gutman reminds us, that "technology has developed a power so completely of its own making that it overrides human participation" (1982: 2). The aim of my research has been to describe the artist and the creation of the image's prototype and, in doing so, to establish a social context for the style and development of the printed image. Using data from my work with major South Indian popular artists, I identify in this essay some of the sacred dimensions of the relationships between people and mass-produced images in India and describe how some of these relationships are evolving.

The range of images in modern India is vast. My focus in this essay is on pictures printed in color, especially those of Hindu gods and goddesses, collectively referred to as *sami patam,* or "god pictures," in Tamil. Although pictures are applied to everything from key chains to biscuit tins, I refer here mainly to single paper sheets in various sizes sold piece by piece and often framed (thus commonly referred to as "framing pictures") or distributed as calendar images or souvenirs. The discussion is based on pictures painted and printed in South India, although many of these are circulated throughout India and abroad.

Most typical foreign travelers in India in the late 1960s and early 1970s simply ignored printed pictures. They registered as background, a colorful

if somewhat garish part of the visual landscape. Ironically, the one mean-ingful association often made was with psychedelic art of North America. Pic-tures of Hindu deities had been appropriated by North American popular culture and juxtaposed with strobe-light effects and Day-Glo colors as sym-bolic elevation. It was not until I worked closely with traditional artists in the rural areas of Madurai and Ramnathapuram Districts in Tamil Nadu that I began to recognize the significance of these pictures in relation to the other more ancient arts that were my primary concern. The strict lines often drawn between the handmade and the machine-made, between the arts of the elite and those of the folk, and between icon and decoration began to blur, and what had been background slowly became foreground.

Ordinary Indians were unaware of the origins and makers of these im-ages, but the village artists with whom I worked had connections that grad-ually led me to many of the major artists working for the printing industry in South India. My informants held these "calendar artists" and their pre-decessors in the highest esteem, not only for their commercial success but also for their extraordinary influence on other artists in India and for the extent to which their work has become part of people's lives. These are the "masters" in this essay's title, artists who have molded the popular aesthet-ics of twentieth-century India.

THE HERITAGE OF POPULAR ART

The direct "genealogy" of Indian popular art can probably be traced to the last two decades of the nineteenth century, when Indian artists sent paint-ings of gods and goddesses to Europe for printing, which were then returned to India for distribution. However, most of today's painters for the popular market trace their heritage to Raja Ravi Varma (1848–1906). Ravi Varma was a very successful portrait and landscape painter whose depictions of Hindu gods and goddesses and legendary (*Puranic*) stories (fig. 8.1) launched the popular painting industry in India and whose romantic style continues to influence Indian painters more than a century after he began his work (Chai-tanya 1960; Venniyoor 1981). In response to his patrons' encouragement and the demand for his work, which was originally rendered in oils, Varma es-tablished India's first chromolithographic press in Bombay in 1891.

Ravi Varma learned to paint from his uncle Raja Raja Varma, one among many talented artists in his family, the Koil Tampurans of Kilimanur, Kerala. The family's high status in the court of Travancore also gave Ravi Varma some access to European techniques and styles, both through lithographed re-productions from Italy and Germany and through contact with European artists such as Theodore Jenson, who was a guest of the Travancore court and carried out several commissions in 1866.

Among the traditional artist communities that influenced the development

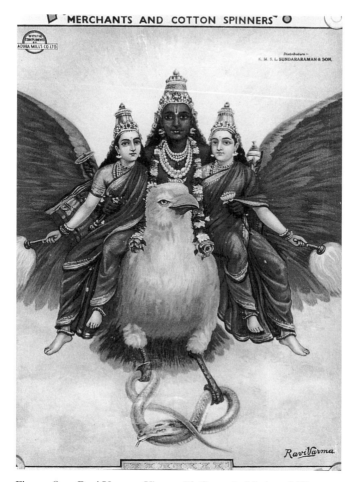

Figure 8.1. Ravi Varma, *Visnu with Consorts*, Madura Mills calendar image, c. 1920.

of popular art, the Rājus of Tanjore and Trichninopoly were prominent. Originally from the Andhra region, the Rājus migrated south to Tamil Nadu during the sixteenth century under the patronage of the Nayak and Marāthā kings (Appasamy 1980; Ramaswamy 1976). The work of the Rājus and related communities like the Naitus of Madurai was, and in some cases still is, creating and renovating wall and ceiling paintings in temples, decorating processional vehicles (*vakana*), and painting plaster sculpture on temple gates (*kāpuram*) and towers (*vimāna*) (fig. 8.2). These groups also developed techniques for

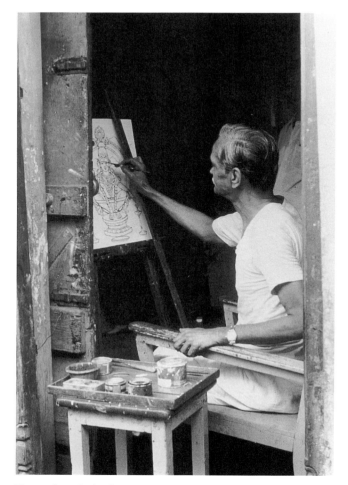

Figure 8.2. Artist from a temple-painting family working on calendar-size painting, Madurai. Photograph by Stephen R. Inglis.

painting on wood, glass, and mica panels, and these portable paintings of Hindu deities and saints became the earliest framed pictures in South India. "Tanjore paintings," as they have come to be called, often embossed with precious metals and encrusted with pearls and semiprecious stones, can be seen in temples, community prayer halls (*kutam*), and the halls and puja rooms of substantial homes throughout Tamil Nadu. The styles of these paintings, while based on the correct measurements and attributes for gods and goddesses

described in traditional texts, developed distinctive characteristics that ultimately influenced the lithographed image styles. Tanjore paintings were responsive to changes in popular taste and show not only the influences of the Tamil kingdoms' persistent styles but also those of Muslim and European fashion. Other local and regional craft skills also influenced popular aesthetics (Maduro 1976). Many painters for the printing industry were heirs to a tradition of carving in ivory and wood (e.g., K. Madhavan 1907–1973) or metal engraving (e.g., M. Ramalingkum 1933–1990). The knowledge of these skills is evident in the fine decorative design in South Indian prints and the elaboration of jewelry and architectural features.

The heritage of Indian popular art is not, however, limited to Indian artistic traditions. By the 1850s, the Government School of Arts and Crafts in Madras, like similar art schools run by the British in Calcutta and Bombay, offered a program that combined Western classical training in high realism with some reference to Hindu and Buddhist traditions of architecture and sculpture. The teachers were fired with a zeal to reform what they considered degenerate Indian styles and techniques and to revive the glorious ancient art of India. The graduates, among them C. Kondiah (1898–1976) and K. Madhavan, learned techniques of shading and lettering and studied design. The emphasis in the Government College's syllabus on "commercial art" may have had considerable influence on work produced by graduates. As early as the 1880s it was reported in Calcutta that the cheap color lithograph representations of gods and goddesses that had appeared in the market were based on paintings turned out by "ex-students of the Calcutta School of Art" (Mukharji, cited in Nagam Aiya 1906).

Many of the major lithographic artists of the mid-twentieth century developed their skills as painters of theater scenery. These included K. Madhavan, who worked for Kanniya Company, for N. S. K. Nadar, and for T. K. Brothers drama companies in the 1930s and 1940s, and T. S. Subbiah (1920–), who began his career as a theater company electrician and has become one of today's most successful popular painters.

The subjects of the dramas were primarily episodes from the Epics, and many troupes also performed adaptations of Tamil folk stories. Each troupe included at least one artist to prepare the backdrops and create the effects on which this kind of entertainment depends. The elaborate backdrops were part of what distinguished these "special dramas" from the more ancient Tamil street theater (*teru kuttu*).

The heritage of drama backdrop painting is evident in several ways in the style of contemporary popular art. First, the backgrounds of calendar and puja prints of deities are often elaborate architectural settings based on the drama backdrop style. The temple pillars, thick draperies, and graphically rendered decorative scrollwork of popular prints, often employing several different ranges of perspective, are drawn directly from the large painted

cloth backdrops of the dramas. Painting highlights onto backgrounds as if the scenes were dramatically lit is another feature that has survived the transition from the theater to the printed image.

In the earliest Indian lithographs (such as those from the Varma presses at the turn of the century), the artists favored pastoral backgrounds and gods and goddesses in outdoor settings, the styles of which were strongly influenced by European-derived landscape painting. The next generation of painters for the popular market replaced this preference for nature with "fancy" (architectural or fantasy) backdrops, yet the pastoral backgrounds that survived in the work of artists of Kondiah's generation show a flattening and conventionalization that is more like theater scenery than the easel-painting realism attempted by artists in Varma's day (fig. 8.3).

Drama backdrop styles also influenced the relationship between the primary figure or figures and the background in popular art. The earlier attempts by painters for the popular market to integrate the key figures into the scenes (for example, a startlingly human-looking Shiva walking casually in a forest) were modified by artists trained on backdrops to a presentation in which the key figures were conceptually separate from the paintings' backgrounds. Popular images of the 1930s to 1950s look more like actors on a stage, more like the traditional Indian convention of presenting the deity within a context or frame and yet separable from it, simultaneously a character in a story and an icon, and accessible in either way for the viewer or devotee. This apparent tension is evident in village drama itself. Actors have described to me how the narrative flow of dramas is occasionally interrupted by members of the audience worshiping the main characters. Indeed, entertainment and worship in India often coexist (see Hiltebeitel 1988; Blackburn 1988).

Photographs introduced another influence on the evolving South Indian popular style. The relationship between popular printed pictures and photography has been discussed by Judith Gutman (1982) and Daniel Smith (1978), particularly in regard to photography's influence on portraiture and popular images of saints and political leaders. Gutman's own photographic collection includes examples that have been inset into paintings, photographs that have been overpainted, and of course paintings derived from photographs. It is likely that calendar artists were involved in all of these processes, resulting in their establishment of conventionalized portrait versions of important figures, probably derived from photos, and also well-known versions of important carved or cast temple images painted from photographs, for which the demand continues to grow at pilgrimage centers. In addition, the stylized backdrops drawn from drama scenes "frame" both the wedding couple in their photos and the deity in many of the early paintings mass-produced by the printing industry.

Yet there are other connections between the print and the photograph, perhaps less direct but more profound. Calendar artists were vitally interested

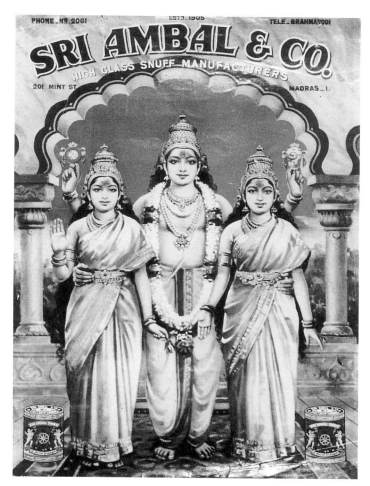

Figure 8.3. K. Madhavan, *Visnu with Consorts,* Sri Ambal (snuff manufacturers) calendar image, c. 1950.

in the technology of image production and reproduction. Their status was bound up with photography, a medium still regarded with considerable awe by most people in Tamil Nadu in the middle of the twentieth century. They were eager to improve their product and to experiment with any new equipment or technique that became available for either photography or painting.

The flowing graphic style that the second generation of calendar artists introduced to South Indian popular art changed printed images from reproductions of paintings to mature and flexible poster images in their own

right. This transition was based on several key innovations. One was the nature of the painting materials themselves. In the 1940s most painters for the print market used oil paints on canvas or prepared surfaces. A major painting took a month or more to complete. They soon changed to German powder tempera colors and more recently to Camlin watercolors, with which a painting can be finished in three to four days. The painting surface became standardized to twenty-by-thirty-inch panels of artist's board.

Another major innovation was the acquisition in the early 1960s of the airbrush, the key to subtle shading effects that previously could be achieved only by laborious overlays in oil or wash techniques in watercolor. Airbrushing became a central part of popular aesthetics.

Perhaps most important in the style set by South Indian calendar artists was their understanding of the printed image's potential as a communication medium. They simplified the image of the deity passed down to them from the first generation of painters to have work reproduced and made it bolder, more colorful, and more visually compelling. They made their representations livelier, in keeping with the increasing role of prints in public spaces. Because they were trained photographers as well as painters, they understood the changes taking place in the printing industry. Many artists first had their paintings printed just as photo-offset machines were beginning to replace the more labor-intensive lithographic presses. In Sivakasi, where virtually all their paintings were printed, the first modern photo-offset press was installed in 1956.

Another boost for South Indian artists was that Sivakasi became the largest printing center in India. The extraordinary efforts of the Nātār industrialists' community transformed this Tamil desert village from a small matchbox and fireworks producer to a major industrial center, India's "Little Japan." By 1979 there were 350 photo-offset machines and more than 1,000 litho and letterpress units in operation. Beginning, as Ravi Varma had, with imported machines and technicians from Germany, Japan, and Czechoslovakia, the Sivakasi printers developed their own skills and helped develop the Indian printing press manufacturing capacity. It was to Sivakasi that artists began to take their work; their close contacts there enabled them to keep in touch with the publishers and through them with the public, whose response was to become so important to the direction their work would take.

The relationship between teacher (*guru*) and student (*celā*) is crucial for understanding popular Indian art. Artists in training followed a traditional sequence of watching, then assisting, then copying, then developing new versions. This is also the process through which one can trace the course of popular art in South India.

During the first phase of his training, an artist typically signs his teacher's name to all his work. As an established artist in his own right, he may still sign his guru's name above his own. One of Kondiah Raju's illustrious students, M.

Ramalingkum, signed Kondiah's name to his own work from 1956 to 1958, both names from 1958 to 1962, his own name from 1962 to the early 1970s, and from then until his death his own name and the name of his studio, "Chithiralayam." In this way, the "signing" of paintings, which was imported to Indian art with European painting, has been adapted to the Indian notion of the artist as a link in an artistic chain. One result of the devotion of students (and perhaps the allegiance demanded) is that it seems impossible now to establish how many published pictures are the work of the master's own hand.

This kind of genealogy of artistic training helps to account for the continuity of process and style in painting for the lithographic market in South India during this century and to identify the elements, both local and imported, that combined to create the prevailing images. The close "hereditary" relationships of the artists and their attitude toward copying, reproducing, and recycling one another's designs have contributed to the evolution of strongly accepted popular images of deities. On the one hand, copying or plagiarism is a major feature of the history of all "poster aesthetics," and "each important poster artist partly feeds on earlier schools of poster art" (Sontag 1970: 4). On the other hand, few Indian popular artists have absorbed the ideology of the modern artist in Western society—the notion of the creative individual, isolated, spontaneous, and self-motivated. Most of the artists referred to here consider themselves an integral part of a tradition, responsible to their families, gurus, and god in the course of their work.

Despite the multitude of commercial applications to which their popular images have been put, calendar artists' attitudes toward their work show continuity with the artist's traditional role in Indian society. These include the notion of the creative process as a sacred act and the artist as temporary priest, subject to certain domestic purity restrictions and rituals associated with work, especially work on paintings of deities (Inglis 1984: 240). These artists are keenly aware of the uses to which their printed designs are put and feel their responsibilities as priests toward consumers as devotees. Many popular artists were born into traditional communities of artists. A majority are of the artisan (*Asari*) castes and so were hereditarily prepared to approach their work from a traditional set of beliefs.

THE USE OF IMAGES

Most Indian paintings originally were an integral part of the buildings for which they were designed. The "portable" painting traditions, such as the scrolls of Bengal and Gujarat displayed by itinerant bards or the pilgrimage paintings of Puri or Nathdwara, were all highly localized and specialized. In South India most traditional painters worked for temples. People viewed paintings during their visits to temples or monasteries. Printing technology and rapid reproduction have tended to reverse this situation, in that the

painting travels to the viewer rather than the viewer to the painting. In the painting's travels, its meaning changes, or rather "its meaning multiplies and fragments into many meanings" (Berger 1976: 19).

Distribution

Much has changed since "Ravi Varma's printed pictures" were included in a list with "bouquets, gaslights and other items of foreign decoration" as "high-class" furnishings to "make houses grand and glorious, even in the eyes of modernists" (Sarkar 1917: 65). Today, prints are not confined to either grand houses or those of "simpler Hindus" (Basham 1977: ix). At the beginning of the twentieth century, Ravi Varma and his brother struggled for days to produce a few hundred prints. The business, according to a contemporary account, "was not believed to be paying" (Nagam Aiya 1906: 265). By the time C. Kondiah Raju and his followers began painting for the popular print market in the 1950s (Inglis 1995), several large printing firms were turning out 200,000 to 300,000 prints a year. S. S. Brijbasi and Sons printed more than 7.5 million pictures in 1985 (Anton-Warrior 1986); the larger companies—for example, Sankareswari, Orient, National, and Coronation in Sivakasi—now probably each produce more than 10 million images a year. Such mass production made artist M. Ramalingkum, who had single designs printed in runs of 100,000 and produced up to 100 designs a year for several decades, one of the most published painters in world history. But it has also ensured that prints of Hindu religious subjects now appear in places and in forms that never existed before.

Whereas Kondiah Raju's paintings of *Ganjendira Motsam* and *Minakshi Kalyanam* became two of the most beloved images throughout South India in the 1950s, his disciples' most popular images can be found from Kanyakumari to Kuala Lumpur and from Calcutta to Capetown. This process of dissemination has dramatically increased the "recognition factor" of various deities. These artists' depictions of Meenankshi and Murugan have become the images South Indians associate with these deities, and these core images continue to appear in the work of the artists' students and those they inspired. These standardized portrayals of particular deities have become far better known and more easily recognized than any historical or regional representation could have been in the past. The same, of course, applies to the most widely published artists' representations of film stars, politicians, and saints (Daniel Smith 1978). So pervasive have the "standard" images become that in smaller shrines and temples in South India one often sees a printed image of the deity mounted outside the sanctum of a temple and even pasted on the wall above the carved image itself. In an ironic way the printed image adds "authenticity" to the three-dimensional image. In the temples where this happens, the printed image augments the prestige of the local version

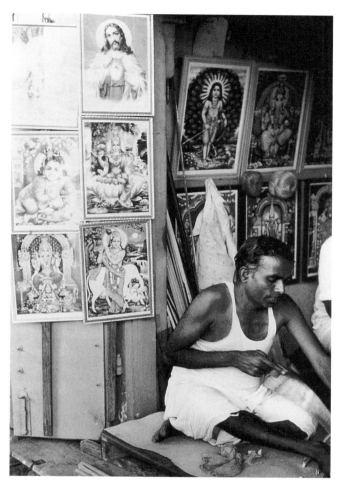

Figure 8.4. "Framing prints" for sale in a shop, Madurai.
Photograph by Stephen R. Inglis.

by linking it to the larger network of the deity, which includes the cities, bigger temples, and "famous places." There is an element of "hyper-reality" in these prints. Their bright colors, shiny finishes, and appealing designs complement rather than detract from the dark carved images.

Visualizing the deities through popular depictions links not only virtually all markets, temples, and pilgrimage places in India but also Hindu residences, workplaces, shops, and places of worship throughout the world (fig. 8.4). One is tempted to say that a "national aesthetic" goes beyond religious

identity alone, in that the prints with their particular stylistic history are distinctively Indian and yet are far more pervasive than any of the folk, regional, or classical styles—those officially "chosen representatives of a National Tradition" (Singer 1959). The ubiquity, portability, and mobility of these images have drawn Hindus closer to one another in the ways they perceive the divine and have provided a more unified vision of the Hindu pantheon. Printed pictures are thus one key element in the "Pan-Hinduism" that develops as Indians become increasingly mobile within their own country and part of regionally diverse Hindu communities abroad.

Every year, sales representatives leave their giant printing companies in Sivakasi with fat catalogs and order books to sell religious designs for calendars, book covers, labels, and posters throughout India and abroad. The catalogs include pictures of all the gods and goddesses, an *utsava murti* or processional icon to be toured among the devotees. Through this process, the power concentrated in sacred centers is diffused to wherever devotees live, work, and worship.

Commerce

Although we do not know to what commercial uses all the earliest prints were put, we do know that, for example, M. Ramalingkum's first print was used for a Sri Ambal Coffee calendar in 1956 and that K. Madhavan's first illustration was for Burmah-Shell in 1940. Printed paintings of Hindu deities were used as part of commercial advertising as early as the 1920s, and in South India the large textile mills and tobacco snuff companies were among the most consistent clients. By the 1950s businesses of every kind purchased printed pictures of deities as advertising posters and calendar images. Since that time the same images have been used in various sizes on greeting cards, school notebooks, fans, and flyers as well as on all kinds of packaging and labeling.

Part of the character of modern media is that the members of the public are viewed as both spectators and customers, and printed images in India as in other industrializing countries have increased in number along with consumers. But it would be erroneous to assume that the commercial context is essential to the printed image in India or that the artist is simply a hired hack out to please a client. The commercial element of the divine image has remained secondary to its creation and distribution as an aesthetic expression in the broadest sense, an expression that transcends any particular slogan or advertisement. The same image is regularly sold as a "framing picture" and as a calendar illustration. For most of the public, the sponsors of the calendar are secondary and interchangeable. If initially used as a calendar illustration, a print is often clipped and framed when the year expires, thereby becoming a sacred icon. Thus, although the image may be symbol-

ically appropriated by a publishing company and then by a consumer, the relationship between artist and audience and between deity and devotee is maintained.

Worship

Among a collection of older printed pictures one may be surprised at the number that have been daubed with sandalwood paste or vermilion powder and even scorched with incense. It has been possible to record dozens of ways in which printed pictures are used in worship and to document how they have become an important form of religious icon in modern India.

There are few shops in India in which prints are not the focus of some daily ritual, and prints serve similar purposes in public buildings, schools, offices, and private homes. Framed prints are taken out in procession, mounted on temple chariots, and carried around by beggars. There are probably few travelers who have not said a silent ecumenical prayer to a garlanded print mounted on the dashboard of a careening scooter, taxi, or express bus. The acceptance of the printed picture as a suitable focus of worship has several implications for ritual and religious practice.

Because prints are widely available and cheap, and occasionally even free, almost anyone can afford to own one. As a result, more private worship may take place in the home and less at the temple. Widespread ownership has perhaps also contributed to the growth of cults, whose momentum often relies on a shared talisman or other symbol (e.g., Santoshima or Aiyappan). The accessibility of the images, their portability, and their flexibility (in that they lack the conventional associations of the three-dimensional representations with priests and other specialists) enable people more easily to claim devotion to a deity whose image they possess. In the case of people of low caste, this may be a deity with whom interaction in temple worship is socially prohibited.

Another aspect of worship involves pilgrimage. An important part of the pilgrimage experience, especially for Hindus, has been *darshan,* the chance to stand in the presence of a particular deity (Babb 1981). In some ways the pilgrim can perpetuate this experience by acquiring and worshiping a memento from the holy place. Through the wide distribution of printed pictures, the chance to obtain such mementos, and by extension the chance to "stand before the deity," is no longer limited to those who have made the journey. The image of Tirupati Balaji in print form is available in Madurai, Puri Jagganath in Calcutta, or Nathdwara Nathji in Bombay. Any of them can be had in Nairobi or Singapore. One of the most widely circulated prints in South India today is the image of Aiyappan. While growing numbers of people make the rigorous Aiyappan pilgrimage to Kerala, the availability of the image in print form makes a degree of participation in the cult possible

for those unable or unwilling to travel. Printed pictures do not, of course, replace or duplicate the pilgrimage experience, but perhaps their wide availability facilitates a "vicarious" pilgrimage (Bharati 1963: 165; Diehl 1956: 250) within the larger process of vicarious ritualization (Singer 1959).

Another facet of the use of images in India involves the inextricable relationship between pilgrimage and tourism. On the one hand, the movement of peoples throughout India to pilgrimage centers has traditionally involved "sightseeing" and related leisure activities that are difficult to differentiate from the sacred goals. On the other hand, the late-twentieth-century phenomenon of middle-class tourism of Indians to destinations in their own country (which in numbers and importance far outstrips foreign tourism) retains elements of the sacred journey and almost invariably includes sacred or quasi-sacred sites on the itinerary. In both instances, prints are mementos that function simultaneously as sacred talismans and souvenirs. The growing range of prints that illustrate temples, monuments, gardens, and landscapes as well as important local deities seem to address this market.

Multiple Images

Many years ago on a journey to find a family friend who lived in a village near Hoshiarpur, Punjab, I was sitting in the office of the Communist Party of India looking up at a line of framed prints. They were identical in size and frame, and each was daubed with sandalwood paste and garlanded with desiccated marigolds. The line included depictions of Marx, Ganesa, and Gandhi. This experience, confusing at the time, alerted me to the flexibility that printed pictures have introduced into the construction of visual and symbolic sets. As meaningful as the choice and use of a single print may be, the juxtaposition of printed pictures also offers an extremely rich field for analysis.

On the one hand, the image-covered facades of modern Indian towns and cities randomly display India's links with countries throughout the world; on the other, in some arenas in India prints are juxtaposed in patterns that express religious ideology and change. One of these is the private space in larger Indian homes devoted to worship, the puja room, in which the imagery of the family's religious heritage is accumulated, often in conjunction with photographs, three-dimensional images, and other souvenirs. Another is the temple, monastery, or community hall in which framed printed pictures often line the tops of the walls documenting the religious "genealogy" of larger social groups. A third arena is the shop, in which framed prints have become a major part of the physical and social ambiance, whether they amount to a few calendars hanging limply in a tea stall or a splendid series of framed and garlanded prints in a traditional jeweler's or confectioner's shop (fig. 8.5).

Figure 8.5. Lithographed images decorate a shop selling religious offerings, Madurai. Photograph by Stephen R. Inglis.

In all these collections, various juxtapositions, made possible by the ubiquitous nature of the printed image, provide evidence of the religious ideology of the accumulators and the users. First, we can detect personal attitudes and allegiances in the selections made, hierarchies established, and priorities clearly identified through relative size, quality, and placement. The range and variety of images available allow an individual, family, or group to creatively construct a particular pantheon, independent of the traditional lim-

itations of caste allegiance or craft prerogative. There is both a great deal more image choice and a great deal more flexibility for change than in the past. Second, there is the historical development of collections. Using these groups of prints, we can now document important additions to divine assemblages. The prints from the early part of the century already have an aura of time past, and more conservative traditional businesses seem to find it appropriate to retain a set intact, although newer prints are often added to the older series when a new member of the firm becomes influential, a new kind of customer emerges, or a family or community event so dictates.

Collections of prints are often a diary or album of experiences for those who assemble them. Despite its initial disposability, a print can take on an aura of great social or cultural value through the passage of time and incorporation into a physical and spiritual space. Groupings of prints often document the travels of the owners to pilgrimage places or important temples. Each assemblage is symbolically a confluence of deities or places and thus a personal or communal map of the sacred geography of a family or group.

In all these ways groups of prints are more meaningful than the sums of individual pieces. They are a means of group identification, a visual code by which members of subgroups announce and recognize themselves and record and depict their attitudes and alliances. When prints of other religious themes, movie stars, politicians, saints, children, and landscapes are juxtaposed, as they often are, with the images of gods and goddesses, the possibilities for expression are extremely varied. In all this there seems to be no risk of "cultural indigestion" in Sontag's terms (1970). Prints of the Bengali patriot Netaji Subhas Chandra Bose, the U.S. president John F. Kennedy, the former Tamil chief minister M. G. Ramachandran, and the Hindu deity Minakshi coexist in the image-rich world of South India. The seemingly indiscriminate juxtaposition of printed pictures has become a way of "anthologizing" the divine hierarchy and often placing this hierarchy in a context of other significant images that compete for attention in the modern world.

CONCLUSION

In all the ways suggested above, Indian painting has both retained and expanded its sacred meaning in printed form; this meaning has become richer, more complex, and more diverse. The large volume of reproduction does not necessarily challenge the authenticity or potency of the sacred image. Hinduism has a deeply rooted capacity to accommodate multiple versions and manifestations. The connections between sources and emanations are fluid and receptive to the wider circulation of sacred images through new media. The ephemerality and disposability of printed pictures are not necessarily indications of a reduction of sacred power. Although prints are some-

times framed and preserved, most are simply discarded. The cyclical and ephemeral nature of artistic creation and consumption is a central theme in Hindu religious practice, one that is reproduced in the annual calendar cycle (Inglis 1988).

For the South Indian calendar artists of the mid-twentieth century, the transition from making paintings for specific clients and purposes to making paintings for printing was a natural one, a part of their evolving sense of the expanding role of images in South Indian society. The flexibility that enabled them to work in several media simultaneously and to serve with equal effect religion, politics, and entertainment is characteristic of their artistic heritage rather than a departure from it. Their special contribution was to "humanize" the stylized and remotely superhuman representations of deities in the classical Pallava, Chola, and Pandya styles, to "nationalize" the regional craft skills to which they were heir, and to integrate those styles with the evolving aesthetics of their own and other popular media, particularly the cinema. The printed versions of their paintings are accessible to ordinary people in India because they "quote" both the traditional structure of divine depiction and a modern style of public communication. Although the techniques of reproduction may have "detached the reproduced object from the domain of tradition" in some societies (Benjamin 1969b: 223), in South Asia the new technologies created diverse and complex opportunities for the diffusion of sacred meaning and practice.

Artistic Innovation
and the Discourses of Identity

Elizabeth Hickox and Karuk Basketry
A Case Study in Debates on Innovation and Paradigms of Authenticity

Marvin Cohodas

This essay considers the production and reception of baskets woven for sale as curios in the early twentieth century by Elizabeth Conrad Hickox (1872–1947) of the Karuk region in northwestern California (fig. 9.1). Hickox specialized in the lidded trinket basket, a form developed for the curio trade.[1] Between 1908 and 1934 her works were purchased by Grace Nicholson, a curio dealer in Pasadena, California, who specialized in basketry. Nicholson's records provide almost unparalleled documentation of the work of a single weaver.[2] Until 1926 Nicholson recorded her purchases of baskets by Hickox and others in a ledger and also photographed Hickox, her baskets, and those of other weavers.[3]

Although the Lower Klamath basketry style is so homogeneous that neither weavers nor non-Native experts can judge ethnic origin (Wiyot, Tolowa, Hoopa, Yurok, or Karuk) for undocumented pieces, Hickox's baskets are immediately identifiable. They display unique characteristics of shape (the high, narrow knob), technique (superfine stitching with limited color scheme), and design (complex interrelation of primary and secondary motifs). Anthropologist Lila O'Neale, who interviewed Hickox extensively in 1929, attributed Hickox's individuation to the demands of her patron, Grace Nicholson, although this view refutes both documentary evidence and Hickox's own words as preserved in O'Neale's notebooks. Elizabeth Hickox's development of a signature style thus serves as a well-documented case study for examining debates about tradition and innovation in judgments of authenticity.

Hickox's baskets participated in the Native American curio trade that climaxed between 1880 and 1920. This trade formed part of a globalized commoditization of ethnicity dominated by the expanding Victorian bourgeoisie in English-, French-, and German-speaking countries in Europe and North

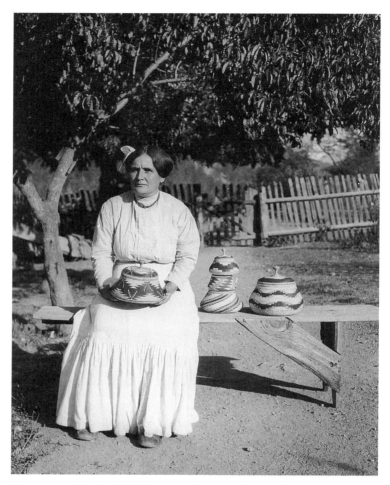

Figure 9.1. Elizabeth Hickox seated next to her baskets, 1913. Photograph by Grace Nicholson. Grace Nicholson Papers, Huntington Library. Reproduced by permission of the Huntington Library, San Marino, California.

America (Howe 1976). These forms of ethnic curio consumption were not uniform either in their specific features or in the meanings applied to them; issues of authenticity and tradition were, in particular, inconsistently weighted. "Tradition" and "authenticity" continue to be slippery notions, imposed on Native American products (along with those of other colonized peoples) as part of the process of subordination and exploitation. They have

both changed and been resisted throughout the twentieth century, the period during which they have been most extensively applied. Some of the debates are illustrated by both the production of Elizabeth Hickox's trinket baskets and their changing meanings to Euro-American consumers.

THE MODERNIZATION PARADIGM
AND ITS AUTHENTICITY BOUNDARY

The evolutionary paradigm dominant during the second half of the nineteenth century constructed a set of sequential links among peoples and their objects that formed a linear trajectory of social and technological progress. During the late nineteenth century a crucial shift began to occur. The evolutionary paradigm was gradually replaced with a relativist construct that Richard Wilk (1991: 3) has termed the "modernization paradigm," a polar opposition of the *modern* (characterized by technology, progress, capitalist commerce, industrialization, alienation from nature, materialism) and the *premodern* or *primitive* (characterized by precapitalist forms of production and exchange, adherence to tradition, closeness to nature, spiritualism). The modernization paradigm constructed temporal gaps, dividing the contemporaneous lifestyles and practices of the world's peoples into categories relevant either to the past (premodern) or to the future (modern).

Peoples considered to represent the modern and premodern poles were not, in fact, divided by a spatial, temporal, or even an economic gap but were related through capitalism—as capital to labor and colonizer to colonized. The gap was ideological: constructed in discourse to mystify exploitative relations of production. Touristic consumption both arose from this conceptual distance between modern and premodern and served to maintain and reproduce the ideological gap by transforming ethnically marked objects and practices of the colonized "fourth world" into leisure-time entertainments that obscured exploitation in labor.

Promulgation of this ideological polarity led to shifts in the ways that Native basket curios were appraised. Earlier, curios made with Euro-American materials (threads or dyes) or with overt paraphrases of Euro-American forms (including shapes such as cups and saucers and motifs such as letters and numerals) were appreciated by some as evidence of progress and hence of the evolutionary potential of Native Americans. This valorization of change was often connected to women's philanthropic activities aimed at Native assimilation, and it supported parallel federal land-ownership and education programs. The development of an opposed relativist paradigm in the late 1880s was closely associated with the growth of international corporate and finance capitalism. The new economic elite in North America, allied with the expanding bourgeoisie, began to adopt Native Americans as their premodern ancestors, a construction designed not only to define individual Canadian or

American identity within a community of industrialized nations but also as a tool in the exploitation of immigrant non-Anglo laborers. Under the modernization paradigm, innovations in basketry that had earlier been appreciated as evidence of progress came to be rejected as evidence of contamination and degradation. Fearing what seemed the imminent doom of Native American societies (and their availability to ideological appropriation), the new capitalist elite financed expeditions of salvage anthropology to collect objects, myths, and descriptions of technologies and ceremonial practices.

These salvage practices involved attempts to erase evidence of change related to modern capitalist interventions. Such changes were classified as the loss of "traditional culture" and hence "acculturation." These assessments carried negative connotations because of the dichotomous character of the modernization paradigm, which constructed change as a virtue and a sign of progress when associated with dominant Euro-American groups, but as a threatening vice when associated with subordinated groups such as Native Americans.

Privately supported policies of preservation based on relativism were, however, as unsuccessful as those governmental, evolution-based policies of assimilation they were developed to resist. Native Americans, on the one hand, refused to surrender their identity as the original human occupants of the New World while, on the other, they intermarried (particularly with Euro-Americans and Mexican Americans), adopting the practices of Euro-American groups (food, clothing, technology, substance abuse, religion), and actively sold their labor, goods, resources, and often land. These practices rendered the premodern/modern boundary between Natives and Euro-Americans increasingly hard to define.

Increasingly, too, judgments of authenticity became an ideological tool for reinforcing this permeable boundary. In processes of industrializing production, notions of authenticity had proven useful for constructing a premodern/modern boundary between the unique, handmade crafts and "spiritualistic" art, sharing signs of individuality associated with the bourgeoisie and the mechanically mass-produced commodities associated with the laboring classes. "Authenticity" also measured the degree to which Native American objects and practices could operate as metonyms for the premodern, constructing a purified, ostensibly precontact past. The constructions of "authentic tradition" imposed on indigenous peoples of North America were disempowering because they were descriptions of an imaginary past lifestyle that no living Native American could attain.

Many Aboriginal peoples contested such judgments, forcing dominant groups constantly to reinforce the boundaries of the modernization paradigm and their use of tradition and authenticity as its defensive fortifications. In sum, authenticity is not an essential trait of objects or practices but a discursive boundary-marking construction specifically associated with late-Vic-

torian anthropological imaginings of "primitive" societies and contemporaneous curio market valuations. Through its construction of alterity, it served to maintain the modernization paradigm as an ideological component of the subordination and exploitation of colonized societies.

<div style="text-align: center;">

AUTHENTICITY AND OBJECTS:
COLLECTORS' FINE ART AND TOURISTS' SOUVENIRS

</div>

Daniel Miller (paraphrasing Barthes) has written that an important function of material objects and other signifying practices is to provide "artificial resolutions to real contradictions in society," utilizing "the ambiguities and tendencies of the process of signification itself in order to effect its apparent closures" (1987: 145). Virginia Dominguez (1986) foregrounds the ethnographic museum collection in late-Victorian North America as the site of such closures, which could constitute and reproduce the myth of Native/white separation. Dominguez shows how objects produced in contexts of Native American (and other non-Western) societies could be appropriated, reclassified, and displayed in museums as metonyms of an imagined precontact lifestyle in order to reify the West's reductive definition of a "primitive" Other and thereby its self-definition as "modern." Jean Jacques Simard (1990) argues further that inferred representations of the "modern Western self" in texts and object displays were as reductive as representations of the "primitive non-Western other." He writes that "the much-favored modern definition of the Whiteman as a morally delinquent, environmentally estranged, socially alienated and materialist creature is historically emergent, and cannot make sense without reference to the opposite traits of the true Indian" (1990: 354).

As Ruth Phillips (1995) details, one of the most important processes by which museums reinforced the boundary between the modern and the premodern was in judgments of authenticity applied to objects they actively collected as well as to those donated by private patrons. Museum curators claimed to define the premodern/modern division on the basis of production, judging as authentic those objects produced for indigenous use—or replicas of such produced for anthropologists—and dismissing as inauthentic souvenir objects produced explicitly for sale. In practice, however, objects that *appeared* "traditional," whether or not they were made for sale, could be authenticated and recontextualized within the museum setting and analyzed as evidence of precontact technology or religion.

Museums were not the only or even the major sites of boundary construction through object display. Rather, private consumption for household decor dominated the curio trade at its peak. In late-Victorian bourgeois ideology, the modern/premodern distinction between "progressive" material change and "traditional" spiritual or moral values also defined the discursive split between public and private spheres. Bourgeois households were

maintained as premodern preserves through the matriarchal cult of domesticity, which was articulated symbolically through women's task of decorating reception spaces (front halls as well as parlors). Objects were chosen for display not only to articulate the household's class position (through judgments of taste), to define nationality (by celebrating premodern antecedents), or to create a hierarchy of gender (by defining the home as a place of male leisure) but also, through chains of signification, to reinforce the household as a premodern space protected from capitalist materialism.

Native curios were privileged in bourgeois parlor decoration as metonymic representations of the premodern, their significations enhanced by handmade production and utilitarian function, two aspects of the premodern also valorized in the contemporary American Arts and Crafts Movement. Bourgeois women philanthropists, especially those operating through settlement houses, included the textile work of immigrant women in the category of crafts; hence debates over assimilation or preservation of Native American societies were linked with conflicts over whether women's needlework was modern industry or premodern craft. All these categories (curios, crafts, the invented Indian, the cult of domesticity) exemplify the premodern component of the late-Victorian modernization paradigm. As Hobsbawm (1983) shows, characterizations of the premodern as a traditional past were constructed on the basis of present rather than past conditions and thus were actually "invented traditions."

In the literature on basketry curios from the end of the nineteenth century, the authentic/inauthentic dichotomy was also directed explicitly at the construction of the consumer's economic class. Purchases of unique and expensive fine-art curios characterized high-class collectors as persons of knowledge and taste gallantly engaged in the preservation of Native tradition, whereas acquisitions of mass-produced and inexpensive souvenirs constructed their purchasers as ignorant, crass tourists unwittingly encouraging the degradation of the Native. The consumer's ability to discriminate relied on visual examination, since both categories of objects were made for sale to suit Euro-American tastes, and in some cases both were made by the same individual. Some objects resisted classification by sharing characteristics of both categories. The trinket baskets of Karuk weaver Annie Super, for example, combined "authentic" fine technique with "inauthentic" animal designs.

The dichotomy of fine art and souvenir thus subsumed a continuum of goods developed to meet the diverse taste requirements of consumers as well as practices of consumption that ranged from occasional tourism to financial investment. More recently, this dichotomy has been contained within a generalized category of "tourist arts," a term that in early basketry literature would have been an oxymoron. Its acceptance today demonstrates that while racialized judgments of authenticity (based on indigenous use versus commercial production) have become entrenched throughout North American

society, class divisions that previously distinguished categories of "art" and "souvenir" have been elided.

AUTHENTICITY AND CHANGE AMONG BASKETRY PRODUCERS

Twentieth-century practitioners of cultural relativist anthropology (along with other consumers of the premodern) learned to reconfigure textually colonized non-Western societies in an allochronic framework that removed them from history and the present (Fabian 1983). They developed a theory of "primitive cultures" as societies with homogeneous value systems resulting in universal adherence to "tradition," rather than individual innovation. Native curio producers continuously negotiated the ambiguous and shifting Euro-American boundary between "tradition" and "innovation," adapting creatively to Western tastes and changing definitions of their own "authenticity" while avoiding overt signs of innovation that would jeopardize the value of a curio product as metonym for the premodern. Museum authentication of innovative curio objects was facilitated by the very flexibility of a boundary that was discursive rather than tangible.

When preservationism was taken up as a popular cause in opposition to federal assimilation policies, the authenticity of curio baskets became an important issue for upscale collectors and dealers because only a "traditional" piece—its connotations of belonging to the past contributing to a presumption of rarity—could be expected to increase in value. Private dealers and collectors also judged value according to fineness of weave, which indicated exceptional skill and labor investment. Although technical quality increased with the use of metal tools, assumptions that the true relevance of indigenous life was in the past and that Euro-American influence contaminated Native society and therefore degraded object production allowed dealers and collectors to invert technical quality as a marker of past tradition. Works that combined high quality with an absence of overt paraphrases of Euro-American form or design were accepted by dealers and collectors as traditional, allowing them to function both metonymically as signifiers of a purified precontact past and financially as investments guaranteed to appreciate.

Consumers also expected authentic curios to be produced in premodern settings—by poor Native women living in indigenous shelters and engaged in precontact modes of subsistence. Dealers rarely disenchanted their clients about the facts of production; rather, it was characteristic of "dealer lore" to manufacture an "authentic" premodern context of production to satisfy the touristic desires of consumers (Spooner 1986). Indeed, the most expensive of all curio baskets were those by Washoe weaver Louisa Keyser (Dat so la lee), whose patron Amy Cohn hid the actual circumstances of her innovative curio production behind an elaborate lore, manufacturing a store of significations that attracted purchase as much as the physical basket (Cohodas 1992).

Similarly, Grace Nicholson did not reveal to her clients that the Hickoxes were a mixed-race family of considerable economic status and social influence in their region. Elizabeth's husband, Luther Hickox, owned a gold mine and was part owner of a sawmill. In 1916 he also became a justice of the peace, and around that time he purchased what may have been the first automobile in the locality. He drove the car on official business, taking his stepdaughter, Jessie Merrill (who was educated at the Sherman Institute in Riverside, California), as secretary, and his daughter, Louise Hickox, as translator. He also used the car to take gold to the mint in San Francisco and to mail Elizabeth's baskets to Nicholson in Pasadena. When Elizabeth came along she used her basket-weaving income to shop for more fashionable clothes than she could obtain locally.

Furthermore, although Nicholson classified Hickox's baskets as Karuk because the family lived in the Karuk area, neither Elizabeth nor Luther had Karuk ancestors. Both had Euro-American fathers who brought Native women into the area to serve as wives and housekeepers—Elizabeth's mother was Wiyot, and Luther's was Hoopa. Accurate information about the Hickox baskets would have frustrated consumers' demand for curios to be authentically premodern in form and mode of production and stylistically characteristic of a particular "tribe."

As Euro-Americans strove to recontextualize these objects, selecting and distorting information in order to reinforce a strategic boundary, many Native producers endeavored instead to create curios that gave material expression to the growing interrelationships and interdependencies of Native and Euro-American societies. Synthesizing indigenous techniques and designs with a modern form adapted to Euro-American display produced an object that, although hybrid, was designed to be interpretable in Euro-American environments as an indigenous form. Thus consumers, associating "past tradition" with fine quality and a lack of overt Euro-American borrowings, authenticated Hickox's lidded trinket basket, even though it had been designed specifically for Euro-American interior settings such as mantels or bric-a-brac displays. Hickox went further than many in adapting the trinket basket to its curio function, undermining its associations with storage. She wove an elegant but fragile knob, she made the object small and light to encourage viewers to pick it up, and she put designs on the interior to discourage owners from placing objects inside and to encourage them to open the basket for appreciative examination.

INNOVATION AND AUTHENTICITY

To function as a sign of premodern "tradition," the curio object had to suggest the past and absence of change, but to function as fine art it also had to manifest individual genius. Many private collectors of Native American

curios were willing to pay higher prices for objects of known and distinguished authorship because the more expensive "fine-art" curios could be expected to appreciate more in market value. Because of the greater financial and social rewards, some Native American producers such as Elizabeth Hickox strove to meet the taste requirements of this upscale fine-art market. Curio dealers like Nicholson mediated between Native producers and wealthy Euro-American consumers, facilitating the circulation of objects as well as information about origin and authorship. Nicholson continually promoted Hickox (together with Pomoan weavers Mary and William Benson) as unique artists, elevating prices on their baskets accordingly.

A contradiction thus arose within the notion of the authentic: homogeneity and traditionalism were expected for ethnographic classification as artifact, but individuality and uniqueness were expected for aesthetic categorization as fine art. Dealers specializing in the high-end market probably first worked out the solution to this contradiction around 1900 by separating innovation from individuation. Basketry dealers like Nicholson and the Cohns maintained that in this era of commercialized trinket production the highest quality and most individualized baskets were the most traditional (Cohodas 1992: 104–8). The superior weaver's individuality as artist was thus constructed as her unique preservation of—not departure from—tradition.

These dealers then promoted particular women, generally no more than one for each "tribal" division, as "the last of the great weavers." For example, Nicholson wrote that Elizabeth Hickox was "the greatest weaver, who ever lived of these people" and attempted to authenticate the individual character of her baskets by claiming falsely that "old designs and old forms were obtained by research."[4] These dealers thus added to the metonymic use of curio objects as signifiers of the premodern the synecdochal use of a single, supposedly more "traditional" producer to stand in for the precontact "tribal" group. This synecdoche also had economic ramifications; works by the "last of the great weavers" increased in rarity-value not only because these weavers were considered unique but also because, with their inevitable demise, there would presumably be no superior "traditional" weavers remaining to produce such "authentic" objects.

PROFESSIONALIZED ANTHROPOLOGICAL DEBATES ON AUTHENTICITY

Although the emphasis on quality and the unique contributions of individual weavers dominated popular and academic discourse on Native basket weaving for a time, both were eventually rejected by (university-based) professionalized relativist anthropology. This newer approach to Native basketry was formulated primarily by Alfred Kroeber and his colleagues and

students at Berkeley between 1901 and 1908, when their collecting and pub-
lishing activities were financed by Phoebe Apperson Hearst. Most of the bas-
kets Kroeber and his associates were shown in the field had been made for
sale and incorporated designs made bolder or more complex to attract the
attention of potential buyers. Following standard relativist divisions of con-
temporary phenomena into traditional or acculturated categories, Berke-
ley anthropologists generally selected from these wares only those forms as-
sociated with indigenous use (mainly food processing) and rejected those,
like the lidded trinket basket, that had been adapted to function as curios.
Hence, although Kroeber wrote his monumental *Handbook of the Indians of
California* at the height of the curio trade[5]—and the period of Hickox's most
intense production for Nicholson—and although he gave extended space
to the Lower Klamath, his area of special interest, he excluded both the
commercial market and the resulting adaptations and innovations of curio
baskets.

Many museums did not take a similarly hard line; several accepted do-
nations that included baskets made by Hickox, including Harvard's Peabody
Museum (in 1908 and 1913), the University of Pennsylvania Museum (in
1918), Chicago's Field Columbian Museum (in 1920), and later the South-
west Museum of Los Angeles (several times during the 1930s). These mu-
seums' more relaxed approach, required by their public constituencies, in-
volved active recontextualizations in museum displays that reinstated the
authenticity boundary to maintain the modernization paradigm.

For example, when the collection of an important Nicholson client, Patty
Stuart Jewett, was donated to the University of Pennsylvania Museum upon
her death in 1918, curator B. W. Merwin described some of its more strik-
ing pieces in an article for patrons in the *Museum Journal*. Choosing from
among many Lower Klamath baskets in Jewett's collection, Merwin selected
for comment only the two woven by Hickox: "The Karok Indians of north-
ern California are represented by a pair of the most graceful miniature stor-
age baskets. Both specimens show the same beautiful workmanship and
painstaking care in the selection of the materials. They are almost identi-
cally the same size and form, and even the lids with their graceful handles
are very similar" (1918: 237).

Merwin's recontextualization required two separate operations. First,
Merwin authenticated the lidded trinket basket form (rather than dis-
missing it entirely, as Kroeber did) by constructing these examples as minia-
tures or models of functional storage baskets. Second, Merwin ignored the
striking difference of these pieces from other Lower Klamath baskets in
the collection in order to construct them as exemplars defining an un-
changing and shared tribal style. To transform heterogeneity into a rela-
tivist homogeneity in this way, Merwin must have actively suppressed the
information on authorship that would have come with the baskets, since

they had been packed and sent to the museum by Nicholson herself. In contrast to the importance of individuation in marketing curio baskets and in much of the accompanying literature,[6] even the moderate relativist approach of museums required curators to erase evidence of individuality and thereby to maintain a construct of "culture" involving shared values that avoided conflict and maintained tradition as changeless. As Richard Handler explains:

> Much scholarly writing on these societies posits individuality at the level of the social whole rather than the human individual. There is even an elaborate theory of social evolution which asserts that in "primitive" societies—in contrast to the modern west—persons are imprisoned by hide-bound traditions which block the emergence of creative individuality. Much, though by no means all, ethnographic writing omits reference to individuals and posits instead generic social actors. (1992: 24)

However, requirements for changelessness also depended in part on the medium. The gendered Western hierarchy of art and craft generated greater expectations of "hide-bound tradition" for women's products such as basketry.

After the Second World War, baskets made by Elizabeth Hickox were purchased directly from Nicholson or her estate by several museums, including the Denver Art Museum (in 1946), the Los Angeles County Museum of Natural History (in 1951), and the Heye Foundation (in 1956). One of the Heye Foundation baskets, the largest and perhaps the most spectacular of her works on display at the Museum of the American Indian in New York, where Dover Publications is headquartered, was used for the cover of its 1976 reissue of Kroeber's *Handbook of the Indians of California* (fig. 9.2). This ironic juxtaposition highlights the contradictions in museum and academic positions on authenticity. As we have seen, Kroeber had refused to consider Hickox's baskets despite their contemporary valorization in museum settings. And although her authorship was well documented in Heye Foundation correspondence with Nicholson's secretary, it was suppressed both in museum displays and on the Dover book cover so that her baskets could exemplify precontact tradition.

Through such recontextualization, curators enacted a taxonomic shift, but one opposite to that defined by James Clifford (1988). Clifford describes a process whereby objects made for indigenous use were aestheticized and recontextualized as art within a museum framework. Here, in contrast, objects originally made for sale and display as art were instead de-aestheticized and recontextualized as functional ethnographic specimens or their authentic replicas. In numbers, this ethnographic recontextualization may far outweigh the aestheticization of objects that Clifford decries. Ethnographic collections are bursting with such objects, many purchased by museum eth-

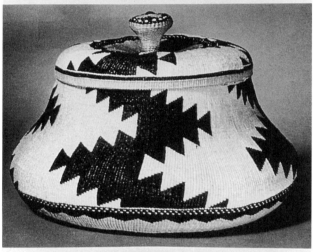

Figure 9.2. Cover of 1976 Dover reprint of Alfred L.
Kroeber's 1925 *Handbook of the Indians of California.*
Reproduced by permission of Dover Publications.

nographers or their agents from curio dealers such as Nicholson. The fact
that most baskets in museum collections were not used did not jeopardize
their usefulness in constructing an image of a timeless, premodern society.
Instead, these innovative responses to Euro-American ethnographic and
touristic consumption (the two are hard to separate) have been studied and
presented textually as exemplifying unchanging tradition, the necessary re-
sult of an allochronic discourse of alterity.[7]

LILA O'NEALE AND HICKOX'S INDIVIDUATION

The individuation of Hickox's basketry was given its most extended treatment and interpretation by Lila O'Neale in her dissertation on Yurok-Karok basket weaving, written under Kroeber and published in 1932. Although O'Neale interviewed more than forty Lower Klamath weavers, Elizabeth Hickox appears to have been her primary informant. She wrote of Hickox: "Her opinions on standards and conventional proportions are valuable; her own feelings with regard to quality were apparent in the discussions of each phase of basketry; she knew each from the angle of the best way to do things for the highest quality result" (O'Neale 1932: 175).

Following the work of Boas's team on Salishan weaving, O'Neale intended to investigate ethno-aesthetics as a means of (1) differentiating what she considered the timeless tradition of indigenous weaving from the acculturation of contemporary curio adaptations, (2) demonstrating the limits that tradition imposed on weavers by examining objects that both adhered to and broke these conventions, and (3) determining how weavers promulgate shared tradition over time. O'Neale did not question weavers about the aesthetics of currently produced works but instead brought a set of photographs of Lower Klamath baskets collected a quarter-century or more earlier, which, although they came from the earliest documented and institution-based collections from this region, also showed significant curio-trade modifications.[8] A part of O'Neale's mission was to use weavers' identifications of good and bad taste to differentiate "authentic" from commercial traits in these early collections.

O'Neale incorporated information on commercial weaving not to give it currency but to construct it as acculturated and thereby to define as traditional any weaving for Native use. Considering the trinket basket an adaptation of indigenous form, O'Neale included discussions of it (thus exceeding Kroeber's narrow limits), but she excluded forms developed for the curio trade that lacked indigenous precedent (covered bottles, napkin rings, place mats, wall hangings, etc.), referring to these as "freak baskets" or "aesthetic atrocities." O'Neale's preference of tradition over innovation was not shared by many of her informants, who were especially appreciative of Karuk weaver Nettie Ruben's souvenir innovations (fig. 9.3):

> She is better known and more often spoken of than any other one weaver on the Klamath river. She has made every sort of basket but the Jumping dance basket, besides novel shapes and fancies for sale to tourists. . . . She makes clothes and market baskets of all sizes from the two-inch gift sizes up. . . . She has tried her hand at crocheting, has made arrows, paper flowers, and other non-basketry objects. According to general opinion, whatever [Nettie Ruben] attempts is well done. (1932: 173)

O'Neale's conclusion on the promulgation of tradition was that Lower

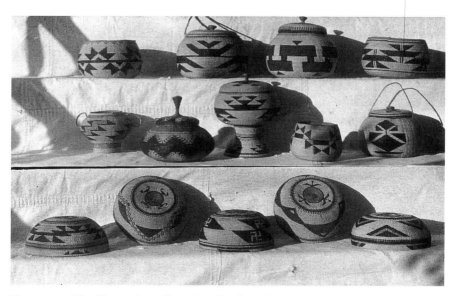

Figure 9.3. The Young (now Hover) collection of Karuk baskets, 1929, including lidded trinket basket by Elizabeth Hickox (middle row, second from left) and sugar bowl probably by Nettie Ruben (middle row, left end). Photograph by Lila O'Neale. Courtesy of the Bancroft Library, University of California, Berkeley.

Klamath weavers habitually took the easiest route—for the present acceding to debased demands of the market but destined to fall back into traditional grooves when commercial production ceased. Strikingly, Hickox's interview became the cornerstone for O'Neale's arrogant argument, perhaps because she was her primary and most articulate informant, and also because the quality and individuality of her work represented the greatest challenge to anthropological constructs of shared values and style. O'Neale thus devoted her section on innovation to Hickox, but robbed her of agency by ascribing the individuation of her approach to the sophistication of her patron's tastes:

> One of the best, if not the best, Karok weavers in the territory today has never made freak baskets nor copied foreign shapes. [Hickox] cannot be considered typical. She and her family have had more contact with white people than is usual, and for a long time her tastes have been molded, perhaps unconsciously, by the likes and dislikes of a patroness who contracts for the family's entire output. (1932: 158)

To substantiate weavers' passive submission to market forces, O'Neale probed Hickox further. Instead of questioning Hickox about trinket basket weaving, she asked her repeatedly whether she would accede to any de-

mand of her patron, even for crass objects like placemats. Three times Hickox replied that she would not, but once she replied that, yes, she would even follow a demand for a particular color. Note that Hickox was at that time weaving all her curio baskets in the same color scheme (yellow on black) on which Nicholson claimed no influence and that Nicholson was satisfied with Hickox's limitation to the lidded trinket basket shape. Note also that Hickox's final and most complete response to this insistent line of questioning was negative: "Even if Miss N. wanted it, I'd hate to do it. Hard, and not real Indian idea. Never made them. Not good taste."[9] Then observe that O'Neale privileged Hickox's single affirmative response as the foundation for her general argument on the passivity of Lower Klamath weavers:

> And yet, No. 28 admitted, so strong is the feeling that the craft must be profitable as well as pleasurable, and much as she might dislike to, that she would accept even a commission to make table mats. If her patroness asked for them, she would execute the order as if it were a detail like color arrangement. Basketry is a business with the Yurok-Karok women, molded by their traditions and conventions, to be sure, but yielding in all but technique to the demands of trade. (1932: 158)

As brutal as we now perceive these distortions to be, they were not exceptional in O'Neale's time; they represented the effects of anthropology's requirement to conform to and reproduce the modernization paradigm by constructing "primitive" societies as changeless, belonging to the past, and subordinate.

BOURDIEU'S MODEL OF HOMOLOGY

I first began noticing the Hickox baskets while researching Washoe weaving in museums and private collections, taking advantage of opportunities to photograph works from other regions for teaching purposes. The Hickox pieces' elegant form, superfine texture, small scale, and fragility stood out. Looking into Nicholson's records of her relationships with basket weavers, I accepted O'Neale's explanation that patronage was responsible for the uniqueness of Hickox's baskets. Nicholson's photographic documentation added further support to the patronage explanation. Compare, for example, the photograph of Elizabeth Hickox taken in 1913 (fig. 9.1) with that of another weaver identified as Oak Bottom Jack's wife (fig. 9.4). Like many other Lower Klamath curio basket weavers depicted in photographs, Oak Bottom Jack's wife has spread on the ground an array of basket types using the full range of decorative materials to attract maximum attention from potential consumers. In contrast, Elizabeth Hickox, seated on a bench in her garden and elegantly dressed and relaxed, is posed with baskets extremely

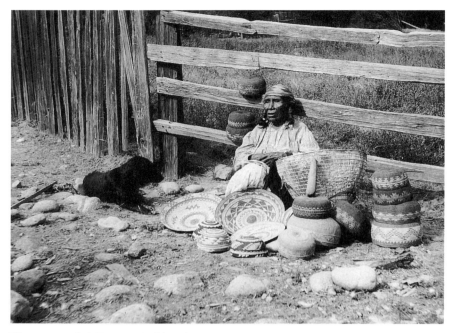

Figure 9.4. Oak Bottom Jack's wife, c. 1911–17. Photograph by Grace Nicholson. Grace Nicholson Papers, Huntington Library. Reproduced by permission of the Huntington Library, San Marino, California.

limited in shape and color scheme because, as here recorded, her patron returns annually to acquire all she makes.

However, further research revealed that Hickox had chosen to specialize in weaving for the "fine-art" or high-priced end of the curio market before meeting Nicholson in 1908, when Nicholson noted in her diary that Hickox's were "the finest baskets of all."[10] Examination of baskets collected at this time demonstrated further that Hickox had already developed most of her distinctive weaving characteristics. The patronage explanation thus fell apart.

Searching then for an explanation that would grant agency to Hickox while still incorporating commercial production for non-Native consumption, I pursued a correlation between the unique elegance and refinement of Hickox's weaving, in contrast to works by other weavers, and the extremely high economic and social status of the Hickox family, which created a social gap between them and many other full-blood and mixed-race Karuk.[11] This correlation found theoretical grounding in Pierre Bourdieu's model of homology among objects, producers, and consumers, which asserts that "producers are led by the logic of competition with other producers and by the specific in-

terests linked to their position in the field of production" to produce "distinct products which meet the different cultural interests which the consumers owe to their class conditions and position" (1984: 231). Bourdieu argues further:

> The functional and structural homology which guarantees objective orchestration between the logic of the field of production and the logic of the field of consumption arises from the fact that all the specialized fields . . . tend to be governed by the same logic . . . and from the fact that the oppositions which tend to be established in each case . . . are mutually homologous . . . and also homologous to the oppositions which structure the field of the social classes. . . . The correspondence which is thereby objectively established between the classes of products and the classes of consumers is realized in acts of consumption only through the mediation of that sense of the homology between goods and groups which defines tastes. Choosing according to one's tastes is a matter of identifying goods that are objectively attuned to one's position and which "go together" because they are situated in roughly equivalent positions in their respective spaces. (1984: 232)

Correlation of the position of the Hickox baskets within the field of Lower Klamath basket production with the position of the Hickox household in the field of local social relations must be expressed as homology rather than analogy because of the complex circumstances and strategic choices that enable the range of objects produced to approach the range of social relations structuring the field of production. Strategic choices often serve not to retain class position but to elevate it; hence Hickox's production of baskets in an elevated style must be considered not as objectively reflecting her family's status but as contributing to the active construction of that status. Furthermore, the homologous relationship of objects, producers, and consumers in their respective fields should be expanded to include the dealer— in this case Nicholson, who stood at the top of the basket-dealing trade during the years of her most intense relationship with Hickox (1911–1917).

Although Bourdieu does not clarify how homology is attained, but instead invokes the objective logic of field structures, the trajectory of the Hickox baskets provides one example of this process as economic and social action. Hickox's invention of baskets with superfine technique and her innovative approach depended on her ability to devote considerable time to the enterprise and to wait for long periods (often a year) to be remunerated. In contrast, it appears from O'Neale's descriptions of her informants that weavers in worse economic circumstances, who depended on basket sales for continuous cash flow, were more likely to adopt time-saving devices or simpler curio forms in order to produce baskets more rapidly and in higher volume. For weavers like Hickox, who had sufficient income from other sources to invest in long-term production, the financial rewards were exponentially greater. Hence Hickox's manufacture of the most labor-intensive basketry product on the Klamath River was enabled by, commensurate with, and par-

tially constructive of her social and economic position within the region. Similarly, in the field of exchange, Grace Nicholson had sufficient economic standing to gamble on the higher exchange value of labor-intensive products over the long term. And, in the field of consumption, collectors interested in sound financial investment could afford the higher price and longer wait for a significantly higher rate of appreciation, and others interested in museum donation could invest in the exchange of significant economic for social capital.

POSTSCRIPT AND CONCLUSION

Bourdieu's model of homology facilitates investigation of Native American and other interethnic curio objects without imposing primitivizing judgments of authenticity. Other methods that avoid such judgments include Arjun Appadurai's (1986) tracing of objects' trajectories as they move from production through exchange to consumption, and as they reenter the commodity phase in later instances of exchange, and Nicholas Thomas's (1991) focus on identifying the changing meanings of objects as they move through a sequence of exchange events. These are but three examples of current critical rejection of conventional anthropology's discourse on alterity; all three provide members of powerful academic establishments with a satisfying sense of righting historical wrongs and of fostering emancipation rather than subordination.

However, many Aboriginal American peoples are threatened by this process. Adopting Euro-American definitions of their authenticity can help produce a secure livelihood for producers of curios and "cultural performances"; it can also provide a positive image within popular discourse on environmentalism and for some a path toward recovering pride in Native identity that assimilative and abusive educational programs attempted to destroy. For example, in the 1990 exhibit of Hickox baskets curated by Ron Johnson of Humboldt State University, Karuk historian Julian Lang and Karuk weavers Nancy Richardson Riley and Josephine Lewis provided opportunities for strengthening positive Karuk identity on many levels, including showing respect for elders in attendance and for a heritage now represented by Hickox (Reese Bullen Gallery 1991). Hickox's example also thereby inspired current weavers.

Many Aboriginal American groups have also found that, in the context of continued Euro-American domination, asserting their own definitions of Native authenticity is a productive route to legal self-determination. Egyptian-American anthropologist Lila Abu-Lughod refers to this form of indigenous resistance as "reverse orientalism," but warns that while "this valorization . . . of the previously devalued qualities attributed to them may be provisionally useful in forging a sense of unity and in waging struggles of empower-

ment, . . . because it leaves in place the divide that structures the experiences of selfhood and oppression on which it builds, it perpetuates some dangerous tendencies" (1991: 144–46). Like Abu-Lughod, Canadian First Nations artist Paul Chat Smith calls upon anthropologists to tell individual and fully implicated lives rather than manufacturing authenticity through generalization and alterity (1994).

Authenticity, including relations between individuation and innovation, thus remains a topic of debate among Aboriginal Americans as well as anthropologists and art historians, who have long appropriated the right to speak for them. Today's academics, like Native peoples, are faced with a choice of imperfect methods of fostering Native sovereignty. Whichever choice is made, it is important that the agenda be explicitly stated. For example, I have rejected certain notions of authenticity because they have been imposed to ensure Euro-American domination; I hope that their rejection will enable Native Americans to define the meaning their history will have for them—but I also recognize the validity of opposing Native views.

I believe that it is even more important for those academics still using notions of authenticity to be explicit about their methods and agendas. My point arises from the reinscription of the authenticity paradigm in recent literature on interethnic curios. For example, labeling all these works "tourist arts" foregrounds a particular circumstance of consumption that not only denies the importance of dealers in constructing the authenticating significations and relational values on which market valuation and ethnographic classification are often based, but also invokes all the notions of the inauthentic the term "tourist" has come to entail. Judgments of authenticity are also inscribed in subtler ways. Many current studies investigate contexts of curio *production* to *demonstrate* authenticity, by searching for precontact roots or meanings that presuppose authentic and timeless traditions. At the same time, studies that investigate contexts of *consumption* frequently *deny* the authenticity of objects made for sale in order to authenticate relationally those objects thought to be made for indigenous use. Current debate over whether intersocietal arts must necessarily be reduced in semantic content provides a prominent example (Jules-Rosette 1984: 219).

The choice to retain or abandon the authenticity paradigm thus has important political and economic as well as intellectual implications. For non-Native academics, a decision to perpetuate notions of authenticity in literature on interethnic curios requires clarification of purpose: is it to support the political goals of producing peoples, or perhaps to support their curio market? If not so clarified, in defining the "authenticity" of others for whom we have no right to speak, we perpetuate colonialist practice.

10

Threads of Tradition, Threads of Invention

Unraveling Toba Batak Women's Expressions of Social Change

Sandra Niessen

Europeans were latecomers to insular Southeast Asia, the nexus of ancient trade between India and the Far East. First the Portuguese, then the British and the Dutch braved the seas to obtain exotic Southeast Asian spices. Cloth figured centrally in the procurement of these Southeast Asian products, and the developments associated with the Industrial Revolution in Europe served the foreign traders well. By the nineteenth century, Europe had a hegemonic hold on the Southeast Asian markets and ancient trade infra-structures. One of the effects of this European success was the suppression of the local cloth "industry," which was seen as rivaling cheap European goods. By the time Indonesia achieved independence in 1949, it had ceased to cultivate cotton and dyes on a viable commercial level, and local in-habitants were avid consumers of foreign cloth and clothing. Later colo-nial efforts to promote the now demoted "craft" by encouraging quality competitions and staging huge "annual markets" to celebrate and sell the goods both locally and to foreign visitors did little to restore indigenous production.

The Batak people living in the mountainous interior of North Sumatra experienced this history. Located adjacent to the Strait of Malacca, one of the most significant trade entrepôts in Southeast Asia, the Bataks enjoyed foreign trade for centuries, incorporating foreign design ideas and tech-niques into their own textile tradition. When Europeans finally managed to penetrate the heart of their territory in the middle of the nineteenth cen-tury, change was rapid. Within sixty years, the entire region had been an-nexed by the Dutch colonial power.

Local cloth production, despite predictions of its ultimate demise, hung on stubbornly but was transformed in the process. Today, weavers are con-

centrated in only a few areas and supply only local ritual clothing and gift-exchange needs. The simple wrapped hipcloth and draped shouldercloth have become obsolete in daily life. Dresses, blouses, suits, and machine-made Malay sarongs have replaced the handmade Batak clothing. The appearance of the textiles has also changed. An article published early in the twentieth century records how the European missionaries helped weavers expand their color palette and refine their products by introducing aniline dyes and machine-spun yarns (Joustra 1914). Today, the use of natural indigo is exceptional and rare in some isolated regions, and the use of natural red and yellow dyes has been entirely phased out, as has hand spinning. Now incorporated into the cash economy, weavers, who are among the poorest peasants, weave to supplement their income. Often they cannot afford their own products. They have low incomes and heavy ritual responsibilities. The majority produce as quickly and cheaply as possible to meet the local market demand. The number of textile gifts transferred at weddings has increased dramatically, keeping pace with an exploding population and expanding family ties. In other words, the putative decline in woven quality of the textiles in general has been paired with an increase in textile production. The need for speed and low cost has encouraged weavers to make thin textiles by using less weft and beating it in less firmly; they have also simplified certain patterns and completely avoid others. Some weavers even have to compete with factories that have started to copy their designs using mechanized looms. Current economic circumstances serve Batak weavers poorly because they do not reward high levels of craft.

It is appropriate to interpret changes in Batak textiles primarily in social and economic terms, but these changes have instead been interpreted in the West largely by invoking the myth of "tradition." The Batak weaving arts first claimed popular attention during the early decades of this century when it became obvious that the colonial presence was transforming the cloth.

> To me, antique Batak textiles, especially those from Toba, represent the highest achievement of Indonesian weaving. Hence what now comes from this area is so heart-rending to look at. The contrast between modern and antique products is nowhere else so extreme. . . . Decline through European influence is especially evident in the imported regular yarn dyed in bright aniline colors. (Visser 1918–19: 21–22; my translation)

There are almost no written records about Batak textile types from the Second World War until the 1970s, when scholarly and museum interest in Indonesian textiles was kindled in North America. By then, the despair over the loss of the authentic had changed to resignation, but the terms for evaluating textile decline had not changed appreciably:

> The advent of finely spun commercial yarns and harsh aniline dyes has robbed the plain textiles of the Batak of their gentle sophistication. This example, col-

lected from the Toba Batak before 1884, is evidence of that lost quality. (Gittinger 1979: 98)

Or, again:

> In this volume, we frequently use the "ethnographic present," which describes often idealized conditions, practices, and beliefs that once "originally" obtained, as if they still operated with full effect. In truth, times have changed. Indonesia is eagerly modernizing. The weaving communities have all been affected . . . in fact, no great textiles are produced anywhere in Indonesia today. (Holmgren and Spertus 1989: 23)

Especially since the 1980s, anthropologists and art historians have attempted to expose the myth of "tradition" as a political projection of the West on an undifferentiated Other (e.g., Dominguez 1986; R. Phillips 1989a; Price 1989; Wolf 1982). The concept has been powerful in shaping the reception of Indonesian textiles by the West. Present-day collectors and connoisseurs of Indonesian textiles eschew "commoditized" pieces in their search for "authenticity." The rubric "museum quality" is applied to specimens of the past that have remained in good condition and especially those that contain no trace of Western influence. Indonesian textile exhibits have been dedicated to specimens that affirm the popularly held definitions of "authenticity," and anthropologists, myself included, have dedicated their research to the "original conditions" referred to above by Robert Holmgren and Anita Spertus. It is no wonder that "modern" Batak textiles are absent from museum collections, making it appear as if there were no "modern era" in Batak textile history—an absence symptomatic of the Western conceptual screening of non-Western arts. Ruth Phillips, for example, has written of North American art history: "It is as though Native American artists, in keeping with predictions of their imminent disappearance, had been rendered invisible through much of the twentieth century" (1989a: 10).

I first traveled to Indonesia in 1970, steeped in the rhetoric of the decline of the Batak textile tradition, and I tried zealously to find a "traditional" weaver in one of the more isolated Toba Batak regions, with the hope of gleaning whatever authentic details might remain concerning a disappearing art (Niessen 1985). Returning in 1986, I visited a different region of North Sumatra, where I met a clever weaver named Nai Ganda (fig. 10.1), who, when she got to know me better, described a textile she was "inventing." This bit of information confronted my understanding of Batak textile decline. After my initial blank reaction, I rushed headlong into the conviction that I had stumbled upon a "great moment of cultural and artistic revival." I have since come to realize that making sense of Nai Ganda's inventions is a rather more complex task. This is the project that I take up here.

The Batak of North Sumatra comprise six ethnic groups: Toba, Karo,

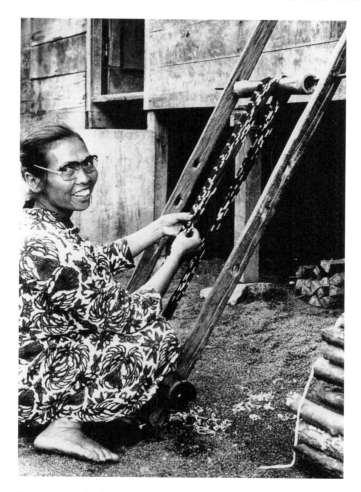

Figure 10.1. Nai Ganda, an ikat-maker, pulling the ikat ties
out of her freshly dyed yarn. Photograph by Sandra Niessen.

Simalungun, Pakpak/Dairi, Angkola, and Mandailing. All but the Pakpak/
Dairi Batak have a history of weaving. The weaving regions break down fur-
ther into sub- or style-regions characterized by variations in local custom, aes-
thetic, and technical heritage. Nai Ganda lives in the Silindung Valley, south
of Lake Toba, the most productive Toba Batak weaving center. It is also the re-
gion that produces the most modern textile variants. The weavers employ the
brightest dyes and the finest machine-spun yarns to weave narrow shoulder-

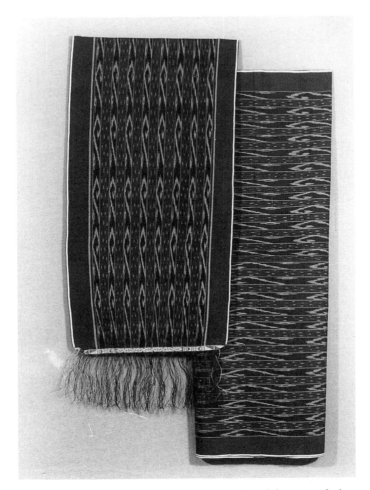

Figure 10.2. The *gundung pahu*, one of Nai Ganda's recent design
inventions. She made a sarong and shouldercloth using this
pattern. This is a current fashion trend in the Silindung Valley;
sales help to recover part of the market Batak weavers have lost
to modern clothing trends. Photograph by Sandra Niessen.

cloths and sarongs of the same patterning (fig. 10.2), while following fashion
trends emanating from Indonesia's fashion centers, such as urban Java. These
textiles contrast with the large somber textiles of the past deemed suitable for
ritual purposes but certainly not for fashion. Their weaving strategies have even
allowed Silindung Valley weavers to reclaim a corner of the clothing market

lost in colonial times to Western and Malay styles of dress. They are proud of their achievements, and when they wear their fashion cloths, they feel that they are competitive in terms that count in the modern day and within national standards. They are fond of calling to mind that Ibu Tien, President Suharto's (now-deceased) wife, acquired some of their handiwork. Too expensive for the weavers themselves to afford, the textiles are purchased primarily by more affluent Batak urbanites, who are delighted to be able to express their Batak ethnicity without compromising their fashionability. Responding to the recent craze of ethnic cloth styles and clothing fashions on the international market, Silindung Valley weavers have also begun to weave cloth to be tailored into Western-style suits, dresses, ties, and other apparel items.

Toba Batak from other regions say the Batak of the Silindung Valley have strayed from their authentic, indigenous roots, but valley inhabitants point with pride to their refined ways and speech; their larger and better market, schools, and hospitals; their connections with the outside world; and their illustrious history as the center of the German mission and the regional government. This "most modernized" place is a prolific center of weaving, in part because of the scarcity of land for planting rice to feed the burgeoning population. Apart from the fact that the tradition of weaving exists, however, almost nothing is known about Silindung Valley weaving.

To understand the nature of Nai Ganda's textile inventions the observer would have to know something about how the Bataks typologize their textiles. Toba Batak textiles comprise three panels: two identical side panels flanking a main, central panel that contains most of the patterning. The textiles are renowned for their ikat (patterns tie-dyed into the warp before the cloth is woven) and supplementary warp and weft patterning. They are constructed using a round, continuous warp on a backstrap loom. When the finished textile is cut out of the loom, often a patterned edging is twined into the base of the textile, and the dangling warp ends are twisted into fine fringes. Each of the dozens of Batak textile "types" is woven to conform to the specific design strictures of that "type." Each is named and serves a particular social function. The type called *ragi hotang*, for instance, has a characteristic size, color, and set of design embellishments. Each weaver knows one or more textile types, depending on her interests, where she grew up, her age, her skill, and the locale into which she married (women tend to weave the textiles of their village of residence and often change what they weave when they marry into another village). When she sets out to make a cloth, she has the entire process mapped out in her mind. She knows which colors of yarn to purchase and dye, how much of each is required, which size of warping frame will yield the correct length of textile, in which order to place her yarns on the warping frame, and so on. She knows which embellishments are optional, which are essential, and which will make an ordinary or an extraordinary variant of her planned textile type. She also knows

that to stray too far from the accepted design conventions is to make a "nameless" cloth of no defined social or ritual value—a "mere cloth" (*sekkasekka*).

NAI GANDA'S TEXTILE INVENTIONS

The inventions I describe here center on ikat technique and design. Nai Ganda is an ikat specialist. She is always on the lookout for new ikat patterns, which is one of the reasons she likes to keep a stall in the Saturday market. As an ikat producer and seller, she has some control over many of the textile patterns sold in the market. She is not merely a maker and supplier of ikat yarn; in many cases she is the originator of the pattern dyed into that yarn. She quickly adopts new design trends to capitalize on them, and she tries to launch her own. When successful, her work, for a fashion moment, is the center of attention. She is a sensitive barometer of the fashion climate and someone other Batak textile inventors have to reckon with. On Saturdays she combs the section of the market that sells imported cloth and looks for inspiration. She seeks influences, old and new, Batak and foreign, to transform into local tastes.

In long conversations with her I learned about some of the processes by which Silindung Valley textiles have taken on their "modern" appearance and what that means technically for the weaver as well as for the visual design. I learned that the first invention she described for me, the one that challenged my understanding of the Batak weaving arts, was not a unique occurrence. Nai Ganda's inventions take several forms.

1. Aesthetic Update of Ritual Textiles for the "Modern Context"

Somber ritual textiles are modernized by making them smaller, dying them with bright, unorthodox colors, often enlarging and simplifying the ikat patterning, and adding an overlay of gold or silver weft patterning characteristic of the Muslim Malay world (see, e.g., fig. 10.3). Nai Ganda showed me three textiles (called *ragi botik, harungguan,* and *gipul/silinggom*) she had added to the repertory of "updated" Silindung Valley textiles. In their modernized form, they became shouldercloths unsuitable for ritual wear but charming to wear to church or to fancy outings, such as political gatherings.

The *gipul/silinggom* was an old hipcloth I had purchased from a neighboring region and showed to her. The ikat pattern inspired her to make variants of it until she was pleased with the results. Nai Ganda's favorite words to describe her aesthetic goals are "bright" and "well defined." The textiles had to be splashy enough to attract buyers to her market stall, one of about three dozen at the Saturday market. Her experiments revealed her skill at adapting a pattern—the techniques of which she could decipher from the appearance of the old cloth—to suit her region's aesthetic. In this case, she

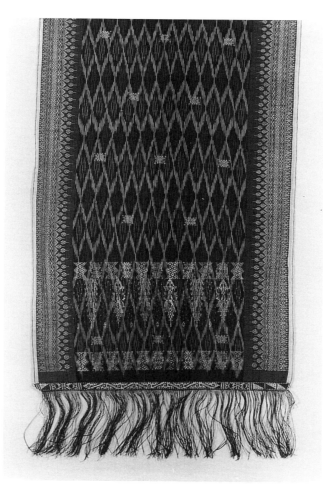

Figure 10.3. A modern *simarpusoran* textile showing currently popular gold supplementary weft patterning. Its ikat pattern was the inspiration for the textile in fig.10.4 and Nai Ganda's hybrid cloth, the *sibolang rasta na marpusoran*. Photograph by Sandra Niessen.

simplified the ikat pattern, enlarging and widening it until it claimed attention in a different way from the subtle, understated original.

2. *Pattern Transposals in New Technical Media*

In the invention Nai Ganda called *gundung pahu* (fig. 10.2), she used the ikat technique to make a motif commonly twined into the fringe edges of

Batak textiles. To my knowledge, the pattern is unprecedented in the ikat medium. However, detailed study of the Batak textile repertory does reveal a tendency to produce the same motifs with different techniques. Certain textiles integrate the same pattern in supplementary warp and weft, ikat, and twining—all in the same cloth (Niessen 1991). Because this tendency is common in textiles throughout the Batak area, this invention by Nai Ganda could be hailed as a demonstration of the health of the Batak textile aesthetic even in this "most modernized" region. Indeed, this region has given itself the widest latitude to experiment with Batak design principles.

Nai Ganda took pains to explain that her new pattern was true to Batak tradition. She pointed out that all Batak motifs originate from the designs carved and painted on the walls of Batak houses and that she had chosen her design inspiration from this same source. This is an interesting justification given that the Silindung Valley has so distanced itself from the ancient traditions of woodcarving that only a single precolonial dwelling with carved wood is left in the valley. The textile invention betrays the two roots of Silindung Valley identity, one buried in the Batak past and one feeling its way into the future.

3. Design and Technical Hybrids

A third category of invention demonstrates how involutionary tendencies in the Batak weaving arts extend to the technical processes of creating ikat patterning. Technical aspects of two different cloth types are combined to produce a hybrid cloth of slightly altered appearance, which a non-Batak eye may not be able to detect, but which a Batak weaver's knowledge would allow her to determine.

Ikat patterning in Batak textiles is found only in the warps, or the lengthwise yarns of the textile. An ikat pattern may incorporate every warp of the cloth, but more frequently groups of patterned warps are separated at designated intervals by plain warps to yield the desired effect. In her *udanudan* (raindrops) textile (fig 10.4) Nai Ganda added plain warps at more frequent intervals between the ikatted warps of the pattern known—when it is warped in the usual fashion—as *simarpusoran* (fig. 10.3). The addition of the plain warps weakened the definition of the pattern.

"Watering down" the ikat of a textile is generally associated with the decline of Indonesian textiles. It is a way for weavers to cut their costs, ikat yarn being more expensive than plain yarn. However, the *udanudan* pattern does not represent an attempt by Nai Ganda to cut costs. The unorthodox way she distributed the plain warps altered the appearance of the pattern to produce a chaotic profusion of different colors, which inspired the name of the cloth. She succeeded in giving an impression not of a weak version of a familiar pattern but of a brand new pattern. The tightness of the weave, the precision of the ikat, the quality of the materials, and the sophisticated mar-

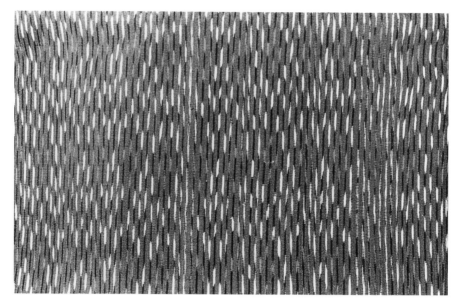

Figure 10.4. The *udanudan* invention. Its chaotic profusion of colors does not betray the original *simarpusoran* ikat design (see fig. 10.3). Photograph by Sandra Niessen.

ket for which it was produced all indicate that Nai Ganda's motive was not to produce a fast and cheap cloth to meet the economic constraints of the lower-end market.

The invention Nai Ganda called the *sibolang rasta na marpusoran* is a composite of two locally familiar and popular ikat patterns, one belonging to the *simarpusoran* (fig. 10.3) and one belonging to the *sibolang rasta*. The innovative aspect of this textile is technically the most complex of the innovations so far described.

Batak ikat is a precision product. The motifs are not approximated, but the steps of production are prescribed to the smallest detail. To understand the nature of Nai Ganda's hybrid ikat invention, it is important to note that the ikat maker begins by warping groups of to-be-ikatted warps (*mamutik*). The number of groups and the number of warps in each group correspond invariably with the cloth type. The groups of yarn are tied off at intervals to resist the dye and result in the desired pattern. Ikat production comprises separate steps, but these processes are conceptually unified to form a single unit with the cloth type; the resulting cloth is "realized technique." The technical details of cloth production do not exist abstractly or separately from the finished product.

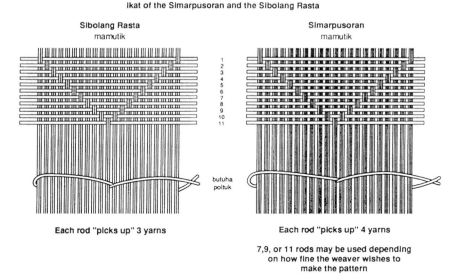

Ikat of the Simarpusoran and the Sibolang Rasta

Sibolang Rasta
mamutik

Simarpusoran
mamutik

butuha
poltuk

Each rod "picks up" 3 yarns

Each rod "picks up" 4 yarns

7,9, or 11 rods may be used depending
on how fine the weaver wishes to
make the pattern

Figure 10.5. Grouping the to-be-ikatted warp of the *simarpusoran* and the *sibolang rasta* textiles. The weaver inserts rods in her warp to separate out the warp groupings, which are later tied off according to the appropriate design template to resist the dye (see the tied-off warp in fig. 10.1). Illustration by Sandra Niessen.

To make her *sibolang rasta na marpusoran* hybrid, Nai Ganda grouped the warps (*mamutik*) as if to make the ikat of the *sibolang rasta* (fig. 10.5) and tied them off as if to make the *simarpusoran* (see patterning in fig. 10.3). The inventiveness of the cloth is in its merging of the two otherwise discrete design-technique categories, as its name, itself a hybrid, suggests. Typically, the denotation of the textile type is equally a denotation of the techniques used to make it.

In a similar kind of merger, which Nai Ganda called *sibolang rasta na marsimeoreor,* she combined the ikat features of the *si tolu tuho na marsimeoreor* and the *sibolang rasta.* This hybrid grouped the to-be-ikatted warped (*mamutik*) as for a *sibolang rasta,* tied off those warps as for a *si tolu tuho,* and interspersed the ikatted and plain warps of the finished cloth as for a *si bolang rasta.*

Nai Ganda's textile experiments are profoundly instructive of the nature of the Toba Batak woven arts. The image of the Batak woven arts that persists in the West is of a finite set of cloths of spectacular beauty and integrity that have been succeeded by flimsy cloth of compromised aesthetic and of no

consequence. Yet Nai Ganda derived her design inspirations from her technical legacy. Because Batak weavers are able to decipher the techniques used to create finished cloths, they are able to learn from them about the possibilities inherent in their technical and design heritage.[1] Nai Ganda's inventions expose an alternative to the conventional interpretation of "tradition." In contrast to a tradition defined as a repertory of finished textile types, the Batak textile tradition can be more accurately perceived as a set of textile possibilities inhering in the local conceptualization of technology. Some of these possibilities have been selected by weavers and by historical circumstance, and their finished cloths are tangible expressions of the weaving tradition. Tradition, in this sense, is a cognitive corpus. Finished textiles are but clues to its technical and design dimensions.

INNOVATION AND CONSERVATISM IN BATAK TEXTILE HISTORY

Because it is axiomatic that art is a reflection of culture, it is remarkable that so little attention has been paid to one mechanism that imparts culture to cloth, namely production techniques. In a seminal article, Junius Bird (1960) shared a discovery, based on his examination of several millennia of Andean archaeological textile remains, that weaving technology is so resistant to change that mapping the distribution of weaving techniques and designs may yield strong indications of culture contact and diffusion. As some technical information is recoverable through textile structure, the finished textiles as well as the technical procedures are important historical documents.

Bird's hypothesis deserves testing in other regions of the world. The Batak technical corpus may add an interesting layer of complexity to Bird's proposition because it is as much a demonstration of immutability as it is, in combination with design inspiration, a vehicle of innovation. The Batak weaving tradition is balanced between the two poles of innovation and conservatism. The more Toba Batak textiles change, the more they remain the same. Heather Lechtman (1975) used the term "technological style" to describe the cultural nature of technique and technology. I interpret Batak weaving technology as tangible, heartening evidence of Batak cultural vigor—a strong argument for the creative adaptability of the culture in times of unprecedented social change of unprecedented force. Were "decline" to be expressed in a loss of technical know-how, evidence of such loss would be serious indeed. The textile market pushes woven products strongly in certain directions. Should these forces be so powerful as to crowd out certain kinds of technical know-how, the resulting change could be characterized as erosion. In some areas of Batak country, there is evidence of this, which thus serves to underscore the significance of the Silindung Valley textile inventions described above.

Batak cloth and clothing production is explicitly a women's contribution

to and interpretation of Batak culture; the conceptual unity that is "realized technique" is a feature of Batak women's knowledge; the technological study of Batak textiles is a study of parts of the thought world and the daily lived world of Batak women weavers. In itself, this is an important reason to explore the epistemic terrain of Batak—and Indonesian—textile production. The perceived "decline" in Indonesian textiles, which has thwarted much exploration of the modern phase of the weaving traditions, has thereby precluded serious attention being given to this aspect of women's conceptual universe. The knowledge that is stored in textile production is difficult to tap because it requires, in addition to a philosophical analytical orientation, a hands-on understanding of the functioning of the loom and other procedures involved in cloth making. Furthermore, women's technico-aesthetic "way of knowing" is not a verbal or verbalized way of knowing. Many studies have examined the verbal metaphors of technique. Marie Jeanne Adams (1971), for example, discussed the making of Sumbanese textiles in terms of the local conceptualization of the cycle of life; I have done the same with reference to Batak textile production (Niessen 1985); Marta Weigle (1982) explored themes of time and fertility in myths, legends, and other verbal expressions around the world; and Brinkley Messick (1987) has characterized the verbal couching of loom manipulations in North Africa as "subordinate discourse"—that is, as female expressions within a male-dominated cultural universe. The extent to which these verbal and conceptual domains are shared by both genders or are exclusive to women has not been sufficiently explored, but I submit that the logocentricity that pervades acknowledged "higher forms" of scholarship has deflected focus from the knowledge invested in the hands-on of craft regardless of who practices it, an oversight that is especially deleterious when the search for women's thought worlds has proved so elusive to anthropology and art history (Niessen 1994).

I learned to understand Nai Ganda's announcement of her new textile invention not merely as disclosure but as part of the two-sided phenomenon of constructing new pieces and promoting them in the market where she maintained her stall. She seemed to enjoy cornering an audience to extol her own talents. She spoke as if the future of weaving in the Silindung Valley rested on her unique ability. Her ideas were endless, she said. She stayed awake at night thinking about new creations and then tackled them in the morning. "It would be boring, wouldn't it," she looked to me for confirmation, "if patterns never changed?" This was her quarrel with Batak regions where textiles are not "fashionably modern." Her exultant and urgent tone is one of the tools of her trade. Nai Ganda is exceedingly poor. Her need to survive is uppermost. She stays awake at night, not just because she is riding the crest of a creative wave but because she is the main income earner in a household with numerous children. The textile market is her primary source of income— and she is just one of several competing ikat makers in the valley.

The market is one of the main drivers of invention. It is not, however, a new influence on textile production. Before the establishment of certain economic structures by the colonial regime, the Batak already used a complex trade infrastructure, which transferred raw and spun cotton, strung looms and finished cloth, and dyed and undyed yarn—the traded goods reflecting regional weaving specialties and geographic, climatic, and social circumstances (Niessen 1993). Today, it is not unusual for weavers to supplement their income using their weaving skills and the marketplace; only the scale is unprecedented. Early on Saturday mornings, before the sun rises, the weavers or their agents assemble in the market to sell their week's work to middlemen. Textiles are their buffer against the poverty that accrues when farmland is overpopulated and in short supply. Some middlemen buyers, such as Nai Ganda, are locals who stay in the valley and sell only on market days; some are itinerant and professional stall proprietors who move each day to a different market; some are emissaries from yet more distant market networks, who stock up and head back from where they came—all before sun-up. Thus are Silindung Valley weavings distributed weekly throughout the Toba Batak region and beyond. In addition, there is a considerable trade in commissioned textiles and sales through personal contacts, family, and friends. Weavers and stall proprietors cannot help but jockey for the profits of the trade.

The market drives Batak textile inventions, just as it drives the global fashion business, though on a different scale. The accepted wisdom that only modern Western society has fashion (Rouse 1989; Sapir 1937; Simmel 1957) legitimizes the role of market forces in the creation of clothing and textile design in the West, while supplying yet another argument against the legitimacy of commoditized artistic products outside the West. The West has required non-Western arts to be nonfashion- and non-market-oriented in order to be "traditional" and "authentic" and thus worthy of preservation and scrutiny.

The concept of the "authentic" and "traditional" shaped not only my understanding of what I saw in North Sumatra but also my reading of museum collections and the Batak archives. Museum collections, oral and written sources, and a survey of textile types currently in use in Toba Batak society indicate that certain core textile types—such as the *surisuri, sibolang, bolean, ragidup,* and *mangiring,* among others—have been in use for at least two centuries. A conception of the Batak textile repertory as stable and invariant is easily generated by the constancy of these traditional Batak textile types, and the stable repertory has cooperated with the Western ahistorical definition of "tradition" to encourage the interpretation of departures from the repertory as descents, as though from grace, but at least from the "authentic." Nai Ganda's innovations demand a new interpretation. Archival evidence supports the possibility of dynamism in the Silindung Valley weaving tradition in precolonial times. Until I learned to see Nai Ganda's inventions, I had interpreted the disappearance of certain textile types only as further evidence

of decline. The phenomenon of textile invention offers the possibility that the "loss" of some textile types is part of the natural life cycle. Not all textile types make it into the stable core of the repertory. Rare and singular items in a dynamic tradition may be taken as clues of past inventions and evidence of unique life cycles of Batak textile types. Early in the twentieth century, J. H. Meerwaldt, for instance, recorded names of textile types in the Silindung Valley that were then worn, especially by young women (Adam 1919), but now these types are no longer remembered. However popular they may have been in their day, these textiles were no more incorporated into the stable core of designs important to ritual than Nai Ganda's current inventions. In contrast, the current popularity of the fashionable *sadum* textile is so great that it has become acceptable, amid great controversy, to wear and even in particular circumstances to bestow in ritual settings (Niessen 1989). Before this transformation is interpreted as a corruption of traditional customary law, it is instructive to recall that the *mangiring*, an unshakable member of the stable core of Batak textile types, probably originated in neighboring Aceh, and through the process of diffusion only gradually became indispensable to Batak ritual life.

Extrapolating from current Silindung textile inventions, it would appear that textiles on the fringe of the core types experience the rise and fall of being created and then falling from popularity and disappearing—perhaps only temporarily—from view and memory. Unfortunately, archival and museum records are too thin to reveal the rates of invention and disappearance. Economic forces, however, have probably increased the rate of turnover.

To equate a textile tradition with a textile repertory is to unduly restrict it by denying its generative source. Batak textile history is a testament to the ancient and ongoing technical ability of weavers to incorporate foreign design and technique into their repertory. The marketplace appears to have exerted increasing pressure on the innovativeness and marketing skills of weavers. Just as the invention of new woven products is not a recent phenomenon, the market has been important in shaping the textile arts since long before the colonial presence (Niessen 1993). It is not fortuitous that Nai Ganda, like other Silindung Valley ikat makers, has had to supplement her exceptional weaving skill with her own booth at the marketplace. Because the market has become the primary force behind the success of innovative cloths, the pejorative reading of commoditized cloth is as much a misunderstanding of Batak textile and economic history as the monolithic atemporal view of the "traditional" textile repertory. Employed together, both biases negate the inventive work that drives the tradition, and hence, especially, the period of recent Silindung woven arts that are adaptive responses to the accelerating pressures of the marketplace and social change.

The Western-aesthetic perspective has measured the decline of textiles in terms of their visual departure from those of past centuries. A holistic per-

spective integrating the reality of North Sumatran daily life, however, recognizes Silindung Valley textiles as a feat of technical, artistic, economic, and ethnic survival in a rapidly changing world. The changes occurring on Silindung Valley looms represent the culmination of creative accommodations to a new religion, government, and economic system; but the new techniques and designs still manifest Toba Batak identity and even allow for a particular Silindung Valley brand of Toba Batak identity. The Silindung Valley cloths are now the most highly priced of all the Batak woven textiles. They use the finest imported yarns and the best chemical dyes; they are woven densely and carefully, and their market is upscale. None of the quick, this-is-only-a-token-for-ritual-purposes appearance characteristic of much current production for ritual mars this important segment of the Silindung Valley products.

Had I conceived Silindung Valley textile history in such dynamic, holistic terms, I should not have been surprised, but rather should have expected to hear the talented Nai Ganda discuss strategies for advancing her textile tradition, using the marketplace as her forum and her weaving tools and know-how as her creative framework. The influence of modernization on Indonesian cultures is the theme of a discussion that has been taking place for many decades in a variety of forms and forums. The techniques of Nai Ganda's inventions are exciting for the insight they provide into the nature of transformation in the Batak weaving arts, and more broadly, into the transformation of a cultural and aesthetic system. Nai Ganda's inventions demonstrate the profound ability of material construction procedures to mirror changes within society as a whole. Her work also suggests the remarkable reliance by Batak women on their conservative tradition of design and technical knowledge, and thereby the extraordinary resilience of a Batak cultural system when accommodating outside forces. How generally characteristic this is of Batak sociocultural change deserves to be investigated. Are the conservatism and resilience characteristic only of the cultural contribution of women, and especially weavers, whose participation (relative to that of men) in the political, economic, religious, and educational realms brought by the colonial establishment has been minimal? What is the gendered division of labor that propels Batak society into the future in terms of involutionary, as distinct from revolutionary, change?

The understanding of an Indonesian weaving tradition that I offer here is modest because it is local, not universal; it derives from and is pertinent to only a body of textiles produced in a small corner of North Sumatra. However, the results are important because they are a part of Batak women's epistemology. The Batak weaving tradition documents Batak women's contribution to their culture and manifests their conceptualization of social change.

Drawing (upon) the Past
Negotiating Identities in
Inuit Graphic Arts Production

Janet Catherine Berlo

James Clifford, in his essay "Traveling Cultures," muses on a classic photo-graphic image of the anthropologist in his tent. He presents it as a trope for an old-style ethnological endeavor in which a scholar (presumably male and white) pitches his tent in the center of a village and, from that small, cloth-bound base of operations, expounds upon the culture surrounding him (1992: 96–116). Clifford goes on to discuss travel and displacement—pitching tents here and there—as late-twentieth-century cultural metaphors around the globe. He suggests that "native informants," no longer seen sim-ply as the oral source for the Western narrative text, should be reframed in our minds as co-travelers or co-inscribers. By this act, we would shift the tra-ditional boundaries between who is informer and who is authority, who is the traveler and who exists unchanged at home, and decenter who inscribes the data about a culture.

I use Clifford's image as a point of departure to examine some issues in contemporary Inuit (Canadian Eskimo) art production.[1] These issues have to do with marketing art for consumption outside the culture of its makers, the role of non-Natives in this marketing venture, the role of the individual artist in general and of the female artist in particular in an intercultural artis-tic enterprise, and the complex and still not well understood role(s) the graphic arts play within a few contemporary Inuit communities in the Cana-dian Arctic. This case study considers a group of drawings by one contem-porary artist, Napachie Pootoogook, who lives in Cape Dorset on southwest Baffin Island.

Clifford's words have particular resonance for an analysis of a series of draw-ings made by Napachie over the past twenty-five years. In these images she often represents herself in relation to tentlike structures of various sorts (fig. 11.1). In so doing, Napachie reveals glimpses of an Inuit woman's artistic iden-

Figure 11.1. Napachie Pootoogook, *Drawing of My Tent,* 1982, Cape Dorset, stonecut and stencil print. Reproduced by permission of the West Baffin Eskimo Co-operative Limited, Cape Dorset, Northwest Territories, Canada.

tity. She presents herself unequivocally as one who can bridge historical and cultural chasms, a traveler across both temporal and geographic realms.

Obviously, Napachie's drawings cannot stand as a metonym for all contemporary Inuit art; neither can my own scholarly research stand as the verifiable art-historical or anthropological "truth." There is no one truth, only multiple points of view that shift as rapidly as artistic and social situations shift. My own tent, pitched briefly and only recently in Northern Studies, is that of an art historian who became interested in Inuit prints and drawings in part because the questions that arose as I first looked at these graphic arts were questions I have asked about Native arts produced in other times and contexts, having long been interested in intercultural or transcultural arts (Berlo 1983, 1984, 1990a, 1996).

These questions include: What is the process by which arts made within one culture come to be a medium of exchange with another? How do these arts function as didactic or explanatory visual "texts"? What elements of their identity do the makers highlight in these intercultural arts and why? In looking at the Inuit situation in particular, I encountered additional questions: Why does the Inuit production of intercultural arts focus so unremittingly on a traditional view of Inuit life, a view that is already two generations out

of date? What role does the individual play in an artistic system constructed on cooperative and collaborative models? What role does the gender of the artist play in an artistic production scheme that draws upon some traditional Inuit values and some modern Western ones?

Numerous social forces come into play in the production and consumption of graphic arts in the Canadian Arctic.[2] Four of the most important are the co-op, the artist, the larger indigenous community, and the external art market. All exist in symbiosis; all help to perpetuate stereotypical images of the Eskimo (but for quite different reasons, as we shall see). The relationships among these entities are complex, subtle, and varied, and I can only begin to limn some aspects of those relationships here. By focusing on the work of one artist, I ground my discussion in verifiable particulars rather than broad generalities.

THE COOPERATIVE MOVEMENT AND GRAPHIC ARTS PRODUCTION

Although Inuit artists have been making objects to sell to outsiders since the time of first contact in the seventeenth century, a formal marketing structure for these transactions was inaugurated first in the 1950s, for stone carving, and then in the fifteen years after 1958, for the marketing of limited-edition prints from several different communities. Numerous studies have chronicled the rise of arts and crafts cooperatives in the Canadian Arctic (Butler 1976; Goetz 1977, 1993; Martijn 1964; Mitchell 1993; M. Myers 1979, 1984; Simard 1982). These co-ops have had major responsibility for producing and marketing arts and crafts since the 1960s. Most Arctic co-ops also sponsor other businesses, including retail stores, commercial fishing enterprises, and small inns.

The first experiments in printmaking occurred in the newly established West Baffin Eskimo Cooperative in Cape Dorset in 1958 and 1959. These were followed by the institution of programs modeled loosely after Cape Dorset's in the communities of Povungnituk (1962), Holman (1965), Baker Lake (1970), and Pangnirtung (1973). Each co-op operates slightly differently, but they all follow a common model. An individual makes a drawing that is bought by the co-op. A group of people, made up of Inuit co-op members and non-Native advisers, decides which drawings will be chosen as the basis for a stone-cut, silkscreen, lithograph, or other type of print. Usually about forty of these prints, in runs of fifty per image, form the yearly edition of prints for a community. In some co-ops, the artist who made the drawing has little more to do with the process after the initial purchase of the drawing. In others, the artist may cut the stone or stencil for the print him- or herself, or it may be done by a specialized team. The actual pulling of the print is handled by Native specialists. At first, these specialists were trained by outside artists who served as resident advisers to the programs. More recently, printmakers from

other Arctic communities have traveled to Cape Dorset to be trained by the printmaking team there (Peter Palvik, personal communication, 1991).

Because of my interest in gender studies, I have long found it noteworthy that women's artwork is so well represented in the contemporary Inuit art scene (Berlo 1989, 1990b). Its inclusion begins in the co-op. Co-ops have always purchased both women's and men's drawings, and both have been well represented in annual print editions since their inception. At most co-ops today, women are involved in the day-to-day running of the shop as well as in the production of prints (fig. 11.2; see also Berlo 1989: 304–8).

For the first twenty years at Cape Dorset, a small team of nine men did all the stone cutting and printing.[3] Some were graphic artists, others were successful sculptors, and some were motivated primarily by the wages paid for their labor. More recently, a few women have been involved in the printing processes. The two principal outside advisers at Cape Dorset, James Houston and Terry Ryan, are both male. In contrast, at the Sanavik Co-op at Baker Lake, four female and seven male printers were employed in 1970, the first year of the co-op's operation. By 1982 those figures were reversed. The Sanavik Co-op has had a female shop manager, artist Ruby Arnganaaq, who later became president of the co-op and was from 1983 to 1985 a member of the Canadian Eskimo Arts Council (see below). The non-Native arts advisers at Baker Lake for the first few years were Sheila and Jack Butler, both practicing artists. It is likely that they served as role models for the active participation of both sexes in all aspects of the graphic arts program (Butler 1976, 1995).

Most people think of the Inuit co-op in an idealized way—as a business venture that uniquely combines the Inuit sensibility (an interest in group values, consensus in decision making, and the sharing of goods and profits) with marketing skills from the dominant culture. As sociologist Marybelle Mitchell has astutely summarized:

> Canada's position on northern development has always been marked by considerable ambiguity; and it may be speculated that the co-operative form of business was selected as the ideal development vehicle because it would enable the Inuit (hence the state) to keep one foot in both worlds. Americans had forthrightly declared that the traditional culture must be suppressed in the interests of assimilating Alaskan Natives. The Danes took an opposite but equally unequivocal stance: that Greenlanders, being inferior, could never be assimilated and that they should, therefore, be helped to become better Eskimos. Canadians, however, have vacillated in between, believing on the one hand that the culture was doomed and that the people must be assimilated, and on the other that they should be helped to live off the land in ways that would not cause undue violence to the traditional culture and the romantic concept of the noble savage.
>
> Co-operatives, capitalizing on traditional activities and values, were a felicitous form, accommodating Canadian ambivalence by both "modernizing" Inuit (involving them in a wage economy) and enabling them to retain roots

Figure 11.2. Artist Susie Malgokak printing a stencil at the Holman Art Co-op, 1991. Photograph by Janet Catherine Berlo.

in the past (espousing principles of egalitarianism and expanding traditional activities). As Louis Tapardjuk, a past president of Canadian Arctic Co-operatives Federation Limited, explained so succinctly: "We're all aware that the co-op is the best vehicle for joining the two activities of culture and money." (1993: 342)

In 1965 the Department of Northern Affairs (the Canadian government agency responsible for Native issues as well as concerns like mining and timber use) created Canadian Arctic Producers (CAP), the Inuit-owned wholesale marketplace for the arts of the Northwest Territories. Today it works jointly with Tuttavik, Inc., the outlet for the co-ops of Arctic Quebec. Prints, drawings, sculpture, and other arts and crafts are marketed through these channels to retailers worldwide.

One other agency is worthy of mention in relation to Inuit graphic arts. The Canadian Eskimo Arts Council (1961–1989) played a pivotal role both in "quality control" and in bringing Eskimo prints to the world's attention. Made up principally of high-profile individuals in Canada's art community (as well as a few Inuit artists), the Arts Council literally gave an imprimatur to the prints issued each year. It was founded at the request of the Cape Dorset Co-op, according to Virginia Watt, a former member, "to give technical ad-

vice on design problems and approve the graphics which would be released to the public. This approval was first indicated by an ink chop, and shortly after by a blind chop placed on each print. Throughout the years this advice has almost always been taken by the co-ops. The committee was also to be involved with setting the standards of distribution and promotion of the art" (Watt 1993).[4] All of these government structures, sustained with millions of dollars of aid over three and a half decades, have helped to market Canadian Inuit art in a way unprecedented and unparalleled elsewhere in fourth world arts production.

The art co-ops, which seemed so promising in the 1960s and 1970s, developed fissures in some communities in the 1990s. For example, the Sanavik Co-op at Baker Lake, which produced some of the most innovative and boldest Inuit prints and drawings ever made, has closed its doors. Its closure has given rise to more ad-hoc entrepreneurial activities. Many Baker Lake artists produce wonderful drawings that they now sell directly to tourists, museums, and art dealers.

By far the largest, best-known, and most successful print shop is at the West Baffin Eskimo Co-op at Cape Dorset. It started issuing prints in 1958 and is still going strong. Notably, this co-op formed its own marketing arm, Dorset Fine Arts, in 1978 in Toronto, divorcing itself from Canadian Arctic Producers.

THE INDIVIDUAL ARTIST AND THE EXTERNAL ART MARKET: A CASE STUDY OF THE GRAPHIC ARTS OF NAPACHIE POOTOOGOOK

There has long been a bipolar model at work in the field of ethnographic arts. Much scholarship has focused on normative statements about the group, about tradition, and about a collective aesthetic instead of on what is specific and individual. The resulting impression that individual agency is of less importance in small societies than in our own has been one of the fictions of Western culture and Western scholarship about non-Western art— a blindness to individuality and creativity under conditions different from our own. The opposing and balancing fiction, what I would call the "Michelangelo syndrome," focuses obsessively on the work of a handful of "exceptional" artists whose work is supposed to "transcend" their cultural matrix. In Native American art history, this pattern has been repeated in several regions, most notably those in which touristic art production has been in the forefront. One thinks of the lionization of María Martínez, the early-twentieth-century innovator of blackware pottery at San Ildefonso pueblo and arguably the most famous Indian artist ever (Babcock 1995; S. Peterson 1977; Wade 1986). At the time of the craze for California baskets during the same years, the myth-making and profit-making that surrounded Washoe basket maker Dat so la lee (Louisa Keyser) ensured that her work,

like that of María Martínez, commanded extravagantly high prices in an era when most Native artists received only a dollar or two for a pot or a basket (Cohodas 1986, 1992).

We have cut ethnographic arts to fit the mold established for European art in the Renaissance, creating a small number of well-known "geniuses" working in a sea of anonymity. In Inuit graphic arts, this imprimatur was given in the 1960s to two artists, Pitseolak Ashoona and Kenojuak Ashevak, both female and from Cape Dorset, and in the following decade to Jessie Oonark, a woman from Baker Lake. This lionization of a handful of individuals is in the interest of art market investors and also helps fuel the constant need for intrigue and excitement in the international art market. While the financial stakes are meager in comparison with the frenzy for a van Gogh or Cézanne, when a piece by María Martínez or Louisa Keyser or an early Kenojuak is presented at auction, new price records generally are set. Pitseolak, Kenojuak, and Oonark (they are universally recognized by these single names) have all also achieved substantial recognition for their work, including election to the Royal Canadian Academy of Arts, receipt of the Order of Canada, treatment in scholarly monographs, and the depiction of their works in films and on postage stamps (see Blodgett 1985; Blodgett and Bouchard 1986; Eber 1971).

In contrast, then, to some ethnic art traditions that continue to be marketed to the Western world as the products of anonymous craftspeople (such as Guatemalan textiles, Navajo rugs, Shipibo pottery, and almost all African art), Inuit art has, since the late 1950s, been presented to outsiders as art made by particular individuals. Most sculpture has the artist's name incised on the stone; all prints are signed with the name of the artist upon whose drawing the print is based, and sometimes the printmaker is acknowledged as well. In contrast, writings about Inuit art from the 1950s to the 1970s focused principally on this art as a collective cultural phenomenon, with the exception of studies of the few notable artists already mentioned. But as Inuit art-historical studies came of age in the 1980s, scholars began to examine the work of many more individuals in some detail (see, for example, Blodgett 1983; Leroux, Jackson, and Freeman 1994).

Despite my remarks on the distorting effect of the lionizing of a few individual "geniuses" at the expense of the rest, I hasten to emphasize the continuing importance of examining the art of individual artists in small societies. Although this may seem to be a rather old-fashioned art-historical impulse in these days of "the new art history," I believe that in the details of one artist's vision and practice we can see choices articulated and decisions being made—decisions that may be harder to discern on a more generalized level of group practice. When enough studies of different individuals are completed and their patterns compared, perhaps a truer and less distorting art history may emerge.

Since the early 1990s it has become fashionable to give credence to "the Native voice" in the interpretation of works of art. This is, of course, worthwhile in many respects, and Inuit people must study, use, and interpret the artworks of their culture in any way they see fit. Yet an exclusive reliance on interviews or statements by artists for the analysis of their art can be sadly limiting. Art historians, perhaps more than sociologists or anthropologists, are well aware of the limits of artists' self-analysis. Most artists speak more eloquently through their works than in an after-the-fact exegesis of those works. Artists' statements of intention can be sadly reductive, whether those artists are from Cape Dorset, Tribeca, or Paris.

Inuit prints offer a special opportunity for the study of individual artists; small catalogs are published each year, illustrating the works offered for sale by individual communities. Yet until recently, few people outside the small circle of Inuit art scholars were aware of another equally important resource, the thousands of extant drawings by Inuit artists. Only a relatively small number of these works have been transformed into silkscreen, stencil, or stonecut prints. Such drawings provide a wealth of data about northern life, self-representation, gender relations, and other concerns of Aboriginal people, most of whom have been drawing on paper for only two generations. Unmediated by the printmaking process, and uncensored by well-meaning consultants and arts councils, the drawings reveal a range of Inuit artists' representational concerns that is, in my opinion, more varied, more highly nuanced, and more sophisticated than the annual editions of prints, which might be seen as the "official" or canonical oeuvre.

Until the mid-1980s, there was little analysis of these drawings as an art form (see M. Jackson 1985; M. Jackson and Nasby 1987), despite the fact that drawings by individual artists can be easily studied in extensive Native-held collections. Several art co-ops in northern communities maintain archives of drawings that are used as inspiration for prints. The West Baffin Cooperative at Cape Dorset (a community of about a thousand people) houses the largest and most up-to-date printmaking facility in the North. Over the past thirty years it has assembled by far the largest drawing archive: It owns more than 110,000 drawings and is still collecting.[5] These collections provide an opportunity unparalleled in the world, I believe, for the study of individual artistry. They also provide an almost untapped opportunity for anthropological and art-historical studies of a host of other topics having to do with acculturation, creativity, iconography, and representation. The bulk of the archive was transferred in 1991 to the McMichael Canadian Collection in Kleinburg, near Toronto (see Hague 1991).[6]

In the fall of 1991 I examined some four thousand drawings by Napachie Pootoogook. One of my intentions was to investigate the discrepancy that I thought existed between Cape Dorset's public artistic face and its private one: the difference between the prints issued by the co-op, which tend, with some

exceptions, to be decorative, cute, and simple, and the small number of draw-
ings I had seen that seemed to me to be more complex and subtle. Although
the Dorset prints are wildly popular in the urban art markets of southern
Canada, the United States, and Europe, many of the images seem more ap-
propriate to calendars and greeting cards than to fine-art prints. Owls are
ubiquitous, as are scenes of women and children, sometimes sentimentally
labeled "Arctic madonnas" (see Lipton 1984).

Of course some prints belie the simplistic view of Inuit people as "happy
carefree Natives" suggested by the owls and madonnas. One by Napachie
Pootoogook, called *Drawing of My Tent* (fig. 11.1), engaged my attention as
almost no other Cape Dorset print had, for it clearly demonstrated the artist's
subtle grasp of the complexities of self-representation and exemplified the
deliberate way in which Inuit graphic artists market their past for an audi-
ence to the south.

In this self-portrait Napachie depicts herself holding a drawing of an old-
style caribou skin tent. Although that drawing is the work of art she seems
to present to the viewer, it has a double message, for in the old days a finely
crafted caribou-skin tent was one of the artistic contributions of Inuit women,
along with skin clothing. Today, however, the artist's depiction of the old-
style tent, rather than the tent itself, is her artistic contribution. In her scene
within a scene, Napachie holds a drawing of an old-style tent but stands in
front of her own tent—a modern canvas one with a wooden door. Her son
emerges from the tent wearing a baseball cap. The work of art that Napachie
really presents to us—the 1982 print—encompasses three worlds of women's
work: the old ways of the Inuit tent maker, the world of the Inuit artist who
represents those old ways in graphic arts, and the modern representation of
herself presenting those two stages of the past. Napachie here uses art to ne-
gotiate the shifting terrain between past and present, tradition and moder-
nity, delineating these juxtapositions in her art. Knowing about this Napachie
print, I was eager to examine her complete corpus of drawings to see if this
was a continuing theme in her work or an aberration, for such reflexivity
and multiple referencing are rare in Inuit art.

Born in 1938, Napachie Pootoogook has been prolific with works in pen-
cil and watercolor since the early 1960s. Her mother is the renowned artist
Pitseolak Ashoona, and an interest in inscribing the traditional ways of
women is surely one of the legacies that Pitseolak passed on to her, as well
as an astonishing productivity. Pitseolak has more than six thousand draw-
ings in the archive, more than any other northern artist; with four thousand
drawings, Napachie is not far behind. Her work illuminates issues of gender
and representation and explodes some erroneous views widely held about
Inuit graphic arts. *Drawing of My Tent,* Napachie's reflexive and witty com-
mentary on a contemporary Inuit woman's life and art, is clearly influenced
by the work of her mother. A related Pitseolak drawing, *The Critic* (c. 1963),

Figure 11.3. Napachie Pootoogook, *Untitled,* 1960–65, Cape Dorset, graphite on paper. Collection of the West Baffin Eskimo Co-operative Limited, on loan to the McMichael Canadian Art Collection (CD32.480). Reproduced by permission of the West Baffin Eskimo Co-operative Limited, Cape Dorset, Northwest Territories, Canada.

shows two Inuit women displaying their work to a male viewer (Leroux, Jackson, and Freeman 1994: fig. 5). In the early 1960s Napachie, too, did pencil drawings that show the artist making drawings or presenting drawings for the inspection of outsiders (fig. 11.3). This has continued to be a persistent though minor theme in her work since then.[7] In one drawing, Napachie depicts several artists at work together inside the large art co-op building at Cape Dorset (fig. 11.4). In several others, she shows herself being photographed by a male visitor as she works in her tent, a baby asleep on her back (fig. 11.5).[8] (This is not an uncommon circumstance for a female artist in the Arctic, as fig. 11.2 demonstrates. At the Holman Art Co-op I was impressed by the precision with which artist Susie Malgokak registered her stencils for a print for the 1992 season while, on Susie's back, her daughter played.)

Of the many drawings in which Napachie depicts herself making or hold-

Figure 11.4. Napachie Pootoogook, *Untitled* (artists at the co-op), 1981–82, Cape Dorset, colored pencil and felt-tip pen on paper. Collection of the West Baffin Eskimo Co-operative Limited, on loan to the McMichael Canadian Art Collection (CD 32.3598). Reproduced by permission of the West Baffin Eskimo Co-operative Limited, Cape Dorset, Northwest Territories, Canada.

ing drawings, it is noteworthy that the Inuit printmakers and the white art advisers at the co-op chose to make a print of *Drawing of My Tent,* which omits the white buyer and shows only the artist presenting her work to the viewer. It reminds me of the traditional *pornographic* gaze, in which women are featured alone, rather than with a male companion, so that the relationship between the viewer and the object of his desire is not mediated in any way. Though an odd analogy, I find it an apt one. With only a few notable exceptions, elements of the world to the south are conspicuous by their absence in Inuit prints. The fiction maintained for the general public is that of a special, unmediated relationship between the "pristine" indigenous artist and the purchaser of the print. Presumably this fantasy would be ruined by acknowledging that the economy of art making is a transitive one between northern artist and southern patron and that this fact is central to modern Inuit life. Most prints retain an unacculturated look, although they are made by modern citizens of the Canadian Arctic, some of whom have traveled extensively and almost all of whom have been exposed to southern ways for their entire adult lives.[9]

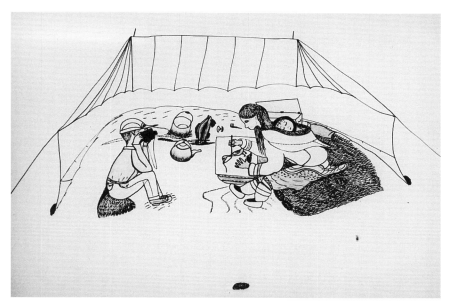

Figure 11.5. Napachie Pootoogook, *Untitled* (man photographing the artist), 1981–82, Cape Dorset, colored pencil and felt-tip pen on paper. Collection of the West Baffin Eskimo Co-operative Limited, on loan to the McMichael Canadian Art Collection (CD 32.3565). Reproduced by permission of the West Baffin Eskimo Co-operative Limited, Cape Dorset, Northwest Territories, Canada.

At Cape Dorset, the male artist Pudlo Pudlat (1916–1992) seems to have been chosen as the one artist to represent the Inuit view of technology, as his are the only drawings selected for prints that show the clash of northern and southern ways (Routledge and Jackson 1990). This theme appears in Napachie Pootoogook's drawings as well, but few of hers have been chosen as prints. Between 1978 and 1981, for example, she executed a series of drawings that featured airplanes. In one fantasy image, an Inuk shoots arrows at the plane while the rest of the family flees (Berlo 1993: fig. 8). Did an unconscious gender bias on the part of the art advisers and those who chose the images for print production lead them to grant the male artist, rather than the female, greater prominence in exploring mechanical and technical iconography in his prints? It remains to be seen how many Cape Dorset artists have grappled with such images. Certainly very few have appeared in the prints. When the Cape Dorset Drawing Archive finishes its enormous project of putting all 110,000 images on videodisc and computerizing them by artist, subject matter, technique, and the like, these questions can be more fully explored.

NEGOTIATING IDENTITIES:
DRAWING THE PAST AND THE DRAW OF THE ART MARKET

When I was conducting research in 1991 at the co-op in Holman, a remote hamlet in the northwestern part of Canada's Northwest Territories, I looked at more than four thousand drawings kept in safes in the co-op. Fewer than five were inscribed with any aspect of contemporary Inuit life: no snowmobiles, wooden houses, televisions, watches, or sweatshirts. I asked one of the young artists, a thirty-year-old printmaker named Peter Palvik, about this. His laconic reply, given as Paul Simon's latest album blared in the background, was, "I guess all that new stuff just isn't very interesting, is it?"

Yet the next day, in the Holman Council Office, I came upon a print made by Louie Nigiyak entitled *Humiliation in Court*. It depicts a scared-looking Inuk standing in front of a judge's table. Behind him, six other Inuit watch the proceedings. When I asked Peter Palvik about it, a look of consternation passed over his face. "That's just for us. That's not for white people. We don't put prints like that in the brochure to sell. We only made an edition of four." The prominent placement of this print on the wall of the council office suggests that the pain of legal troubles is a message that can be successfully conveyed to other Inuit through the medium of art. The fact that someone had endeavored to do this had meaning for the entire community.

Inuit artists are beginning to grapple in their work with the painful realities of life in the North. A 1993 cover of *Inuit Art Quarterly* (which is widely read by northern artists as well as southern collectors) featured a full-page color photograph of a sculpture by Manasie Akpaliapik, a carver from Arctic Bay.[10] It depicts a man's head. Made of whalebone, the head is expressive not only because of its facial features but also because of the rough, pock-marked surface of the material. A large hand supports the left side of the head. Out of the top of the head sticks a bottle of alcohol. Its shiny, fine-grained soapstone surface contrasts starkly with the rough portrait head. The artist says that the sculpture is about a hangover: "You're fed up; you have this bottle in your head; it's controlling you. I felt it's not just for me but for a lot of Inuit people who are caught in that situation" (quoted in Ayre 1993: 40).

A few younger artists have made the transition to video as an art form (Fleming 1996). Zacharias Kunuk, born in 1957, says, "When I first started, I was carving soapstone. Then I heard you could actually have your work on the screen; so I did some carvings, flew to Montreal, and bought a colour video camera. . . . I wanted to record how hunters come home and drink tea and talk about the day's hunt" (Kunuk 1991: 28). Despite his high-tech medium, however, Kunuk, like Napachie Pootoogook and many other Inuit artists, is interested primarily in recording the past. His 1988 video *Qaggiq* (Gathering Place) shows local people engaged in traditional activities and living in igloos in the early twentieth century. A 1991 work, *Nunaqpa* (Traveling Inland), de-

picts the traditional caribou hunting and fish trapping that the old people remember. Kunuk says, "The idea is to educate people on how we lived and what we used to do. . . . We are saying that we are recording history because it has never been recorded. It's been recorded by southern film makers from Toronto, but we want our input, to show history from our point of view" (1991: 26).

The anthropologist Edmund Carpenter (1973) and others have said of Inuit prints that they are "inauthentic" because they maintain a fiction of Arctic life that is a century out of date. The vast majority of Inuit prints depict the "old ways" of hunting, tracking, sewing hide tents, and so forth. I was surprised to find that most unpublished drawings depict the same thing, despite the fact that modern life in the Arctic is a complex cultural stew. Women sew hide garments by hand while they watch American soap operas on satellite television. Meals include expensive packaged food flown in from the south as well as traditional "country food" like walrus, musk ox, and seal meat. Some artists make whalebone sculptures, and video artists like Zacharias Kunuk make documentaries broadcast by the Inuit Broadcasting Corporation.

Kunuk's remarks suggest that no matter what the medium, a sense of history is an important part of contemporary Inuit art. For many artists, drawing the old ways rather than continuing to follow them is a way of maintaining identity. Women who no longer sew skins together to make tents maintain the cultural memory of doing so as a female area of expertise by recording it in drawings. Napachie does this in a characteristically fresh and direct way. Several prints of her work depict such traditional collective women's work as mending and raising skin tents (Leroux, Jackson, and Freeman 1994: 146, 150). In a series of unpublished drawings executed over a twenty-five-year period, Napachie reenacts this labor again and again.[11] Female expertise with the *ulu* (the woman's curved utility knife) and the sewing needle transforms a patchwork of hides into a watertight boat (Berlo 1993: fig. 13). In this way the cooperative labors of women are celebrated and given their legitimate place in the historical narrative.

Few Inuit women have yet undertaken to write about their own artistic, personal, and historical practices.[12] Yet such autobiographical impulses abound in the visual arts. As historian Hertha Wong has written about another indigenous American art form, nineteenth-century Plains Indian drawings, our Western privileging of the written narrative has caused us to overlook other potential sources of autobiography and history, such as speaking, performing, and painting (Wong 1989: 295). Although Inuit women scholars and artists are not yet writing about their arts and culture in any numbers, their pictorial representations serve as a sort of visual autobiography of women's individual and collective practice in the Arctic over the past century. Of her own work Napachie recalls: "Back in the early days, I

used to draw what I had heard from my mother, the things she used to talk about from long ago. I didn't ask my mother's opinion of what I was going to draw, but when I heard stories from my mother, I drew them the way I pictured them" (Blodgett 1991: 121).

When Napachie represents the kind of tent her grandmother used fifty years earlier, based on the oral reminiscences of her mother, Pitseolak, both the mother's reminiscences and the daughter's art are autobiographical acts. Moreover, they encode women's cultural memories into an enduring art form. They neither pander to a tourist market for quaint images of a simple life nor yearn to reinstall an unrecoverable past. Rather, they are, in Benita Parry's words, engaging in an "intervention that wins back a zone from colonialist representation" (Parry 1987: 46). They are telling us directly about being an Inuit woman over successive generations.

There is certainly an economic reason for producing the prints of images that evoke the old ways. As I have suggested, many southern buyers acquire fictions of nature and Native in the north.[13] But I believe the situation is more complex. These arts are multivocal, simultaneously fulfilling the differing needs of Native artist and southern audience. For much of the southern audience, the works of art do, like other aspects of the so-called primitive world, fulfill people's need for a fictive "Other" who exists in a world nostalgically seen as primordial and unspoiled. This is, indisputably, part of what has made contemporary Inuit art an annual multi-million-dollar industry. But at the same time, we must not lose sight of the fact that for a community of a few hundred people to produce more than 100,000 drawings for only small financial reward in a thirty-year time span, something in the endeavor must also fulfill local needs.

The drawings of Napachie and her colleagues in Cape Dorset provide an alternative to our "official" epistemology in which the Inuit past and the Inuit present are constructed by our representations of Native peoples and their artifacts. By using the visual arts as one mode for defining her identity in a rapidly changing modern world, the Inuit artist insists on the persistence of her own unique cultural identity. The act of making art inscribes and defines a vision of the self that is crucial to Native identity. It signifies power, authenticity, and identity within the Native culture. The artist depicts the reality of late-twentieth-century life in a culture that, while geographically remote, also participates in a global culture.

Unlike the anthropologist's tent to which I referred earlier, Napachie's tent does not stand at the center of her village. She uses it as shelter during the summer, when the Inuit escape the close confines of modern village life and travel over land. The tent is also an emblem of the boundaries between past and present, as well as between the northern experience and the southern market, for whom that northern experience has been transformed into art.

In the 1920s the Danish ethnologist Knud Rasmussen reported the fol-

lowing observations by an Eskimo man in the remote Canadian Arctic, before most Inuit lived in village settlements:

> Now that we have firearms, it is almost as if we no longer need shamans, or taboo, for now it is not so difficult to procure food as in the old days. Then we had to laboriously hunt the caribou at the sacred crossing places, and there the only thing that helped was strictly observed taboo in combination with magic words and amulets. Now we can shoot caribou everywhere with our guns, and the result is that we have lived ourselves out of the old customs. We forget our magic words, and we scarcely have any amulets now. . . . We forget what we no longer have use for. (quoted in Rasmussen 1931: 500)

Yet Inuit women like Napachie Pootoogook clearly still have use for the old ways of hide sewing and making caribou skin tents: these things are transmuted into imagery for modern graphic arts. Because of the work of contemporary artists, traditional women's practices will not soon be forgotten. Napachie's tent creates a space for the Inuit artist not only as a traveler on the land but also as a traveler between cultures and between successive generations of Inuit women. Through her drawing pencils and felt-tip pens, the Inuit artist re-members the identity that so many other forces have conspired to dismember.

(Re)Fashioning Gender
and Stereotype in Touristic Production

Gender and Sexuality in Mangbetu Art

Enid Schildkrout

Mangbetu art constitutes a *style* within the "catalog" of African art forms known in the West, even though it emerged as a genre in the early colonial period as a product of the interaction between African artists and their African and European patrons. Because "authenticity" has usually been equated with "tradition"—problematic as both of those concepts are—Mangbetu art, as a genre, has been dehistoricized at the same time that it has been aestheticized. Many assumptions about the nature of the Mangbetu state, ways of honoring ancestors, and the position of women in Mangbetu society have entered the ethnographic imagination that supports this stylistic description of Mangbetu art.

Elsewhere, Curtis A. Keim and I have discussed the disjunction between Western popular conceptions of the Mangbetu and the documented history and ethnography of northeastern Zaire (Schildkrout and Keim 1990a). We have argued, based on Keim's research into Mangbetu history and on our study of the known corpus of art collected in the nineteenth and early twentieth centuries, that the nineteenth-century description of the Mangbetu by Georg Schweinfurth (1874, 1875), the first Western visitor to the area, laid the basis for subsequent descriptions, which all exaggerated the centralization and stability of the state (see also Keim 1979). Sculpture representing Mangbetu people was inevitably described as court art; wooden figures, for example, were assumed to be representations of "aristocratic ancestors" (see Société des Expositions du Palais des Beaux-Arts 1988: 310). Although there was a relationship between chieftainship and art, it was based less on religion than this suggests and more on the fact that chiefs were patrons of the arts, commissioning objects to give as gifts and tribute to other Africans as well as to Europeans.

In this essay I explore one aspect of Mangbetu art—the representation

of gender and sexuality in Mangbetu-style (hereafter simply referred to as Mangbetu) wood sculpture, ceramics, and graphic art. Characteristically in Mangbetu art women are shown with elongated heads resembling Egyptian royalty. This image—of the Mangbetu as woman—has become the quintessential representation of the Mangbetu, thus exemplifying the "feminization" of the Other (see, for example, Babcock 1993). But Mangbetu artists in the early colonial period also sculpted and drew men. These depictions incorporate exaggerated representations of male sexuality: in the American Museum of Natural History collection, for example, there is a wood carving of an almost nude soldier holding a gun taller than he is (fig. 12.1). The man wears only a cap and a cartridge belt and has a large erect penis sticking out under his belt. There is also a ceramic pot with a handle representing a man, with a penis longer than the man's head protruding from one side of the pot (see Schildkrout and Keim 1990a: 242). Drawings on ivory horns, boxes, and gourds show copulating couples. These examples have, I think, a pornographic intent, in that they were meant to shock and amuse. At the same time, these representations are satirical portraits mocking the foreigners who commissioned the art that objectified the Mangbetu as women. In addition, many pieces of Mangbetu art represent changing images of female sexuality. All of these objects provide visual evidence of some aspects of the encounter between Africans and Europeans. They express African artists' perceptions of colonial power relationships through sexual imagery. The contrast in the way men and women are depicted can be related to disruptions in gender relationships under colonial pressure.

Although I cannot fully explore European images of the Mangbetu here, it is important to note that Europeans photographed, drew, and painted the Mangbetu extensively. A major trope in this work is the Mangbetu woman with an elegantly combed elongated head and, most of the time, a scantily clad lower body and bare breasts. Mangbetu women's heads were reproduced on postcards and postage stamps, in decorative jewelry (fig. 12.2), on calendars, in guidebooks, and even on a car radiator ornament (Musée Municipal de Boulougne-Billancourt 1989: 115). Mangbetu women, often described as the "Parisians of Africa," became stereotypical expressions of the Western fascination with the merged categories of the erotic and exotic African.

In this essay I survey the development of Mangbetu art in the early part of the twentieth century, examine the European fascination with images of Mangbetu women, and look at Mangbetu art as a response to this interest. I am interested in the underlying dialogue between Western consumers and non-Western artists. Both contribute to the creation of the product, in this case Mangbetu-style art and the partially invented tradition that serves as a supportive text. With this particular example, we are dealing with a discourse on sexuality. The dialogue is one that takes place mainly between African and Western men, because for the most part men were the artists and donors

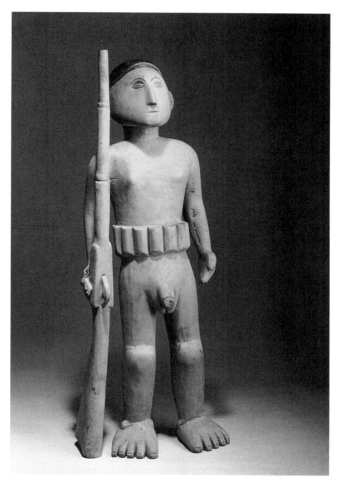

Figure 12.1. Carved figure of a soldier by an Azande artist from northeastern Zaire, collected in 1914 by Herbert Lang. Height 62.3 cm. American Museum of Natural History Cat. no. 90.1/3321. Photograph by Lynton Gardner. Courtesy of the Department of Library Services, American Museum of Natural History.

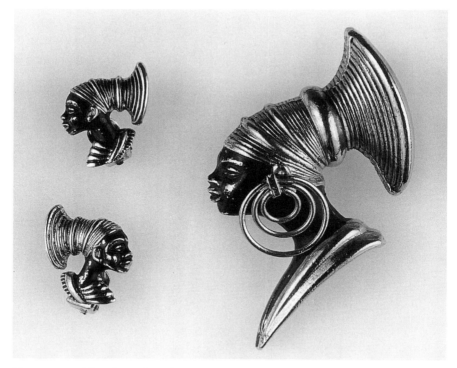

Figure 12.2. Silver brooch and earrings representing the head of a Mangbetu woman. Private collection. Photograph by Craig Chesek.

of the art as well as the earliest consumers. Embedded in this transcultural creative process were crucial changes in the way Mangbetu women related to art. Women were transformed from artisans to models; colonialism recast the status of women from subject to a fetish of the Western imagination.

A BRIEF HISTORY OF MANGBETU ART

Northeastern Zaire is not an area well known for either sculpture or masks, the two forms of African art most appreciated by Western collectors. Nevertheless, from the first decade of the twentieth century a certain style defined the art of this region. Functional items like knives, musical instruments, and ceramic jars were embellished with carvings depicting the elongated head and fanlike coiffure popular among Mangbetu women (fig. 12.3). As a sign of aristocratic status, people under the influence of the Mangbetu ruling clan, the Mabiti, practiced a form of permanent head elongation by

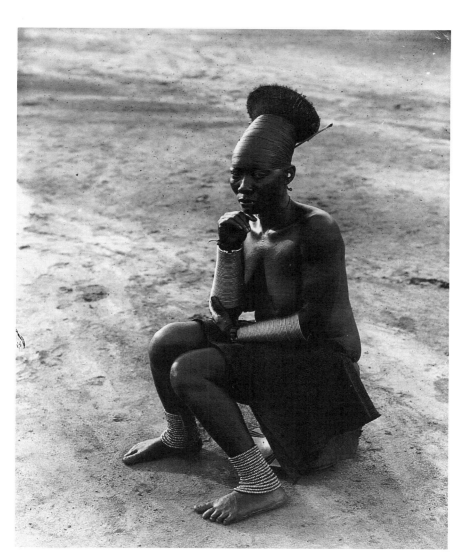

Figure 12.3. Mangbetu woman, 1910, showing the wrapped, elongated headdress fashionable at the time and subsequently represented in ceramics, woodcarving, and ivory. American Museum of Natural History Neg. no. 224507. Photograph by Herbert Lang. Courtesy of the Department of Library Services, American Museum of Natural History.

binding the skulls of male and female infants. Head elongation has ceased, but the results can still be seen in elderly people.

Around 1900, carvings showing long heads adorned with elaborate hairstyles were placed on a variety of objects: the necks of ceramic jars, the wooden covers for bark boxes, the arms and backs of wooden steamer chairs, handles of metal knives and other tools, the ends of many kinds of musical instruments, and ivory hairpins. Many objects were made with multiple heads: double-headed pots, hairpins with six or seven heads, chairs with heads protruding from every possible piece of wood, harps with heads on the neck and on the tuning keys. With the exception of steamer chairs, which were based on a Western model, all of these forms existed within the repertoire of Mangbetu material culture before foreigners took notice of the art in the region; but before contact such objects were rarely adorned with sculpted heads. As Keim and I have shown, the increase in production of this type of art cannot be separated from the demands created by the foreigners who entered the region at the end of the nineteenth century.

Although the Mangbetu people themselves did not have a tradition of anthropomorphic art before the end of the nineteenth century, the idea of adorning functional objects with heads was present in the region. Figurative art per se was not a European or colonial import, since it is known that the Azande, the Barambo, and others did adorn functional objects with heads. These types of objects were collected as early as the 1850s by Europeans, including the Italian travelers Giovanni Miani and Romolo Gessi and the English travelers Mr. and Mrs. James Petherick and Alexandrine Tinne. The Bongo in the southern Sudan made trumpets and funerary sculpture decorated with heads, described by the German botanist Georg Schweinfurth (1836–1925) in the 1870s, and the Nzakara, Ngbaka, and Azande (then known as the Niam-Niam) made harps adorned with heads.

Anthropomorphic objects collected in the nineteenth century are not always representations of women. In the earliest European comment on an anthropomorphic harp, for example, Schweinfurth states that the head on one Niam-Niam (Azande) harp was said to be a representation of King Munza of the Mangbetu.[1] It has been argued that the head was a woman's (de Dampierre 1992: 28), but since both men and women had elaborate braided hairstyles at the time, this is far from certain. Some of the earliest known anthropomorphic objects, such as an ivory dagger in the American Museum of Natural History, collected by agents of King Leopold during the 1890s, seem to be gender-neutral. Many of the heads sculpted on nineteenth-century harps are generic human heads; others are long-eared animals, probably bats. The issue in the figurative objects made before the colonial period seems to be whether humans or animals were represented at all or whether the objects were simply decorated with geometric motifs.

Collecting in this region began on a large scale in the 1890s. The Congo

Free State (CFS) took control in 1885, but the administration did not reach the northeast until 1891. In the CFS period, King Leopold II sponsored expeditions for major museums in Europe and the United States. In addition, a great many objects were collected as curios and souvenirs by Europeans who passed through or worked in the area. We have estimated that at least 20,000 objects were exported from the region by 1915. This foreign interest in the material culture of a previously little-visited region clearly had some effect on production.

Objects of beauty were valued and exchanged across ethnic boundaries before the art market developed, and an argument can easily be made that the art of northeastern Zaire has "always" emerged out of the contact between different ethnic groups, first between Africans and later between Africans and Europeans. African rulers commissioned and exchanged fine knives, musical instruments, and pottery. Gifts of artwork were used in diplomatic exchanges and as a form of tribute before Europeans ever set foot in the region (Mack 1990). Some leaders employed artists in workshops to make objects in wood, metal, ivory, and clay—for example, fine daggers and hairpins that were worn in displays of wealth. Schweinfurth's note on an Azande harp, mentioned above, suggests that some of the art in this region was made by artists from one group portraying members of other groups.

The increased production of anthropomorphic art in the Mangbetu style was, however, unquestionably associated with a shift in patrons and audience from other Africans to Westerners. The perceptions and misperceptions of taste and the stereotyping of African life by both Africans and Europeans led to the commoditization of tradition. Westerners admired and collected certain types of objects that they labeled "typically Mangbetu." The paradox, of course, is that the "tradition" that developed was not a tradition at all but an innovation that emerged in the context of colonial contact. The Western demand for certain kinds of objects, most often for objects that represented Mangbetu women, created both a market and a "tradition" that served as its ideational basis.

MARKETING TRADITION

Building on Nelson Graburn's seminal study of ethnic and tourist art (1976) and Dean MacCannell's discussion of tourism (1989), a growing number of scholars have explored how the commoditization of tradition, and with it the creation of ethnic art, takes place at and defines the epistemological boundary between cultures (see, for example, Dominguez 1986). Bennetta Jules-Rosette (1984) described the kinds of transactions that occur in such a market in terms of semiotics. Meaning is created as producers and consumers communicate and adjust their behavior and the art they produce and acquire in accordance with their perceptions of each other's needs, desires,

and intentions. There is no doubt that the exchange of art at the boundary zone of cultures creates not only representations of culture, embodied in art, but also culture itself, as producers invent and reinvent themselves and their societies in the form of marketable traditions.

The invention and reinvention of tradition is a universal cultural and historical process and does not depend on contact between disparate cultures and societies—witness, for example, the reinvention of American history at colonial Williamsburg (Gable and Handler 1993). However, in colonial situations, as Mary Louise Pratt notes, inequality is often inherent in "contact zones"—"social space[s] where disparate cultures meet, clash and grapple with each other, often in highly asymmetrical relations of domination and subordination" (1992: 4). In the African colonial contact zone, the category "Western consumers" is a large and heterogeneous one, including tourists and souvenir buyers, art collectors and museums, ethnographers and naturalists. Nevertheless, given the fact that they have all entered the scene right on the heels of the introduction of a cash economy, based on a currency to which they, and not the Africans, have ready access, it is not surprising that their tastes should have a formative effect on the production of art.

Ethnic art inevitably tends to become static as it expresses the interacting stereotypes of consumers and producers. The extreme example of such stasis is found in mass-produced tourist curios, whether made "by hand" in workshops or produced en masse in factories. But these objects are merely one end of a continuum. From the point of view of the artisan/producer as an economic agent, these curios represent the most successful end of the continuum. Although they originate as innovative responses to market demand, their success leads to mass reproduction with minimal further innovation. The pendulum swings between innovation and subsequent imitation or repetition of form, but both are responses to market forces.

In surveying a century of Mangbetu artisan production, one is struck by the contradictions arising from artisans' need to find an identifiable and marketable style, on the one hand, and their desire to innovate, on the other. Jules-Rosette (1984) and Steiner (1994) describe how artists often miscalculate the changing demands. With the Mangbetu, one can make the case that the tension between innovation and defining a style ultimately meant the demise of an entire genre, for the Mangbetu virtually ceased producing art (at least in northeastern Zaire) after the Second World War. This also means that the really fine works of "typical" Mangbetu art preserved in museums and private collections should be reevaluated, not as examples of "traditional" art but as the dynamic and creative expression of a particular historical period, made by artists who were photographed and interviewed and who often left a stylistic, and sometimes even a written, signature on their works. Rather than expressing tradition, this art distills the encounter between Westerners and Africans in the early years of the twentieth century.

EARLY DESCRIPTIONS OF MANGBETU WOMEN

While demand for Mangbetu art created a market in the early twentieth century, it was framed by ideas that Westerners had inherited from the first foreign visitors to the region. Images of the Mangbetu were based on a complicated mixture of myth and reality, fueled by Western fantasies about Africa and by Mangbetu manipulation of those fantasies. After Schweinfurth in 1874 published a hyperbolic description of the Mangbetu court of King Mbunza, visitors to the region saw the Mangbetu as the most politically and artistically advanced people in the area. Schweinfurth's description and drawings depicted a powerful ruler, Mbunza, dancing before his 180 wives—each one's body painted with distinctive geometric designs—in an immense meeting hall (150 feet long by 60 feet wide by 50 feet high) made of carved posts and reeds. The German botanist praised the architectural skill of the Mangbetu, noted the fine workmanship of their pottery and ironwork, described the tools they used to carve ivory, and mentioned the assertiveness of the women. Thus all subsequent Western visitors had heard about the cleanliness and beauty of Mangbetu villages, the monumental architecture, the fine craftsmanship, and the lascivious "painted" women.

Schweinfurth's account of the Mangbetu included a long passage that described the women and introduced themes that were repeated by many subsequent observers.

> Polygamy is unlimited. The daily witness of the Nubians only too plainly testified that fidelity to the obligations of marriage was little known. Not a few of the women were openly obscene. Their general demeanor surprised me very much when I considered the comparative advance of their race in the arts of civilization. Their immodesty far surpassed anything that I had observed in the very lowest of the negro tribes, and contrasted most unfavourably with the sobriety of the Bongo women, who are submissive to their husbands and yet not servile. The very scantiness of the clothing of the Monbouttoo women has no excuse. (1874, 2: 91)

Subsequent observers modified Schweinfurth's image, sometimes turning the notion of immodesty into the idea that Mangbetu women were outspoken and independent. Schweinfurth himself noted that Mangbetu women owned property, and a number of others contrasted the comportment of the Mangbetu with that of the Azande, noting that while Azande women ran into their houses when Europeans approached, the Mangbetu women were free to interact with foreigners and could be seen discussing politics and community events with men, both African and European. For example, Belgian commandant Christiaens wrote: "The European is received [by the chief] . . . surrounded by important advisors and his principal wives. These are much less shy than their Zande sisters, far from avoiding the gaze of the white man, they are very flattered when they see that they have attracted attention and

they do not hesitate, far from it, from making conversation" (in Van Over-
bergh and de Jonghe 1909: 344; my translation).

There were, of course, many contradictions in these accounts, with some
observers noting that these supposedly independent women were the ab-
solute property of their husbands, that they were "bought" with bride price,
and that they were responsible for most of the agricultural labor.

The physical appearance of Mangbetu men and women, especially their
hairstyles and body decoration, was a major topic in texts written before 1909.
Most authors noted the elaborate hairstyles of men and women and described
body painting, particularly how women spent hours painting designs, simi-
lar to those painted on bark cloth, on each other's bodies.

In addition to these texts, a growing corpus of artwork and photography
represented Mangbetu women to a European and American audience. In
an early compendium of references to the Mangbetu (Van Overbergh and
de Jonghe 1909), eight of nine unattributed photographs at the end of the
book show Mangbetu women. In general, there were two genres of pho-
tographs: anthropological photographs, which showed males and females
in static views that could be used for purposes of "scientific" measurement,
and "art" photographs, which showed women doing things or, more often,
posed to show off their adornments, hairstyles, scarification, and body paint-
ing. In both genres, the image of the long-headed Mangbetu woman became
a standard European expression of the exotic and erotic beauty of Africa.

DISSEMINATION OF IMAGES OF THE MANGBETU

With the visits of Belgian ethnographer Armand Hutereau and German zo-
ologist Herbert Lang around 1910,[2] images of the Mangbetu began ap-
pearing in newspapers, magazines, posters, and advertisements, and even
eventually on a Belgian postage stamp. Photography, painting, and drawing
all contributed to an iconography of the Mangbetu that was strongly, al-
though by no means exclusively, focused on women. (Male chiefs were the
main counterpoint to this, often shown dancing before their wives or oth-
erwise surrounded by women.) Although Hutereau and Lang saw themselves
as scientists and their photographs primarily as documentation, in the pub-
lic print media the presentation of the Mangbetu woman as exotic and erotic
beauty became the dominant image.

By the 1930s the image of the "long-headed Mangbetu" woman was vir-
tually a logo of Belgian colonialism, and it soon became iconic in all of
French-speaking Africa. It was featured in images at the 1931 and 1937 French
Expositions, on postcards and posters, in guidebooks and art galleries. This
image was simultaneously exotic, erotic, and easily aestheticized, for in the
1920s and 1930s the statuesque elongated female figure fit nicely with some
of the emerging preoccupations of Art Deco style. A number of exhibitions

followed the French Citroën expeditions to Africa and Asia, and Alexandre Iacovleff, the official painter for these voyages, also produced the murals for the French liner *Normandie*. Iacovleff's Mangbetu paintings became key images in the popular representation of Africa (see below).

In addition to artists' firsthand renditions of the Mangbetu, photography was important in the production and dissemination of this imagery. Photography among the Mangbetu has a long history that I can only summarize here (see Schildkrout 1991). Herbert Lang, the leader of the American Museum of Natural History Congo Expedition (1909–15), lived among the Mangbetu with his coworker, ornithologist and watercolorist James Chapin. Lang was particularly interested in photography and took more than 10,000 pictures of the fauna, flora, and people of northeastern Congo. Many of these were published in newspapers and magazines.

After 1915 other photographers visited the region and focused their lenses even more exclusively on women.[3] Many close-ups, shot at angles that exaggerated the elongation of the head, were reprinted on postcards and in magazines. Casimir Zagourski's images, for example, were issued in several series of postcards, including one of 216 images printed on photographic paper called *L'Afrique qui disparaît*. A number of filmmakers also focused on women, including a *National Geographic* crew that accompanied James Chapin on a visit in the 1920s. Grace Flandrau, a writer and filmmaker (whose film has not been found), visited in 1929 and published an account of her journey in which she described how the village of Ekibondo was becoming a magnet for tourists, photographers, and filmmakers, with the Mangbetu actively collaborating in the construction of images of themselves (Flandrau 1929: 302; Schildkrout and Keim 1990a: 45). Martin Birnbaum traveled to the area in 1939 and described how Chief Ekibondo presented his village and its women to tourists:

> But when I met Chief Ekibondo, dressed in white duck and wearing a wrist watch, I began to suspect that all this charming grouping of forest giants and ornamental huts was done with a keen eye for business. He encourages women to show how they dress their hair, to pound manioc and other foodstuffs in the open, to pose for photographs and sell their negbes and neatly woven hats without crowns. . . . I felt that Ekibondo was as enthusiastic about "tourisme" as Mussolini himself, and I was tempted to give him a bitter account of white exploitation of primitive paradises. Fortunately, perhaps, there was no time. At any rate, he has not yet built a hotel or rest house for whites. (1939: 83)

In looking at images from this period it is important to remember that the camera, particularly the box camera, was far from unobtrusive. The subjects always knew they were being photographed, and sometimes they were given prints of the images. The act of posing and the circulation of the subsequent images inevitably influenced how the Mangbetu perceived themselves and

their relationship to the gaze of foreigners. Lang, for one, developed his photographs in the field and gave prints to many of the subjects. Images were transferred from one medium to another: we know that African artists produced objects that represented the same images that were being captured on film. Even in the 1980s one visitor came upon a painting of Queen Nenzima, the wife of Chief Okondo, made by a Zairian artist who seems to have copied the image from a Lang photograph. The painting may have been done decades after Lang's departure (Didier Demolin, personal communication, 1989). As Christraud Geary (1998) notes, images have been copied from one medium to another continuously, first from painting to engraving, and later from photography to painting and even to film. The Mangbetu woman was a major trope in the industry of inventing Africa, and it served African artists as well as European consumers.

European and American painters began to visit the northeastern Congo in the 1920s. Paul Travis visited the village of Ekibondo in the 1920s and continued to paint scenes of Mangbetu life for many years after his return to his home in Cleveland. (Some of these works are now in the Cleveland Museum of Art.) Russian painter Alexandre Iacovleff published a portfolio of drawings in 1928 based on his travels with the French Citroën expedition of 1924–25 (fig. 12.4). He, too, visited Ekibondo, the chief most accessible to visitors at the time (Iacovleff 1928). Iacovleff's sumptuous drawings of Mangbetu women and children have a warmth and intimacy about them, but also transform these beauties into the epitome of Art Deco style (see also À la Vielle Russie 1993). A portfolio of engravings by Henri Kerels, issued for the Belgian Pavilion at the 1937 Paris Exposition, includes a woodcut (fig. 12.5) of a woman playing a harp, kneeling beside a ceramic pot whose head is a reflection of the woman's head (Kerels 1937).

WOMEN AS SUBJECTS OF ART

In addition to making images of the Mangbetu that became part of the Western iconography of Africa, visitors began to collect objects. The earliest nineteenth-century collectors brought back small survey collections of the material culture of the region's people. Although Schweinfurth's collection was lost in a fire in Africa, other collections made their way into European museums: Junker's to Leningrad; those of the Italians Miani, Gessi, and Antinori to Rome and Florence; Tinne's to Liverpool; the Pethericks' to Kent; Emin Pasha's to Vienna.[4] Once the Mangbetu area came under Belgian control, expeditions began collecting artifacts somewhat more systematically. Those that collected the most objects were the Belgian ethnographic expedition of Armand Hutereau, for the Musée Royal de l'Afrique Centrale in Tervuren, and the American Museum of Natural History Congo expedition led by Herbert Lang.

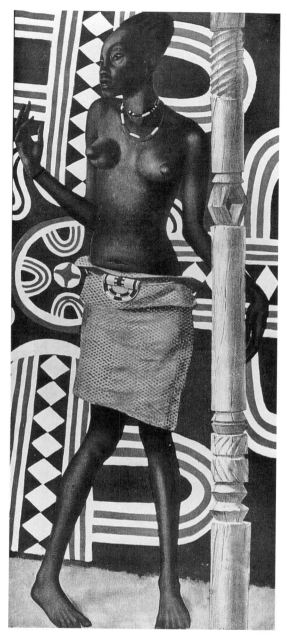

Figure 12.4. Alexandre Iacovleff, *Molende, la Mang-
betu*. From *Alexandre Iacovleff: Dessins et Peintures
d'Afrique,* edited by Lucien Vogel (Paris, 1927), plate
39. Collection Louis de Strycker, Brussels. Repro-
duced by permission.

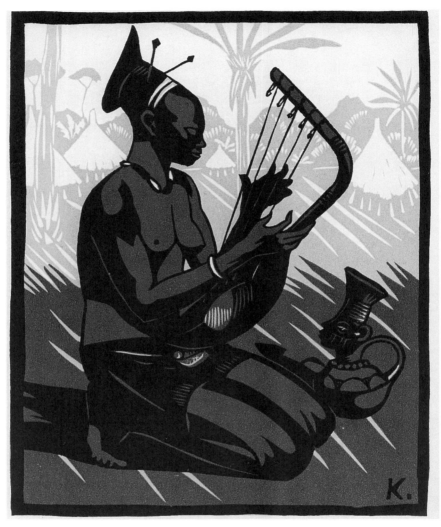

Figure 12.5. Henri Kerels, *Musicienne*. From *Arts et métiers congolais: Douze gravures originales en couleurs* (Brussels: Editions de Belgique, 1937), plate 12. Collection Louis de Strycker, Brussels. Reproduced by permission.

There were important differences between collecting images and texts and collecting artifacts. The first, of course, required a degree of compliance from the Mangbetu, but the latter depended on suppliers, chiefs and artists mostly, who calculated the demand and supplied the objects. Some of the collectors, particularly the earliest ones, intended to collect what was already there, but the increase in demand created problems of supply. Some collectors commissioned certain kinds of objects. Lang, for example, commissioned some replicas of objects in use and also encouraged artists to apply their skills in new ways—for example, he commissioned a series of representational drawings on bark cloth. Chiefs commissioned objects for Lang, including ivory versions of European implements, such as knives and forks, napkin rings, and letter openers (Lang 1918; Schildkrout and Keim 1990b). Other buyers, like the many Belgian administrators who lived in or passed through the area, favored certain kinds of objects over others. Mangbetu artists and patrons played pivotal roles in the collecting process, gathering and creating artifacts to meet new foreign demand.

Hutereau and Lang may have been the most active collectors in the years between 1909 and 1915, but they were not the only ones. In fact, Lang obtained his first example of anthropomorphic art from a colonial administrator: an iron dagger with a beautifully carved handle in the form of a woman. Lang noted that all the daggers in this style were carved by one artist, worn for display when new, and used as utilitarian implements when old. At that time, anthropomorphic objects clearly were not common among the Mangbetu. Both Hutereau and Lang wrote in their notes that the Mangbetu did not use such carvings for religious rituals and that carvings of animals or humans were seen by the Mangbetu simply as embellishments, as "art for art's sake." Contrary to the use of "fetishes" elsewhere in the Congo, the early collectors among the Mangbetu exclaimed that figurative carvings seemed to have no religious meaning. This attitude toward art is surely one of the factors that allowed the Mangbetu and some neighboring artists to respond so readily to demands for certain kinds of objects in the early colonial period. Not bound by ritual prescriptions relating to the use of figurative sculpture, they were able to assess and adapt to what they perceived to be the tastes of a new audience.

If Western tastes influenced the production of Mangbetu art, we need to know who exactly the Westerners were who admired, collected, and influenced Mangbetu art. Besides the ethnographers, who not only collected whatever they found but also, in different ways, communicated their responses to the artists and suppliers, there were other collectors, including government administrators, military officers, and traders. There were also Catholic and Protestant missionaries. These visitors did not all have similar tastes or even interest in visual art; some of the missionaries, for example, were clearly anti-art; others started schools for the teaching of arts and crafts. Nevertheless,

the evidence from the art itself and from the written comments we have suggests that craftsmanship and naturalism, particularly the correspondence between the appearance of the people and their representation in wood and clay, were the qualities most admired by those visitors who collected art.

Collectors communicated their preferences through their choices of items to purchase and through the prices they were willing to pay. Figurative sculpture was admired and valued more highly than nonrepresentational work, and ivory objects fetched a higher price than wooden ones. Although Westerners did not introduce figurative sculpture, they did encourage its production. Heads carved on pots, knives, hatpins, and other objects increasingly came to represent not just human forms but specifically female forms. By the 1920s and 1930s, ceramic jars more often had exaggerated breasts. This development can be seen by comparing pots that were collected around 1910 with those collected in the 1920s. Women became the models and subjects of art, and less and less the producers.

Until the early 1920s, women made most of the basketry and pottery. They made all of the household pottery and all of the baskets, and probably did most of the house painting. Men made woven hats and did metalwork and wood carving. When Schweinfurth described Mangbetu pottery in the 1870s, he noted the finely decorated pots made by women. His drawings are similar to pots collected by Lang forty years later (see Schildkrout, Hellman, and Keim 1989),[5] although in the period of Lang's residence things had already begun to change. Although women continued to produce pottery for the domestic market, once anthropomorphic pottery became popular, men began producing as well. At the same time, objects that had mainly geometric decoration, like the beautiful pots made by women, remained within the indigenous economy and were eventually replaced by new materials. Women were unable to take advantage of the new opportunities for income generation presented by the expanding market in artifacts.

This gender shift may have involved input from the northern neighbors of the Mangbetu, the Azande. Among the Azande, men were traditionally potters, according to Lang and E. E. Evans-Pritchard (1960, 1963, 1965). When the Mangbetu began producing pottery with female heads, men sculpted the heads. Herbert Lang photographed a male potter—the same man who made the pot with the protruding phallus described earlier—and also noted that men made the "art pottery." Lang did not say that all these male potters were Azande, leaving us to ponder whether Azande men made Mangbetu-style pots, or Mangbetu men took up pottery in addition to wood carving, ivory carving, and ironwork (the answer is almost certainly both). In any case, women were pushed aside in the production of this highly valued commodity. In a series of photographs taken in the 1940s (now housed in the Musée Royal de l'Afrique Centrale in Tervuren), a woman is seen making a coil pot. When she gets to the neck of the pot, a man comes over and sculpts the head.

It was these same male artisans who made the ostentatious male figures mentioned earlier and who incised the scenes of copulating couples on ivory and gourd. These objects, although finely crafted, were clearly made for foreign male consumers, and they are part of the African response to the Western gaze. Although collectors have often described the more sedate Mangbetu carvings and pots as "traditional" art, as representations of ancestors and royalty, they have not realized that most figurative Mangbetu-style art needs to be understood in historical as well as cultural terms. An appreciation of what was going on in the early years of colonial contact allows us to look at this genre of non-Western art in a subtler and perhaps more self-conscious way.

The Mangbetu case illustrates a number of issues that are common to the production of ethnic or tourist art in colonial and postcolonial contact situations. New art forms are mediated by the tastes and pocketbooks of foreign consumers. At the same time, the images this enterprise engenders actually produce culture: invented tradition becomes the text that validates the art. African artists are not passive in these circumstances, for they also select and develop the images that work (and sell). They thereby comment and act on their own culture and society as well as the society of the foreigners. They may be mocking the erotic tastes and sexual proclivities of foreigners, but the foreigners often see this as a form of African self-mockery. In the Mangbetu hall of mirrors, as in many others, this happens at the expense of women, who became more important as the subjects of sculpture, produced and consumed by men, and less important as artists in their own right.

Defining Lakota Tourist Art, 1880–1915

Marsha C. Bol

Sizable collections of Lakota Plains Indian art were amassed early in the twentieth century. They are filled with objects that refer to a traditional lifestyle—a lifestyle for which such things had ceased to be necessary long before they were collected and, in some cases, long before they were actually made. The artistic record in other Native North American regions suggests that many of these objects were produced for a new audience, a non-Native clientele. However, it is often virtually impossible to distinguish objects made for Lakota use from those made for a non-Lakota audience unless they display clear evidence of wear or use.

This essay explores questions pertaining to the Lakota arts made for the non-Native market from 1880 to 1915. What avenues, for example, did the Lakota have for marketing their arts? What artistic themes and forms best met the desires of the market, and what selection criteria did the collectors use? And why is it now so difficult to distinguish the arts made for the tourist market from those made for Lakota use—a distinction that is possible to make for many other regions of Native North America?

Since the mid-1970s, many researchers have examined the development of Native American tourist arts in the Southwest (Babcock 1990; Brody 1976; Kent 1976; Parezo 1983; Rodee 1981; Wade 1985; Weigle 1989; Weigle and Babcock 1996), the Northwest and the Arctic (Graburn 1976b; Lee 1991; Wright 1982; Wyatt 1984), the Far West (Bates and Lee 1990; Cohodas 1979, 1986, 1992), and the Northeast (Gordon 1984; Phillips 1989b, 1990, 1991), but very little has been written about the Plains, with the exception of the development of ledger art.[1] This lack is surprising since the Plains Indian is even today the most widely recognized popular image of the American Indian around the world (Ewers 1964: 531, 543).

THE LAKOTA IMAGE

American Indians—who would not have in mind tall redskins, in feather headdresses galloping over the prairie with noble, aristocratic features, clothed in buffalo skins and deer hide; and who would not think of courageous and fearless hunts and battles?

WILFRIED NOLLE, *DIE INDIANER NORDAMERIKAS,* QUOTED IN FÖRST 1992: 35–37

This statement by a German author characterizes the popular image of the American Indian that persists in Europe, Asia, and North America. Undeniably, this description refers to the prereservation Plains Indian. If the Plains Indian is the archetypal Native American, then the most famous of the Plains Indians are the Lakota, more familiarly known as the Sioux. In 1990 they were the stars of the Academy Award–winning film *Dances with Wolves*. A century earlier, the Lakota were the best-known Native Americans in the world (Trans-Mississippi and International Exposition 1898: 96). Before being settled on reservations in South Dakota during the last quarter of the nineteenth century, the Lakota had experienced a glorious hundred-year period as a proud and independent nation. As the most populous Plains nation, they dominated a wide territory, prospering as buffalo hunters and mounted raiders.

The Lakota warriors have become known as the "classic" American Indians. They fought in the renowned Battle of Little Big Horn and the Battle of Wounded Knee. The exploits of the Lakota chiefs—Sitting Bull, Red Cloud, and Crazy Horse—are legendary; a Lakota man's profile served as a model for the "Indian head" nickel (Ewers 1964: 542). But it was with the advent of Wild West shows and international expositions that the Lakota image became so widely known. Buffalo Bill Cody toured his "Wild West" show from 1883 to 1917 and made several European tours. Some 50 million people saw his show in thirty-four years, and by 1885 it was one of the most popular forms of entertainment in the world (Rogers 1981: 6–7). Enthusiastic viewers included the crowned heads of Europe, and in 1890 the performers received the blessing of the pope.

Cody printed millions of advertising posters, which he lavishly posted wherever he went. Most of the Indian posters displayed the Lakota racing across the broadside with feather bonnets flying (see fig. 13.1) (Rogers 1981: 7). Buffalo Bill employed mainly Oglala Sioux from the Pine Ridge Reservation, whom he sometimes listed in the program under other tribal affiliations (Deloria 1981: 502). The list of Lakota participants in Buffalo Bill's Wild West show and the many other similar shows reads like a Who's Who of important Sioux leaders. It includes Sitting Bull, Red Cloud, Black Elk, and Kicking Bear and Short Bull, two leaders of the Ghost Dance who were released from prison to participate in Cody's European tour, as well as a younger generation made up of these leaders' sons (Russell 1970: 39, 69).

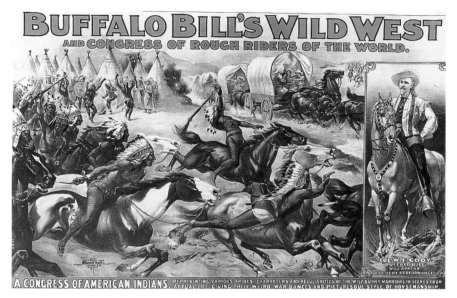

Figure 13.1. "A Congress of American Indians," 1899. Courtesy of the Library of Congress.

So large were the numbers of Lakota recruited that their absence was felt by the entire community. Chief Red Fox recalled, in 1893, that "one hundred and twenty Sioux Indians from the Pine Ridge Reservation left the reservation . . . to join the show" (Red Fox and Sherman 1968: 26). Wearing full regalia, they dramatized mock battles and chase scenes, always impersonating (and embellishing) the warrior and hunting life of the pre-reservation era.

LAKOTA RESERVATION ARTS

Ironically, with the move to the reservations in the last quarter of the nineteenth century, the very circumstances that had attracted the imagination of people around the world to these nomadic people underwent profound change. The supply of buffalo and other game was radically depleted. Facing the loss of their livelihood, their pride, and their unbounded homeland after a series of military defeats and treaty negotiations, the disheartened Lakota were forced to remain within the confines of a series of reservations in the Dakotas. They thus no longer needed the specialized objects that supported a seasonally nomadic life style, such as transportable and unbreakable hide bags, tipis, and large quantities of horse gear. Objects of war and warrior societies, too, had limited use. With the overhunting of big game

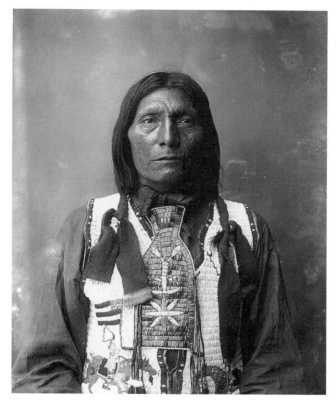

Figure 13.2. Man from Rosebud Reservation, South Dakota, with quilled necktie. Photographer unknown, probably taken at the St. Louis World's Fair, 1904. Courtesy of the Smithsonian Institution, National Anthropological Archives.

such as the bison, deer, and elk, Lakota artists had difficulty procuring the materials needed to make many of their traditional objects.

Amid these changing circumstances, the Lakota people, especially the women, took fresh initiative, applying their skills to newly available products. Greater access to trade goods and annuity supplies provided new materials that required less laborious techniques. Lakotas substituted brass kettles for buffalo stomachs as cooking vessels and wool blankets for hide robes; they replaced hide clothing with cotton muslin and used canvas for tipis. They also applied decoration to the surface of every conceivable new product. They beaded doctors' bags and suitcases, as well as leather gauntlets and gloves, saddles, and bridles for horses. They quilled neckties (fig. 13.2) and umbrellas, and one woman even quilled a gramophone horn cover.

They made objects for new purposes; those who converted to Christianity, for example, made embroidered hymnal covers and church vestments. As the Lakota language was recorded and translated, inscriptions in English and Lakota, names, and dates were worked into beaded, quilled, and painted designs. At the end of the nineteenth century, the Lakota were still extremely prolific producers of art, even under such profoundly changed circumstances (Bol 1993: 366). In fact, so prolific was their output that the eminent Plains scholar John C. Ewers observed that if a museum has only one piece of Native American art it is likely to be made by a Lakota (John Ewers, personal communication, October 12, 1982).

LAKOTA TOURIST ART MARKETS

Many who saw the Wild West shows then wanted to own a piece of Lakota memorabilia. The Europeans were as enthusiastic as the Americans in their desire for souvenirs. A London newspaper reported on Buffalo Bill's Wild West show concession in 1887: "Cigar stands, soda fountains, Indian curiosity stores and photograph stands, the latter sometimes selling 1,000 a day, the greatest number being of Buffalo Bill, and the next of Red Shirt—a wonderfully fine-faced Indian" (Cody 1887). In particular, moccasins and bows and arrows sold in large quantities (Foreman 1943: 202). One agent wrote to a trader: "I think I can sell a few [moccasins] in Chicago as people in this town think them quite odd and will buy them as a souvenir more than anything else" (Barten 1908). Relatives at home on the reservation helped to meet the demands of an eager non-Native audience. W. H. Barten, a store owner near the Rosebud and Pine Ridge reservations, wrote to the owner of the Miller Brothers' 101 Ranch Wild West in 1907, saying: "The Indians here are making a good deal of beadwork to send to their relatives in your show and it is important for us to know here how to address the packages containing the beadwork" (Barten 1907).

The Lakota family of John Y. Nelson exemplifies the connections between performance, commodification, and collecting. The Nelsons traveled with Buffalo Bill's Wild West show for more than ten years beginning in 1883 (Secrest 1969: 62). A body of distinctive beadwork can be traced to the women in the family, who were photographed several times wearing examples of their work, in particular, a fully beaded dress (fig. 13.3). The mother, Jenny Nelson, was an Oglala who had married John, an Anglo-American who lived most of his life with the Lakota. He both acted as interpreter and performed as the Deadwood stagecoach driver in the shows. The beaded dress seen in the photograph is related to a small girl's fully beaded dress and a boy's fully beaded shirt, both of which were donated to Chicago's Field Museum of Natural History in 1893, the year of the Chicago World's Columbian Exposition. All three pieces share a similar design, featuring a blue beaded field with characteristic bands of alternating units of color.[2]

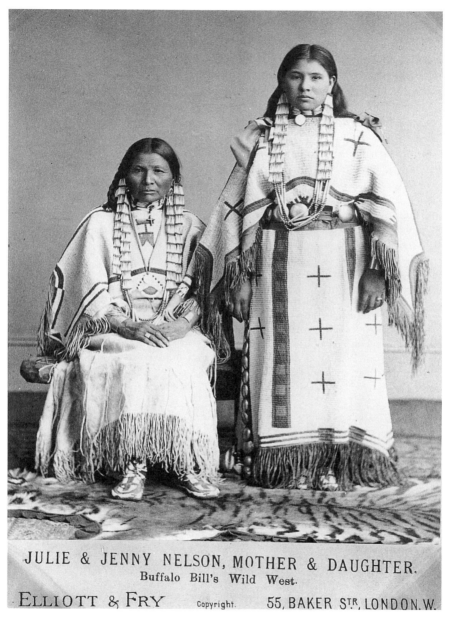

JULIE & JENNY NELSON, MOTHER & DAUGHTER.
Buffalo Bill's Wild West.

ELLIOTT & FRY Copyright. 55, BAKER STR, LONDON. W.

Figure 13.3. "Julie and Jenny Nelson, Mother and Daughter. Buffalo Bill's Wild West." The names of the two women are reversed in the caption. Photograph by Elliott & Fry, London. Courtesy of the Buffalo Bill Historical Center, Cody, Wyoming.

Buffalo Bill's Wild West show had performed at the 1893 exposition, just outside the main entrance, and it had been Cody's biggest and best season (Russell 1970: 42–43). Jenny Nelson and her family were there, and the museum's donor probably purchased these objects from them during the exposition. The beaded woman's dress was probably purchased then also, since it later appeared in a private collection in Evanston, Illinois, just north of Chicago (Feder 1965: pl. 5). All of these pieces were probably made by Jenny Nelson, her daughter, or another family member traveling with the Wild West show.

International expositions and world's fairs were in their heyday during the last quarter of the nineteenth century and the beginning of the twentieth. Displays of Indian people in full regalia were an important aspect of virtually all of them. At the 1898 Omaha Trans-Mississippi Exposition, for example, an Indian Congress, funded by a U.S. government appropriation of $45,000, was a special feature. The official guidebook to the fair described this "exhibit":

> Here is arranged a living ethnological exhibit of rarest interest and this is undoubtedly the strongest feature of the Exposition. Four acres are covered with tepees and wickiups of the tribes of the aboriginal inhabitants of the continent. . . . Here delegations of live redmen illustrate the customs, habits and modes of life existing now and formerly, and about their dwellings can be seen the apparel, weapons, utensils and appliances for war and peace. If there were no other interesting spectacle on the grounds this would compensate the visitor for a journey from the opposite side of the globe. (Trans-Mississippi and International Exposition 1898: 48–49)

One visitor verified the popularity of the Indian Congress, listing as the three great features of the exposition "the food exhibit, the electrical exhibit and—the Indians" (Russell 1970: 64).

The emphasis of the Indian Congress was on exhibiting a last look at the vanishing American Indians and their exotic past, which was of far more interest to the fairgoers than the present-day Indian realities. The largest delegation to the Omaha fair was made up of the Lakota, or Sioux, who were linked in the minds of the American public to the notion of the daring, warfaring past (Rieske 1974: 16). According to the *Official Guide Book to the Trans-Mississippi and International Exposition:* "They [the Sioux] are the most famous of all our Indians and until within a few years were the most vigorous and successful warriors. . . . Representatives are to be found on the Exposition grounds at all times" (1898: 96). Lakota men strolled around the fairgrounds wearing their "eagle-feather war bonnets" and participated in staged mock battles, much like those of the Wild West shows (Haynes 1910: 222, 229–30). The women did beadwork, while "the men made their weapons of war and hunting" (Rieske 1974: 16). Evidently sales of these items were

brisk, for according to the exposition historian: "the articles they made were readily disposed of to patrons of the Exposition" (Haynes 1910: 221). But fairs, expositions, and Wild West shows provided only intermittent markets for Lakota artisans.

Anglo-American traders on the Plains saw an opportunity to develop a lucrative and more stable Plains Indian art market by advertising through the mail. They printed wholesale and retail mail-order catalogs, which they sent to dealers and customers around the country, touting themselves as "the largest dealers" of "genuine Sioux Indian curios and beadwork . . . in the world" (Strong 1915: 1). The catalogs offered a wide selection of traditional objects ranging from breechclouts to war clubs. Easterners could stay at home and select from among the offerings. Feather "war" bonnets could be ordered with a double trailer, a single trailer, or no trailer, and with a choice in the species of eagle feathers. Women's beaded hide dresses were available with either 1,200 square inches of beadwork or, for a lower price, with only 1,000 square inches (Lillie and Lyon, n.d.: 7, 15). Moccasins could be ordered with a choice of "beaded toe; one-half beaded; three-quarters beaded; solidly beaded over tops; beaded all over, top and bottom" (Stilwell 1971: 2).

It is notable, however, that these mail-order catalogs of Lakota arts did *not* offer trader-introduced designs or make concessions to the different lifestyles and comfort requirements of the non-Indian market. For example, moccasins were not sized to correspond to shoe sizes.[3] If anything, the various traders emphasized the one-of-a-kind, the traditional, and the "historical and ceremonial" attributes of their stock. Pawnee Bill's Indian Trading Post catalog proudly noted: "We never get two pieces of beadwork with the same design . . . it is through the great personal friendship with the various Indian tribes, that gives us an opportunity of securing much of the historical ceremonial articles that have made the Indian tribes so attractive and interesting to the collectors of museum specimens" (Lillie and Lyon, n.d.: 3).

If we are to assume that these traders knew their business, then they deliberately appealed to what they believed their clientele would most readily purchase—items that represented the Aboriginal lifestyle, not objects that conformed to the non-Native mode. One catalog pointed out to buyers: "Probably there is no article of Indian make which is so well known and is so distinctively Indian as the moccasin" (Kincaide 1933: 8).

Traders and store owners often formed personal collections as they came in contact with Lakota artists and family members. Nellie Star Boy Menard recalled one store owner at Pine Ridge who amassed a collection by routinely trading caskets to family members for fine Lakota artwork (Nellie Menard, personal communication, September 9, 1993). Many professionals who were stationed in Dakota territory, such as doctors, military men, Indian agents, schoolteachers, and missionaries, formed personal collections with purchases and gifts. And then, of course, ethnologists such as

Clark Wissler and Frances Densmore collected Lakota objects specifically for museums.

Yet even with all of this activity, exposure, and publicity, a Lakota tourist art market apparently never developed special objects adapted for sale to non-Indians. When preparing for the 1904 St. Louis World's Fair, the U.S. government appointee in charge of the Indian exhibit sent letters to reservation agents throughout the West seeking Indian artisans to travel to the fair to demonstrate and sell their traditional arts. Most of the officials from the Plains regions sent discouraging replies, saying that their wards made nothing for sale. In contrast, the agents from the Southwest reported that in their region artists readily produced such arts as pottery, baskets, silverwork, and rugs for an increasing tourist market. A contingent of Lakota artists did attend the St. Louis fair, producing objects of "buckskins, beads, porcupine quills and bows and arrows," but it was the Southwest artists who captured the interest of reporters and the public (Trennert 1993: 278–81, 289).

COLLECTING BEYOND THE PLAINS

It is important to examine the marketing of Plains objects within the broader North American context of the late nineteenth century. In the Southwest new markets developed, particularly for Pueblo pottery and Navajo blankets transformed into rugs, about the time that such things became obsolete within their home communities (J. J. Brody 1976: 83; Batkin, this volume). Mail-order catalogs allowed Victorian women to select Navajo rugs for their floors from the convenience of their own home (Rodee 1981). Travelers could purchase Pueblo pottery from Indian women vendors at train stops, and Anglo women adorned themselves in Navajo jewelry.

In California and the Far West, collectors filled their shelves with Native American baskets. George Wharton James, founder of a basket fraternity, wrote in a 1901 article entitled "Indian Basketry in House Decoration": "Mrs. Lowe of Pasadena, California, possesses the largest and finest collection of Indian baskets in the world . . . number[ing] over 1000 specimens . . . in her library many choice baskets were tastefully displayed on and around the book cases. . . . Indian baskets were used as receptacles for waste paper, newspapers, photographs, cards, etc . . . that made this room a most unique and highly pleasing one" (621).

By 1890 in the Northwest, thousands of tourists cruised up the popular Inside Passage of Alaska by steamship. They were met at various stops along the way by Native vendors selling objects made specifically for the travelers: whimsical basketry, model totem poles, carved salad forks, and so forth. On the Northwest Coast, just as in the Southwest, the large majority of souvenir hunters were women. One such visitor to Alaska in 1884 declared that she had purchased so many souvenirs that the captain threatened to charge ex-

tra on the homeward passage for the excess baggage (M. Lee 1991: 7–9). She likely took all of her purchases home to decorate her Victorian house and those of friends and relatives.

In the Northeast, Tuscarora women began selling beaded items at Niagara Falls around 1850. Victorian white women purchased items directly from the Indian women (Gordon 1984). They purchased purses, bags, and other objects to wear themselves or to give as gifts to other white women. And they purchased items to decorate their Victorian homes. At home Victorian women created bric-a-brac displays, filled curio cabinets, and furnished cozy corners with their purchases (M. Lee 1991: 9–11).

COLLECTING LAKOTA ARTS

Where, then, are the Lakota arts adapted for new markets? Why did the Lakota response differ from those of other regions, which successfully converted their arts to larger-scale production and new market desires? One obvious answer is that tourism in the Dakotas was minimal. There was little spectacular scenery—the only attractions were the Badlands, Mt. Rushmore in the Black Hills (which did not become an attraction until 1933), and the Corn Palace in Mitchell, South Dakota, which was one of many such "vegetable" structures during the era of midwestern fairs and expositions. There were no resorts like those at the Grand Canyon, Saratoga Springs, and Glacier National Park. There was no equivalent to the Inside Passage steamship tours to Alaska, the Fred Harvey detours in the Southwest, or the Santa Fe Railway train stops at charming spots; no portal of the Palace of the Governors on the Santa Fe plaza, no Niagara Falls for honeymooners and sightseers. A trip to the reservation in South Dakota did not mean a visit to the ancestral, folkloric homes and villages of Indian people as it did in the Southwest and Northwest. And the sparse non-Native population of the state, mainly ranchers and farmers, generally had little interest in Native arts.

But there were and continued to be private individuals who actively collected Lakota arts. The many private collections now deposited in public museums attest to this. I suggest that certain characteristics of these collectors and the criteria they used to evaluate potential acquisitions did not promote and probably even inhibited the development of innovations in art forms among the Lakota. Furthermore, these criteria were imposed throughout North America and Europe by consumers who had clear and definite notions about who a Sioux Indian was and should continue to be.

Like anthropologists and field researchers, Plains art collectors wanted the old, the antique, and the historic. They were interested in objects that represented the glorious past of the Plains warrior and the "tipi lifestyle." Plains collectors shared some of the attributes that Molly Lee (this volume)

associates with "basket collectors." They had strict standards of authenticity and prized the traditional artifact, but whereas the basket collector desired evidence of prior Native use, the Plains collector sought objects that had belonged to famed owners or had seen battlefield experience.

A lively business developed in artifacts from the Battle of Little Big Horn and those associated with famous chiefs such as Red Cloud and Sitting Bull. Pat Ryan, whose Omaha letterhead described him as a "Dealer in all Kinds of Indian Goods and Relics," wrote to Pittsburgh collector John A. Beck in 1902, saying, "We have a great many articles which belonged to Noted Chiefs such as Geronimo, Sitting Bull, Red Cloud" (Ryan 1902). And during the thirty-three years she worked for the Indian Arts and Crafts Board, Nellie Star Boy Menard recalls, people frequently brought things in to the Sioux Indian Museum in Rapid City that they believed had once belonged to Sitting Bull or Red Cloud (personal communication, September 9, 1993). No one could have accumulated as many items as Sitting Bull is credited with owning, especially in Lakota society, which valued the generosity of gift-giving over personal ownership. No fewer than three rare hair-fringe shirts are attributed to Red Cloud, who was unlikely to have had more than one.[4] Mail-order catalogs, furthermore, offered original ghost dance shirts from the historic Battle of Wounded Knee, together with several that the catalog stipulated as "not historic" (Strong 1915: n.p.).

By and large, the collectors of Lakota arts were (and are) men. The preponderance of men in museum donor records and the ownership of collections still in private hands supports a particular gender alignment in the Plains that differs from that in other regions. Male collectors seem to have found the artifacts of prereservation warrior society particularly fascinating. These collectors were especially fond of the implements of war: bows and arrows, clubs, gun cases, knife sheaths, war society staffs, coup sticks, and shields are disproportionately numerous in museum collections, as are hide paintings and drawings on ledger paper depicting armed conflict. All manner of weapons were also readily available for sale in mail-order catalogs. L. W. Stilwell of Deadwood, South Dakota, advertised in his 1908–9 wholesale catalog: "I am making every effort among all the western reservations to keep a well assorted stock of beadwork and weapons . . . to supply dealers" (Stilwell 1971: 1). Pawnee Bill's Indian Trading Post offered seven different types of war clubs for sale (Lillie and Lyon, n.d.: 15–16). Weapons were consistently noted as an especially popular item for sale at the Wild West shows, the Omaha Trans-Mississippi Exposition, and the St. Louis World's Fair.

Men collected male war-trophy and status signifiers, such as feather "war" bonnets and hair-fringe shirts, which were often referred to as "scalp" shirts. Pawnee Bill's Trading Post sold five varieties of Lakota "war shirts" and eleven different types of "war bonnets" (Lillie and Lyon, n.d.: 15–16). These patterns of consumption are not only from the past; in a 1992 newspaper article, a male

Native American arts dealer in New York referred to a hair-fringe shirt once belonging to Chief Spotted Tail, then on exhibit at the New York Customs House, saying: "I'd kill 25 people for that shirt" (Reif 1992). Interest of this intensity continues among male collectors of Plains objects to the present.

Male collectors sought items made exclusively for Plains men, such as pipes and pipe bags, and large numbers of these have found their way into museum collections. In the photo of Charles P. Jordan in his store in Rosebud, South Dakota, numerous beaded pipe bags hang on the walls and from the rafters (fig. 13.4). Collectors were also interested in the gear used to decorate the horses that had contributed immeasurably to the development of a successful hunting and raiding society.

Exotic articles, such as baby carriers, moccasins, turtle amulets, leggings, and hide dresses also held appeal and were collected in numbers. These objects were probably considered representative of the prereservation "tipi days" and therefore unmistakably "Native." The hide, sinew, and other materials used to fabricate these objects and the techniques used to decorate them with porcupine quillwork and beadwork were also equated with "Indianness." Ironically, beadwork, which uses glass beads imported from Europe, was and continues to be the art most singled out as representative of American Indian work.

Since the collectors were mainly men, they had no interest in arts adapted to Victorian home decor, traditionally the domain of women, or in artistic objects modified for Victorian women to wear. It was the traditional items that interested these men. A Plains collection housed at home might be displayed in the collector's designated "Indian Room." Many of these rooms were clearly meant as men's spaces, filled with weapons mounted on the walls and mantle along with animal trophy heads and male forms of entertainment such as billiard tables.

Hide dresses and leggings, beaded baby carriers, and breastplates did not easily fit into a Victorian woman's wardrobe or her home. There was no impetus for Lakota items to be adapted to such new uses as Anglo-American women's clothing or feminine items of Victorian decor, as occurred in the Southwest and the Northeast. Furthermore, there was very good reason to maintain the prereservation status quo in Lakota arts. Plains collectors were attracted to these arts precisely because they retained the traditional prereservation forms, and so collectors and the intermediary traders stimulated and encouraged the Lakota to continue making these objects long after they became outmoded in Lakota daily life.

In addition to individual collectors, organized groups also commissioned and purchased Lakota arts. Some of the commissioned works incorporated group insignias. In one photograph, Sarah Blue Eyes, a Lakota beadworker living on the Rosebud reservation, holds a pillow ornamented with a Masonic design (fig. 13.5). The Shriners of Mandan, North Dakota, near Bis-

Figure 13.4. Charles P. Jordan at his store in Rosebud, South Dakota, 1912.
Photograph by J. S. Tannery, Madison, Nebraska. Courtesy of the Nebraska State
Historical Society.

marck, assembled a Lakota collection, and members dressed themselves in
Lakota warriors' clothing for organizational events (Dave Wooley, personal
communication, April 24, 1993).

Mail-order catalogs targeted organizations that required Native arts for
their activities. Pawnee Bill's Indian Trading Post catalog stated inside the
front cover: "We have Sioux Indian Curios for the Collector, costumes for
Medicine Shows and Movie Actors and make a specialty of fitting out RED-
MEN LODGES, BOY SCOUT and CAMPFIRE GIRLS organizations" (Lillie and
Lyon, n.d.: 2–3).[5] It is important to note that, with the single exception of the
Campfire Girls, all of these organizations, including the Masons, are frater-
nal men's groups. Other, less formally organized groups, again composed pri-
marily of white males, were American Indian enthusiasts known as hobbyists.
Powers identifies the hobbyist movement in the United States as a post–World
War II phenomenon, but dates "hobbyist-like activities" earlier, to at least 1910
(1988: 557–59). He postulates the origins to be the Boy Scouts of America In-
dian lore program, which was formalized with a merit badge in 1911.

Hobbyist activities have also emphasized the application of prereservation
arts, in particular the arts of Plains Indian people, such as tanning, quillwork,
and beadwork. Some hobbyists have themselves become quite proficient in
these arts, painstakingly fashioning replicas of Plains costumes, which they

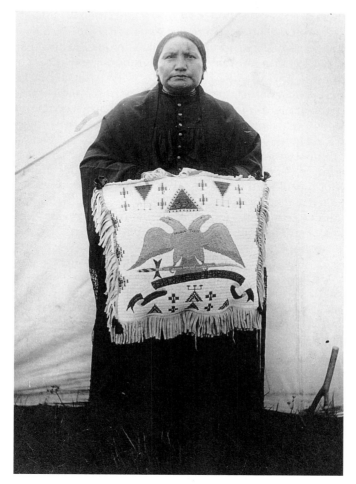

Figure 13.5. Sarah Blue Eyes holding a beaded pillow deco-
rated with a Masonic design, c. 1900. Photographer unknown.
Courtesy of the Nebraska State Historical Society.

wear in their powwows, the principal activity of hobbyist groups. From their
inception, these groups have looked to the prereservation past, emphasiz-
ing the Aboriginal lifestyle and arts of their Plains subjects, often forming
personal collections of historic artwork and purchasing pieces from Native
artists, which are newly made but in the old style.

Equally enthusiastic about Plains Indian Aboriginal life are European hob-

byists, particularly those residing in Germany and Great Britain, where there is a lengthy tradition of interest in Native Americans. Buffalo Bill's Wild West shows stimulated interest in American Indians among European boys, as did the writings of Karl May and others. German hobbyists dressed up as Indians as early as the late nineteenth century (Taylor 1988: 567). Through the decades European hobbyist group activities have regularly culminated in large tipi encampments of reenactors dressed as prereservation Plains Indians, attired in both replicated and Native-made costume components.

For the Lakota, their heritage was (and is) a source of great pride. Because art was an important link to the values of the old order, the continued production of traditional objects was not only a pleasant task but a reinforcement of meaningful social organization. The Lakota have continued to make quilled and beaded objects for themselves, as well as for others. Their culture maintains continuity with the past, but not just as a replica of an earlier era; Lakota culture is also the present and the future.

Attitudes exemplified by art collecting, however, have not helped to make the Lakota adequately known and understood by the modern-day non-Native populace, who have preferred not to connect the extreme poverty (the highest in the nation) and the severe social problems of the twentieth-century Lakota (which began with the move to the reservation) with the proud and prosperous warriors and hunters of the nineteenth century. Generated by the fame of the Plains Indian wars and their fanciful reenactment in the Wild West shows and expositions, the mold of the Lakota Indian was cast indelibly in nostalgia for the past; it is a tenacious image still accepted throughout the world and not easily extinguished.

These attitudes have contributed to a set of circumstances that together prevented the development of new forms of Lakota arts for non-Native markets, as happened elsewhere in North America. As a result, although many museum collections are indeed filled with Lakota arts made for sale, we have not recognized them as such because they look the same as arts made for Lakota use. The only difference is that they have never been used.

Studio and Soirée

Chinese Textiles in Europe and America, 1850 to the Present

Verity Wilson

In 1935 the ladies of the Morgan Park Woman's Club of Chicago were entertained at their spring luncheon by Mademoiselle Maria Leontine. This "international dancer," as she billed herself, gave a program of "Ceremonial Dances of China." The club ladies were not only delighted by the dancing but also thrilled "to see the exquisite collection of costly costumes she wore." We learn from Maria Leontine's publicity handout that these "costly costumes" were "magnificent," "ancient," and what is more, "not stage properties but authentic garments worn by Celestial ladies and men of other days." The accompanying photographs show this beguiling performer dressed in the type of embroidered robes that certain Chinese people might have worn forty or so years previously and that were fairly readily available for purchase by non-Chinese both within China and elsewhere.

Apart from what seem to be wedding garments, the dancer's clothes would probably not be recognized as ceremonial garb within the context of late imperial China. The ceremonies may have existed only in Mlle. Leontine's creative imaginings, even though in the gushing prose of her handout "she has seen much of foreign lands, and has absorbed the exotic manner of the far east."[1]

Maria Leontine invented new cultural meanings for the Chinese dresses she chose to wear. They literally clothed her in the mysterious aura of the East. It was what her audience expected. This reusing of clothes from the late nineteenth century to the present in circumstances different from those for which they were made is the focus of this essay. In particular, two types of clothing from China serve to illuminate a particular moment in colonial history. In different ways, both the dragon robe (fig. 14.1) and the fringed embroidered shawl embodied for their non-Chinese owners that country's

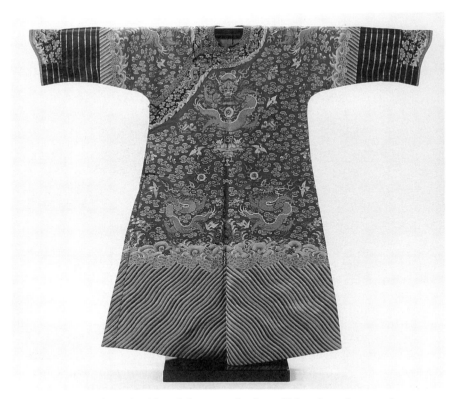

Figure 14.1. Man's embroidered dragon robe from China, late nineteenth century. Photograph by Ian Thomas. Courtesy of the Board of Trustees of the Victoria and Albert Museum, London (Museum no. T.219-1948).

supposed characteristics, although neither item falls entirely within the boundaries of tourist art.

The entire phenomenon of obtaining and using artifacts from another culture is comprehended only by reference to the notion of a discerning orientalism, first and most forcefully expressed by Edward Said (1978). Most work in this field has concentrated on an analysis of written texts. However, articles of material culture, when deployed in specific social contexts, are equally rich "texts" for a study of orientalist patterns of representation.

The dragon robe was used in China in the seventeenth, eighteenth, and nineteenth centuries as a hierarchical garment. It was worn by male bearers of rank in the Chinese bureaucracy. Its salient features are the hem design of stripes representing water with turbulent waves above, mountain peaks rising from the water, and symmetrically placed dragons among clouds covering the

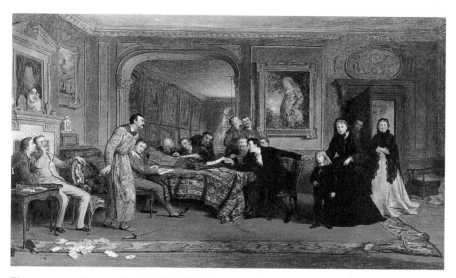

Figure 14.2. George Smith, *The Rightful Heir,* exhibited at the Royal Academy in 1874. Courtesy of Mallett and Son, London.

main body of the garment. It closes to one side with spherical buttons on shanks that fasten through loops. When worn in its original setting, the robe was part of an ensemble that included a plain dark overgarment with a rank badge sewn to back and front. This overgarment concealed all but the hem and the horsehoof-shaped cuffs of the dragon robe (V. Wilson 1986: 12–29).

George Smith's melodramatic painting *The Rightful Heir,* exhibited at the Royal Academy in 1874, reveals how far these meritorious Chinese administrators' uniforms could stray from their initial frame of reference (fig. 14.2). Somber-suited gentlemen are depicted sitting around a table studying a disputed will. Two frightened ladies in crinolines and a small boy in a velvet suit confront the wicked usurper, who is wearing a Chinese dragon robe. For the Victorians who viewed this painting, the robe not only visually singled out the imposter but marked his character as that of a "bounder," the implications being that "Orientals" were not to be trusted. The artist's choice of garment for his villain was deliberate, one he knew would be "read" negatively by his audience. This angry Victorian is as far as he could be from a dignified mandarin, and there are other "readings" of the dragon robe, as we shall see. How was it that dragon robes like this came to be transmitted to English drawing rooms even before the fall of the Chinese empire? What made them especially attractive to Europeans and Americans, so attractive, in fact, that any Chinese coat came to be called a "mandarin" coat? (A variety of Chinese dress styles reached the West in great quantity.)

To answer the first question, how the robes came to Europe, we should note three points. First, a Chinese who had been given rank and office in the civil service did not have his dragon robe ensemble bestowed on him as part of his appointment. He, his family, or a benefactor had to purchase the robes. The ensemble could be more or less grand according to his means. It could be specially ordered or bought off the peg. So, in a sense, the robes had always been commodities, and although this was not how the foreigners who bought them as souvenirs wished to see them, it did make them available. Second, there were plenty of them. Twenty thousand civil and military officials helped govern the country during the Ming dynasty, and the number was not much smaller during the succeeding Qing dynasty, from which most of the extant dragon robes come. Third, their use was not confined solely to officials. Bridegrooms traditionally wore the dragon robe ensemble or an approximation of it on their wedding day, even if normally they were not entitled to do so. Toward the end of the imperial period, rank could be purchased; it could also be bestowed on individuals for services rendered. The powerful Canton merchant Wu Bingjian (1769–1843), or Howqua as he was known to foreigners, was painted several times wearing the dragon robe insignia of his purchased rank in a pose of studied casualness alien to the conventions of accepted Chinese body language. However, when we understand the circumstances of the paintings' execution it becomes clear that they were not destined for a Chinese audience at all, not even for the sitter himself, but were done to bolster Western interests in the China trade. Wu Bingjian was favorably regarded by Western merchants, and the Westernized portraits of him (all copied from an oil painting by an Englishman, George Chinnery [1774–1852]) stressed this apparent accord (Clunas 1984: 54, 57, plate 34). Howqua's dragon robe arguably lent official weight to this amity.

None of the people described above had achieved status through success in the civil service examinations, but we can speculate that these individuals eagerly appropriated the outward mark of status, in this case the dragon robe. Some foreigners in China could legitimately don the dragon robe. The large body of Catholic missionaries enjoyed the right to wear them, and the fathers were expected to exercise that right at certain formal functions. A handbook of Chinese etiquette, *Politesse Chinoise,* written for the missionaries and published in 1906, attempted to clarify the Chinese dress code, among other information. The author, Father Kiong, himself a Chinese Catholic, admitted confusion over certain points of dress.

In the years just before the establishment of the republic in 1911, certain non-Chinese were given quasi-official rank in the Chinese bureaucracy. Edward Brennan was one such person. An official of the European-staffed Imperial Chinese Maritime Customs, he was granted the right to wear the insignia of the First Class of the Third Division of the Imperial Chinese Order of the Double Dragon on December 18, 1908. A list of the clothing that com-

prised his dragon robe ensemble survives, as does part of the regalia itself and a photograph of him wearing it (fig. 14.3).[2] Unlike the missionaries, he was never required to wear the attire on official duty, so the clothes became essentially just a kind of fancy dress. When his service abroad was over, he took them home as a memento of China. The orders bestowed on foreigners were not the same as those given to the Chinese but were created especially for Westerners. Thus, Edward Brennan and those like him could endow themselves with a little Chineseness without sacrificing their perceived Western attributes. As with all non-British titles, permission to accept such an honor had to be granted by the reigning British monarch, and the understanding was that such acceptance did not then entitle the holder to the privileges of the British title system. Edward Brennan's investiture document in the name of the king of England, Edward the Seventh (r. 1901–10) clearly states this, implying the inferiority of foreign ranks. The anxiety about becoming submerged by another culture runs through many of the sources quoted here. Even the dancer Maria Leontine, despite her seeming willing immersion in the manners of the East, retained, we are told, "the clear seeing vision of her own United States."[3]

So dragon robes were not hard to obtain. In the nineteenth and early twentieth centuries, even within the Chinese community, their exclusivity had been undermined. If we follow Igor Kopytoff's (1986) model we can think of dragon robes as having "life histories." In his essay "The Cultural Biography of Things: Commoditization as Process," Kopytoff suggests that the different types of biographies that anthropologists use to build up a profile of a given society can be just as fruitfully applied to things as to people. Similar questions, he argues, can be asked about both artifacts and humans, and the resulting answers can "make salient what might otherwise remain obscure" (1986: 66–68). Where does a dragon robe begin its "life," who made it for whom, and what did it represent for the succession of people who owned it? A robe may have been ordered by a Chinese bureaucrat who could have been casual or careful in his color and design choices within the set limits. It would have passed through several hands during its production and been worn, admired, cared for, stained, or torn. Maybe it was discarded, sold, and exhibited in circumstances vastly different from those at the beginning of its life. All those possibilities raise pertinent questions about the material culture of a society. What most concerns us here is the point at which objects move away from their expected life patterns, as all dragon robes have done to a greater or lesser degree, and are, as Kopytoff says, "culturally redefined" (1986: 67). At this stage in their biographies they are exposed to what anthropologists have termed a diversion (Appadurai 1986a: 16–29). The conditions have been set for them to be sold to Westerners.

Why did Westerners buy them? The criteria of age and quality, although important, did not seem to be uppermost in the minds of the foreigners who

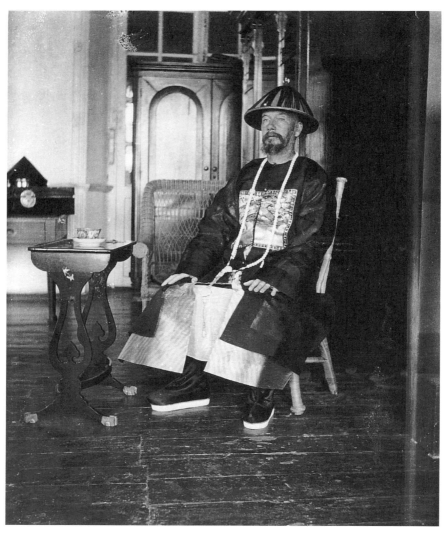

Figure 14.3. Edward Brenan, a deputy commissioner in the Imperial Chinese Maritime Customs, wearing dragon robe insignia, c. 1908. Courtesy of the Far Eastern Department of the Victoria and Albert Museum, London.

sought to own them. Few robes had any antiquity at all when they were first purchased, although sometimes the "sales pitch" probably convinced the buyer otherwise, and there is evidence that Chinese embroidery in general was exposed to smoke and to the sun to make it appear old (H. Strong 1933: 258). The majority of these garments are adequately but not supremely crafted. It seemed to satisfy the customer that they were "all done by hand," as if this mode of production were unique to China and commanded a special reverence. (The implications of handwork are discussed later.)

Despite their commonplace nature and the ease with which they could be obtained, dragon robes represented for some Europeans the spirit of the East. Everything certain Westerners wanted to believe about China was embodied in these garments. At the very time that Chinese society was going through a series of disastrous dislocations, dragon robes were held up as symbols of an ordered empire, static and wisely ruled. This picture, as we know and as many knew at the time, was far from the truth. Foreigners came to localize in dragon robes all the potentialities of a civilization they perceived to be as far removed from their own as was possible and to project onto the costumes all their personal aspirations of what a society should be like. They took home these robes as tangible evidence of a myth.

The "life histories" of oriental carpets, which Brian Spooner (1986) writes about, in some respects parallel those of dragon robes. Although the carpets are commodities, they also function partly as symbols. Their semiotic charge, an important ingredient in making a carpet "authentic" as defined by dealers and collectors, is achieved in several ways. One way, for example, has been to reconstruct the meanings of the decorative elements that had been forgotten by the most recent generations of weavers. The paucity of available information concerning these carpets means that Westerners can make them fit their own needs. This is what happened with dragon robes. Their Western owners sought to equate each isolated motif with a particular felicitous sentiment in ways that would probably not be recognized either by those who produced them or by the Chinese civil servants who wore them.

A standard practice with souvenirs from any destination is to give or send them to friends who stay at home. Dragon robes functioned on this level too and in so doing were twice or more removed from their original sociocultural context. The possibilities for their misinterpretation were thus compounded, and it is easy to see how fantasies grew up and were perpetuated around them. We could go further and say that mystification was an essential corollary to the appropriation of these robes.

An earnest English diplomat we know only as Scott provides a telling example of this mystification, despite the fact that he saw himself as a serious student of China and had a seemingly genuine wish to understand the uses and meanings of the dragon robe. Part of his interesting letter regarding dragon robes is lost, including the exact date, but we know from a reference

to the republic that it was after 1911, when dragon robe insignia were no longer worn officially in China.[4] It seems that Scott took it upon himself to purchase a dragon-robe set in Beijing for a friend back in England. It is not entirely clear whether Scott himself did most of the buying, but at least one item, the hat plume, was purchased for him by his Chinese teacher "by means of wise pulling." He explains this as "what [an] Englishman would consider a very sharp nature." From the tone of the letter it seems that by this time the sale of dragon robes, if not a completely open affair, was at least a feasible one for those "in the know" and needed no particular credentials. Some items did prove more difficult to obtain than others, but the slightly clandestine nature of the transaction hinted at in this letter serves to shroud the whole process in a deliberate equivocalness rather than arise from any unease on the part of the purveyor about the disposal of such potent apparel.

The correspondent says that "the purchase of this outfit has afforded me no end of pleasure, instruction and amusement," and despite a veneer of fun, there is a pressing insistence that his friend in England should know how all the parts go together and what each one is called. To this end, Scott was to forward "a complete set of photographs explaining all the details with regards to the wearing of these clothes including a set of pictures of the various movements of the Kow-tow" (Hevia 1993: 57–58, 62–66). He is upset that the pigtail is missing and thinks the outfit is "ruined without it." Although there seems to be an emphasis on "getting it all right"—comprehension of the minutiae of the dragon robe will lead to an understanding of "China"—the whole transaction in fact reinforces the perceived "otherness" of Chinese people.

British and American families who own dragon robes today and have inherited them from a past generation do not, by and large, view these garments as commodities. They may tacitly acknowledge that the robes were looted on the occasions when the Western powers, "to protect their interests," used violence against the Chinese population. But they rarely say the robes were purchased in the marketplace because to admit as much would be to strip them of those associations held so dear by their owners—that is, the mostly erroneous link between dragon robes and the Chinese imperial court. A dragon robe that can be described as "looted from the Summer Palace," with all its aristocratic ramifications, becomes a desired provenance, whereas owning a robe that was merely shopped for impoverishes that provenance (Hevia 1994).

A series of exhibitions of Chinese dress in museums across North America from the 1940s on, while bringing much thoughtful information to our attention, nonetheless did nothing to dispel the myth that dragon robes were thoroughly bound up with the person of the Chinese emperor. The exhibits, and the books and catalogs that accompanied them, were often provocatively titled—*Costumes from the Forbidden City* (Priest 1945), *In the Presence of the Dragon Throne* (Vollmer 1977), *Secret Splendors of the Chinese Court* (Denver Art Museum 1981), and *Dragon Threads: Court Costumes of the Celestial Kingdom* (Apfel

1992)—but these titles are misleading. Although some dragon robes from these exhibits have some connection with the imperial court, the majority of them do not. This supposed connection, however, is the aspect that the visiting public prioritized and retained. The belief in courtly associations is hard to shake and greatly increases the coats' desirability.

Given these overwhelming courtly and aristocratic connotations in the Western cultural imaginary, it is hardly surprising to find a dragon robe used as prop in the opulent setting of John Mansfield Crealock's painting *The Red Sofa,* dated 1912, the year after the much-reported and much-anticipated fall of the Qing dynasty (1644–1911) and its replacement by the Chinese Republic (fig. 14.4). Balanced at opposite ends of the sofa are the twin "others" of the feminine and the Orient, the latter lending an aura of cultured aestheticism to the stark blocks of color that make up the composition. The effect is the same as the French words that adorn the conversations of the heiresses in the novels of Henry James (Lurie 1992: 7, and last colorplate between pp. 178 and 179).

It is obvious then that purchasers of dragon robes wished to possess them in order, as Nelson Graburn says, to "get close to the native spirit." In his introductory chapter to *Ethnic and Tourist Arts* (1976), Graburn centers his discussion on a redefinition of the terms "folk art" and "primitive art." Building on an earlier study, he identifies different types of "Fourth World" art and recognizes the interrelatedness among them. One type, souvenirs, he defines as artifacts made to satisfy the customer rather than to please the artist, where "the profit motive or the economic competition of poverty override aesthetic standards" (1976a: 6) He does concede the many instances of traditional arts being sold as souvenirs, and these would include dragon robes. Even before they came to be made especially for foreigners, they possessed Graburn's defining requisites for souvenirs. He writes that souvenirs should be "cheap, portable, understandable," and "it helps if they are useful" (1976a: 15).[5]

The dragon robe fulfills all of Graburn's criteria. Its survival in such numbers means that it could never have cost a vast amount of money. Although it is now difficult to compare prices, we know that in 1908 Edward Brennan paid twenty-five Mexican dollars (those silver dollars being one of the usual currencies in China at that time) for his dragon robe and 1.8 dollars to the tailor who made it up. In the period after the 1911 revolution, Scott paid twice that sum for his friend's robe.

These straight-seamed garments were easy to pack and transport, and as for being "understandable," it helped, of course, that the dragon robe was immediately recognizable as a garment. Its shape meant there was little hesitation about the way to put it on, although, not being gender-specific to Western eyes, it was frequently worn by Western women as well as men. The robes were interpreted by their new owners in ways that best accorded with their particular unquestioning view of a timeless China.

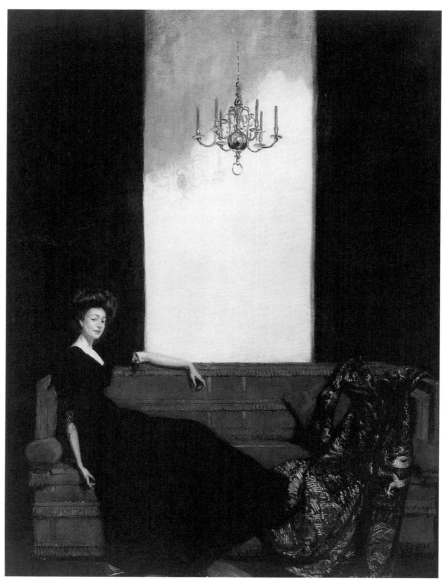

Figure 14.4. John Mansfield Crealock, *The Red Sofa*, exhibited at the Royal Academy in 1912. Courtesy of Mallett and Son, London.

This near-reverence for an artifact from far away did not, however, prevent the robes from being altered to something more useful—Graburn's final mark of a souvenir. The wicked uncle's dressing gown in Smith's genre painting (fig. 14.2) has had the horsehoof cuffs taken off and the original buttons transferred from the side to the sleeve ends, where they become a decorative feature rather than a means of closure. A tasseled cord has been added round the waist, and the whole has been transformed into something more wearable in European terms. An 1895 catalog of Yuletide gifts from Liberty's store in Regent Street, London, suggests other uses for these Chinese garments. It informs us that "these robes form some of the most beautiful examples of Chinese needlework. Used in the original shape, [they] are suitable for fancy costumes, or reconstructed to form square or oblong pieces, [they] are invaluable as draperies for pianos, table covers and wall hangings." Prices ranged from three to ten guineas.

Dragon robes became invalidated on reaching Europe, even though they may have been purchased as authentic signifiers from within the culture. There is no doubt that at first most foreigners acquired the genuine article because the supply was so abundant. Although we can discount Maria Leontine's dictum that Chinese embroidered robes like hers were "extinct" by 1935, there was a development in the making of silk wearing apparel in modified Chinese style and decoration from the 1920s onward, if not before. Most of these garments were for women and were styled "mandarin coats," "coolie coats," and "lounging garments" (Herman 1954: 157). Not until the Second World War do we have evidence of nearly exact copies of dragon robes being made especially for sale to the Allied troops stationed in India.[6] Itinerant Chinese salesmen toured the encampments selling trinkets to take back home. Dragon robes in pastel shades with widely spaced embroidery motifs were among the things offered, and in 1980 the New York department store Bloomingdale's, as part of a Chinese merchandising venture, displayed Chinese robes on loan from the Metropolitan Museum of Art alongside reproduction garments that had labels in English and Chinese stating "Made in China for Bloomingdale's." Bloomingdale's stressed the handmade aspect of all the Chinese crafts they had imported, but as Debora Silverman says in her critique of this China project, the artifacts "were produced at human assembly lines, where massive orders for hand-painted fans, bowls, plates, and clothes were filled by intensive division of labor and specialization. The 'timeless artisans' who supplied the Bloomingdale's shelves and racks worked at repetitive, painstaking tasks in which scores of skilled laborers contributed a monotonous small part in the creation of a single craft product" (1989: 29).

Chinese shawls were featured in the Bloomingdale's marketing initiative; earlier, British soldiers had brought them back from India. The "biographies" of the shawls contrast with those of the dragon robes, however. A picture from a trade catalog published by the China National Textiles Import and Export

Corporation in 1979 shows a Chinese model advertising one of these shawls. The promotional photograph could be seen as misleading because, unlike dragon robes, the shawls were never worn by the Chinese themselves. The shape is entirely unknown in the annals of traditional Chinese dress. They were a bulk commodity exported from China to Europe and America, and they figured prominently in customs lists and silk statistics. Like Chinese porcelain produced for export, they were expressly for foreigners and, in that respect, they follow an established path.

There is some tentative evidence to suggest that these flamboyant wraps were first ordered by traders from Latin America and that the style may, in part, be based on the Mexican rebozo, a large fringed mantle. Some rebozos are known to have been woven from Chinese silk (Robinson 1987; V. Davis 1988). A Spanish prototype for these Chinese shawls should perhaps be questioned: although Spanish ladies undoubtedly wore shawls and mantillas before the Chinese started exporting their version to the West, an extensive search through Spanish pictorial archives of the eighteenth century has not yet produced a single representation of an embroidered and fringed shawl like the Chinese shawls. It is possible that Chinese artisans, encouraged by foreign merchants, invented this artifact in order to sell it, perhaps adapting a Hispanic American style in the late eighteenth and early nineteenth centuries. When these appealing garments found their way to Spain, they were taken up enthusiastically and appear there with great regularity in paintings and early photographs, so much so that they almost seem to have been adopted as part of the national dress of Spain (Ortiz Echagüe 1933; Aguilera 1948). They also started to be manufactured in Spain itself directly after the style of those made in China (Robinson 1987: 70).

In the three countries of production (China, Spain, and the Philippines), the embroidered designs on the shawls are flowers or motifs taken from the traditional Chinese patterning repertoire. This decoration is in fact "a debased exoticism, signalling in the design sphere China's increasing political and economic subordination to the West. Dragons, bamboos and pagodas are combined and recombined to emphasize a stereotyped 'mysterious' East" (Clunas 1987: 20).

There is some dispute over when the shawls were first made and when they became popular in Europe and the Americas. Fashion plates in journals from both sides of the Atlantic illustrate "China shawls" from the early 1800s onward, but the shawls in these pictures do not always look like those that today we regard as having been made in China. The incorrect identification of the countries of origin of these shawls points up the West's ignorance of Asia. Their starting date of manufacture cannot have been much before the end of the eighteenth century. Even so, Liberty of London saw fit to advertise in its 1930 catalog of shawls one that was "reproduced in China from an old Chinese shawl," thus giving the impression that they had a long history of pro-

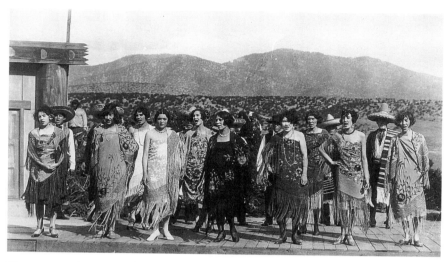

Figure 14.5. A troupe of female performers, Los Trovadores de Santa Fe, New Mexico, 1926. Courtesy of the Museum of New Mexico (Neg. no. 52742).

duction and that they were an item of dress with which the Chinese were familiar, two assumptions we know to be false (Liberty and Co. 1930: 10).

Although precisely dating the shawls is difficult, their Chineseness seems not to have been stressed in the early and middle decades of the nineteenth century as much as it was later. In the earlier period, white-on-white versions were particularly popular for brides and lent them a demure air (J. Lee 1984: 178, 218). By the 1880s, this connotation had been lost, and Chinese fringed shawls came to have "arty," somewhat bohemian associations. They no longer belonged to the mainstream of fashion and were featured in nearly all of Liberty's catalogs. The first of these, produced in 1881, set the tone by announcing the availability of these shawls in "art colours" (Liberty and Co. 1881: 120).

Perhaps it is at this point that the Spanish and New Mexican dimension fused with the Chinese in the minds of northern Europeans, imbuing these shawls with a mix of gypsy abandon and a promise of the East. A photograph from 1926 shows a troupe of female performers, Los Trovadores de Santa Fe, dressed in almost nothing but these silk shawls (fig. 14.5). Several issues of a Parisian magazine, *Les Modes,* illustrate mannequins dressed in the same way during the 1920s; and in 1925 an export shawl was exhibited at the Exposition Internationale des Arts Décoratifs et Industriels Modernes in Paris. Millen and Company, which displayed the shawl in this ambiguous presentation of Chinese design, must also have been the type of import-

export business that supplied the ladies appearing in *Les Modes* (Clunas 1989: 104–5).

Time and again, from the end of the nineteenth century to the 1930s, the Chinese embroidered shawl stands for all that is fiery, risqué, seductive, and sensuous—anything, in fact, that is apart from the ordinary. Kees van Dongen, a Dutch painter who often joined Picasso in sketching the lion-tamers, clowns, and acrobats at the Cirque Medrano in Paris, characteristically clothed his models in Chinese shawls or draped the shawls over balconies in the portraits he painted around 1910 (see Dongen 1990: 65, 157–58, 211). In the 1970s Harry More-Gordon, a Scottish painter, posed his nude model on a shawl in a painting called *Bed of Roses*.[7]

The performing arts, too, have featured the shawls as added "atmosphere." Describing Odette's house in the first part of *Remembrance of Things Past*, Marcel Proust writes that Swann left his lover's bedroom and "climbed a staircase that went straight up between dark painted walls hung with oriental draperies, strings of Turkish beads, and a huge Japanese lantern suspended by a silken cord" (Proust 1985: 1, 240). In Volker Schlondorff's film *Swann in Love*, based on Proust's novel, the set designer realized the "oriental draperies" of the text as shawls from China. And in the 1982 Franco Zefferelli production of *La Traviata*, Theresa Stratas languished as Camille against cushions spread with Chinese export shawls.

In its July 1927 issue, the *China Journal*, an English-language periodical for the expatriate community in Shanghai, carried an article on European motifs in Chinese art. But the advertisements, often so telling about Western aspirations in China, are particularly noteworthy. Again, a wide range of artifacts and services are offered, including passage home ("home," of course, being tacitly understood as the more "civilized" shores of Europe and America). Also advertised are art curio stores, which undoubtedly sold both dragon robes and shawls and to which those contemplating booking passage home surely repaired to secure souvenirs that embraced the Chinese way of life as they saw it. The advertisement for "Foot Ease" chiffon hose, or tights as we now call them, made for the dancer, depicts a lady of European origin dressed in only a fringed, floral shawl and mantilla. As she dances to the rhythm of the castanets she holds aloft, she shows off her legs, presumably clad in "Foot Ease." Shawls had become firmly connected with dancing, abandon, and the stereotypical Spanish way of expression. The colonials who leafed through the magazine could not have predicted the irony such a picture presents to us today.

In conclusion, both the dragon robe and the shawl function as souvenirs. Each is a synecdoche, a part of the whole, where that whole is "China." Their biographies form part of the larger inscription of the Western self on the world of goods (S. Stewart 1984).

15

The Indian Fashion Show

Nancy J. Parezo

"Something *really* new for fashion show followers is being staged tomorrow at the University Museum," declared journalist Judy Jennings in the *Philadelphia Inquirer* in 1952. "An Indian Fashion Show with a magnificent collection of authentic North American Indian women's costumes from many tribes and periods will be modeled with commentary by Dr. Frederic H. Douglas, curator of the Department of Native Art in the Denver Art Museum" (Jennings 1952). The presentation, one of a series begun in the early 1940s, featured "the latest thing in a skin housedress, which by the simple addition of a wool shawl becomes 'an afternoon tea-time frock'" (*Denver Post* 1950). Conceptualized as a specialized haute-couture show, the Indian Fashion Show was a living museum exhibit, social event, costume party, collection of cultural treasures, entertaining stage show, and popularized research enterprise. It was one of the most successful anthropological outreach programs ever presented in the United States because, as "the last word in fashion shows," it was unique, original, and captured the audience's imagination (*Denver Post* 1950). Through this ingenious venue, Douglas stimulated American fashion design; he transformed museological heirlooms and ethnographic specimens into art and design possibilities for a rapidly changing industry during a period when Americans sought to express their nationalism and civility by combining nostalgia and futurism.

By creatively using the mechanism of ambiguous authenticity to manipulate the categories of art, fashion, and universality, the scholarly Douglas became an educator and tastemaker who eradicated the dualistic distinction between art and artifact in women's culture. Rather than transform indigenous dress into commodity itself, Douglas's Indian Fashion Show worked through a variant inscription of the Western modes of commodity produc-

243

tion described by Ruth Phillips and Christopher Steiner in their introduction to this volume. Conceptualized as respectful borrowing between equivalent cultures rather than as appropriation, Douglas's show presented women's art (i.e., clothing and personal adornment) as design inspiration that could be manipulated by modern fashion designers to clothe the modern woman. He utilized Indian dress much as European painters used primitive art as design inspiration or as the Indian Arts and Crafts Board felt Indian pottery and baskets could be utilized as decoration for the modern home. The process amounted to a repositioning of indigenous dress as haute couture in an attempt to eradicate what Douglas felt to be prevalent false hierarchies between primitive art and fine art, indigenous people and "civilized" people, men and women—hierarchies that debased and marginalized the artistic efforts of indigenous peoples.

The Indian Fashion Show raises many questions about the role of museums and anthropologists in the commoditization of American Indian art: issues such as race, class, ethnicity, authenticity, gender, images of women's bodies, aesthetics, primitivism, representation, modernity, and conspicuous consumption.[1] In this essay I outline and briefly discuss Douglas's challenge to the existing dichotomization of art and artifact—a challenge that he, together with René d'Harnoncourt, had already tackled through their innovative exhibits at the 1939 San Francisco world's fair and at the Museum of Modern Art in 1941. For more than a decade, Douglas sought, through creative exhibits and educational programs at the Denver Art Museum, to combat the devaluation of women's art and to create a more humane world through the elimination of prejudice and intolerance. In the process he afforded Indian attire a place in modernity, although he relied on Euro-American designers to actualize this. An examination of the Indian Fashion Show reveals the effectiveness of commoditizing venues as premier marketing events. At the same time, it offers a critique of all commercialization and modernizing efforts. As will be demonstrated, Douglas used a universalizing argument of a feminine love of beauty and a humorous presentation in which irony and satire were the rhetorical devices for a moralizing critique of American consumerism. Just as modernist artists "discovered" non-Western art, so Douglas showed American women and designers how to "discover" indigenous dress and fold it into their own social categories. Yet at the same time, Douglas presaged the postmodernist critique of modernity by lampooning fashionable rhetorical pretensions.

THE INDIAN FASHION SHOW

The Indian Fashion Show was a product of Frederic Douglas's fruitful imagination. It was developed in 1941 and presented throughout the United States eight times in 1942 before Douglas was drafted, and more than 180 times

between 1947 and his death in 1956. It consisted of fifty-three of what Douglas called "colorful, imaginative and ingenious" historic ensembles from thirty-five different cultures. Made between 1830 and 1950, all were part of the Denver Art Museum's collection and had been amassed by Douglas during the 1930s and 1940s.[2] Douglas acquired the dresses from Indians, families with pioneer ancestors, and traders and merchants specializing in Indian art, as well as through exchanges with other museums. The pieces were deliberately chosen to reflect Indian artistry and the breadth of stylistic variation exhibited by Native American cultures. They were genuine, technically perfect, aesthetically pleasing in the maker's and Anglo-American cultural paradigms, and "typical" yet outstanding. There were no uninteresting or unrefined dresses, just as there are no uninspiring artifacts in the Denver Art Museum, due in no small part to Douglas's collecting and representational strategies.

Douglas was one of the country's foremost museologists and ethnographic material culture specialists. He was also one of the first to combine training in anthropology and art history and studio art in a descriptive ethnographic paradigm. The Indian Fashion Show was the outcome of Douglas's research on clothing,[3] as well as his passion for collecting objects with aesthetic quality using principles of connoisseurship. It also reflected his desire to make museum exhibits more interesting and his insistence on using original materials to illustrate lectures.[4]

Douglas designed the Indian Fashion Show to promote interracial understanding; he dramatically pointed out resemblances between peoples and showed that other cultures exhibited aesthetic merit that could be admired in Euro-American terms. Douglas wanted to prove that Americans should *not* emphasize the "slight superficial differences between the races" and that anthropologists could destroy barriers between peoples by teaching the *genus touristorum Americanorum* (as he described middle-class Americans) to eliminate racial and cultural stereotypes, especially those about American Indians.[5] As a member of the Indian Arts and Crafts Board, Douglas was also committed to promoting and encouraging Indian art. He saw museum exhibits as an ideal venue for educating the buying public. Exhibits were crucial tools in an economic development venture to convey aesthetic principles and create markets.

To accomplish these goals and encourage cultural cross-fertilization, Douglas had to eliminate prevalent and tenacious stereotypes. He proposed to show that (1) there was no such thing as a generic Indian; (2) Indian women did not wear feathers and head-bands; (3) Indians were not naked and dirty; (4) Indian women created art and had good taste; (5) "primitive" peoples had fashion, and their clothes were not fossilized; and (6) Indians were not dead. Douglas wanted to take on the great American myths about Indians as portrayed by movies, novels, and Wild West shows.

Douglas's original goal was not to transform artifacts into commodities but to increase cross-cultural understanding through racial and social tolerance. He felt that it was women, not men, who could do this. To quote him from a 1954 interview:

> A new family moves into a block, the old-timers notice the new housewife uses three clothes pins instead of two to hang out her clothes. They say, "She is different," and they feel she is wrong. They shouldn't. She is just a human being, same as they are. If they would start thinking about her many points of similarity to them instead of that one little quibble of difference, they would accept her. That's the thing about these dresses. The women see them, and they realize Indian women are interested in pretty clothes, too. . . . [The show] helps to promote a feeling of kinship. (*Waco News-Tribune* 1954)

Douglas chose women as his tool and audience because he felt that one "genetic" trait, a common instinctual interest in pretty clothes, had universal applicability and overrode cultural and racial distinctions. He argued:

> Women of both Indian and White groups share a deep common interest in fine clothing and have achieved results which in many ways have remarkable similarity in purpose and function if not in actual details. . . . Like her White sister the Indian woman is well aware of new materials for construction and decoration, and of the most effective use of these. Her styles change more slowly than those of our life—but in response to the same felt need for something different now and then. She recognizes clearly that different types of garments are indicated for different purposes; that dressing up does something important for a woman's psyche. (Douglas, n.d.)

Douglas was, however, ambivalent about fashion. As an adherent of the sociologist Thorstein Veblen's theories, he saw fashion as essential but frivolous, irrational, and overly confining, something only those with wealth and leisure could engage in. Nevertheless, it was useful and even necessary for modern society, for it invigorated, opened up new vistas, enriched and diversified life made monotonous by mass production. Since fashion was for the wealthy and trickled down to the masses and Douglas wanted to induce cultural change, he presented his message to a select social group. He chose Euro-American middle- and upper-class women because he thought they were educable. This idea was based on the old Chautauqua model of the lecture series as a venue for inducing social reform.

The living exhibition was innovative museologically. It was designed to move away from what Douglas described as anthropology's "queer suspicious, formal atmosphere" of cluttered displays and boring lectures, bits and pieces of disjointed information, and the artificial separation of "primitive" and "civilized" peoples. To catch the audience's attention and educate unobtrusively, Douglas decided that the Indian Fashion Show had to display the *best* fashion artistry he could locate. His choices were clearly

based on a connoisseurship approach to the material; he rejected clothing that did not express dignity or elegance. The dresses were not representative of "average" technical skill; there were no rags, no plain or skimpy dresses, no examples of inexpensive or lower-class housedresses, no army-surplus coats obtained from whites without cultural reinterpretation. There was nothing that could not be designated traditional with the patina of a valued heirloom. Just as an haute-couture show by definition presents the most original, creative, startling, and beautiful apparel in order to influence the market, so Douglas displayed only clothing that he considered worthy of notice and emulation—colorful artistry of the finest quality. The outfits were not ideal types, nor was there a one-dress-to-one-culture equivalency. Each ensemble was aesthetically pleasing and chosen to make an impression, but it was not a contrived reflection. Douglas insisted that he was showing authenticity, not someone's preconceptions of what Indians "should" look like.

The Indian Fashion Show was embedded in Douglas's extensive scholarship and contained no replicas or reproductions. With the exception of some moccasins, everything was handmade by Indian women. But Douglas's choices represented a selective reality—that of the Indian princess rather than the hardworking older woman, or "squaw." The attire of princesses would speak for all women in a venue designed to express universalist inclusiveness. Indian princesses became the equivalent of Euro-American princesses. As Douglas told a colleague while planning the first presentation:

> My basic idea is to give a style show exactly like the conventional ones except for the clothes. . . . I believe the whole point of the thing will be to stick as rigidly as possible to the usual formula and make the kick of the radically different clothes come from the contrast of them to the usual kinds of women's wear. Then we can demonstrate that "high fashion" has always existed and that women are women the world around.[6]

Douglas presented women with new values for indigenous dress as well as a critique of fashion in contemporary American society, the model of Indians as the natural holders of good taste who can and should be emulated, and a new exoticized romance myth. In the process he influenced fashion in the United States by furnishing new ideas to an industry constantly seeking new looks; he manipulated the cultural meanings of dress, eradicated the distinction between art and artifact, and gave new expressive properties to dress-as-art. In order to demonstrate how effectively Douglas did this, I summarize here how he consciously and unconsciously provided something for everyone through his use of ambiguous authenticity to reposition ethnographic clothing as art and as a source for clothing design using one of the first arguments for a universal women's culture.

PRESENTING INDIAN ATTIRE

Tall, with silvery hair and a marvelous stage presence, Douglas commanded the audience's attention as he described the individual ensembles. Douglas began each show by stressing "the deep common interest that both Indian and white women share in fine clothing and how they have achieved results which in many ways have remarkable similarity in purpose and function if not in actual details of materials used."[7] He noted that "all of the clothes are of Indian manufacture and none is a replica, a costume for a Wild West Show, or someone's idea as to what an Indian dress ought to be like." He thus immediately assured his audience that what they would see was authentic.

Models came on stage singly, as they would in a standard fashion show. He first presented a series of dramatic dresses to startle and captivate the audience and to subconsciously make the point that Plains women were like Parisian fashion models: statuesque and just as skinny. Douglas's first script emphasized that good taste was an everyday matter; he labeled the first dress, a Cheyenne deerskin dress, a housedress. "The basic T-shape Plains dress of deerskin was a long neck-to-ankle affair with little or no decoration. This work dress of about fifty years ago is lightly beaded and has a touch of painted decoration. It has square-cut sleeves ending in long fringes, both red and yellow paint supplementing the beading, and tin jinglers at the lower corners." Next came a semi-formal Ponca dress made of a quill-decorated deerskin to emphasize that the Plains dress was used for special occasions. This ensemble was followed by a Cheyenne blue-beaded deerskin dress: "The formal dress of a wealthy matron of 75 years ago, a 'mid-Victorian' style" that is "classically simple." With these three pieces Douglas made his basic points: that the clothing of Plains and white women shared functional equivalency, timeless good taste, dramatic flair, and basic forms and variations and were appropriate for specific social purposes.

In order to present the garments as universally beautiful apparel, explicate what was implicit in the images, and translate the traditional into established modern cultural categories, Douglas used an interplay of concepts that his audience understood—fashion, antiquity, timelessness, modesty, and beauty—glossed by fashion terminology that he had found in *Vogue*. For example, as a woman walked on stage in an old-style Oglala Sioux dress and held out her arms to display the dress's detail, Douglas said: "This Plains basic T-shaped dress is made of beautifully tanned white deerskin cut with an immense full-beaded bodice that emphasizes and is enriched by white beads. The distribution of beadwork and decorative fringe is perfect, and the use of eagle down on the bodice gives an extra elegance. Highlighted by a matching beaded belt, leggings, and moccasins, it is high fashion on the Plains at its best!" (See fig. 15.1.)

Douglas occasionally shifted from gendered fashion rhetoric to a more

Figure 15.1. Oglala Sioux white beaded deerskin formal,
dress no. 5. Old style, made in 1885, South Dakota. White
tanned deerskin with white beaded yoke bodice with yellow,
red, black, and blue beads and eagle down feathers. Match-
ing row of beadwork at bottom and long fringe. Worn with
heavily beaded Arapaho leggings and moccasins and Arapaho
beaded bag. Northern Plains silver belt sometimes substituted
for beaded belt shown in photograph. Modeled by Radcliffe
College co-ed, November 1951. Photograph by Watson Smith.
Courtesy of the Museum of Northern Arizona Photo Archives
(Neg. no. MS 173-I-87).

didactic ethnographic voice in order to describe how a dress fit into historic time and place, noting especially the cultural origin, age, and history of individual dresses. The status of the original wearer was often described, especially when the ensemble spoke to the wealth and artistic abilities of the maker. Douglas directed the viewer's attention to the different materials, decorations, and decorative techniques used—woven cloth and skins, the hem cut, beading color, the length and fineness of fringing. With the Shoshone yellow deerskin formal, for example, he indicated the very long, fine fringes on the wing sleeves, the golden yellow of dyed deerskin, and the brilliant blue beaded bands on the bodice.

Douglas used dresses to illustrate an important principle of clothing design: that decoration is positioned for richest effect. To depict this he used several ensembles, including an 1885 Crow formal with a straight skirt and long, closed wing sleeves made of scarlet wool imported from Europe and "trimmed with Venetian glass beads in floral designs adapted on the Plains from the Great Lakes tribes." When the decorative effect was on the back, Douglas reminded the audience of its similarity to the emphasis on the back in Euro-American formal wear of the 1930s and 1940s. The head could also carry the key visual accent. A Caddo cloth formal, a black satin skirt and red cotton cape-yoked overblouse with a silver-trimmed deep bertha collar, was accentuated by "an elaborate and unique velvet butterfly headdress of cascading ribbon and silver brooches, adapted from the Pennsylvania Dutch or Germans, 250–300 years ago."

While using the flowery rhetoric of fashion shows humorously, Douglas actually relied on two overlapping but ultimately contradictory categorization schemes to demonstrate universal equivalencies. The first was data-based and grew out of his examination of museum collections: Douglas was very interested in constructing stylistic and manufacturing taxonomies that could be used to identify objects. He displayed a range of types so that the audience obtained an overview of selected clothing styles as cultural climaxes. He chose an example of the western fore-and-aft apron seen at its "highest development"—a Navajo two-piece wool, sleeveless, blanket dress, which was "made gay with a colorful wool sash, a blanket cape and appropriate silver jewelry." The eastern wrap-around skirt was represented by an Osage silk appliquéd wool formal (fig. 15.2): "a wrap-around broadcloth skirt worn with a velvet beaded blouse and a large shawl of broadcloth. . . . Both the skirt and shawl have quantities of colorful silk ribbon appliqué in the large floral bead-like design favored by the tribe. The sash of braided wool with interwoven beads can be worn tied in the back with ends forming something like a bustle." The northern slip-and-sleeve dress, typified by an Ojibwa old-style skin dress, had detachable sleeves—a style, Douglas noted, that was no longer made. This etic categorization stressed the idea that native dresses were variants on main garment ideas that could be designated classical traditions.

Figure 15.2. Osage silk appliquéd wool formal, dress no. 26. Two-piece dress shown without blue broadcloth shawl. Modern, twentieth century, Oklahoma. Navy blue wrap-around broadcloth skirt (folded and pleated) worn with navy blue blouse in wool velvet. Silk appliquéd in white and red made in floral beadlike designs. Appliqué also on red and green horizontal bands on skirt. Ribbon streamer in white, blue, and red hangs from braided wool sash in red, white, and blue, which could be worn as a bustle in back. Worn with plain, unbeaded moccasins and no leggings. Modeled by Radcliffe College co-ed, November 1951. Photograph by Watson Smith. Courtesy of the Museum of Northern Arizona Photo Archives (Neg. no. MS 173-I-91).

Like all museum curators, Douglas often authenticated objects. He insisted that anyone could identify the cultural origins of a dress by learning certain diagnostic features. He noted, for example, that a particular deerskin elktooth formal had tailored raglan sleeves rather than the more common cape sleeves and that only the Crow used this construction feature. But Douglas simultaneously demonstrated that cultural styles influenced each other and that groups constantly emulated and reinterpreted their neighbors' attire. He used a Jicarilla Apache deerskin formal as an example of the transformation that occurred when the western fore-and-aft apron dress met the Plains T-shaped dress; the addition of the short cape-sleeved blouse atop the heavily fringed Plains-style skirt demonstrated that crucial cultural reinterpretation had been successfully accomplished. Indian women's creative adaptability was also emphasized in the script for the Taos skin dress: "It is something like the basic Plains T-shape but has two-toned colored deerskin which made it distinctively Taos; it is unusual because the main decorated area is around the bottom of the skirt instead of the bodice. . . . The women of Taos were the only Puebloans to wear skin dresses and acquired them from the Utes or Jicarilla Apaches."

Douglas's second categorization was grounded in his common-sense understanding of middle- and upper-class women's clothing types, how dress was used in daily life, and what women expected to see in a fashion show. This functional typology stressed the occasions for which particular dresses were appropriate, theoretically reflecting contemporary suburban women's roles. Dispersed throughout were hints of how women could use American Indian women's creativity in their own social and artistic work if they followed Douglas's tasteful suggestions. Accordingly, the dresses were designated as (1) classical formals, such as a Ute red wool dress made of purchased cloth cut in the traditional T-shape pattern, texturally contrasted with deerskin side fringes and accented with a broad belt studded with brass nails; (2) colorful housedresses, epitomized by a Seminole patchwork everyday dress—a huge, cotton patchwork skirt, whose loose cape blouse of silk "makes the dress most colorful, bordering on abandon"; and (3) afternoon tea dresses, profiled by the Kiowa "red sleeves" wool dress (fig. 15.3), a Plains T-shaped dress with blue front and back panels, red side panels and wing sleeves, "accented by the effective use of a silver belt and soft white deerskin boots."

There were also ensembles for special occasions such as attending a religious service (i.e., church): "The wonderful Kiowa Ghost Dance Society ceremonial dress is made of pure white deerskin with small painted designs, particularly on the bodice and shoulders. With its tasteful simplicity and superb draping of sleeves and skirt it represents the best in Indian high fashion. There are high, soft, yellow, skin boots and a silver belt, from which hangs an awl case, to complete the costume." And for debutante parties there were the Mescalero and Chiricahua Apache puberty dresses: "For their debut,

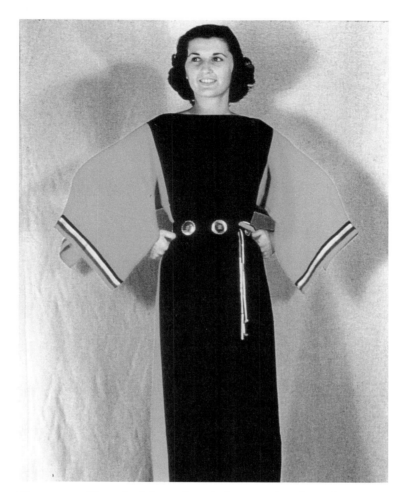

Figure 15.3. Kiowa "red sleeves" wool afternoon/tea dress, dress no. 12. Old style but of modern (1920s) manufacture, Oklahoma. A basic T-shaped dress with front and back panels in blue wool and side panels and wing sleeves of red wool bordered in white and dark blue wool. The bottom of the skirt has a plain border of white and red wool. To demonstrate that this was a "second-best dress," a silver belt of Kiowa manufacture and plain white deerskin boots were the only accessories used. Modeled by Radcliffe College co-ed, November 1951. Photograph by Watson Smith. Courtesy of the Museum of Northern Arizona Photo Archives (Neg. no. MS 173-I-88).

some Apache girls still wear a two-piece deerskin dress dyed a rich dark yellow through staining with yellow ochre. . . . It is trimmed with bead striping and tin jinglers on both skirt and poncho top. Of course, the high skin boots must match."

Although there was no casual wear such as shorts, lingerie, or swimsuits, there were other equivalents, such as a "classic little black dress"—the Hopi wool dress made of black handwoven wool folded into a rectangle, "fastened at one shoulder, creating an off the shoulder look and an interesting bodice. There is a broad red wool sash to hold the cloth around the body." Douglas emphasized its minimalist simplicity comparable to the established elegance of a Chanel dress. There was also a "sundress"—an old Chippewa dress made of two large pieces of deerskin trimmed into rectangles and sewn together along the sides. And for "rainwear," viewers saw a Kwakiutl cedar bark housedress: "A two-piece costume of woven shredded cedar bark is extremely smart and simple. There is a wrap-around skirt and a severely cut, sleeveless cape-blouse which carries out the flaring line of the wide-brimmed hat of spruce root. This costume is designed for rainy weather and is set off by silver bracelets." One of the highlights of the presentation was a sports ensemble originally made by the Naskapi (fig. 15.4): "This is a painted skin sports dress from the Naskapi studios—a much older house of fashion designers than Schiaparelli. Women of the tribe, which is native to Labrador, found it just the thing for accompanying their braves on a hunting trip."

Douglas felt his two taxonomies were valid and complementary because of his conceptions of women: "Provided she is not reduced to ultimate poverty, no Indian woman will go to a social function in a work dress, or vice versa" (Douglas 1951: 35). For Douglas, the difference between a work and a formal dress lay in complexity—ornamental features added to the work dress eliminated the need to buy separate ensembles. Indian women never fell into the trap of conspicuous consumption. Douglas showed numerous examples of how a work dress, the functional equivalent of an American fashion designer's "basic dress," was sartorially transformed through the creative use of accessories to serve numerous social purposes. For example, when displaying an Ojibwa appliquéd formal, Douglas said: "A peaked cap, painted in geometric designs converted the housedress to a costume for 'street' or 'formal' wear. Moccasins, leggings, and a bag were all heavily beaded and the final touch was a fur stole."

The transformative qualities of accessories were key to Douglas's arguments, and he emphasized many types of footwear, handbags, beaded sashes, and belts. He argued that Indians used imagination in their decorative choices, mixing and matching; jewelry was not ensemble-specific but "used day after day without any relation to a specific dress." Indian women thus demonstrated what Douglas considered to be innate good taste. They never let classic items go out of style and did not resort to faddism. Like other

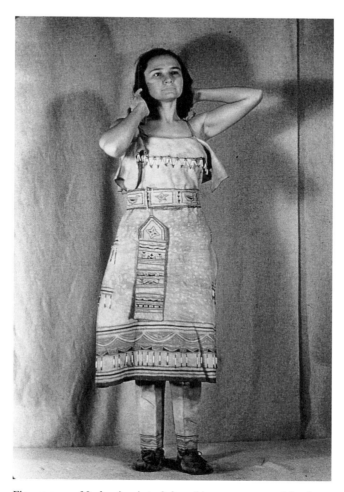

Figure 15.4. Naskapi painted deerskin sports ensemble, dress no. 48. Old style, made before 1880, Labrador. Light gray painted caribou skin dress with pants—modeled with and without detachable sleeves, with and without reversible cape and accessories of hat, mittens, and bag. Geometric designs painted in red and blue, beadwork in white. Used to demonstrate how Indian women adapted their clothes to the weather. Modeled by Radcliffe College co-ed, November 1951. Photograph by Watson Smith. Courtesy of the Museum of Northern Arizona Photo Archives (Neg. no. MS 173-I-88).

fashion authorities, Douglas insisted that viewers could show their fashion acumen by emulating those who had innate good taste.

Emulation should not take the form of direct borrowing, however, which would have been culturally inappropriate. Sandwiched in the middle of the presentation was the most daring ensemble of the show, the Hupa shell-trimmed elkskin formal, a topless dress (fig. 15.5). Although Douglas did not suggest copying this design, he emphasized its elegance as a formal and reminded his audience that Indians were actually America's first designers. "This is the most 'native-looking costume' in the show but the Hupa Indians have created the first backless formal dress. It is made of a two-piece elkskin skirt. An enormous necklace of rare and highly prized dentalium shells completely covers the front. The outfit is completed by a bowl-shaped basket 'beanie cap'. This is a 'must.'"

Douglas emphasized adaptability and economy as mediating themes, as well as the value of handmade and personalized fashion that emphasized nostalgia and freedom from the dictates of European fashion; the problem was, he also contended, women had an innate craving for novelty. His solution—create newness by adding something as simple as a new hat. The Nez Perce beaded wool dress clearly illustrated this point: "This T-shaped dress of dark blue wool replaces the usual skin in a rich garment with a heavily beaded bodice and wing sleeves. . . . There are two traditional hats: one is a tall beaded high-crowned, fez made of deerskin covered with beads and the other is a flaring fur crown in which a strip of moose skin is tied in a circle so as to form a halo of long hair." Douglas, likewise, emphasized the creativeness of Indian women in their superimposition of Euro-American materials on traditional designs. In his script for the Iroquois beaded cloth formal, Douglas pointed out that imported French broadcloth and wool had been used to make a beaded navy blue wrap-around skirt; it was strikingly embroidered in lacy white beadwork along the hemline and up one side and worn with a long red overblouse or red calico jacket trimmed with beaded edging, ribbon, and silver ornaments.

The program inevitably ended with a wedding dress, mimicking the haute-couture presentation, which always ended by presenting the fashionably dressed woman with an elegant white gown to wear at her rite of passage. Here the wedding dress was made by the Hopi, and Douglas spoke of it in specific ethnographic detail: "The Hopi bride still appears in this traditional all white dress. This dress, similar to the housedress but of white cotton brocade, was woven by the bridegroom and has a white cotton sash and a huge white cotton blanket robe. . . . No jewelry was worn with this dress."

As a finale, Douglas assembled the models on stage to demonstrate the beauty of the whole. In a primitivist use of the Native as Noble Savage to critique capitalist society, he closed with a cautionary moral tale about modernity, its views of women, the fickleness of fashion, and European cultural dom-

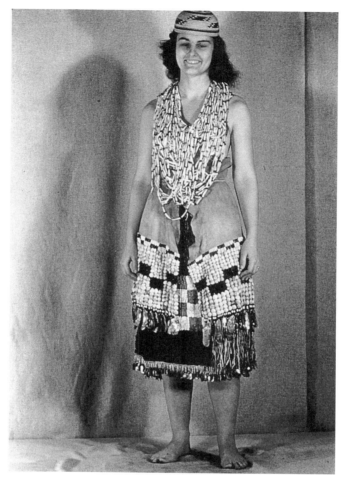

Figure 15.5. Hupa or Tolowa backless/sun-back shell-trimmed elkskin formal, dress no. 36. Made in the late nineteenth century, northern California and Oregon. Topless dress with heavily beaded, light brown elkskin skirt (white, black, and red beads, shells, and seeds) over long fringed deerskin skirt. Enormous necklace of dentalium shells covers breasts. Model was barefoot and wore woven basket cap. Used as example of Western fore-and-aft apron. Modeled by Radcliffe College co-ed, November 1951. Photograph by Watson Smith. Courtesy of the Museum of Northern Arizona Photo Archives (Neg. no. MS 173-I-83).

ination, and rhetorically asked the audience if they or the Indians were free. "We are slaves to the French and other designers. We are also slaves to our neighbors because we try to dress like the Jones's." He argued:

> We do not like it but we diet and exercise, buy expensive undergarments in order to impress others. Our idea of fashion is different from the Indian folk, theirs is to keep a dress that will always be as beautiful as when it was made— ours is to make something that will have entirely different lines so that people will feel ashamed to appear in a year-old style. This forces them to spend a lot of money for a new wardrobe. This in turns shows others that a woman has money. For Indians this status comes in their ability to demonstrate that they can weave a piece of cloth, embroider it and look festive in it.

This summary highlighted the persistence of beauty and the stability of good management. Like primitivism, good taste was timeless. Douglas had shown his audience how to appreciate each garment for its individual elegance and to acknowledge Indian women as traditional, ancestral artists who chose dress as their means of aesthetic expression.

A FASHION SUCCESS

After an hour and a half the audience judged for themselves whether Douglas's contentions were correct. At the first offering the standing-room-only audience of more than seven hundred women "oohed and awhed [*sic*]."[8] As he jokingly wrote to his friend Katherine Bartlett of the Museum of Northern Arizona, the audience had been "positively dazzled by the surprising beauty of the costumes. There have been so many requests for other showings that I feel inspired to quit the museum business and make myself into the Ziegfield of the Red Man!"[9] When Douglas resurrected the program in 1947 the response was the same. By 1952 the popularity of the Indian Fashion Show had all but overwhelmed Douglas's other activities. He commented: "It seems odd. . . . Here I am, a scholarly museum curator, up to my ears in fashion" (quoted in Applegate, n.d.). More than 300,000 people saw the show, not counting those who viewed it on television. Douglas had created a potential market.

There is no question that Douglas's program was a marketing success, and he was quick to capitalize on it by eliciting the help of fashion designers, who eagerly commoditized the design ideas. For example, at the Philbrook Art Center on October 25, 1942, two of the guests were Ethel Mahier of the University of Oklahoma's art department and her sister Frances Mahier Brandon. After seeing the program, the Mahiers, with the help of Mabel Morrow of the Indian Arts and Crafts Board, designed a line of clothing, jewelry, and accessories based on the Indian designs. Their creations were sold by Stanley Marcus and later reinterpreted in 1943 by internationally famous cou-

turiers Clare Potter, Lily Daché, I. Miller, and Palter de Liso. The Mahiers' suede jackets and dresses in Kiowa blue, Indian red, red ochre, green earth, parfleche, and buckskin with matching "beanies," fringed gloves, moccasins, and silver and turquoise jewelry were hits. Neiman Marcus's large window displays and ads in *Vogue* pointed out the connection between contemporary fashion and Indian arts and crafts.

By 1948 Douglas was telling his audience to use Indian dress as a source of design for their own clothes. The fashions of the 1952–55 seasons were resplendent with creations based on the clothing in the show. *Life, Look,* and *Vogue* showed adaptations of Plains, Apache, and Navajo attire. Douglas had provided "new looks"; they did not rival Dior's New Look, but they have had tremendous staying power through their transformations into Southwest regional dress.

The most successful adaptation was the "squaw dress." In fall 1954 Douglas loaned the dresses to Gimble's Department Store in Philadelphia for an exhibition and runway presentation at which Princess Red Rock, "a full-blooded Ojibwa Indian," modeled the "authentic" attire. Gimble's also displayed the new "squaw dresses" sweeping the country; these were designed by DeDe Jonson and Tiana Pittelle and marketed under the label "Albuquerque Originals." Jonson and Pittelle credited Douglas's fashion show, which they had seen several times, as the inspiration for the new fashion trend (*Waco News-Tribune* 1954).[10]

The squaw dress was based on ensemble no. 40, the Navajo "everyday two-piece dress," with its "familiar very full cotton skirt and velvet blouse trimmed with silver buttons." The squaw dress was the most-discussed Indian design, and Douglas often commented on it to correct fanciful theories that were being postulated about its origin. But the Plains, Tlingit, and Western Apache ensembles were also reinterpreted by fashion designers searching for fresh ideas. Almost everything in the Indian Fashion Show was used. By 1953 Douglas himself was overwhelmed by the process and had no idea where it would end. In a 1954 interview he commented, "The dress trades peoples [*sic*] see that the Indian dress is the last untouched fashion source. I'm curious to see which of the fabulous designs in the Indian costumes will emerge in white man's dress in the future" (*Waco News-Tribune* 1954). And he would have been amazed. Contemporary ads are full of Indian-inspired designs, even though most are based on the tenacious stereotypes that Douglas had tried to eradicate rather than on ethnographic realities.

AMBIGUOUS AUTHENTICITY

Douglas was successful in transforming museological heirlooms and ethnographic specimens into design possibilities because he offered consumers and designers "authenticity" and "novelty" as personalized variations on time-

lessness. He understood that fashion and its symbolic messages are highly context-dependent. The same ensemble could be interpreted differently depending on how its constituent messages were decoded, understood, and appreciated or rejected by different taste groups, ethnic groups, and social strata. Douglas understood that fashion is rarely precise and explicit.

Douglas and commentators on the show always stressed its authenticity, because this claim was always questionable. Paradoxically, Douglas's own response to this problem—making authenticity ambiguous and situationally fluid—is one reason the clothing was so readily commoditized. Every newspaper article mentioned that the clothing was real and authentic. Douglas opened and closed every presentation with a pledge of authenticity. He loved to point out that not a feather or beaded headband would be seen because these were only used by Indians who had seen too many movies. Yet Douglas undermined his own message of purity and authenticity by simultaneously stating that origin was not important. The tremendously varied materials, styles, and adornment in the extremely handsome attire were "well worth looking at without any thought of their racial origins."[11] And he was not above mixing cultures when required to do so in order to fill holes in the collections. Sioux moccasins and leggings were worn with a Crow dress. Men's moccasins were sometimes worn by the female runway models because Anglo-American women's feet were too large for indigenous women's footwear. Douglas's ideas on women mediated these contradictions. Since women are women the world around, he believed, the clothes of one group could really be the clothes of all. Authenticity entered into the equation insofar as the clothing had actually been made or used by American Indian women. The pledge of authenticity was stressed partly to ensure Douglas's believability as an authority and partly as a way to help women use the designs without prejudice.

Douglas continually had to discover ways to reauthenticate the show, the clothing, and himself as arbiter and tastemaker because of his decision to use Anglo-American models and the constant threat of their stereotypically mimicking Indians. At his first show Douglas tried to obtain the services of Indian models from the Phoenix Indian School in order to lend extra credibility to his claims of authenticity. However, the adolescent girls giggled so much at the dress rehearsal that Douglas switched to models from the Junior League. He continued to use Euro-American co-eds, sorority girls, and members of the Junior League and women's guilds as his models, although he always tried to find local Indian women, if possible. As he rationalized in a letter to a colleague, if he had used only Indian models he would have played into the racial stereotype that only Indian women can wear Indian clothing, and no transference to the American clothing system could have occurred. Still, Douglas was uncertain that he had made the right decision. In the early presentations he toyed with the idea of having the white models use wigs and makeup to

resemble Indians, but doing so was not really practical. He told the models to be themselves but tried to downplay their obvious Nordic characteristics. He preferred brunettes, but if blondes had to be used, "The girls should wear as little make-up as possible and elaborate hair-dresses, such as masses of tight blonde curls, are violently discouraged."[12]

In venue after venue Douglas reiterated that models were to be cooperative mannequins and make no attempt to portray "Indian antics." Unfortunately this was a losing battle. At one presentation a model dyed her hair black; at another, all models appeared with tan makeup on their bodies. Some braided their long hair, put war paint on their cheeks, and vocalized "war whoops" on stage. Douglas's letters are full of laments over similar stereotypical behaviors. But he should not have been surprised, for to the models, the Indian Fashion Show was a form of escapist play in the spirit of a costume party.

Douglas was able to overcome the potential threat of racially "inauthentic women" undermining the authenticity of the Indian Fashion Show by intentionally playing on the inherent ambiguity and ambivalence of fashion. Fashion is based on rapid change, which can occur because clothing is multivocal and conveys inconsistent meanings. According to Fred Davis (1992), ambiguity, with its connotation of multiple meanings and our experience of it, underscores the possibility of alternation, contradictions, and obscure interpretations. This ambiguity is combined in the United States with contradictory and often oscillating subjectivities about fashion, women, and Indians. Douglas played on the instructive confusions and conceptual richness of these contradictions and multiple meanings in the rhetoric for the Indian Fashion Show. It is both the conscious and unconscious recognition that these "ingenious equivocations, calculated duplicities, and artful conceits" found in everyday life are at the heart of fashion and art as processes that made the Indian Fashion Show work as a commoditizing venue (F. Davis 1992: 22; see also Eco 1979; Empson 1953). Commoditization occurs more easily with textiles and clothing than with other forms of indigenous art and artifact because they can be easily used in shifting contexts and express crucial intracultural variability. Grant McCracken has stated that textiles encode "fundamental categories, principles, processes and emotions of social life" but that these features are rarely consistent (1990: 62). In fact, it is this inconsistency that makes them ripe for the constant fluidity of fashion.

Americans use clothing to define and redefine their ambivalences about gender, social status, and sexuality—their very identities. Dress reflects gender roles, occupations, social status, social hierarchy, group affiliations, wishes, and concepts of beauty. Clothing can communicate multiple and shifting meanings because these meanings are not always sharply drawn. As Leigh Schmidt (1989) has whimsically said, "clothes . . . are good to think with." The ambiguity inherent in clothing communication allows designers and

consumers to be reflective about their own inherent identity ambiguities, thereby giving them the power to manipulate and even erase the dichotomies between the primitive and the civilized, the traditional and the modern, and art and artifact that Indian attire presented. And Douglas and his audience did just this. Douglas argued empirically with fashionable and aesthetically pleasing attire and artifacts transformed into art, while his audience responded by playing at being Indian princesses and conscientious consumers who recognized classics and inherent beauty. He offered them a safe form of escape but one in which they could celebrate their creativity and artistry as women. As a potential trend-setter and cultural arbiter, Douglas understood, although he would not have articulated it as such, that fashion as a shifting code first startles and captivates the sensibilities of a public. If this public, here middle- and upper-class women, accepts the introduced code modifications, the fashion will be a success. In order to captivate, Douglas had to abolish the established categories of art and artifact, primitive and civilized, and meld them into a universal paradigm in which all forms of material culture are available to be commoditized and aestheticized.

Douglas was able to reconfigure Indian clothing as part of the cultural capital of American fashion by providing women with new images of themselves as Indian princesses and legitimizing that image. He legitimized American women's borrowing from all cultures (in this case, from "primitives") by emphasizing that Indians had already borrowed from us and that creative people continually thought through and manipulated ideas regardless of their cultural origins. In such a model the idea of appropriation does not enter; only natural borrowing exists. Creativity transcends cultural and racial boundaries; art and its sources are universal. Douglas validated his contentions by insisting that (1) gender was more fundamental than race or culture, (2) specific fashions were situationally not culturally dependent, (3) fashion was not the exclusive possession of elites but a right of all women, (4) a desire for pretty clothes was a genetic constituent of women's makeup, and (5) fashion's constituent symbols are understood and appreciated in a variety of ways. These claims also authorized the consumer activities of wealthy socialites: it was "normal" for women to want pretty clothes. This message was a very palatable one for a bourgeois member of a capitalist society for it validated the naturalness of the status quo.

Also satisfying was the message that women no longer had to be slaves to European fashion designers who only wanted to enhance their own profits at the expense of consumers. Women would be free, like the Noble Savage, if they used the fashions and creative adaptive processes of Indian women, America's ancestral peoples. They could use the successes of the nation's progenitors to create their own unique and classic fashion. In this sense, Douglas's presentation was very time- and place-specific, a creation of larger movements present in the United States of the 1940s and 1950s. Americans

were trying to assert their independence from European cultural hegemony in the arts, and the Indian Fashion Show played on prevalent themes of the movement (see Rushing 1992).

Douglas encoded a new "authenticity" for Indian attire as expressive cultural products and design ideas by using clothing as a visual metaphor for romanticized identity. This was an ambiguous authenticity, because "meanings [in clothing] are ambiguous in that it is hard to get people in general to interpret the same clothing symbols in the same ways" (F. Davis 1992: 9). By showing a variety of attire, Douglas gave women numerous opportunities to find at least one outfit that they could use in their own wardrobes. These viewers gained a new appreciation for the beauty of Indian dress. Whether women changed their other views about Indians and whether Douglas was successful in eliminating stereotypes are still matters of debate, but I doubt that many deeply held attitudes were changed. For in a fashion show, the moderator is an authority figure who tries to convince the audience that what is seen is new, unique, and desirable. The dialogue is designed to sell and persuade; truth and facts are not crucial elements in the sales pitch and can obscure the central message: buy me. A fashion show is in essence an entertaining and taste-making marketing tool for a multi-million-dollar industry. It is too ambiguous to serve as the format for a voluntary education effort whose humanistic purpose is to increase cross-cultural understanding. In the final analysis, then, rather than educate, the Indian Fashion Show commoditized Native culture; in so doing, it created both fantasy and stylistically hybrid images.

PART FIVE

Collecting Culture
and Cultures of Collecting

Tourism and Taste Cultures
Collecting Native Art in Alaska at the Turn of the Twentieth Century

Molly Lee

The widespread exoticizing of Native peoples in Western culture has had a far-reaching influence on the substance and contours of anthropological discourse. It explains, for instance, the abundance of research into the effects of Western collecting on Native art systems relative to the scarcity of inquiries into why Westerners are attracted to Native arts in the first place (e.g., Graburn 1976; R. Phillips 1989b; Ray 1977; Wyatt 1984).

A recent surge of interest in collecting non-Western art, however, has begun restoring this imbalance (see, e.g., Clifford 1987, 1988; Dominguez 1986; Gordon 1988; S. Jones 1986; Karp and Lavine 1991; Price 1989; Torgovnick 1990). Here, too, though, the literature has emphasized the exceptions. Ignoring the rank-and-file middle-class collectors, who constitute the majority, researchers have focused on the more spectacular collecting of museums and generous patrons (e.g., Cole 1982, 1985). This essay about collecting Native artifacts in Alaska at the turn of the twentieth century takes a different tack. Focusing on several types of middle-class collecting in a circumscribed area at one moment in history, it capitalizes on one of the few solid lines of evidence we have about the dynamics of tourist art in an early phase.

TOURISM AND COLLECTING ALONG ALASKA'S INSIDE PASSAGE

In Alaska the history of artifact collecting during the American period was shaped by the rapid development of tourism (Norris 1985). Not long after the Alaska Purchase of 1867 a handful of hardy adventurers began trickling north aboard American trading vessels. In 1878 General George S. Wright, commanding officer of the Military District of Alaska (as it was then designated), led a party of sightseers on a brief excursion up the Stikene River in the extreme southeastern part of Alaska. In 1879 John Muir first saw Glacier

Bay and publicized its scenic majesty in a series of widely disseminated newspaper articles and a best-selling book (Muir 1915).

Thereafter, tourism grew by leaps and bounds. In 1882, the same year that the transcontinental railway reached Puget Sound, General Nelson A. Miles, another army officer posted to Alaska, conducted the first full-fledged cruise up the Inside Passage (Villard 1899: 35). Two years later the Pacific Coast Steamship Company instituted regular Inside Passage service; only a year after that, the first Alaskan guidebook was published (Scidmore 1885). By 1890 an average of 5,000 tourists made the trip up Alaska's interior waterway each summer (Hinckley 1965: 70–71; Norris 1985: 16; Wyatt 1989).

As a tourist destination, Alaska was uniquely suited to the nineteenth-century sensibility. Its scenic beauty was the very incarnation of wilderness, a key symbol of national identity at that time (R. Nash 1967, 1981; Sears 1989; Turner 1920). As Zinmaster put it, "As America pushed westward . . . primitive nature yielded to civilization, forests became farms, paths became highways and cities replaced log cabins. . . . Alaska, a country of primitive nature [began to attract] large numbers of tourists" (1946: 3).

But Alaska also appealed to a danger-courting strain in the nineteenth-century imagination. The unpopular purchase of Seward's Icebox had generated wildly exaggerated tales of the former Russian colony as a wasteland of ice and snow. These stories greatly overdramatized conditions along the heavily forested Inside Passage, where rain occurs almost daily and snow only seasonally, but the fabricated element of risk added allure to a projected tour of the North (Norris 1985: 3).

Following closely on the heels of scenic wonder was the enticement of "primitive" people. "The Native people [of Alaska] are the most interesting study of ethnologists, and totems in a living and advanced stage may be studied on the spot," promised an early guidebook (Scidmore 1898: 1). Of the four Native groups in Alaska (Eskimos, Aleuts, Athapaskan, and Northwest Coast Indians), tourists routinely saw only Northwest Coast (Tlingit) Indians. Nevertheless, hardly any early traveler failed to mention them. As a rule, descriptions of the Indians were as overwrought as those of the landscape. Wrote one early tourist of Tlingit wood carvers: "They are the artistic savages of the world. . . . On the seaward face [of totem poles] the savage sculptor has exhausted his barbaric imagination in cutting in hideous faces . . . that . . . make one think of some nightmare of his childish days. . . . Every utensil . . . is sculptured deep with diabolical designs" (Gerrish, n.d.: 306–7).

By the time they arrived in Alaska, then, tourists had been conditioned to respond to both scenery and "savage" with the distinctive mixture of awe and dread characteristic of nineteenth-century reactions to nature and nature's people (Loomis 1977). Moreover, it seems that from the outset Native people were thought of as metonyms for Alaska, and Native artifacts as metonyms for the people who made them. One line of evidence is the rapid

politicization of Native artifacts. In 1869, when Secretary of State William Seward visited Alaska to champion the Alaska Purchase, he was showered with Native artifacts wherever he went (Sessions 1890: 93).

TASTE CULTURES AND TOURIST ART

James Clifford tells us that the history of collecting is concerned with what specific groups chose to value and exchange from the material world at a given historical moment (1988: 221). What specific groups collected Alaska artifacts? What objects did they gather? And what did these objects mean to them?

Collecting art produced by Alaska Natives was an epiphenomenon of the bourgeois craze for exotica that followed in the wake of colonialism and industrialization. However widespread, this enthusiasm did not always manifest itself similarly. There was no one collector, but several. A useful model for analyzing the differences is Herbert Gans's (1966, 1974) concept of taste cultures. Predating the more theoretical work of Pierre Bourdieu (1984), Gans argues that complex societies are composed of consumer subgroups distinguishable by aesthetic preference. Gans labels these groups taste cultures:

> There are a number of popular cultures, and they as well as high culture are all examples of . . . taste cultures . . . whose values are standards of taste or aesthetics. . . . A taste culture consists of the painting and sculpture, music, literature, drama, and poetry; the books, magazines, films, television programs; even the furnishings, architecture, foods, automobiles and so on, that reflect similar aesthetic standards. (1966: 551)

Analysis of more than a hundred turn-of-the-century private collections of Alaska Native art suggests that buyers fell into three taste cultures based on the object types they collected, the locations where they purchased them, their definition of authenticity, their gender, and their later disposition of objects.[1] In the following sections I show how each taste culture arrived at a set of discriminations and how these reflected and reinforced other distinguishing cultural values. I also look at the gendered patterns of collecting, the definitions of authenticity, and the modes of display specific to each.

TOURIST COLLECTORS

The bulk of Native art collectors were tourists on the Inside Passage cruise (fig. 16.1).[2] The most distinctive feature of this group is that they were collectors by chance, not choice. Tourists normally bought Native-made objects only once and in limited quantity as souvenirs commemorating their trips. The purchase was meaningful as a personal experience, but Native people played only a supporting role.

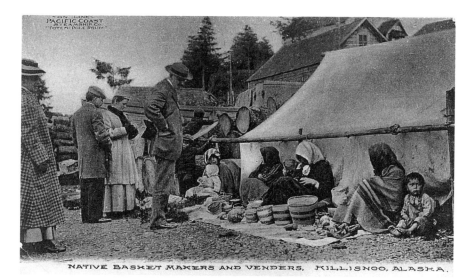

Figure 16.1. Tourists examining the wares of Tlingit women, Killisnoo, Alaska, c. 1900. Alaska, Yukon Territory, British Columbia Postcard Collection (PCA-145-V.9-Natives-S1–17). Courtesy of the Alaska State Library.

What did the Alaska trip signify to the average tourist? By the 1890s, leisure travel was an increasingly common form of conspicuous consumption among the growing middle class. The Alaskan cruise, though less expensive than a trip to Europe, was still beyond the means of most. A round-trip ticket from San Francisco cost $130 in 1894 dollars, roughly twice the price of a man's suit (Norris 1985: 10–11; Pacific Coast Steamship Company 1894). Thus, those who went up the Inside Passage did so partly because it was a status marker. "You will have lots of stories to tell . . . which will make you the lion of your social gathering and the envy of those who stayed at home," promised an Alaska excursion brochure (Pacific Coast Steamship Company 1900: 19). In sum, the Native artifacts that tourists bought commemorated an expensive adventure of which the artists themselves were merely a part. That these souvenirs became valuable later, when Native material culture was reclassified as art, was incidental.[3] Souvenirs, in contrast to collectibles, are valuable only to those who buy them. The curio's resonance comes not from its monetary worth, which is inconsequential, but from its ability to concretize time and space in a meaningful and substantive fashion. According to Beverly Gordon: "[People] can't hold on to the non-ordinary experience [of travel], for it is by nature ephemeral, but they can hold on to a tangible piece of it, an object that came from it. Western culture tends to

define reality as 'that which you can put your hands on.' When one puts his hands on a souvenir he is not only remembering he was there, but proving it" (1986: 136).

Even tourists who purchased artifacts for souvenirs wanted them to be genuine. In fact, authenticity was a key concern of all three groups of artifact buyers. The search for authenticity has been a widespread theme throughout late-nineteenth- and twentieth-century Western culture. In his seminal book *The Tourist: A New Theory of the Leisure Class,* Dean MacCannell convincingly shows that pursuit of an "authentic Other" is a major impetus of modern travel (1989: 91–105). How better to immortalize the "authentic Other" than by taking home something made by his (or her) own hand? Nonetheless, artifact collectors had different ideas about what constituted genuineness. Just as there is no one paradigmatic tourist, there is no one concept of authenticity. On a scale from least to most demanding, tourists were at the least selective end of the continuum. For instance, it was all but essential that members of the two other buyer groups obtain their artifacts from a Native person's hands, but tourists frequently bought from non-Native curio dealers along the Inside Passage.

Of all collectors, tourists had the most relaxed standards of authenticity. One traveler speculated (probably rightly) that by 1890 most Native artifacts for sale along the Inside Passage were made expressly for the marketplace (Collis 1890: 106). Tourists sustained the weak fiction that the artifacts they bought were the same artifacts used by Indians. "You can buy everything here," one traveler enthused, "everything that the Native Indians use in their everyday life" (Dennis 1895: 70–71). If they had chosen to examine those objects thoughtfully, however, it would have been easy enough to see that the totem poles, canoes, drums, baskets decorated with bright commercial dyes, silver jewelry, beaded bags, button blankets, and dance staffs offered for sale were mass-produced and would have been of little use to the Indians other than as commodities.

Most curio collectors were female. At this time, travel and travel writing were among the few occupations outside the home open to middle-class women (Birkett 1989; Hamalian 1981; Mills 1993). Eliza R. Scidmore, author of the first guidebook to Alaska (she had been a member of Nelson Miles's 1884 tour), was one such woman (McLean 1977), and over the next thirty years or so hundreds of others followed her lead, publishing descriptions of their Alaskan travels (e.g., Bugbee 1893; Collis 1890; Higginson 1908; Manning 1884).

One major effect of gender on tourist collecting was that women bought Alaskan souvenirs that would fit into home displays, incorporating them into the dense accumulation of bric-a-brac that constituted middle-class interior decoration of the moment (Green 1983; Saisselin 1985). The only unifying feature of bric-a-brac displays was the exotic origins of the many objects they incorporated; the constituent elements themselves were a

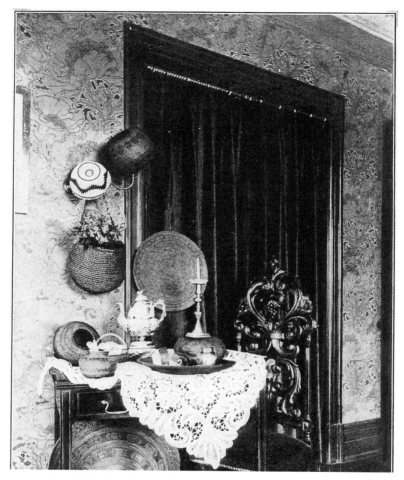

Figure 16.2. Eclectic mixture of Euro-American objects and Native
American baskets in a turn-of-the-century bric-a-brac display. From
Harper's Bazaar, vol. 35 (1901): 471. Courtesy of the Library of Congress.

typological, functional, and formal hodgepodge (fig. 16.2). The total effect,
which Williams has aptly described as the "exotic-chaotic aesthetic" (1982:
70–73), is explained by the lure of newly available foreign goods (a by-
product of colonialism), the proliferation of mass-media such as advertis-
ing, and the rise in disposable income among the middle class (Bronner
1989; Lears 1989).

Because objects made by Alaska Natives were not accorded special treat-
ment in bric-a-brac displays, there is little specific information about their

use in interior decoration. What is certain is that the turn of the twentieth century is the first period in which Native American objects were widely used in household decoration (M. Lee 1991; see also Csikszentmihalyi and Rochberg-Halton 1981; Halle 1993a, 1993b). Period photographs show them mixed in haphazardly with other exotica (e.g., Haigh 1986). Tourist collectors did not assign Native Alaskana any particular prominence but incorporated it into the jumble of household decoration along with souvenirs from other exotic places.

BASKET COLLECTORS

The second group of collectors enthusiastic about Alaska Native art were the basket collectors, for whom the turn of the twentieth century is justly famous (Herzog 1989, 1996). At that time, Alaska and California were the principal localities where Indian baskets were still obtainable. There were several types of collections, each of which often numbered in the thousands. Some contained examples from as many different Native American groups as possible; others focused on specimens from a particular geographic area (fig. 16.3). Basket collecting has received some attention in the literature (e.g., Bates and Lee 1990; N. Jackson 1984; Washburn 1984), though scholars' interests usually focus on specific histories and taxonomies rather than on the cultural matrix in which this phenomenon arose. It will be instructive, then, to consider the cultural factors underlying the wide appeal of the Indian basket at this moment in history.

For the most part, turn-of-the-century basket devotees shared a common attitude toward Native Americans and their artifacts. It echoed the outlook of the decorative arts reform movement that took the urban intelligentsia by storm at the end of the nineteenth century (Stein 1986). An outgrowth of the British Arts and Crafts Movement, the decorative arts reform movement (and also its later manifestation, the American Arts and Crafts Movement) arose as a protest against the industrialization that increasingly overwhelmed the West, separating individuals from the fruits of their labor. Typical adherents were educated, democratic-minded women, who sought to combat their mounting ennui by promoting communally based handicrafts.[4] Small-scale societies such as those of the American Indians often served as models of the close relationship between art and life that decorative arts reformers envisioned as the salvation of modernity (Boris 1986; Lears 1981). The Indian basket quickly became a key symbol of this burgeoning antimodernism.

The appeal of Indian baskets rested on a fortuitous blend of practicality, aesthetics, and ideological consideration. Baskets were small, light, handmade, relatively cheap (at least in the early days), and easy to transport. Contrasting dramatically with the ubiquitous stamped-out pots and

YAKUTATS

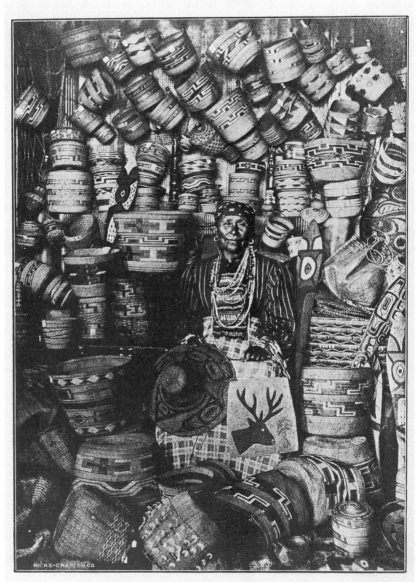

Alaska Indian Baskets

Figure 16.3. "Yakutats: Alaska Indian Baskets." Alaskan (Northwest Coast) basket collection from a 1902 mail-order catalog of the Frohman Trading Co., Portland, Oregon. Source: Binford and Mort Publishers, Portland, Oregon.

pans of the Industrial Age, they embodied the essence of all that the anti-modernist espoused. Like souvenir collectors, basket enthusiasts were usually female.[5]

The reinvention of the Indian basket as an antimodernist symbol flowed from the collectors' belief that baskets were sacred objects. Some Native California groups burned baskets in funeral ceremonies, following the widespread custom of destroying a person's possessions after death. But generally, among Native American cultures of the Far West, Indian baskets were utilitarian. What is more, by the time the belief in their sacredness became entrenched, Indians were making relatively few baskets for their own use (Washburn 1984).

The most persuasive evidence for the purported sacredness of the Indian baskets was the equally fallacious supposition that their decorative designs were sacred symbols. One collector wrote, for example: "When the art of basketry was at its height . . . the same . . . symbol meant one thing to the Indian on the mountains and another to him who roamed the deserts. Thus a zigzag design may mean waves . . . a prayer for preservation from shipwreck to one who dwells on the coast and . . . a prayer for protection against lightning inland" (Wilkie 1902: 3).

In reality, Native American groups usually named basket designs for natural phenomena. Among the Tlingit, for instance, common pattern names were "half the head of a salmonberry," "fern frond," "shark's tooth," and "wave" (Emmons 1991: 219–20). Anthropologist Alfred Kroeber fought an uphill battle against the widely disseminated belief in the basket's sacred symbolism. His impatience is evident in his field report on the California Pomo:

> A typical pattern name . . . [an animal part combined with a descriptive term, such as "deer-back arrowhead crossing"] is exactly descriptive. . . . Such a practical purpose, and not any religious or symbolic motive . . . seems to be at the base of these designs and pattern names. If there is a difference between the Pomo and ourselves, it is that among [the Pomo] these conventional figures give no evidence of . . . ever having had a symbolic significance. (1909: 25)

The persistence of basket collectors' misapprehensions suggests that something meaningful was at stake. Beyond objectifying the supposed connection between handwork and personal fulfillment, the strong emphasis on a putative encoding of religious symbolism on basket designs suggests (as Kroeber implies) that collectors were projecting onto them their concern about the waning power of Christian symbols in Western culture (Lears 1981: 13). In contrast to tourists' reclassifying artifacts as souvenirs, decorative arts reformers transformed the Indian basket into a kind of fetish. As Clifford points out: "Rather than grasping objects only as . . . artistic icons, we can return to them . . . their lost status as fetishes . . . with the power to fixate rather than simply the capacity to edify or inform" (1988: 229).

Of all collectors of Alaska Native art, basket collectors had the most narrowly defined standards of authenticity. Spurning the garishly decorated aniline-dyed baskets sold to tourist collectors, they preferred to ferret out the few remaining examples still being used by Native women. "There is not a basket [in my collection]," boasted one, "which the Indians supposed, when it was made, would ever be owned by whites" (Brown 1898: 54–56). Especially prized were baskets that showed signs of wear and those increasingly rare examples that bore traces of Native food or burns from the hot stones used to cook food in them. Wrote one discriminating collector: "During my two visits to the village of Yakutat in the summer of 1902, I especially sought for specimens of the basketry of olden time. A vigorous search produced three old baskets, two of which were then in actual use . . . and the third had been cast away as worn out. . . . They . . . seemed to speak more of the people's life than did the bright and beautiful modern baskets" (Meany 1903: 213).

If obtaining baskets still in use proved impossible, collectors settled for traditional types made for the market, spurning those "faked after meretricious color, designs or shapes" (quoted in Washburn 1984: 60). They were unaware that Native weavers often returned to earlier shapes and natural dyes after years of disuse, not out of aesthetic preference, but in response to growing Euro-American market demand (Washburn 1984).

The buying patterns of decorative arts reformers mirrored their dedication to the indigenous. Some went north as tourists, selecting from among the tourist wares the few types to their liking. In general, though, basket collectors were more worldly and had more collecting venues open to them. Often straying far from the beaten path, the more dedicated hired canoes and Indian guides to take them to remote settlements where their chances of finding traditional wares were better (e.g., Maxwell 1905). At the height of the basket craze, the Alaska Steamship Company even arranged special tours for basket collectors, which stopped at out-of-the-way settlements such as Hoonah or Yakutat (MacDowell 1905).

As the basket craze wound down and fewer and fewer baskets remained in Native hands, collectors increasingly resorted to tactics spurned by their earlier counterparts. Practicing a form of indirect tourism (Aspelin 1977), they sometimes ventured no farther afield than the shop of the nearest dealer, of whom there were increasing numbers in western American cities (Connor 1896: 3; Washburn 1984).

Unlike souvenir buyers, basket lovers did not scatter their prizes among the bric-a-brac that passed for household decor in the period. In keeping with their status as fetish, baskets were singled out for special treatment. Some collectors set aside entire rooms for exhibiting their collections (Starr 1889). Others outfitted the corners of public rooms such as parlors with diagonal shelving, grouping their collections to create a "cozy corner" (*House Beautiful* 1905: 41). Featuring the collection in an isolated setting again underscores

the significance of the Indian basket and all that it represented to the cult of the primitive, objectifying the romantic ideas the collectors had about Native American cultures, not as a form of altruism, but as a nostalgic symbol of the loss of cherished aspects of their own pasts.

SPECIAL ACCESS COLLECTORS

I call the final group of Alaska Native art enthusiasts special-access collectors (fig. 16.4). Socioeconomically middle class, this taste culture had preferences and practices that approximated those of the elite philanthropist collectors, who are the subject of Douglas Cole's research on the collecting of Northwest Coast objects (1982, 1985). Special-access collectors cannot be considered tourists in the strict sense of the term, for they either lived in Alaska for extended periods (e.g., E. Harrison 1905: 59) or traveled repeatedly to remote parts of Alaska in conjunction with professional activities. Some were missionaries (Jackson 1881); others teachers (Baird 1965; Meany 1903) or government employees such as circuit judges (*Nome News* 1902), military officers (Fast 1871), or revenue cutter (later United States Coast Guard) personnel (Porcher 1903–4; Hooper 1881). At the same time, special-access collectors call into question the conventional definition of tourism (V. Smith 1989). Like tourists, they were away from home, but unlike them, they pursued a leisure activity while working.

Unlike both other groups of early tourists, special-access collectors were usually male. Gender influenced most of the characteristics that define this group, such as the type of object collected, collection location, the time devoted to gathering objects, and the eventual disposition of the objects. Like basket collections, special-access collections tended to be larger than a few objects, which is all that most tourists generally gathered as souvenirs. The collections were often built over a period of years by people familiar with Alaska Natives and the full range of their material cultures. For instance, the collection of Captain Edward G. Fast, who was attached to the U.S. Army commander's staff at Sitka for several years after 1867, consisted of more than six hundred objects. Primarily products of the Northwest Coast Indians, they encompassed the full range of Alaska Native material culture. Included were shamanic objects; war, hunting, and fishing gear; clothing and objects for personal adornment; utilitarian objects such as bowls and baskets; and those used for leisure pastimes such as dolls, toys, and gambling games (Fast 1871).

One less-recognized effect of gender on many special-access collections is the proportionately larger amount of genuinely sacred material they contained. As Teilhet (1978) has pointed out, sacred domains and their attendant objects are generally controlled by men in small-scale societies, whereas the activities of women are confined to the secular. Because this rule of thumb

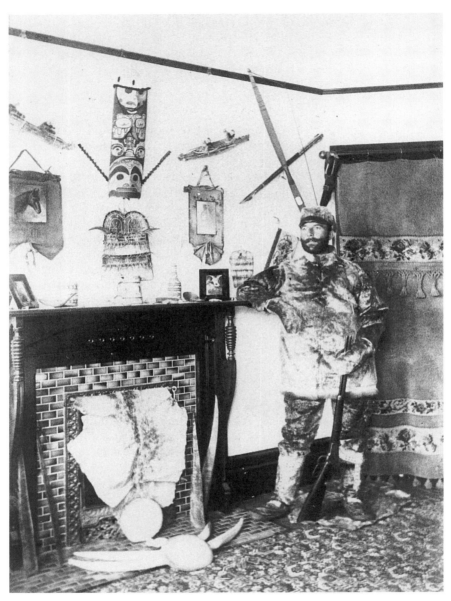

Figure 16.4. N. Winterhalter, a special-access collector, showing off his Alaska Native artifacts after returning home to Berkeley, California, 1896. The collection includes Northwest Coast, Aleut, and Eskimo objects. Courtesy of the Anchorage Museum of History and Art, Anchorage, Alaska (Photograph no. 88.61.9).

pertained in Alaska, Euro-American male collectors probably had greater access to religious artifacts than female collectors. This explains the significant amount of Northwest Coast sacred material donated to the world's great museums by institutional collectors during this period, most of whom were male (Cole 1985).

Another characteristic seemingly linked to gender is that, on the whole, special-access collectors thought of Alaska Native artworks as "scientific" ethnological specimens. This view stemmed from the perspective of earlier antiquarian collectors, who looked upon Native artifacts as witnesses to "the concrete reality of an earlier stage of human Culture . . . confirming Europe's triumphant present" (Clifford 1988: 228). Thus, when speaking of their artifacts, special-access collectors often cloaked their covetousness in the legitimizing mantle of science. The most common strategy was to interpret the collection as proof of one or another of the evolutionary theories then in fashion. Wrote Captain Fast: "To the scholar the relics which I found will afford material for the most interesting ethnological investigations. They may give a positive [taxonomic] key to the origin of these people and, perhaps, considerably assist in solving the much discussed problem of whence our continent has been populated" (1871: 6).

Like decorative arts reformers, special-access collectors were interested only in artifacts made for Native use. However, for them authenticity had less to do with the romantic patina conferred upon the objects by Native use than with the assurance that they accurately represented Native culture in a "primitive stage"—even though "traditional" household and hunting equipment undoubtedly was fabricated expressly for sale. Special-access collectors disparaged innovation. For instance, W. Gadsden Porcher, who cruised the Aleutians on a revenue cutter in 1903, said of Aleut baskets made for sale: "These monstrosities are . . . the result of competition and the desire to invent something new that will attract [tourists]" (1903–4: 581).

It is difficult to generalize about the fate of special-access collections after they crossed the cultural divide. Long-term Alaska residents sometimes decorated their parlors with artifact collections (e.g., E. Harrison 1905). Elsewhere, special-access collectors also used their collections to suggest that Native artifacts (and by extension their makers) were closely associated with Nature, not Culture (Graburn 1989a). Frequently, they were displayed alongside stuffed animals and trophy heads (*Sitka Alaskan* 1883) (fig. 16.4). Furthermore, the connection of Native artifacts to Nature and maleness is suggested by the male-associated spaces where such collections were often installed: in rustic country houses (*Ladies' Home Journal* 1900: 2–3), on the walls of smoking rooms (William Barr Dry Goods Co. 1901), and in dens (Arthur 1906).

Some special-access collectors at the high end of the continuum donated their collections to museums (e.g., Borden 1928); others became dealers that

sold to them. This conflation of private goals with commercial or scientific ends parallels their collectors' anomalous status as both "tourists" and professionals. For instance, George T. Emmons, son of a naval officer at Sitka and one of the best-known dealers in Alaska Native art, started out as a collector (Emmons 1991). Army Captain W. F. Turner sold artifacts from his rooms at Sitka as early as 1883 (*Sitka Alaskan* 1883). Revenue officers such as Calvin Hooper and Captain Michael Healy both sold raw ivory out of the north, and Hooper, at least, also collected for large museums such as the Smithsonian (Hooper 1881).

CONCLUSION

Why is it useful to render modes of collecting more intelligible? Collectors' claims notwithstanding, most of what they bought had been made for sale. Since Graburn's (1976) seminal publication bestowed the status of art upon such objects, the scholarly community has come increasingly to champion them. Some twenty years later, however, the exchanges between producer and consumer (whether of words, trade goods, or money) that surround these objects are still little understood. Because the artists are in one culture and consumers in another, the feedback process is hard to track. Beyond the few reliably documented objects, then, consumer demand is our greatest data bank for laying bare the forces driving the arts of acculturation.

As a case study of the cultural construction of meaning, this essay also advances a general theory of collecting. To the different taste cultures an Indian basket, for example, could equally represent a souvenir, a fetish, or a scientific specimen. The later aestheticizing of non-Western art subsumed all three categories under the rubric "Native art" (Mullin 1992; Seban 1996). As Clifford has pointed out, these categories are as fluid as the values of the culture that reclassifies them (1988: 228–29). Thus, taxonomy is culture-bound rather than scientific law and carries with it its own set of assumptions, exclusions, and contradictions.

This research also contributes to the study of tourism in Alaska by linking the rise of leisure travel with the rise in the Native art market. Alaska Native art received its first wide dissemination as a result of the steady flow of tourists to the North. Thus tourism and Native art were mutual stimulants. Along with the ever-growing supply of imported consumer goods, tourists' steady demand for souvenirs was probably the major contributor to the sharp decline in artifacts produced for Native consumption.

A corollary to the study of tourism and tourist art is the question of authenticity as a paramount cultural value. Disillusionment with mass production and industrialization were prime motivations for searching out the authentic Native Other and attaching meaning to Others' associated objects (MacCannell 1989). We have already seen that the different taste cultures

constructed authenticity for Native art by plucking the object from its environment and infusing it with meanings all their own (Clifford 1988: 228). However, analysis of these data makes it evident that authenticity was not a unified concept; standards differed from taste culture to taste culture, becoming increasingly restrictive on the higher rungs of the socioeconomic ladder—yet another example of a culture-wide value manipulated by different groups according to their own internal logic (Cohen 1988: 376). This analysis, then, provides a tentative model for the historical evolution of tourist art (e.g., Cohen 1983; Graburn 1984) and for the dynamic interactions between tourism and Native arts around the world today.

Tourism Is Overrated

Pueblo Pottery and the
Early Curio Trade, 1880–1910

Jonathan Batkin

In 1880 the transcontinental railroad reached New Mexico. With trains came tourists, and over the next few decades Pueblo Indian pottery changed dramatically: nontraditional vessels and figurines were made in great numbers.[1] Those facts appear to be linked in a causal relationship, and the resulting perception that tourism directly effected changes in pottery is entrenched in the literature, reinforced by images of Pueblo women selling pots to Victorian-era tourists at the Laguna Pueblo train stop (J. J. Brody 1990: 1–3; Dillingham 1992; Simmons 1979: 211).

Although much has been written about Pueblo pottery, the early curio trade in the Southwest has never been described. Some authors have credited Santa Fe's early curio dealers with a small role in the promotion and sale of pottery to tourists (Babcock, Monthan, and Monthan 1986: 14–17; Batkin 1987a: 28–29; Lange 1995). In reality, however, those dealers were instrumental in developing an enormous market that did not rely on tourism. Pueblo potters took their wares to Santa Fe, where they sold or traded them to curio dealers. Through wholesale distribution and mail-order marketing, the dealers shipped pottery by the barrelful on trains. By the early twentieth century the curio trade comprised hundreds of dealers throughout the United States, many of them offering Pueblo pottery supplied by dealers in Santa Fe. It is only logical that this episode in the history of Pueblo arts has been forgotten: the ephemeral literature documenting it is extremely hard to find.

PUEBLO POTTERY IN THE LATE NINETEENTH CENTURY

By 1880 Pueblo potters had been adapting their wares to meet the needs and tastes of Europeans for nearly three hundred years. Pottery was a house-

hold commodity in colonial times, and we know from accounts as early as 1694 that the Pueblos took it to Santa Fe to sell (Espinosa 1942: 198). However, pottery was not treasured and was seldom mentioned in documents before the Mexican War. Put simply, pottery was meant to be used, broken, and discarded. One visitor of the 1850s said the Pueblos "make earthenware for domestic use, and carry considerable quantities of it to the towns to be sold. It consists principally of jars . . . which are light and porous" (W. W. H. Davis 1938: 83). A visitor in the 1860s observed that "nearly all of the pottery used by the Mexicans is of Pueblo manufacture" (Meline 1868: 231).

To the market in the Santa Fe plaza the Pueblos took "fruit, trout, and game from the mountains, and, also, nearly the sole industrial productions of the country,—jars, dishes, and cups of pottery, some of it painted so as to impart an almost Etruscan or Egyptian air" (Meline 1868: 156). Potters also peddled their wares. In Santa Fe in 1881 John Gregory Bourke purchased pottery from a Pueblo couple who were offering it door-to-door (Bourke 1935: 304–5); and at San Juan Pueblo he noted that potters were "very busy making pottery, not for household use alone, but for sale in Santa Fe as well" (Bourke 1936: 268).

Potters still made traditional household vessels in 1880 and continued to make them for many years; indeed, though today they are marketed as art objects, they have been made continuously in some pueblos up to the present time. Many new types of pottery evolved in the late nineteenth century. Of those, figurines, especially from Cochiti, have commanded the most attention (fig. 17.1). Scholars have focused on their possible descent from religious icons, association with Pueblo clowning, and embodiment of social commentary (Babcock 1986; Babcock, Monthan, and Monthan 1986; Lange 1993, 1995). Other items not formerly made in quantity include vases, pitchers, and other forms modeled after Euro-American prototypes, and miniatures of traditional shapes. Many were finely made, while others were hastily fashioned (fig. 17.2).

Santa Fe's early curio dealers acquired the majority of their pottery from the Pueblo communities that were closest to Santa Fe, especially Tesuque, immediately to the north, and Cochiti, which is to the south. The most illuminating account of potters marketing their work is of Martina Vigil and her husband Florentino Montoya. Already noted potters at San Ildefonso before 1900, they moved to Cochiti sometime around 1905 (Batkin 1987b). There they raised their niece, Tonita Peña, who became the most famous Native American woman painter of her generation. Speaking of the period between about 1905 and 1910, Peña once said that Martina could shape thirty-five water jars in a day. Martina and Florentino had a room where they stored and from which they sold their pots, but they also delivered them to dealers in Santa Fe. Florentino packed pots in their wagon with straw to make the trip, which took two days.[2]

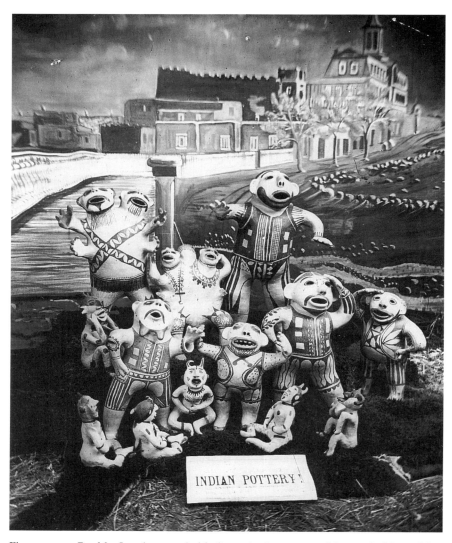

Figure 17.1. Pueblo figurines probably from the inventory of Aaron Gold, c. 1880.
The large figurines are finely made examples from Cochiti; the smaller examples,
from Tesuque, are precursors of the Tesuque rain god. The tallest figure, back
right, now in the collection of the University of Kansas Museum of Anthropology,
is twenty-eight inches tall. Photograph by Ben Wittick. Courtesy of the School of
American Research Collections in the Museum of New Mexico (Neg. no. 16293).

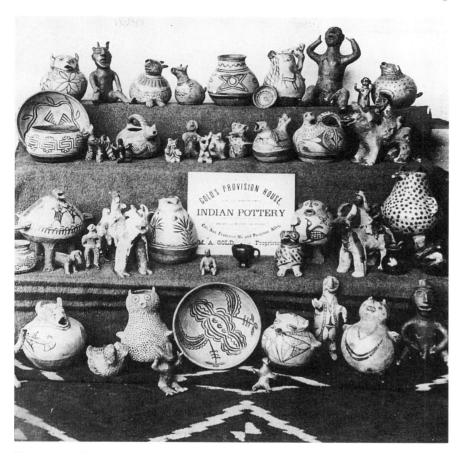

Figure 17.2. Pottery, mostly from Tesuque and Cochiti, in Aaron Gold's inventory, c. 1881. Five pieces were reproduced in H. H. Tammen's earliest known catalog (see fig. 17.5)—the jar at top center, the bowl at bottom center, the bird effigy to the left of the bowl, the horned effigy at bottom left, and the three-legged bird effigy above it. Photograph by B. H. Guerney. Courtesy of the Museum of New Mexico (Neg. no. 741).

Early curio dealers also sold food and dry goods, and it is safe to assume that in addition to cash, potters accepted flour, canned goods, and other merchandise in exchange for pots.[3] Potters then wholesaled their work, relieving them of the need to market or peddle it, and perhaps making it easier for them to produce the great quantities required to supply the curio trade.

Nontraditional vessels purchased from unknown Santa Fe "traders" were among the earliest pots collected for the Bureau of Ethnology (Stevenson

1883: 421–22), but the curio trade was soon criticized. W. H. Holmes of the Bureau of Ethnology said New Mexico "is flooded with cheap and, scientifically speaking, worthless earthenware made by the Pueblo Indians to supply the tourist trade." Because genitalia were depicted on some early figurines, he described curio dealers as a "very vulgar element of the white population"; he described their business as "spurious" (Holmes 1889). This attitude prevailed for decades. Kenneth Chapman, who was responsible for building the major pottery collections of Santa Fe, rejected some pottery collected in 1886, saying the items were "grotesque forms" and, "We have . . . felt it more important to collect the larger jars and bowls that have been in actual use."[4]

THE EARLY CURIO TRADE IN SANTA FE

The most important early curio dealers in Santa Fe, Aaron Gold (Moses Aaron Gold, 1845–84) and Jake Gold (Isaac Jacob Gold, 1851–1905), were sons of Louis Gold, a Polish merchant active in Santa Fe from the 1850s to 1880. Aaron, Jake, and another brother, Abe, left their mother in New York and joined Louis—Aaron arrived in 1855, Abe in 1859, and Jake in 1862.[5] Aaron is the first known to have purchased Indian artifacts. In 1868, while running a store at Peñasco in Taos County, he traded whiskey to an Apache for "a buckskin" and was convicted of selling liquor to Indians.[6] Until 1875 he worked in Santa Fe and Taos counties as a retail and wine merchant and as a sutler. From 1875 on he stayed in Santa Fe, running various stores and a saloon.[7]

Records are insufficient to identify Santa Fe's first curio dealer, but Aaron was the first to advertise store space devoted to the purpose. An ad for Gold's Provision House began running in the *Daily New Mexican* on February 27, 1880, less than three weeks after the first train steamed into town.[8] The shop, at the corner of San Francisco Street and Burro Alley, offered "groceries and provisions" and was "the only place in town where Rare Specimens of Indian Pottery, ancient and modern," could be purchased (fig. 17.3). The great scholar Adolph Bandelier paid his first visit to Aaron in August 1880, noting that he was offered only "recent" pottery (1966: 72–73).[9] When the wife of President Rutherford B. Hayes visited Aaron that October, she was "highly pleased by what she saw, purchasing some of the finest specimens and sending them to Ohio."[10]

Gold's example was followed quickly by Louis Fisher, a merchant who specialized in wool, hides, and pelts.[11] Fisher's first ad appeared only days after Aaron's, saying, "Montezuma Pottery!! The most Attractive Curiosities, made by the Indians of the country a large assortment of which is now in hand."[12] In a photograph of newly made Cochiti figurines and effigy vessels from Fisher's inventory, there is a sign saying, "Rare Specimens [of] Ancient Montezuma Pottery, Taken from Recent Excavations in New Mex-

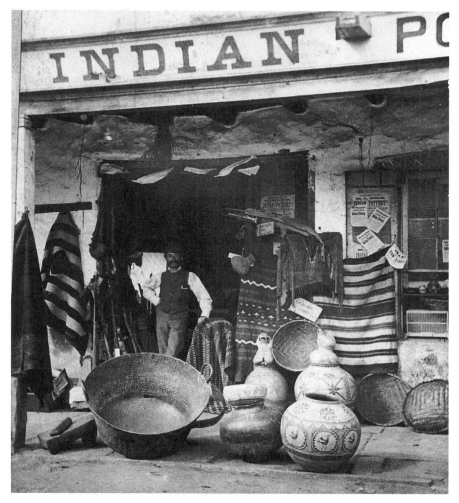

Figure 17.3. Aaron Gold at the San Francisco Street entrance to Gold's Provision House, 1880. Handbills say "Indian Pottery!" Photograph by Ben Wittick. Courtesy of the Museum of New Mexico (Neg. no. 86877).

ico" (Batkin 1987a: 110). Fisher's business, like Aaron Gold's, lasted only a few years.[13]

Aaron Gold's brother Jake secured his first business license in August 1876, registering as a *viandante*, which could mean "peddler" or "itinerant merchant," and paying taxes for two pack animals. It is tempting to suppose that he was trading in the pueblos near Santa Fe, but there is no evidence to sup-

port this. In May 1881 he leased six rooms across the street from Aaron's store, apparently the location of his "Indian Pottery and curiosity shop," as described in McKenney's *Business Directory* (1882: 339).[14] On July 14, 1882, Adolph Bandelier went with Jake to Feast Day at Cochiti, and "Gold bought pottery, old things, Victoriano's shield, and rubbish in general" (Bandelier 1966: 341). Bandelier respected Gold and visited him often when in Santa Fe, writing, "Jac. Gold has a magnificent collection of Indian goods" (1966: 238).[15]

By 1883 Jake had taken over Aaron's store, where he remained for more than fifteen years.[16] His first ads proclaimed: "Dealer in Indian and Mexican Pottery (From Old Mexico), Ancient Montezuma Relics, Curiosities, Etc. All kinds of Indian made goods. Indian tanned skins, curious specimens from the CLIFF DWELLERS and thousands of articles found with no other dealer in America." Sanborn maps document rapid growth of Gold's Free Museum: a small room used for "curiosities" in 1883 was, by 1886, used for "feed" and a larger room for curiosities (Sanborn Map Company 1883, 1886).[17]

Jake Gold was a showman. An 1894 article about his shop explained that Gold's visitors were greeted by his parrot with, "Good morning, my dog," in Spanish, but before they could dwell on the parrot's "indelicacy," Gold would be at work:

> You can purchase the last pair of trousers worn by Columbus, the sword De Soto wore, the hat of Cabeza de Vaca or the breastplate of silver worn by Cortez; that is, if Jake thinks you want any of these things after hearing you talk, and "sizing you up," he will call into play an eloquence so convincing and an indifference about selling, noted so genuinely that you fain would believe.
>
> At any hour of the day you will find his shop crowded with Indians and Mexicans huddled about his stove, rolling and smoking cigarettes and with their curios displayed at their feet or hidden in the folds of their blankets. They wait for only Jake to barter with them. They have the utmost respect for him, for he treats them squarely in a bargain. (Wray 1894)

Gold was dogged by legal problems. He lost his store in 1899 and spent most of 1901 in the state penitentiary.[18] During that time, he corresponded with J. S. Candelario, a friend and local pawnbroker.[19] Just before Gold's release, Candelario secured his first retail license, preparing to open his own curio store, and when Gold got out he went to work for Candelario.[20] Under a 1902 contract Candelario agreed to provide space and to pay for merchandise, and Gold agreed to buy, price, sell, pack, and ship in exchange for 25 percent of the net proceeds. The business was the sole responsibility of Jake Gold and was to be "known and styled and carried on" under the name "Jake Gold's Old Curio Store."[21] The partnership lasted only a year, and Gold died shortly thereafter.[22]

Jesus Sito Candelario (1864–1938) was known to everybody simply as "Candelario."[23] His store was a "must" for travelers, royalty, and presidents.

Teddy Roosevelt "once hurried his breakfast coffee to see and hear Candelario in action," and Candelario himself said, "The tourists want to hear tales, and I am here to administer the same." His treasures included Ben Hur's trunk and the skull of Henry Ward Beecher "as a boy" (Dunne 1948: 11).[24] If scientists disdained curio dealers, Candelario was an exception; several paid visits, and George H. Pepper purchased pottery from him for the American Museum of Natural History.[25] Candelario kept the store until 1936, calling it the Old Curio Store and Original Old Curio Store; in advertising he called himself Candelario the Curio Man.[26]

Candelario's records survive, though they include only letters and orders received. Their richness is enhanced by the fact that his business was shaped by Jake Gold and was therefore a continuation of Gold's Free Museum. Candelario specialized in goods made by Spanish New Mexican weavers and by artisans at Tesuque. He also generalized in merchandise acquired from other specialists: he purchased Navajo textiles and silver from traders on the Navajo reservation, Acoma pottery from Simon Bibo of Laguna, Zuni pottery from George W. Bennett at Zuni, Jicarilla Apache baskets from a young Jicarilla at Dulce named Albert Garcia, Papago baskets from Hugh Norris at San Xavier, Hopi baskets from Lorenzo Hubbell at Ganado, and so on.[27] This information is invaluable—it explains how every curio dealer operated at the time.

Many items made at Tesuque for Candelario had been made in earlier times for Jake Gold; "rain gods" are the most familiar (fig. 17.4) These are small humanlike figurines, usually seated, with their legs together and extended straight in front. Many hold objects or have them in their laps, often small pots. Other items made at Tesuque for Candelario include bows and arrows, beaded purses and watch fobs, clubs, rattles, hand drums, and pottery pipe bowls with wooden stems. In 1883 Adolph Bandelier borrowed from Jake Gold "a little tambourine recently made to order by the Indians of Tesuque."[28] Hand drums of this type were made by covering commercial wooden cheese rings with thin rawhide from sheep or goats. Each club and rattle was made by covering a stick handle with untanned cowhide or horsehide from the animal's rump, tail intact. Hundreds of hides and cheese rings were needed to make these objects, but their source is unknown; they could have been supplied by local butchers or by Gold and Candelario.

Candelario sold rain gods one hundred to the barrel. A rain god cost fifteen cents in 1905, but a barrelful cost $6.50. The quantity in which they were made and sold is staggering. Orders by the barrel were common, and one dealer asked Candelario to quote a price on five thousand.[29] Curio dealers shipped all pottery in barrels: Thomas S. Dozier, another local dealer, said, "Usually I pack in barrels, with cloth tops, containing from fifteen to thirty pieces, according to size" (Dozier c. 1905: 12).

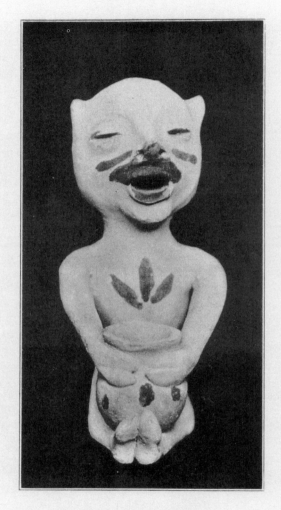

TESUQUE RAIN GOD.

These miniature Idols are made by the Tesuque Pueblo Indians, New Mexico.

They average six inches in height, are of all colors, oddly decorated,

and sell for thirty-five cents each.

Figure 17.4. A Tesuque rain god, illustrated in the Indian Print Shop's catalog of 1907. The shop acquired rain gods by the barrel from Candelario. Private collection.

ORIGINS OF THE MAIL-ORDER CURIO TRADE

Pueblo pottery was an important commodity in the nascent mail-order curio trade, and the first dealer to offer it in a catalog was probably H. H. Tammen of Denver (1856–1924), who established his business in 1881. The earliest of his catalogs known to the author is *Western Echoes. Devoted to Mineralogy, Natural History, Botany, &c., &c* (Tammen 1882).[30] In addition to goods suggested in the title, Tammen offered Native American artifacts, including Pueblo pottery. One engraved illustration explains Tammen's source: the five vessels appear in a photograph of Aaron Gold's stock taken around 1881 (figures 17.2 and 17.5).Under the heading "Pueblo Indian Idols," Tammen illustrated two prototypes of rain gods. He said, "They are looked upon by the Indians as gods, such names as 'The God of War,' 'God of Pain,' 'God of Hunger,' 'God of Plenty,' etc., being given them." He also said the Indians "retain the old Aztec rites, and each day at sunrise ascend to the tops of their houses, expecting the coming of the long-looked-for Montezuma" (Tammen 1882: 11).

Similar comments appear in a catalog from G. D. McClain of Denver. With an engraving of pots and rain gods, headed, "Mexican Pottery and Idols Made by the Indians," is this text:

> It must have taken centuries of toil and slow inventive genius to produce the wonderful objects worked in clay by the early Aztec inhabitants of that country. These relics are very numerous and to be found on every hand. The art seems to have been handed down through centuries, as we find the Indian descendants of that lost race all over Old and New Mexico producing potteries and little gods after the style of their Aztec fathers. The work is done by hand and no thought given to the design until the clay is in their hands. . . . Of the *tepitoton,* or little gods . . . it is said Bishop Zumarraga destroyed twenty thousand, such as the God of Storms and Master of Paradise, God of War, God of Plenty, God of Pain, etc. . . . You will find them interesting as cabinet specimens and bric-a-brac. (McClain c. 1890: 11)

These remarks are clearly related to Louis Fisher's "Montezuma Pottery" and Jake Gold's "Montezuma Relics." Fisher deliberately misrepresented newly made pottery as ancient, but the association between Montezuma and the Pueblo Indians could have been suggested to these traders by the Pueblos themselves. Legends of Montezuma were widespread among the Pueblos in the nineteenth century and appear in early popular literature from New Mexico (Brevoort 1874: 143). This complicated distortion of fact was explained in a marvelous piece of research by Adolph Bandelier (1892).

Tammen's catalog *Western Echoes* was followed by *Objects of Interest from the Plains and Rocky Mountains* (Tammen 1886) and *Relics from the Rockies* (Tammen c. 1887). In these catalogs Tammen described figurines and effigy pots as toys and said that each was made "as a study for a boy or girl, a prize for

the Ethnologist, or odd decoration for a Whatnot [a type of cabinet]" (c. 1887: 21). He offered pottery in lots, each pot identified by source, such as Acoma, Zuni, or San Juan; by function, such as "eating," "medicines," or "worship"; and by its "Indian name," which in most cases was actually its Spanish name— for example, *olla* or *canasta*. The pots were sold only in lots and shipped in barrels because they were "very bulky and express charges and packing on single pieces too costly." In the event a described pot was out of stock, Tammen substituted "such others as will be equally rare and odd" (1886: 21).

The earliest known curio catalog from New Mexico, a small piece of paper folded to eight pages, was published about 1887 by Jake Gold. Gold plagiarized almost every word of his text. His descriptions and illustrations of trap-door spiders and nests were taken from Tammen's catalogs, his text and illustrations of Navajo weaving were taken from Washington Matthews's "Navajo Weavers" (1884), and his text on Santa Fe was lifted from McKenney's *Business Directory*. Although Gold undoubtedly supplied curio dealers elsewhere with pottery, it is not mentioned in this pamphlet.

In 1889 Gold published a larger pamphlet, *Catalogue of Gold's Free Museum and Old Curiosity Shop*. Gold repeated the content of his earlier pamphlet and summarized Pueblo pottery in a few lines. He also listed mineral specimens, mounted and preserved insects and reptiles, animal hide robes and rugs, and other things that were also sold by H. H. Tammen. Obviously, these things were readily available from some source, perhaps Tammen himself. Mexican semiprecious stones, rag dolls, wax figures, pottery, and other goods would have been supplied by jobbers in Mexico or perhaps by traders in border towns, such as W. G. Walz of El Paso. A dealer in musical instruments and curios and a friend of Gold's, Walz published a beautiful curio catalog in 1888 (Walz 1888).

Gold claimed "his collectors are all the time gathering curios from the remotest parts of the Territory where the stranger could not penetrate" (1889: 16), and in 1894 he told Henry Russell Wray that he employed two hundred collectors, who traded Germantown yarns and chromolithographs of saints for artifacts for his store (Wray 1894). Gold developed an impressive network of suppliers, but he did not have to employ anybody to acquire things. Almost everything offered in his 1889 catalog could have been delivered by its makers or shipped to him by rail. Records from Candelario's store document transactions with dozens of reservation traders and urban curio dealers; as we have seen, these were probably the same people who supplied Gold before 1899.

STRATEGIES OF THE MAIL-ORDER CURIO TRADE

To draw business, leading curio dealers, including the earliest mail-order dealers, engaged in self-promotion and the creation of an atmosphere of

credibility and wonder. The simplest way to establish credibility was to claim that one had been in business for a long time. Aaron and Jake Gold used their dates of arrival in Santa Fe to say "Established 1855" and "Established 1862." Candelario used a somewhat earlier date, 1603, and liked to say that the store had been in his family's possession since then (Dunne 1948: 41).

Naming or describing one's store as a museum was common and was an incentive for mail-order customers to visit. McClain's Mineral Museum had an operating miniature mountain and ore sampling works: "This is one of the Attractions when you visit the city" (McClain c. 1890: front cover). When H. H. Tammen opened his store in 1881, an article in the *Denver Daily Tribune* said:

> There is one establishment in Denver that not tourist, traveler or visitor should miss seeing, and that is the free museum of Mr. H. H. Tammen. . . . It is a complete, varied and extensive exhibition of the natural history of the Great West. . . . The idea [is] so novel, and at the same time so praiseworthy . . . that the proprietors . . . have enjoyed a large and lucrative patronage from . . . opening day. . . . [The visitor can] find himself down in the bowels of the earth . . . where they are digging out the gold and . . . can transform himself into a traveler, suddenly arriving in the center of an Indian country, where their articles of peace and war are awaiting examination. (Tammen c. 1887: inside front cover)

Tammen was the most influential dealer among those whose catalogs emphasized the Southwest and Rocky Mountain regions during the 1880s and 1890s, and his market can be readily discerned from his catalogs. He offered "mineral cabinets" for children, parents, and educators; mounted heads of game animals for hotels and saloons; clocks encrusted with mineral specimens for crowded Victorian mantels; and crochet hooks with agate handles for the industrious. His catalogs were similar to one another until 1900, when a new type of "novelty" emerged. Banners of commercially tanned hide with painted or burned portraits of Indians and slices of orange wood with burned images were offered together with dolls, toys, and items that had appeared in earlier catalogs (Tammen 1904). The suggested relationship between Indians and nature persisted in curio catalogs for decades. Even the new novelties that appeared around 1900 were made of materials that suggested a connection with nature. These were produced by companies that also manufactured "Indian suits," "Rough Rider suits," and moccasins.[31]

Catalog texts illustrate how the representation of Native American objects evolved. The rain god and its precursors are good examples of artifacts made more appealing during the 1880s through utter misrepresentation. The rain god evolved rapidly to become a uniform and standardized object by 1887, when its association with ancient people and its function as an object of worship were widely stated. But the source of the misinformation had to be the Santa Fe dealers who supplied Tammen, and Tammen

must have decided that rain gods had become too common to sell as idols, eventually losing interest in them. In his catalog *Curious Things from the Rocky Mountains,* he said: "As an interesting and odd piece of bric-a-brac they have no equal. 'Oh! What a Booby Prize,' is what the ladies exclaim when they see one" (c. 1896: 23). Although the rain god was Tammen's trademark from about 1887 on and appears as such on the cover of his 1904 catalog, he did not offer it for sale within.

The imagined imminent loss of Indian cultures guaranteed the ultimate rarity of objects. This illusion was used by many dealers, playing off the public's ignorance about the ready supply of objects for the trade. L. W. Stilwell of South Dakota ordered regularly from Candelario and in a 1904 catalog offered clubs of the type made at Tesuque, presumably acquired from him. He said of these and other items that they "have never been known to be so hard to procure, and the demand is very active. Only a few more years and these things will not be procurable at all" (Stilwell 1904: 44). Nothing, however, surpasses the sales pitches for Navajo silver swastika jewelry. Public interest in swastikas must have been spurred by publication of Wilson's study (1896), and curio dealers were quick to respond. One dealer said that with the Navajos, the swastika "is held in great reverence, and only those who are good and true are allowed to possess one. . . . A favorite native method of wearing the Swastika is as a heavy pendant from strands of beads worn around the neck, when it rests conspicuously upon the breast. Protected in this way the Indians become fanatics and perform most wonderful deeds of valor and endurance" (Benham Indian Trading Company 1905a).

Francis E. Lester of Mesilla Park, New Mexico, epitomizes another breed of mail-order dealer, emphasizing craft and home decoration. Starting his business about 1898, Lester's early catalogs were devoted principally to Mexican drawn linen items such as doilies, handkerchiefs, and tablecloths; but beginning in 1904 he included items supplied by Candelario, among them rain gods and everything else made at Tesuque (Lester 1904: 40).[32] By 1907 "Indian handicraft" occupied considerable space in his catalogs. Lester frowned on the new trend toward mass-produced novelties, saying, "Visit the average curio store and see for yourself the burned leather and wood rubbish unblushingly called 'Indian handiwork'" (1907a: 71).

Claiming to be the "Largest Retailers of Genuine Mexican and Indian Handicraft in the World," Lester's first trademark was a circle enclosing a cross with his company name and either the slogan "To Make Homes More Beautiful" or "To Beautify Homes." Writing on the "Decorative Value of Indian Handicraft," Lester spoke of our "modern idea of home decoration":

> First in usefulness . . . comes the Indian blanket. Anyone who has seen a Mission style interior furnished with a Navajo blanket . . . and with Indian blankets for portieres, hung flat and drawn lightly back, much as the old Flemish

door tapestries were used, cannot fail to have been impressed with the harmony of the scheme. . . . Indian basketry and pottery come as close seconds to blanketry in decorative usefulness. . . . the natural colors . . . will be found to harmonize beautifully with almost all furnishing schemes. (1907a: 72)

Like Tammen, Lester was a major force in the mail-order trade. By 1907 he claimed to have 150,000 customers (Lester 1907b: 2), and a photograph of his employees, reproduced on the cover of a 1910 mailing, shows a staff of fifty (Lester 1910).[33] His merchandising was slick, and his catalogs exhibited fine contemporaneous design reminiscent of leading women's magazines of the period. Like many curio dealers, he advertised in national publications catering to hobbyists and women, including the *Philatelic West and Camera News for the Man with a Hobby* and the *Ladies' Home Journal*.[34] The value of advertising in these serials was stated by the advertising manager for the *Chicago Collectors Monthly,* which was "devoted to Stamp, Coin and Curio Collecting": "The class of people we reach is the kind interested in the better grade of Indian and Mexican handiwork and who have the money to purchase what they want."[35]

One interesting development, the promotion of an "Indian corner" in people's homes, coincided with the peak of the mail-order trade around 1905. The most explicit publication was issued by the Benham Indian Trading Company. *A Starter for an Indian Corner* offered a Tesuque clay pipe, a Zuni fruit basket, an Apache bow and arrows, a small Navajo loom with an incomplete textile, three pieces of Pueblo pottery, a small hand drum from Isleta, a Ute war club, and a tinted photograph of an Indian in a leather frame with burned designs, all for $3.75 (Benham Indian Trading Company 1905b). Candelario issued a similar pamphlet the same year. He offered the buyer a choice of nine different "corners," each including the contents of the preceding corner plus a few more objects, and ranging in price from $6 to $50 (Candelario 1905).[36]

The peak of the mail-order trade around 1905, the emphasis on handicraft, and promotion of the Indian corner are all due to the influence of the Arts and Crafts Movement, but it was not simply interest in the handmade that drew attention to Indian arts. In an effort to champion Indian baskets, George Wharton James wrote an article for *Handicraft,* the journal of the Society of Arts and Crafts, Boston, explaining that "white women" could be literally transported by the experience of weaving Indian-style baskets. "It will show us the worth of real work, and reveal the value of the efforts of these simple aborigines. We shall learn that they 'felt,'—were sentient, poetic, religious" (James 1903a: 271).

A leading Arts and Crafts publication, the *Indian School Journal,* was printed at the Indian Industrial Training School in Chilocco, Oklahoma, under the direction of Edgar K. Miller. Miller trained young Indians in press-

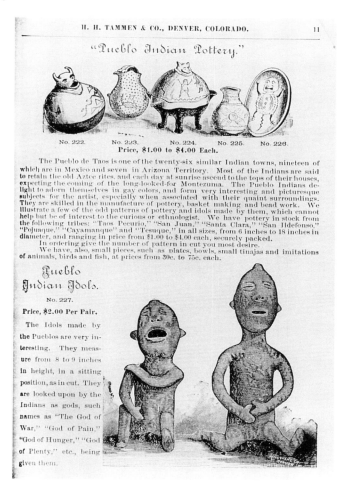

Figure 17.5. Engraved illustrations in H. H. Tammen's 1882 catalog, *Western Echoes,* include a rendering of pots from Aaron Gold's inventory and two precursors of the Tesuque rain god. Courtesy of the Western History Department, Denver Public Library.

work and offered the shop's services to anybody desiring stationery and other printed material. The shop's letterhead read "The Indian Print Shop, Handicrafters." In 1905 "Indian goods" were added to the inventory of the school store and shortly thereafter transferred to the Indian Print Shop. Before long Miller was engaged in a mail-order business, printing his own catalogs (In-

dian Print Shop 1905, 1907). He offered Navajo rugs, Tesuque rain gods, which he purchased from Candelario (fig. 17.5), and all the other items that could be obtained from curio dealers and reservation traders.[37]

In Miller's network was the Roycroft community of East Aurora, New York, whose founder, Elbert Hubbard, espoused the ideals of the Arts and Crafts Movement not only through his shops' products but also through publications of his Roycroft Press. The Roycroft Shops produced furniture, metalwork, and lighting fixtures, and in a small retail space they offered their products and other goods. In a 1905 letter to the Indian Print Shop, Hubbard's wife, Alice, explained that Navajo rugs purchased from them sold well, but other items did not.[38] As suggested by Francis Lester, Navajo rugs were ideal accents in a room with Mission-style furnishings, and in an issue of *The FRA*, one of the Roycroft publications, J. B. Moore, the famous reservation trader of Crystal, New Mexico, described Navajo weavers as "Indian-Roycrofters" (Moore 1910). Coincidentally two of Moore's four famous catalogs were printed by the Indian Print Shop (Moore 1987: 98, 103). Many reservation traders and curio dealers advertised in the *Indian School Journal* and equivalent publications from other parts of the country, such as the *Native American*, printed by students of the Phoenix Indian School.

CONCLUSION

Tourism is presumed to have been the driving force behind the evolution and consumption of Pueblo pottery after 1880, but curio dealers reached a much larger audience through their catalogs and advertising. The earliest catalogs played on the public's ignorance and nostalgia, but as the Arts and Crafts Movement took hold, curio dealers shifted the emphasis of their promotions to handicraft. By 1905 the curio trade was an inescapable presence. Hundreds of dealers offered curios in specialty stores and in corners of groceries, pharmacies, and post offices; they were even present at the expositions in St. Louis in 1904 and Portland in 1905, selling goods supplied by Candelario and others as quickly as they could be sent.[39]

Santa Fe's early curio dealers were pioneers in a vast, nationwide phenomenon. The mail-order trade and the network of dealers was so great an influence on middle-class collecting that its lack of recognition in the literature of Native American arts is truly remarkable. The deliberateness with which anthropologists spurned the curio trade may account partially for its obscurity. Only a handful of institutions that collected Native American artifacts between 1880 and 1910 have in their possession even a single curio catalog from that era, though by a conservative estimate more than one hundred were published. It is hoped that this first attempt to describe some aspects of the trade will encourage further examination of it.

PART SIX

Staging Tourist Art

Contexts for Cultural Conservation

Indian Villages and Entertainments
Setting the Stage for Tourist Souvenir Sales

Trudy Nicks

"Beadwork sells much better in a set-up like Poking Fire than through shops where it will just sit on a shelf," Leo Diabo remarked during an interview in the Mohawk village of Kahnawake, Quebec, in early 1991.[1] The Poking Fire "set-up" to which he referred was a tourist attraction developed by John Mc-Comber, also known as Chief Poking Fire, in the village of Kahnawake in the 1930s. Originally known as "Chief Poking Fire Totum [*sic*] Pole Indian Village," McComber's enterprise provided visitors with a highly staged representation of Indians as exotic Others (fig. 18.1). At the height of its popularity as a tourist attraction, Leo Diabo remembered, as many as twenty stands sold beadwork souvenirs on the grounds of the village. Each stand displayed the work of up to ten beadworkers from the community.

John McComber died in 1979, leaving the tourist village to his descendants. The village has declined as a business in the years since his death, but in the early 1990s it still attracted tourists from as far away as Europe and continued to provide a sales outlet for locally made beadwork souvenirs.

INDIAN AGENCY

The Poking Fire village is far from an isolated example of how Indian people have catered to tourism. The advent of mass tourism in the second half of the nineteenth century provided many opportunities for Indians in the eastern Woodlands and elsewhere to trade on their cultural Otherness. Villages featuring "exotic"—that is, non-Western—peoples and their cultures became popular attractions at international exhibitions in North America and overseas. Indian villages were developed at many holiday resorts and historic sites, as well as in or near Indian communities.[2]

To date we have a better understanding of the motives of the tourists for

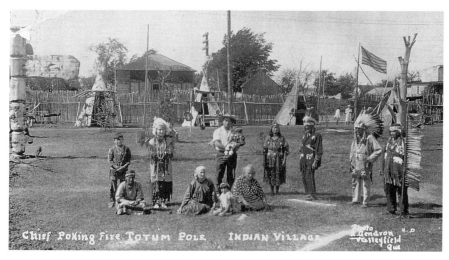

Figure 18.1. Postcard of Poking Fire village and costumed performers in early years of operation. Photograph by R. Gendron, Valleyfield, Quebec.

visiting these sites than of the reasons Indian people became involved in them. The literature on ethnic tourism analyzes the influence of mass tourism on "the restoration, preservation, and fictional recreation of ethnic attributes" (MacCannell 1984: 377). It has been pointed out that this approach overemphasizes overt cultural features and does not adequately account for nontourist encounters with outsiders (Gamper 1985: 251). It also privileges the idea of "pure" or "real" cultures in its concern for "fake" representations on the part of ethnic hosts (Van Den Berge and Keyes 1984: 345–46).

A broader perspective, which takes into account the history of Indian-European encounters and the creative accommodations made by both parties in these meetings, offers a more productive approach to understanding the active roles played by Indians in their encounters with tourists. Ruth Phillips (1991) has used such an approach in her analysis of imagery on nineteenth-century Huron tourist arts. She has emphasized the historical development of tourist arts as a two-way process in which Native producers and non-Native consumers both contribute imagery and make conscious decisions, and she has explored the creative roles played by the Huron makers of the objects. A historical and cross-cultural perspective is equally useful for studying Indian agency in the construction of the contexts in which such souvenir arts have been sold. Like the constructivist position described by Edward Bruner (1994), this approach sees culture as emergent, always alive and in process, and continually being reinvented.

This essay considers representations of Indian culture presented at Chief Poking Fire's village in the context of the long history of encounters between Europeans and the Mohawk residents of Kahnawake. Poking Fire's village provided tourists with a restricted view of the lives of the citizens of Kahnawake, but not one without local cultural and historical relevance. If the choice of representations accommodated twentieth-century tourists' expectations, it was also an authentic expression based on a long history of negotiating intercultural encounters with Europeans. This essay also discusses some contemporary Indian views on the uses and problems of Poking Fire–style presentations for present-day encounters between themselves and non-Indian others. Contemporary opinion is divided about whether the stereotyped imagery of these representations can be used strategically to gain recognition for First Nations as separate, vital cultures in the modern world or whether they work against the achievement of the ultimate goal of self-determination.

KAHNAWAKE

The village of Kahnawake dates to the establishment of mission villages on the St. Lawrence River in the seventeenth century. These villages were to be safe havens where Iroquois converts to Christianity would be removed from the corrupting influences both of their unconverted relatives and of the French (Blanchard 1982; Devine 1922; Richter 1985). In fact, the community never seems to have been particularly isolated.

Over a period of two centuries, the Mohawks of Kahnawake were military allies first of the French and then of the English. Kahnawake people were actively engaged in the early fur trade through New York. By the end of the eighteenth century and well into the nineteenth, they were traveling to the Far West under contracts to the XY, North West, and Hudson's Bay fur companies (Nicks 1980). During the fur trade period they earned a reputation as highly skilled voyagers who, as Colin Robertson of the Hudson's Bay Company noted in 1819, "in either a rapid or traverse [display] calmness and presence of mind which never forsakes them in the greatest danger" (Robertson 1939: 56).

The decline of the fur trade in the nineteenth century led Iroquois to seek other occupations outside of the community, including rafting logs and piloting boats on the Ottawa and St. Lawrence Rivers (Devine 1922: 402; Jasen 1993: 55–57; William 1877–79: 92). Patricia Jasen argues that the Iroquois boatmen and raftsmen were the very embodiment of the Noble Savage for nineteenth-century tourists on the St. Lawrence River. The romantic imagery was reinforced in nineteenth-century tourist guidebooks, which played up the dangers of the Lachine rapids located opposite the village of Kahnawake and the skill and strength of the Iroquois boatmen and pilots. For their part,

the boatmen and pilots added to this image by adopting boat songs and dress evocative of the earlier voyageur era (Jasen 1993: 55–57; Jasen 1995: 61–66; Beauvais 1985).

Kahnawake men served with British Commander Lord Garnet Wolseley in two major military campaigns of the late nineteenth century. Sixty men accompanied the 1870 Red River expedition to build roads and do portage work for Wolseley's soldiers (Devine 1922: 407). In 1884–85 Kahnawake men were among the fifty Iroquois hired by Wolseley to take boats over the cataracts of the Nile in his attempt to rescue General Gordon's garrison at Khartoum (Devine 1922: 416; Stacey 1959).[3]

In the 1850s Kahnawake men worked on the construction of the Victoria Bridge at Montreal, and since the late nineteenth century they have worked as ironworkers on major construction sites in Canada and across the United States (Katzer 1972). The present community is very active nationally and internationally in furthering the cause of Iroquoian sovereignty. In 1990 this cause brought the community into armed confrontation with the Quebec police and the Canadian army when Kahnawake sided with the neighboring Iroquois of Kanesatake in a land claim issue.[4] In short, Kahnawake residents have a long history of involvement with the world beyond their community.

KAHNAWAKE ENTERTAINERS

Of particular interest to the present study is the early involvement of people from Kahnawake in the entertainment business, both at home and abroad. Europeans seem always to have been interested in observing performances by Indians. Descriptions of Iroquoian ceremonial and social dances appear in seventeenth-century records (Blanchard 1984: 101). At the beginning of the nineteenth century, George Heriot, deputy postmaster of British North America, described and illustrated the staging of ceremonial dances at the Huron village of Lorette for visitors from Quebec City (R. Phillips 1984: 53, 91).[5]

Nineteenth-century entertainments at Kahnawake included sports events such as canoe races and lacrosse games. According to David Blanchard, it was a demonstration of these skills for the Prince of Wales at the opening of the Victoria Bridge in 1860 that led to Kahnawake performers' overseas careers in the entertainment business (1984: 99). From the 1860s through the first decade of the twentieth century, Kahnawake families traveled to Great Britain and Europe to perform before royalty and at public venues, including the Universal Exhibition in Paris, as well as various events at Earl's Court, White City, and Wembly in London (Blanchard 1984: 105; Beauvais 1985; King 1991). The performances included sports exhibitions, dances, and demonstrations of craft production and domestic activities.[6] Blanchard's research (1984) shows that these performances were produced by the Indians themselves and

were derived from their own cultural traditions of sports, pantomime dances, and dress. At the same time, Kahnawake entertainers were traveling across Canada and the United States with their own "medicine shows." The sale of craftwork was part of the shows at home and abroad. At least in North America, patent medicines were also offered for sale to audiences.[7]

The advent of the Wild West show had a major influence on Kahnawake entertainers. Their early experience with this type of performance included the Buffalo Bill Wild West Show staged in 1893 to coincide with the Chicago Columbian Exposition. Some Kahnawake performers went on to join Wild West shows staged by Pawnee Bill and Texas Jack in Canada, the United States, Europe, and South Africa. The Mohawks who traveled to Europe with Texas Jack were advertised as Sioux Indians, a piece of fabrication that apparently did not offend the audiences. The *Neue Freie Presse* of Vienna reported on May 8, 1890:

> Whether the Indians really belong to the tribes named in the program might well make little difference to the Viennese; they are looking savage enough with their yellow and red painted faces and bodies and their feather ornaments, and it cannot spoil the general exotic impression of the picture that some of the Messrs. Ogalalla-Sioux and Arrapahoes are wearing colored Oxford shirts and other products of the modern clothing industry. (Quoted in Riegler 1988: 19–20)

The Wild West shows established the Plains Indian as the standard of Indianness for audiences in North America and overseas by the end of the nineteenth century. As a result, the Iroquois performers had to adjust their image to meet the expectations of their white audiences. According to John Beauvais of Kahnawake, "in light of the audience's preference to see the 'real' wild west, [we] had to adopt the 'Sioux look,' to make-up new dances and songs and to learn trick horse riding" (1985: 136). In the 1911 Coronation Exhibition at White City in London, Iroquois performers who had previously appeared in exhibitions dressed in eastern Woodlands attire now dressed in Plains feather bonnets and hide clothing (King 1991).

In the twentieth century, Kahnawake performers appeared in a variety of entertainment venues. They were a major part of the 1908 Quebec pageants to mark the Champlain Tercentenary and the Hiawatha pageant that grew out of it. They ultimately inherited the costumes and props and continued to perform the pageant in the eastern United States until 1920 (Blanchard 1984: 109). They also moved into vaudeville, where they acted in pantomimes (including, according to Blanchard, an "authentic Indian scalping" of General Custer), demonstrated feats of strength, and performed musical entertainments.

The best-remembered Kahnawake vaudevillian is Esther Deer, a member of the Deer family that had toured with Texas Jack for five years at the turn

of the twentieth century before striking out on their own.[8] Using the name Princess White Deer, she traveled widely in Europe with her own dance interpretations of Native legends as well as "oriental" dances (Blanchard 1984; Nicks and Phillips 1995). Her eclectic theatrical wardrobe, now at the Kanien'kehaka Raotitiohkwa Cultural Centre in Kahnawake, includes Plains-style clothing (e.g., a bright pink Sioux-style feather bonnet with trailer) and Zulu beadwork.

Other Kahnawake performers worked as movie extras in New York, danced on Broadway, and appeared in exhibitions and club shows (Beauvais 1985). On the sports side of the entertainment industry, Kahnawake was represented by the father and son wrestlers Joe and Carl Bell, alias "War Eagle" and "Don Eagle." They too appeared in Plains Indian feather bonnets, moccasins, and other articles of adornment. Carl's son remembers that the Plains-style moccasins were made by Joe Bell's wife "for the camera, for show in the tourist arena" (Flint Eagle, personal communication, 1991). She also made "Don Eagle souvenir dolls" dressed in beaded hide suits, which she sold at his wrestling matches.

The sale of craftwork produced at Kahnawake was a common part of most entertainments. The McComber family, builders of Chief Poking Fire's village, has made and sold beadwork since the nineteenth century. In the McComber family papers there are permits to sell handicrafts in the midwestern and far western United States dated as early as the 1890s.

STAGING OTHERNESS

John McComber's decision to build his Totem Pole Village in Kahnawake in 1936, in the midst of the Great Depression, was an astute business decision. The village was well situated to take advantage of the tourist trade. Located on the south shore of the St. Lawrence River opposite Montreal, it is in a popular tourism corridor that stretches from Quebec City to Niagara Falls. Both these sites have been major tourist attractions since the early nineteenth century (Jasen 1993; Lessard 1987; Wolfe 1962). Chief Poking Fire's Indian village became another destination in an existing market. Moreover, he had access to performers and producers of souvenirs within the community where a tradition of involvement in the tourism and entertainment industry was well established. For more than half a century the village opened every summer to receive tourists.

The major physical features of the Poking Fire village grew, over the years, to include a palisade of poles, a central building for performances and for the display of historical artifacts and the sale of souvenirs, stylized totem poles, handicraft booths in the shape of Plains tipis or small sheds, a wishing well, and a grotto.[9] The shallow wishing well was stocked with turtles and provided a venue where tourists could gather to hear Chief Poking Fire expound on

their significance to Iroquois people. The mixed Woodlands, Plains, and Northwest Coast imagery was quite appropriate to tourist expectations of Indianness. The main building may not have looked too much like the Iroquois longhouse it claimed to be, but it was suitably covered with natural bark and decorated with symbols of Indianness and nature (fig. 18.2). After it burned in the 1950s, it was replaced with the present quonset-style structure.

Plains Indian imagery had been part of the Kahnawake entertainment repertoire since the end of the nineteenth century. The tipi sales booths were complemented by Plains dress worn by Chief Poking Fire himself and by children and adults from the community who performed social dances for the enjoyment of visitors. Souvenir postcards of the village show the chief and family "on the trail" with horses and travois (fig. 18.3). The totem poles at Poking Fire's village were among the first introduced to the Woodlands, and the source of this inspiration could have been Canadian Pacific Railway's advertising (King 1991: 41; Jonaitis, this volume), the Canadian government's efforts to involve Indians in Quebec and Ontario in the production of tourist souvenirs (Nicks 1982, 1990), or the McComber family's own wide-ranging travels.

The grotto represented a shrine to Kateri Tekawitha, a young Christian Iroquois woman who died in Kahnawake in 1680.[10] Her tomb is in the mission church of Saint Francis-Xavier in Kahnawake, which, given its seventeenth-century construction date, is a tourist attraction in its own right as well as an important site of pilgrimage for Native and non-Native Catholics. Kateri Tekawitha was declared Venerable by Pope Pius XII in 1943 and beatified by Pope John Paul II in 1980. She is an important figure well beyond Kahnawake. By building a shrine in her honor, John McComber provided a link to the early history of the local community in his tourist-oriented village.

Live performances were an important part of the touristic experience in Poking Fire's village. There were lectures by Chief Poking Fire, demonstrations of archery and rope tricks, and dances by local performers. Until the 1990s, dance crews of twenty or more performers provided daily entertainment throughout the summer. Marjorie McComber remembers that the dances performed included the Welcome, Friendship, Hunting, and Maiden dances, as well as one performed by "old ladies" (personal communication, 1991).

Perhaps the most spectacular entertainments were the naming ceremonies at which Chief Poking Fire officiated. Over the years he gave Mohawk names to a number of honorary chiefs and princesses. A partial list of the recipients in the McComber family papers includes sports figures, politicians, business officials, and entertainers. A Montreal poet, Lady Amy Redpath Roddick, who provided funds to construct the first museum building and the grotto honoring Kateri Tekawitha, was named Princess Gathering Words in 1939. Conrad Hilton was named Chief King of Hotels in 1958. The next year three officials from the Montreal Sportsman's Show were also named honorary chiefs. Each was presented with a Plains-style headdress of dyed turkey feath-

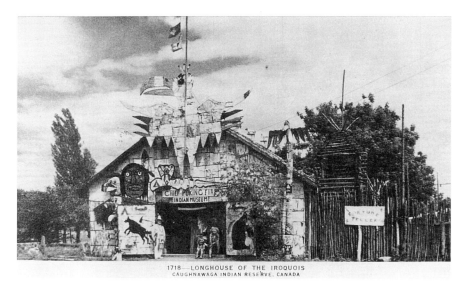

Figure 18.2. Postcard from 1950s showing first "Longhouse" at Poking Fire village.

ers, a wooden pipe, and a birchbark scroll inscribed with his or her name, honorary title (in Mohawk and English), and the date of the ceremony.

The widow of one of these recipients, Phil Novikoff, presented his regalia to the Royal Ontario Museum in 1992. Mrs. Novikoff placed great importance on the honor Chief Poking Fire had bestowed on her husband in 1959, emphasizing the connection it represented to the Mohawk culture. From the McCombers' perspective, these naming ceremonies were mainly important as public relations functions. The ceremonies were usually commissioned by outsiders, who specified the recipients and paid the costs incurred, including the cost of the regalia, which was made by local women who worked in the village. There are other examples of naming ceremonies at the same time in which the recipient of the honorary name was specifically selected by the community. The Royal Ontario Museum recently received the headdress presented to Malcolm Montgomery, Q.C., in 1958, in recognition of his legal services on behalf of the Confederacy Chiefs of the Six Nations Iroquois at Brantford, Ontario. He was given the name Tie-wa-gai-nah ("he who interprets the law"), according to his wife. His headdress is styled after a traditional *gastoweh* and made of wild turkey and golden eagle feathers, rather than resembling a brightly colored Plains-style bonnet.

The Montgomery example seems closer in spirit and significance to the historical Iroquoian practice of establishing alliances with outsiders through adoption and gift giving. Iroquois gave honorary names to Europeans at least

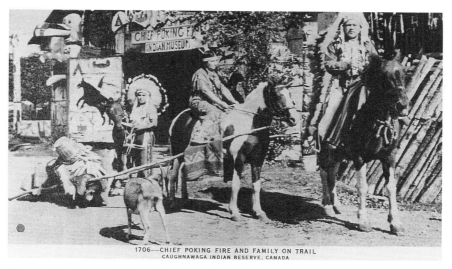

Figure 18.3. Postcard from the 1950s showing Chief Poking Fire and family members in Plains Indian dress during performance.

as early as the end of the eighteenth century (Chadwick 1897: 98–103). The McComber name itself arrived in Kahnawake during the eighteenth century when Gervais McComber, a native of Massachusetts, was adopted as a member of the Kahnawake community (Devine 1922: 421). In the hands of Chief Poking Fire, naming ceremonies certainly underwent embellishment and commoditization. Still, he arguably followed rather than invented the tradition. Perhaps most important, he interpreted a tradition using imagery that represented the very essence of Indianness for tourists.[11]

SOUVENIRS

The staged village and its associated entertainments provided an environment that evoked authenticity and Indianness for outsiders. It was a stage that, as Leo Diabo has observed, greatly enhanced the salability of the beadwork produced in the community (1991 interview with author). Like the village itself, the beadwork souvenirs meant different things to tourists and to community members. For the tourists they were mementos of an exotic Other that existed primarily in their own imaginations and was reinforced by the staged village. The producers of beadwork certainly catered to this market. Beyond their economic value in tourist exchanges, however, the souvenirs represented personal skill and social and historical links within the community.

Contemporary beadworkers speak fondly of the social side of souvenir pro-

duction.[12] Production was often carried out by groups of women. Children might be recruited to thread needles, string beads for fringes on beaded items, and draw designs or write words (e.g., "Good Luck" or "Ottawa Fair") on objects to guide the beadworkers, not all of whom knew English. Adult women today remember that as children they were often given the task of picking beads up from the floor, not realizing at the time that the beads were discards and the task merely one to keep them out of the way.

Production networks could also serve as a form of community social security. A number of the major producers and sellers of souvenirs farmed out the production of certain types of objects or parts of production processes to needy families. In interviews in Kahnawake, community members related several stories of women working long, late hours to produce beaded chains and leather bookmarks to support their families. The economic independence gained through such work was a source of personal pride.

The historical links represented by Kahnawake beadwork span many generations. By the early nineteenth century, the production of beadwork, moccasins, snowshoes, and basketry for sale to the Montreal market was well established.[13] In the 1990s, several beadworkers, a number of them elderly women, still employ patterns they inherited from their mothers and grandmothers. The creation of beaded souvenirs remains an important tradition in Kahnawake today. Beaded birds, boats, horseshoes, picture frames, and pincushions have been made for generations. Kateri dolls—two-dimensional beaded images of girls with black braids and long dresses—have been a local specialty at least since the 1940s. The strength of identity attached to these forms is attested to by a young woman from Kahnawake who took up beadworking about 1990. Self-taught, she has become one of the most skilled beadworkers in the community. Although some of her production techniques are innovative, she has remained faithful to the styles that have characterized Kahnawake beadwork for generations.[14]

In the context of the politics of identity, it is useful to consider the link between objects and oral traditions, the former being the visual referents and reminders of the traditional beliefs and values embedded in the latter. Tuscarora artist Jolene Rickard (1992) argues that beaded objects such as birds and pin cushions are mnemonic objects as surely as wampum belts and condolence canes are, and that they thus serve as reminders of spiritual, economic, and cultural survival. "The practice of looking at things to remember is our way" (Rickard 1992: 108). Rickard also reminds us that the term "whimsies," which antique dealers and others often apply to beadwork souvenirs, is hardly appropriate given the significance of these objects for Indian people (1992: 109). "Whimsies" suggests trivial things, which may be an accurate enough description of the recreational or fancy beadwork produced in non-Indian Victorian households, but it surely misrepresents the importance of beadwork in the Native community.

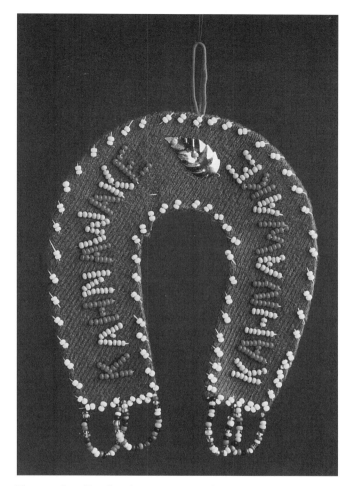

Figure 18.4. Beadwork souvenir purchased by author at
Poking Fire village in September 1991. Maker unknown.
Courtesy of the Royal Ontario Museum (ROM 991.150.3).

Beaded objects reflect new issues in the battle to maintain social and po-
litical identities at the end of the twentieth century. Now souvenirs refer to
"Kahnawake," a more accurate rendering of the Mohawk name for the com-
munity than "Caughnawaga," which appears on pieces from midcentury and
earlier (fig. 18.4). The change to the more accurate term was initiated by
the Cultural Centre in 1980. Traditional styles of beadwork are now being
adapted as souvenirs of the annual powwow held at Kahnawake to com-

Figure 18.5. Beadwork souvenir made by Robin Delaronde,
Kahnawake. Created for powwow commemorating 1990
Oka crisis. Courtesy of the Royal Ontario Museum (ROM
992.70.1).

memorate the armed standoff between the Mohawk and the federal and
provincial governments in 1990 (fig. 18.5).

Although locally produced beadwork is sold and traded within the com-
munity, where old pieces and fine quality new work are especially prized,
the major destination for these productions has always been the tourist mar-
ket. People at Kahnawake today recall trips to summer fairs and exhibi-

tions in Ottawa and Toronto to sell their beadwork.[15] Over the years, souvenirs have been sold through stores operated by various families on the reserve. Young adults recall that as children they hawked souvenirs made by local women to the busloads of tourists who came to see the sights of Kahnawake in the 1950s and 1960s. And during the summer months from the mid-1930s to the mid-1970s, the beadworkers of Kahnawake gathered to sell their wares from the booths provided by John McComber at his totem pole tourist village.

CONCLUSION

This brief investigation of the historical and cultural contexts for Chief Poking Fire's village provides some insight into the Indian agency behind such productions. The accommodation to the imagined exotic Other of the tourist is based on Kahnawake's long experience of intercultural encounters and is the source of the mutual intelligibility that ensured the commercial viability of the village. There is also an element of cultural resistance involved. The existence of the tourist village acknowledged otherness but served to restrict access to Mohawk culture as lived by its members in the community beyond the palisades of Poking Fire's village.

Contemporary Indian people are divided in their opinions of the value of such staged representations of otherness today. Many still earn their living catering to the tourist industry at sites not so different from Poking Fire's village. They argue that as entertainers they are involved in a valid profession. During an interview in Kahnawake one community member remarked that children who grew up working and performing in the village also grew up knowing who they were and therefore did not get into trouble. In this sense, the tourist village provided a source of cultural continuity and cohesion. The village is also credited with providing an important source of employment and thus stability for the community during the lean years of the Depression (Blanchard 1984: 113). Chief Poking Fire seems to have had some status as a leader in the fight for Indian rights. In a photograph that appeared in the Ottawa *Evening Citizen* in 1943, he is shown wearing his Indian village Plains-style regalia as part of a delegation that presented a petition to the prime minister of Canada concerning the Indians' exemption from military service and income tax. The fact that the news media focused on him in reporting the story attests to the significance of his position as a point of contact between the Indian and non-Indian communities.

Others argue, however, that the stereotypes, both positive and negative, reinforced by tourist-oriented presentations work against present-day Indian struggles for social, economic, and political autonomy. As long as people in mainstream society think of Indian cultures as something that existed only

in the past, and of Indian peoples as having no role in mainstream history and society, they will not be inclined to take seriously the aspirations of First Nations.

For some Indian people, the way to deal with stereotypes is not to accommodate them but to confront them. For example, the Woodland Cultural Centre at the Six Nations Reserve in Ontario faced the problem of tourists who refused to come into their museum because the staff were not wearing feather bonnets and hide clothing and were therefore not *real* Indians (Doxtator 1988: 6). The Cultural Centre's response was not to dress up the staff but to develop an exhibition, entitled *Fluffs and Feathers: An Exhibition on the Symbols of Indianness,* that critically examined the history and implications of stereotyping Indian people.[16] The exhibition, like the Poking Fire village, drew in visitors by presenting a vast array of colorful art and artifacts representing highly stereotyped images of Indians. It then invited people to consider the uneven power relations inherent when one group is able to ascribe to another a predetermined set of characteristics.

These stereotypes still have great appeal, a fact not lost on those who wish to disseminate more appropriate information about Indian peoples. One such individual is Jim Skye, a Six Nations Iroquois who still tours with the family dance troupe he inherited from his uncle in 1946 (Peers 1993).[17] The troupe's costumes are a mixture of Plains and Woodlands styles. Their performances include Iroquoian social dances, bull whip demonstrations, recitations of the Thanksgiving address in an Iroquoian language by younger members of the troupe, and a sometimes pointed commentary by Jim Skye. Much as the Woodland Cultural Centre's *Fluffs and Feathers* exhibition does, Jim Skye uses the appeal of stereotyped imagery to capture the attention of a non-Indian audience. When he has their attention he uses the opportunity to apprise them of Indians' perspectives on their own cultures, histories, and relationships with the non-Indian world. From the community perspective, the dance troupe provides an opportunity for families to work together and to reinforce their own cultural identity, much as the Poking Fire village does. The dance troupe is seen as a legitimate part of contemporary Indian culture, a point underscored by their inclusion in a book on Native American dance published by the Smithsonian's National Museum of the American Indian (see LaFrance 1992).

Modern powwows also trade on the appeal of cultural otherness for non-Natives. These events are important expressions of cultural identity for contemporary Indian people, but when such gatherings are advertised to the public at large, their significance for Indian people may well be downplayed. For example, a brochure for the 1994 Toronto International powwow held at the Sky Dome, the city's major sports complex (which holds 50,000 spectators), refers to "our heritage and culture," to "authentic Indian Arts and Crafts," and to "authentic First Nations foods." It also promises a mesmeriz-

ing "spectacle" of "sounds and colour" that "you will remember for a life-time." As with all good advertising, the brochure appeals to familiar imagery. In order to make people aware of the vitality of Indian cultures, of which powwows are one expression, you first have to get them to attend.

In all of these cases the interesting issue is not Indian peoples' misrepresentation of some "real" or "pure" tradition to outsiders. A cultural purity approach implies that Indian cultures are mired in the past and incapable of responding creatively to new situations. A consideration of the active roles adopted by both parties in cross-cultural encounters allows us to avoid the dilemma of casting Indians in such a passive mode and forces us to recognize the significance of tourists' preconceived ideas about Indian Others in determining the forms of these encounters. As Bruner has argued, we must consider how people read or experience "text" in order to appreciate the nature of the representation involved (1994: 407).

Joy Hendry has suggested the need to consider how meaning may be embedded in the act of representation rather than in some underlying "essence." "Perhaps we have been so concerned recently with the notions of 'deconstruction' and of 'unpacking,'" she writes, "that we have failed to take enough notice of the construction itself, of the value of the packaging that we so quickly throw away" (1993: 7). If we think of Indian villages and entertainments as creative ways of packaging, which often take advantage of opportunities to manipulate stereotypes, we will come closer to appreciating the dynamic intercultural encounters they in fact represent. Chief Poking Fire's village demonstrates how one Mohawk community negotiated meanings across cultural boundaries to come up with a representation of Indianness that for many years appears to have satisfied the needs and goals of both participants in the encounter.

Art, Tourism, and Cultural Revival in the Marquesas Islands

Carol S. Ivory

The Marquesas Islands form an archipelago some 750 miles northeast of Tahiti. The six inhabited islands, Nuku Hiva, Ua Pou, Ua Huka, Tahuata, Hiva Oa, and Fatuiva, are often described in terms of mystery and foreboding. Indeed, they are quite dramatic: volcanic peaks plunge directly into the sea, their sharp ridges separating deep valleys from one another. There are no coral reefs; the Pacific's waves crash directly and forcefully onto the shore. Along with the Society Islands, the Marquesas were a major dispersal point for Polynesians who ventured thousands of miles farther to settle islands as distant as Hawai'i, Easter Island, and eventually, New Zealand.

For most of their history, the Marquesas Islands have been far removed from the tourists and traffic common to many parts of the Pacific. Yet tourists throughout Polynesia and elsewhere are familiar with Marquesan art because its distinctive style has been adopted by contemporary carvers in many other island groups. Hotels and restaurants with Polynesian themes, often far from the Pacific, are frequently decorated in Marquesan style—witness Trader Vic's, whose salt and pepper shakers, lamps, and structural posts are all variations of Marquesan tiki, or human figures.

Known primarily for their personal body decoration, including extensive tattooing and intricate ornaments, and for their finely carved work in wood, stone, bone, and ivory, Marquesans have been engaging in trade since Captain James Cook's four-day stopover in 1774. Until around 1880 the products collected were those made for and used by Marquesans as part of their own particular Polynesian lifestyle. After 1880 there was a sudden and dramatic change in the type and style of objects made. Significantly, they were made as commodities, works intended for sale to both an internal and external market. Though discernibly different, they remained distinctly Mar-

Figure 19.1. The *Aranui II* with passengers disembarking at Takapoto, Tuamotu Islands, May 1993. Photograph by Carol Ivory.

quesan and, on the whole, high in quality, as they do today at the end of the twentieth century.

Tourism in the Marquesas Islands in the 1990s unquestionably differs from that at any previous time in this remote archipelago's history of contact with the West. It is also probably different from tourism in many other places in the world. Much of the tourism in the Marquesas today is tied directly to the *Aranui II,* a combination working freighter and cruise ship (fig. 19.1). Since its introduction in 1990, when it replaced its smaller predecessor, this ship has had a dramatic impact on the rhythm of life in this rugged outpost of French Polynesia.

The relatively small but predictable market provided by the *Aranui*'s passengers has combined with a vibrant contemporary Marquesan cultural renaissance to profoundly affect both the visual and the performing arts. It has stirred a search for new products that will be attractive and affordable for tourists, while at the same time encouraging experimentation in carving the wooden objects long associated with the Marquesas, such as bowls and clubs, which today are too expensive for most tourists.

This essay looks at both the present and the past, seeking to find the continuities and trace some of the changes in the types of objects Marquesans

exchanged with and sold to Western visitors. The aim is to place the contemporary Marquesan tourist "scene" within a historical framework that provides a means to understand, evaluate, and appreciate the changes and challenges Marquesans have faced, and continue to face, in adjusting to and accommodating Western hegemony and colonial domination.

"TOURIST" ART 1774–1880

Although the Spaniard Mendaña was the first European to visit the Marquesas, in 1595, sustained contact only began with the arrival of Captain Cook in 1774.[1] Trade began immediately, and though procuring food and water was crucial for the British, they also engaged in a brisk exchange for cultural objects, especially weapons and ornaments such as headdresses and gorgets. While a large portion of these objects were collected systematically by the scientists on board Cook's ship, notably the Forsters, ordinary crewmen acquired similar "souvenirs" for themselves, many of which later ended up in museums throughout Europe.

This exchange continued in the first half of the nineteenth century as whalers and sandalwood traders stopped in the Marquesas to refuel. Although new materials and products entered Marquesan society in the first half of the nineteenth century, those acquired from Marquesans remained remarkably consistent in style and form and continued to be those used by the Marquesans mainly as weapons or as ornamentation. During this period, finely carved and distinctively Marquesan objects seem to have been especially popular, given their large numbers in museum collections today. These include carved wooden war clubs ('u'u) and stilt steps (vaeake).[2]

Interestingly, as early as the late 1810s, the musket had replaced the war club both as premier prestige object and as weapon of choice for Marquesans. Yet clubs continued to be made and collected well into the middle of the nineteenth century. It could be argued that their popularity with visitors was one factor that encouraged their production, despite their less important role in Marquesan life.

In the case of stilt steps, Greg Dening has suggested that their large numbers in museums, with virtually no observers' comments on their use, may mean that they were "one of the first things to go" in Marquesan culture (1980: 235). I would also suggest that their relatively small size, unusual purpose, and again, distinctive style, made them particularly suitable or desirable as a "souvenir" and that demand for them by visitors may have encouraged their continued production. In other words, clubs and stilt steps may have been the Marquesas' first "tourist art": commodities spurred on by a foreign market after their internal Marquesan function ceased to be integral.

Until 1842, when the islands were claimed by the French, the Marquesans had been able to maintain many of their "traditional" ways and beliefs.

Numerous Marquesan objects collected in the 1840s by French military and government agents attest to this. After 1842 life in the Marquesas changed dramatically. In Nuku Hiva, where the French were present in large numbers (as both military personnel and missionaries), prohibitions on cultural practices were effective and many activities, such as tattooing, carving, and feasting, ceased. In other areas, intertribal warfare fed by a new dependence on alcohol made life chaotic. In all parts of the Marquesas, diseases (smallpox, syphilis, influenza, and many others) ravaged the people and reduced their numbers to from 80,000–100,000 in 1774 to 5,246 by the first official census in 1887 (Rollin 1974: 63). Whole valleys, and very nearly whole islands, were abandoned. Comments from missionaries and government agents, the few foreigners living in the Marquesas at the time, suggest that the legal prohibitions, combined with war and disease, brought an end to the need for and production of objects once important to Marquesan life. Demand from an internal market ceased for a time, and many carvers died. In 1880 the French military suppressed the last warring groups on Hiva Oa, and an uneasy, empty, desolate peace descended on the Marquesas.

Objects acquired by foreigners in the 1850s through 1870s reflect these conditions. In fact, very few collections were compiled during this time. The most significant is the C. D. Voy collection from the early 1870s, now in the University of Pennsylvania Museum. It includes objects that were once sacred and rarely traded, such as tiki. Most of the items are still "traditional" in type and style, probably heirlooms from earlier times. A few appear to be rudimentary in form, perhaps hastily made or produced by an untrained carver for sale.

One possibly significant piece from this period, accessioned in 1865, is now in the Museum of Mankind in London (no. 61). It is the first paddle collected that has low-relief carving covering its blade surface. In addition, what is unusual about this piece is that its motifs are Western-inspired: naturalistic representations of a pineapple, coconut, palm leaves, stars, and so on. Although the practice of covering the surfaces of objects with low-relief patterns was soon to become widespread, the motifs used were typically Marquesan, not Western. The imposition of Western motifs on the paddle suggests that it was made specifically for sale to a Western visitor and that it might be the first in a new phase of art made specifically for a tourist industry. With a resilience like that of the Marquesan people themselves, Marquesan art soon began a second life, primarily in the form of objects made for trade.

TOURIST ART 1880–1930

In the 1870s, while the old cultural ways were waning, two separate but related economic developments stimulated the rebirth of Marquesan art by the beginning of the 1880s. A contract between the French administrative

government and the American shipping firm of Crawford, based in San Francisco, established a regular monthly route between San Francisco, the Marquesas, and Pape'ete to bring mail, supplies and a few intrepid visitors. At the same time trading posts were set up in the Marquesas by Crawford and other firms, notably the mainly German-owned Société Commerciale de l'Océanie, which also operated three small cargo vessels that sailed between Pape'ete and the Marquesas (Eyriaud des Vergnes 1877: 85–86; Aldrich 1990: 128–29). Both prompted Marquesans to search for ways to earn money or credit to buy the imported goods now regularly delivered to the Marquesas. Most written accounts from the period mention copra, pigs, and a type of fungus as the main articles offered by Marquesans for export. Yet, significantly, at this very time a distinctive new style of carving began to appear. The new types of carved objects, intended for sale, included model canoes, bowls in European-derived shapes, and coconuts. All collections after 1880 include such pieces, and they quickly came to predominate.

The primary characteristic of the new style is an all-over, low-relief surface patterning similar to that found in Marquesan tattoos (fig. 19.2). These late-nineteenth-century objects tend to be smaller in size and made from paler and lighter-weight woods. In contrast, the earlier pieces, which are often quite large, are made from *toa,* a very heavy dark wood (*casuarina*), and their smooth dark surfaces have either no relief carving, in the case of bowls and paddles, or highly conventional motifs, usually confined to bands or specific areas, as in the case of *'u'u* (war clubs).

The first author to discuss these pieces and to identify them as "tourist art" was the German psychiatrist Karl von den Steinen, who spent six months in the Marquesas in 1897. In his encyclopedic compendium *Die Marquesaner und Ihrer Kunst* (1925, 1928a, 1928b), he refers to a *Fremdenindustrie* (foreigner industry) centered in Fatuiva, the southernmost of the islands (1928a: foreword). He illustrated pieces, including carved war clubs, paddles, bowls, and coconuts (many of which are now in the Museum für Völkerkunde in Berlin), that he identified as being part of this new production (1928b: plates B, C, D).

In 1920 the Bernice P. Bishop Museum in Honolulu sent Ralph Linton and the husband and wife team of E. S. C. Handy and Willowdean Handy to the Marquesas as part of the Bayard Dominick Expedition. Despite their enormous contributions, their studies also exhibit the limitations now recognized in works of the period—that is, the tendency to freeze cultures and peoples into an anonymous, timeless, and unchanging "ancient past." They assumed that the types and styles of objects present in 1920, particularly bowls and paddles, were the same as those made in "ancient" times, despite a lack of historical evidence. All three dismissed contemporary early-twentieth-century carvings, made in the late-nineteenth-century style, as "degenerate," while at the same time using them to construct their image of the past.[3]

Figure 19.2. Carved bowl collected on Fatuiva by Karl von den Steinen in 1897. Courtesy of Museum für Völkerkunde, Berlin (Accession no. VI 15,866).

Linton, in particular, gave carved bowls an importance beyond all other objects he discussed (1923: 355–76). He assumed they were the most numerous "ancient" object in museum collections and spent twenty pages describing their different types and designs.[4] Linton found himself in a dilemma, however, because he was forced to admit that only one of the carved containers was from "other than the later period of European contact" and that the bulk were "unquestionably commercial products" (1923: 367–69), which, by implication, invalidated their "authenticity" for Linton. In fact, there are only three bowls with carved surface designs in museums with collection dates earlier than 1894, and none of these has completely reliable collection documentation or, in any case, dates before 1850.

The ubiquitousness of the carved patterns on all of the late-nineteenth- and early-twentieth-century model canoes, paddles, clubs, and especially bowls led Linton to conclude that such carved surfaces were the primary source of tattoo motifs and that tattoo designs were influenced by and copies of these. I would argue, however, that the reverse is true: this later-style carving drew primarily on tattoo patterns for its inspiration.

At the time that the Bayard Dominick Expedition visited the Marquesas,

the same designs did indeed appear both on the surface carving of objects and in the tattoo patterns found on living people. However, also by this time, nearly all examples of earlier art forms had been removed from the Marquesas. Von den Steinen, for example, commented that not one of the older-type clubs was to be found in all of the islands at the time of his 1897 visit (Steinen 1925: foreword). Literally the only models left for artists were living ones, whose tattoos remained visible, if faded, on their bodies. Tellingly, Willowdean Handy quoted a learned Fatuiva artist who lamented the current style of making carved bowls and insisted that there were different images for skin and for wood carving and that "only fools put body images on food bowls. . . . Very bad to eat from bowls covered with images meant for the body" (Handy 1965: 111).

Such apparently conservative views were few, however, because the late-nineteenth-century style had by that time become firmly established. Ironically, the very studies that criticized and dismissed the new style as "degenerate" have become the vehicle for its continuity. In the 1950s Willowdean Handy's study *L'art des Iles Marquises* (1938) was rented by carvers for 400 CPF (several U.S. dollars). Bob Suggs, an archaeologist who worked in the Marquesas in the 1950s and again in the 1990s, offers this anecdote: an artist in the late 1950s, from whom Suggs bought a bowl covered with tattoo designs, boasted proudly that his work was "real Handy stuff" (personal communication, 1994).

Today, in the 1990s, three-ring binders filled with photocopied pages primarily from von den Steinen, but also from Handy, are still popular sourcebooks, and the style of the late nineteenth and early twentieth centuries prevails. Thus what is considered "traditional" today in the Marquesas is really a form of carving developed for sale about one hundred years ago.

TOURISM IN THE TWENTIETH CENTURY

Since the late nineteenth century, the most common means of "tourist" travel to the Marquesas has been by private yacht. The archipelago is the first landfall for those who leave North America's West Coast for the South Pacific. Because of their relatively small numbers (now about 150 yachts a year), independence in terms of transportation and shelter, and sporadic (though mainly seasonal) arrivals, their effect on tourism in the Marquesas is limited to a few guided excursions, the purchase of supplies, some meals at one of the local restaurants, and the acquisition—of course—of some objects by which to remember the Marquesas.

From the late 1930s until the 1950s, there were virtually no contemporary pieces collected or accessioned into museum inventories. The Great Depression and Second World War undoubtedly reduced the number of people traveling the Pacific for pleasure, while also cutting off support for

anthropological expeditions, though large military transports did refuel in Taipi Valley during the war (Allmon 1950: 80). Undoubtedly, objects continued to be carved, but the demand seems to have dropped. Carved objects were sent to Tahiti, where the local population avidly bought them for their own domestic use (K. Stevenson, personal communication, 1994). Certainly, carved bowls and other objects are found in Marquesan homes and are used by people today in serving foods.

In a 1950 article in *National Geographic,* the only export discussed is copra; the "best carvers," according to the author, lived on Fatuiva, but there is no mention of carved objects for sale (Allmon 1950: 104). Three large bowls in the collection of the chief of Omoa, Fatuiva, are pictured, one of which was in the chief's family for seventy years (since about 1880) (Allmon 1950: 74).

By the 1950s both the repertoire of objects (mainly bowls) and the range of motifs had become very limited, according to Bob Suggs (personal communication, 1994). He remembers three designs that he saw routinely being carved in the 1950s, all drawn from tattooing: the *niho peata* (shark's teeth), *mata komoe* (a face design), and *aka hau* (pandanus roof). One new object, an oversize adze with an elaborately carved handle, seems to have been introduced at this time, as well as painted tapa or bark cloth. Others began to appear for sale in the 1960s as Marquesans experimented with products to sell. These included long spearlike "canes," and once again carved human figures. All remain in the general repertoire of artists today and are discussed further below.

Suggs reports that in the 1950s everything made in the archipelago was sold from there (personal communication, 1994). By the 1970s, Dening has indicated, the artifacts made in the Marquesas were for export, mainly to Tahiti (1980: 290). No doubt a new market developed in Tahiti as a result of both increased tourism after the opening of Faaa Airport in 1961 and the establishment of the French nuclear testing program in the nearby Tuamotus not long thereafter. Both brought thousands of foreigners to Tahiti, creating thousands of new jobs. Many Marquesans moved to Tahiti, and today some 10,000 live there, while about 8,000 live in the Marquesas themselves.

The growing tourist market in Tahiti in the 1960s and 1970s may have spurred the expansion of the Marquesan repertoire. While there are many tourist articles for sale in Tahiti, most originate in other parts of French Polynesia. Tahitians themselves are known for shell jewelry, decorated pareu (sarong-like cloths), and *tifaifai* (appliquéd quilts). However, many of the biggest-selling items, like black pearls, are brought in from the Tuamotu and Gambier Islands, and woven pandanus hats and mats come from the Australs. The carvings for sale in Tahiti are nearly always Marquesan in style and fall into three main categories: (1) those shipped over from the Mar-

quesas (the smallest number), (2) those made by Marquesans who have moved to Tahiti, and (3) those made by non-Marquesans (of a variety of ethnic backgrounds) living in Tahiti. In many tourist centers, mass production for tourist markets often results in stereotyped images that only vaguely resemble the original model. Many carvings for sale along the waterfront in Pape'ete tend to be of this kind—they are made by non-Marquesans, broadly based on Marquesan motifs, and only freely (and often poorly) reflective of Marquesan aesthetics.

Although air travel is now available to French Polynesia, this has had little direct effect on tourism in the Marquesas themselves. About 170,000 tourists a year visit French Polynesia today, but most stay in the Society Islands—Tahiti, Mo'orea, Bora Bora, and others (*Tahiti Beach Press* 1995–96: 16). Very few venture as far as the Marquesas. From the mid-1980s until the early 1990s, there were only two, continually overbooked Air Tahiti flights a week on eighteen-seat planes from Pape'ete to the Marquesas. By the mid-1990s, forty-two-seat planes had begun making five flights a week to Nuku Hiva and two per week to Hiva Oa. Tahuata and Fatuiva have no airstrips, and only one trip weekly connects to Ua Pou. The airfares for nonresidents are high, more than US $600 for a round-trip between Pape'ete and Nuku Hiva, plus another US $160 round-trip for the helicopter service, which most first-time visitors take, between the airport and the town of Taiohae.[5] Passengers are mainly French government officials and Marquesans, who pay a lower rate.

Factors other than cost and isolation have limited tourism in the Marquesas. There are only five small hotels, four on Nuku Hiva and one on Hiva Oa; rooms in homes and simple cabins also provide accommodation. Most travel is over steep dirt roads by four-wheel-drive vehicles, and such trips require large amounts of both time and stamina. The northern islands are infested with sand fleas, or *nonos,* which make otherwise idyllic beaches uninhabitable. So very few tourists actually stay on the islands for any length of time.

The greatest influence on tourism has been the *Aranui II.* In addition to supplying the islands with the many goods upon which people depend, it is the new pipeline for visitors to the Marquesas. It has dramatically changed the role and character of tourism in the Marquesas, including, of course, the arts (D. Kimitete, personal communication, 1994).

The *Aranui II* is the only regularly scheduled, relatively reasonably priced, comfortable mode of transportation for passengers heading to the Marquesas. Its sixteen-day round-trip (from Pape'ete) includes stops at each of the six islands, generally taking in twelve or so villages, and returning every three and a half to four weeks on a regular, published schedule. It contains air-conditioned staterooms for up to sixty people and has sleeping space on two stern deck areas for additional passengers (including numerous Marquesans who travel back and forth on the much cheaper lower deck).

Arrangements have been made both on board and with the local inhabitants of each valley to accommodate tourism. Two trilingual facilitators assist the mainly American, French, and German guests, lead them on outings and activities at each stop, and act as liaisons with Marquesan drivers, restaurant owners, and village officials. When the ship arrives in port, especially at the smaller villages, all regular activities come to a halt as up to one hundred passengers disembark, sometimes for only an hour or two.

Needless to say, this new form of regular tsunami-like tourism has had a considerable impact on life in the Marquesas. Depending on the ship's arrangements with each village, varying degrees of preparation and planning take place in the days before the ship's arrival. In the places where the passengers are scheduled to eat on shore, dance groups practice and make new costumes, and residents weave leis and headbands of greenery and prepare feasts of lobster, shrimp, marinated raw fish, fruits, and popoi (a Marquesan staple consisting of a kind of breadfruit pudding). Artisans in all the villages know that they will have an opportunity to sell their wares and must be ready with enough quality pieces to compete for the tourists' money. Once the tourists leave, life returns to normal until the time approaches for the next arrival of the *Aranui*.

There is another important reason—separate from but nonetheless related to tourism—that the arts have changed in recent years. This is the resurgence of interest by the Marquesans themselves in their own culture and history, sparked by the creation in the 1970s of Motu Haka, a cultural association with chapters on each island. Carving is taught in the schools by recognized artists such as Damien Haturau on Nuku Hiva. New museums have been built at Vaipaee on Ua Huka and Hakahau on Ua Pou. The former contains mainly high-quality replicas of nineteenth-century carvings made by the artist Joseph Va'atete (D. Kimitete, personal communication, 1994). Handicraft centers there and in each of the other two villages on Ua Pou also display carved bowls, paddles, and clubs for sale. The *Aranui* passengers visit all three centers during their day-long excursion on the island.

Another aspect of the cultural renaissance is the establishment of interisland arts festivals, held every four years. Since their inauguration in 1987, they have encouraged interim local festivals, created opportunities for competition winners to travel to Europe and the United States, and provided models for young Marquesans to emulate in the performing and visual arts.[6] Although these festivals are primarily for Marquesans, visitors are welcome; the *Aranui* arranged its schedule so that passengers could, for two days, attend the festival held in December 1995.

This renewal of Marquesan culture is reflected in many ways: new sculptures have been made to decorate dance plazas (*tohua*), tattooing is undergoing a visible resurgence, and a wide variety of objects are made for sale at booths during the festivals. These changes affect tourism as well:

more sophisticated performances are presented for visitors; tourist facilities are being built; and better-quality, more varied objects are being made for sale.

CONTEMPORARY MARQUESAN ART

In 1986 one guidebook about Tahiti noted that the "supply of Marquesan objects is sporadic at best; the artisans simply cannot be bothered with filling orders" (McDermott 1986: 222). By that time of course, the first, smaller *Aranui* had begun to bring tourists to the Marquesas, and the cultural renaissance was well under way. Rather than assume that the Marquesans were indifferent about filling orders for Tahiti, it is more reasonable to suppose that they were preoccupied with a growing demand for their goods in the archipelago itself.

While continuing to make the carved items that have come to be the staples of the market, many people are exploring new forms, returning to some older ones, and combining the two in the hope that they will capture the tourists' attention, as well as francs. Bowls have remained a consistent seller, and the club and the paddle, rarely seen between 1950 and 1970, seem to have made a comeback (fig. 19.3). These three objects can be found especially on the islands of Nuku Hiva and Ua Huka, the two islands most highly regarded for their carving (D. Kimitete, personal communication, 1994). They are among the largest and most expensive pieces made and sold (US $300 and up). Though based on late-nineteenth- and early-twentieth-century models, the motifs are often larger and more defined than those created a century earlier. They cover most of the object's surface but are more varied than those done several decades ago, probably owing to the greater availability of photocopies from von den Steinen. They are also more highly polished, a trend that seems to have started in the 1960s.

Spears and spearlike canes are turned out in considerable numbers by different artists. They are large (three to four feet long) and cumbersome. Perhaps because so many are produced, they are generally of poorer quality and more stereotypical than many other objects for sale. Marquesans also make ukeleles, which are often carefully finished with incised designs, but these are made primarily for internal use. The same is true of wooden saddles for horses. Both of these items, however, are occasionally made for foreigners.

Among the most difficult items to acquire, but greatly admired, are carved coconuts. The work of Charles Siegel on Fatuiva far surpasses that of the others who work in this medium. He enjoys an island-wide reputation, and each piece he makes is spoken for before it is finished. Using a process developed in the early twentieth century, the artist first chars the coconut, blackening it, and then begins carving. The uncut, raised portion remains black, while the cutaway area is lighter, revealing the natural color

Figure 19.3. Club, paddle, and bowl by Edgar Tamarii for sale, Taiohae, Nuku Hiva, May 1993. Photograph by Carol Ivory.

of the uncharred coconut shell. Bracelets and earrings made with this technique have gained great popularity in recent years and are the specialty of a woman carver on Nuku Hiva named Bernadette (Pere) Haiti (D. Kimitete, personal communication, 1994).

The renewed interest in the human figure is a distinctly late-twentieth-century phenomenon. Beginning in the 1960s, a number of artists created images of human figures in the form of tiki. Some of these figurines were highly simplified; others, as in the work of the late artist Joseph Kimitete, were quite elaborate, with patterned surfaces and crownlike headdresses.

The tiki is a form that probably dates far back into the prehistory of Marquesan and many other Polynesian cultures. Generally representing ancestors, or sometimes gods, tiki were made in stone, bone, wood, and ivory. Similar images are found in the early contact period on stilt steps and ear ornaments, and as freestanding figures on sacred ritual areas (*me'ae*) far up the valleys or near large festival grounds, called *tohua*. In typical Polynesian style, they are frontal images with large heads, hands either at the sides or on the stomach, and thick flexed legs. The Marquesans particularly emphasized the eyes, which are large and often framed with arched brows. The surfaces are generally smooth, or in the case of the stilt steps, covered with striated lines and some tattoo designs.

In the late-twentieth-century figures, two changes can be seen in the depiction of the body (fig. 19.4). First, many of the tiki are now made in a more "realistic" style, with naturalistic proportions, a variety of postures, and accoutrements such as clubs, headdresses, and ornamentation. Second, whether creating relief or fully three-dimensional figures, artists may employ narrative elements, frequently incorporating two or more figures, engaged in various activities, in a complicated composition. Often a particular story, myth, or historical person or event is depicted.

These figures have become important in the decoration of new churches. Three islands, Nuku Hiva, Ua Pou, and Tahuata, have had churches built since the 1970s. These new churches all have stations of the cross and statues of Old and New Testament prophets and saints, as well as pulpits with carved figures. The biblical figures are shown in relatively naturalistic proportions and depicted with religious symbols that have a distinctly Marquesan flavor: traditional shell and fiber headdresses are used for royal figures such as Christ and David, and Peter is depicted with a Marquesan-style fishnet and canoe.

Many of the artists who worked on these churches have also been actively involved in the restoration of old or the building of new *tohua*, or dance areas. After 1774, in the early historical period, writers described *tohua* that could hold as many as 10,000 spectators (Thomas 1990: 177). The ruins of these stone platforms have been mostly hidden in the dense second-growth forests found throughout Marquesan valleys. In conjunction with the island-wide festivals now being held, two *tohua* have been restored: one at Hatiheu, Nuku Hiva, and another at Ta'aoa, Hiva Oa. New ones have been built at Taiohae on Nuku Hiva, at Atuona on Hiva Oa, and at Hakahau on Ua Pou (the last in 1995).

Although precontact stone statues remain on some of the sites, new ones have been made for Hatiheu, as well as for the new *tohua* at Taiohae (Moulin 1990). These sculptures are all in the narrative style, many of them very complex works. Although the new and restored *tohua* were established specifically for the festivals, they are now important for tourism as well. At each of the ship's main stops, an expedition by foot, or more often by four-wheel-drive pickup, is arranged to visit the *tohua* site. Tourists take photos and listen to brief lectures on the history of the site. Today, more sites are being cleared for tourists to visit, and youth from all six islands are being taught English and trained to act as guides.

In addition to creating figures for churches and *tohua*, several contemporary artists make tiki for sale. They range in size from very small (less than an inch) to quite large and heavy. The small ones are made from sandalwood, usually as earrings or pendants. The more substantial ones are free-standing pieces of sculpture. Some remain quite close to the early-contact type, but differ in having large areas of carved surface patterns (often representing tattoos) and in being made of highly polished rosewood. These

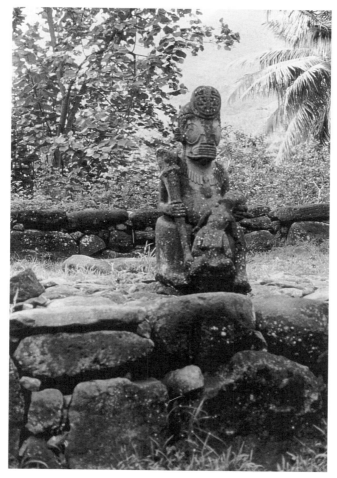

Figure 19.4. Recent tiki by Severin Taupotini on *tohua* (dance site), Hatiheu, Nuku Hiva. Photograph by Carol Ivory.

figures, like most of the carved objects made by Marquesans, are of high quality and demand high prices, hundreds of U.S. dollars.

Historically, most of the art objects were made by Marquesan men. As in other Polynesian societies, the arts were sacred activities, requiring not only technical skill but also ritual knowledge. Men were the carvers and tattooers. Women made the tapa, or barkcloth, used for clothing, bedding, and other domestic purposes; men made the tapa used for sacred and ritual activities.

In the Marquesas, tapa was usually either left its natural color, which dif-

fered with the species of bark used, or dyed yellow or orange. In rare cases it was painted with designs, probably by male artists because the functions were apparently associated with the sacred. In other parts of Polynesia, in contrast, tapa was not only made but also painted by women. Only six examples of painted Marquesan tapa from early contact times are known: three pieces of wood covered with designs that form an abstracted face and three human skulls covered with tapa painted to reproduce tattooed facial markings.

This background is significant because one of the most distinctive art forms evolving today is the tapa made and painted by the women of Fatu-iva, the most isolated of all of the islands with only two small villages, Omoa and Hanavave, and a total population of five hundred (Stanley 1992: 196). In the mid-1950s this new art form emerged. It features designs, mainly drawn from tattoo motifs, painted onto relatively small squares or rectangles of tapa. The pieces range in size from about five inches square to about three feet long and one to two feet wide. They are made from different barks, so the colors vary, and a few are dyed yellow with a natural powder (*eka*) that comes from Nuku Hiva. Today, in addition to tattoo designs, some women are painting narrative scenes similar to many of those seen in the carved figures. Some of the most popular images are drawn from historical illustrations, notably those made by the Krusenstern Expedition of 1804. Others show women making tapa or pounding breadfruit into the paste or pudding called popoi.

Although some of this tapa is sent to Nuku Hiva and Tahiti to be sold, most of it finds its market on the *Aranui*. While the *Aranui* offloads its cargo early in the morning at Omoa, at least a dozen women arrive on board with their wares wrapped in cloth or plastic. They spread the pieces around for the passengers to browse through and purchase (fig. 19.5). After a couple of hours, they return to the village, and the tourists soon follow. A short tapa-making demonstration is held, after which the tourists wander along the one road through Omoa, sometimes finding women with more tapa displayed on their open porches.

There are also women in Hanavave who make painted tapa, although they do not board the boat with their wares. There, tourists simply walk along the village's main street, where the women sit on the ground with their work laid out on pieces of cloth. The prices in both villages range from US $5 to $75 or so, depending on the size of the tapa, with an average price somewhere around US $20. Many of the tourists scoff at the tapa and consider it an inferior craft; although some pieces may look hastily made, many of the women are careful and highly creative artists. Some of the hotels in Tahiti have started using this tapa to decorate their halls, and it can now be found for sale there. But there is no question that the regular stop of the *Aranui* is the impetus for the tremendous recent growth in this art form.

Figure 19.5. Women showing painted tapa to the author on board the *Aranui II,* Omoa, Fatuiva, May 1993. Photograph by Robin K. Wright.

Another new sale item made predominantly by women is also appearing: painted pareu, the long piece of cotton cloth worn by both men and women in French Polynesia. A popular tourist entertainment throughout French Polynesia is a show demonstrating the seemingly infinite number of ways to wrap oneself in a pareu (one show takes place on the *Aranui* during the forty-hour crossing from the Tuamotus to the Marquesas). Most of the pareu sold

in the islands are mechanically printed and imported from Tahiti, but some Marquesan women buy unpainted pareu (or bolts of cloth) and then hand-paint them with designs or narrative images similar to those seen on tapa.

T-shirts are also printed, stenciled, and hand-painted for sale to tourists. They are made of very lightweight cotton, which is popular with foreigners unaccustomed to the heat and high humidity of the islands. Several artists who make both painted pareu and T-shirts are found in Hatiheu, a village of about 150 people on the northern coast of Nuku Hiva. They are strongly encouraged by Mayor Yvonne Katupa, in whose restaurant the women spread out their pieces of cloth.

Other items are also produced locally for sale. Pandanus is woven by both men and women into hats and baskets, especially on Ua Pou. These are rather fragile and do not always last very long. Sweet-smelling sandalwood dust is sold in small packages, as is *monoi,* a fermented blend of coconut oil and herbs used to scent the body and ward off the dreaded *nonos* (sand fleas).

CONCLUSION

Cultural life in the Marquesas Islands is undergoing a far-reaching renaissance. There is both a renewed interest in the past and a developing vision for the future. The seriousness of this can perhaps best be seen in the establishment of the Pa'evi'i Documentation Center on Nuku Hiva in 1993. Local Marquesan and French social and political leaders have joined with foreign scholars from a wide variety of fields to develop a Marquesan research and cultural center. Currently, the emphasis is on collecting anything published on the Marquesas, and more generally on Polynesia. Future plans include a multimedia visual resource center and eventually a museum.

The regular arrival of the *Aranui* with its full load of passengers has stimulated additional efforts to promote tourism. For example, there is a growing interest in developing organized tours around particular interests, such as archaeology, which would utilize both the *Aranui* and local resources like hotels and restaurants more extensively (R. Corser, personal communication, 1994). The hotels in Taiohae have begun to advertise abroad, and one now collaborates with Club Med to bring in more guests. In 1995 Gaston Floss, president of the territorial government, announced plans to construct a long-planned international airport on Nuku Hiva, along with a new road from the airport to Taiohae. The new facilities would enable a Boeing 737, Boeing 767, or Airbus 310 to land (*Tahiti Beach Press* 1995–96: 16). These plans have created much talk, but the project will take considerable time to complete; moreover, the existing hotels and restaurants could not support such a surge in tourism. For the remainder of the 1990s, tourism will probably maintain its current ebb and flow, linked mainly to the *Aranui.*

If recent trends are any indication, the arts should continue to develop in exciting new ways, grounded perhaps in a better understanding of the past as the resources of the Pa'evi'i Center and the new museums grow. At the same time they are likely to be inspired by increased contact with the larger world. There seems to be an unprecedented cultural energy flowing these days in the Marquesas, one that holds great promise for the Marquesan art of the future.

Ethnic and Tourist Arts Revisited

Nelson H. H. Graburn

I have been asked to open this concluding chapter with a short description of how I developed my interest and ideas in the field of ethnic and tourist arts and brought them to publication in *Ethnic and Tourist Arts: Cultural Expressions from the Fourth World* (1976). I then briefly explore the shifting academic climate and changing attitudes toward ethnic and tourist arts since my introduction to the topic in 1959. Finally, I offer some comments on the essays published in this volume, suggesting possible relations to those in Ethnic and Tourist Arts and discussing how this new collection contributes to and defines the current research in this field.

THE JOURNEY TOWARD PUBLICATION OF *ETHNIC AND TOURIST ARTS:* MY INITIAL EXPERIENCE OF INUIT ART

The story begins in 1958, when I left Cambridge with a bachelor's degree in social anthropology to attend graduate school at McGill University in Montreal. My first direct experience with the commoditization of non-Western arts came in 1959, when I was sent to study the Eskimos (now Inuit) of the Hudson Strait region of the Canadian Arctic, specifically to carry out a "community study" of the village of Sugluk (now Salluit) for the Northern Coordination and Research Centre of the Canadian government's Department of Northern Affairs (DNA). Although this was also ostensibly my master's thesis fieldwork (Graburn 1960), I was given little direction by my professors at McGill, and even less by my government employers.

In studying the changing economic bases of Inuit life, I encountered the already widespread Inuit occupation of carving, in their spare time, figurines in the local gray-black soapstone for sale to a retail market of white people. The carvings were sold either directly, to the crews of visiting ships and the

six or seven non-Inuit village residents, or indirectly, through the Hudson's Bay Company store or the DNA Northern Service Officer.

The carvers liked the fact that they could get money for their efforts, though I calculated that the rate of pay was perhaps less than fifty cents per hour. As I later showed, in the recent economic history of the village carving and handicrafts had constituted up to 50 percent of the total income in some years (Graburn 1969a: 156–60). In 1960 I carried out another community study of Lake Harbour, Northwest Territories, on the opposite side of the Hudson Strait, and found very similar patterns, although the available stone was a much more attractive greenish serpentine and the carvers sold their work only through the Hudson's Bay Company (Graburn 1963a). Although I admired their skill and even bought soapstone and ivory souvenirs in the North, my main opinion was that this creative work was a fitting way to earn money without the strict discipline of wage labor in a situation of change from local subsistence to a commercial economy. I believe that is how the Inuit saw it too.

What really piqued my interest was the barrage of quite different sorts of information about the "art" form found in the literature, stores, and museums, which fed a growing retail market in southern Canada and the United States. Much of the "sales pitch" asserted that this newly discovered but ancient Inuit art form was formerly part of ritual life and revealed the spiritual nature of their animist world (e.g., Houston 1954). The contrast with "reality" was so great that I was determined one day to research this topic and present the "other" point of view.

While engaged in graduate work at the University of Chicago (1960–63), advised by Julian Pitt-Rivers, Fred Eggan, David Schneider, and Paul Friedrich, my focus was naturally on kinship and social structure (Graburn 1963b, 1964), and I probably thought that the anthropology of art did not exist. Immediately after finishing my Ph.D. in late 1963, I carried out a year of field research (1963–64) in the Inuit and Naskapi-Cree communities of the Hudson Strait and Hudson Bay areas, working for the Cooperative Cross-Cultural Study of Ethnocentrism organized through the University of Chicago and Northwestern University. Staying with Inuit families in eight villages that year, I had a good chance to observe the practices and discussions of the "art industry," even though my main research focus was on ethnicity and ethnohistory (Graburn 1966a, 1972). Again, my strong impressions were that for most Inuit carving was a very satisfactory kind of supplementary livelihood but was neither as culturally (and nutritionally) satisfying as hunting nor as economically satisfying as full-time wage labor.

Teaching at Berkeley

In fall 1964 I took a teaching position in the anthropology department at the University of California at Berkeley. I was even more determined to carry

out research that focused on Inuit art and so planned to learn more about the anthropology of art. I thought I could best do so by teaching it. I asked if I could offer the scheduled course called "Art and Culture," usually taught by William Bascom—and did so for the first time in 1966.

The extant theoretical literature said little or nothing about the kind of art I had encountered among the Inuit. However, a second strong stimulus to research this work came when I attended a lecture by a visitor to Berkeley, Professor Stuart Morrison of Auckland, about the context and production of the arts of the Maori in New Zealand. There were so many similarities to what I had encountered that my anthropological vision enlarged considerably. I told the participants in my graduate seminar on "culture change" about my field experience and the inspiration of the Maori example, prompting one, Sonya Salamon, to write a paper titled "Art Complex and Culture Change" using cross-cultural examples.

At the 1966 annual meeting of the American Anthropological Association (AAA) in Pittsburgh, I gave a paper entitled "Eskimo Soapstone Carving: Innovation and Acculturation," expressing the opinions I had formed during field research focused on other topics in 1959, 1960, and 1963–64 (Graburn 1966b). The paper attracted a wide audience, and I gave out many copies of it there and in response to written requests. It was quickly picked up and published in *Transaction,* whose editors supplied the illustrations and a new title, "The Eskimos and 'Airport Art'" (Graburn 1967). It appeared again as "How the Eskimos Went Commercial" in the British journal *New Society* (Graburn 1968), and not long after that as "The Eskimos and Commercial Art" in *The Sociology of Art and Literature* (Graburn 1970a). This showed that there was considerable scholarly interest in a case study of "the arts of acculturation."

The National Science Foundation and the National Institute of Mental Health Small Grants Program supported my return to the Eastern Canadian Arctic in 1967–68 to carry out intensive research on Canadian Inuit art. Ironically, although the NSF funded the project (after changing the title to "Aspects of Eskimo Culture"), the anthropologically oriented Wenner-Gren Foundation and the Institute of International Studies at Berkeley flatly turned down my grant proposals. The latter wrote to me that "this is a marginal proposal from the point of view of the main research undertaken in the Institute."

In September 1967 my wife and I traveled from Berkeley to the Canadian North, via Victoria, Vancouver, New York, Montreal, and Ottawa, examining museum and private collections of historical and contemporary Canadian Inuit art along the way. When I arrived in Ottawa, I was told that George Swinton, a professor of art at the University of Manitoba in Winnipeg, and then the leading authority on Canadian Inuit art (Swinton 1965), had read my 1966 paper and had tried to encourage the Canadian government to

refuse permission for my research in the Arctic because, it was said, he thought I had "the wrong attitude."

In the Arctic I lived in Povungnituk, Hudson Bay, where my wife had a position as a Federal Day School teacher. It was my base throughout the year, with sojourns of up to two months in other important art-producing communities of Sugluk (Salluit), Cape Dorset, Port Harrison (Inujjuak), and Great Whale River (Kujjuarapik). I used interviews, questionnaires, and photographs to stimulate commentary, tried carving myself, and organized a carving competition that attracted eighty-six entries in Povungnituk (Trafford 1968). This fieldwork, followed by shorter stays in the Canadian North in 1972, 1976, and 1986, formed the basis of most of my publications on the subject.

The 1970 AAA Meeting in San Diego

Soon after my return to Berkeley in 1968 I was asked by Peter Lengyel, editor of UNESCO's *International Social Science Journal,* to write a follow-up on my original, much-republished paper on Canadian Inuit art. I suggested that he might like a broader view of the arts of acculturation, the comparative context in which I intended to place the analysis of the Inuit case. He accepted the offer, and my essay was published as "Art and Acculturative Processes" (Graburn 1969b). In it I followed Stewart Morrison's preliminary classification of Maori art productions into (1) arts of contemporary cultural significance to the people (which I called "functional fine arts"), (2) fine arts generally made for sale ("commercial fine arts"), and (3) souvenir arts. I also added a fourth category, "assimilated fine arts," to group the work of ethnic artists who use the media and subject matter of the dominant society— the exemplar case being the Australian landscape watercolorist Albert Namatjira (Batty 1963).

This article in turn drew more correspondence, perhaps in part because UNESCO published it in French, Spanish, and German in addition to English. While I was bent on publishing the Canadian Inuit data, I thought I might also aim toward a broader work, with comparative case studies. I asked Cristel Sivero, a student in my "Art and Culture" course, to survey the literature on the arts of acculturation; she found forty articles. I delivered a paper titled "Art as a Mediating Mechanism in Acculturation Processes" at the AAA meeting in New Orleans (Graburn 1969c). In this paper I emphasized the positive role of commercial arts in economically transitional contexts, suggesting that they provide a livelihood, are not subject to wage labor discipline, and bring prestige and pride to minority peoples rather than the low status attached to the forms of manual labor usually available to them.

In "Art and Pluralism in the Americas" (Graburn 1970b), I developed an-

other direction in the study of the arts of colonized peoples. Here I focused on the use of the arts of the conquered civilizations and internally colonized peoples of the Americas by the dominant, conquering national societies. I suggested that the latter may use the arts of the conquered peoples as symbols of their own national identity in order to differentiate themselves both from the European mother countries and from other adjacent ex-colonies. At the same time, I argued that the commercialization of such art forms reflects and molds perceptions of the ethnicity of the subject peoples. Here I also introduced a fifth classificatory category, the "reintegrated arts," an awkward term I used to describe circumstances in which the minority peoples take over the technical and expressive forms from the conquering society as part of production for their own use—for example, Navajo weaving and Kuna use of cloth and scissors to make *mola* blouses.

In order to build or even to create the intellectual field of the "arts of acculturation," I set out to organize a session at the AAA meetings where a number of case studies could be presented. Knowing hardly any such case studies or authorities, I wrote in February 1970 a general letter of solicitation to every person listed in the American Anthropological Association's *Guide* as having an interest in art, to the faculty of the departments of art and design at Berkeley, and to many others: a total of more than eighty people. About half of them replied, expressing interest in or support for the project, although many could not attend the conference.[1]

Among those who did attend the 1970 AAA meetings in San Diego and gave papers in the session entitled "Contemporary Developments in Non-Western Arts" were a number whose work ultimately appeared in the volume *Ethnic and Tourist Arts* (1976), including Dan Biebuyck, Jerry Abramson, Tom Charlton, Don Lathrap, Carole Kaufmann, Paula Ben-Amos, Scott Ryerson, and William Bascom. Other participants, such as Nancy Williams and Beatrice Pendleton, were among a growing number of graduate students at Berkeley whom I persuaded to carry out field research on the project. Others who could not attend the AAA meetings, such as Sid Mead and Kate Peck Kent, submitted papers that were included in the book. They in turn suggested that I contact additional authorities such as J. J. Brody, who also contributed to the book.

A sense of the importance of studying *contemporary* non-Western arts was spreading at Berkeley. The recently formed Native American Studies Program brought Kiowa artist-instructor Dennis Belindo to teach at Berkeley. Carl Gorman was teaching at the University of California at Davis, and contemporary African arts were beginning to appear in local galleries. In the summer of 1970 Berkeley's University Extension asked me to organize a three-day course called "Art and Artists in a Changing World: Non-Western Peoples." This event, which included film screenings and guest speakers on

Oceanic, Australian, Peruvian, Huichol, and Makonde arts, was a kind of dress rehearsal for the AAA meetings later that fall. I gave two slide lectures that formed the basis for talks I have repeated in many venues on the topic: "What Is Ethnic Art?" and "Contemporary Canadian Eskimo Art."

The following spring I delivered a plenary address at the annual meeting of the Kroeber Anthropological Society in Berkeley on "A Program for Research in Art and Pluralism" (Graburn 1971). That presentation set forth my contention that this research was central to the understanding of the colonial predicament and the ethnic self-image of many minority peoples. It looked at art production as a more positive form of integration than the usual "division of labor by race" found in plural societies. Though I envisioned that such a program could perhaps be organized through the Lowie Museum at Berkeley or through a newly created institution, it in fact was carried forward by many of my students and by others in anthropology and art history, leading to the kind of work found in this volume.

Another opportunity to advance the field arose when Douglas Schwartz, president of the School of American Research in Santa Fe, New Mexico, suggested to me right after the session at the 1970 AAA meetings that I hold an advanced seminar on the subject at the school. Flattered by this generous offer, I made plans for another conference that would involve a smaller group of people in the consideration of theoretical issues of greater depth, as against the more broadly comparative volume that I saw stemming from the San Diego meetings.

I invited some of the earlier collaborators—Kent, Maduro, Bascom, Ben-Amos—along with some new ones—Edmund Carpenter, Ulli Beier, William Davenport, Richard Beardsley—and suggested as a topic title "Contemporary Developments in Folk Art." Beier declined, and closer to the April 1973 seminar date Bascom and Davenport both withdrew because of illness. The replacements included graduate student Lucy Turner, who had recently completed a master's thesis in folklore on psychedelic posters in the Berkeley area. Ben-Amos suggested we invite Charles Cutter, an art historian at Yale who was an expert on Dan masks. Yvonne Lange, curator at the Museum of International Folk Art in Santa Fe, also volunteered a paper.

The seminar was extremely interesting, in part because of the diversity of case studies presented—including Turner's poster art, Beardsley's Japanese folk art, and Carpenter's tribal art potpourri. All the sessions were taped, transcribed, and sent to the participants for revision. Unfortunately some of the revisions took years to extract. The final reviewers' report (in early 1977) concluded that the papers were too disparate and did not form a collectively solid set, that my introduction (on the history of the position of the study of art within anthropology, folklore, and aesthetics) was too broad and ambitious, and that Carpenter's manuscript contained mainly passages that had already been published elsewhere. Only Ben-Amos's essay, "Pidgin Languages

and Tourist Arts," was recommended for immediate publication without further revision (Ben-Amos 1977).

Preparation and Publication of Ethnic and Tourist Arts, *1970–1976*

Soon after the AAA meetings in San Diego, I prepared a prospectus for a collection, called *Art and Change in the Modern World: The Arts of Non-Western Peoples,* which was accompanied by Kate Peck Kent's illustrated paper on Pueblo and Navajo weaving. I included abstracts of regional chapters—on Alaskan Eskimo ivory carving, Indian paintings of the Plains and Southwest, Huichol yarn painting, the arts of the Aranda of central Australia, modern Makonde sculpture, and Akamba woodcarving—which never materialized. To pay the contributors for their book chapters and photographs and to cover the secretarial and production expenses of a large illustrated book, I submitted grant applications to the Wenner-Genn Foundation (which again turned me down) and to the Institute of International Studies at the University of California at Berkeley (which funded the project).

Berkeley graduate students played an important role in the development of the project, even though many started with no particular interest in non-Western arts. For instance, of the two already mentioned as symposium participants, Beatrice Pendleton was in fact a palaeolithic archaeologist, and Nancy Williams was preparing for her doctoral research in legal anthropology. Later other students in my graduate seminars "Contemporary Arts" and "Comparative Study of Ethnic Arts" helped in other ways, examining and critiquing the literature and working on the actual production of the book. Some of these students, such as Gobi Stromberg, Ron (later Renaldo) Maduro, and Setha Low, already had field experience and eventually contributed chapters to the volume on Amate bark paintings, Rajathsan Brahmin paintings, and contemporary Ainu sculpture respectively (Stromberg 1976; Maduro 1976; Low 1976). Robert Gill, a museum ethnologist of the Southwest and an auditor in one of my courses, wrote on Laguna pottery (Gill 1976).

Later, I worked especially closely with Mari Lyn Salvador, an anthropologist of art and trained photographer who entered graduate school after three years in the Peace Corps working with the Kuna *mola*-makers of Panama (Salvador 1976a, 1976b, 1978). Together, in 1972, we produced a 442-page preliminary version of the book, "Contemporary Developments in Non-Western Arts," with all the photos screened and inserted. This was the collection eventually sent out for publishers' reviews, as well as the version that served as a text in my "Art and Culture" class until 1976.

While this was going on, the staff of the Lowie Museum at Berkeley saw some of my papers and publications on the subject. I was invited to join with museum anthropologists Larry Dawson and Vera-Mae Fredrickson in creat-

ing a major exhibition illustrating many of the processes of artistic change and pluralism from the museum's collections. Aided by Dawson's encyclopedic knowledge of both ethnological and archaeological processes and cases, this resulted not only in an unprecedented exhibition but also in a small published catalog, *Traditions in Transition: Culture Contact and Material Change* (Dawson, Fredrickson, and Graburn 1974), which may have been the first monograph published on our topic. Dedicated to the stimulating works of Edmund Carpenter, the catalog looked at innovation, revival, and extinction; at the differing effects of commercialization; and at the articulation of ethnic identities through the cross-cultural arts. It was mailed out to more than forty of my growing circle of correspondents and was favorably reviewed, thus alerting a wide audience to our topic.

Meanwhile, the prospectus met with mixed responses from the many publishers to whom I had sent it. Some presses I contacted never replied. More commonly, I received a polite letter saying "the potential market is too limited," or, more vaguely, "it does not fit in with our current publishing plans," or "we steer clear of picture books with production complications when possible." There were, however, a number of publishers who expressed interest and wanted to know more, some enthusiastically and others less so: "if you can't get another publisher, we might . . ." Grant Barnes, an editor at the University of California Press, was enthusiastic early on but worried about the cost of reproducing the hundred-plus plates. The book was finally nearing acceptance at another publisher, when Barnes contacted me again with renewed enthusiasm. He took a quick look at the latest version and decided to go ahead on the spot.

Though some photographs had to be replaced, very little further rewriting of the case studies was necessary. However, I completely rewrote and elaborated my introductory chapter in light of the latest literature. Specifically I worked on the relationship between the categories ("functional," "commercial," "reintegrated," and so on) and the contextual factors (intended audience and aesthetic-formal sources and traditions)—finally arriving at the much-copied matrix diagram (Graburn 1976a: 8). The sheet of paper with my first rough rendering of that diagram still hangs on the shade of the desk lamp I use today. The revised chapter was in turn heavily edited by my friend and former student Ronald Davison. The only unusual problems I had with the University of California Press concerned the title. The director of the press thought that "tourist arts" were paintings of Notre Dame done by lady tourists on the banks of the Seine, and he asked whether non-Western arts meant "eastern" or Ivy League! After considerable thought, we came up with the descriptive and political title *Ethnic and Tourist Arts: Cultural Expressions from the Fourth World* (1976), which avoided the problematic term "primitive art." The title's reference to "ethnic" and "tourist" arts made the ethnocen-

tric assumption that in an increasingly plural world, the more marginal peoples, those of the Third and Fourth Worlds, would be deemed "ethnic" and that they were increasingly visited by tourists from the West or First World. While this remains largely true, much recent work has focused on the transnational movements of "ethnic" peoples toward the metropolis, though usually as refugees and workers, not tourists; this may increase the likelihood of the production and distribution of "ethnic arts," including crafts, clothing, body ornamentation, and, of course, cuisine. Furthermore, the original designation of the cultural expressions of the Third and Fourth Worlds has become somewhat anachronistic since the relative demise of the Second World, the Communist bloc.

WHAT HAS HAPPENED SINCE THE
PUBLICATION OF *ETHNIC AND TOURIST ARTS*?

The essays in the present volume contribute to the many advances in the study of the arts of plural societies that have emerged since the publication of *Ethnic and Tourist Arts* in 1976. As my previous remarks have demonstrated, when the book first came out, serious anthropological and art-historical study of these arts was long overdue. The world of scholarship had unfortunately avoided the analysis of arts embedded in culturally plural contexts, many of which had for some time been part of a "World Art System."[2] Since 1976 some general works on the anthropology of art have fully incorporated and explored this additional perspective (e.g., Anderson 1979, 1989, 1990; Anderson and Field 1993; Feest 1980; Coote and Shelton 1992). Others, such as Robert Layton in *The Anthropology of Art* (1981), have persisted in limiting their consideration to the "traditional" politically and ritually embedded arts in societies that are suspended in the apparent isolation of the "ethnographic present." This limited view is found even in Layton's revised edition (1991), in spite of criticism in reviews (Graburn and Badone 1983) and the general critique of such static ethnography (e.g., Fabian 1983; Marcus and Fisher 1986). However, in his recent work on Australian Aborigine art, Layton (1992) has shown himself to be fully cognizant of such developments.

Other writers have focused on these acculturative or hybrid arts, both in areas of the world, such as Africa, where the traditional "primitive" arts were sought and found (Younge 1988; Vogel 1991), and in those literate great civilizations whose own art worlds have inevitably fallen under Western influences, such as Thailand (H. Phillips 1992), China (Laing 1988), and India (Inglis, this volume). In these publications, just as in many of the new traditions discussed in *Ethnic and Tourist Arts*, the focus is on innovative art styles that draw on local and external sources of forms and probably have new, of-

ten commercial, functions too. It is illuminating that in our literature we find it far easier to dwell upon, accept, and analyze the commercial nature of what are called "crafts" (see J. Nash 1993)—a category that we treat as inherently hybrid and marginal—than to do so for "arts."

To summarize, I have so far noted the expansion of analytical space to encompass a focus on the so-called hybrid arts as well as the formerly dominant traditional arts, and I have pointed out two arenas in which a specific focus on different kinds of hybrid arts has been the subject matter of recent studies. But we must not forget that the distinction between purebred and hybrid is also a historically contingent creation of our analytical minds, as are the distinctions between art and non-art and between art and craft. Two important recent anthropological works show us that the purebred/hybrid distinction is not always either useful (Morphy 1991: 2) or relevant (Neich 1993).

Howard Morphy claims that the structural and aesthetic patterns underlying both functional (inwardly directed) and commercial (other-directed) bark painting of the Yirrkala Yolngu of Arnhem Land cannot be differentiated—that is, that both purebred and hybrid art share the same structure. In other words, these contemporary art productions, like many others, have a dual purpose: arts with the same formal structure have two intended audiences, internal and external. Similarly, Silverman's chapter in this volume clearly shows the production of certain genres for internal consumption as *functional traditional* arts and for sale as *commercial fine* arts, as well as the invention of new genres for export—*novelties,* as charted by *Ethnic and Tourist Arts* (see Graburn 1976a: 5–16).

Roger Neich's recent work examines the relatively short-lived art form of figurative painting in Maori meeting houses, which lasted from 1870 to 1910. This tradition is hybrid in the sense that it was stylistically influenced by *pakeha* (white) culture but expressed Maori cosmology during a period of intensive colonialism. Yet Neich is able to analyze this complex and widespread tradition as an art form in all its rich dimensions without recourse to arguing about or labeling its pure versus miscegenous background as though it were some special, unusual form of Native art. I suspect that Neich's work presages a future in which we will realize that all art traditions are temporally limited and yet exhibit internal change over time, and that nearly all cultural contexts, when examined in detail, exhibit some level of subcultural, regional, or national discontinuity and exchange.

The main advances in this complex topic, many of which are illustrated in the essays in this volume, include the following: (1) an expansion of the analytical field to highlight the forces of colonialism and the great time depth of the arena of production; (2) a stress on the dynamic agency of the three groups of actors in this context: artist/producers, intermediaries, and consumers; and (3) a concern with the implications and multiple interpretations of "authenticity."

The Arena of Production

We are beginning to examine more deeply the sociocultural complexity of the production of most non-Western art forms with a full realization of the influence of the colonial or postcolonial, often touristic, context in which they were embedded and the far greater historical depth that is entailed. In the past twenty years, landmark works contributing to this increase in understanding include Douglas Cole's *Captured Heritage* (1985), Arjun Appadurai's *The Social Life of Things* (1986), James Clifford's *The Predicament of Culture* (1988), and Nicholas Thomas's *Entangled Objects* (1991), as well as Neich's *Painted Histories* (1993).

In this volume almost all the contributors demonstrate their profound awareness of the historical depth of the colonial contact situation in which works of art, which have ended up in museums and private collections, were produced. Up until the publication of *Ethnic and Tourist Arts*, the anthropology profession's analyses of non-Western arts were dominated by models of the symbolic, ritual, and political embeddedness of these "authentic, traditional" functional arts, otherwise known as "primitive" or "non-Western" arts (Gerbrands 1957). The ethnic and tourist arts were the "marked" cases—that is, the anomalous arts produced in colonial and trade contexts, works that, because of their bastard or derivative nature, were in the opinions of many not worth examining and analyzing. Recent studies in anthropology and art history, including many in this volume, have almost succeeded in reversing the situation. We now realize that practically all the objects in our ethnographic collections were acquired in politically complex, multicultural colonial situations. Furthermore, we can state unequivocally that unless we include the sociopolitical context of production and exchange in our analyses we will have failed in our interpretation and understanding.

First, much as dealers, museum curators, tourism directors, and contemporary Third and Fourth World peoples might like to present the historical artifacts as "purebred" functional symbols of rich and discrete heritages, we are forced to realize that even if they appear to show no acculturated deviation from embedded functionalism, these arts may well be intentional reproductions or replicas made for trade decades after their original intrasocietal functions ceased (Graburn 1976a: 5–6, 20). Bol (this volume) explains why the export of Lakota artifacts is a form of "indirect tourism" (Aspelin 1977) attesting to the collectors' longings for an imaginary "contact-traditional" stage of culture at some frozen time in the "ethnographic present" (Fabian 1983). In this fantasy time, Plains Indians can continue to exist while the realities of Indian reservation life can be ignored entirely.

Second, and in contrast, the chapters in this volume by Ivory on Marque-

san export arts and by Jonaitis on the monumental and portable arts of the Northwest Coast of America strongly suggest that the arts we have long thought of as traditional may have been invented or at least stimulated, enlarged, and proliferated in response to the new contact-era functions of trade and tourism. Unaware of these processes, however, the consumer public and even students in undergraduate courses on these arts may, more than willingly, continue to collude in the fiction that these "primitive arts" are indeed products of a traditional alien culture, ripped out of context for their pleasure.

A third historical possibility is illustrated by Phillips's contribution to this volume, in which she exposes what would nowadays be called "artifaking" (see also Holm 1988). So strong are the consumer's and the collector's desires to preserve and experience alterity that only Phillips's art-historical detective work can show us that the supposed consumers of Huron colonial arts were also imitators and makers, and for very good reasons (see also Lee, this volume). The desire of Canadian colonial ladies to appropriate a local (tourist) art form is typical of conquerors' attempts to build an "ethnic" identity separate from the homeland by taking the cultural space of the conquered peoples (Graburn 1969b). This is related to a larger set of phenomena that encompasses hobbyists' play at "cowboys and Indians" in America and Europe, and Lewis Henry Morgan's rejection of his classical European formation when he forsook the Gordian Knot social club in favor of the League of the Iroquois.

Actors in the Arena

Within this enlarged and deepened analytical setting, recent works have focused on the agents rather than the objects. This more dynamic understanding examines the active parts played by the artists themselves, the intermediaries, and the consumers. Though it is often difficult to understand the motivations and actions of actors in past settings, essays such as those in this volume by Cohodas, Nicks, and Batkin have given us masterful demonstrations of the power of ethnohistorical analyses, using written and oral sources as well as examination of the artifacts themselves (see also Neich 1993). Other historical analyses—such as those by Wilson, Parezo, and Jonaitis in this volume—have found it more difficult to understand artists as agents, so have concentrated on the more accessible intermediaries and consumers. Niessen, Steiner, and Kasfir have conducted field research that enabled them to understand and present the points of view of all three sets of agents, especially the artists and intermediaries. Berlo, using more art-historical methods—or perhaps the anthropological "study of culture at a distance"—has attempted to understand the motivations of a Canadian Inuk artist solely through the examination of her work in a museum collection.

The advances of the past twenty years have shown us the complexity and

fluidity of the agency of the personnel in ethnographic arts. Artists may intentionally work in a variety of styles or even genres in order to reach a number of consumer markets (see especially the recent literature on Africa: Jules-Rosette 1984; Steiner 1994; Schildkrout, this volume; Kasfir, this volume). We have also learned that artists may play the role of intermediaries (Lee 1991; Silverman, this volume; Ettawageshik, this volume), and that different artists within small-scale societies may choose to play very different roles (Cohodas, this volume).

The Predicament of the Artist

In nearly all the chapters of this book, the artists were or are creating works primarily for an external market that is part of, even marginally, the metropolitan World Art System. While acknowledging that the patron or consumer places constraints on all producers of art, the difference between the situations of "hybrid" arts of this volume and the stereotypic functional arts of prior anthropological analyses is that the artists dependent on the cross-cultural market are rarely socialized into the symbolic and aesthetic system of the consumers who support them (see Bloch 1974). The rules of the game lie outside of their society, at least until structural assimilation has drawn them into the metropolitan art school and gallery circuits (Graburn 1989b, 1993a, 1993b).

Thus these artists live in a minefield of rules that they overstep at their peril.[3] For instance, the Australian Aborigine watercolorist Albert Namatjira worked in the style of his white mentor Rex Battarbee and engendered dangerously ambivalent reactions among the Australian public, including his being granted (white) citizenship and his downfall among those who were either racist or envious of his fame (Batty 1963; Amadio 1986).

Until very recently, few Native artists were able to attend art schools and, like Namatjira, many knew little about the rules and expectations of the metropolitan world of mainstream art. It is still the case that some do not even know that there is an "art world" and may not be familiar with the Western concept of art itself. They may continue to produce artifacts for sale whose forms are based on traditional intracultural productions, with whatever modifications the foreign buyers seem to want. The chapters by Ivory, Phillips, Silverman, and Schildkrout in this volume show us that outside demands can lead to modifications or even to new genres of productions (see also Graburn 1976a, 1978; Steiner 1994).

Yet in many parts of the present-day globe, Third and Fourth World peoples have been exposed to mainstream arts and have had access to some of the technical materials for producing such arts. In addition, in colonial situations as well as in wealthier countries, increasing numbers of such artists have attended art schools and have come into contact with the ideology and

history of (Western) art, which includes such values as originality, artistic freedom, and individual creativity. Surprisingly, none of the essays in the volume deals directly with the latter situation and the resulting conflicts between tradition and artistic freedom (cf. Graburn 1993b; Wade 1986).

Artists' exposure to mainstream arts and technical materials is represented here by Berlo's analysis of the drawings for prints made by Canadian Inuit artist Napachi Putuguk (or Napachie Pootoogook). In Cape Dorset, Baffin Island, as well in other Inuit villages, artists are given drawing paper, pencils, and crayons and asked to create images that will be bought by the cooperative and later considered for transformation into limited-run prints for sale. Berlo shows us that images of the southern/contemporary world are virtually absent from Napachi's drawings (and from the drawings of all but a very few other Inuit artists). This is because the intermediary artistic advisers, interpreting market demands, only select images with traditional, visibly Inuit, content or with depictions of nature. Exceptions to this are rare, such as the work of the outstanding (female) artist Jessie Oonark or the (male) artist Pudlo Pudlati (Graburn 1987a; 1987b).

The continuing separation of the art circuits for Native arts and mainstream, mainly Euro-American, arts poses a growing problem for non-Western arts because, through art school training or other forms of exposure, many Native artists are using techniques and genres characteristic not of their traditional worlds but of the metropolitan World Art System. In consequence, the content of their work may not be instantly recognizable as "ethnic," a situation probably aggravated by the appropriation of so many ethnic motifs by non-Native artists. In order to compete and to avoid rejection by world markets, Native artists have to signal their ethnicity through a variety of formal and symbolic devices (see Sturtevant 1986: 41–44).

The work of artists with names that are clearly Native in origin is readily identified as "ethnic." Those without such names may emphasize their tribal affiliation instead. Others present traditional content or use motifs and color schemes that cognoscenti know to be Native. Other signaling devices include titles that evoke Native identity and written statements within the work that testify to a Native point of view. Inclusions of recognizably non-Native content, motifs, color schemes, names, and titles may draw criticism or rejection by the market.

These parameters indicate how ethnic artists everywhere in the world continue to be subjected to immense pressures to create only those arts (and crafts) that cater to the image desired by the mainstream art market. Even the breakthrough exhibition *Magiciens de la Terre* in Paris (Centre Georges Pompidou 1989), which exhibited the works of First, Third, and Fourth World artists side by side, revealed by this very juxtaposition that the "ethnic" artists were expected to create something stereotypically traditional, yet the metropolitan (white) artists were allowed to draw their images from anywhere

and to appropriate motifs or materials from nature or from cultural alterity without limitation.

Creativity of the Mediator

For analytical purposes we may state that there are always three agents involved in the production and consumption of hybrid arts in complex societies: artist, middleman, and consumer. It is, of course, the middleman who imposes the specific predicament on the artists. When the artists and the consumers are culturally, geographically, or temporally far apart, the mediating agent assumes greater importance. It is he or she who not only transmits the physical art object from the producer to the consumer but who also controls the important flow of information about the object's origin, age, meaning, and producer (Barbash and Taylor 1992; Steiner 1994). This includes the important information about the status of the artifact as commodity or treasure (Appadurai 1986b).

Equally important in most circumstances is the function of transmitting back to the producer the demands of the marketplace and the ideology of the collectors. Such information may be transmitted merely in terms of price or repeat orders, or as specific information about form, content, color, materials, and so on (see essays by Berlo, Schildkrout, and Inglis in this volume). Silverman (this volume) gives a vivid account of how Iatmul artists, like artists everywhere, keenly watch the facial expressions and nonverbal cues of the audience of potential buyers as they circulate among the art objects on display.

The contributions by Bol, Cohodas, Lee, and especially Batkin focus on situations in which mediators are often in control of the content of the production, the price, and the interpretation that inevitably accompanies transcultural sales. Batkin shows us that in New Mexico the entrepreneurial middlemen were often responsible for creating new forms of arts for trade based on their familiarity with the markets, including mediators farther down the chain of distribution. Not all mediators are concerned with sales. In Parezo's account of the performances of curator Frederic H. Douglas the highly manipulative mediator promotes a particular intercultural ideology, and in Wilson's tale Mlle. Maria Leontine promotes her own sophistication as an entertainer and dancer.

Frank Ettawageshik's forebears in upper Michigan, Chief Poking Fire (John McComber) and his family at Kahnawake outside Montreal, and the anthropologists and administrators who directed the restoration of totem poles all promoted their own livelihoods and catered to tourists by expressing a strong ideology of the authenticity of various Indian productions and ways of life (see, respectively, Ettawageshik, Nicks, and Jonaitis in this volume). Though they fostered some aspects of continuity in Indian life in col-

onized North America, all had their own ideas about what kind of authenticity would attract the tourist market.

Collectors and Consumers

Molly Lee states in her essay in this volume that there has been plenty of research on the effects of Western collecting on Native art producers—the feedback process mentioned above—but too little on the motivations of collectors or consumers. This stems in part from the fact that the latter are members of the metropolitan societies from which anthropologists have gazed outward toward the Other—and indeed, one may hasten to add, anthropologists have often been the collectors. Until the 1960s, anthropologists rarely looked at the culture of their own societies, let alone their own collecting practices and habits. Although sociologists have for a century or more studied Western societies, they, too, have only recently focused on people's domestic possessions and the small scattering of ethnic arts included among them (see, for example, Csikszentmihalyi and Rochberg-Halton 1981; Halle 1993a, 1993b).

Lee's pioneering work segments a particular market, North American amateur collectors,[4] between 1880 and 1920, and divides their activities, and thus the type of arts they collected, by "taste cultures," which generally reflect their education and gender. Similarly, Alice Horner's definitive work on authenticity and creativity in the Cameroons (1990, 1993a, 1993b) highlights the creative roles of white promoters and collectors in both constructing meanings in the arts for themselves and in stimulating creativity among African artists.

The Construction of Authenticity

A recent, heightened concern with "authenticity" operates in the discourse about ethnicity, mainly within the consuming society both at the level of judging the art forms and more self-consciously. With rare exceptions (e.g., Sapir 1924), anthropologists have not considered authenticity to be an analytical category or a measure of a culture, a people, or their art forms. Authenticity and genuineness were folk categories, measures by which people in certain historical or cultural situations judged cultural productions. As Ettawageshik points out in this volume, for scholars to consider the idea that contemporary Native art is not authentic is dangerously close to stating a position that no anthropologist could take—that the Native people who made it are not authentic either. As late as 1978, in my analysis of audiences' reactions to two transcultural art forms (Canadian Inuit soapstone sculptures and wooden replicas of traditional Algonkian artifacts sold as Cree Craft), I duly reported that many of the audience thought the latter lacked authen-

ticity because they looked commercial (Graburn 1978: 67–69), whereas they thought that the Inuit sculptures, which were in fact an entirely new art form, looked authentic (Graburn 1976b). I proposed a change to my lay definition of the inauthentic as something mislabeled, or purporting to be something it was not. The de facto concept of authenticity for tourist arts and ethnic images was that commercial replicas of traditional artifacts (such as Cree Craft) were fakes, while novelties like Inuit sculptures that had not existed in the precommercial era were accepted as authentic because they were not replicas of anything—even though the promotional story of their precontact existence and religious importance was clearly untrue.

I suspect that concern with authenticity has grown within anthropology for two reasons. First, it has always been a central topic for art historians who have worked with museum curators in pronouncing whether art objects were genuine or fake—that is, whether they were actually created by the signatory artist or in the historic period claimed. With respect to the often anonymously created transcultural arts, the arena in which art historians and anthropologists have come together, as in this volume, this concept of authenticity as "truth in information" was enlarged to exclude those objects made for sale, even if the tribal culture was correctly identified.[5] Second, the transcultural arts we now study are most often found in touristic contexts, and *it is the tourists who are most concerned with authenticity,* a fact central to the growing scholarly analysis of tourism initiated by Dean MacCannell in his influential book *The Tourist: A New Theory of the Leisure Class* (1989).

In the literature on tourism, which MacCannell's work long dominated, it was commonly said that tourists left their home environments in order to search for authenticity elsewhere—in other times (the past), in other places, or in the lives of other peoples—and that they were doomed to failure because tourist attractions were created just for them. What was not clearly stated in this tourism literature was that authenticity is a concept tourists carry with them in their heads, a concept that was probably never to be found in other times, places, or peoples—or at least not until the tourists arrived!

Authenticity is a central concern of many of the papers in this collection. This is not, I hope, because the authors judge the art forms by this standard, but because it is a culturally constructed concept that has important meanings for the consumers and increasingly the producers of these art forms. The cultural construction of authenticity, paralleling the construction of "primitive art" (Maquet 1986) and "tradition" (Horner 1990), only became clear when it was shown, first, that authenticity is always a variable, meaning different things to different subcultures (Cohen 1988), and second, that other analysts have not assumed that authenticity was ever "really there," like an elusive Holy Grail (Frow 1991).

Erik Cohen (1988) and others have shown that authenticity is a concept whose salience generally varies in relation to a person's amount of formal

education. For instance, in viewing a historical reconstruction or reenact-
ment, the most educated are the most critical of the authenticity of the at-
traction, while those with little formal education may just enjoy the show and
not think about its authenticity. People who make judgments on the basis of
authenticity are, of course, attempting to demonstrate, to themselves if no
one else, a superior knowledge and power of discrimination. Art historians
and museum curators have worried about authenticity most because their
professional standing and authority depends on their powers of discrimina-
tion. Cohodas (this volume) shows clearly that the imprecation of authen-
ticity is a device for maintaining power and stratification in colonial systems.

The essays in this book that elaborate on this popularly important con-
cept are concerned with its differential meanings to different actors in the
diachronic drama of the production and consumption of transcultural arts.
Ettawageshik, a practicing Native artist, wants to affirm that all commercial
Indian products are authentic because they are reflections of Indian peo-
ples' interaction with other cultures. At the same time, he has gone to con-
siderable lengths to revive what one might call a hyper-traditional precon-
tact art form, Odawa pottery, which had lain dormant for 150 years.

Lee's essay clearly shows the stratified and gender-entailed meanings of
authenticity among the collectors of early Alaskan Native tourist arts. She
avers that all tourist-collectors were concerned with authenticity (though we
cannot be sure of that). While the mass tourists were concerned only with
geographical specificity and Native-made claims, other amateurs, more ed-
ucated and claiming superior status, and the dealers who catered to them,
wanted objects that were made for Native use and had actually been used.
The cases recounted by Phillips, Kasfir, and Schildkrout also show the gen-
der-entailment among the collectors of souvenir arts, which in turn is trans-
mitted back to the producers. With enough feedback, the consumers'
(mis)understandings can become internalized in the producers' new iden-
tities, as Edmund Carpenter (1972) warned some time ago. Or, as Nicks
shows, the paraphernalia and performances specific to the tourist trade may
be maintained as a sphere quite separate from normal community life.

The use of the discourse of authenticity among Native art producers is
more problematic. It is quite clear that those such as Ettawageshik, who are
intimate with the non-Native world, understand and are suitably wary of oth-
ers' imposition of the concept on them and their work. Yet the importance
of authenticity to tourists and collectors is soon learned by Native artists and
mediators and takes a central place in the language of selling. Often we are
not told whether the Native peoples use the concept of authenticity as a re-
sult of their contacts with the metropolitan world system or, of equal im-
portance, if they have a comparable unacculturated discourse about gen-
uineness and spuriousness.[6]

Nevertheless, all our case studies fall within the postcontact, colonial, or

postcolonial period. Many show us that what started out as tourist trade goods, perhaps deemed trinkets by the makers as well as by the consumers, have taken on an importance more central to the colonized peoples. For instance, many Canadian Inuit have complained to the federal government that making soapstone sculptures is now "their thing" (just as they have with commercial fox trapping), and they therefore want competition from white people to stop. Ivory shows us the part that nontraditional tourist arts are taking in the Marquesan cultural revival, and Berlo finds importance in the "sold and archived forever" images created by Inuit women artists. The differential meanings of tourist arts for the Samburu, described by Kasfir, attest not to their unimportance but to their very specific and perhaps increasing significance. And nearly all the Northwest Coast art forms, reused, revived, and elaborated, are, as Jonaitis shows us, of central importance to the viable and vibrant culture of the peoples of the Pacific Northwest.

NOTES

355

PREFACE

1. "Contemporary Developments in Folk Art," School of American Research Advanced Seminar, No. 17, April 16–20, 1973, School of American Research Library, Santa Fe, N. Mex.

1. ART, AUTHENTICITY,
AND THE BAGGAGE OF CULTURAL ENCOUNTER

1. For recent studies on the development of consumer culture in England and America during the eighteenth and nineteenth centuries, see Brewer and Porter 1993 and Bronner 1989.

2. Parker and Pollock wrote, for example, that "myths about creativity and the limiting, distorting way art historians write about the past have deep roots in our social structure and ideologies. . . . They are powerful and pervasive and the feminist attempt to challenge them is rendered difficult precisely because we have been produced within the dominant social order" (1981: 45).

3. See Collingwood's *Principles of Art* (1938: 15–41) and the earlier *Outlines of a Philosophy of Art* (1925). The headings of articles in standard reference works such as the *Encyclopedia of World Art* (1959), for example, continue to present this scheme (see, in particular, articles on "Art," p. 763 ff. and "Handicrafts," p. 269 ff.). It can be argued that the first major alternative theory to the standard oppositionality of tool forms to art forms presented in such Idealist texts was posed by George Kubler in *The Shape of Time* (1962).

4. Dominguez (1992) has analyzed this process as the global imposition of a broader dichotomy of elite European notions of Culture/*Kultur* and democratizing Boasian notion of "culture."

5. See Maurer 1986 and King 1986 for important discussions of how the Western concepts of "quality" and of the "traditional" have intervened in the assignment of value.

6. The evaluation of earlier, less "civilized" traditions of European and Near Eastern art—the problem of aesthetic relativism—became, for the new history of art, a central problem, described by Podro as "how we can make a work of art, which is in part constituted by beliefs which we do not share, part of our own mental life without some inward treachery or mental schism" (1982: 3).

7. Maurer (1986) has argued that the criteria of aesthetic quality applied by many Native American peoples are based on precisely opposite assumptions, which hold the functional attributes of an object to be fundamental to its aesthetic.

8. Chapman demonstrates that Pitt Rivers's cultural evolutionist concept of museum collecting and display were formulated by the late 1860s, although the museum organized according to his theories at Oxford did not take shape until the 1890s.

9. Richards also notes that visitors flocked to the displays of objects for sale in far greater numbers than they did to the official, museum-like, exhibitions (1990: 32–33).

10. Semper was commissioned by the London representatives of Canada, Turkey, Sweden, and Denmark to design their display spaces. The Canadian and Turkish sections would certainly have included "tribal" products (Mallgrave 1983).

11. Alldridge contributed masks and textiles to the British Museum and the Brighton City Museum and Art Gallery.

12. The aesthetic complicity that is said to exist among all "primitive" peoples parallels in some sense the arguments surrounding the connections between "primitive" and "modern" art. In stressing that objects from all over the world can sit quite happily together and get along in the modern home, authors often point to the similarity "between a painting by Paul Klee and a sculpture from New Mexico, a Giacometti and a clay-covered skull from New Ireland or a figure from Tanzania, a Gauguin and a relief carving from the Javanese Buddhist temple complex at Borobudur, a Zande throwing knife and a Matisse cutout, a Brancusi and a Baule mask, a Max Ernst and a Dan spoon" (Borel 1994: 14–15).

2. MY FATHER'S BUSINESS

The editors wish to thank James M. McClurken for his assistance in obtaining the photographs that illustrate this essay.

1. Peter H. Welsh, unpublished discussion paper for the panel "Hybrid/Purebred: Art, Authenticity, and Touristic Production in Colonial Contexts," joint meeting of the Council for Museum Anthropology and the American Ethnological Society, Santa Fe, New Mexico, April 15–17, 1993.

2. The Honorable Neil Abercrombe, U.S. representative from Hawaii. Comments at the committee hearing on H.R. 2376, a bill to reaffirm and clarify the federal status of two Michigan Indian bands. September 17, 1993.

3. NUNS, LADIES, AND THE "QUEEN OF THE HURON"

1. Although I refer in this essay primarily to the Lorette Huron part of this production, Ruth Whitehead (1987a, 1987b) has meticulously documented the pro-

duction of moosehair embroidery by Mi'kmaq and Malecite women, and much of what I say refers equally to those two groups.

2. See Phillips 1995 for a discussion of the changing museological treatment of moosehair-embroidered bark work and other souvenir arts.

3. See Parker 1989 for a more general discussion of the gender bias behind art history's neglect of embroidery as a medium of art.

4. See Phillips 1998 (chap. 3) for a discussion of the dolls and canoe models the nuns made during the mid-eighteenth century to represent the Aboriginal people to their French patrons.

5. They also made and sold artificial flowers and fancy food confections and sewed shirts for the Indian trade.

6. On eighteenth-century images of the Indian as Noble Savage, see Berkhofer 1978, Dickason 1984, R. Pearce 1988, and Donald Smith 1974.

7. The author of the *Annals* of the Hôtel Dieu expressed to a correspondent in 1729 her qualified approval of Lahontan's account (Letter of Mére de St. Ignace of October 25, 1729, cited by Jamet 1939), and mentioned in the foreword her familiarity with writings on Canada including, "the customs of the Savages, . . . the multitude of their nations [and] the difference of their languages" (J. Francoise Juchereau, de St. Ignace, Avant Propos, Jamet 1939: 1, n. 1).

8. See Phillips 1998, pp. 110–11, figs. 4.4 and 4.5, for illustrations of these objects.

9. Rijksmuseum voor Volkenkunde, Leiden, B191-53.

10. *Nova Scotia Gazette and the Weekly Chronicle,* January 20, 1789, p. 4, col. 2. (Newspaper File, Public Archives of Nova Scotia).

11. The present whereabouts of the box are unknown. Barbeau also collected for the Canadian Museum of Civilization a moosehair embroidered box containing a yellowing note stating "This box belongs / to Marie Josephte fortin / daughter of Captain fortin of la Petite / Riviere. Should anyone steal it she begs the thief / very humbly to bring it back very quickly without taking anything / that is inside it / or else he will be pursued with all the force of the law / Josephte fortin / the 14 September 177?" (Barbeau 1943: 90–91; my translation). Although the note does not directly establish whether the young woman made the box herself, it makes clear the value it had for her.

12. Cothele House is now owned by the National Trust and was formerly the property of the Edgecumbe family. The family papers, which might have illuminated its history, were destroyed during World War II.

13. The Nova Scotia Museum acquired the bookmark (80.105.1) from the maker's granddaughter. The envelope enclosing the bookmark bears the note: "Red Indian work done by Sarah Rachel Uniacke. She had a squaw come to instruct her every week." I am grateful to Ruth Holmes Whitehead and Marie Elwood for sharing this information with me.

14. The manufacture of those objects had already been going on at Lorette for at least two decades, as evidenced by an inscription on a set of dressed dolls in the Canadian Museum of Civilization (III-H-429, 430, 431) stating that they were bought at Lorette in 1788.

15. Alcohol consumption may also have been positively associated with its use as a technique for the attainment of out-of-body experiences.

16. Canadian Museum of Civilization, III-H-400.

17. New U.S. Customs duties introduced in the 1890s also crippled the trade.

18. One news correspondent described the clothes as "ridiculous burlesques upon those the real Indians wear" (*New York Herald,* August 26, 1860).

4. TOURIST ART AS THE CRAFTING OF IDENTITY IN THE SEPIK RIVER (PAPUA NEW GUINEA)

Fieldwork in 1988–1990 was funded by a Fulbright Fellowship and the Institute for Intercultural Studies; additional support was provided by the Department of Anthropology and the Graduate School of the University of Minnesota. A return visit in June–August 1994 was made possible by funding from the Wenner-Gren Foundation for Anthropological Research and DePauw University. I am deeply grateful to these institutions. All photographs that illustrate this article were taken by the author in 1988–1990 and 1994 in Tambunum village, Papua New Guinea.

1. For Pacific Island tourism see Farrell 1979, Cohen 1982, Macnaught 1982, Helu-Thaman 1993, N. Douglas 1996, and, more generally, MacCannell 1989, Cohen 1988, Crick 1989, D. Nash and Smith 1991, D. Pearce and Butler 1993, and Bruner and Kirshenblatt-Gimblett 1994.

2. For the fate of "primitive art" in the "civilized" world of Western connoisseurship and museums, see Price 1989, Thomas 1991: chap. 4, O'Hanlon 1993, S. Errington 1994b, Steiner 1994, Marcus and Myers 1995.

3. This recalls the debate in the mid-1980s surrounding the Museum of Modern Art's exhibition of the "affinity between the tribal and modern" (Clifford 1985).

4. Museum displays also figure in the Western discourse of the "primitive" Other (see Karp and Lavine 1991; S. Pearce 1993; Ames 1993; Webb 1994; R. Phillips 1995; Kahn 1995).

5. My critique of the film discusses issues not covered in this essay, including the erotics of the touristic (and cinematic) gaze, local agency and resistance, and the authenticity of tourist experiences. See also Bruner 1991, Lutkehaus 1989, and Mac-Cannell 1992.

6. Ethnographic accounts of traditional Iatmul art include Bateson 1946; Forge 1966, 1973; Kelm 1966; Newton 1967; Hauser-Schaublin 1983; and E. Silverman n.d., 1996b.

7. In anthropology, the symbolic homology of the body, morality, and society is ultimately Durkheimian, although it can also be traced to Hobbes, and even to the Greek notion of the polis. "Moral" and "grotesque" body symbolism is particularly evident, Lipset and Silverman (n.d.) argue, in the famous *naven* ceremony discussed by Bateson (1958).

8. Canoes from other Iatmul and non-Iatmul villages constantly visit Tambunum in order to sell for money pottery, fruit, vegetables, fish, sago, shells, etc. Occasionally, Eastern Iatmul women will exchange baskets for these items.

9. Papua New Guinea's currency is the kina. In December 1990, 1 kina was worth $1.05 (U.S.); in March 1996 it was equal to $0.75 (U.S.).

10. Some village-based carvers regularly send consignments of their works to dealers in Port Moresby, the capital city of Papua New Guinea. Tambunum has a close

relationship with an art dealer in Sydney, and an art shop in Port Moresby was managed by an Eastern Iatmul man in the 1980s. Tambunum is thus in an unusually advantageous position from which to engage the tourist trade.

11. Nevertheless, there is no commercialization of ritual in the village as there is elsewhere in the country (Boyd 1985; Gewertz and Errington 1991: chap. 2; see also Volkman 1990).

12. Established in 1988, the lodge was financed by a Sydney-based tourism company and the art dealer mentioned in note 10. Each year the village received an additional 10 percent ownership of the lodge until it was jointly owned. A portion of the profits, which had not yet begun to accrue in 1994, will be placed in a national bank account and reserved for village-wide projects.

13. For tourist art in other regions of Papua New Guinea, see Abramson 1976, Counts 1979, and Lewis 1990. For Australian Aboriginal art, see Layton 1992; F. Myers 1989, 1991, 1994; and Michaels 1994.

14. For example, Eastern Iatmul resent tourists' asking for "second" prices; accordingly, they inflate the "first" price.

15. Eastern Iatmul women also sell their baskets to nationals in the market in Wewak, the capital town of the East Sepik Province.

16. Plaited baskets woven on Vanuatu display a similar symbolization of national unity or *kastom* (Keller 1988).

17. Eastern Iatmul are adept at making new carvings look old by soaking them and exposing them to smoke. The aesthetic value of age was introduced to them by art dealers.

18. A common source for extramural art styles is *The Artifacts and Crafts of Papua New Guinea: A Guide for Buyers,* a forty-three-page, abundantly illustrated guide, lacking both publication date and authorship—affirming, perhaps, the timeless and anonymous ethos of "primitive" art.

19. On traditional art, these eyes represent the watchfulness of mothers who look after their children and the village more generally.

5. SAMBURU SOUVENIRS

The fieldwork for this article was carried out during 1991, 1992, and 1993. Initial funding in 1991 was from the Social Science Research Council and the Emory University Research Committee; three subsequent trips were funded by Emory University Faculty Development Awards. I am grateful to Michael Rainy for introducing me to Samburu in 1987, and to Kirati Lenaronkoito, who since 1991 has been my closest collaborator in all research dealing with Samburu *lkunono*. I also wish to thank the Office of the President of the Republic of Kenya for permission to pursue my study of blacksmiths. The phrase "land in amber" appears as a chapter title in Hammond and Jablow (1992: 157).

1. Because most do not possess cameras, their own collections of photographs, carefully laid away, are usually acquired as gifts from the spectator/photographer—whether tourist, missionary, or ethnographer.

2. Samburu, or Lokop, is a dialect of Maa, an eastern Nilotic language. Inter-

nally, they refer to themselves as a separate "tribe," partly because of the forced removal of other Maasai from adjacent grazing lands in Laikipiak in 1911. Yet the language, material culture, social organization, and key aspects of the ritual system are in their broadest outlines very similar to those of the core Maasai. Away from Samburu District, Samburu are most often assimilated (by other Kenyans, by tourists, and even by themselves and many core Maasai) into the broader ethnic identity of "Maasai."

3. That is, it is a possession that is too imbued with meaning to exchange or give away permanently but that may be used to validate certain important transactions (see Weiner 1992: 33–40).

4. A term coined by Jacques Maquet (1986: 69) to describe those foci of cultural practice that embody a strong aesthetic component.

5. I have twice accompanied groups of U.S. college students to Samburu district. Virtually every male student on those trips, where bonding with Samburu males is encouraged in an effort to help students participate in the culture, came away with some version of a spear.

6. David Brown has pointed out to me that it would be misleading to suggest that the Maasai and Samburu do not "incorporate and process the outer world" like everyone else (personal communication, 1993). Instead, Samburu and Maasai behavioral norms for warriors place a high value on an unflinching composure in all situations, which spectators then interpret as imperviousness.

7. The two categories actually overlap in that some of the more expensive postcard representations of Maasai and Samburu are in fact reproductions of art-book photographs by Carol Beckwith (*Maasai,* 1980), Angela Fisher (*Africa Adorned,* 1984), Mohamed Amin (*Last of the Maasai,* 1987), and others.

8. The most popular innovation has been the beaded watchstrap cover, which warriors began making for themselves, to decorate the wristwatches they bought with their newly acquired cash.

6. AUTHENTICITY, REPETITION, AND THE AESTHETICS OF SERIALITY

1. Benjamin's essay, "Das Kunstwerk im Zeitalter seiner technischen Reproduzierbarkeit," was originally published in *Zeitschrift für Sozialforschung* (vol. 5, no. 1, 1936) and in French translation as "L'oeuvre d'art à l'époque de sa reproduction mécanisée." Benjamin wrote a revised version of the essay that was published only posthumously in 1955—Walter Benjamin, *Schriften,* edited by Gretel and Theodor Adorno (Frankfurt: Suhrkamp, 1955). It is the second essay that was translated into English by Harry Zohn and published in *Illuminations* (New York: Schocken Books, 1969). My comments on Benjamin's essay are taken from my reading of the English translation, as well as from Joel Snyder's (1989) commentaries, which also rely on the earlier French and German versions (cf. Buck-Morss 1977: 286).

2. This passage on the "withering" of the aura remains highly problematic in the overall interpretation of Benjamin's essay. "If Benjamin's concept of aura is vague and problem-ridden, the notion of its *withering* (his term is *verk ümmern,* literally to

become stunted, to languish) and its ultimate destruction as a consequence of reproduction is nowhere explicated" (Knizek 1993: 360).

3. I use the term "tourist art" in this essay as a shorthand for objects of art and souvenirs made specifically for export to foreigner consumers. Other essays in this volume, including the introduction, address the history and semantics of the term "tourist art" more critically, pointing out its complexities and shortcomings. My first-hand observations of African tourist art are based on eighteen months of field research in the art markets of Côte d'Ivoire from 1987 to 1991.

4. Hartmann Schedel, *Registrum huius operis libri cronicarum cum figuris et ymaginibus ab inicio mundi* (Nuremberg: Anthonius Koberger, 1493).

5. Printed by H. M. Gousha, a division of Simon and Schuster, Paramount Communications Company, 1989.

6. Crowley's review of Graburn's volume, however, goes on to praise the book, noting that "it is required reading for anyone seriously interested in the relationship between culture and the creation of art" (1977: 8). For an excellent overview of general attitudes toward "tourist art" in Africa before the publication of Graburn's book, see especially Bascom 1976.

7. The artworks are also surrounded by prominently displayed book titles—*African Art, Luba, Afro-American Arts of the Suriname Rain Forest,* etc.—which serve, I suggest, in an almost subliminal way to authenticate the objects that decorate the room.

8. Fieldnotes, Abidjan, Côte d'Ivoire, January 29, 1988.

9. Also see Duerden 1968, Leiris and Delange 1968, Meauzé 1968, Wassing 1970, Gillon 1979, and Meyer 1992.

10. Ben-Amos does not address the question of "redundancy" in exactly the same way that I propose here, but she does mention "standardization" as one of the elements that pidgin languages and tourist arts have in common. For the artist, standardization "establishes guidelines for production; in other words it tells him how to go about carving specific forms in a situation in which he is attempting to establish a repertoire of meaningful items" (Ben-Amos 1977: 130). For the purchaser, on the other hand, standardization helps guide a selection of objects: "In a well stocked showroom, such as is common in large workshops, creative individuality would be chaotic for the person entering the new situation (faced with an unfamiliar code) and standardization minimizes his choice by giving him a set of formal and easily observable guidelines (size, subject matter) to operate with" (130).

11. Repetition in language also functions to minimize the discomforts of an encounter with the unknown: "One of the things repetition might in general be doing is forestalling events or situations that people are afraid of, like silence or ambiguity or chaos or sense of formlessness. Repetition can be a very basic ordering principle that is reassuring" (Johnstone et al. 1994: 10).

12. Such masks are referred to by traders in Côte d'Ivoire as "*masques Kenya*" (see Steiner 1994). The reference to a country in East Africa supports the process of iconographic deterritorialization and calls attention to the pan-African qualities of such figures. Similar beaded masks and statues also make their way *to* Kenya, where they are sold alongside Kamba, Samburu, and Maasai goods (see Kasfir 1996: 154–55).

13. On the notion of a *re*discovery of African art in the history of New York City exhibitions, see Steiner 1996b.

7. NORTHWEST COAST TOTEM POLES

A good deal of the research upon which this essay is based was compiled by Aaron Glass, my research associate, with whom I am working on a book about the cultural biography of totem poles. I am indebted to Bill Holm, Steve Brown, Candy Waugaman, Zena Pearlstone, Kate Duncan, John Vilette, and Dinah Larsen for the information they provided about totem poles. I also greatly appreciate the careful reading of this paper by my colleagues Janet Catherine Berlo and Ruth Phillips.

 1. See Swanton 1905 for an account of this pole's meaning. Shortly after the pole came to Seattle, the city had to pay the Tlingit for it (Higginson 1908: 79–80).

 2. The pole standing today in Pioneer Square is a replica of the original.

 3. Seventeen miles north of Ketchikan is Totem Bight State Historical Park, which has additional CCC totem poles as well as a clan house complete with an attached pole. In Wrangell, the Indian CCC restored the facade of Chief Shakes's house as well as its several poles.

 4. My thanks to Kate Duncan for generously providing the information about the Olde Curiosity Shop.

8. MASTER, MACHINE, AND MEANING

I wish to thank Erica Claus and K. Muthusamy Velar for their assistance in assembling the collections and information on which this essay is based, and also Dr. Daniel Smith for many collegial exchanges of material and for his enthusiasm. My research in India was supported by the Shastri Indo-Canadian Institute and the Social Sciences and Humanities Research Council of Canada.

9. ELIZABETH HICKOX AND KARUK BASKETRY

 1. Fields (1985) reviews Lower Klamath weaving techniques, materials, and forms.

 2. Works of Elizabeth's daughter, Louise Hickox, not as well documented, are treated elsewhere (Cohodas 1997).

 3. The Phoebe A. Hearst Museum of Anthropology at the University of California, Berkeley, now holds this ledger.

 4. Grace Nicholson Papers, box 14 (Huntington Library, San Marino, Calif.).

 5. Although first published in 1925, the manuscript was completed in 1917.

 6. This would include not only popular literature, such as women's and craft magazines, but also the anthropological literature produced by the Smithsonian Institution and the Bureau of American Ethnology.

 7. See also Washburn's (1984) discussion of museum basketry and Jonaitis's (1992) discussion of model Haida houses and totem poles carved by Charles Edenshaw.

 8. These consisted of baskets collected by Kroeber for the University of California Museum, those from the California Academy of Science collection destroyed in the 1906 San Francisco earthquake, and those photographed in the Hoopa Valley by Pliny Earle Goddard for his 1903–4 publication.

9. O'Neale notebook 7, p. 17 (Bancroft Library, University of California at Berkeley).

10. Diary entry of July 18, 1908, Grace Nicholson Papers, box 16 (Huntington Library, San Marino, Calif.).

11. O'Neale alluded to tensions arising from this social distance, writing of Hickox that "her work is seen in the district too seldom to call forth detailed comments. Were she in active competition with other local weavers, there would have been a good deal said of her divergence from traditional forms" (1932: 175).

10. THREADS OF TRADITION, THREADS OF INVENTION: BATAK

Field research for this article was conducted in North Sumatra in 1986 under the auspices of LIPI and with the sponsorship of Universitas HKBP Nommensen in Medan, North Sumatra. Funding for the research was generously provided by WOTRO-ZWO of the Netherlands. In 1990, a return visit was made possible by a Canadian SSHRCC grant (1989) and a Killam Post-Doctoral Fellowship (1988–1990) from the University of Alberta. An earlier version of this essay was read at the Textile Society of America conference in 1990 and published in the proceedings of that conference (Niessen 1990). I am grateful to Marlene Cox-Bishop, Anne Lambert, and Ruth Phillips for their comments on earlier drafts of this essay.

1. One effect of the focus on "traditional" and "authentic" textiles has been the avid collection of the older textiles in the Batak region. The area is now considered "cleaned out" of these textiles. Although the loss of textile specimens does not directly affect the weaving tradition, the loss of the range of designs does impoverish the cultural store of the textile heritage. The weavers have fewer and fewer design templates to refer to and to "read" technically in the making of new textiles.

11. DRAWING (UPON) THE PAST: INUIT GRAPHIC ARTS

1. The indigenous peoples of the Canadian Arctic refer to themselves as Inuit. In Alaska, two distinct ethnic designations, Yup'ik and Inupiaq, are preferred to the general term Eskimo.

2. The other principal arts in the Canadian Arctic are sculpture and textiles. Carving, however, has been a somewhat more individual and entrepreneurial activity than drawing and printmaking. An individual carver may market his art directly to a patron, through a co-op, or, until recently, through the Hudson's Bay Company. For this reason, it is more difficult to document trends about subject matter and individual artistic oeuvres. For a discussion of contemporary carvings that move beyond both the traditional style and marketing system, see Wight 1991.

3. See Blodgett 1991 for a history of the West Baffin Co-op and a detailed analysis of the transformation of drawings to prints.

4. While some have criticized the council for maintaining a bland sameness to the look of Inuit prints, its role was to champion high-quality works marketed as "fine art" and to enforce copyright laws.

5. The co-op at Holman, a community of about 350 people, maintains an archive of more than four thousand drawings done since the early 1960s, which I examined

on a trip to the Arctic in the summer of 1991. The small drawing archive belonging to the Baker Lake co-op was destroyed by fire in the late 1970s.

6. The staff has begun an ambitious program of shows and publications that draw on this rich resource (see Blodgett 1991; Blodgett and Gustavison 1993).

7. Out of some four thousand drawings, fewer than twenty depict the art of drawing.

8. See also drawings labeled CD.32.1936, 2423, 3279, 3332, 3410, and 3997 at the Cape Dorset archive at the McMichael Canadian Art Collection.

9. Most Arctic communities have had satellite televisions since the 1980s. Inuit children are more familiar today with Ninja turtles than they are with traditional Inuit tales of warfare and shamanic transformation.

10. *Inuit Art Quarterly* 8(4). See also the work of Ovilu Tunnillie (Leroux, Jackson, and Freeman 1994: 229, 235).

11. See, for example, in the Cape Dorset archive at the McMichael, drawings CD.32.2862, 3067, 3243, and 4058.

12. See Freeman 1983 and Eber 1971. The recent exhibit and catalog by Leroux, Jackson, and Freeman (1994) is the first ambitious attempt to undertake such a project.

13. For broader discussions of this phenomenon, see Fienup-Riordan 1990 and Brody 1987.

12. GENDER AND SEXUALITY IN MANGBETU ART

1. From an unpublished note found in the archives at the Frobenius Institute, Frankfurt.

2. Data from Lang throughout this essay are drawn from his fieldnotes (1909–14), housed in the Department of Anthropology Archives at the American Museum of Natural History, New York.

3. For related discussions, see E. Edwards 1992, Graham-Brown 1988, and Kolodny 1978.

4. These collections can be found in, among other places, the Museo Luigi Pigorini in Rome, the Merseyside Museum in Liverpool, and the Ethnographic Museums in Leningrad and Vienna.

5. Schweinfurth also wrote that women did wood carving, a fact that was never confirmed.

13. DEFINING LAKOTA TOURIST ART, 1880–1915

This research was supported by grants from the M. Graham Netting Research Fund of the Carnegie Museum of Natural History. Charles Hansen, director of the Museum of the Fur Trade, Chadron, Nebraska, shared generously of his knowledge and experience about Plains trading posts.

1. The one art form that was clearly developed for sale to the Western market is the ledger drawing, particularly as produced by the Southern Plains warriors imprisoned at Fort Marion, Florida. Several authors address the development of ledger art (see Berlo 1985, 1996; Peterson 1971; Greene 1992; Szabo 1988, 1993, 1994). Two

essays (by Walton and Ewers) discuss the Blackfeet arts market developed by the Great Northern Railway at Glacier National Park beginning in 1910 (Walton, Ewers, and Hassrick 1985: 10–45).

2. The girl's dress (#15767) and the shirt (#15790) were collected by Ed. E. Ayer. A baby carrier (#15751), also given by Ayer to the Field Museum, may have been made by the same maker.

3. The Mohonk Lodge catalog (Kincaide 1933) from Colony, Oklahoma, was an exception. However, the Mohonk did no trading among the Lakota.

4. Two of these shirts are owned by the Carnegie Museum of Natural History (#23102–16844 and #8743–2, which is missing). The third is at the Plains Indian Museum, Buffalo Bill Historical Center in Cody, Wyoming. There are likely more in other collections.

5. "Redmen Lodges" refers to the improved Order of Red Men, a white men's secret society founded in 1834 and based on "aboriginal American traditions and customs." By 1921, the Redmen had a membership of more than one-half million throughout the United States (A. Schmidt 1980: 287).

14. STUDIO AND SOIRÉE: CHINESE TEXTILES

1. "Mlle Maria Leontine, International Dancer, presents 'The Mystery of the Chinese Maiden' and Ceremonial Dances of China in Authentic Antique Costumes," c. 1935, publicity brochure in the possession of the author.

2. These are in the possession of Edward Brennan's heirs, and the correspondence pertaining to them is with the author.

3. "Mlle Maria Leontine."

4. Manuscript letter in the Ipswich Museum, Ipswich, Suffolk, England; typescript in the possession of the author.

5. For a wide variety of illustrations of souvenirs, see Pollig 1987.

6. Oral evidence from present owners who, time and again, say this is how their dragon robes were obtained.

7. Harry More-Gordon, *Bed of Roses,* watercolor from the collection of Mr. and Mrs. J. E. H. Wolff, in the Scottish Gallery, Edinburgh.

15. THE INDIAN FASHION SHOW

1. These and other issues will be fully explored in my forthcoming study on the Indian Fashion Show.

2. A few pieces designed specifically for the show were added during the early 1950s.

3. Along with Irene Emery, Douglas was *the* expert on Indian clothing in this period.

4. Douglas felt that slide presentations were inadequate to convey the beauty of an art form. He used original materials whenever possible. He also felt that art was made to be used, not to sit on museum shelves. The use of attire was unusual for the period, especially for such an extended time away from the museum. Douglas eliminated from consideration ensembles that would have been damaged through use.

Contemporary conservators, trained with greater sensitivity to the preservation and care of ethnographic materials, would not allow the materials to be used in such a presentation today.

5. The quotations in this section are from the promotional flyer and guide written by Douglas and sent to prospective hosts. It can be found in the files of the Denver Art Museum.

6. Frederic Douglas to Eula Murphy, February 2, 1942, Denver Art Museum files.

7. Douglas's comments in this section come from his presentation scripts and production notes (1951, 1952), from an interview in *The Arizonian* (1953), and from Douglas (n.d.), Denver Art Museum files.

8. Mamie Heard to Frederic Douglas, October 1, 1942, Denver Art Museum files.

9. Frederic Douglas to Katherine Bartlett, March 3, 1942, Denver Art Museum files.

10. The designs were said to be based on Navajo attire but were really a mixture of Indian, nineteenth-century Anglo-American, and Spanish design and garment cut.

11. Frederic Douglas to Mary Chapman, July 8, 1942, Denver Art Museum files.

12. Ibid.

16. TOURISM AND TASTE CULTURES: ALASKA

I thankfully acknowledge the Bancroft Fellowship, University of California, Berkeley, and the Winterthur Program in American Studies for their support of this research. I am grateful also to Nelson H. H. Graburn, Kesler E. Woodward, and an anonymous reviewer for insightful comments on earlier drafts of this essay.

1. This analysis bears out studies of modern tourists that have described typologically similar subgroups (Graburn 1989a; Smith 1989).

2. This group corresponds to Valene Smith's category of incipient mass tourists (1989: 13): tourists to Alaska went north in a steady stream and were sheltered from the lack of amenities there by the tourism infrastructure (e.g., shipboard accommodations).

3. The increase in value is the result of the process that Michael Thompson (1979) has aptly dubbed "rubbish theory." Over time, as the result of increasing rarity, souvenirs, following a cycle applicable to many cultural artifacts, were reclassified from the relatively insignificant category of souvenirs (Thompson's "rubbish") to the more rarefied category of "antique" and thus became collectible.

4. These buyers correspond to the group Valene Smith has called Elite-Explorer tourists (1989: 12).

5. Even so, George Wharton James, the most famous turn-of-the-century Indian basket collector, was a man. James was the author of numerous books and articles about baskets (e.g., James 1901, 1903b) and edited *The Basket: The Journal of the Basket Fraternity*, a periodical published in 1903 and 1904. According to Michael Thompson (1979), women often control cultural domains that have no prestige, but once a domain becomes prestigious or lucrative, it is frequently taken over by men. This seems to have been the case with Indian basket collecting, which had been growing in popularity for some two decades before James began publishing, but thereafter became his undisputed province.

17. TOURISM IS OVERRATED: PUEBLO POTTERY

For encouragement and assistance, I would like to thank Cordelia Snow; Sandy Jaramillo and Al Regensberg of the New Mexico State Records Center and Archives (NMSRCA); Orlando Romero of the Museum of New Mexico History Library (MN-MHL); and Arthur Olivas and Richard Rudisill of the Museum of New Mexico Photo Archives (MNMPA). Staff members at many other libraries and archives nationwide also provided generous assistance.

1. "Pueblo," uppercased, refers to the people or is used as part of the proper name of a community; lowercased it refers generally to a Pueblo town.

2. "Field-Notes on Pottery-Makers of San Ildefonso and Cochiti—1948," Kenneth M. Chapman (KMC) collection, School of American Research. They sold their pots to Candelario and Juan Olivas.

3. Pueblo Indians used cash for some purchases and taxes starting in Spanish colonial times. Leavened breads became part of the Pueblo diet in the eighteenth century or earlier (Batkin 1987a: 23–24). Flour sacks, metal pans and pails, wooden crates, lanterns, and other commercial items are plainly evident in historical photos of Pueblo homes and storerooms.

4. Sarah Goldie to KMC, no date; and KMC to Sarah Goldie, November 7, 1927, KMC collection, School of American Research.

5. Aaron's arrival in 1855 was documented in the *Santa Fe Weekly Democrat,* January 6, 1881, NMSRCA; other dates are deduced from various evidence.

6. *United States v. Aaron Gold,* Selling Liquor to Indians, Terr. of New Mexico Supreme Court Case #79, Exp. 8, NMSRCA.

7. For Aaron's licenses in Territorial Archives of New Mexico (TANM), see reels 51 and 52, NMSRCA.

8. The first train arrived February 9, 1880 (*Weekly New Mexican,* February 14, 1880). The February 27 issue of the daily was the first after a two-year hiatus; weekly papers for the period 1878–1880 lack ads for the Provision House.

9. It has been assumed that Bandelier met Jake, but Jake did not have a business at that time (Bandelier 1966: 72–73).

10. Account of Mrs. Hayes in *Santa Fe Weekly Democrat,* January 6, 1881, NMSRCA. The pottery she purchased, now at the Rutherford B. Hayes Presidential Center in Fremont, Ohio, includes effigy vessels and other shapes from Cochiti, San Ildefonso, Tesuque, and Zuni.

11. Fisher arrived in Santa Fe in 1877 or 1878 (*Santa Fe Weekly Democrat,* January 6, 1881, NMSRCA). Business licenses can be found only for his wife; Territorial Auditor, TANM reel 51, frame 784, NMSRCA.

12. *Santa Fe Daily New Mexican,* March 10, 1880, MNMHL.

13. Fisher moved to San Francisco Street, a few doors east of Jake Gold, around February 1, 1883; he left Santa Fe in or before 1886 (*Santa Fe Daily New Mexican,* March 2, 1883, MNMHL; Santa Fe County Deeds Y: 437, Santa Fe County Courthouse [SFCC]).

14. Lease in Santa Fe County Deeds R2: 111–113, SFCC. A sketch of the rooms on the lease can be matched to the 1883 Sanborn map.

15. Bandelier purchased things from Gold and from Charles H. Marsh, a taxidermist who also sold curios (Bandelier 1966: 330, 360).

16. Ads from January 13 to March 27, 1883, identify Jake as manager; but starting June 6, 1883, as proprietor. The paper was not printed from March 27 to June 6. Jake may have taken this space earlier: McKenney's directory identifies Aaron only as a saloonkeeper (1882: 339).

17. Sanborn maps are often called "fire maps" or "insurance maps."

18. National Archives, Rocky Mountain Region, Denver, Record Group 21, Records of the District Courts of U.S. New Mexico Territory; and Santa Fe District Court Records, NMSRCA.

19. JSC Collection (JSCC), Box 85, Business Correspondence (BC) 1901, MNMHL.

20. Candelario's license in the name of his wife, September 1901, Territorial Auditor, TANM Reel 51, NMSRCA. Gold took inventory December 29, 1901, JSCC, S-22, #6f, MNMHL.

21. Santa Fe County Contracts B: 393–395, NMSRCA. Jake and his wife lost the store through foreclosure, and in 1901 after changing hands at least once, it was purchased by Abe Gold's wife, Mary. Abe established his first retail curio business there named "Gold's Old Curiosity Shop and Free Museum," which George Dorsey described (1903: 22). Abe died in 1903, and the business changed hands several more times.

22. They parted ways because Gold was losing his mental faculties because of complications of syphilis. They still corresponded, but Gold was committed to the Territorial Insane Asylum, where he died in December 1905. Gold to Candelario, December 11, 1903, JSCC, Box 85, BC 1903, MNMHL. Gold's obituary, December 20, 1905, *Santa Fe New Mexican,* MNMHL.

23. Doyle (1968) claims Gold managed Candelario's store starting in 1885; this and many other statements in that article are incorrect.

24. Candelario's shop was a few doors east of the site of Gold's Free Museum and coincidentally was once occupied by Louis Fisher.

25. GHP to JSC, JSCC, Box 92, BC 1908, MNMHL.

26. JSC's death certificate indicates he worked until 1936. See Batkin 1987a: 201 n. 48 for pots with the abbreviation CTCM on them.

27. JSCC, MNMHL.

28. Bandelier made a painting of the drum, now in the Vatican Library (Bandelier 1969: 111; 1970: 152–53).

29. H. W. Wyman to JSC, JSCC, Box 85, BC, 1904, MNMHL. This order probably was not filled, not because Candelario could not do it, but because Wyman, through further correspondence, proved unreliable.

30. From comments made in *Western Echoes,* it appears this was not Tammen's first catalog.

31. Indian Novelty Co. to JSC, JSCC Box 91, BC 1908, MNMHL.

32. FEL to JSC, BC 1904, MNMHL.

33. Cited courtesy of Special Collections, New Mexico State University, Las Cruces.

34. Ads for Lester and others appear in the *Philatelic West,* October 1904; ads for Lester, Tammen, and many other dealers appear in issues of the *Ladies' Home Journal* the same year.

35. H. L. Lindquist to JSC, JSCC Box 91, BC 1908, MNMHL.

36. The flyer was printed by the *Estancia News,* Estancia, New Mexico. P. A. Speckman to JSC, January 29, 1905, JSCC, Box 86, BC, 1905, MNMHL.

37. Superintendent of Chilocco Agricultural School to Winfield S. Olive, January 8, 1906. Chilocco Indian School, Store, September 1903–June 1906, Oklahoma Historical Society Archives. E. K. Miller to JSC, JSCC, Boxes 88, 90, BC 1906–1907, MNMHL.

38. Alice Hubbard to O. H. Lipps, December 13, 1906, Chilocco Indian School, Print Shop, October 5, 1905–February 27, 1906, Oklahoma Historical Society Archives.

39. Various dealers, JSCC, BC 1904–1905, MNMHL.

18. INDIAN VILLAGES AND ENTERTAINMENTS

This essay is based on a joint research project with Ruth Phillips. The support of a Getty Senior Research Grant and a Social Sciences and Humanities Research Grant are gratefully acknowledged. I would also like to thank the McComber family and the Kanien'kehaka Raotitiohkwa Cultural Centre in Kahnawake, Quebec, for their generosity in facilitating research on the Poking Fire village and on the production of beadwork in Kahnawake.

1. Leo Diabo is a contemporary beadworker and silversmith in the community. He was interviewed by the author.

2. Indian "villages" are also part of summer fairs and exhibitions such as the internationally famous Calgary Stampede, where participants compete for "best tipi" in the village.

3. A service medal awarded to an Iroquois who participated in this campaign is in the Oronhyatekha collection at the Royal Ontario Museum (Cumberland 1904: 83–84).

4. The confrontation was initiated when the non-Native community of Oka sought to extend their golf course onto lands claimed by the Mohawk people of Kanesatake. The "Oka crisis" was widely reported by the news media. An analysis of the crisis and its historical and political contexts is provided by Grabowski (1991).

5. In 1807 Heriot described the staging of ceremonial dances: "We assembled together in the evening a number of males and females of the village, who repeatedly performed their several dances, descriptive of their manner of going to war" (quoted in R. Phillips 1984: 53).

6. A series of postcards from Earl's Court in the possession of the author shows basket making by "White Fawn (Abenaki)"; "Deepsky and Mrs. Scarface (Iroquois) grinding corn"; "Iroquois Chief Scarface" in Woodlands-style dress, shading his eyes and looking into the distance; and the "War Dance of Chief Akwirranoron."

7. The files of the Indian Affairs Department in the National Archives of Canada contain dozens of letters from Indians requesting permits to sell "wares of their own making" across the dominion without having to buy municipal peddler's licenses. One such letter, from 1911, is in an envelope bearing the picture of Chief White Cloud, from Caughnawaga (Kahnawake), who advertised himself as a medicine man.

8. James Deer and his brother John formed "The Famous Deer Brothers, Champion Indian Trick Riders of the World," which performed, sometimes with larger Wild West shows, during the 1890s (Nicks and Phillips 1995).

9. The description of the village and staged events is based on interviews with people in Kahnawake, photographs in the collections of the Kanien'kehaka Raoti-

tiohkwa Cultural Centre, and old postcards that were still for sale at the Poking Fire village in 1991 or collected elsewhere by the author.

10. For related debates over the associations of Kateri Tekawitha to traditional Iroquois beliefs, see Koppedrayer 1993 and Blanchard 1982.

11. Even the widow of Professor Montgomery expressed disappointment that he had not received a Plains-style headdress rather than the less showy and less well recognized *gastoweh*.

12. This discussion is based on interviews in Kahnawake in January 1991.

13. See British Parliamentary Papers, *Canada,* vol. 3, 1834; and British Parliamentary Papers, *Canada,* vol. 12, 1839.

14. In an interview on January 30, 1991, Robin Delaronde stated that she had taken up beadworking "because I take a real interest in the culture and I noticed this stuff is . . . dying out, so I wanted to try it." In an interview on March 14, 1996, Robin noted that she had access to old Kahnawake patterns through her boyfriend's family.

15. In one interview a woman stated that as a child she had been left home when her grandmother went to sell beadwork (including hers) at the Ottawa Fair because she was blond and, therefore, did not look "Indian" enough to meet the expectations of potential customers.

16. This exhibition was mounted at the Woodland Cultural Centre in Brantford, Ontario, in 1988; it was later remounted in collaboration with the Royal Ontario Museum and toured in Canada from 1993 to 1995.

17. At the opening of an exhibition at the Bata Shoe Museum in Toronto in February 1993, the bull whip demonstration was performed by Red Cloud, Jr. Jim Skye and his dancers have appeared across North America, in Europe, and in South America.

19. ART, TOURISM, AND CULTURAL REVIVAL IN THE MARQUESAS ISLANDS

The research for this essay was made possible by two grants from the American Council of Learned Societies and by financial support from Washington State University. I would also like to express my *ka'ohas* to Debora Kimitete, Bob Suggs, Karen Stevenson, Rose Corser, and Robin Wright. Any errors are mine.

1. See Greg Dening's *Islands and Beaches* (1980) for a moving history of the Marquesas.

2. Most books and catalogs on Pacific and Polynesian art include illustrations of these. See, for example, Wardwell 1967, 1994. In nearly ten years of research in more than sixty-five museums, I have documented some 2,500 Marquesan objects. The largest number of these are clubs, the second largest stilt steps.

3. See Ivory 1990, 1993 for a fuller discussion.

4. Bowls are, in fact, relatively numerous in museum collections, with some 135 recorded to date. Even more numerous are ear ornaments, stilt steps, and clubs from the early-contact period.

5. Ground transportation is available for about US $30 one way. The trip is a hair-raising two- to three-hour, sixty-kilometer ride on precarious mountain roads.

6. They also have significant political implications; see Moulin (1994).

EPILOGUE: ETHNIC AND TOURIST ARTS REVISITED

1. Among those unable to accept the invitation for the 1970 AAA meeting were Richard Beardsley, Barry Craig, Ulli Beier, Edmund Carpenter, William Davenport, Warren D'Azevedo, Johannes Fabian, Adrian Gerbrands, Marija Gimbutas, Henry Glassie, Erna Gunther, Karl Heider, Bill Holm, Michael Owen Jones, Adrienne Kaeppler, Phillip Lewis, Philip McKean, Charlotte Otten, Roy Seiber, Dorothy Jean Ray, and Robert Farris Thompson.

2. The term "World Art System," which parallels Howard Becker's "Art Worlds" (1982), was first suggested to me by Berkeley graduate student Sarah Murray (cited in Graburn 1989b: 1), whose research focuses on the contemporary national arts of Indonesia.

3. An extreme case of overstepping the line occurred when a former Berkeley graduate student, Wendy Rose, a Hopi-Maidu artist and poet, wrote a term paper on the constraints facing Native American artists, basing her observations on discussions with friends in the Native American art world. As a result of engaging in this very revealing research, she was dropped by her agent in New York.

4. Lee's work here focuses on the nonprofessional consumers, unlike most anthropological accounts, which have examined collecting for resale to museums or directly for museums. Her classification is a representation of their motivations at the time of travel to Alaska, for, as we know, some of these collectors sold most of their acquisitions after they got back and, eventually, almost all of these collections were sold on the art market or donated to museums.

5. Though there are various and somewhat arbitrary cut-off dates for the authenticity of, say, African arts (e.g., pre-1940 or pre-1900), I have heard art historian Dennis Duerden proclaim in a public lecture at Berkeley that no authentic art had come out of Africa for four hundred years—that is, since the beginning of European contact and colonialism.

6. During my research among the Canadian Inuit over the past thirty-five years, I have noted the use of the suffix *-tuinak* to indicate that something is ordinary, typical, and hence genuine—for example, *umiatuinak* is a "real" (i.e., skin) boat, not an imported canoe, wooden whaleboat, or ship. However, the suffix is only used as a marker for what should be the "unmarked" category, when something new or different is available for comparison. Thus an *inutuinak* is a "real or ordinary person"— that is, an Eskimo, not a white person (*qallunak*) or an Indian (*irqillik*). The Inuit have always lived near Cree Indians, but I have no way of knowing how such a morpheme was used before canoes, whaleboats, ships, or white people arrived.

REFERENCES

Abramson, J. A. 1976. "Style and Change in an Upper Sepik Contact Situation." In Nelson H. H. Graburn, ed., *Ethnic and Tourist Arts: Cultural Expressions from the Fourth World*, pp. 249–65. Berkeley: University of California Press.

Abu-Lughod, Lila. 1991. "Writing against Culture." In Richard G. Fox, ed., *Recapturing Anthropology: Working in the Present*, pp. 137–62. Santa Fe, N.Mex.: School of American Research Advanced Seminar Series.

Adam, Tassilo. 1919. *Tentoonstelling van Bataksche Kunstvoorwerpen.* Batavia: Nederlandich-Indische Kunstkriry.

Adams, Kathleen M. 1995. "Making-Up the Toraja? The Appropriation of Tourism, Anthropology, and Museums for Politics in Upland Sulawesi, Indonesia." *Ethnology* 34: 143–53.

Adams, Marie Jeanne. 1971. "Work Patterns and Symbolic Structures in a Village Culture, East Sumba, Indonesia." *Southeast Asia* 1: 321–28.

Aguilera, Emiliano M. 1948. *Los trajes, populares de España: Vistos por los pintores españoles.* Barcelona: Ediciones Omega.

À la Vielle Russie. 1993. *Alexandre Iacovleff, Paintings and Drawings. Catalogue of an Exhibition.* New York: Didier Aaron.

Aldrich, Robert. 1990. *The French Presence in the South Pacific, 1842–1940.* Honolulu: University of Hawaii Press.

Alldridge, Thomas J. 1910. *A Transformed Colony: Sierra Leone as It Was, and as It Is, Its Progress, Peoples, Native Customs and Undeveloped Wealth.* London: Seeley.

Allmon, Charles. 1950. "Shores and Sails in the South Seas." *National Geographic* 47(1): 73–104.

Alloula, Malek. 1986. *The Colonial Harem.* Minneapolis: University of Minnesota Press.

Alpers, Svetlana. 1988. *Rembrandt's Enterprise: The Studio and the Market.* Chicago: University of Chicago Press.

Alsop, Joseph. 1982. *The Rare Art Traditions: The History of Art Collecting and Its Linked Phenomena Wherever These Have Appeared.* New York: Harper and Row.

Amadio, Nadine, et al. 1986. *The Life and Work of an Australian Painter.* S. Melbourne, Australia: Macmillan.

Ames, Michael. 1993. *Cannibal Tours and Glass Boxes: The Anthropology of Museums.* Vancouver, B.C.: University of British Columbia Press.

Amin, Mohamed, and Duncan Willetts. 1987. *The Last of the Maasai.* London: Bodley Head.

Anderson, Richard L. 1979. *Art in Primitive Societies.* Englewood Cliffs, N.J.: Prentice Hall.

————. 1989. *Art in Small-Scale Societies.* Englewood Cliffs, N.J.: Prentice Hall.

————. 1990. *Calliope's Sister: A Comparative Study of Philosophies of Art.* Englewood Cliffs, N.J.: Prentice Hall.

Anderson, Richard L., and Karen Field, eds. 1993. *Art in Small-Scale Societies: Contemporary Readings.* Englewood Cliffs, N.J.: Prentice Hall.

Anton-Warrior, H. 1987. *Indische Farbdrucke im Besitz des Hamburgischen Museums für Völkerkunde.* Mitteilungen aus dem Museum für Völkerkunde. Hamburg neue Folge 16: 105–48.

Apfel, Iris Barrel. 1992. *Dragon Threads: Court Costumes of the Celestial Kingdom, Chinese Textiles from the Iris Barrel Apfel and ATTATA Foundation Collections, Newark Museum.* Newark, N.J.: Newark Museum.

Appadurai, Arjun. 1986a. "Introduction: Commodities and the Politics of Value." In Arjun Appadurai, ed., *The Social Life of Things: Commodities in Cultural Perspective,* pp. 3–63. Cambridge: Cambridge University Press.

————, ed. 1986b. *The Social Life of Things: Commodities in Cultural Perspective.* Cambridge: Cambridge University Press.

Appasamy, Jaya. 1980. *Tanjavur Painting of the Maratha Period.* New Delhi: Abhinav.

Applegate, Roberta. N.d. "Indian Fashions Display Good Style, Color." *Miami Herald* [1954?].

Arima, Eugene. 1983. "The West Coast People: The Nootka of Vancouver Island." *British Columbia Museum Special Publication* 6.

The Arizonian. 1953. "No Squaw Dresses at This Fashion Show." *The Arizonian* 27 (March): 6.

Arthur, James. 1906. "Let's Have a Den." *Countryside Magazine and Suburban Life* 3: 273–74.

Aspelin, Paul L. 1977. "The Anthropological Analysis of Tourism: Indirect Tourism and the Political Economy of the Mamainde of Mato Grosso, Brazil." *Annals of Tourism Research* 4(3): 135–60.

Ayre, John. 1993. "Carving Is Healing to Me: An Interview with Manasie Akpaliapik." *Inuit Art Quarterly* 8(4): 34–42.

Babb, Lawrence A. 1981. "Glancing: Visual Interaction in Hinduism." *Journal of Anthropological Research* 37: 387–401.

Babcock, Barbara A. 1986. "Pueblo Clowning and Pueblo Clay: From Icon to Caricature in Cochiti Figurative Ceramics, 1875–1900." *Visible Religion* 4: 280–300.

————. 1990. "'A New Mexican Rebecca': Imaging Pueblo Women." *Journal of the Southwest* 32(4): 400–437. Special issue, "Inventing the Southwest," edited by Joseph Carleton Wilder.

————. 1993. "Bearers of Value, Vessels of Desire: The Reproduction of the Reproduction of Pueblo Culture." *Museum Anthropology* 17(3): 43–58.

————. 1995. "Marketing Maria: The Tribal Artist in the Age of Mechanical Repro-

duction." In Brenda Jo Bright and Liza Bakewell, eds., *Looking High and Low: Art and Cultural Identity,* pp. 124–50. Tucson: University of Arizona Press.

Babcock, Barbara A., Guy Monthan, and Doris Monthan. 1986. *The Pueblo Storyteller: Development of a Figurative Ceramic Tradition.* Tucson: University of Arizona Press.

Baird, Donald. 1965. "Tlingit Treasures: How an Important Collection Came to Princeton." *Daily Princetonian* (Princeton, N.J.), February 16: 6–11, 17.

Bakhtin, Mikhail. 1984. *Rabelais and His World.* Bloomington: Indiana University Press.

Bandelier, Adolph F. 1892. "The 'Montezuma' of the Pueblo Indians." *American Anthropologist* 5(4): 319–26.

———. 1966. *The Southwestern Journals of Adolph F. Bandelier, 1880–1882.* Charles H. Lange and Carroll L. Riley, eds. Albuquerque: University of New Mexico Press; Santa Fe: School of American Research and Museum of New Mexico Press.

———. 1969. *A History of the Southwest. A Study of the Civilization and Conversion of the Indians in Southwestern United States and Northwestern Mexico from the Earliest Times to 1700. Volume I: A Catalogue of the Bandelier Collection in the Vatican Library.* Ernest J. Burrus, S.J., ed. Rome, Italy: Jesuit Historical Institute.

———. 1970. *The Southwestern Journals of Adolph F. Bandelier, 1883–1884.* Charles H. Lange and Carroll L. Riley, eds. Albuquerque: University of New Mexico Press.

Barbash, Ilisa, and Lucien Taylor. 1992. *In and Out of Africa.* VHS, 59 min. Based on original research by Christopher B. Steiner. Los Angeles: Center for Visual Anthropology, University of Southern California.

Barbeau, Marius. 1930. "Totem Poles of the Gitksan." *Anthropological Series 12. National Museum of Canada Bulletin* 61.

———. 1943. *Saintes Artisanes: 1. Les Brodeuses,* Montreal: Cahiers d'Art Arca, II.

Barkan, Elazar, and Ronald Bush, eds. 1995. *Prehistories of the Future: The Primitivist Project and the Culture of Modernism.* Stanford: Stanford University Press.

Barlow, Kathleen, Lissent Bolton, and David Lipset. 1987. *Trade and Society in Transition along the Sepik Coast.* Sydney: Australian Museum.

Barnard, Nicholas. 1991. *Living with Folk Art: Ethnic Styles from around the World.* Boston: Little, Brown.

Barten, W. H. 1904–24. Barten's Activities as Wild West Show Contractor for the Sioux Indians at Pine Ridge Agency. 1904–24 Papers. (Ms 406). Ms. on file, Lincoln: Nebraska State Historical Society Archives.

Bascom, William. 1976. "Changing African Art." In Nelson H. H. Graburn, ed., *Ethnic and Tourist Arts: Cultural Expressions from the Fourth World,* pp. 303–19. Berkeley: University of California Press.

Basham, A. L. 1977. "Introduction." In Vassilis G. Vitsaxis, *Hindu Epics, Myths and Legends in Popular Illustrations,* pp. ix–x. Delhi, India: Oxford University Press.

Bates, Craig, and Martha J. Lee. 1990. *Tradition and Innovation: A Basket History of the Indians of the Yosemite–Mono Lake Area.* Yosemite National Park, Calif.: Yosemite Association.

Bateson, Gregory. 1946. "Arts of the South Seas." *Art Bulletin* 28: 119–23.

———. 1958. *Naven: A Survey of the Problems Suggested by a Composite Picture of the Culture of a New Guinea Tribe Drawn from Three Points of View.* 2d rev. ed. London: Wildwood. Originally published in 1936.

Batkin, Jonathan. 1987a. *Pottery of the Pueblos of New Mexico, 1700–1940.* Colorado Springs, Colo.: Taylor Museum of the Colorado Springs Fine Arts Center.

———. 1987b. "Martina Vigil and Florentino Montoya: Master Potters of San Ildefonso and Cochiti Pueblos." *American Indian Art Magazine* 12(4): 28–37.

Batten, Charles L., Jr. 1978. *Pleasurable Instruction: Form and Convention in Eighteenth-Century Travel Literature.* Berkeley: University of California Press.

Batty, J. D. 1963. *Namatjira, Wanderer between Two Worlds.* Melbourne, Australia: Hodder and Stoughton.

Baudrillard, Jean. 1968. *Le Système des objets.* Paris: Editions Gallimard.

Beauvais, Johnny. 1985. *Kahnawake.* Kahnawake: Khanata Industries.

Becker, Howard S. 1982. *Art Worlds.* Berkeley: University of California Press.

Beckwith, Carol. See Saitoti, Tepilit Ole.

Ben-Amos, Paula Girschick. 1971. "Social Change in the Organization of Wood Carving in Benin City, Nigeria." Ph.D. diss., Indiana University, Bloomington.

———. 1976. "'À la Recherche du Temps Perdu': On Being an Ebony-Carver in Benin." In Nelson H. H. Graburn, ed., *Ethnic and Tourist Arts: Cultural Expressions from the Fourth World,* pp. 320–33. Berkeley: University of California Press.

———. 1977. "Pidgin Languages and Tourist Arts." *Studies in the Anthropology of Visual Communication* 4(2): 128–39.

Benham Indian Trading Company. 1905a. *Swastika Indian Jewelry.* Albuquerque, N.Mex.: Benham Indian Trading Company.

———. 1905b. *A Starter for an Indian Corner.* Albuquerque, N.Mex.: Benham Indian Trading Company.

Benjamin, Walter. 1969a. "Unpacking My Library: A Talk about Book Collecting." In *Illuminations,* ed. and intro. Hannah Arendt, trans. Harry Zohn, pp. 59–67. New York: Schocken.

———. 1969b. "The Work of Art in the Age of Mechanical Reproduction." In *Illuminations,* ed. and intro. Hannah Arendt, trans. Harry Zohn, pp. 217–51. New York: Schocken.

Berger, John. 1976. *Ways of Seeing.* London: BBC and Penguin Books.

Berkhofer, Robert F., Jr. 1978. *The White Man's Indian: Images of the American Indian from Columbus to the Present.* New York: Alfred A. Knopf.

Berlo, Janet Catherine. 1983. "Wo-Haw's Notebooks: 19th Century Kiowa Indian Drawings in the Collections of the Missouri Historical Society." *Gateway Heritage: Journal of the Missouri Historical Society* 3(2): 2–13.

———. 1984. *Teotihuacan Art Abroad: A Study of Metropolitan Style and Provincial Transformation in Incensario Workshops.* Oxford: British Archaeological Reports, International Series.

———. 1985. "Wo-Haw, A Kiowa Artist at Fort Marion, Florida." *Phoebus 4: A Journal of Art History.* Tempe: Arizona State University.

———. 1989. "Inuit Women and Graphic Arts: Female Creativity and Its Cultural Context." *Canadian Journal of Native Studies* 9(2): 293–315.

———. 1990a. "Portraits of Dispossession in Inuit and Plains Graphic Arts." *Art Journal* 49(2): 15–26.

———. 1990b. "The Power of the Pencil: Inuit Women in the Graphic Arts." *Inuit Art Quarterly* 5(1): 16–26.

———. 1993. "Autobiographical Impulses and Female Identity in the Drawings of Napachie Pootoogook." *Inuit Art Quarterly* 8(4): 4–12.

————. 1996. *Plains Indian Drawings 1865–1935: Pages from a Visual History.* New York: Harry N. Abrams and American Federation of Arts.

Bharati, A. 1963. "Pilgrimage in the Indian Tradition." *History of Religions* 3: 136–67.

Bird, Junius. 1960. "Suggestions for the Recording of Data on Spinning and Weaving and the Collecting of Material." *Kroeber Anthropological Society Papers* 22: 1–9.

Birkett, Dea. 1989. *Spinsters Abroad: Victorian Lady Explorers.* Oxford: Basil Blackwell.

Birnbaum, Martin. 1939. "The Long-Headed Mangbetus." *Natural History* 43: 73–83.

Blackburn, Stuart H. 1988. *Singing of Birth and Death.* Philadelphia: University of Pennsylvania Press.

Blair, Emma H., ed. 1911. *The Indian Tribes of the Upper Mississippi Valley and Region of the Great Lakes, as Described by Nicolas Perrot, French Royal Commissioner to Canada; Morrell Marston, American Army Officer; and Thomas Forsyth, United States Agent at Fort Armstrong.* 2 vols. Cleveland, Ohio: Arthur H. Clark.

Blanchard, David. 1982. "' . . . To the Other Side of the Sky': Catholicism at Kahnawake, 1667–1700." *Anthropologica* 24: 77–102.

————. 1984. "For Your Entertainment Pleasure—Princess White Deer and Chief Running Deer—Last 'Hereditary' Chief of the Mohawk: Northern Mohawk Rodeos and Showmanship." *Journal of Canadian Culture* 1(2): 99–116.

Blier, Suzanne Preston. 1989. "Art Systems and Semiotics: The Question of Art, Craft, and Colonial Taxonomies in Africa." *American Journal of Semiotics* 6(1): 7–18.

Blixen, Karen (Isak Dinesen). 1966. *Out of Africa.* London: Jonathan Cape. Originally published in 1937.

Bloch, Maurice. 1974. "Symbols, Song, Dance, and Features of Articulation: Is Religion an Extreme Form of Traditional Authority?" *European Journal of Sociology* 15: 55–98.

Blodgett, Jean. 1983. *Grasp Tight the Old Ways.* Toronto: Art Gallery of Ontario.

————. 1985. *Kenojuak.* Toronto: Firefly Books.

————. 1991. *In Cape Dorset We Do It This Way: Three Decades of Inuit Printmaking.* Kleinburg, Ontario: McMichael Canadian Art Collection.

Blodgett, Jean, and Marie Bouchard. 1986. *Jessie Oonark: A Retrospective.* Winnipeg: Winnipeg Art Gallery.

Blodgett, Jean, and Susan Gustavison. 1993. *Strange Scenes: Early Cape Dorset Drawings.* Kleinburg, Ontario: McMichael Canadian Art Collection.

Bol, Marsha Clift. 1993. "Lakota Beaded Costume of the Early Reservation Era." In Janet Catherine Berlo and Lee Anne Wilson, eds., *Arts of Africa, Oceania, and the Americas: Selected Readings,* pp. 363–70. Englewood Cliffs, N.J.: Prentice Hall.

Boniface, Priscilla, and Peter Fowler. 1993. *Heritage and Tourism in the "Global Village."* New York: Routledge.

Borden, Courtney Louise. 1928. *The Cruise of the Northern Light: Explorations and Hunting in the Alaskan and Siberian Arctic.* New York: Macmillan.

Borel, France. 1994. *The Splendor of Ethnic Jewelry from the Colette and Jean-Pierre Ghysels Collection.* New York: Harry N. Abrams.

Boris, Eileen. 1986. *Art and Labor: Ruskin, Morris and the Craftsman Ideal in America.* Philadelphia: Temple University Press.

Bourdieu, Pierre. 1984. *Distinction: A Social Critique of the Judgement of Taste.* Trans.

Richard Nice. Cambridge, Mass.: Harvard University Press. Originally published in French in 1979.

Bourke, John Gregory. 1935. "Bourke on the Southwest, VII." Lansing Bloom, ed., *New Mexico Historical Review* 10(4): 271–322.

———. 1936. "Bourke on the Southwest, X." Lansing Bloom, ed. *New Mexico Historical Review* 11(3): 217–82.

Bowden, Ross. 1983. *Yena: Art and Ceremony in a Sepik Society.* Oxford: Pitt Rivers Museum.

Boyd, David J. 1985. "The Commercialization of Ritual in the Eastern Highlands of Papua New Guinea." *Man,* n.s., 20: 325–40.

Brevoort, Elias. 1874. *New Mexico. Her Natural Resources and Attractions. . . .* Santa Fe, N.Mex.: Elias Brevoort.

Brewer, John, and Roy Porter, eds. 1993. *Consumption and the World of Goods.* New York: Routledge.

Brody, Hugh. 1987. *Living Arctic.* London: Faber and Faber.

Brody, J. J. 1976. "The Creative Consumer: Survival, Revival, and Invention in Southwest Indian Arts." In Nelson H. H. Graburn, ed., *Ethnic and Tourist Arts: Cultural Expressions from the Fourth World,* pp. 70–84. Berkeley: University of California Press.

———. 1990. *Beauty from the Earth: Pueblo Indian Pottery from the University Museum of Archaeology and Anthropology.* Philadelphia: University Museum.

Bronner, Simon G. 1989. *Consuming Visions: Accumulation and Display of Goods in America, 1880–1920.* New York: W. W. Norton.

Brown, Clara Spalding. 1898. "The Art of Indian Basketry." *Catholic World* 68: 52–59.

Bruner, Edward M. 1991. "Transformation of Self in Tourism." *Annals of Tourism Research* 18: 238–50.

———. 1994. "Abraham Lincoln as Authentic Reproduction: A Critique of Postmodernism." *American Anthropologist* 96(2): 397–415.

Bruner, Edward M., and Barbara Kirshenblatt-Gimblett. 1994. "Maasai on the Lawn: Tourist Realism in East Africa." *Cultural Anthropology* 9: 435–70.

Buck-Morss, Susan. 1977. *The Origin of Negative Dialectics.* New York: Free Press.

Bugbee, Anna M. 1893. "The Thlinkets of Alaska." *Overland Monthly* 22: 185–96.

Butler, Sheila. 1976. "The First Printmaking Year at Baker Lake." *The Beaver* (Spring): 17–26.

———. 1995. "Baker Lake Revisited." *C Magazine* 45: 22–33.

Buzard, James. 1993. *The Beaten Track: European Tourism, Literature, and the Ways to "Culture," 1800–1918.* Oxford: Clarendon Press.

Cameron, Roderick. 1955. *Equator Farm.* London: Heinemann.

Candelario, J. S. 1905. *If the Corners Do Not Contain What You Desire, Select from This List and Write Me. The Old . . . Curio Store. . . .* Santa Fe, N.Mex.

Carpenter, Edmund. 1972. *Oh, What a Blow That Phantom Gave Me!* New York: Holt, Rinehart and Winston.

———. 1973. *Eskimo Realities.* New York: Holt, Rinehart and Winston.

Centre Georges Pompidou. 1989. *Magiciens de la terre.* Paris: Centre Georges Pompidou.

Chadwick, Edward Marion (Shagotyohgwisaks). 1897. *The People of the Longhouse.* Toronto: Church of England Publishing Company.

Chaitanya, Krishna. 1960. *Ravi Varma.* Delhi, India: Lalit Kala Akademi.

Chapman, S. D. 1972. *The Cotton Industry in the Industrial Revolution.* London: Macmillan.

Chapman, William Ryan. 1985. "Arranging Ethnology: A.H.S.F. Pitt Rivers and the Typological Tradition." In George W. Stocking, Jr., ed., *Objects and Others: Essays on Museums and Material Culture,* pp. 15–48. History of Anthropology 3. Madison: University of Wisconsin Press.

Clifford, James. 1985. "Histories of the Tribal and the Modern." *Art in America* 73(4): 164–77, 215. Reprinted in *The Predicament of Culture,* pp. 189–214. Cambridge, Mass.: Harvard University Press, 1988.

———. 1987. "Of Other Peoples: Beyond the 'Salvage Paradigm.'" In Hal Foster, ed., *Discussions in Contemporary Culture* 1, pp. 121–30. Seattle, Wash.: Bay Press.

———. 1988. *The Predicament of Culture: Twentieth-Century Ethnography, Literature, and Art.* Cambridge, Mass.: Harvard University Press.

———. 1992. "Traveling Cultures." In Lawrence Grossberg, Gary Nelson, and Paula Treichler, eds., *Cultural Studies,* pp. 96–116. New York: Routledge. Reprinted in James Clifford, *Routes: Travel and Translation in the Late Twentieth Century,* pp. 17–46. Cambridge, Mass.: Harvard University Press, 1997.

———. 1997. *Routes: Travel and Translation in the Late Twentieth Century.* Cambridge, Mass.: Harvard University Press.

Clunas, Craig. 1984. *Chinese Export Watercolours.* Far Eastern Series. London: Victoria and Albert Museum.

———. 1987. "Introduction." In Craig Clunas, ed., *Chinese Export Art and Design,* pp. 12–21. London: Victoria and Albert Museum.

———. 1989. "Chinese Art and Chinese Artists in France, 1924–1925." *Arts Asiatique* 44: 100–106.

Cockloft, Jeremy. 1960. *Cursory Observations Made in Quebec Province of Lower Canada in the Year 1811.* Toronto: Oxford University Press.

Cody, William F. 1887. Manuscript 58. Newspaper cuttings 1887. Lincoln: Nebraska State Historical Society Archives.

Cohen, Erik. 1982. "The Pacific Islands from Utopian Myth to Consumer Product: The Disenchantment of Paradise." *Cahiers du Tourisme,* Ser. B, No. 27.

———. 1983. "The Dynamics of Commercialized Arts: The Meo and Yao of Northern Thailand." *Journal of the National Research Council of Thailand* 15(1), 19/3, pt. 2: 1–34.

———. 1988. "Authenticity and Commoditization in Tourism." *Annals of Tourism Research* 15: 371–86.

Cohodas, Marvin. 1979. *Degikup: Washoe Fancy Basketry, 1895–1935.* Vancouver: Fine Arts Gallery, University of British Columbia.

———. 1986. "Washoe Innovators and Their Patrons." In Edwin L. Wade, ed., *The Arts of the North American Indian: Native Traditions in Evolution,* pp. 203–20. New York: Hudson Hills Press.

———. 1992. "Louisa Keyser and the Cohns: Mythmaking and Basket Making in the American West." In Janet Catherine Berlo, ed., *The Early Years of Native American Art History: The Politics of Scholarship and Collecting,* pp. 88–133. Seattle: University of Washington Press.

———. In press. *High on the Rivers: The Hickoxes of Somes Bar and Constructions of the California Basket Curio.* Tucson: University of Arizona Press; Los Angeles: The Southwest Museum.

Cole, Douglas. 1982. "Tricks of the Trade: Northwest Coast Artifact Collecting, 1875–1925." *Canadian Historical Review* 63(4): 439–60.

———. 1985. *Captured Heritage: The Scramble for Northwest Coast Artifacts.* Seattle: University of Washington Press.

Collingwood, R. G. 1925. *Outlines of a Philosophy of Art.* London: Oxford University Press.

———. 1938. *The Principles of Art.* London: Oxford University Press.

Collis, Septima. 1890. *A Woman's Trip to Alaska: Being an Account of a Voyage Through the Inland Seas of the Sitkan Archipelago in 1890.* New York: Cassell.

Connor, J. Torrey. 1896. "Confessions of a Basket Collector." *The Land of Sunshine* 5(1): 3–10.

Coote, Jeremy, and Anthony Shelton, eds. 1992. *Anthropology, Art and Aesthetics.* Oxford Studies in the Anthropology of Cultural Forms. Oxford: Clarendon Press.

Counts, David R. 1979. "Adam Smith in the Garden: Supply, Demand, and Art Production in New Britain." In Sidney M. Mead, ed., *Exploring the Visual Arts of Oceania,* pp. 335–41. Honolulu: University of Hawaii Press.

Crick, Malcolm. 1989. "Representations of International Tourism in the Social Sciences: Sun, Sex, Sights, Savings, and Servility." *Annual Review of Anthropology* 18: 307–44.

Crowley, Daniel J. 1977. Review of *Ethnic and Tourist Arts: Cultural Expressions from the Fourth World,* Nelson H. H. Graburn, ed. *African Arts* 10(4): 8.

———. 1985. "The Art Market in Southern Oceania." *African Arts* 18: 68–74.

Csikszentmihalyi, Mihaly, and Eugene Rochberg-Halton. 1981. *The Meaning of Things: Domestic Symbols and the Self.* Cambridge: Cambridge University Press.

Cumberland, F. Barlow. 1904. *The Oronhyatekha Historical Collection.* Toronto: Independent Order of Foresters.

Dampierre, Eric de. 1992. *Harpes Zande.* Paris: Klincksieke.

Danto, Arthur, R. M. Gramly, Mary Lou Hultgren, Enid Schildkrout, and Jeanne Zeidler. 1988. *ART/artifact: African Art in Anthropology Collections.* New York: Center for African Art and Prestel Verlag.

Darling, David, and Douglas Cole. 1980. "Totem Pole Restoration on the Skeena, 1925–30: An Early Exercise in Heritage Conservation." *BC Studies* 47: 29–48.

Davis, Fred. 1992. *Fashion, Culture and Identity.* Chicago: University of Chicago Press.

Davis, Virginia. 1988. "The Mexican Jaspe (Ikat) Rebozo: Comments on Its History, Significance and Prevalence." In *Textiles as Primary Sources, Proceedings of the First Symposium of the Textile Society of America 1,* pp. 117–21. Washington, D.C.: Textile Society of America.

Davis, W. W. H. 1938. *El Gringo, or New Mexico & Her People.* Santa Fe, N.Mex.: Rydal Press. Originally published in 1857.

Dawson, Lawrence E., Vera-Mae Fredrickson, and Nelson H. H. Graburn. 1974. *Traditions in Transition: Culture Contact and Material Change.* Berkeley, Calif.: Lowie Museum of Anthropology.

Deloria, Vine, Jr. 1981. "The Indians." In *Buffalo Bill and the Wild West,* pp. 45–56. Brooklyn, N.Y.: Brooklyn Museum.

Dening, Greg. 1980. *Islands and Beaches: Discourse on a Silent Land; Marquesas, 1774–1880.* Carlton, Vic.: Melbourne University Press.

Dennis, James T. 1895. *On the Shores of an Island Sea: Travels in Alaska.* Philadelphia: Lippincott.

Denver Art Museum. 1981. *Secret Splendors of the Chinese Court: Qing Dynasty Costume from the Charlotte Hill Grant Collection*. Denver, Colo.: Denver Art Museum.

Denver Post. 1950. "Indian Style Show at Loretto." *Denver Post*, March 25.

Devine, E. J., S.J. 1922. *Historic Caughnawaga*. Montreal: Messenger Press.

Dickason, Olive Patricia. 1984. *The Myth of the Savage, and the Beginnings of French Colonialism in the Americas*. Edmonton: University of Alberta Press.

Diehl, C. G. R. 1956. *Instrument and Purpose: Studies on Rites and Rituals in South India*. Greerlup: Lund.

Diereville, Sieur de. 1933. *Relation of the Voyage to Port Royal in Acadia or New France*. Ed. John Clarence Webster. Toronto: Champlain Society.

Dillingham, Rick, with Melinda Elliott. 1992. *Acoma and Laguna Pottery*. Santa Fe, N.Mex.: School of American Research Press.

Dominguez, Virginia. 1986. "The Marketing of Heritage." *American Ethnologist* 13(3): 546–55.

———. 1992. "Invoking Culture: The Messy Side of Cultural Politics." *South Atlantic Quarterly* 91(1): 19–42.

Dongen, Kees van. 1990. *Van Dongen: le peintre, 1877–1968*. Paris: Musée d'Art Moderne de la Ville de Paris.

Dorsey, George. 1903. *Indians of the Southwest*. Chicago: Passenger Department, Atchison, Topeka and Santa Fe Railway System.

Douglas, Frederic H. N.d. Department of Indian Art. Flier describing collections and activities of the department, Denver Art Museum.

———. 1951. Program Notes and Script for "The Museum of Man, Indian Fashion Show" for September 24. On file in Denver Art Museum.

———. 1952. Program Notes and Script for Second Annual Tucson Festival. "One Hundred Years of Indian Fashions." April 16. On file in Denver Art Museum.

Douglas, Mary. 1966. *Purity and Danger: An Analysis of Concepts of Pollution and Taboo*. London: Routledge and Kegan Paul.

Douglas, Mary, and Baron Isherwood. 1979. *The World of Goods: Towards an Anthropology of Consumption*. New York: W. W. Norton. Rev. ed. published by Routledge, 1996.

Douglas, Ngaire. 1996. *They Came for Savages: 100 Years of Tourism in Melanesia*. Lismore, N.S.W.: Southern Cross University Press.

Doxtator, Deborah. 1988. *Fluffs and Feathers: An Exhibit on the Symbols of Indianness; A Resource Guide*. Brantford, Ontario: Woodland Cultural Centre.

Doyle, Gene F. 1968. "Candelario's Fabulous Curios." *Denver Westerners Monthly Roundup* 24(9): 3–13, 20.

Dozier, Thomas S. c. 1905. *About Indian Pottery*. Española, N.Mex.: Thomas S. Dozier.

Drucker, Philip. 1948. "The Antiquity of the Northwest Coast Totem Pole." *Journal of the Washington Academy of Sciences* 38: 389–97.

———. 1951. "The Northern and Central Nootkan Tribes." *Bureau of American Ethnology Bulletin* 144.

Duerden, Dennis. 1968. *African Art*. Colour Library of Art. Feltham, England: Hamlyn House.

Dunne, "Bee Bee." 1948. "Santa Fe's First Museum." *New Mexico* 26 (August): 11, 37, 39, 41.

Eber, Dorothy, ed. 1971. *Pitseolak: Pictures Out of My Life*. Seattle: University of Washington Press.

Eco, Umberto. 1979. *A Theory of Semiotics*. Bloomington: Indiana University Press.
———. 1984. *The Role of the Reader: Explorations in the Semiotics of Texts*. Bloomington: Indiana University Press. Originally published in 1979.
———. 1985. "Innovation and Repetition: Between Modern and Post-Modern Aesthetics." *Daedalus* 114(4): 161–84.
Edwards, Elizabeth, ed. 1992. *Anthropology and Photography 1860–1920*. New Haven: Yale University Press; London: The Royal Anthropological Institute.
Edwards, Michael M. 1967. *The Growth of the British Cotton Trade, 1780–1815*. New York: Augustus M. Kelly.
Emmons, George T. 1991. *The Tlingit Indians*. Ed. Frederica de Laguna. Seattle: University of Washington Press.
Empson, William. 1953. *Seven Types of Ambiguity*. London: Chatto and Windus.
Encyclopedia of World Art. 1959. 17 vols. New York: McGraw-Hill.
Errington, Frederick, and Deborah Gewertz. 1989. "Tourism and Anthropology in a Post-Modern World." *Oceania* 60: 37–54.
———. 1996. "The Individuation of Tradition in a Papua New Guinean Modernity." *American Anthropologist* 98: 114–26.
Errington, Shelly. 1994a. "What Became Authentic Primitive Art?" *Cultural Anthropology* 9(2): 201–26.
———. 1994b. "Unraveling Narratives." In Paul M. Taylor, ed., *Fragile Traditions: Indonesian Art in Jeopardy*, pp. 139–64. Honolulu: University of Hawaii Press.
Espinosa, Jose Manuel. 1942. *Crusaders of the Rio Grande: The Story of Don Diego de Vargas and the Reconquest and Refounding of New Mexico*. Chicago: Institute of Jesuit History.
Evans-Pritchard, Deirdre. 1989. "How 'They' See 'Us': Native American Images of Tourists." *Annals of Tourism Research* 16: 89–105.
Evans-Pritchard, E. E. 1960. "A Contribution to the Study of Zande Culture." *Africa* 30: 309–24.
———. 1963. "A Further Contribution to the Study of Zande Culture." *Africa* 33: 183–97.
———. 1965. "A Final Contribution to the Study of Zande Culture." *Africa* 35: 21–29.
Ewers, John C. 1964. "The Emergence of the Plains Indian as the Symbol of the North American Indian." *Smithsonian Institution Annual Report for 1964*, pp. 531–44, Pls. 1–18. Washington, D.C.: Smithsonian Institution.
Eyriaud des Vergnes, P. E. 1877. *L'archipel des Iles Marquises*. Paris: Berger-Levrault et Cie.
Fabian, Johannes. 1983. *Time and the Other: How Anthropology Makes Its Object*. New York: Columbia University Press.
Fagg, William. 1959. *Afro-Portuguese Ivories*. London: Batchworth Press.
———. 1965. *Tribes and Forms in African Art*. London: Methuen.
Faris, James C. 1988. "'ART/artifact': On the Museum and Anthropology." *Current Anthropology* 29(5): 775–79.
Farrell, Bryan H. 1979. "Tourism's Human Conflicts: Cases from the Pacific." *Annals of Tourism Research* 6: 122–36.
Fast, Edward G. 1871. *Catalogue of Alaskan Antiquities & Curiosities, now on Exhibition at the Clinton Hall Art Galleries, Astor Place & 8th Street*. New York: Leavitt Strebeigh.
Feder, Norman. 1965. *American Indian Art*. New York: Harry N. Abrams.
Feest, Christian F. 1980. *Native Arts of North America*. London: Thames and Hudson. Rev. ed. published in 1992.

Fields, Virginia, ed. 1985. *The Hover Collection of Karuk Baskets.* Eureka, Calif.: Clarke Memorial Museum.

Fienup-Riordan, Ann. 1990. *Eskimo Essays: Yup'ik Lives and How We See Them.* New Brunswick, N.J.: Rutgers University Press.

Fisher, Angela. 1984. *Africa Adorned.* New York: Harry N. Abrams.

Fiske, John. 1990. *Introduction to Communication Studies.* 2d ed. London: Routledge.

Flandrau, Grace. 1929. *Then I Saw the Congo.* New York: Harcourt, Brace.

Fleming, Kathleen. 1996. "Igloolik Video." *Inuit Art Quarterly* 11(1): 26–35.

Foreman, Carolyn Thomas. 1943. *Indians Abroad.* Norman: University of Oklahoma Press.

Forge, Anthony. 1966. "Art and Environment in the Sepik." *Proceedings of the Royal Anthropological Institute of Great Britain and Ireland for 1965,* pp. 23–31.

———. 1973. "Style and Meaning in Sepik Art." In Anthony Forge, ed., *Primitive Art and Society,* pp. 170–92. London: Oxford University Press.

Först, Dietmar. 1992. "We Germans Love Indians." *The Bulletin* 127: 35–37. Vermillion: Institute of American Indian Studies at the University of South Dakota.

Frank, Patrick. 1989. "Recasting Benjamin's Aura." *New Art Examiner* 16(7): 29–31.

Freeman, Minnie Aodla. 1983. "Living in Two Worlds." In Martina Jacobs and J. B. Richardson III, eds., *Arctic Life: Challenge to Survive,* pp. 195–201. Pittsburgh, Pa.: Carnegie Institution.

Frow, John. 1991. "Tourism and the Semiotics of Nostalgia." *October* 57: 123–51.

Gable, Eric, and Richard Handler. 1993. "Colonialist Anthropology at Colonial Williamsburg." *Museum Anthropology* 17(3): 26–31.

Gamper, Josef. 1985. "Reconstructed Ethnicity: Comments on MacCannell." *Annals of Tourism Research* 12: 250–53.

Gans, Herbert. 1966. "Popular Culture in America: Social Problem in a Mass Society or Social Asset in a Pluralist Society?" In Howard S. Becker, ed., *Social Problems: A Modern Approach,* pp. 549–65. New York: Wiley.

———. 1974. *Popular Culture and High Culture: An Analysis and Evaluation of Taste.* New York: Basic Books.

Geary, Christraud. 1998. "Nineteenth-Century Images of the Mangbetu in Explorers' Accounts." In Enid Schildkrout and Curtis A. Keim, eds., *The Scramble for Art in Central Africa,* pp. 133–68. Cambridge: Cambridge University Press.

Gerbrands, Adrian A. 1957. *Art as an Element of Culture, especially in Negro-Africa.* Mededlingen van het Rijksmuseum voor Volkerkunde, no. 12. Leiden: Brill.

Gerrish, Theodore. N.d. *Life in the World's Wonderland: A Graphic Description of the Great Northwest.* Biddeford, Maine: Press of the Biddeford Journal.

Gewertz, Deborah. 1983. *Sepik River Societies: A Historical Ethnography of the Chambri and Their Neighbors.* New Haven, Conn.: Yale University Press.

Gewertz, Deborah, and Frederick Errington. 1991. *Twisted Histories, Altered Contexts: Representing the Chambri in a World System.* Cambridge: Cambridge University Press.

Gill, Robert R. 1976. "Ceramic Arts and Acculturation at Laguna." In Nelson H. H. Graburn, ed., *Ethnic and Tourist Arts: Cultural Expressions from the Fourth World,* pp. 102–13. Berkeley: University of California Press.

Gillon, Werner. 1979. *Collecting African Art.* London: Studio Vista.

Gittinger, Mattiebelle. 1979. *Splendid Symbols: Textiles and Tradition in Indonesia.* Washington, D.C.: Textile Museum.

Goddard, Pliny Earle. 1903–4. "Life and Culture of the Hupa." *University of California Publications in American Archaeology and Ethnology* 1(1): 1–88.

Godsell, Patricia, ed. 1975. *The Diary of Jane Ellice.* [Toronto]: Oberon Press.

Goetz, Helga. 1977. *The Inuit Print.* Ottawa: National Museum of Man.

———. 1993. "Inuit Art: A History of Government Involvement." In Gerald McMaster, ed., *In the Shadow of the Sun: Perspectives on Contemporary Native Art,* pp. 357–81. Hull, Quebec: Canadian Museum of Civilization.

Gold, Jake. c. 1887. *Gold's Free Museum.* Santa Fe, N.Mex.

———. 1889. *Established 1862. Catalogue of Gold's Free Museum and Old Curiosity Shop, Santa Fe, N.M. Wholesale and Retail.* Santa Fe, N.Mex.

Goldwater, Robert J. 1967. *Primitivism in Modern Art.* New York: Vintage. Originally published in 1938.

Gombrich, E. H. 1950. *The Story of Art.* London: Phaidon.

———. 1960. *Art and Illusion: A Study in the Psychology of Pictorial Representation.* Bollingen Series 35. Princeton, N.J.: Princeton University Press.

Goodfellow, John C. 1923. *The Totem Poles in Stanley Park.* Vancouver: Art, Historical, and Scientific Association of Vancouver, B.C.

Gordon, Beverly. 1984. "The Niagara Falls Whimsey: The Object as a Symbol of Cultural Interface." Ph.D. diss., University of Wisconsin, Madison.

———. 1986. "The Souvenir: Messenger of the Extraordinary." *Journal of Popular Culture* 20(3): 135–47.

———. 1988. *American Indian Art: The Collecting Experience,* with Melanie Herzog. Madison, Wisc.: Elvejem Museum of Art.

Grabowski, Jan. 1991. "Mohawk Crisis at Kanesatake and Kahnawake." *European Review of Native American Studies* 5(1): 11–14.

Graburn, Nelson H. H. 1960. "The Social Organization of an Eskimo Community: Sugluk, P.Q." Master's thesis, McGill University.

———. 1963a. *Lake Harbour N.W.T.: The Decline of an Eskimo Community.* NCRC 63–2. Ottawa: Northern Co-ordination and Research Centre, Dept. of Northern Affairs and National Resources.

———. 1963b. "Taqagmiut Eskimo Kinship Terminology." Ph.D. diss., University of Chicago.

———. 1964. *Taqagmiut Eskimo Kinship Terminology.* NCRC 64–1. Ottawa: Northern Co-ordination and Research Centre, Dept. of Northern Affairs and National Resources.

———. 1966a. "Mixed Communities." In M. van Steensel, ed., *People of Light and Dark,* pp. 120–28. Ottawa: Queen's Printer.

———. 1966b. "Eskimo Soapstone Carving: Innovation and Acculturation." Paper delivered at the annual meeting of the American Anthropological Association, Pittsburgh, Pa.

———. 1967. "The Eskimos and 'Airport Art,' " *Transaction* 4: 28–33.

———. 1968. "How the Eskimos Went Commercial." *New Society* (London).

———. 1969a. *Eskimos without Igloos: Social and Economic Development in Sugluk.* Boston: Little, Brown.

———. 1969b. "Art and Acculturative Processes." *International Social Science Journal* (UNESCO, Paris) 21(3): 457–68.

———. 1969c. "Art as a Mediating Mechanism in Acculturative Processes." Paper de-

livered at the annual meeting of the American Anthropological Association, New Orleans.

———. 1970a. "The Eskimos and Commercial Art." In M. C. Albrecht, J. H. Grant, and M. Griff, eds., *The Sociology of Art and Literature*, pp. 33–34. New York: Praeger.

———. 1970b. "Art and Pluralism in the Americas." *Anuario Indigenista* (Mexico City) 30: 191–204.

———. 1971. "A Program for Research on Art and Pluralism." Plenary Address at the annual meetings of the Kroeber Anthropological Society, Berkeley.

———. 1972. *Eskimos of Northern Canada*. 2 vols. New Haven, Conn.: Human Relations Area Files.

———. 1976a. "Introduction: The Arts of the Fourth World." In Nelson H. H. Graburn, ed., *Ethnic and Tourist Arts: Cultural Expressions from the Fourth World*, pp. 1–32. Berkeley: University of California Press.

———. 1976b. "Eskimo Art: The Eastern Canadian Arctic." In Nelson H. H. Graburn, ed., *Ethnic and Tourist Arts: Cultural Expressions from the Fourth World*, pp. 39–55. Berkeley: University of California Press.

———. 1978. "'I Like Things to Look More Different Than That Stuff Did': An Experiment in Cross-Cultural Art Appreciation." In Michael Greenhalgh and Vincent Megaw, eds., *Art in Society: Studies in Style, Culture and Aesthetics*, pp. 51–70. London: Duckworth.

———. 1984. "The Evolution of Tourist Arts." *Annals of Tourism Research* 11(3): 393–419.

———. 1987a. "Inuit Art and the Expression of Ethnic Identity." *American Review of Canadian Studies* 17(1): 47–66.

———. 1987b. "Inuit Drawings: The Graphics behind the Graphics." In Marion Jackson and Judith Nasby, eds., *Contemporary Inuit Drawings*, pp. 21–29. Guelph, Ontario: MacDonald Stewart Art Centre.

———. 1989a. "Tourism: The Sacred Journey." In Valene L. Smith, ed., *Hosts and Guests: The Anthropology of Tourism*, pp. 21–36. 2d ed. Philadelphia: University of Pennsylvania Press. Originally published in 1977.

———. 1989b. "The Predicament of the Contemporary Ethnic Artist." Paper presented at the plenary session of the annual meeting of the German Ethnological Society, Marburg, Germany.

———. 1993a. "The Fourth World and Fourth World Art." In *In the Shadow of the Sun: Perspectives on Contemporary Native Art*, pp. 1–26. Mercury Series Paper 124. Ottawa: Canadian Museum of Civilization.

———. 1993b. "Arts of the Fourth World: The View from Canada." In Dorothea Whitten and Norman Whitten, eds., *Imagery and Creativity: Ethnoaesthetics and Art Worlds in the Americas*, pp. 171–204. Tucson: University of Arizona Press.

Graburn, Nelson H. H., ed. 1976. *Ethnic and Tourist Arts: Cultural Expressions from the Fourth World*. Berkeley: University of California Press.

Graburn, Nelson H. H., and Ellen Badone. 1983. Review of Robert Layton, *The Anthropology of Art* (New York, 1981). In *Royal Anthropological Institute Newsletter* 55: 11–12.

Graham-Brown, Sarah. 1988. *Images of Women: The Portrayal of Women in Photography of the Middle East, 1860–1950*. London: Quartet Books.

Green, Harvey. 1983. *The Light of the Home: An Intimate View of the Lives of Women in Victorian America*. New York: Pantheon Books.

Greene, Candace. 1992. "Artists in Blue: The Indian Scouts of Fort Reno and Fort Supply." *American Indian Art Magazine* 18(1): 50–57.

Grosse, Ernest. 1928. *The Beginnings of Art*. New York: D. Appleton. Originally published in 1897.

Guerin, Leon. 1900. "The Hurons of Quebec." *Report of the British Association for the Advancement of Science*, London.

Gunn, S. W. A. 1965. *The Totem Poles in Stanley Park, Vancouver, B.C.* Vancouver: Whiterocks Publications.

Gutman, Judith M. 1982. *Through Indian Eyes*. New York: Oxford University Press and International Center of Photography.

Haddon, Alfred C. 1902. *Evolution in Art: As Illustrated by the Life-Histories of Designs*. New York: Walter Scott.

Hague, Libby. 1991. "Kleinburg North and Dorset South: A Working Model." *Inuit Art Quarterly* 6(4): 4–11.

Haigh, Jane G. 1986. *Alaska Pioneer Interiors: An Annotated Photographic File*. Alaska Historical Commission, Studies in History No. 137. Fairbanks, Alaska: Tanana-Yukon Historical Society.

Hall, Dinah. 1992. *Ethnic Interiors: Decorating with Natural Materials*. Photographs by James Merrell. New York: Rizzoli.

Hall, Michael D., and Eugene W. Metcalf, Jr., eds. 1994. *The Artist Outsider: Creativity and the Boundaries of Culture*. Washington, D.C.: Smithsonian Institution Press.

Halle, David. 1993a. "The Audience for 'Primitive' Art in Houses in the New York Region." *Art Bulletin* 75(3): 379–96.

———. 1993b. *Inside Culture: Art and Class in the American Home*. Chicago: University of Chicago Press.

Halliday, Jan. 1996. "Creek Culture." *Alaska Airlines Magazine*. February: 52–55.

Hamalian, Leo, ed. 1981. *Ladies on the Loose: Women Travelers of the 18th and 19th Centuries*. New York: Dodd, Mead.

Hammond, Dorothy, and Alta Jablow. 1992. *The Africa That Never Was: Four Centuries of British Writing about Africa*. Prospect Heights, N.J.: Waveland Press; orignally published in 1970; also published as *The Myth of Africa*. New York: Library of Social Sciences, 1977.

Handler, Richard. 1992. "On the Valuing of Museum Objects." *Museum Anthropology* 16(1): 21–28.

Handy, Willowdean. 1938. *L'art des Iles Marquises*. Paris: Editions d'Art et d'Histoire.

———. 1965. *Forever the Land of Men: An Account of a Visit to the Marquesas Islands*. New York: Dodd, Mead.

Hannon, Kerry. 1997. "Out of Africa: American Collectors Are Discovering the Wonder of Tribal Art." *U.S. News and World Report*, May 5: 71–73.

Harrison, Edward S. 1905. *Nome and the Seward Peninsula*. Seattle: E. S. Harrison.

Harrison, Simon. 1987. "Cultural Efflorescence and Political Evolution on the Sepik River." *American Ethnologist* 14: 491–507.

———. 1993. "The Commerce of Cultures in Melanesia." *Man*, n.s., 28: 139–58.

Hauser-Schaublin, Brigitta. 1983. "The Mai-Masks of the Iatmul, Papua New Guinea: Style, Carving, Process, Performance and Function." *Oral History* 11: 1–53.

Haynes, James B. 1910. *History of the Trans-Mississippi and International Exposition of 1898*. St. Louis, Mo.: Woodward and Tiernan Printing Co.

Helu-Thaman, Konai. 1993. "Beyond Hula, Hotels, and Handicrafts: A Pacific Islander's Perspective of Tourism Development." *The Contemporary Pacific* 5: 104–11.

Hendry, Joy. 1993. *Wrapping Culture: Politeness, Presentation and Power in Japan and Other Societies*. Oxford: Clarendon Press.

Henry, John F. 1984. *Early Maritime Artists of the Pacific Northwest Coast, 1741–1841*. Seattle: University of Washington Press.

Herman, Theodore. 1954. "An Analysis of China's Export Handicraft Industries to 1930." Ph.D. diss., University of Washington.

Herzog, Melanie. 1989. "Gathering Traditions: The Arts and Crafts Movement and the Revival of American Indian Basketry." Master's thesis, University of Wisconsin, Madison.

———. 1996. "Aesthetics and Meanings: The Arts and Crafts Movement and the Revival of American Indian Basketry." In Bert R. Denker, ed., *The Substance of Style: Perspectives on the American Arts and Crafts Movement*. Winterthur, Del.: Winterthur Museum.

Hevia, James L. 1993. "The Macartney Embassy in the History of Sino-Western Relations." In Robert A. Bickers, ed., *Ritual and Diplomacy: the Macartney Mission to China, 1792–1794*. Papers presented to the 1992 conference of the British Association for Chinese Studies marking the bicentenary of the Macartney Mission to China, pp. 57–79. London: Wellsweep.

———. 1994. "Loot's Fate: The Economy of Plunder and the Moral Life of Objects 'From the Summer Palace of the Emperor of China,'" *History and Anthropology* 6: 319–45.

Higginson, Ella. 1908. *Alaska: The Great Country*. New York: Macmillan.

Hiller, Susan, ed. 1991. *The Myth of Primitivism: Perspectives on Art*. London and New York: Routledge.

Hiltebeitel, Alf. 1988. *The Cult of Draupadi*. Chicago: University of Chicago Press.

Himmelheber, Hans. 1975. "Afrikanische Kunsthändler an der Elfenbeinküste." *Zeitschrift für Ethnologie* 100(1): 16–26.

Hinckley, Ted C. 1965. "The Inside Passage: A Popular Gilded Age Tour." *Pacific Northwest Quarterly* 56(2): 67–74.

Hinde, Sidney Langford, and Hildegarde Hinde. 1901. *The Last of the Masai*. London: Heinemann.

Hine, Thomas. 1996. "Notable Quotables: Why Images Become Icons." *New York Times*, Section 2 (Arts and Leisure), February 18: 1, 37.

Hjort, Anders. 1979. *Savanna Town: Rural Ties and Urban Opportunities in Northern Kenya*. Stockholm: Stockholm Studies in Social Anthropology.

Hobsbawm, Eric. 1983. "Introduction: Inventing Traditions." In Eric Hobsbawm and Terence Ranger, eds., *The Invention of Tradition*, pp. 1–14. Cambridge: Cambridge University Press.

Holm, Bill. 1983. *Smoky-Top: The Art and Times of Willie Seaweed*. Seattle: University of Washington Press.

———. 1988. "Artifaking." Paper presented at the University of California, Berkeley.

Holmes, W. H. 1889. "Debasement of Pueblo Art." *American Anthropologist* 2(4): 320.

Holmgren, Robert J., and Anita E. Spertus. 1989. *Early Indonesian Textiles from Three Island Cultures: Sumba, Toraja, Lampung.* New York: Metropolitan Museum of Art and Harry N. Abrams.

Hooper, Calvin L. 1881. Unpublished diary. California Academy of Sciences Archives, San Francisco.

Horner, Alice E. 1990. "The Assumption of Tradition: Creating, Collecting, and Conserving Cultural Artifacts in the Cameroon Grassfields (West Africa)." Ph.D. diss., University of California, Berkeley.

———. 1993a. "Personally Negotiated Authenticities in Cameroon Tourist Arts." Paper presented at International Seminar on "New Dimensions of Tourism Research." Osaka, Japan: National Museum of Ethnology.

———. 1993b. "Tourist Arts in Africa before Tourism." *Annals of Tourism Research* 20(1): 52–63.

House Beautiful. 1905. "The Cozy Corner: A Final Word." *House Beautiful* 19(1): 41–43.

Houston, James A. 1954. *Canadian Eskimo Art.* Ottawa: Queen's Printer.

Howe, Daniel Walker. 1976. "Victorian Culture in America." In Daniel Walker Howe, ed., *Victorian America,* pp. 3–28. Philadelphia: University of Pennsylvania Press.

Iacovleff, Alexandre. 1928. Dessins et peintures d'Afrique, exécutés au cours de l'expédition Citroën Centre Afrique. Deuxième mission Haardt, Audouin-Dubreuil.

Indian Print Shop. 1905. *Catalogue of real Navajo Blankets sold by the Indian Print Shop.* 1st ed. Chilocco, Okla.: Indian Print Shop.

———. 1907. *Navajo Blankets [and] other Indian handiwork, for distribution by the Indian Print Shop.* . . . Illustrated catalog. 2d ed. Chilocco, Okla.: Indian Print Shop.

Inglis, Stephen. 1984. "Creators and Consecrators: A Potter Community of South India." Ph.D. diss., University of British Columbia.

———. 1988. "Making and Breaking: Craft Communities in South Asia." In Michael W. Meister, ed., *Making Things in South Asia: The Role of the Artist and Craftsman,* pp. 153–64. Philadelphia: Department of South Asia Regional Studies, University of Pennsylvania.

———. 1995. "Suitable for Framing: The Work of a Modern Master." In Lawrence A. Babb and Susan S. Wadley, eds., *Media and the Transformation of Religion in South Asia,* pp. 51–75. Philadelphia: University of Pennsylvania Press.

Innes, Miranda. 1994. *Ethnic Style, from Mexico to the Mediterranean.* New York: Cross River Press.

Ivory, Carol. 1990. "Marquesan Art in the Early Contact Period: 1774–1821." Ph.D. diss., University of Washington.

———. 1993. "Re-Viewing Marquesan Art." In Philip J. C. Dark and Roger G. Rose, eds., *Artistic Heritage in a Changing Pacific,* pp. 63–73. Honolulu: University of Hawaii Press.

Jackson, Marion E. 1985. "Baker Lake Drawings: A Study in the Evolution of Artistic Self-Consciousness." Ph.D. diss., University of Michigan.

Jackson, Marion E., and Judith Nasby. 1987. *Contemporary Inuit Drawings.* Guelph, Ontario: Macdonald Stewart Art Centre.

Jackson, Nancy S. 1984. "Northwest Coast Basketry Collections and Collectors: Collections in the Thomas Burke Memorial Washington State Museum." Master's thesis, University of Washington.

Jackson, Sheldon. 1881. *Report of the Rev. Sheldon Jackson, D.D. Upon the Condition of Education in Alaska.* Washington, D.C.: U.S. Government Printing Office.

James, George Wharton. 1901. "Indian Basketry in House Decoration." *The Chautauquan: A Magazine for Self-Education* 33 (April–September): 619–24. Cleveland, Ohio: Chautauqua Press.

———. 1903a. "Indian Handicrafts." *Handicraft* 1(12): 269–87.

———. 1903b. *Indian Basket Weaving.* Los Angeles: Whedon and Spreng.

Jamet, Albert. 1939. *Les Annales de L'Hôtel-Dieu de Quebec, 1636–1716.* Quebec City: Hôtel-Dieu de Quebec. Reprinted in 1984.

Jasen, Patricia. 1993. "From Nature to Culture: The St. Lawrence River Panorama in Nineteenth Century Ontario Tourism." *Ontario History* 85(1): 43–63.

———. 1995. *Wild Things: Nature, Culture, and Tourism in Ontario, 1790–1914.* Toronto: University of Toronto Press.

Jennings, Judy. 1952. Judy Jennings Notebook. *Philadelphia Inquirer.* November 12.

Jensen, Robert. 1994. *Marketing Modernism in Fin-de-Siècle Europe.* Princeton, N.J.: Princeton University Press.

Johnstone, Barbara, et al. 1994. "Repetition in Discourse: A Dialogue." In Barbara Johnstone, ed., *Repetition in Discourse: Interdisciplinary Perspectives,* pp. 1–20. Norwood, N.J.: Ablex.

Jonaitis, Aldona. 1986. *Art of the Northern Tlingit.* Seattle: University of Washington Press.

———. 1988. *From the Land of the Totem Poles: The Northwest Coast Indian Art Collection at the American Museum of Natural History.* Seattle: University of Washington Press.

———. 1989. "Totem Poles and the Indian New Deal." *Canadian Journal of Native Studies* 9: 237–52.

———. 1992. "Franz Boas, John Swanton, and the New Haida Sculpture at the American Museum of Natural History." In Janet Catherine Berlo, ed., *The Early Years of Native American Art History: The Politics of Scholarship and Collecting,* pp. 22–61. Seattle: University of Washington Press.

———. 1993. "Traders of Tradition: The History of Haida Art." In *Robert Davidson: Eagle of the Dawn,* pp. 3–23, 157–65. Vancouver: Vancouver Art Gallery in association with Douglas and McIntyre.

Jonaitis, Aldona, ed. 1995. *A Wealth of Thought: Franz Boas on Native American Art.* Seattle: University of Washington Press.

Jones, Owen. 1856. *The Grammar of Ornament.* London: Day and Son.

Jones, Suzi. 1986. "Native Art by Fiat and Other Dilemmas of Cross-Cultural Collecting." In John Michael Vlach and Simon J. Bronner, eds., *Folk Art and Art Worlds: Essays Drawn from the Washington Meeting on Folk Art,* pp. 243–66. Ann Arbor, Mich.: UMI Research Press.

Joustra, M. 1914. "De Weefschool te Lagoeboti." *Eigen Haard* 40: 66–67, 99.

Jules-Rosette, Bennetta. 1984. *The Messages of Tourist Art: An African Semiotic System in Comparative Perspective.* New York: Plenum Press.

———. 1990. "Simulations of Postmodernity: Images of Technology in African Tourist and Popular Art." *Visual Anthropology Review* 6(1): 29–37.

Kahn, Miriam. 1995. "Heterotopic Dissonance in the Museum Representation of Pacific Island Cultures." *American Anthropologist* 97: 324–38.

Karp, Ivan, and Steven D. Lavine, eds. 1991. *Exhibiting Cultures: The Poetics and Politics of Museum Display.* Washington, D.C.: Smithsonian Institution Press.

Kasfir, Sidney Littlefield. 1984. "One Tribe, One Style? Paradigms in the Historiography of African Art." *History in Africa* 11: 163–93.

———. 1992. "African Art and Authenticity: A Text with a Shadow." *African Arts* 25(3): 40–53, 96–97.

———. 1996. "African Art in a Suitcase: How Value Travels." *Transition* 6(1): 146–58.

Katzer, Bruce. 1972. "The Caughnawaga Mohawks: Occupations, Residence, and the Maintenance of Community Membership." Ph.D. diss., Department of Political Science, Columbia University.

Kaufmann, Christian. 1985. "Postscript: The Relationship between Sepik Art and Ethnology." In Suzanne Greub, ed., *Art of the Sepik, Papua New Guinea: Authority and Ornament,* pp. 33–47. Basel: Tribal Art Centre and Editions Greub.

Keim, Curtis A. 1979. "Precolonial Mangbetu Rule: Political and Economic Factors in Nineteenth-Century Mangbetu History (Northeast Zaire)." Ph.D. diss., Indiana University, Bloomington.

Keller, Janet D. 1988. "Woven World: Neotraditional Symbols of Unity in Vanuatu." *Mankind* 18: 1–13.

Kelm, Heinz. 1966. *Kunst vom Sepik. Vol. 1. Mittellauf.* Veröffentlichungen des Museums für Völkerkunde Berlin (n.s.) 10 (Abteilung Südsee 5).

Kent, Kate Peck. 1976. "Pueblo and Navajo Weaving Traditions and the Western World." In Nelson H. H. Graburn, ed., *Ethnic and Tourist Arts: Cultural Expressions from the Fourth World,* pp. 85–101. Berkeley: University of California Press.

Kerels, Henri. 1937. *Arts et métiers Congolais: douze gravures originales en couleurs.* Brussels: Les Editions de Belgique.

Kincaide, Reese. 1933. *Genuine Indian Bead Work and Art Goods.* Catalogue. Colony, Okla.: Mohonk Lodge.

King, J. C. H. 1986. "Tradition in Native American Art." In Edwin L. Wade, ed., *The Arts of the North American Indian: Native Traditions in Evolution,* pp. 64–92. New York: Hudson Hills Press.

———. 1991. "A Century of Indian Shows. Canadian and United States Exhibitions in London 1825–1925." *European Review of Native American Studies* 5(1): 35–42.

Knizek, Ian. 1993. "Walter Benjamin and the Mechanical Reproducibility of Art Works Revisited." *British Journal of Aesthetics* 33(4): 357–72.

Kohl, Johann Georg. 1861. *Travels in Canada, and through the States of New York and Pennsylvania.* Trans. Mrs. Percy Sinnett. London: George Manwaring.

Kolodny, Rochelle. 1978. "Towards an Anthropology of Photography: Frameworks for Analysis." Master's thesis, McGill University.

Koppedrayer, K. I. 1993. "The Making of the First Iroquois Virgin: Early Jesuit Biographies of the Blessed Kateri Tekawitha." *Ethnohistory* 40(2): 277–306.

Kopytoff, Igor. 1986. "The Cultural Biography of Things: Commoditization as Process." In Arjun Appadurai, ed., *The Social Life of Things: Commodities in Cultural Perspective,* pp. 64–91. Cambridge: Cambridge University Press.

Kramer, Pat. 1995. *Totem Poles.* Vancouver: Altitude Publishing Canada.

Krapf, Ludwig [J. Lewis]. 1860. *Travels, Researches, and Missionary Labours, during an Eighteen Years' Residence in Eastern Africa.* Boston: Ticknor and Fields.

Krause, Aurel. 1956. *The Tlingit Indians: Results of a Trip to the Northwest Coast of America and the Bering Straits.* Seattle: University of Washington Press.

Krauss, Rosalind E. 1986. *The Originality of the Avant-Garde and Other Modernist Myths.* Cambridge, Mass.: MIT Press.

Kroeber, Alfred L. 1909. "California Basketry and the Pomo." *American Anthropologist* 11: 233–49.

———. 1976. *Handbook of the Indians of California.* New York: Dover. Originally published in 1925, Washington, D.C.: Bureau of American Ethnology, Smithsonian Institution.

Kubler, George. 1962. *The Shape of Time: Remarks on the History of Things.* New Haven, Conn.: Yale University Press.

Kunuk, Zacharias. 1991. "Zacharias Kunuk: Video Maker and Inuit Historian." *Inuit Art Quarterly* 6(3): 24–28.

Ladies' Home Journal. 1900. "House in the Northwest Built of Logs." First Series of Pictorial Articles, "Some Successful Country Houses." October: 2–3.

LaFrance, Ron. 1992. "Inside the Longhouse: Dances of the Haudenosaunee." In Charlotte Heth, gen. ed., *Native American Dance: Ceremonies and Social Traditions,* pp. 19–31. Washington, D.C.: National Museum of the American Indian, Smithsonian Institution, with Starwood Publishers.

Laing, Ellen J. 1988. *The Winking Owl: Art in the People's Republic of China.* Berkeley: University of California Press.

Lambert, John. 1810. *Travels through Lower Canada, and the United States of North America, in the Years 1806, 1807, & 1808.* 2 vols. London: Richard Phillips.

Lang, Herbert. 1918. "Famous Ivory Treasures of a Negro King." *American Museum Journal* 18(7): 527–52.

Lange, Patricia Fogelman. 1993. "Pueblo Pottery Figurines: Art as Social Criticism." Ph.D. diss., New York University.

———. 1995. "Nineteenth-Century Cochiti Figurines: Commodity Fetishes." *Museum Anthropology* 19(1): 39–44.

Lannoy, Richard. 1971. *The Speaking Tree: A Study of Indian Culture and Society.* London: Oxford University Press.

Layton, Robert. 1981. *The Anthropology of Art.* London: Elek.

———. 1991. *The Anthropology of Art.* 2d ed. Cambridge: Cambridge University Press.

———. 1992. "Traditional and Contemporary Art of Aboriginal Australia: Two Case Studies." In Jeremy Coote and Anthony Shelton, eds., *Anthropology, Art and Aesthetics,* pp. 137–59. Oxford: Clarendon Press.

Lears, Jackson. 1981. *No Place of Grace: Antimodernism and the Transformation of American Culture, 1880–1920.* New York: Pantheon.

———. 1989. "Beyond Veblen: Rethinking Consumer Culture in America." In Simon J. Bronner, ed., *Consuming Visions: Accumulation and Display of Goods in America, 1880–1920,* pp. 73–98. New York: W. W. Norton.

Lechtman, Heather. 1975. "Style in Technology: Some Early Thoughts." In *Material Culture: Styles, Organization, and Dynamics of Technology,* pp. 3–20. St. Paul, Minn.: West Publishing.

Lee, Jean Gordon. 1984. *Philadelphians and the China Trade, 1784–1844.* Philadelphia: Philadelphia Museum of Art.

Lee, Molly. 1991. "Appropriating the Primitive: Turn-of- the-Century Collection and Display of Native Alaskan Art." *Arctic Anthropology* 28(1): 6–15.

Leiris, Michel, and Jacquelin Delange. 1968. *African Art.* London: Thames and Hudson.

Lemire, Beverly. 1991. *Fashion's Favourite: The Cotton Trade and the Consumer in Britain, 1660–1800.* Pasold Studies in Textile History 9. Oxford: Oxford University Press.

Leroux, Odette, Marion E. Jackson, and Minnie Aodla Freeman. 1994. *Inuit Women Artists: Voices from Cape Dorset.* Hull, Quebec: Canadian Museum of Civilization.

Lessard, Michel. 1987. *The Livernois Photographers.* Quebec: Musée du Québec.

Lester, Francis E. 1904. *The Francis E. Lester Company . . . Indian Rugs Woven to Order, Fine Navajo Blankets, Pottery, Baskets, Mexican Drawnwork, Mexican Fire Opals.* Mesilla Park, N.Mex.

———. 1907a. *Indian and Mexican Handicraft.* Mesilla Park, N.Mex.

———. 1907b. *Indian and Mexican Handicraft: A Special Holiday Offering.* Mesilla Park, N.Mex.

———. 1910. *Seventh Annual Inventory Sale of Navajo Blankets, Mexican Drawn Linens, Indian Pottery, Mexican Silk Scarfs . . . , Etc.* Mesilla Park, N.Mex.

Lewis, Phillip. 1990. "Tourist Art, Traditional Art and the Museum in Papua New Guinea." In Allan and Louise Hanson, eds., *Art and Identity in Oceania,* pp. 149–63. Honolulu: University of Hawaii Press.

Liberty and Co. 1881. *Eastern and Miscellaneous.* No. 1. London: Liberty and Co., 1, p. 120.

———. 1930. *Silk Shawls.* No. 335. London: Liberty and Co.

Lillie, Maj. Gordon W. (Pawnee Bill), and Ray O. Lyon. N.d. *Pawnee Bill's Indian Trading Post (Oldtown).* Catalogue. Wholesale Catalog no. 5. Pawnee, Okla.

Linton, Ralph. 1923. *The Material Culture of the Marquesas Islands.* Memoirs of the Bernice Pauahi Bishop Museum. Vol. 8; Bayard Dominick Expedition Publication no. 5. Honolulu: Bishop Museum Press.

Lips, Julius E. 1937. *The Savage Hits Back; or, the White Man through Native Eyes.* Trans. Vincent Benson. London: Lovat Dickson. Republished in 1966.

Lipset, David M. 1987. *The Melanesian Ethic and the Spirit of Capitalism: Democracy in Papua New Guinea (1964–86).* Working Paper no. 9. Institute of International Studies, University of Minnesota, Minneapolis.

Lipset, David M., and Eric K. Silverman. N.d. "The Grotesque and the Moral: Ritual Figurations of the Body and Society in Iatmul Naven Ceremonies and the Murik Noganoga'sari."

Lipton, Barbara. 1984. *Arctic Vision: Art of the Canadian Inuit.* Ottawa: Canadian Arctic Producers.

Little, Kenneth. 1991. "On Safari: The Visual Politics of a Tourist Representation." In David Howes, ed., *The Varieties of Sensory Experience,* pp. 148–63. Toronto: University of Toronto Press.

Loomis, Chauncy C. 1977. "The Arctic Sublime." In U. C. Knoefplmacher and G. B. Tennyson, eds., *Nature and the Victorian Imagination,* pp. 95–112. Berkeley: University of California Press.

Low, Setha M. 1976. "Contemporary Ainu Wood and Stone Carving." In Nelson H. H. Graburn, ed., *Ethnic and Tourist Arts: Cultural Expressions from the Fourth World,* pp. 211–26. Berkeley: University of California Press.

Lurie, Alison. 1992. *The Language of Clothes.* Rev. ed. London: Bloomsbury. Originally published in 1981.

Lutkehaus, Nancy C. 1989. "'Excuse Me, Everything Is Not All Right': On Ethnography, Film and Representation." *Cultural Anthropology* 4: 422–37.

Lutz, Catherine A., and Jane L. Collins. 1993. *Reading National Geographic*. Chicago: University of Chicago Press.

Maalki, Liisa. 1994. "Citizens of Humanity: Internationalism and the Imagined Community of Nations." *Diaspora* 3(1): 41–68.

MacCannell, Dean. 1984. "Reconstructed Ethnicity, Tourism and Cultural Identity in Third World Communities." *Annals of Tourism Research* 11: 375–91.

———. 1989. *The Tourist: A New Theory of the Leisure Class*. Rev. ed. New York: Schocken. Originally published in 1976.

———. 1992. *Empty Meeting Grounds: The Tourist Papers*. New York: Routledge.

MacDowell, Lloyd. 1905. *The Totem Poles of Alaska*. Seattle: Alaska Steamship Company.

Mack, John. 1990. "Art, Culture and Tribute among the Azande." In Enid Schildkrout and Curtis A. Keim, *African Reflections: Art from Northeastern Zaire*, pp. 217–33. New York: American Museum of Natural History; Seattle: University of Washington Press.

Mackay, Charles. 1859. *Life and Liberty in America; or, Sketches of a Tour in the United States and Canada in 1857–8*. New York: Harper and Brothers.

Maclean, Neil. 1994. "Freedom or Autonomy: A Modern Melanesian Dilemma." *Man*, n.s., 29: 667–88.

Macnair, Peter, and Alan Hoover. 1984. *The Magic Leaves: A History of Haida Argillite Carving*. Victoria: British Columbia Provincial Museum.

Macnaught, Timothy J. 1982. "Mass Tourism and the Dilemmas of Modernization in Pacific Island Communities." *Annals of Tourism Research* 9: 359–81.

Maduro, Renaldo. 1976. "The Brahmin Painters of Nathdwara, Rajasthan." In Nelson H. H. Graburn, ed., *Ethnic and Tourist Arts: Cultural Expressions from the Fourth World*, pp. 227–44. Berkeley: University of California Press.

Mallgrave, Harry Francis. 1983. "The Idea of Style: Gottfried Semper in London." Ph.D. diss., University of Pennsylvania.

Manning, Agnes M. 1884. "To Alaska." *Overland Monthly* 3: 241–55.

Maquet, Jacques. 1986. *The Aesthetic Experience: An Anthropologist Looks at the Visual Arts*. New Haven, Conn.: Yale University Press.

Marcus, George E., and Michael M. J. Fischer, eds. 1986. *Anthropology as Cultural Critique: An Experimental Moment in the Human Sciences*. Chicago: University of Chicago Press.

Marcus, George E., and Fred R. Myers. 1995. "The Traffic in Art and Culture: An Introduction." In George E. Marcus and Fred R. Myers, eds., *The Traffic in Culture: Refiguring Art and Anthropology*, pp. 1–51. Berkeley: University of California Press.

Marcus, George E., and Fred R. Myers, eds. 1995. *The Traffic in Culture: Refiguring Art and Anthropology*. Berkeley: University of California Press.

Martijn, Charles A. 1964. "Canadian Eskimo Carving in Historical Perspective." *Anthropos* 59: 546–96.

Matthews, Washington. 1884. "Navajo Weavers." *Third Annual Report of the Bureau of Ethnology to the Secretary of the Smithsonian Institution, 1881–1882*, pp. 371–91. Washington, D.C.

Maurer, Evan M. 1986. "Determining Quality in Native American Art." In Edwin L. Wade, ed., *The Arts of the North American Indian: Native Traditions in Evolution*, pp. 142–55. New York: Hudson Hills.

Mauss, Marcel. 1990. *The Gift: The Form and Reason for Exchange in Archaic Societies.* Trans. W. D. Halls. New York: W. W. Norton. Originally published in English in 1954.

Maxwell, Laura W. 1905. "Canoeing through Southeastern Alaska." *Overland Monthly* 46: 4–14.

May, R. J. 1977. *The Artifact Industry: Maximising Returns to Producers.* Boroko, Papua New Guinea: Institute for Applied Economic and Social Research.

McClain, G. D. c. 1890. *G. D. McClain's Illustrated Catalogue of Mineral Ornaments and Souvenirs of the Great Rocky Mountain Regions.* Denver, Colo.

McCracken, Grant. 1990. "Textile History and the Consumer Epidemic: An Anthropological Approach to Popular Consumption and the Mass Market." *Material History Bulletin* 31: 62–83.

McDermott, John. 1986. *How to Get Lost and Found in Tahiti.* Honolulu: ORAFA.

McEvilley, Thomas. 1992. *Art and Otherness: Crisis in Cultural Identity.* Kingston, N.Y.: Documentext/ McPherson.

McIlwraith, Thomas. 1948. *The Bella Coola Indians.* 2 vols. Toronto: University of Toronto Press.

McKenney, L. M. & Co. 1882. *McKenney's Business Directory of the Principal Towns of Central and Southern California, Arizona, New Mexico, Southern Colorado and Kansas. . . .* Oakland and San Francisco, Calif.: Pacific Press.

McLean, Isabel C. 1977. "Eliza Ruhamah Scidmore: One of the First Travel Writers on Alaska." *Alaska Journal* 7(4): 238–43.

Mead, Margaret. 1938. "The Mountain Arapesh: An Importing Culture." *Anthropological Papers* 36: 139–349. New York: American Museum of Natural History.

———. 1978. "The Sepik as a Culture Area: Comment." *Anthropological Quarterly* 51: 69–75.

Meany, Edmond S. 1903. "Attu and Yakutat Basketry." *Pacific Monthly* 10: 211–19.

Meares, John. 1790. *Voyages Made in the Years 1788 and 1789.* London: Logographic Press. Reprinted in 1967 by Da Capo Press, New York.

Meauzé, Pierre. 1968. *African Art.* London: Weidenfeld and Nicolson.

Meline, James F. 1868. *Two Thousand Miles on Horseback. Santa Fe and Back. A Summer Tour through Kansas, Nebraska, Colorado, and New Mexico, in the Year 1866. . . .* New York: Hurd and Houghton.

Merwin, B. W. 1918. "The Patty Stuart Jewett Collection." *The Museum Journal* 9(3–4): 225–43.

Messick, Brinkley. 1987. "Subordinate Discourse: Women, Weaving and Gender Relations in North Africa." *American Ethnologist* 14(2): 210–25.

Meyer, Laure. 1992. *Black Africa: Masks, Sculpture, Jewelry.* Paris: Editions Pierre Terrail.

Michaels, Eric. 1994. "Bad Aboriginal Art." In *Bad Aboriginal Art: Tradition, Media, and Technological Horizons.* Minneapolis: University of Minnesota Press.

Miller, Daniel. 1987. *Material Culture and Mass Consumption.* Oxford: Basil Blackwell.

Mills, Sara. 1993. *Discourses of Difference: An Analysis of Women's Travel Writing and Colonialism.* New York: Routledge.

Mitchell, Marybelle. 1993. "Social, Economic, and Political Transformation among Canadian Inuit from 1950–1988." In Gerald McMaster, ed., *In the Shadow of the Sun: Perspectives on Contemporary Native Art,* pp. 333–56. Hull, Quebec: Canadian Museum of Civilization.

Moore, J. B. 1910. "This Navajo Indian Rug was woven and designed by the Navajo's expert weaver, Bi-Leen Alti Bi-Zha-Ahd." *The FRA* (May): viii.

———. 1987. *J. B. Moore, United States Licensed Indian Trader.* Albuquerque, N.Mex.: Avanyu Publishing.

Morgan, Lewis Henry. 1967. *League of the Ho-de-no-sau-nee or Iroquois.* New York: Corinth Books. Originally published in 1851.

Morphy, Howard. 1991. *Ancestral Connections: Art and an Aboriginal System of Knowledge.* Chicago: University of Chicago Press.

Morris, Rosalind. 1994. *New Worlds from Fragments: Film, Ethnography, and the Representation of Northwest Coast Cultures.* Boulder, Colo.: Westview Press.

Moulin, Jane Freeman. 1990. "The Cutting Edge of Tradition." *Pacific Arts* 1/2: 36–49.

———. 1994. "Chants of Power: Countering Hegemony in the Marquesan Islands." *Yearbook for Traditional Music* 26: 1–19.

Muir, John. 1915. *Travels in Alaska.* New York: Houghton Mifflin.

———. 1979. *Travels in Alaska.* Boston: Houghton Mifflin. Reprint of 1915 edition.

Mukerji, Chandra. 1983. *From Graven Images: Patterns of Modern Materialism.* New York: Columbia University Press.

Mullin, Molly H. 1992. "The Patronage of Difference: Making Indian Art 'Art, not Ethnology.'" *Cultural Anthropology* 7(4): 395–424.

Musée Municipal de Boulougne-Billancourt. 1989. *Coloniales 1920–1940.* Paris: Graphireal.

Museum of Modern Art (MoMA). 1936. "The United States Government and Abstract Art." *The Bulletin of The Museum of Modern Art* 3(5): 2–6.

Myers, Fred. 1989. "Truth, Beauty, and Pintupi Painting." *Visual Anthropology* 2: 163–95.

———. 1991. "Representing Culture: The Production of Discourse(s) for Aboriginal Acrylic Paintings." *Cultural Anthropology* 6: 26–63.

———. 1994. "Beyond the Intentional Fallacy: Art Criticism and the Ethnography of Aboriginal Acrylic Painting." *Visual Anthropology Review* 10: 10–44.

Myers, Marybelle. 1979. "Soapstone Carving and the Co-op Movement in Arctic Quebec." *Arts and Culture of the North* 3(4): 179–82.

———. 1984. "Inuit Arts and Crafts Cooperatives in the Canadian Arctic." *Canadian Journal of Ethnic Studies* 16(3): 132–53.

Nagam Aiya, V. 1906. *The Travancore State Manual* 3: 259–71. Trivandrum.

Nash, Dennison, and Valene L. Smith. 1991. "Anthropology and Tourism." *Annals of Tourism Research* 18: 12–25.

Nash, June, ed. 1993. *Crafts in the World Market: The Impact of Global Exchange on Middle American Artisans.* Albany: State University of New York Press.

Nash, Roderick. 1967. *Wilderness and the American Mind.* New Haven, Conn.: Yale University Press.

———. 1981. *Tourism, Parks and the Wilderness Idea in the History of Alaska.* Alaska in Perspective Series 4(1). Anchorage: Alaska Historical Commission.

Neich, Roger. 1993. *Painted Histories: Early Maori Figurative Painting.* Auckland, New Zealand: Auckland University Press.

Newcombe, W. A. 1931. Review of *Totem Poles of Gitksan* by C. M. Barbeau. *American Anthropologist* 33: 238–43.

Newton, Douglas. 1967. "Oral Tradition and Art History in the Sepik District, New

Guinea." In June Helm, ed., *Essays on the Verbal and Visual Arts*, pp. 200–215. Seattle, Wash.: American Ethnological Society.

Nicks, Trudy. 1980. "The Iroquois and the Fur Trade in Western Canada." In Carol M. Judd and Arthur J. Ray, eds., *Old Trails and New Directions: Papers of the Third North American Fur Trade Conference*, pp. 85–101. Toronto: University of Toronto Press.

———. 1982. *The Creative Tradition: Indian Handicrafts and Souvenir Arts*. Edmonton: Provincial Museum of Alberta.

———. 1990. "Indian Handicrafts: The Marketing of an Image." *Rotunda* 23(1): 14–20.

Nicks, Trudy, and Ruth Phillips. 1995. "From Wigwam to White Lights: Princess White Deer's Indian Acts." Paper presented to the Native American Workshop, April, Oporto, Portugal.

Niessen, Sandra A. 1985. *Motifs of Life in Toba Batak Texts and Textiles*. KITLV Verhandelingen Series no. 110. Dordrecht: Foris Publications.

———. 1989. "The Sadum: A Batak Cloth of Sumatra." *Tribal Art* (Musée Barbier-Mueller) 2: 15–24.

———. 1990. "Toba Batak Textile Inventions." In Mattiebelle Gittinger and R. J. Adroskoleu, eds., *Textiles in Trade: Proceedings of the Textile Society of America Biennial Symposium*, pp. 223–33. Washington, D.C.: Textile Society of America.

———. 1991. "Meandering through Batak Textiles." *Ars Textrina: The Art of Weaving* 16: 7–47.

———. 1993. *Batak Cloth and Clothing: A Dynamic Indonesian Tradition*. Kuala Lumpur: Oxford University Press.

———. 1994. "Words Can't Weave Cloth: Limits of the Textual for the Weave Technical." In Lynne Milgram and Penny van Esterik, eds., *The Transformative Power of Cloth in Southeast Asia*, pp. 128–34. Montreal: Canadian Asian Studies Association.

Nome News. 1902. "A Curio Collection." February 3: 2.

Norris, Frank. 1985. *Gawking at the Midnight Sun: The Tourist in Early Alaska*. Studies in History no. 170. Anchorage: Alaska Historical Commission.

Nuytten, Phil. 1982. *The Totem Carvers: Charlie James, Ellen Neel, and Mungo Martin*. Vancouver, B.C.: Panorama Publications.

O'Barr, William M. 1994. *Culture and the Ad: Exploring Otherness in the World of Advertising*. Boulder, Colo.: Westview Press.

O'Hanlon, Michael. 1993. *Paradise: Portraying the New Guinea Highlands*. London: British Museum Press.

———. 1995. "Modernity and the 'Graphicalization' of Meaning: New Guinea Highland Shield Design in Historical Perspective." *Journal of the Royal Anthropological Institute* 1: 469–93.

O'Neale, Lila M. 1932. "Yurok-Karok Basket Weavers." *University of California Publications in American Archaeology and Ethnology* 32(1).

O'Rourke, Dennis. 1987. *Cannibal Tours*. VHS, 77 min. Los Angeles: Direct Cinema.

Ortiz Echagüe, José. 1933. *España, tipos y trajes: 120 láminas*. Barcelona: Sociedad General de Publicaciones.

Pacific Coast Fire Insurance Company. 1940. *Our Fifty Years: 1890–1940*. Vancouver, B.C.: Pacific Coast Fire Insurance Company.

Pacific Coast Steamship Company. 1891. *All about Alaska*. Seattle: Pacific Coast Steamship Company.

———. 1894. *All about Alaska.* San Francisco: Goodall, Perkins & Co., General Agents.

———. 1900. *Alaska Excursions.* San Francisco: Goodall, Perkins & Co., General Agents.

———. 1911. *Alaska via Totem Pole Route.* Seattle: Pacific Coast Steamship Company.

Parezo, Nancy J. 1983. *Navajo Sandpainting: From Religious Act to Commercial Art.* Albuquerque: University of New Mexico Press.

Parker, Roszika. 1989. *The Subversive Stitch.* London: Routledge and Kegan Paul. Originally published in 1984.

Parker, Rozsika, and Griselda Pollock. 1981. *Old Mistresses; Women, Art and Ideology.* New York: Pantheon.

Parry, Benita. 1987. "Problems in Current Theories of Colonial Discourse." *Oxford Literary Review* 9(1–2): 46–50.

Paulme, Denise. 1962. *African Sculpture.* London: Elek Books.

Paulson, Ronald. 1975. *Emblem and Expression: Meaning in English Art of the Eighteenth-Century.* London: Thames and Hudson.

Pavitt, Nigel. 1991. *Samburu.* London: Kyle Cathie.

Pearce, Douglas G., and Richard W. Butler. 1993. *Tourism Research: Critiques and Challenges.* London: Routledge.

Pearce, Roy Harvey. 1988. *Savagism and Civilization: A Study of the Indian and the American Mind.* Rev. ed. Berkeley: University of California Press. Originally published in 1967.

Pearce, Susan M. 1993. *Museums, Objects, and Collections: A Cultural Study.* Washington, D.C.: Smithsonian Institution Press.

Peers, Laura. 1993. "Native Cultural Performance and Issues of Representation." Paper presented to Anthropology 724 seminar, McMaster University, April.

Peterson, Karen Daniels. 1971. *Plains Indian Art from Fort Marion.* Norman: University of Oklahoma Press.

Peterson, Susan. 1977. *The Living Tradition of Maria Martinez.* Tokyo: Kodansha International.

Phillips, Herbert P. 1992. *The Integrative Arts of Modern Thailand.* Berkeley, Calif.: Lowie Museum of Anthropology, University of California; Seattle: University of Washington Press.

Phillips, Ruth B. 1984. *Patterns of Power: The Jasper Grant Collection and Great Lakes Indian Art of the Early Nineteenth Century.* Kleinburg, Ontario: McMichael Canadian Collection.

———. 1989a. "Native American Art and the New Art History." *Museum Anthropology* 13(4): 5–13.

———. 1989b. "Souvenirs from North America: The Miniature as Image of Woodlands Indian Life." *American Indian Art* 14(2): 52–63, 78–79.

———. 1990. "Moccasins into Slippers: Woodlands Indian Hats, Bags, and Shoes in Tradition and Transformation." *Northeast Indian Quarterly* 7(4): 26–36.

———. 1991. "Glimpses of Eden: Iconographic Themes in Huron Pictorial Tourist Art." *European Review of Native American Studies* 5(2): 19–28.

———. 1995. "Why Not Tourist Art? Significant Silences in Native American Museum Representation." In Gyan Prakash, ed., *After Colonialism: Imperial Histories and Postcolonial Displacements,* pp. 98–125. Princeton, N.J.: Princeton University Press.

———. 1998. *Trading Identities: Native Art and the Souvenir in Northeastern North America, 1700–1900.* Seattle: University of Washington Press.

Phillips, Ruth B., and Dale Idiens. 1994. "'A Casket of Savage Curiosities': Eighteenth-Century Objects from North-eastern North America in the Farquharson Collection." *Journal of the History of Collections* 6(1): 21–33.

Podro, Michael. 1982. *The Critical Historians of Art.* New Haven, Conn.: Yale University Press.

Pollig, Herman, ed. 1987. *Airport Art: Das exotische Souvenir.* Exotische Welten, Europäische Phantasien, Insitut für Auslandbeziehungen. Stuttgart: Editions Cantz.

Porcher, W. Gadsden. 1903–4. "Basketry of the Aleutian Islands." *The Craftsman* 5(6): 575–83.

Powers, William K. 1988. "The Indian Hobbyist Movement in North America." In Wilcomb E. Washburn, ed., *History of Indian-White Relations,* vol. 4, pp. 557–61, of *Handbook of North American Indians,* William C. Sturtevant, gen. ed. Washington, D.C.: Smithsonian Institution Press.

Pratt, Mary Louise. 1992. *Imperial Eyes: Travel Writing and Transculturation.* New York: Routledge.

Premdas, Ralph R. 1987. *Ethnicity and Nation-Building: The Papua New Guinea Case.* Centre for Developing Area Studies, Discussion Paper no. 50. Montreal: McGill University.

Price, Sally. 1989. *Primitive Art in Civilized Places.* Chicago: University of Chicago Press.

Priest, Alan. 1945. *Costumes from the Forbidden City.* New York: Metropolitan Museum of Art.

Proust, Marcel. 1985. *Remembrance of Things Past.* 3 vols. Trans. C. K. Scott Moncrieff and Terence Kilmartin. Harmondsworth: Penguin.

Ramaswamy, N. 1976. *Tanore Painting: A Chapter in Indian Art History.* Madras, India: Kora's Indigenous Arts and Crafts Centre.

Rasmussen, Knud. 1931. "The Netsilik Eskimos." *Report of the Fifth Thule Expedition, 1921–24* 8(2). Copenhagen: Gyldenal.

Ray, Dorothy Jean. 1977. *Eskimo Art: Tradition and Innovation in North Alaska.* Seattle: University of Washington Press.

Red Fox, Chief William, and Lenore Sherman. 1968. "I Was with Buffalo Bill." *Real West* 11: 26–28, 64–65.

Reese Bullen Gallery. 1991. *Elizabeth Conrad Hickox: Baskets from the Center of the World.* Arcata, Calif.: Humboldt State University.

Reif, Rita. 1992. "Museum Displays Indian Artifacts." *New York Times,* November 15.

Rhodes, Richard. 1993. "Drunkards, Thieves and Liars: Stereotypes of Indians." Paper presented to the Algonkian Studies Conference, Carleton University, Ottawa.

Ricciardi, Mirella. 1977. *Vanishing Africa.* New York: Holt, Rinehart and Winston.

Rice, Faye. 1996. "Faking It With Nan and Kenny: Can a Socialite Spot a Phony?" *Fortune,* May 27: 138–40.

Richards, Thomas. 1990. *The Commodity Culture of Victorian England: Advertising and Spectacle: 1851–1914.* Stanford, Calif.: Stanford University Press.

Richter, Daniel K. 1985. "Iroquois versus Iroquois: Jesuit Missions and Christianity in Village Politics, 1642–1686." *Ethnohistory* 32(1): 1–16.

Richter, Dolores. 1980. *Art, Economics and Change: The Kulebele of Northern Ivory Coast.* La Jolla, Calif.: Psych/Graphic Publishers.

Rickard, Jolene. 1992. "Cew Ete Haw I Tih: The Bird That Carries Language Back to Another." In Lucy R. Lippard, ed., *Partial Recall,* pp. 105–11. New York: New Press.

Riegler, Johanna. 1988. "'Tame Europe' and the 'Mysteries of Wild America': Viennese Press Coverage of American Indian Shows, 1886–1898." *European Review of Native American Studies* 1(1): 17–20.

Rieske, Bill and Verla. 1974. *Historic Indian Portraits: 1898 Peace Jubilee Collection in Color.* Salt Lake City, Utah: Historic Indian Publishers.

Robertson, Colin. 1939. *Colin Robertson's Correspondence Book, September 1817 to September 1822,* E. E. Rich, ed. London: Champlain Society for the Hudson's Bay Record Society.

Robinson, Natalie V. 1987. "Mantónes de Manila: Their Role in China's Silk Trade." *Arts of Asia* 1: 65–75.

Rodee, Marian E. 1981. *Old Navajo Rugs: Their Development from 1900 to 1940.* Albuquerque: University of New Mexico Press.

Rogers, Phyllis. 1981. *The Image of the American Indian, Produced and Directed by "Buffalo Bill."* UCLA Museum of Cultural History Pamphlet Series, no. 13. Los Angeles: Regents of the University of California.

Rollin, Louis. 1974. *Moeurs et coutumes des anciens Maoris des Iles Marquises.* Papeete: Stepolde; Paris: La Pensée Moderne.

Root, Deborah. 1996. *Cannibal Culture: Art, Appropriation, and the Commodification of Difference.* Boulder, Colo.: Westview Press.

Rosman, Abraham, and Paula G. Rubel. 1990. "Structural Patterning in Kwakiutl Art and Ritual." *Man,* n.s., 25: 620–40.

Ross, Doran H., and Raphael X. Reichert. 1983. "Modern Antiquities: A Study of a Kumase Workshop." In Doran H. Ross and Timothy F. Garrard, eds., *Akan Transformations: Problems in Ghanaian Art History,* pp. 82–91. Los Angeles: Museum of Cultural History.

Rouse, Elizabeth. 1989. *Understanding Fashion.* Oxford: BSP Professional Books.

Routledge, Marie, with Marion E. Jackson. 1990. *Pudlo: Thirty Years of Drawing.* Ottawa: National Gallery of Canada.

Rushing, W. Jackson. 1992. "Marketing the Affinity of the Primitive and the Modern: René d'Harnoncourt and 'Indian Art of the United States.'" In Janet Catherine Berlo, ed., *The Early Years of Native American Art History: The Politics of Scholarship and Collecting,* pp. 191–236. Seattle: University of Washington Press.

Russell, Don. 1970. *The Wild West or a History of the Wild West Shows.* Fort Worth, Tex.: Amon Carter Museum.

Ryan, Pat. 1902. Letter to John Beck, April 8, 1902. Pittsburgh: Carnegie Museum of Natural History, Anthropology Archives.

Sahlins, Marshal. 1992. "The Economics of Develop-man in the Pacific." *RES* 21: 12–25.

Said, Edward W. 1978. *Orientalism.* New York: Pantheon Books.

Saisselin, Remy G. 1985. *Bricobracomania: The Bourgeois and the Bibelot.* London: Thames and Hudson.

Saitoti, Tepilit Ole, and Carol Beckwith. 1980. *Maasai.* New York: Harry N. Abrams.

Salvador, Mari Lyn. 1976a. "The Molas of the Cuna Indians, a Case Study of Art Criticism and Ethno-Aesthetics." Ph.D. diss., University of California, Berkeley.

———. 1976b. "The Clothing Arts of the Cuna of San Blas, Panama." In Nelson H. H. Graburn, ed., *Ethnic and Tourist Arts: Cultural Expressions from the Fourth World,* pp. 165–82. Berkeley: University of California Press.

———. 1978. *Yer dailege! Kuna Women's Art.* Albuquerque, N.Mex.: Maxwell Museum.

Sanborn Map Company. 1883. *Map of Santa Fe, New Mexico, October 1883.* New York: Sanborn Map and Publishing Company.

———. 1886. *Map of Santa Fe, New Mexico, June 1886.* New York: Sanborn Map and Publishing Company.

Sapir, Edward. 1924. "Culture: Genuine and Spurious." *American Journal of Sociology* 29: 401–29. 1937. "Fashion." In Edwin R. A. Seligman, ed., *Encyclopaedia of the Social Sciences,* vol. 5, pp. 341–45. New York: Macmillan.

Sarkar, B. K. 1917. *The Folk Element in Hindu Culture.* London: Longmans, Green.

Schildkrout, Enid. 1991. "The Spectacle of Africa through the Lens of Herbert Lang." *African Arts* 24(4): 70–85, 100.

Schildkrout, Enid, and Curtis A. Keim. 1990a. *African Reflections: Art from Northeastern Zaire.* New York: American Museum of Natural History; Seattle: University of Washington Press.

———. 1990b. *Mangbetu Ivories: Innovations between 1910 and 1914.* Discussion Papers in the African Humanities no. 5. Boston: Boston University African Studies Center.

Schildkrout, Enid, Jill Hellman, and Curtis A. Keim. 1989. "Mangbetu Pottery: Tradition and Innovation in Northeast Zaire." *African Arts* 22(2): 38–47.

Schmid, Jurg. 1990. "The Response to Tourism." In Nancy Lutkehaus et al., eds., *Sepik Heritage: Tradition and Change in Papua New Guinea,* pp. 241–44. Durham, N.C.: Carolina Academic Press.

Schmidt, Alvin J. 1980. *Fraternal Organizations.* Westport, Conn.: Greenwood Press.

Schmidt, Leigh Eric. 1989. "A Church-Going People Are a Dress-Loving People." *Church History* 58: 45.

Schor, Naomi. 1992. "Cartes Postales: Representing Paris 1900." *Critical Inquiry* 18: 188–245.

Schweinfurth, Georg A. 1874. *The Heart of Africa: Three Years' Travels and Adventures in the Unexplored Regions of Central Africa from 1868 to 1871.* 2 vols. Trans. Ellen E. Frewer. New York: Harper and Bros.

———. 1875. *Artes Africanae: Illustrations and Descriptions of Productions of the Industrial Arts of Central African Tribes.* Leipzig: F. A. Brockhaus.

Scidmore, Eliza Ruhamah. 1885. *Alaska: Its Southern Coast and the Sitkan Archipelago.* Boston: D. Lothrop.

———. 1898. *Appleton's Guide-Book to Alaska and the Northwest Coast.* New York: Appleton.

Sears, John F. 1989. *Sacred Places: American Tourist Attractions in the Nineteenth Century.* New York: Oxford University Press.

Seban, Laurel P. 1996. "The Search for a Usable Past: The Appropriation of Native American Art/ifacts." Master's thesis, University of California, Davis.

Secrest, William B. 1969. "'Indian' John Nelson." *Old West* 5: 24–27, 60–63.

Segy, Ladislas. 1955. *African Sculpture Speaks.* New York: Lawrence Hill.

Semper, Gottfried. 1989. "Science, Industry, and Art: Proposals for the Development of a National Taste in Art at the Closing of the London Industrial Exhibition (1852)." In *The Four Elements of Architecture and Other Writings,* pp. 130–67. Trans. Harry Francis Mallgrave and Wolfgang Herrmann. Cambridge: Cambridge University Press.

Sessions, Francis C. 1890. *From Yellowstone Park to Alaska.* New York: Welch, Fracker.

Shannon, Claude E., and Warren Weaver. 1949. *The Mathematical Theory of Communication.* Urbana: University of Illinois Press.

Shiner, Larry. 1994. "'Primitive Fakes,' 'Tourist Art,' and the Ideology of Authenticity." *Journal of Aesthetics and Art Criticism* 52: 225–34.

Silver, Harry R. 1976. "The Mind's Eye: Art and Aesthetics in an African Craft Community." Ph.D. diss., Stanford University.

———. 1981a. "Carving Up the Profits: Apprenticeship and Structural Flexibility in a Contemporary African Craft Market." *American Ethnologist* 8: 41–52.

———. 1981b. "Calculating Risks: The Socioeconomic Foundations of Aesthetic Innovation in an Ashanti Carving Community." *Ethnology* 20(2): 101–14.

Silverman, Debora. 1986. *Selling Culture: Bloomingdale's, Diana Vreeland, and the New Aristocracy of Taste in Reagan's America.* New York: Pantheon Books.

Silverman, Eric Kline. N.d. "Paint as Agency, Mythopraxis and Gender in Two Sepik River Societies: Aesthetic Meaning as Multidimensional Experience."

———. 1995. "Person, Shame and Conduct in New Guinea." Paper presented at the Annual Meeting of the American Anthropological Association, Washington, D.C.

———. 1996a. "On Cannibal Tours, Touristic Travails and Postmodern Platitudes: Is There Trouble in Paradise?" Paper presented at the Annual Meeting of the Association for Social Anthropology in Oceania, Kailua-Kona, Hawaii.

———. 1996b. "The Silent Aesthetic of Desire: Psychodynamic Perspectives on Iatmul Art, Gender and the Body." Paper presented at the Annual Meeting of the American Anthropological Association, San Francisco.

———. 1996c. "The Gender of the Cosmos: Totemism, Society and Embodiment in the Sepik River." *Oceania* 67: 30–49.

Simard, Jean Jacques. 1982. "La production cooperative d'art et d'artisanat inuit au Nouveau-Quebec." *Etudes/Inuit/Studies* 6(2): 61–91.

———. 1990. "White Ghosts, Red Shadows: The Reduction of North American Natives." In James A. Clifton, ed., *The Invented Indian: Cultural Fictions and Government Policies,* pp. 333–69. New Brunswick, N.J.: Transaction.

Simmel, Georg. 1957. "Fashion." *American Journal of Sociology* 62(6): 541–58.

Simmons, Marc. 1979. "History of the Pueblos since 1821." In Alfonso Ortiz, ed., *Southwest,* vol. 9, pp. 206–23, of *Handbook of North American Indians,* William C. Sturtevant, gen. ed. Washington, D.C.: Smithsonian Institution.

Singer, Milton B. 1959. "The Great Tradition in a Metropolitan Centre: Madras." In Milton B. Singer, ed., *Traditional India: Structure and Change,* pp. 141–82. Philadelphia: American Folklore Society.

Sitka Alaskan. 1883. "A Valuable Collection." July 1: 3.

Smith, Daniel. 1978. "Hindu 'Desika' Figures." *Religion* 8(1): 40–67.

Smith, Donald. 1974. *Le Sauvage: The Native People in Quebec Historical Writing on the Heroic Period (1534–1663) of New France.* Mercury Series, History Division Paper no. 6. Ottawa: National Museums of Canada.

Smith, Paul Chat. 1994. "Home of the Brave." *ÒCÓ Magazine* 42: 30–42.

Smith, Valene L. 1989. "Introduction." In Valene L. Smith, ed., *Hosts and Guests: The Anthropology of Tourism,* pp. 1–17. 2d ed. Philadelphia: University of Pennsylvania Press. Originally published in 1977.

Snyder, Joel. 1989. "Benjamin on Reproducibility and Aura: A Reading of 'The Work

of Art in the Age of Its Technical Reproducibility.'" In Gary Smith, ed., *Benjamin: Philosophy, Aesthetics, History*, pp. 158–74. Chicago: University of Chicago Press.

Société des Expositions du Palais des Beaux-Arts. 1988. *Ututombo: L'Art d'Afrique noire dans les collections privées belges.* Brussels: Société des Expositions du Palais des Beaux-Arts.

Sontag, Susan. 1970. "Posters: Advertisement, Art, Political Artifact, Commodity." In Dugald Stermer, ed., *The Art of Revolution*, pp. 1–17. New York: McGraw-Hill.

———. 1977. *On Photography.* New York: Dell.

Spear, Thomas, and Richard Waller, eds. 1993. *Being Maasai: Ethnicity and Identity in East Africa.* London: James Currey.

Speck, Frank G. 1977. *Naskapi: The Savage Hunters of the Labrador Peninsula.* Norman: University of Oklahoma Press. Originally published in 1935.

Speiser, Felix. 1966. "Art Styles in the Pacific." In Douglas Fraser, ed., *The Many Faces of Primitive Art: A Critical Anthology*, pp. 132–60. Englewood Cliffs, N.J.: Prentice Hall. Article originally published in German in 1941.

Spooner, Brian. 1986. "Weavers and Dealers: The Authenticity of an Oriental Carpet." In Arjun Appadurai, ed., *The Social Life of Things: Commodities in Cultural Perspective*, pp. 195–235. Cambridge: Cambridge University Press.

Stacey, C. P. 1959. *Records of the Nile Voyageurs, 1884–1885: The Canadian Voyageur Contingent in the Gordon Relief Expedition.* Publications of the Champlain Society, no. 37. Toronto: Champlain Society.

Stanley, David. 1992. *Tahiti-Polynesia Handbook.* Chico, Calif.: Moon Publications.

Starr, Laura B. 1889. "An Indian Room." *Decorator and Furnisher* 14(2): 38, 45.

Stein, Roger B. 1986. "Artifact as Ideology: The Aesthetic Movement in Its American Cultural Context." In Doreen Bolger Burke, ed., *In Pursuit of Beauty: Americans and the Aesthetic Movement*, pp. 23–51. New York: Metropolitan Museum of Art and Rizzoli.

Steinen, Karl von den. 1925. *Die Marquesaner und Ihrer Kunst: Tatauiering.* Vol. 1. Berlin: Dietrich Reimer.

———. 1928a. *Die Marquesaner und Ihrer Kunst: Plastik.* Vol. 2. Berlin: Dietrich Reimer.

———. 1928b. *Die Marquesaner und Ihrer Kunst: Die Sammlungen.* Vol. 3. Berlin: Dietrich Reimer.

Steiner, Christopher B. 1985. "Another Image of Africa: Toward an Ethnohistory of European Cloth Marketed in West Africa, 1873–1960." *Ethnohistory* 32(2): 91–110.

———. 1993. "Textiles and the Modern World System: A Commentary." Paper read at the conference "Cloth, the World Economy, and the Artisan: Textile Manufacturing and Marketing in South Asia and Africa, 1780–1950." Dartmouth College, April 23–25.

———. 1994. *African Art in Transit.* Cambridge: Cambridge University Press.

———. 1995. "Travel Engravings and the Construction of the Primitive." In Elazar Barkan and Ronald Bush, eds., *Prehistories of the Future: The Primitivist Project and the Culture of Modernism*, pp. 202–25. Stanford, Calif.: Stanford University Press.

———. 1996a. "Can the Canon Burst?" *Art Bulletin* 78(2): 213–17.

———. 1996b. "Discovering African Art . . . Again?" *African Arts* 29(4): 1–8, 93.

Stevenson, James. 1883. "Illustrated Catalogue of the Collections Obtained from the Indians of New Mexico and Arizona in 1879." *Second Annual Report of the Bureau of Ethnology to the Secretary of the Smithsonian Institution, 1880–81*, pp. 307–422. Washington, D.C.

Stewart, Hillary. 1990. *Looking at Totem Poles.* Seattle: University of Washington Press.

Stewart, Susan. 1984. *On Longing: Narratives of the Miniature, the Gigantic, the Souvenir, the Collection.* Baltimore, Md.: Johns Hopkins University Press. Reprinted by Duke University Press, 1993.

Stilwell, L. W. 1904. *Retail Catalogue No. 11. Established 1884. Twentieth Century Catalogue 1904. Black Hills Natural History, Indian Relic and Curio Establishment.* Deadwood, S.Dak.

———. 1971. *Wholesale Price List, Season of 1908–1909.* Reprinted for Four Winds Indian Trading Post. St. Ignatius, Mont.: Mission Valley News.

Stolpe, Hjalmar. 1927. "Studies in American Ornamentation, a Contribution to the Biology of Ornament." In Hjalmar Stolpe, *Collected Essays in Ornamental Art.* Stockholm: Aftonbladets Tryckeri. Originally published in 1896.

Strathern, Marilyn. 1988. *The Gender of the Gift: Problems with Women and Problems with Society in Melanesia.* Berkeley: University of California Press.

Stromberg, Gobi. 1976. "The Amate Bark-Paper Paintings of Xalitla." In Nelson H. H. Graburn, ed., *Ethnic and Tourist Arts: Cultural Expressions from the Fourth World,* pp. 149–62. Berkeley: University of California Press.

Strong, Allen A. 1915. *Strong Curio Co.* Catalogue. Gordon, Nebr.

Strong, Hilda Arthurs. 1933. *A Sketch of Chinese Arts and Crafts.* 2d ed. Peking: H. Vetch. Originally published in 1926.

Sturtevant, William C. 1986. "The Meanings of Native American Art." In Edwin L. Wade, ed., *The Arts of the North American Indian: Native Traditions in Evolution,* pp. 23–44. New York: Hudson Hills; Tulsa, Okla.: Philbrook Art Center.

Swanton, John. 1905. "Explanation of the Seattle Totem Pole." *Journal of American Folk-Lore* 18: 108–10.

Swinton, George. 1965. *Eskimo Sculpture.* Toronto: McClelland and Stewart.

Szabo, Joyce M. 1988. "Captive Artists and Changing Messages: The Paloheimo Drawing Books at the Southwest Museum." *Masterkey* 62(1): 12–21.

———. 1993. "Patrons and Historic Reconstructions: Muslin Paintings of the Death of Sitting Bull." Paper delivered at the American Society of Ethnohistory, November 5, Bloomington, Indiana.

———. 1994. *Howling Wolf and the History of Ledger Art.* Albuquerque: University of New Mexico Press.

Tahiti Beach Press. 1995–96. "Tahiti Prepares for the 21st Century with Dramatic Changes." *Tahiti Beach Press* 4(261), December 27–January 3: 2, 5, 13, 16.

Tammen, H. H. 1882. *Western Echoes. Devoted to Mineralogy, Natural History, Botany, &c., &c.* Denver, Colo.

———. 1886. *Objects of Interest from the Plains and Rocky Mountains.* Denver, Colo.

———. c. 1887. *Relics from the Rockies.* Denver, Colo.

———. c. 1896. *Curious Things from the Rocky Mountains.* Denver, Colo.

———. 1904. *The H. H. Tammen Curio Co. Denver, Colo. Established 1881.* Denver, Colo.

Taylor, Colin F. 1988. "The Indian Hobbyist Movement in Europe." In Wilcomb E. Washburn, ed., *History of Indian-White Relations,* vol. 4, pp. 562–69 of *Handbook of North American Indians,* William C. Sturtevant, gen. ed. Washington, D.C.: Smithsonian Institution Press.

Teilhet, Jehanne. 1978. "The Equivocal Role of Women Artists in Non-literate Societies." *Heresies* 1(4): 96–102.

Terrell, John, and Robert L. Welsch. 1990. "Trade Networks, Areal Integration, and Diversity along the North Coast of New Guinea." *Asian Perspectives* 29: 155–65.

Thomas, Nicholas. 1990. *Marquesan Societies: Inequality and Political Transformation in Eastern Polynesia.* Oxford: Clarendon Press.

———. 1991. *Entangled Objects: Exchange, Material Culture, and Colonialism in the Pacific.* Cambridge, Mass.: Harvard University Press.

———. 1996. "Cold Fusion." *American Anthropologist* 98: 9–25.

Thompson, Michael. 1979. *Rubbish Theory: The Creation and Destruction of Value.* Oxford: Oxford University Press.

Thomson, Joseph. 1885. *Through Masai Land.* London: S. Low, Marston, Searle and Rivington.

Tillinghast, Jon K. 1966. "Bear Essentials." *Alaska Airlines Magazine.* February: 44–51.

Tooker, Elizabeth. 1994. *Lewis H. Morgan on Iroquois Material Culture.* Tucson: University of Arizona Press.

Torgovnick, Marianna. 1990. *Gone Primitive: Savage Intellects, Modern Lives.* Chicago: University of Chicago Press.

Trafford, Diana. 1968. "Takurshungnaituk: Povungnituk Art." *North* 15: 52–55.

Trans-Mississippi and International Exposition. 1898. *Official Guide Book to the Trans-Mississippi and International Exposition.* June to November 1898. Omaha: Megeath Stationery.

Trennert, Robert A. 1993. "A Reservation of Native Arts and Crafts: The St. Louis World's Fair, 1904." *Missouri Historical Review* 87(3): 274–92.

Turner, Frederick Jackson. 1920. *The Frontier in American History.* New York: H. Holt.

United States Treasury Decisions. 1928. "C. Brancusi v. United States." Treasury Decision no. 43063, pp. 428–31. *United States Treasury Decision,* vol. 54 (July–December). Washington, D.C., 1929.

Van den Berge, Pierre, and Charles Keyes. 1984. "Introduction: Tourism and Re-Created Ethnicity." *Annals of Tourism Research* 11: 343–52.

Van Overbergh, Cyrille, and Eduard De Jonghe. 1909. *Les Mangbetu.* Brussels: Institut International de Bibliographie, Albert de Wit.

Venniyoor, E. 1981. *Ravi Varma.* Madras: Government of Kerala.

Villard, Henry. 1899. *A Journey to Alaska.* New York: Privately printed.

Visser, H. F. E. 1918–19. "Tentoonstelling der Oost-Indische Weefsel-Collectie van Kerckhoff in het Museum voor Land- en Volkenkunde te Rotterdam (Eind Maart tot Half Juni 1918)." *Cultureel Indie* 7: 17–33.

Vogel, Susan Mullin, ed. 1991. *Africa Explores: 20th Century African Art.* New York: Center for African Art; Munich: Prestel-Verlag.

Volkman, Toby Alice. 1990. "Visions and Revisions: Toraja Culture and the Tourist Gaze." *American Ethnologist* 17: 91–110.

Vollmer, John E. 1977. *In the Presence of the Dragon Throne: Ch'ing Dynasty Costume (1644–1911) in the Royal Ontario Museum.* Toronto: Royal Ontario Museum.

Waco News-Tribune. 1954. "Curator Sees Squaw Dresses as Key to World Understanding." *Waco News-Tribune,* October 1.

Wade, Edwin L. 1985. "The Ethnic Art Market in the American Southwest, 1880–1980." In George W. Stocking, Jr., ed., *Objects and Others: Essays on Museums and Material Culture,* pp. 167–91. History of Anthropology, vol. 3. Madison: University of Wisconsin Press.

————. 1986. *The Arts of the North American Indian: Native Traditions in Evolution*. New York: Hudson Hills; Tulsa, Okla.: Philbrook Art Center.

Wakefield, Priscilla. 1806. *Excursions in North America, described in Letters from a Gentleman and his Young Companion, to their Friends in England*. London: Darton and Harvey.

Walton, Ann T., John C. Ewers, and Royal B. Hassrick. 1985. *After the Buffalo Were Gone: The Louis Warren Hill, Sr., Collection of Indian Art*. St. Paul, Minn.: Northwest Area Foundation.

Walz, W. G. 1888. *Illustrated Catalogue of Mexican Art Goods and Curiosities. Also Indian Goods. For Sale by the Mexican Art and Curiosity Store, W. G. Walz, Proprietor*. El Paso, Tex.

Wardwell, Allen. 1967. *The Sculpture of Polynesia*. Chicago: Art Institute of Chicago.

————. 1994. *Island Ancestors: Oceanic Art from the Masco Collection*. Seattle: University of Washington in association with the Detroit Institute of Arts.

Washburn, Dorothy. 1984. "Dealers and Collectors of Indian Baskets at the Turn of the Century in California: Their Effect on the Ethnographic Sample." *Empirical Studies of the Arts* 2(1): 51–74.

Wassing, René S. 1970. *The Arts of Africa*. London: Thames and Hudson.

Waters, Walter. 1940. *Totem Lore*. Wrangell, Alaska: Bear Totem Store.

Watt, Virginia. 1993. "The Canadian Eskimo Arts Council Did Not Limp onto the Scene." *Inuit Art Quarterly* 8(4): 51–53.

Webb, Terry D. 1994. "Highly Structured Tourist Art: Form and Meaning of the Polynesian Cultural Center." *The Contemporary Pacific* 6: 59–86.

Weigle, Marta. 1982. *Spiders and Spinsters: Women and Mythology*. Albuquerque: University of New Mexico Press.

————. 1989. "From Desert to Disney World: The Santa Fe Railway and the Fred Harvey Company Display the Indian Southwest." *Journal of Anthropological Research* 45(1): 115–37.

Weigle, Marta, and Barbara Babcock, eds. 1996. *The Great Southwest of the Fred Harvey Company and the Santa Fe Railway*. Phoenix, Ariz.: Heard Museum.

Weiner, Annette. 1992. *Inalienable Possessions: The Paradox of Keeping-While-Giving*. Berkeley: University of California Press.

Weld, Isaac. 1799. *Travels through the States of North America and the Provinces of Upper and Lower Canada during the years 1795, 1796, and 1797*. 2 vols. London: Printed for John Stockdale, Picadilly.

Western Airlines. 1962. *Much about Totems*. Seattle: Western Airlines.

Whitehead, Ruth Holmes. 1982. *Micmac Quillwork*. Halifax: Nova Scotia Museum.

————. 1987a. "I Have Lived Here since the World Began." In *The Spirit Sings: Artistic Traditions of Canada's First Peoples*, pp. 17–49. Toronto: McLelland and Stewart; Calgary: Glenbow Museum.

————. 1987b. "East Coast." In *The Spirit Sings: The Artistic Traditions of Canada's First Peoples: A Catalogue of the Exhibition*, pp. 11–36. Toronto: McLelland and Stewart; Calgary: Glenbow Museum.

Wight, Darlene. 1991. "Inuit Tradition and Beyond: New Attitudes toward Art-Making in the 1980s." *Inuit Art Quarterly* 6(2): 8–15.

Wilk, Richard R. 1991. *Household Ecology: Economic Change and Domestic Life among the Kekchi Maya in Belize*. Tucson: University of Arizona Press.

Wilkie, Harriet C. 1902. "American Basketry." *Modern Priscilla* 16(4): 1–2.

William Barr Dry Goods Co. 1901. *Nooks and Corners*. St. Louis, Mo.

William, Clint. 1877–79. "The Aborigines of Canada under the British Crown." *Transactions of the Literary and Historical Society of Quebec*, n.s., 9: 63–113.

Williams, Rosalind H. 1982. *Dream Worlds: Mass Consumption in Late Nineteenth-Century France*. Berkeley: University of California Press.

Wilson, R. Kent, and Karen Menzies. 1967. "Production and Marketing of Artefacts in the Sepik Districts and the Trobriand Islands." *New Guinea Research Bulletin* 20: 50–75.

Wilson, Thomas. 1896. "The Swastika, the Earliest Known Symbol, and Its Migrations; with Observations on the Migration of Certain Industries in Prehistoric Times." *Report of the U. S. National Museum . . . for the Year Ending June 30, 1894*, pp. 757–1011. Washington, D.C.

Wilson, Verity. 1986. *Chinese Dress*. Far Eastern Series. London: Victoria and Albert Museum.

Wolf, Eric R. 1982. *Europe and the People without History*. Berkeley: University of California Press.

Wolfe, Roy I. 1962. "The Summer Resorts of Ontario in the Nineteenth Century." *Ontario History* 54(3): 149–63.

Wolff, Janet. 1984. *The Social Production of Art*. New York: New York University Press. Originally published in 1981.

Wolff, Norma H. 1985. "Adugbologe's Children: Continuity and Change in a Yoruba Woodcarving Industry." Ph.D. diss., Indiana University.

Wollen, Peter. 1991. "Cinema/Americanism/the Robot." In James Naremore and Patrick Brantlinger, eds., *Modernity and Mass Culture*, pp. 42–69. Bloomington: Indiana University Press.

Wong, Hertha. 1989. "Pictographs as Autobiography: Plains Indian Sketchbooks of the Late Nineteenth and Early Twentieth Centuries." *American Literary History* 1(2): 295–316.

Wray, Henry Russell. 1894. "A Gem in Art: Henry Russell Wray's Jolly Portrayal of a Visit to Gold's Curiosity Shop." *Weekly New Mexican Review*, June 21.

Wright, Robin K. 1982. "Haida Argillite: Carved for Sale." *American Indian Art Magazine* 8(1): 48–55.

Wyatt, Victoria. 1984. *Shapes of Their Thoughts: Reflections of Culture Contact in Northwest Coast Indian Art*. New Haven, Conn.: Peabody Museum of Natural History, Yale University; Norman: University of Oklahoma Press.

———. 1989. *Images from the Inside Passage: An Alaskan Portrait by Winter and Pond*. Seattle: University of Washington Press in association with Alaska State Library.

Young, Robert J. C. 1995. *Colonial Desire: Hybridity in Theory, Culture, and Race*. London: Routledge.

Younge, Gavin. 1988. *Art of South African Townships*. London: Thames and Hudson.

Zilberg, Jonathan. 1995. "Shona Sculpture's Struggle for Authenticity and Value." *Museum Anthropology* 19(1): 3–24.

Zinmaster, William. 1946. "Alaskan Tourist Industry." Master's thesis, University of Pennsylvania.

CONTRIBUTORS

Jonathan Batkin is director of the Wheelwright Museum in Santa Fe, New Mexico. He is a specialist in the Native American art of the Southwest and author of *Pottery of the Pueblos of New Mexico, 1700–1940* (1987).

Janet Catherine Berlo is the Susan B. Anthony Chair of Gender and Women's Studies and professor of art history at the University of Rochester. Her publications include *Plains Indian Drawings 1865–1935: Pages from a Visual History* (1996) and *The Early Years of Native American Art History* (1992).

Marsha C. Bol is associate curator of anthropology at the Carnegie Museum of Natural History, Pittsburgh. She has published widely on the arts of Plains peoples of North America and on the role of gender in the production of those arts.

Marvin Cohodas is professor of art history at the University of British Columbia. He has published extensively on Pre-Columbian art and on the turn-of-the-century commoditization of Northwest Coast basketry. His books include *The Great Ball Court of Chichen Itza* (1978) and *Degikup: Washoe Fancy Basketry, 1895–1935* (1979).

Frank Ettawageshik is tribal chairman of the Little Traverse Bay Bands of Odawa Indians in Michigan and a member of the Michigan Humanities Council. He is a practicing potter who works in traditional and contemporary styles and a descendant of a family of Odawa artists and tourist art dealers.

Nelson H. H. Graburn is professor of anthropology at the University of California, Berkeley. He is the editor of the pioneering volume *Ethnic and Tourist Arts: Cultural Expressions from the Fourth World* (1976) and, with Molly Lee, au-

thor of the *Catalogue Raisonné of the Alaska Commercial Company Collection* (1996). He is an associate editor of the *Annals of Tourism Research.*

Stephen R. Inglis is director of research at the Canadian Museum of Civilization, Ottawa. Since receiving his doctorate in anthropology from the University of British Columbia, based on research with rural potter-priests in South India, he has specialized in the study of artists and their communities.

Carol S. Ivory received a Ph.D. in art history from the University of Washington. She is currently associate professor in the Department of Fine Arts at Washington State University. She is currently at work on a book about Marquesan sculpture and tapa cloth.

Aldona Jonaitis is director of the University of Alaska Museum and a scholar in Native American art specializing in the Northwest Coast. Her most recent books include *Chiefly Feasts: The Enduring Kwakiutl Potlatch* (1991) and *A Wealth of Thought: Franz Boas and Native American Art History* (1995).

Sidney Littlefield Kasfir is associate professor of art history at Emory University. She is a specialist in the arts of Nigeria and Kenya and author of *The Wounded Warrior: Colonial Transformations in African Art* (forthcoming) and *Contemporary African Art* (in press).

Molly Lee is curator of ethnology and history at the University of Alaska Museum and associate professor of anthropology at the University of Alaska, Fairbanks. She is currently doing fieldwork in southwestern Alaska for a study of Yup'ik Eskimo coiled basketry and is beginning research for a study on the role of missionaries in the development of Native art.

Trudy Nicks is senior curator in the Department of Anthropology at the Royal Ontario Museum. She has published articles and catalogs on Metis ethnohistory, art, and early western Canadian Indian tourist art. She recently served as co-chair of the Canadian Task Force on Museums and First Nations.

Sandra Niessen is associate professor of anthropology at the University of Alberta. Out of her extensive fieldwork in Indonesia she has published numerous articles on the development of Toba Batak textiles and a book entitled *Batak Cloth and Clothing: A Dynamic Indonesian Tradition* (1993).

Nancy J. Parezo is curator of ethnology at the Arizona State Museum and has published extensively on Navajo sandpaintings and the history of women in anthropology and museums. Her books include *Navajo Sandpainting: From Religious Act to Commercial Art* (1983) and *Hidden Scholars: Women Anthropologists and the Native American Southwest* (1993).

Ruth B. Phillips is director of the Museum of Anthropology and professor of fine arts and anthropology at the University of British Columbia. She has

published on historic and contemporary Great Lakes Indian art, as well as the arts of the Mende of Sierra Leone, West Africa. Her recent books include *Representing Woman: Sande Masquerades of the Mende of Sierra Leone* (1995) and *Trading Identities: The Souvenir and Native North American Art from the Northeast, 1700–1900* (1998).

Enid Schildkrout is curator of anthropology at the American Museum of Natural History and adjunct professor of anthropology at Columbia University. She is the author, with Curtis A. Keim, of the award-winning exhibition catalog *African Reflections: Art from Northeastern Zaire* (1990) and coeditor of *The Scramble for Art in Central Africa* (1997).

Eric Kline Silverman is assistant professor of Anthropology at DePauw University. In addition to studying Sepik River tourism and art, he is completing a book on body symbolism, gender, and the self in Iatmul *naven* rituals.

Christopher B. Steiner is Lucy C. McDannel '22 associate professor of art history and director of Museum Studies at Connecticut College. He is the author of *African Art in Transit* (1994) and coeditor of *Perspectives on Africa: A Reader in Culture, History, and Representation* (1997). He has taught anthropology and art history at the University of Southern California, University of California at Los Angeles, and the University of East Anglia, and has held senior fellowships at the School of American Research and the Getty Research Institute.

Verity Wilson is assistant curator for the Far East at the Victoria and Albert Museum, specializing in the study of textiles. Her current research focuses on the religious vestment traditions of China. She is the author of *Chinese Dress* (1986).

INDEX

Indexer: Ruth Elwell
Compositor: Integrated Composition Systems
Text: 10/12 Baskerville
Display: Baskerville
Printer: Data Reproductions